Volume 33 / 1998

METROPOLITAN MUSEUM JOURNAL

Editorial Board

Executive Editor, Barbara Burn

As Barbara Burn relinquishes her position as Executive Editor of the *Metropolitan Museum Journal*, a position she has
held for eleven years, the members of the Editorial Board express their appreciation of her professionalism, commitment,
and collegiality.

The publication of volume 33 of the *Journal* was made possible in part by Lee Paula Miller and The Adelaide Milton de
Groot Fund, in memory of the de Groot and Hawley families.

The *Metropolitan Museum Journal* is published annually by The Metropolitan Museum of Art, 1000 Fifth Avenue, New York,
New York 10028, and is distributed by the University of Chicago Press, P. O. Box 37005, Chicago, Illinois 60637.

ISSN 0077–8958
Library of Congress Catalogue Number 68–28799
Copyright © 1998 by The Metropolitan Museum of Art

Designed by Bruce Campbell, on a format initially conceived by Peter Oldenburg
Production by Richard Bonk
Composition by Ilana Greenberg
Printed by Meridian Printing
Bound by Acme Bookbinding Co., Inc.

Contents

ABBREVIATIONS

MMA—The Metropolitan Museum of Art
MMAB—The Metropolitan Museum of Art Bulletin
MMJ—Metropolitan Museum Journal

Height precedes width in dimensions cited.
Photographs, unless otherwise attributed,
are by the Photograph Studio,
The Metropolitan Museum of Art.

The Publications of Edith Appleton Standen, 1986–1998

Our cherished colleague Edith Appleton Standen, Curator Emeritus in the Department of European Sculpture and Decorative Arts at The Metropolitan Museum of Art and internationally respected dean of tapestry studies, died at her home in New York City on July 17, 1998, at the age of 93. Miss Standen's scholarly activity continued unabated to the very end. She inspired all of us in the Museum by her example, while she followed our own efforts with keen interest and encouraging words. One of the Museum's most productive scholars, she was also one of the most frequent contributors to the pages of this *Journal*. In 1985 we celebrated her eightieth birthday by publishing a bibliography of all her writings (*MMJ* 19/20, 1984–85, pp. 5–10). We present herewith a list of her subsequent publications, noting that from 1986 to 1993 she was additionally the indefatigable compiler and distributor of the biennial *Navette-Shuttle*, the main bibliographic source in the tapestry field. Among the completed manuscripts she left at her death, a brilliantly penetrating investigation of armorial tapestries after Le Brun will appear in next year's *Journal*.

1986

Boucher as Tapestry Designer. *François Boucher, 1703–1770*. Exh. cat. New York: MMA, 325–333.

Catalogue of tapestries. *François Boucher, 1703–1770*. Exh. cat. New York: MMA, 334–344.

The *Fragments d'Opéra*: A Series of Beauvais Tapestries after Boucher. *MMJ* 21, 123–137.

Vera Icon: An Early Sixteenth-Century Brussels Tapestry of St. Veronica. *Artes Textiles* 11, 65–67.

1987

Renaissance to Modern Tapestries in The Metropolitan Museum of Art. *MMAB*, Spring, 4–56.

The Zagreb Louvre (letter in response to Andrew Decker's article "Real and Fake in the Zagreb Louvre," *Art News*, Summer 1987). *Art News* 86, no. 8, September, 9.

1988

Ovid's Metamorphoses: A Gobelins Tapestry Series. *MMJ* 23, 149–191.

Soleil sur fond d'or. *Connaissance des Arts* 434, April, 60–69.

Some Tapestries at Princeton. *Record of the Art Museum* (Princeton University) 47, no. 2, 2–18.

1989

Jean-Jacques-François Le Barbier and Two Revolutions. *MMJ* 24, 255–274.

1990

The Jardin des Plantes: An Entrefenêtre for the Maisons Royales Gobelins Tapestry Series. *CIETA Bulletin* 68, 47–52.

1992

The Garden of the Sun-King: A Gobelins Tapestry in the Virginia Museum of Fine Arts. *Arts in Virginia* 30, nos. 2–3, Fall–Winter, 2–9.

Two Drawings for Two Gobelins Tapestries. *Master Drawings* 30, no. 4, Winter, 429–434.

1993

Children of the Sun King: Some Reconsiderations. *MMJ* 28, 121–127.

Madame de Pompadour's Gobelins Tapestries. *Conservation Research: Studies of Fifteenth- to Nineteenth-Century Tapestry*, Lotus Stack, ed. Studies in the History of Art Monograph Series II, vol. 42. Washington: National Gallery of Art, 14–33.

1994

A Banner for St. Peter, Chaillot: Identifying a Savonnerie Panel. *Apollo* 39, January, 46–47.

Country Children: Some *Enfants de Boucher* in Gobelins Tapestry. *MMJ* 29, 111–133.

1996

(with Janet Arnold) The Comte de Toulouse's *Months of Lucas* Gobelins Tapestries: Sixteenth-Century Designs with Eighteenth-Century Additions. *MMJ* 31, 59–69.

1997

Introduction: The Immediate Postwar Period, 1945–51. *The Spoils of War,* Elizabeth Simpson, ed. New York: Harry N. Abrams.

Lisbon's Tiles (letter on painted tiles of Portugal and garden at Luminar). *The New York Times,* June 1, section 5, 16.

1998

The Tapestry Weaver and the King: Philippe Behagle and Louis XIV. *MMJ* 33, 183–204.

Forthcoming (1999)

For Minister or for King: Two Seventeenth-Century Gobelins Tapestries after Charles Le Brun. *MMJ* 34.

Two Costume Drawings by François-André Vincent. *Master Drawings* 37, no. 3.

Forthcoming (2001)

Chapter 15: Early Modern Tapestries and Carpets, c. 1500–1700. *Cambridge History of Western Textiles.* Cambridge: Cambridge University Press.

Some Long Thoughts on Early Cycladic Sculpture

JOAN R. MERTENS

Curator, Greek and Roman Art, The Metropolitan Museum of Art

For Dolly Goulandris

THE OPENING OF THE Robert and Renée Belfer Court in May 1995 brought to fruition the first phase of the reinstallation of the Greek and Roman collections at The Metropolitan Museum of Art. Devoted to Greek art from the Neolithic through the Archaic periods, the Belfer Court presents selections from the department's ample and varied holdings, which document the artistic and cultural evolution from approximately 4500 B.C. to 480 B.C. The installation process afforded an opportunity to reconsider the material from various perspectives. In the present article, I propose to focus attention upon works of art that were made in the Cycladic Islands during the Late and Final Neolithic periods (ca. 5300–3200 B.C.) and the Early Bronze Age (ca. 3200–2200 B.C.).

The points to be addressed—some general, some specific—revolve around the question of continuity. Within the last twenty-five years, the increase in archaeological evidence owing to excavation and the introduction of new lines of investigation have had a considerable impact upon the study of Greek culture before about 1000 B.C. Perhaps the greatest single advance has been the recognition of the degree of interconnection that existed between sites and cultures during chronologically remote periods. In particular, the "Dark Ages," which were believed to represent a period of total desolation between the demise of the Minoan and Mycenaean civilizations about 1200 B.C. and the rebirth of socially organized existence between about 1000 and 900 B.C., are now acquiring a quite different aspect. There is evidence for significant, active communities, of which Lefkandi on Euboea is the best known,[1] and for intensive contact driven by settlement and trade with centers in the eastern Mediterranean, such as Cyprus.[2] Because the *Iliad* and the *Odyssey*, whose composition is generally dated to the eighth century B.C., recount events that took place during and after the Trojan War, conventionally

placed in the twelfth century B.C., these works remain invaluable written sources that span the prehistoric and the beginning of the historical era.[3]

The picture that is now emerging of the Greek world and the eastern Mediterranean is one of extraordinary complexity and unexpected cohesion. The present juncture is conducive indeed to considering appropriate topics from a broad perspective. Such an approach is all the more desirable in view of the fact that from at least 5000 B.C. on, there has been continual habitation of the Greek mainland and the major islands. From time to time, therefore, it is useful to lift a body of material from its most restricted, immediate context and to survey possible points of contact within the larger Greek developmental continuum. I have two specific concerns here: to recognize the evolution of marble sculpture in the Cyclades as one coherent process from the Neolithic period to the end of the Early Bronze Age (known in the Cyclades as the Early Cycladic period) and to isolate some features of Early Cycladic culture that have parallels in the Geometric period (ca. 1000–700 B.C.). Among the scholars of Early Cycladic sculpture and its antecedents, Saul S. Weinberg was distinguished by his particularly broad and deep field of vision. Many of the ideas presented here depend upon, and proceed from, his fundamental study "Neolithic Figurines and Aegean Interrelations," published in 1951.[4]

Situated in the Aegean Sea, in the generally circular conformation that gives them their name, the Cycladic Islands were first populated in antiquity considerably later than other parts of what we know as the Greek world.[5] Although there are traces of habitation in Thessaly, southern Greece, and Crete during the Early Neolithic period (seventh millennium B.C.), the Cyclades were evidently not settled until the Late Neolithic period (late sixth millenium B.C.). The earliest known settlement has been discovered on Saliagos, now a very small island near Paros but at that time part of an isthmus linking Paros and Antiparos. Saliagos produced, among other finds, a marble figure

The notes for this article begin on page 20.

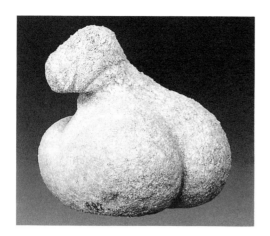 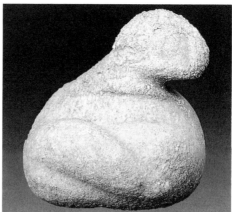

Figure 1. Steatopygous female figure, Cycladic, Neolithic, ca. 5300–4500 B.C. H. 5.9 cm. Paros Museum 887 (photo: Papathanassopoulos, *Neolithic Culture in Greece*, p. 319, no. 240)

of a fat woman, seated with her left leg slung over the right;[6] the exceedingly pronounced thighs and buttocks characterize a condition known as steatopygy and underlie the conventional interpretation of such objects as being associated with fertility (Figure 1). The work is dated between about 5300 and 4500 B.C.

As the quantity of evidence for human activity in the Cyclades during the later phases of the Neolithic period gradually increases, certain features of the time become clear. Given the barrenness of these rocky outcroppings, the inhabitants derived their livelihood from the sea and from indigenous resources, most notably obsidian, a volcanic glass of which the chief Aegean source is Melos; obsidian was used to make

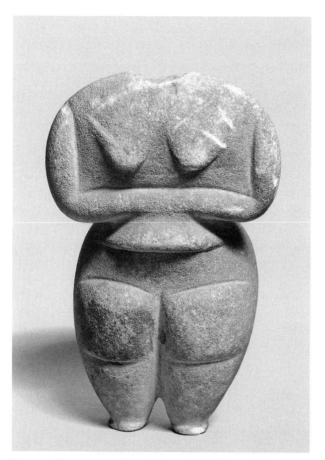

Figure 2. Steatopygous female figure, Cycladic, Neolithic, ca. 5000–3500 B.C. H. 21.5 cm. The Metropolitan Museum of Art, Bequest of Walter C. Baker, 1971, 1972.118.104

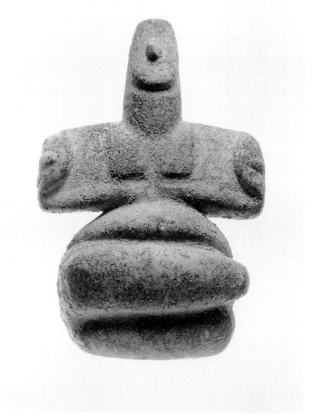

Figure 3. Steatopygous female figure, Cycladic, Neolithic, ca. 5000–3500 B.C. H. 20.5 cm. The Collection of Shelby White and Leon Levy (photo: Sarah Wells)

tools and, as early as the Upper Paleolithic period (before ca. 8000 B.C.), had been brought to the Greek mainland as far north as Macedonia.[7] The significance of obsidian lies in the proof that it provides for intensive exploitation and extensive diffusion around the Aegean world from earliest times.

Another resource abundant on many Cycladic islands is marble. The steatopygous lady from Saliagos demonstrates absolute mastery of the material and of the human figure, as does her contemporary with a tighter silhouette found on Naxos.[8] Several other Neolithic figures of the same type, while lacking in secure provenances, are believed to come from the Cyclades as well.[9] Foremost among them are the examples in Brussels, said to be from Amorgos,[10] and in Oxford, reportedly from Naxos.[11] The pieces in The Metropolitan Museum of Art[12] (Figure 2) and in the collection of Shelby White and Leon Levy[13] (Figure 3) are associated with either the Cyclades or Attica; the discovery of steatopygous ladies on Aegina[14] and in the area of Athens,[15] as well as the results of John Coleman's excavations at Kephala on Keos,[16] belong to the body of evidence for connections between parts of the Cyclades and central Greece.[17] The appearance of accomplished marble figures rendered naturalistically—and no doubt appropriately to their function—at the time when the Cyclades were beginning to be inhabited speaks for the cultural level of the inhabitants, both technically and conceptually. The objection might be raised that the knowledge of marble working, or possibly even the objects themselves, were brought by the settlers, who presumably arrived from the east. Similarities between the Cycladic steatopygous ladies and those from Macedonia, Thrace, Thessaly, and Crete made of both stone and clay militate against this argument. Moreover, the extraordinarily skillful knapping of the obsidian cores into blades and the use of local stone for houses and tombs as well as utensils, pendants, and other small objects indicate that the islanders quickly adapted whatever skills they may have brought to local conditions and resources.

The early marble figures from the Cyclades consist not only of the "voluptuous" type but also of very simple, schematic pieces. Major, recurrent varieties have been categorized as "yarn-winders [*Garnwicklern*]," "spade-shaped," and "violin-shaped."[18] A marble example from Saliagos represents the violin form (Figure 4), while others from the site seem to be summarily worked beach pebbles.[19] The contemporaneity of naturalistic and schematic representations is critically important: given the total absence of written records, and the scarcity and difficulty of other forms of evidence, stylistic criteria figure prominently in establishing relative and absolute chronologies. Since progression from "abstract" to "realistic" is a staple of art-historical taxonomy, often with chronological implications, it is invaluable that Neolithic Saliagos has produced both types.

The transition from the Neolithic period to the Early Bronze Age was an evolutionary process.[20] Evidence is only slowly accumulating for sites in the Cyclades that continued from one era to the next;[21] a hallmark of the Early Bronze Age is the burgeoning of settlements with distinctive cultural assemblages that also permit chronological determinations.[22] The earlier phases of the Early Cycladic period—Early Cycladic I and II—are also known as the Grotta-Pelos culture, after two typesites, while the mature phase of Early Cycladic II is associated with the Keros-Syros culture. This period, about 3200 to 2200 B.C., saw the flowering of Cycladic marble sculpture, the profusion of figures as well as of vessels.

The study and classification of Cycladic figures began in the 1880s, when British and German traveler-scholars undertook the first visits and excavations that yielded prehistoric objects. Momentum increased significantly as the twentieth century progressed; archaeological activity enormously augmented the available material, which in turn prompted ever more refined analyses of the sculptural varieties, the identification of individual artists, and other specialized studies.[23] The greatest contributions in these specific areas have been made by Saul Weinberg, Jürgen Thimme, Colin Renfrew, and Pat Getz-Gentle (formerly known as Pat Getz-Preziosi).

The developmental pattern for Cycladic figures, which Pat Getz-Gentle's much-reproduced chart encapsulates

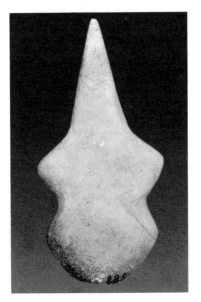

Figure 4. Schematic figure, Cycladic, Neolithic, ca. 5300–4500 B.C. H. 6.6 cm. Paros Museum 885 (photo: Papathanassopoulos, *Neolithic Culture in Greece*, p. 320, no. 242)

9

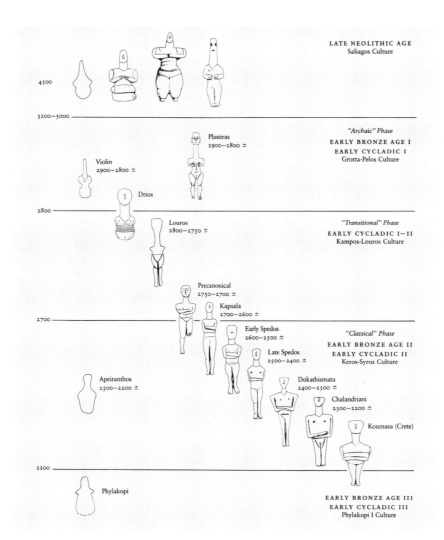

Figure 5. Chart showing the major types of female figure in Cycladic art and their chronological relation. (Pat Getz-Preziosi, *Sculptors of the Cyclades: Individual and Tradition in the Third Millennium B.C.* [Ann Arbor, The University of Michigan Press, copyright The University of Michigan, 1987] p. 8, fig. 3)

in simplified form (Figure 5), provides for the contemporaneity of stylized and naturalistic types. The general tendency within the latter category is toward schematization, even an academic mannerism. Two figures in the Metropolitan Museum's collection may be singled out as illustrations. Probably the most important and most discussed work is the representation of a seated man playing a harplike instrument (Figure 6). Acquired in 1947, before Cycladic art became ubiquitously fashionable, it was doubted in various quarters because its many naturalistic features made it difficult to categorize and date. The musculature of the upper arms, the wristbones and fingernails, and the swelling calves, as well as the articulation of the instrument with its duck's-bill finial[24] and of the high-backed chair, suggested an advanced date, but there was no context into which it readily fitted. Progress on two fronts in the study of this material contributed decisively to the acceptance of the sculpture today. Investigation of the use of polychromy has established

that such details as eyes, mouths, hair, and headdresses were often added in paint; where paint has disappeared, areas of discoloration or very low relief known as ghosts document its original presence. Remains of pigment on the eyes and mouth of the harp player and the ghost at the top of the head are refinements unknown to forgers in the 1940s. A second, particularly significant advance was the observation by Jürgen Thimme that the work was earlier than the other preserved musicians.[25] It could therefore be recognized as a starting point in a process of progressive stylization rather than as a terminus in a process of progressive naturalism.

A paradigm of the consummate but also precarious stylization attained by Cycladic sculptors at their height is the name piece of the Bastis Master, given to the Museum by Christos G. Bastis in 1968 (Figure 7).[26] The work displays a breathtaking balance between the articulation of the various parts of the body and the elongated, slender whole into which they have been

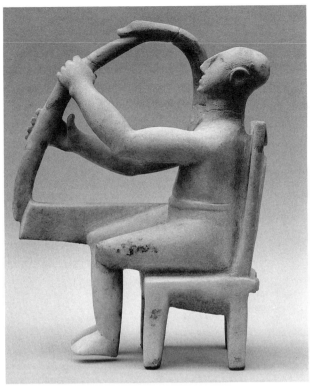

Figure 6. Seated harp player, Cycladic, Early Cycladic I-II, ca. 2800–2700 B.C. H. 29.2 cm. The Metropolitan Museum of Art, Rogers Fund, 1947, 47.100.1

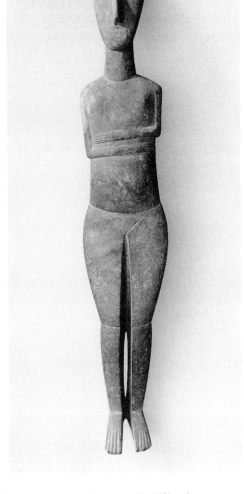

Figure 7. Female figure, Cycladic, Early Cycladic II, ca. 2600–2400 B.C. H. 63.5 cm. The Metropolitan Museum of Art, Gift of Christos G. Bastis, 1968, 68.148

composed. The choreography of curved surfaces in the head, the restrained swelling of the breasts and abdomen, and the downward-pointing toes with slightly convex soles represent exceptional technical command. The great beauty of this work of art lies in its simplicity, a mature rather than a primitive simplicity. During the Early Cycladic II period, when the Bastis figure was made, several types existed concurrently; they tend to be named after sites at which they were found.[27] The Bastis piece represents the Spedos variety, another the Dokathismata variety (Figure 8), a third the Chalandriani variety (Figure 9). What is evident in these works is the stylization, the amount of art, that informs them.

The inclusion of the Neolithic evidence as an integral part of the Cycladic continuum expands and defines the framework for the developments of the Early Cycladic period. The fundamental innovations of the Neolithic age in Greece were the establishment of permanent habitations, agriculture, and animal hus-

bandry. Wherever these mainstays of civilization occur, there are also human and animal figures formed in the local material of choice. Since the Cyclades were populated rather late, their figures appear correspondingly late. In northern Greece and Crete, by contrast, representations exist from the Early Neolithic period on (seventh millennium B.C.).[28] The artistic achievements in the Cyclades are of special interest, however, because of the use of marble, the Greek artistic medium par excellence, and because both chronologically and geographically these achievements are part of an extraordinary cultural continuum spanning the Bronze Age and the first millennium B.C.

Scholars have traditionally viewed Cycladic sculpture as a rather self-contained phenomenon and espoused an evolutionary sequence from the more "primitive" to the more naturalistic that was chronologically confined to the Early Bronze Age.[29] Today we have the benefit of knowing that the two types existed concurrently as early as the settlement on Saliagos. Moreover,

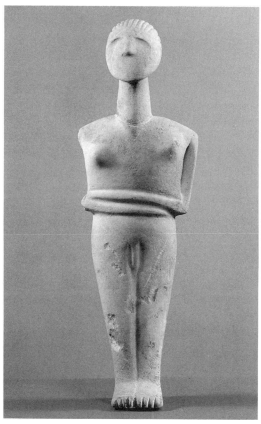

Figure 8. Male figure, Cycladic, Early Cycladic II, ca. 2400–2300 B.C. H. 35.9 cm. The Metropolitan Museum of Art, Bequest of Walter C. Baker, 1971, 1972.118.103

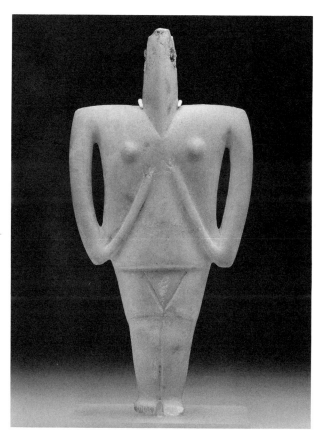

Figure 9. Female figure, Cycladic, Early Cycladic II, ca. 2300–2200 B.C. H. 27.3 cm. The Metropolitan Museum of Art, Bequest of Alice K. Bache, 1977, 1977.187.11

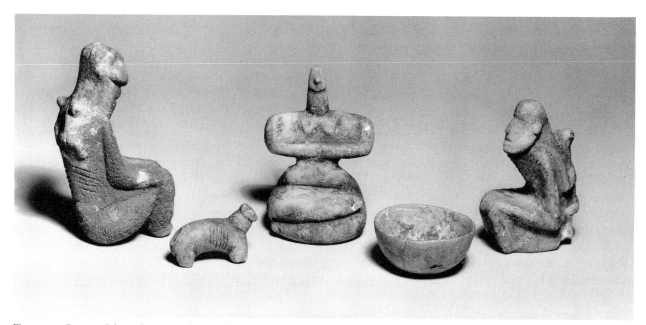

Figure 10. Group of three figures, animal, and bowl, Aegean, Neolithic, ca. 5000–3500 B.C. H. of figure with single child 13.3 cm. The Collection of Shelby White and Leon Levy (photo: Otto E. Nelson)

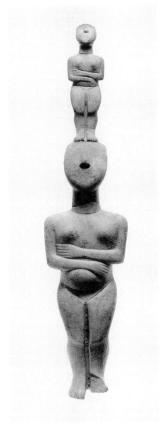

Figure 11. Female figure with a smaller one on her head, Cycladic, Early Cycladic II, ca. 2700–2600 B.C. H. 46.6 cm. The Collection of Shelby White and Leon Levy (photo: Sarah Wells)

Figure 12. Diagrams illustrating the design of Early Cycladic figures. (Pat Getz-Preziosi, *Sculptors of the Cyclades*, p. 37, fig. 15)

the major tendency over the roughly three millennia from the Neolithic to Early Cycladic II/III seems to have been from greater naturalism to greater stylization. Two works in the collection of Shelby White and Leon Levy make this point compellingly.

The first sculpture (Figure 10, far right) belongs to an exceptional Neolithic group[30] that was probably found on the eastern coast of Attica or on Euboea just opposite, thus on a western extension of the Cycladic cultural sphere. A person of indeterminate sex squats down, arms held close to the sides of the body, hands at the knees.[31] There are no specific attributes to indicate the sex nor is there a general feature such as steatopygy. The figure is characterized as withered, through the boniness of the face and the serrated dewlap under the chin. Holding onto his or her back is a child, also of indeterminate sex. The remaining constituents of the group are a seated individual with two small children on its back, a seated steatopygous female, a quadruped, and a bowl. Although the adult

with child raises more questions than it answers, we have no difficulty recognizing and describing each member of the duo, a feature that it shares with the other "naturalistic" Neolithic works.

Compare a very rare Cycladic composition[32] that occurs during Early Cycladic II and consists of a larger female figure supporting a smaller variant of herself on her head. In the Levy-White example (Figure 11), which Getz-Gentle considers transitional between Early Cycladic I and II, the larger figure is pregnant, the smaller is not. Here virtually every physical element has been conceptualized. We have no idea whether the smaller form represents the future—the child, possibly the idea of a child—or the past, preceding generations. While both the Neolithic and Early Cycladic groups evidently have to do with fertility, the placement of the child where it can neither be held nor seen by the adult is unusual; the more obvious mother-and-child combination is best known in the Neolithic iconographic repertoire from a terracotta figure

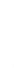

found in Thessaly.[33] The complex composition represented by the two Levy-White pieces (Figures 10, 11) is one of several for which there are both Neolithic and Early Cycladic examples. Another consists of two figures side by side with the arm of one around the shoulder of the other.[34] The two Levy-White groups make particularly evident the shift in emphasis from palpable description in the earlier works to evocation in the later ones. The concomitant question is whether connections may be drawn between types separated by significant chronological and geographic intervals.

Evolution requires continuity. The developments that we have been considering presuppose certain constants. Some are sure, such as the availability of marble and the abrasive materials (pumice, emery, sand, obsidian) with which the stone was worked. Other constants can exist only as plausible working hypotheses, for example, the notion that the steatopygous lady from Saliagos fulfilled roughly the same need or intention as the figure by the Bastis Master. The demands that can be made upon the notion of continuity are considerably more vulnerable when one proposes to make connections between the prehistoric period of the Bronze Age and the Geometric period, which is conventionally dated between about 1000 and 700 B.C. Not only is the time span very long, but it was also punctuated by major upheavals, such as population movements and the virtual cessation of organized, civilized life on most of the Greek mainland, Crete, and many other islands between about 1150 and 1000 B.C. These very considerable obstacles notwithstanding, there are features of the Bronze Age that have counterparts in the early first millennium. I propose to discuss two that are rooted in Early Cycladic art. The virtually complete omission of Minoan Crete and Mycenaean Greece from the discussion that follows can justly be considered a major one; however, just as there are connections, based on evident geographical grounds, between the Cyclades, Euboea, and the immediately adjacent regions of Central Greece, so the Minoan and Mycenaean cultures represent a distinct and extremely complex continuum.[35] Their inclusion to any significant degree would completely change the purpose and scope of our consideration.

The characterization that we have presented of Early Cycladic sculpture as the culmination of a process of artistic refinement depends not only on stylistic criteria but also on a technical phenomenon. One of Pat Getz-Gentle's most far-reaching contributions is the discovery that Cycladic figures were evidently designed according to simple geometric principles and proportions that could be marked on a piece of marble with a compass, a straightedge, and some char-coal or an obsidian flake (Figure 12).[36] In her discussions of individual artistic personalities, she has shown that the use of proportional formulas was an established practice, representing one of the criteria by which a hand may be recognized. The systematization of artistic creation through mathematical formulas speaks for a process that is more intellectual than spontaneous, that runs the risk of becoming mechanical, and that is quite in keeping with the thoroughly conceptual character of the Levy-White "double-decker." While Getz-Gentle is careful to emphasize that not every preserved figure was made according to a proportional canon and that the preserved material exhibits considerable differences in quality, she has demonstrated convincingly the applicability of a mathematical formula not only to individual figures depicted full length but also to those assuming more complex postures, such as the harp players or the groups of two or three figures. These procedures seem to have been used throughout the Early Cycladic period.

There is no other phase of prehistoric Greek art in which scholarship has discerned an equally significant degree of artistic and mathematical conjunction. This combination makes a very prominent reappearance, however, in the art that began to take shape about 1000 B.C., especially in Attica, and is called Geometric. Geometric art is most fully represented by terracotta vases and bronze statuettes and such accoutrements as fibulae (safety pins). The style derives its name from the circles, triangles, and other basic forms that constitute most of the ornament, as well as the parts out of which the figures are composed. As documented by the abundant and varied sequence from Athens, the maturation of the Geometric style can be followed from the first elegant, severe vases decorated exclusively with geometric motifs through those that reveal the progressive introduction of animals and then humans to the great achievements of the eighth century B.C., which are marvels of balance and complexity.[37]

The appropriateness of the word *geometric* to these works of art is evident on many levels. A short look at one of the Museum's monumental funerary vases shows, in equal measure, the limited range of forms that underlies all aspects of the decoration and the remarkable inventiveness with which they are used (Figure 13). For instance, the upper bodies of the mourners flanking the deceased are formed of rectangles and triangles, while those of the warriors below are melded with their shields, which are modified circles. Geometry very likely played a role as well in the accommodation of the decoration to the body of the vase, which is itself a large circle. The distribution of the

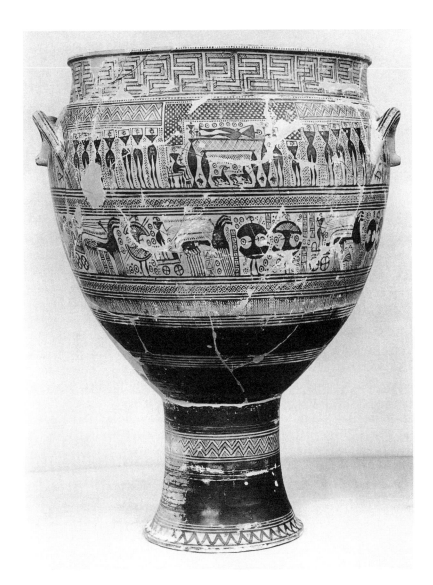

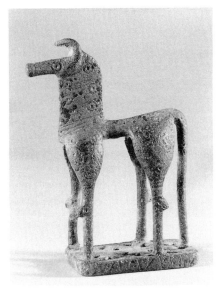

Figure 13. Funerary krater, Attic, Geometric, 2nd half of the 8th century B.C. H. 108.3 cm. The Metropolitan Museum of Art, Rogers Fund, 1914, 14.130.14

Figure 14. Horse, Greek, Geometric, 2nd half of the 8th century B.C. H. 8.4 cm. The Metropolitan Museum of Art, Gift of the H. L. Bache Foundation, 1969, 69.61.4

various motifs around the circumference required forethought, remarkable skill, and, undoubtedly, facility with a compass.

On a more fundamental level, perhaps the single most important feature of such Geometric works is the harmonious interplay between structure and mass. This is a leitmotif that runs throughout Greek art, but during its Geometric phase the ingredients are particularly apparent. The clarity and distinctness with which everything is depicted give this art an analytical, bare-bones character. For example, the shroud that in reality would have covered the dead is raised and regularized so that every particular of the prothesis—the laying out of the body—can be depicted. The construction of the figures out of thin, angular arms, triangular torsos, and rather sinuously articulated legs effectively conveys the combination of hard skeleton and softer musculature and flesh that makes up a human form. The figures also demonstrate how fine a

line exists between the abstraction of a triangle and the corporeality of a torso.

The observations that we have made about a vase are also applicable to contemporaneous, fully three-dimensional bronze sculptures. While lacking in verisimilitude, a horse (Figure 14) is instantly recognizable and conveys very directly the power and elegance of its subject. Worthy of note too is that these figures stand on bases that define their terrain not only in spatial terms but also through the decoration, most often of patterns pierced through the metal.

I should like to propose that there are similarities between the ways in which the Early Cycladic artist and the Geometric artist approached their work. If indeed mathematical calculation figured in the process of design and execution, I do not wish to suggest that it occurred only in these two contexts. The latter provide a good deal of evidence, a point of departure, however, and furnish an incentive for identifying comparable

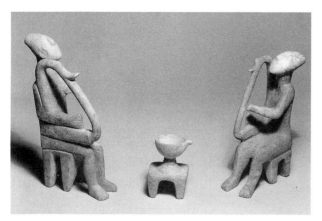

Figure 15. Pair of seated harp players and vase on a support, Cycladic, Early Cycladic II, ca. 2700–2600 B.C. H. 19.8 cm, 17.2 cm. The Collection of Shelby White and Leon Levy (photo: Otto E. Nelson)

modes of work in other periods and materials of artistic endeavor during the Bronze Age in Greece; architecture suggests itself immediately as an obvious area of investigation, glyptics as well. It is, moreover, not my intention to imply here that any direct connection exists between the Early Cycladic and the Geometric artist. The point is to define the question and launch it upon the sea of inquiry.

Our considerations of Early Cycladic sculpture have so far concentrated on matters of development, style, and execution. The realm of iconography also offers abundant possibilities for investigation. I should like to pursue several aspects of the seated harp players.[38] The subject is fraught with difficulty, because it is inseparable from every controversy that concerns Homer and epic poetry; one dares to venture into this terrain, nonetheless, because it is central to every aspect of Greek culture.

The eight or so Early Cycladic harp players that survive form part of the larger category of male figures;[39] although the males represent a variety of special types, such as warriors, they are considerably outnumbered by the female figures. The harp players were probably made over a period of about two centuries as the exceptional achievements of artists who otherwise produced the female statuettes.[40] Five of the preserved harpists belong to a pair: those in the Levy-White collection[41] (Figure 15), those from Thera now in Karlsruhe,[42] and one that was found with a double-pipe player on Keros.[43] The occurrence of harp players in groups of two raises the question of whether and how they performed together and, in the process, leads to a reconsideration of the harpists found singly.

The absence of any contemporaneous circumstantial evidence necessitates a search for applicable parallels. If one believes in the principle of continuity from the Bronze Age into the first millennium, an aggregate of testimony concerning the performance of the Homeric epics provides thought-provoking—and potentially enlightening—information. The *Iliad* and the *Odyssey* are our richest early sources about bards, most notably in the examples of Demodokos and Phemios, as well as their heroic counterparts Odysseus and Achilles.[44] Diogenes Laertius[45] records that Solon passed a law requiring rhapsodes to perform the poems of Homer in relays, with one taking over where another had stopped. In the "Hipparchos," whose authorship by Plato is disputed, the tyrant reportedly required rhapsodes to perform the Homeric epics in order and in relays. Gregory Nagy similarly interprets a significant passage in the *Iliad*;[46] Achilles in his tent is playing his lyre, "beautifully wrought and with a silver bridge," singing the glories of men while Patroklos, seated opposite him in silence, waits for the

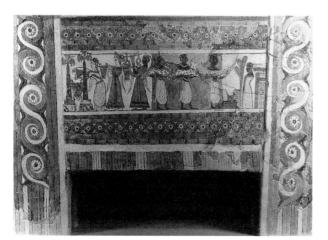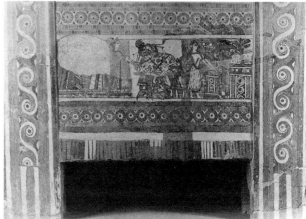

Figure 16. Two panels of the sarcophagus from Haghia Triada, Minoan, Late Minoan III, ca. 1400 B.C. L. 137 cm. Heraklion Museum (photo: Athens, TAP Service)

hero to stop so that he can continue. If Nagy's rendering of the episode is accurate, the practice of "relay recitation" would be attested earlier than the sixth century B.C., when Solon and Hipparchus ruled Athens. The passage opens the possibility that the practice existed at the time of Homer, or of the Trojan War, or perhaps even during preceding eras, when the stories and practices of the oral poet reflected in Homer were formed.

The significance of this literary testimony, and particularly of the passage in the *Iliad*, is that it provides an appropriate point of reference or comparison for the pairs of harp players. Equally important is that it strengthens the possible identifications of these figures beyond their being simply musicians. The pronounced backward tilt of the head in some suggests that they are singing; there is no way, and really no hope, of ever capturing how their song would have sounded. The alternative of recitation places the harp players within the category of poet-performers and also helps to explain why such individuals should be singled out for complex sculptural treatment. In illiterate societies the bard preserved the history and collective memory of a community in his lays. From this perspective, he acquired exceptional status, quite apart from any distinction that he might display as an individual artist. Moreover, it becomes quite understandable that over a period of several centuries such members of a society should be represented in stone, not to say memorialized.

In a welcome exception to the frequent lack of pertinent evidence, representations of lyre players and their instruments appear with some consistency during the Greek Bronze Age after the Early Cycladic period.[47] In the Minoan culture of Crete,[48] there are a number of seals of the Middle Minoan period (ca. 2000–1600 B.C.) engraved with motifs that have been identified as lyres. One of the most celebrated documents of the Late Minoan period, dated about 1400 B.C., is the so-called Haghia Triada sarcophagus, which is made of limestone and decorated with a procession that includes a lyre player and a flute player (Figure 16). This scene and two related ones on wall paintings show musicians in a context quite different from that of performance/recitation.[49] A clay pyxis, or box, dated to the thirteenth century B.C., from western Crete, shows a figure dwarfed by a lyre and accompanied by birds; horns of consecration with double axes suggest a ritual context.[50] The leap to the Geometric period is facilitated by a celebrated bronze in the Heraklion Museum in which a seated man and his lyre are melded into an inseparable unit; he is dated to the eighth century B.C.[51] The comparative material from the Greek mainland is in many respects less rich, and mainly from the Late Bronze Age, the Mycenaean period (ca. 1550–1100 B.C.). The finds do, however, include actual remains of lyres, notably two from Menidi.[52] The palace of Pylos, moreover, included a wall painting of a long-robed musician perched on an extraordinarily gnarled rock and playing an instrument embellished with duck's-head finials; a large white bird levitates before him.[53]

The few examples just cited are intended simply as reminders that harp- or lyre-playing performers are a recurring presence in the Greek world from the Early Bronze Age on.[54] It is evident that they served in a number of capacities. In the *Iliad* and the *Odyssey* bards not only sing of heroic events, but they also accompany the dance or participate in funerary observances.[55] It is most likely that the Early Cycladic musicians used their skills in numerous ways as well. Among the few clues that we have as to what they might be doing is whether they are seated or standing; later literary evidence suggests that a bard was typically seated.[56] In any event, his role of preserving and perpetuating the community's traditions was undoubtedly primary.

While, to my mind, the Cycladic harpists can be seen as remote ancestors of the poet-performers most illustriously represented by Homer, the subject is vexed by the absence of information on critical points. For instance, if the Cycladic figures indeed depict bards, they were singers whose performances rendered the essentials of a narrative but included modifications in each retelling. Most of our ancient literary evidence, however, applies to rhapsodes, professionals who memorized and recited a standardized, written text.[57] The establishment of a canonical text, the ramifications of writing, and the further consequences affecting the performances of originally oral material are among the complicating considerations. An entirely different set of questions concerns such details as the identity of the stringed instruments and the number of strings they had.[58] These matters, however, have to do with the proper integration or definition of the harp players within a long tradition. The major step is for them to be accepted as part of it.

The point of departure for this discussion of Cycladic musicians was the phenomenon of pairs. Before leaving the subject, let us pause over the duo from Keros, which consists of a harp player and a standing man who plays the double pipes. The double-pipe player belongs to a group of at least four standing musicians who play woodwinds but is the only one of the type who is completely preserved; also in the group are one or two syrinx players and two fragmentary figures, the nature of whose instruments cannot be identified.[59]

Figure 17. Neck-pelike, Attic, black-figure, ca. 500 B.C. H. 26.7 cm. The Metropolitan Museum of Art, Rogers Fund, 1907, 07.286.72

The decisive feature of a woodwind player is that he can only accompany poetic recitation; he performs as a soloist purely in a musical capacity. According to ancient sources of the historical period, the aulodes, who sang to strains of the flute, ranked below the kitharodes (Figure 17);[60] one reason may be that their expertise did not encompass both words and music. It would be invaluable to know why a harp player and a double-pipe player were paired as grave goods. Here is another pattern/combination that occurs elsewhere in Bronze Age representations—we noted it on the Haghia Triada sarcophagus, for instance—and it is attested in Homer.[61] By the Archaic period the lyre and double-pipe were established as the two fundamental instruments in Greek culture.[62] The combination in the Keros burial was probably motivated by various factors. Were the figures primarily funerary, lamenting the dead? Do they indicate the profession of the dead? Does the presence of a flute player imply that the practice of recitation accompanied by a flautist already existed? We must await further evidence.

To conclude our thoughts about the harp players, it is worth returning to the Neolithic figures with which we began. To my knowledge, no male figure of Neolithic date has yet been found in the Cyclades. The closest male relative, rendered in marble with consummate delicacy and svelteness, came to light at Knossos on Crete and is dated to the Early Neolithic period, about 6500–5800 B.C.[63] If we survey the surviving Neolithic human figures in all materials, from all parts of Greece,[64] they fall into the three familiar categories, female, male, and schematic. The females, whether steatopygous or normally proportioned, predominate numerically. The males are normally proportioned, which indicates that amplitude was not a distinction, as in certain other cultures. Some males are rendered with particular emphasis on their procreative role, others are not. The schematic figures represent an alternate and parallel mode of expression that may be characterized as symbolic or conceptual, in contrast to the more naturalistic types.

As we concentrate our focus once again on the Cyclades, all of these considerations come into play as one attempts to put together a picture of the evolution from Neolithic to Cycladic representation, from the more descriptive to the more schematic. An enormous problem that lurks beneath the shell of form is the

18

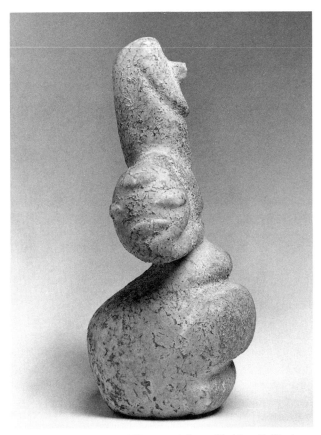

Figure 18. Profile view of Figure 3 (photo: Sheldan Collins)

Figure 19. Detail of Figure 10 (photo: Sheldan Collins)

matter of meaning. How should the figures be understood? We are in no position to entertain even the possibility that marble representations were based upon or inspired by specific individuals. Guided by one of the fundamental quandaries in the interpretation of Greek art of the historical period, however, we can pose the question of whether the more naturalistic renderings—the harp player, for instance—depict mortals, deities, or personifications. In Greek vase painting, from its inception to its South Italian finale, an identification often depends on the inclusion of an attribute or inscription. If we compare the Metropolitan and Levy-White steatopygous ladies, we have no difficulty noting a generic similarity between them. Covering each of her upper arms, however, the Levy-White example has an oval "pad" articulated with short horizontal marks in low relief at top and bottom, left and right (Figure 18).[65] Although we do not, unfortunately, know its meaning, this is an attribute that makes her specific. The Levy-White "elders" with the children on their backs (Figure 19) present an even more pronounced case of figures that are specifically characterized but impossible for us to interpret.

With the large number of female statuettes of the

Early Cycladic period, the question of meaning becomes even more acute because of the simplified forms. The mere quantity may indicate that the question is less important; the role of the figures may have become essentially symbolic. One avenue of investigation that promises to be helpful to this area of inquiry concerns the polychrome articulation.[66] The Metropolitan Museum's harp player introduced the detail of paint ghosts. Other works preserve significant amounts of pigment that not only articulate the head and body but also resemble tattoos. Assisted by new analytical techniques and equipment, current research devoted to features no longer visible to the naked eye may modify our notions of how these objects originally looked and, therefore, what they may have meant.

Our discussion above of mathematical calculation in Cycladic and Geometric art linked two periods that are not normally associated. It seems to me, however, that in yet other respects insights gained for the one might also prove enlightening for the other. Heretofore, both periods were viewed by scholars very much as the tentative precursors of significant developments. Because of their very early date and "modern" look, Cycladic art has tended to be judged more favorably.

Geometric art is often still regarded as primitive, child-like, inept. Until new evidence proves otherwise, the early sculpture of the Cyclades is more accurately understood as the fundamentally symbolic and conceptual maturation of traditions beginning in the Neolithic period. Similarly, I suggest that the Geometric period be viewed as a time of thoroughgoing reorientation and renewal, in which the potency of survivals from the Bronze Age should not be underestimated. The most far-reaching achievements of these three centuries were the establishment of the polis and the Panhellenic sanctuaries, as well as the formation of the Greek alphabet. In order to bring our understanding of Geometric art into line with the larger picture of the period, it is worth focusing on such features as the technical excellence evident in pottery and bronze working, the primacy of order, connection, and hierarchy of complexity in the allotment of decoration to an object, the consistent emphasis on the clear and distinct rendering of every part within its context—whether it is a goat or a shroud in a mourning scene or one unit of a complex meander ornament. I should like to suggest that the supreme achievement of this art, and of this period as a whole, was to forge a new order, a new series of coordinates—political, social, cultural, religious, economic, artistic. The ingredients, as we are beginning to see, were an extraordinarily complex combination of survivals and innovations introduced by new populations and Eastern influences.[67] What we may glean from the artistic creations of the Early Cycladic period is the formulation of a style that, I propose, may be comparable to the Geometric in being rational, symbolic, deceptively simple, and powerfully direct in its vocabulary.

As more and more material remains come to light from the preliterate phases of Greek culture, the more acutely conscious one becomes of the lack of writing to record and transmit the words and the thinking that are so manifestly implicit in so many objects. Given the anthropocentrism of Greek art from the very beginning, the silence of illiteracy is resounding. The Levy-White "elders" with children occur in a group with a steatopygous female; without evidence to the contrary, we should assume that the combination of two aspects of childbearing was deliberate and that special importance may have been ascribed to the elders, perhaps by virtue of the memory that they carried. Again, the Levy-White steatopygous lady embodied fertility, but her attributes also indicate a special status. Whether the Cycladic harp players were singing or reciting, the imminence of words is even greater. And in the female statuettes the calculations underlying their design, as well as the beliefs governing their use, are noticeably

inaccessible to us. For the Geometric period, the loss of words is just as critical, even though the amount of material evidence is greater and more varied. With the first inscriptions of about 700 B.C. and the works of Homer, Hesiod, and their anonymous contemporaries, we finally begin to acquire the tools for communication upon which we are so culturally dependent. Even without them, however, it is eminently worth directing our attention to the first surviving artistic manifestations in the Greek world, remote though they may be. To elucidate them across a distance of several millennia is as challenging and rewarding as sailing the Aegean Sea and fixing upon the stars in the night sky.

ACKNOWLEDGMENTS

Shelby White and Leon Levy have been extraordinarily generous in making their prehistoric pieces available to the Department of Greek and Roman Art, and I express my particular thanks for their permission to publish them here. For permission to publish the Neolithic figures from Saliagos I thank Dr. S. Samartzidou. I am indebted to Pat Getz-Gentle for her comments and improvements to the text, as well as to Elizabeth Marsden, Elizabeth Hendrix, and Mary B. Moore. For assistance with photography, I thank Pelli Fotiadi, Anne Leinster-Windham, Katerina Rhomiopoulou, and Tessa Chrysochoidou.

NOTES

1. Mervyn R. Popham et al., *Lefkandi* I (London, 1979) and following.

2. See, for example, Vassos Karageorghis, *Cyprus in the 11th Century* (Nicosia, 1994).

3. A representative collection of recent studies appears in Jane B. Carter and Sarah P. Morris, *The Ages of Homer* (Austin, 1995).

4. *American Journal of Archaeology* 55 (1951) pp. 121–133.

5. George A. Papathanassopoulos, *Neolithic Culture in Greece* (Athens, 1996) pp. 85–87; see also Jack L. Davis, "The Islands of the Aegean," *American Journal of Archaeology* 96 (1992) pp. 702–704.

6. Papathanassopoulos, *Neolithic Culture*, p. 319; John D. Evans and Colin Renfrew, *Excavations at Saliagos* (British School of Archaeology at Athens, Sup. Vol. 5, 1968) pp. 62–63.

7. Papathanassopoulos, *Neolithic Culture*, pp. 85, 168.

8. Ibid., pp. 320–321.

9. See also Pat Getz-Preziosi, *Early Cycladic Art in North American Collections* (Seattle, 1987) p. 125.

10. Jürgen Thimme and Pat Getz-Preziosi, *Art and Culture of the Cyclades* (Chicago, 1977) p. 419.

11. Weinberg, "Neolithic Figurines," p.128, note 78; Christian Zervos, *L'Art des Cyclades* (Paris, 1957) p. 68; Papathanassopoulos, *Neolithic Culture*, p. 318.

12. Thimme and Getz-Preziosi, *Art and Culture*, p. 419.

13. Dietrich von Bothmer, *Glories of the Past* (New York, 1990) p. 6.

14. Papathanassopoulos, *Neolithic Culture*, p. 318.

15. Ibid., p. 315; Weinberg, "Neolithic Figurines," pp. 122–123.

16. John E. Coleman, *Kephala* (Princeton, 1977) pp. 100–102.

17. Papathanassopoulos, *Neolithic Culture*, pp. 156–157; Davis, "Islands of the Aegean," p. 703.

18. See esp. Olaf Höckmann, "Zu Formenschatz und Ursprung der schematischen Kykladenplastik," *Berliner Jahrbuch für Vor- und Frühgeschichte* 8 (1968) pp. 45–75.

19. Evans and Renfrew, *Saliagos*, pp. 63–64.

20. Papathanassopoulos, *Neolithic Culture*, pp. 191–197.

21. See, for example, Davis, "Islands of the Aegean," pp. 728, 734, 739–740, 741.

22. For one of many accounts, see P. Getz-Preziosi, *Early Cycladic Art in North American Private Collections* (Richmond, 1987) pp. 17–18.

23. See Thimme and Getz-Preziosi, *Art and Culture*, pp. 185–191.

24. In the archaeological literature, this detail is described as both a duck's head and a swan's head. I opt for the former, as there is evidence for the existence of ducks and geese in Neolithic Greece (Papathanassopoulos, *Neolithic Culture*, p. 101).

25. Thimme and Getz-Preziosi, *Art and Culture*, p. 495; see also Pat Getz-Preziosi, "The Male Figure in Early Cycladic Sculpture," *MMJ* 15 (1980), esp. pp. 14–15.

26. Thimme and Getz-Preziosi, *Art and Culture*, p. 468.

27. Pat Getz-Preziosi, *Sculptors of the Cyclades* (Ann Arbor, 1987) pp. 9–23.

28. Papathanassopoulos, *Neolithic Culture*, pp. 293–315, 322–323.

29. "This art has a comfortable self-imposed limit, partly technical, partly illustrating the appeal of standard forms in antique religions, where tradition and security are mutually reinforcing. [The idols] are more than dolls and probably less than sacrosanct images," E. Vermeule, *Greece in the Bronze Age* (Chicago, 1964) p. 52.

30. Von Bothmer, *Glories*, pp. 13–15.

31. It is interesting to compare the pose of a carved pebble from Thessaly: Papathanassopoulos, *Neolithic Culture*, p. 311.

32. Von Bothmer, *Glories*, p. 16. Colin Renfrew, *The Cycladic Spirit* (New York, 1991) p. 115, questions the work's authenticity. The presence of ancient pigment, observed by Elizabeth Hendrix, should help to allay his concerns.

33. Papathanassopoulos, *Neolithic Culture*, p. 307.

34. Ibid., p. 314; Getz-Preziosi, *Sculptors of the Cyclades*, p. 22.

35. For a summary discussion, see Davis, "Islands of the Aegean," pp. 706–708.

36. For a recent summary, see Getz-Preziosi, *Sculptors of the Cyclades*, pp. 36–47.

37. The basic work on Geometric pottery remains Nicolas Coldstream, *Greek Geometric Pottery* (London, 1968). An excellent recent introduction to the Geometric period is Susan Langdon, *From Pasture to Polis* (Columbia, 1993).

38. In general terms, a harp is characterized by its approximately triangular shape, one side of which is taken by the soundbox. The lyre has a soundbox from which arise two arms joined by a crossbar. The kithara is a type of lyre typically used in performance; it is large in size and has a quadrilateral soundbox.

39. Getz-Preziosi, "Male Figure," pp. 7–25; Getz-Preziosi, *North American Collections*, pp. 261–262.

40. Getz-Preziosi, *Sculptors of the Cyclades*, p.41.

41. Von Bothmer, *Glories*, pp. 20–22; Getz-Preziosi, *Sculptors of the Cyclades*, p. 247.

42. Getz-Preziosi, *Sculptors of the Cyclades*, p. 249.

43. Ibid.

44. See esp. *Odyssey*, book 8 (Demodokos); book 1, ll. 154, 337ff., book 22, ll. 330ff. (Phemios); books 9–12 (Odysseus, evidently without instrumental accompaniment); *Iliad*, book 9, ll. 189ff. (Achilles).

45. Gregory Nagy, *Poetry as Performance* (Cambridge, 1996) p. 71.

46. Ibid., pp. 71–73.

47. For useful summaries, see Max Wegner, "Musik und Tanz," *Archaeologia Homerica* (Göttingen, 1968) pp. 2–18; Martha Maas and Jane M. Snyder, *Stringed Instruments of Ancient Greece* (New Haven, 1989) pp. 2–11.

48. The basic article is N. Platon, "Minoike Lyra," in *Charisterion eis A.K. Orlandon* (Athens, 1966) III, pp. 208–232.

49. Maas and Snyder, *Stringed Instruments*, p. 2.

50. Ibid.

51. Ibid., p. 9.

52. Ibid., pp. 7–8.

53. Mabel L. Lang, *The Palace of Nestor at Pylos* (Princeton, 1969) II, pp. 79–80.

54. For the longevity of the duck's-head finial, see also Getz-Preziosi, *North American Collections*, pp. 261–262.

55. Barry B. Powell, *Homer and the Origin of the Greek Alphabet* (Cambridge, 1991) pp. 161–162.

56. In this connection it is important to note the female seated on an impressive high-backed chair; L. Marangou, *Cycladic Culture: Naxos in the 3rd Millennium* (Athens, 1990) pp. 48–51.

57. Informative, readable introductions to this subject are provided by Gregory Nagy, *Pindar's Homer* (Baltimore, 1990), and *Poetry as Performance* (Cambridge, 1996).

58. See, for instance, Wegner, "Musik und Tanz," pp. 2–18.

59. Getz-Preziosi, "The Male Figure," pp. 31–32.

60. Jenifer Neils, *Goddess and Polis* (Hanover, 1992) pp. 58, 60, and passim. See also Nagy, *Pindar's Homer*, p. 104.

61. *Iliad*, book 18, l. 495.

62. See H. Alan Shapiro in Neils, *Goddess and Polis*, pp. 52–75.

63. Papathanassopoulos, *Neolithic Culture*, p. 322.

64. In addition to Papathanassopoulos, *Neolithic Culture*, see esp.

Machteld J. Mellink and Jan Filip, *Frühe Stufen der Kunst* (Berlin, 1974), and Kostas Gallis and Laia Orphanidis, *Figurines of Neolithic Thessaly* (Athens, 1996).

65. The marks may be counterparts in low relief of the painted "tattoos" occurring on the later Cycladic figures. The "pad" itself, however, is the most interesting feature.

66. Getz-Preziosi, *Sculptors of the Cyclades*, pp. 53–54; Pat G. Preziosi and Saul S. Weinberg, "Evidence for Painted Details in Early Cycladic Sculpture," *Antike Kunst* 13 (1970) pp. 4–16; Elizabeth Hendrix, "Painted Ladies of the Early Bronze Age," *MMAB* Winter 1997–98, pp. 4–15.

67. Though somewhat outdated, useful discussions can be found in *The Cambridge Ancient History* II, 2 (1975), esp. Geoffrey S. Kirk, "The Homeric Poems as History," pp. 833–841 and *The Cambridge Ancient History* III, 1 (1982), esp. Nicholas G. L. Hammond, "The Peloponnese," pp. 738–744.

Egyptian Duck Flasks of Blue Anhydrite

BIRI FAY

For Henry George Fischer, Lila Acheson Wallace Curator Emeritus in Egyptian Art

OBJECTS OF DAILY USE are designed primarily for their functional aspect. A jar, for example, must hold its contents, and a mirror must reflect the image of the user. In ancient Egypt, however, many everyday articles were made of such beautiful materials and designed in such imaginative forms that their utilitarian purposes seem almost secondary. This craftsmanship and sense of design reflect the mastery of the ancient artisans who excelled at combining functional, decorative, and symbolic qualities in the objects they created.

Among the best examples of such objects are the highly decorative articles associated with personal hygiene and cosmetics, which were important to both men and women.[1] The handle of a mirror, for instance, may take the form of a handmaiden (Figure 1); a spoon may be shaped like a naked girl pulled through water by a gazelle (Figure 2); and a turtle's back may serve as a grinding surface for paint to be applied around its owner's eyes (Figure 3). Among the most charming ancient Egyptian cosmetic articles are zoomorphic vessels for perfumes, oils, and eye makeup.

As early as 3200 B.C., before Egypt was first unified under a single ruler, its artisans carved small zoomorphic pots for eye paint (Figure 4).[2] There is even evidence that such objects were sometimes used as state gifts. For example, King Pepi I (ca. 2289–2255 B.C.) and two of his sons, who ruled after him in succession near the end of the Old Kingdom, commissioned cosmetic flasks in the form of female monkeys cuddling their babies (Figure 5) as gifts to commemorate royal jubilees, or other celebrations.[3] These flasks were presented to favored individuals, which anticipates a similar practice by the last czars of Russia who, at Easter, presented extravagant eggs fashioned by Fabergé, the court jeweler. Almost three thousand years after Pepi I's reign, during the Late Period, containers in the shapes of animals (Figure 6) continued to be made for the use of both royal and nonroyal individuals. Many of these delightful vessels (Figure 7) are on exhibition in the galleries of Egyptian art at The Metropolitan Museum of Art.

Blue-anhydrite duck flasks epitomize the combination of utility and charm that characterizes these containers (cat. nos. 1–15; Figures 8, 31–45).[4] The duck flasks not only are

functional but also exhibit—through the choice of a highly appealing stone, anhydrite, and the ingenious adaptation of the body of a plucked duck[5] for a vessel—a vivid, imaginative quality. They also manifest the ancient Egyptian artisan's sensitivity to the animals in his environment, as well as his skill at capturing their essence. The finest flask (cat. no. 1; Figure 8) and four other examples (cat. nos. 9–12; Figures 39–42) are in the Metropolitan Museum. Together they constitute the most important group of these rare objects.

The following discussion examines several fundamental questions about the duck flasks that have not been resolved, including when and for what anhydrite was used, their dates, and their relationship to the production of anhydrite objects as a whole. The role of the form, a plucked fowl, is also analyzed in relation to its use as either a cosmetic container or a food offering. In addition, the possible meaning of the form, not only during the owner's lifetime but also in the Hereafter, will be considered. A comparison of the four different stylistic types of duck flasks (Appendix 1) and a catalogue of all known examples (Appendix 2) are presented after the discussion, followed by a Technical Report of organic residues present in some of them by Richard Newman.

THE MATERIAL—ANHYDRITE—AND THE DATE OF ITS USE

Anhydrite is the name of the distinctive mineral[6] from which the duck vessels are carved. In older publications it was often called "blue marble," and although it has long since been properly identified, occasionally the misnomer is still used. W. M. Flinders Petrie held the opinion that the mineral was imported from north of the Mediterranean,[7] but it is now believed to have been quarried somewhere in the Eastern Desert, even though the site is not known. Anhydrite is harder than alabaster, frequently has an attractive lustrous sheen, and varies in color from white to rose to blue. The ancient Egyptians evidently preferred blue, which they used in two special ways. First, with few exceptions, objects carved from this stone are cosmetic containers: eye-paint pots, ointment jars, and flasks for such liquids as oils and perfumes.

© The Metropolitan Museum of Art 1998
METROPOLITAN MUSEUM JOURNAL 33

The notes for this article begin on page 45.

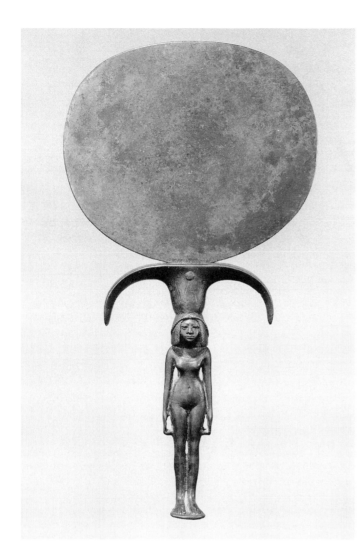

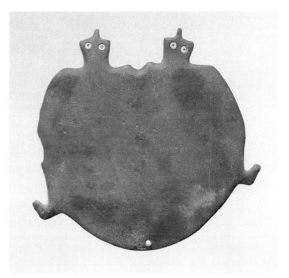

Figure 3. Cosmetic palette in the shape of a double turtle. Predynastic Period, Naqada II, ca. 3600–3400 B.C. Siltstone, H. 15.3 cm. The Metropolitan Museum of Art, Rogers Fund, 1910, 10.176.78

Figure 1. Mirror with the handle in the form of a young, naked woman. New Kingdom, Dynasty 18, ca. 1450 B.C. Bronze, H. 25.8 cm. The Metropolitan Museum of Art, Purchase, Fletcher Fund and The Guide Foundation, Inc. Gift, 1966, 66.99.25

Figure 4. Eye-paint pot in the form of a frog. Predynastic Period, Late Naqada II–Naqada III, ca. 3600–3200 B.C. Serpentine, L. 3.8 cm. The Brooklyn Museum of Art, Charles Edwin Wilbour Fund, 37.648E (photo: The Brooklyn Museum of Art)

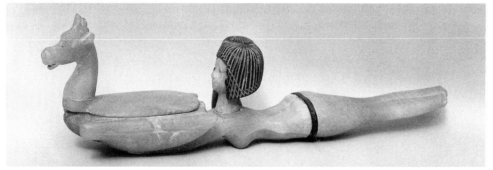

Figure 2. Spoon in the form of a girl pulled through the water by a gazelle. New Kingdom, Dynasty 18, ca. 1390–1350 B.C. Alabaster and siltstone, L. 22.5 cm. The Metropolitan Museum of Art, Rogers Fund, 1926, 26.2.47

Most of these containers are carved in simple, undecorated shapes (Figure 9) that are not restricted to anhydrite but also occur in a variety of other stones. However, a few anhydrite vessels were carved in unusual forms (Figure 10) or decorated with monkeys in bold relief (Figure 11) or with monkeys virtually in the round (Figure 12). The most striking examples have elaborate shapes, such as the baboon (Figure 13) and the fish (Figure 14) in the Metropolitan Museum, and the flasks in the form of plucked ducks (cat. nos. 1–15; Figures 8, 31–45). This is the

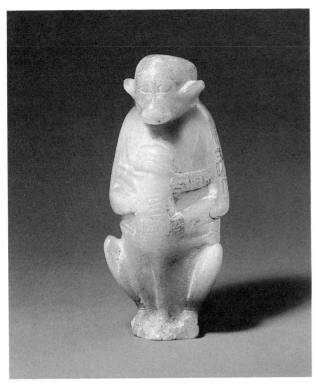

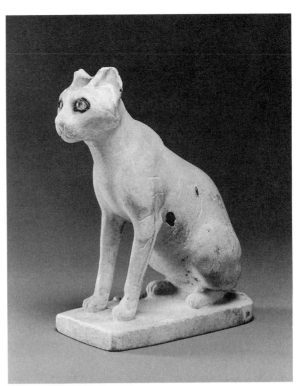

Figure 5. Vessel in the form of a mother monkey and her baby. Old Kingdom, Dynasty 6, reign of Pepi I, ca. 2289–2255 B.C. Calcite, H. 13.7 cm. The Metropolitan Museum of Art, Purchase, Joseph Pulitzer Bequest, Fletcher Fund, and Lila Acheson Wallace, Russell and Judy Carson, William Kelly Simpson and Vaughn Foundation Gifts, in honor of Henry George Fischer, 1992, 1992.338

Figure 7. Jar in the form of a wildcat. Middle Kingdom, early Dynasty 12, ca. 1990–1900 B.C. Calcite, with bronze and rock crystal, H. 14 cm. The Metropolitan Museum of Art, Purchase, Lila Acheson Wallace Gift, 1990, 1990.59.1

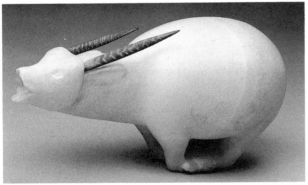

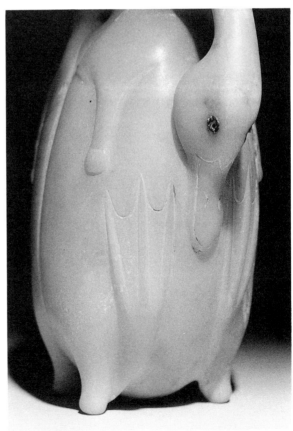

Figure 6. Vessel in the form of a bound oryx. From Meroe, Sudan, West Cemetery, Tomb Beg. W. 609, Late Period, Dynasty 25, ca. 700 B.C. Calcite, L. 17.3 cm. Boston, Museum of Fine Arts, 24.879 (photo: The Museum of Fine Arts)

Figure 8. Flask in the form of a pair of plucked ducklings, detail (Type A, cat. no. 1). Said to be from Mond's excavations behind the Ramesseum at Thebes. Second Intermediate Period, Dynasty 17, ca. 1635–1550 B.C. Anhydrite, with inlaid eyes, H. 17.4 cm. The Metropolitan Museum of Art, Gift of Edward S. Harkness, 1927, 27.9.1

Figure 9. (left to right): Anhydrite cosmetic containers. 89.2.507, 13.180.9, 10.130.1271, 89.2.508, 33.1.36, 04.18.48, 04.18.49. The Metropolitan Museum of Art, Gift of Joseph W. Drexel, 1889 (89.2.507, 508); Gift of Egypt Exploration Fund, 1904 (04.18.48, 49); Gift of Helen Miller Gould, 1910 (10.130.1271); Rogers Fund, 1913 (13.180.9); Rogers Fund, 1933 (33.1.36)

Figure 10 (left to right): Bag-shaped jar. Said to be from Girgeh, Second Intermediate Period, Dynasty 17, ca. 1635–1550 B.C. Anhydrite, H. 12.5 cm. The Metropolitan Museum of Art, Rogers Fund, 1910, 10.176.48. Lentoid flask. Said to be from Girgeh, Second Intermediate Period, Dynasty 17, ca. 1635–1550 B.C. Anhydrite, H. 9.5 cm. The Metropolitan Museum of Art, Rogers Fund, 1910, 10.176.53. Amphora-shaped flask. Said to be from Girgeh, Second Intermediate Period, Dynasty 17, ca. 1635–1550 B.C. Anhydrite, H. 14.8 cm. The Metropolitan Museum of Art, Rogers Fund, 1911, 11.150.29

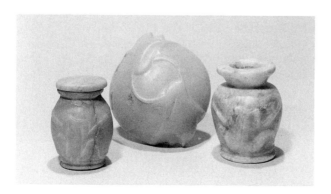

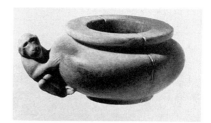

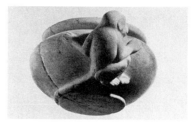

Figure 12. Bowl with clinging monkey. Said to be from Lisht, Second Intermediate Period, Dynasty 17, ca. 1635–1550 B.C. Anhydrite, W. 9.5 cm. Formerly in the Norbert Schimmel Collection, Jerusalem, Israel Museum 91.71.241 (photo: Otto Nelson)

second special feature associated with anhydrite vessels; whereas undecorated cosmetic containers were produced during the Middle Kingdom in a variety of materials, including anhydrite, the elaborate forms were carved almost exclusively in blue anhydrite.

Dating anhydrite objects is problematic. Excavated examples are poorly documented,[8] and consequently, in the light of more recent evidence, dates assigned by excavators and scholars seventy to one hundred years ago are in need of reevaluation and revision. This process reveals that these objects, including duck flasks, were produced during a relatively limited time span. However, the dating of the duck flasks, which involves several additional factors, will be discussed below.

What is usually cited as the earliest datable anhydrite object, the base and feet from a statuette of a woman (Figure 15), was excavated at Deir el-Bahri in the tomb of the steward Henenu, an official who served the Dynasty 11 king Mentuhotep II Nebhepetra (ca. 2061–2010 B.C.).[9] This burial also contained some later material, so the date of the base with feet is uncertain.

Figure 11 (left to right): Bowl and eye-paint pots decorated with monkeys in relief. Middle Kingdom, late Dynasty 13 to Second Intermediate Period, Dynasty 17, ca. 1650–1550 B.C. Anhydrite, H. 5.6 cm, 4.12 cm, 6.8 cm. The Metropolitan Museum of Art, Fletcher Fund and the Guide Foundation, Inc., Gift, 1966 (66.99.16); Bequest of Theodore M. Davis, 1930 (30.8.139); Rogers Fund, 1907 (07.228.93)

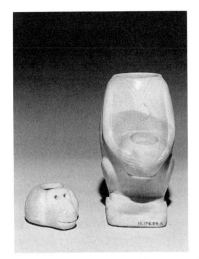
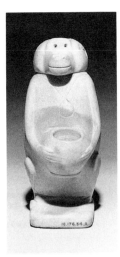

Figure 13. Baboon flask with a removable head. Said to be from Girgeh, Second Intermediate Period, Dynasty 17, ca. 1635–1550 B.C. Anhydrite, H. 12.9 cm. The Metropolitan Museum of Art, Rogers Fund, 1910, 10.176.54

cropped at the elbow joints), are pressed against the body. In two instances (cat. nos. 6, 12; Figures 36, 42), feathers have been left decoratively covering the neck and head of the plucked bird, anticipating by thousands of years a practice still common today among European poulterers when they display game birds in their shops.[14] Each duck has, or had, inlaid eyes. Recessed into the duck heads, the inlays that are preserved consist either of a porous material surrounded by a copper rim or of a black disk.

With two exceptions (cat. nos. 13, 14; Figures 43, 44), the preserved spouts are narrow, with rounded rims. The flasklike contour and the narrow neck suggest that these vessels contained liquids (perhaps a body oil or a perfume), not a solid, which would have been difficult to

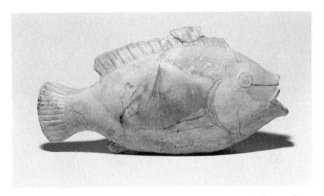

Figure 14. Tilapia-fish flask. Said to be from Girgeh, Second Intermediate Period, Dynasty 17, ca. 1635–1550 B.C. Anhydrite, L. 19.6 cm. The Metropolitan Museum of Art, Rogers Fund, 1910, 10.176.52

Only two anhydrite objects are dated by inscription. One fragment, probably from a beaker (Figure 16), bears the name of Senwosret I (ca. 1971–1926 B.C.)[10] and confirms the use of the stone for vessels at least as early as the beginning of Dynasty 12. Another vessel (Figure 17), found at Dendera, bears the name of King Khaneferefre IV Sobekhotep, the twenty-fifth ruler of Dynasty 13 (ca. 1711–1704 B.C.).[11]

The use of anhydrite as recently as the Second Intermediate Period (ca. 1640–1532 B.C.) is demonstrated by cosmetic containers carved in specific shapes characteristic of that time.[12] Thus, the production of objects carved from blue anhydrite is confined, with two exceptions,[13] to a period that extends from the early Middle Kingdom to Dynasty 17, just over four hundred years, a remarkably short interval in the three-thousand-year history of pharaonic Egypt.

Anhydrite objects are so rare and the period of their production so limited that the ancient source of the material must have been small, and evidently virtually exhausted by Dynasty 18 (ca. 1550–1307 B.C.).

ANHYDRITE DUCK FLASKS

Several features are common to all of the anhydrite duck flasks. Each is carved in the form of a plucked duckling (with short, undeveloped wings rounded at the wrists), or a duck, or a pair of ducks or ducklings arranged back-to-back. The neck of each duck curves forward over its breast, where its bill rests. The legs, which end in splayed webbed feet, and the featherless wings (sometimes

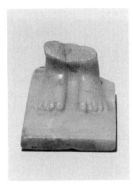

Figure 15. Feet from a statuette of a woman. From Deir el-Bahri, Theban Tomb no. 313 (MMA tomb no. 510), Middle Kingdom, Dynasty 12, ca. 1929–1787 B.C. Anhydrite, H. 3 cm. The Metropolitan Museum of Art, Rogers Fund, 1926, 26.3.220

Figure 16. Beaker fragment inscribed for Senwosret I. Middle Kingdom, Dynasty 12, reign of Senwosret I, ca. 1971–1926 B.C. Anhydrite, H. 3.89 cm. London, British Museum, acquired from Rev. John William Loftie, 1890, 24118 (photo: courtesy of the Trustees of the British Museum)

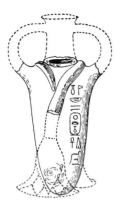

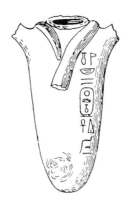

Figure 17a. Amphora-shaped flask inscribed for Sobekhotep IV. From Dendera, Middle Kingdom, Dynasty 13, reign of Sobekhotep IV, ca. 1711–1704 B.C. Anhydrite, H. 10 cm. Cairo, JE 39567 (after Weigall, *ASAE* 9 [1908] p. 107, fig. 2)

Figure 17b. Sobekhotep IV amphora-shaped flask without reconstruction

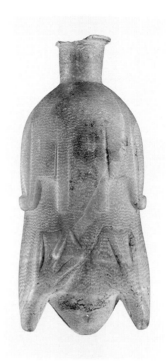

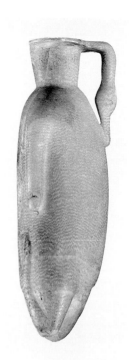

Figure 18a, b. Flask in the form of a plucked duckling with hind toe. New Kingdom, Dynasty 18, ca. 1550–1450 B.C. Calcite, L. 22 cm. Paris, Louvre, E 11175bis (photo: Christian Larrieu, Musée du Louvre, Département des Antiquités Égyptiennes)

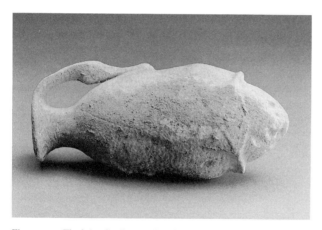

Figure 19. Flask in the form of a plucked duckling. New Kingdom, Dynasty 18, ca. 1550–1450 B.C. Calcite, L. 20.5 cm. Private collection

extract through such a small opening. The analyses performed by Richard Newman, Museum of Fine Arts, Boston (see Technical Report), have confirmed this idea. His findings indicate that the vessel originally held oils or fats. Three different materials were found in the four duck vessels that were tested. Further, Newman's analyses of the organic residues in a total of sixteen blue-anhydrite vessels carved in a variety of shapes show that there is no correlation between the shape of a vessel and its contents.[15]

Abrasions, a sure sign of actual use, are often visible on at least one surface, usually the bird's back. They show not only that the flasks were used in the course of daily life but also that they rested on their backs during routine use, and thus were not set upright in a stand.[16] To retain their

liquid contents, they therefore must have been equipped with a removable stopper, perhaps strips of tightly rolled linen,[17] or a small ball of string wrapped in linen.[18] When the provenance of a duck is known, it is most often Northern Upper Egypt, specifically the area encompassing Girgeh, Abydos, and Thebes, where they have been found in burials.

THE USE AND SYMBOLIC MEANING OF THE DUCK FLASKS

The ancient Egyptians produced a variety of zoomorphic vessels (for example, Figures 4–7). However, except for rare examples (stylistically datable to early Dynasty 18) carved in calcite (Figures 18, 19),[19] presumably after the anhydrite source was exhausted, flasks in the form of plucked ducks[20] were always carved in anhydrite. These are also the only stone flasks that depict prepared food.

Representations of plucked and trussed ducks are common in relief and in painting. They are often found among food staples depicted on the walls of tombs, where they symbolize provisions for the deceased in the Hereafter (Figure 20).[21] As representations of food, the anhydrite duck flasks would thus be expected to contain something edible or drinkable.[22] However, no other

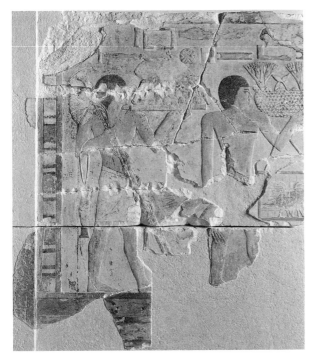

Figure 20. Courtier bringing offerings to King Senwosret I. From the king's mortuary temple at Lisht, Middle Kingdom, Dynasty 12, reign of Senwosret I, ca. 1971–1926 B.C. Limestone, H. 139.7 cm. The Metropolitan Museum of Art, Rogers Fund, 1909, 09.180.13a, b

container carved in anhydrite represents food, and no anhydrite container can be associated with anything but cosmetics, which raises an enigma. How can the interpretation of the ducks as food be reconciled with their interpretation as cosmetic containers?

Perhaps part of the answer lies in their symbolic meaning. Although traces of wear show that the flasks were used in daily life, those with known findspots were included with burial goods, which indicates that their use extended symbolically after the death of the owner. Thus, their role in the funerary context would have been twofold: the ducks symbolically provided food for the inner body and, at the same time, soothing oil or perfume for the outer body.

DATING THE ANHYDRITE DUCK FLASKS

While difficulties involved in dating anhydrite objects in general have already been defined, the process of dating the duck flasks is also complex and involves a range of factors. None of these flasks is inscribed, so dates can be arrived at only through analysis of indirect evidence, and inference. For example, ancient objects can sometimes be dated by the context in which they were found. If an undisturbed grave contains inscribed articles that are datable, or objects that are similar to dated pieces, a date for the entire contents of the burial may be inferred.

Yet this approach is not straightforward for the duck flasks, because details of only one context in which a duck was found are available (cat. no. 5; Figure 35). It was excavated from an undisturbed burial datable to Dynasty 17 (ca. 1635–1550 B.C.), but some scholars have suggested that this flask is an heirloom, implying it was carved a generation or more before the date of the burial. This possibility is sometimes raised when an object does not seem to fit, for whatever reason, the date of its context. Dynasty 17 was the final phase of the Second Intermediate Period, which was a transitional time, characterized by conflict and unrest, that culminated in the expulsion of the Hyksos rulers and the reunification of the Egyptian State at the beginning of Dynasty 18. Because the conditions at that time have been mistakenly viewed as incompatible with the production of sophisticated works of art, the contemporaneity of the excavated duck with its Dynasty 17 context has been questioned. However, a closer look at works of art preserved from Dynasty 17 clearly shows that this material is the prelude to the art of Dynasty 18.[23]

Under the circumstances, the most promising approach to dating the duck flasks entails a study of comparative material, particularly other elaborate blue-anhydrite objects that are not duck flasks. The premise is that if one among a group of objects linked by style, context, or other factors can be dated, then that date may be extended to the entire group. This is the method used in the following endeavor to date these flasks.

With few exceptions the use of anhydrite is restricted to less than five hundred years, from Dynasty 11 at the earliest to Dynasty 17. The chronological position of anhydrite duck flasks within this time is more difficult to define. Dates variously assigned to them range from mid-Dynasty 12 to Dynasty 17, which, if correct, means that these flasks were produced for well over three centuries. Yet, the thirteen complete duck flasks are remarkably similar in both concept and form (see the discussion of stylistic types [Appendix 1], and the catalogue of duck vessels [Appendix 2], at the end of this article). Not only would the consistency they exhibit as a group have been difficult to sustain for hundreds of years, but such a long time span would also have been inconsistent with the typical development of ancient Egyptian applied arts, whose forms and styles changed rapidly in accordance with prevailing fashions. Thus, the popularity of duck flasks was probably brief, and therefore the time within which they were carved was certainly not longer than a generation or two.

Clues to the date of the flasks may be discovered by considering other blue-anhydrite vessels, some of which are decorated in bold relief (for example, Figures 11, 12, 24, and 25), including one (Figure 17) inscribed for a Dynasty 13 king, Sobekhotep IV (ca. 1711–1704 B.C.).[24] This amphora-shaped vessel is decorated with long, cordlike ridges

worked in bold relief, which trail over its shoulders and body. A pair of handles extended upward to a spout that is now lost.[25] Arthur Weigall, who recorded the piece, suggested the thick ridges were lotus stems, and he reconstructed the flask with wide lotus blossoms at the base, which would have supported it in an upright position. However, his assumption that this vessel stood vertically is not necessarily correct. Many of the ducks show traces of wear on their backs from being picked up and put down many times, indicating that the flasks rested on their sides.

Weigall's sketch of the vessel inscribed for Sobekhotep IV shows that at the point where the "stems" are broken off, they must have arched away from the body of the flask, like the necks of the ducks, and then recurved to the point Weigall calls "a broken knob at the bottom of the vase on either side."[26] The round "knobs" indicate that whatever rejoined the vessel at this point was considerably narrower than a lotus blossom. Lotus buds (or something entirely different) may have been carved at the "knobs." For example, the "stems" may represent cobras, whose heads and hoods rose from the knobs.[27]

This flask is significant because it is the only anhydrite vessel carved in an elaborate form that has a fixed date. It demonstrates that by the reign of Sobekhotep IV, in the last half of Dynasty 13, anhydrite vessels with elaborate plastic decoration were being carved; thus, this example may represent the origin of the genre from which the duck flasks evolved.[28]

Shortly after the turn of the last century, the Metropolitan Museum acquired a large and exceptional group of blue-anhydrite vessels (Figure 21), including three of the duck flasks discussed in this article (cat. nos. 9–11; Figures 39–41), all purportedly from a Middle Kingdom cemetery at Girgeh, north of Abydos. This group comprises other vessels with elaborate forms, including a bottle in the shape of a baboon (Figure 13), a fish flask (Figure 14), a monkey group with bodies hollowed as containers (Figure 22), a pair of monkeys (one with a removable head) holding a bottle between them (Figure 23), and several bottles and flasks, some of which imitate pottery forms (Figure 10).

Two of these vessels suggest that the group was made sometime between Dynasty 13 and Dynasty 17. The amphora-shaped bottle (Figure 10, right) is a type produced from Dynasty 13[29] through the Second Intermediate Period and, in a slightly slimmer form, well into Dynasty 18.[30] A second vessel in the Girgeh group, a bag-shaped flask with an everted rim (Figure 10, left), imitates a pottery vessel shape in use from the late Middle Kingdom through the Second Intermediate Period.[31] Together, the two vessels support a late Middle Kingdom to Second Intermediate Period date for the Girgeh group and its three duck vessels (cat. nos. 9–11; Figures 39–41); classified as Type C in the stylistic types in Appendix 1; and also, by analogy, for a fourth stylistically related double-duckling flask found at Abydos (cat. no. 12; Figure 42).

To this point, the range of dates originally suggested

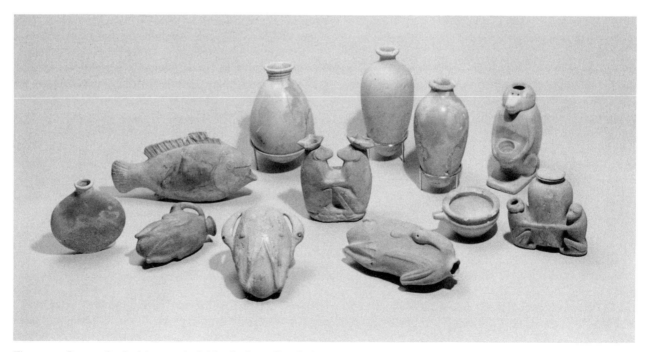

Figure 21. Group of anhydrite vessels. Said to be from Girgeh. Second Intermediate Period, Dynasty 17, ca. 1635–1550 B.C. Anhydrite. The Metropolitan Museum of Art (left to right): Rogers Fund, 1910 (10.176.53, 10.176.52), 1912 (12.182.76), 1910 (10.176.51, 48, 49, 50), 1911 (11.150.29), 1910 (10.176.46, 47, 54), 1912 (12.182.77)

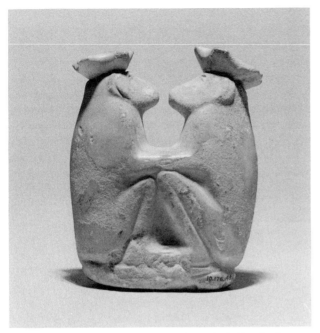

Figure 22. Pair of monkeys as a double flask. Said to be from Girgeh, Second Intermediate Period, Dynasty 17, ca. 1635–1550 B.C. Anhydrite, H. 11 cm. The Metropolitan Museum of Art, Rogers Fund, 1910, 10.176.49

Figure 23. Pair of monkeys holding a jar between them. The body of the monkey at the right is hollowed and the head is removable. Said to be from Girgeh, Second Intermediate Period, Dynasty 17, ca. 1635–1550 B.C. Anhydrite, H. 9.5 cm. The Metropolitan Museum of Art, Rogers Fund, 1912, 12.132.77

for the anhydrite duck flasks (mid-Dynasty 12–Dynasty 17) has been narrowed by about 150 years (Dynasty 13–Dynasty 17), but because they could hardly have been produced with such uniformity for the equivalent of over five ancient Egyptian generations, this interval is still too long. The evidence that narrows the time span further is complex but seems persuasive.

As stated, only one duck flask—Abydos, Tomb X. 52 (cat. no. 5; Figure 35)—was discovered in an undisturbed burial. It was found by T. Eric Peet during the 1911–12 excavating season at Abydos[32] in a burial he dated to the Second Intermediate Period. Robert Merrillees and Barry Kemp,[33] and Janine Bourriau[34] have studied this tomb independently and arrived at similar dates of the Hyksos Period to early Dynasty 18 and Dynasty 17, respectively. Again, however, they too caution that the flask may be an heirloom. If this were confirmed, the flask would not be contemporaneous with the burial where it was found and could actually have been made considerably earlier. While the possibility of an heirloom cannot be ruled out, it does not seem likely, as will be demonstrated.

Other elaborate anhydrite vessels that help to narrow the date for the duck flasks include two bowls decorated with monkeys. On one of the bowls, the monkeys are worked in bold relief (Figure 25), while on the other, a monkey is worked virtually in the round (Figure 12). These bowls are related not only in the way blue anhydrite was used but also by stylistic aspects that support their contemporaneity.

The strongest incentive for including these elaborate monkey dishes within the process of dating the duck flasks is provided by a bowl in the Egyptian Museum, Cairo (Figure 24).[35] The outer walls of the bowl are decorated with a boldly sculpted monkey, together with a pair of ducks (represented as living) with their wings spread around the sides of the bowl. As in the duck flasks, their necks were originally worked free from the bowl. Because this bowl combines both elements, namely monkeys in bold relief and ducks with necks worked free from their bodies, it proves that the types of decoration used for the duck flasks and the elaborate monkey vessels are contemporaneous.

Another elaborate anhydrite bowl decorated with monkeys in bold relief (Figure 25)[36] was found by W. M. Flinders Petrie in an intact burial of a woman at Qurna.[37] On the basis of its contents, Petrie proposed a Dynasty 17 date for the burial.[38] In his assessment Cyril Aldred noted the richness of the tomb, which led him to suggest that it was the burial of a member of the ruling family who died toward the end of Dynasty 17.[39] Janine Bourriau's subsequent analysis of the pottery and the coffin has confirmed this date for the burial.[40] Again, some scholars caution that the monkey bowl may be an heirloom, although no specific reasons are given.[41]

In 1980 Barry Kemp and Robert Merrillees published the E. L. B. Terrace Group.[42] These objects, said to have been found at Lisht, include not only a fragmentary duck

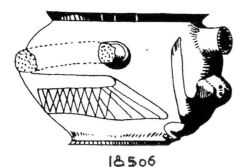

Figure 24. Bowl with monkey and ducks. From Thebes, Second Intermediate Period, Dynasty 17, ca. 1635–1550 B.C. Anhydrite, H. 5 cm, Diam. 6.7 cm. Cairo, Egyptian Museum, CG 18506 (after von Bissing, *Steingefässe* [1907] pl. VIII)

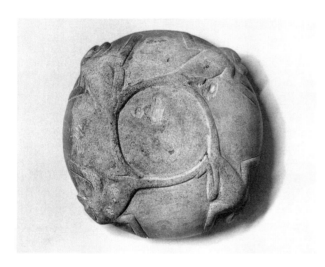

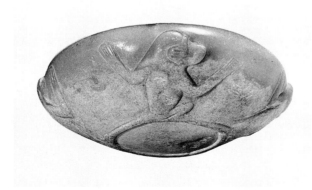

Figure 25. Bowl with monkeys from Qurna. Excavated by Petrie at Kurneh, 1909. From Thebes, Second Intermediate Period, Dynasty 17, ca. 1635–1550 B.C. Anhydrite, Diam. 12 cm. Edinburgh, Royal Museum of Scotland 1909.527.33 (photo: Bernard V. Bothmer, through the courtesy of the Trustees of the National Museums of Scotland)

flask (cat. no. 7; Figure 37) but also the most elaborate known monkey bowl (Figure 12).[43] Kemp and Merrillees state that although there is no proof that all the objects derive from a single burial, the group is "strongly homogeneous." [44] If these objects are from a single find and contemporary with one another, as Kemp and Merrillees suggest, one of them, a female fertility figurine carved in limestone (Figure 26),[45] provides an approximate date for the group, which includes the fragmentary duck flask. The woman's distinctive hair style is found on a number of other fertility figurines [46] and on statuettes of women that are generally datable to Dynasty 17.[47] Although none of the figurines can be dated later than Dynasty 17, a variation of the coiffure is worn by serving girls whose figures are incorporated in the design of Dynasty 18 cosmetic articles,[48] and it even occurs in early New Kingdom tomb paintings,[49] which underscores the proximity of the figurines to Dynasty 18.

A Dynasty 17 date is also supported by the sculptural style of the woman's face; her sharp clear features and large, wide eyes are related more closely to the sculptural style of the New Kingdom than to that of the Middle Kingdom, which is characterized by a fuller, more rounded style. Furthermore, a Dynasty 17 date for the Terrace Group, including the fragmentary duck flask (cat. no. 7; Figure 37) and the elaborate monkey bowl (Figure 12), would coincide with the date of the burial associated with the duck flask at Abydos (cat. no. 5; Figure 35), and also with the elaborate monkey dish at Qurna (Figure 25).

CONCLUSIONS

The foregoing discussion of anhydrite duck flasks and various related objects assesses a range of factors. Considered in isolation, no single factor is conclusive; but together they manifest stylistic and chronological patterns that clarify questions concerning the material (anhydrite), the form of the flasks (a plucked duck), and their date.

The documented use of anhydrite is restricted to a period extending from Dynasty 12 to Dynasty 17 (ca. 1971–1550 B.C.), and because this interval is so short, the ancient source must have been small. The fashion for blue-anhydrite duck flasks was certainly even more limited. The recognition of four stylistic types (see Appendix 1)—closely related through the unusual concept of a duck's body adapted to a flask—suggests that the number of artisans who carved them was small; also, and more significantly, it suggests that all the ducks were created over a relatively short period of time, not longer than a generation or two.

Areas of wear on the undersides of the flasks indicate that they were used in daily life. Although the form, a plucked duck, might suggest they contained food, this is inconsistent

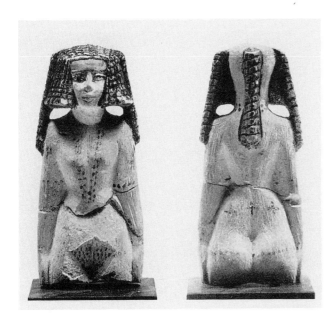

Figure 26a, b. Fertility figurine. Said to be from Lisht, Second Intermediate Period, Dynasty 17, ca. 1635–1550 B.C. Painted limestone, H. 8.2 cm. Formerly in the Norbert Schimmel Collection, Jerusalem, Israel Museum 91.71.229 (photo: Otto Nelson)

with the use of other anhydrite vessels, which was confined to cosmetics. Evidently, the form was symbolic, and in a funerary context the flask served a double purpose. As a representation of a duck, it symbolically provided sustenance for its owner in the Hereafter, and as a container, it provided oil or perfume.

Although only one duck (cat. no. 5; Figure 35) was found in a closed context, which is datable to Dynasty 17, three bowls provide further evidence for the elaborate use of anhydrite at that time. The first (Figure 24), combining a monkey with a pair of ducks with necks worked free from the vessel body, demonstrates that these two motifs were contemporaneous. Because monkeys and ducks occur at the same time, a second elaborate anhydrite bowl with monkeys (Figure 25) from an undisturbed Dynasty 17 burial at Qurna must be contemporary with the duck flask found in a closed context, providing further evidence for the elaborate use of anhydrite during Dynasty 17.

Additional support for this date for elaborate anhydrite vessels comes from a third anhydrite bowl with a monkey worked virtually in the round (Figure 12), and a fragmentary duck flask (cat. no. 7; Figure 37), both from the Terrace Group. Provided that these objects are from a single find and contemporaneous, one of the objects, a fertility figurine (Figure 26) datable to Dynasty 17, provides a date for the group.

That four of the five elaborate anhydrite vessels (two bowls with monkeys and two duck flasks) were found in contexts datable to Dynasty 17 can hardly be coinciden-

tal, and thus the likelihood that all are heirlooms is remote. The two duck flasks and two of the monkey bowls should therefore be accepted as contemporaneous with their Dynasty 17 contexts. Because the form and concept of these examples are so consistent with the rest of the duck flasks, all of them must have been made approximately at the same time.

The late Second Intermediate Period date proposed for the duck flasks and the elaborate bowls with monkeys worked on their sides immediately precedes the New Kingdom. Thus, the plausibility of the proposed date is further strengthened because it coincides with a marked rise in the popularity of cosmetics and luxury goods that occurred during Dynasty 18, the first dynasty of the New Kingdom.[50]

The duck motif, either plucked or as a living fowl, was not used during the Old and Middle Kingdoms, and the monkey appears infrequently. These were two of the most recurrent themes during Dynasty 18, however, not only for cosmetic articles—where they decorate vessels (Figures 27,[51] 28), boxes, and dishes (Figure 29)[52] created for the application and storage of cosmetics—but also for jewelry, utensils, furniture, and ritual implements.[53]

Dated to the late Second Intermediate Period instead of Dynasty 12 or 13, the duck flasks and the monkey bowls anticipate these motifs, and are evidence of the sophistication and high level of workmanship that reemerged in Egypt during Dynasty 17 after a period of general decline in the arts following Dynasty 12. The duck flasks and monkey bowls are early examples of a thematic development that began during the late Second Intermediate Period and continued and expanded during Dynasty 18. This continuity would not exist if the elaborate anhydrite cosmetic vessels, including the duck flasks, were dated significantly earlier.

Appendix 1: Stylistic Types

The thirteen preserved anhydrite duck vessels represent adult birds, ducklings, and two of indeterminate age because the wings are cropped and no other distinguishing features are present. Along with two fragments, they may be organized into four types on the basis of stylistic similarities. At least one major feature, or combination of features, distinguishes each type from the others. The ducks of three of the four types (A, C, and D) are so homogeneous that all examples within each type can be attributed to a single artisan or workshop. Type B exhibits features of A and/or C, which demonstrates the continuity between A and C despite their stylistic differences. In the discussion, the various distinguishing features of each type are indicated in cursive to facilitate identification.

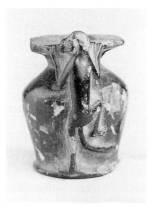

Figure 27. Kohl jar inscribed for Queen Hatshepsut with monkey as a handle. New Kingdom, Dynasty 18, 1492–1479 B.C. Black serpentinite, H. 5.5 cm. Cairo, Egyptian Museum CG 18486 (photo: Christine Lilyquist)

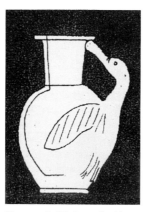

Figure 28. High-necked jar with duck as a handle. New Kingdom, Dynasty 18, ca. 1550–1400 B.C. Calcite. Present whereabouts not known; formerly London, University College, Petrie Museum (drawing after W. M. Flinders Petrie, *Stone and Metal Vases* [London, 1937] pl. XXXIV)

Figure 30. Shrine-shaped box on a corniced table with splayed legs. From an area of plundered tombs behind the Ramesseum, Second Intermediate Period, Dynasty 17?, ca. 1635?–?1550 B.C. Anhydrite, H. 6.9 cm. London, British Museum 65267, bequeathed by Sir Robert Ludwig Mond in 1939 (photo: Biri Fay, courtesy of the Trustees of the British Museum)

Type A. *The head is sharply undercut to the base of the beak, the eye is rimmed in copper, and the eye socket is shown as a depression.*

Type A comprises three ducks (cat. nos. 1–3; Figures 8, 31–33). These are the most elegant and naturalistically worked and exhibit the finest modeling of the body. The treatment of the legs, the arched neck, and the graceful sculpting of the webbed feet are distinctive. The head is large in proportion to the body, and the *eye sockets* are

marked as longitudinal depressions, with the *copper-rimmed eyes* inlaid in the center. The beak pressed against the breast is distinctly outlined, and the nostril holes are marked. The most characteristic feature shared by Type A ducks is the *sharp undercutting of the stone beneath the head, which flattens the underside and separates the head from the body.*

Each wing has two long parallel grooves. Two of the birds are depicted with the undeveloped, rounded wings of ducklings (cat. nos. 2, 3), not the longer folded wings of adults. The wings of the two birds forming the third flask (cat. no. 1) are cropped, but the indication of a milk tooth shows that these are also ducklings. All three Type A ducks are the work of one workshop, probably one artisan.

Type B. *The eye socket may be shown as a groove; the hind toe and the vent may be indicated.*

Although several features are unique to Type B, it is best described as transitional between Types A and C, because all Type B ducks share one or more features with A or C, or both.

Representing ducks or ducklings, four intact examples (cat. nos. 4–7; Figures 34–37) and a fragment (cat. no. 8; Figure 38) are included in Type B. All are slightly more stylized than Type A ducks and not as finely modeled. The head may be full and rounded (cat. nos. 4, 5, and 8; Figures 34, 35, and 38), or treated as an extension of the neck (cat. no. 6; Figure 36). The *eye sockets* of two Type B

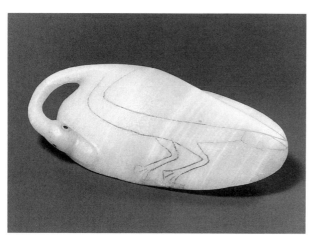

Figure 29. Clam-shaped duck dish with inlaid eye. New Kingdom, Dynasty 18, ca. 1550–1400 B.C. Calcite, L. 15.1 cm. The Brooklyn Museum of Art, Museum Collection Fund, 11.665 (photo: The Brooklyn Museum of Art)

ducks (cat. nos. 4–5) are, in contrast to Type A, *grooves rather than depressions*. The eye sockets of two others (cat. nos. 6, 8) are, like C and D, not indicated at all. The neck is worked free from the body. The wings are either rounded (duckling) or folded at the wrist (adult bird),and may be marked by a single groove, a pair, or none. The *vent may be indicated*. The toes of the webbed feet are rendered as thick ridges, and the *hind toe is included* on three ducks (cat. nos. 4–6; Figures 34–36). It is not possible to determine whether cat. no. 7 (Figure 37) also has a hind toe.

The bird in Strasbourg (cat. no. 4; Figure 34), a duckling, has thick short feet, which relate it to Type C. However, two of its features are found on Type A ducks—the full, well-shaped head undercut to the base of the beak, and the short wings rounded at the wrist, which indicate the bird is a fledgling. The *eye socket rendered as a groove*, and the indication of the *hind toes* and the *vent* are unique to Type B.

Although wings folded at the wrists indicate that the Abydos, Tomb X. 52 (cat. no. 5; Figure 35), example represents an adult bird, it shares many features with the Strasbourg duckling, including the same rendering of the *eye socket*, *hind toe*, and *vent*, which are features unique to Type B ducks; a slightly undercut head and a short foot (only one is preserved) with thick toes that relate both to Type C; and the same prominent elbow and knee joints, and a full, well-modeled head, which are features both birds share with Type A ducks. The similarities between them are so strong that the Abydos and Strasbourg flasks were undoubtedly carved by the same artisan.

The indication of the short *hind toe* occurs on a third Type B example, Durham H. 2259 (cat. no. 6; Figure 36). This duck, like Type C birds, has small eyes and no indication of an eye socket. The top and sides of the bill are recessed here, as on most Type C ducks. The juncture where the feathered neck meets the plucked body is indicated, a detail that also occurs on one Type C duck (cat. no. 12; Figure 42). The wide neck is characteristic of Type A, but the unmodeled head is unique to this piece. The folded wing is marked by a single groove, a feature also found on a second Type B duck (cat. no. 7; Figure 37).

Although the discussion of features shared by Types A, B, and C may seem to blur their distinctions, a closer look reveals a continuity among the three types. Type B ducks are distinguished by the presence of a *hind toe* on three examples (cat. nos. 4–6; Figures 34–36), and the eye shown as a groove and the indication of the vent on two examples (cat. nos. 4–5; Figures 34, 35). A and B are related because two Type B ducks (cat. nos. 4–5; Figures 34, 35), both surely by one artisan, are so similar to the Type A ducks that all may have been carved by the same individual, or by someone working closely with him. As has been shown, other features relate three Type B ducks (cat. nos. 4, 6, and 7; Figures 34, 36, and 37) to Type C. Also, the Strasbourg duckling, one of the two Type B birds by the same artisan (or workshop)

who carved the Type A ducks, was found at Girgeh; and three of the four Type C ducks were also said to have been found at Girgeh. Finally, a milk tooth is indicated on two Type A ducks (cat. nos. 1, 2; Figures 31, 32) and on one Type B duck (cat. no. 5; Figure 35).

These shared features not only support the original point that Type B is transitional between Types A and C, but also demonstrate the continuity among all three types.

Type C. *The head is small in proportion to the body. The eyes are small, the eye sockets are not indicated. The beak is long and narrow, and its surface may be recessed at the side of the head. The neck is narrow. The neck may be turned to one side and/or worked only in bold relief on the vessel wall, not free from the body.*

All four Type C ducks are in the Metropolitan Museum (cat. nos. 9–12; Figures 39–42). In contrast to Types A and B, these birds are simplified and stylized. On two ducks (cat. nos. 10, 12; Figures 40, 42) the *heads and necks are carved in high relief on the sides of the vessel, not free from the body*, a feature unique to Type C. It may be combined with a second stylistic variation found only on Type C ducks, in which the *necks twist to the sides* around the body (cat. nos. 11, 12; Figures 41, 42).

The *beak is recessed* at the sides of the heads on three examples (cat. nos. 9–10, 12; Figures 39–40, and 42). The surface of the fourth example (cat. no. 11; Figure 41) is so deteriorated that it is not possible to determine whether it was treated in a similar manner. On the double duck (cat. no. 12; Figure 42)the junctures where the feathered necks meet the plucked bodies are indicated, a feature it shares with a Type B duck (cat. no. 6; Figure 36). The rounded undeveloped wings of (cat. no. 11; Figure 41) indicate that this is a duckling, like five other Type A, B, and D examples (cat. nos. 2–4, 13, and 14; Figures 32–34, 43, and 44).

The provenance of three Type C ducks (cat. nos. 9–11; Figures 39–41) is said to be a cemetery at Girgeh, the site of the single largest find of anhydrite vessels, which further underscores the homogeneity of Type C. The fourth Type C duck (cat. no. 12; Figure 42) comes from Abydos, less than thirty kilometers south of Girgeh. Presumably, all Type C ducks were made at Girgeh in the same workshop, perhaps by the same artisan.

Type D. *These are the largest ducks, and have elliptical bodies. The head is large and rounded, and the neck is arched far from the body, with only the beak tip pressed against the breast. The mouth of the vessel is surrounded by a sharp rim.*

Type D comprises two ducks (cat. nos. 13, 14; Figures 43, 44) and a fragment (cat. no. 15; Figure 45). Although they are the *largest* of all the duck flasks, they lack the grace and aesthetic balance of Types A, B, and C. The *head is unrealistically rounded* and the *neck arches boldly from the*

35

ellipse-shaped body. The *beak is depicted as if it bends where it touches the breast.* The wings and feet are large and clumsily spread across the expanse of the body. In contrast to the other three types, Type D ducks lack a spout; instead, a *sharp rim surrounds the mouth.* The rounded, undeveloped wings indicate these birds are ducklings.

All Type D examples are presumably the work of a single craftsman who evidently was not as talented as the artisans who carved the Type A, B, and C ducks. The two complete flasks (cat. nos. 13, 14; Figures 43, 44) were originally in the collection of Robert de Rustafjaell, and may therefore have been found together.

Summary

Subtle differences between Types A and B—whether, for example, the eyes are set in depressions or grooves or lack any indication of sockets; and the presence or absence of undercutting beneath the ducks' heads—may reflect gradual development of one artisan's technique as he produced a series of similar objects over time, or the reciprocal influence between two or more artisans working together. More obvious stylistic differences, like those between Type A, C, and D ducks reflect (as suggested in the dating discussion) an artisan's or a workshop's individual interpretation of the subject.

The fundamental continuity of this subject—a duck-shaped flask carved in anhydrite—is evident both in the consistency of the overall form, and in the stylistic details that are shared between and among types. Such continuity is particularly well demonstrated by the Type B ducks that link Types A and C, not only stylistically, but also by common provenance.

Appendix 2: Catalogue of Duck Vessels

* = Personally examined

*1. New York, The Metropolitan Museum of Art, 27.9.1 (Figures 8, 31)

Type A

Anhydrite

Measurements: H. 17.4 cm, W. 15.3 cm, D. 8.7 cm, W. of mouth 3.5–3.7 cm

PROVENANCE: Purchased in Luxor.[54] Said to be from a tomb between Sheikh 'Abd el-Qurna and the Ramesseum, Thebes, perhaps Sir Robert Mond's concession[55]

A flask in the form of a pair of ducklings pressed back-to-back. Their necks arch far from the bodies and bend abruptly. Large, well-formed heads are undercut sharply to the bases of the beaks resting on the birds' breasts. All four inlaid eyes are preserved and set in long depressions. The copper rims of the inlays are very corroded. The beaks are outlined, and the nostrils are shown as short depressions. The milk teeth at the ends of both beaks identify these birds as fledglings. The joints of the wings cropped at the elbows are indicated. Webbed feet are long and the toes narrow. The interior of the integral spout is smoothed. One side of the vessel is encrusted and the surface is deteriorated. This is not only the finest of the duck flasks but also the most unusual because it is the only one designed to stand upright on the elongated knee joints.

A shrine-shaped anhydrite box on a small corniced table with splayed legs in the British Museum (Figure 30)[56] is possibly associated with this double-duck flask. It was recovered by Sir Robert Mond from an area of plundered tombs behind the Ramesseum, in Thebes. According to Mond's report, the area was in use from at least Dynasty 11 through the Late Period. This double-duck flask is also recorded as originally from the same area.

Only half of the box lid is preserved. Dried glue along the break edge and a pair of holes drilled through the lid near the break indicate that the box was repaired in antiquity by tying leather, cord, or wire through a second pair of holes on the lid portion, now lost. Traces of an intercolumnar line beside the edge of the break indicate that the box was decorated or inscribed.

Although proof is lacking, and the only evidence consists of their common material and reports that they were found in the same area, it is nevertheless tempting to associate the double-duck flask with the box because each is such a distinctive piece.

BIBLIOGRAPHY: Terrace, p. 61, BI, 6, pl. XXIII, fig. 24; Arnold, p. 28, no. 27.

*2. Private collection (Figure 32)

Type A
Anhydrite
Measurements: H. 6.8 cm, W. 6 cm, L. 11.4 cm
PROVENANCE: Not known

A flask in the form of a duckling with the head undercut to the base of the beak.[57] The well-formed head is large, and the eyes are set in long depressions. The left copper eye rim and inlay are lost; the right rim is preserved, but corroded. These rims discolored the surrounding area of the head to green. The beak, which includes a fledgling's milk tooth, is outlined, and the nostrils are indicated. The undeveloped wings curve at the wrists, are marked by a pair of grooves, and have prominent elbow joints. The webbed feet are long with narrow toes, similar to the double-duck flask (cat. no. 1; Figures 8, 31), and the knee joints are prominent. The spout was made separately and fits snugly in the prepared recess. Abrasions on the underside, to the right and left of the spine, are distinct signs of use.

This duck flask is so similar to the Metropolitan Museum's double-duck flask that they can be attributed to the same artisan. Although this example is considerably smaller than the one in the Museum, it is as finely carved.

BIBLIOGRAPHY: Sotheby's, London, *Ancient Jewellery, Dark Ages, Egyptian, Greek, Etruscan and Roman Antiquities, South Italian Greek Pottery Vases, Ancient Glass, Middle Eastern Antiquities and Art Reference Books also Mosaics*, December 11, 1989, pp. 38–39, lot 65, ill.

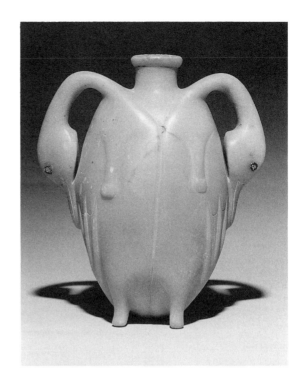

*3. Boston, Museum of Fine Arts 65.1749 (Figure 33)

Type A
Anhydrite
Measurements: H. 7 cm, W. 5.86 cm, L. 15 cm
PROVENANCE: Gift of Horace Mayer

A flask in the form of a duckling,[58] with a sharply undercut head. The original surface on the head is preserved, but the upper surface of the body, which is somewhat longer than the first two flasks of this type, is deteriorated. Abrasions are visible on the underside (where the original surface is intact), especially to the right and left of the spine, which are the surfaces on which the flask normally rested when not being held.

The well-formed head is large and wide, with the eyes inlaid into long depressions at its side. Both copper-rimmed inlays are preserved in the eye recesses. The undeveloped wings, curving at the wrists, are detailed with double grooves and an added narrow line along the inner edges. The beak is outlined and the nostrils are marked. The webs between the toes are detailed with a

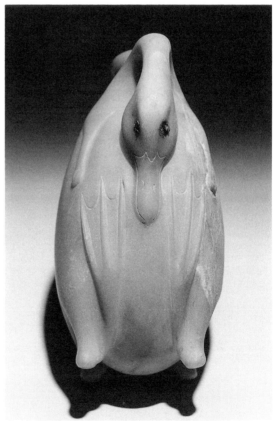

Figure 31a, b. Flask in the form of a pair of plucked ducklings (Type A, cat. no. 1). Said to be from Mond's excavations behind the Ramesseum at Thebes, Second Intermediate Period, Dynasty 17, ca. 1635–1550 B.C. Anhydrite, with inlaid eyes, H. 17 cm. The Metropolitan Museum of Art, Gift of Edward S. Harkness, 1927, 27.9.1

second line, and the toe joints are marked by short lateral lines. The spout is integral with the body. A pair of grooves to either side of the spout form a V on the underside (back) of the bird.

The undercutting of the duckling's head to the base of the beak, the beak detailing, and the eyes set in depressions are features shared with cat. nos. 1, 2 (Figures 31, 32). These features are diagnostic of Type A, as is the superior carving. The curved wrists of the immature wings also occur on cat. no. 2. All three ducks were presumably carved by the same artisan.

BIBLIOGRAPHY: Terrace, p. 61, BI, 1, pl. XXI, figs. 21, 22.

4. Strasbourg, Institut d'Égyptologie 1078 (Figure 34)
Type B
Anhydrite
Measurements: H. 9 cm, W. 7.8 cm, L. 14 cm
PROVENANCE: Girgeh

This flask is in the form of a duckling, with a wide head undercut to the base of the beak and undeveloped wings rounded at the wrists. Black eye disks are inlaid into grooves at the sides of the head. The beak is outlined, the nostrils are marked, and the vent is indicated. The feet have thick toes, and the hind toe is indicated. The duck's right side is damaged and heavily encrusted, and a section is missing at the base of the neck; the spout is lost.

Although this duck exhibits features diagnostic for Type B (short feet with thick toes, a hind toe, eyes set in distinct grooves, and a vent), it is also stylistically related to Type A (the undercutting of the head). Even though

not as finely carved as Type A examples, it is either from the same workshop or was carved by an artisan familiar with that style.

This duckling is recorded as coming from Girgeh; it therefore links Type C with Types A and B (already linked on the basis of strong stylistic parallels), because three of the four Type C ducks are also said to have been found at Girgeh.

The similarity of the Strasbourg duck to Abydos Tomb X. 52 (cat. no. 5; Figure 35), including the unusual indication of their vents, suggests both were carved by the same artisan.

BIBLIOGRAPHY: Jacques Parlebas, *Antiquités Égyptiennes*, exh. cat. (Strasbourg, 1973) p. 51, cat. no. 235, ill. in color on back cover; *La Femme dans l'Égypte Ancienne*, exh. cat., Institut d'Égyptologie de Strasbourg, Musée d'Histoire de Mulhouse, Muséum d'Histoire Naturelle de Colmar (Colmar, 1994) p. 20, cat. no. 21 (where the provenance is given as Thebes).

5. Abydos, Burial X. 52 (Figure 35)
Type B
Anhydrite
Measurements: H. 7.3 cm, W. 6.9 cm, L. 12.5 cm
PROVENANCE: Abydos, Burial X. 52; formerly in the collection of the Art Institute of Chicago (11.451)

A flask in the form of a duckling with a large, wide head that is slightly undercut. The nostrils are marked and rimmed, and the beak is outlined. A fledgling's milk tooth is indicated, a feature that contradicts the long wings,

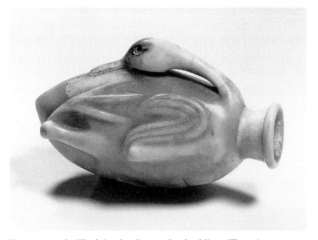

Figure 32a, b. Flask in the form of a duckling (Type A, cat. no. 2). Second Intermediate Period, Dynasty 17, ca. 1635–1550 B.C. Anhydrite, with inlaid eyes, L. 11.4 cm. Private collection (photo: Jürgen Liepe)

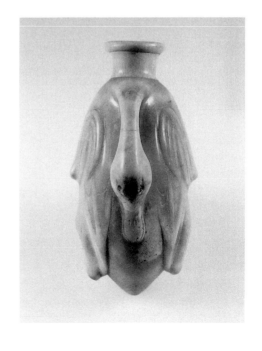

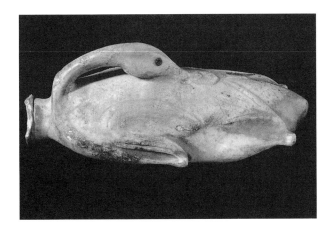

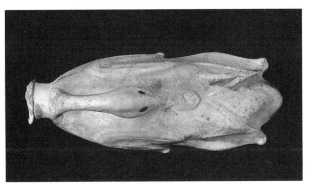

Figure 33. Flask in the form of a duckling (Type A, cat. no. 3). Second Intermediate Period, Dynasty 17, ca. 1635–1550 B.C. Anhydrite, with inlaid eyes, L. 15 cm. Boston, Museum of Fine Arts, Gift of Horace Mayer, 65.1749 (photo: Museum of Fine Arts)

pp. 94–95; Hermann, "Das Motiv der Ente," p. 92, pl. VIIIa; Terrace, p. 61, BI, 2 and 3, pl. XXII, fig. 23 (Terrace did not realize that his 2 and 3 were the same vessel); Kemp and Merrillees, p. 168; Bourriau, p. 141; Aston, pp. 141–142.

*6. Durham, Oriental Museum, H. 2259 (Figure 36)

Type B

Anhydrite

Measurements: H. 6.7 cm, W. 7.5 cm, L. 11.8 cm, Diam. of opening 1.74 cm

PROVENANCE: Formerly in the collection of Sir Charles Hardinge

A flask in the shape of a duck.[61] The head is summarily shaped, and the small eyes were inlaid into the sides of the head with no indication of sockets. Traces of black are preserved in the eye recesses, but no actual part of the inlay is preserved. The top of the beak is recessed. A V-shaped recess at the point where the neck joins the body depicts the feathers on the neck of the duck; this detail occurs on one other example, cat. no. 12 (Figure 42).

The wings are folded at the wrist and marked by a single deep groove. The toes are thick; the hind toe is indicated. The underside is rubbed and abraded, and there is no obvious residue on the interior. A crack runs through the neck along a vein in the stone. Grooves are visible on the interior vessel walls.

A dark plum-red discoloration at several places on the underside may be from a polished wood stand that its former owner, Sir Charles Hardinge, used to display Chinese jades, and, presumably, this piece as well. The spout, separately made, is missing.

which are aspects of a more mature bird. The black eye disks are set in shallow grooves at the sides of the head. The wings fold at the wrist and are marked by a pair of grooves. The preserved foot is short with thick toes, whose joints are modeled, and the hind toe is shown.

This duck flask is the only one found in a closed context. It was excavated by T. Eric Peet in an undisturbed burial at Abydos, dated by Bourriau[59] to Dynasty 17 and by Kemp and Merrillees[60] to Dynasty 17 to early Dynasty 18. Although its head is only slightly undercut and the feet are somewhat clumsy, this object is stylistically related to Type A duck flasks and is presumably from the same workshop. Its similarity to the Strasbourg duck, including the unusual depiction of the vent, indicates that both were carved by the same artisan.

BIBLIOGRAPHY: Peet, *Cemeteries of Abydos* II (1914) p. 61, X. 52, pl. XIII, fig. 14; Thomas George Allen, *A Handbook of the Egyptian Collection of the Art Institute of Chicago* (Chicago, 1923)

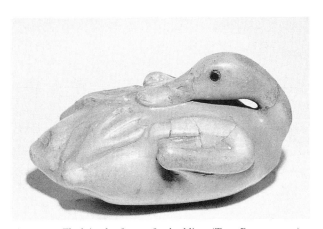

Figure 34. Flask in the form of a duckling (Type B, cat. no. 4). From Girgeh, Second Intermediate Period, Dynasty 17, ca. 1635–1550 B.C. Anhydrite, with inlaid eyes, L. 14 cm. Strasbourg, IES 1078 (photo: Bernard V. Bothmer)

The lack of an eye depression and the recessing of the top of the beak relate this duck flask most closely to Type C.

John Ruffle wrote an interesting anecdote about this flask: "The piece has no Egyptian provenance, but has a curious recent history. It came to the Museum in 1960 as part of a large collection of Chinese (!) jades and other hardstone carvings. This collection was formed by Sir Charles Hardinge, who was a petrologist by training, and who formed his collection for its petrological interest rather than its aesthetic value. He purchased this particular piece from a dealer in London on July 4, 1934, for the handsome sum of £4!" Hardinge gave his collection to the museum in 1960.

BIBLIOGRAPHY: Bourriau, p. 141, no. 143, ill.

7. E. L. B. Terrace Group VII (Figure 37)

Type B
Anhydrite
Measurement: L. 6.7 cm
PROVENANCE: Lisht

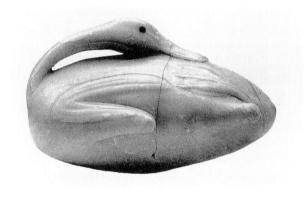

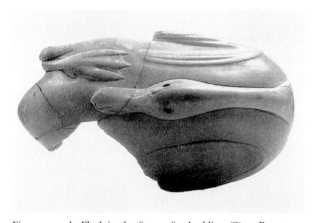

Figure 35a, b. Flask in the form of a duckling (Type B, cat. no. 5). From Abydos, Burial X. 52, Second Intermediate Period, Dynasty 17, ca. 1635–1550 B.C. Anhydrite, with inlaid eyes, L. 9.2 cm. Art Institute of Chicago (photo: Bernard V. Bothmer)

A fragmentary duck flask, with the wing folded at the wrist and marked by a single groove. Although the head and neck of the bird are broken away, traces along the break indicate that its neck was worked free of the body. The toes are thick.

The E. L. B. Terrace Group consists of a number of objects, including this duck flask, said to come from a tomb at Lisht. Barry Kemp and Robert Merrillees were able to record the group, but only after some pieces had been dispersed. Despite the incomplete information about the find, and the lack of proof that the group derives from a single tomb, Kemp and Merrillees noted in their publication of the material that the group was "strongly homogeneous." [62] Provided the objects in the group are contemporary with one another, a date in Dynasty 17 can be suggested for this flask as well as the group on the basis of one of the objects—a female fertility figurine (Figure 26) wearing a wig type that is typical of Dynasty 17. [63] This would also permit a date to be assigned to a second elaborate anhydrite vessel in the group, an elaborate bowl with a monkey clinging to its side in the Israel Museum, Jerusalem (Figure 12).

The head from a duck vessel found at Lisht, which was formerly in the Metropolitan Museum (cat. no. 8; Figure 38), may belong to this flask.

BIBLIOGRAPHY: Kemp and Merrillees, p. 165, VII, pl. 25a.

8. Ex–New York, The Metropolitan Museum of Art (Figure 38)

Type B
Anhydrite
Measurements not recorded
PROVENANCE: From The Metropolitan Museum of Art excavations at Lisht (found in debris); present location not known

A head of a duck from a flask, with eyes inlaid into the side of the head without a groove or depression.

The fragmentary vessel in the E. L. B. Terrace Group (cat. no. 7; Figure 37) is the only duck vessel besides this one known to come from Lisht. It is possible that this head belongs to the Terrace duck flask.

BIBLIOGRAPHY: Terrace, p. 61, BI, 10, pl. XIX, fig. 16.

*9. New York, The Metropolitan Museum of Art, 10.176.51 (Figure 39)

Type C
Anhydrite
Measurements: H. 5.4 cm, W. 9.5 cm, L. 10.4 cm
PROVENANCE: Said to be from Girgeh

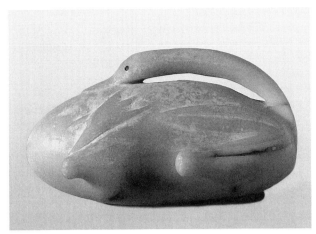

Figure 36. Flask in the form of a duck (Type B, cat. no. 6). Second Intermediate Period, Dynasty 17, ca. 1635–1550 B.C. Anhydrite, with inlaid eyes, L. 6.7 cm. Durham, Oriental Museum, H. 2259 (photo: Oriental Museum)

A flask in the form of two ducks arranged back-to-back. The necks are worked free from the body. The heads are long, and the beaks are long and narrow. The tops of the beaks are recessed. The eyes are small, and the copper eye rims and parts of the inlays are preserved. The wings are cropped at the elbows. The spout is lost, and most of the surface of the vessel is deteriorated.

This flask is distinctly stylized. The ducks' beaks are large in proportion to the heads, and are recessed at their sides.

BIBLIOGRAPHY: Terrace, p. 61, BI, 8, pl. XXIV, fig. 28.

*10. New York, The Metropolitan Museum of Art, 10.176.50 (Figure 40)

Type C
Anhydrite
Measurements: H. 6.9 cm, W. 7.8 cm, L. 14.7 cm
PROVENANCE: Said to be from Girgeh

A duck with an exceptionally long body, its neck is not carved free from the body. The head is long and small in proportion to the body. The beak is long and narrow and recessed at its sides. The eyes are small and were inlaid (one is preserved), but the eye sockets are not indicated. The wings are folded at the wrist. The rim of the spout is broken away.

The original surface is preserved on the back only. A round hole at the tail end of the flask must have been due to an inadvertent action that occurred during the hollowing process, and it was probably fitted with a plug.

This flask shows all characteristics of Type C, including a neck integral with the body (a feature unique to Type C).

BIBLIOGRAPHY: Terrace, p. 61, BI, 5, pl. XXIV, fig. 26.

*11. New York, The Metropolitan Museum of Art, 12.182.76 (Figure 41)

Type C
Anhydrite
Measurements: H. 4 cm, W. 6.1 cm, L. 10 cm
PROVENANCE: Said to be from Girgeh

A flask in the form of a duckling, with its neck worked free from the body and curved to the side. The neck was broken in two places and reattached. The head is small and the beak is long. The small copper-rimmed eyes are inlaid into the head with no indication of the eye sockets. The body is plump, and the wings are slightly rounded at the wrist, indicating that the bird is a fledgling. The spout was made separately and fitted into a recess. The stone is discolored and appears to have lost its original surface.

This is the only vessel that has its head turned to the side and its neck worked free from the body. It is also the only Type C piece with the undeveloped wings of a duckling.

BIBLIOGRAPHY: Terrace, p. 61, BI, 4, pl. XXIV, fig. 25.

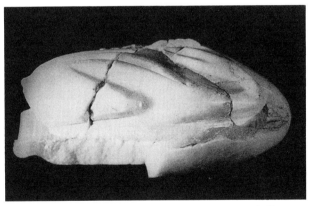

Figure 37. Fragmentary duck flask (Type B, cat. no. 7). From Lisht, Second Intermediate Period, Dynasty 17, ca. 1635–1550 B.C. Anhydrite, with inlaid eyes, L. 6.7 cm. E. L. B. Terrace Group VII (photo: after Kemp and Merrillees, *Second Millenium Egypt*, pl. 25a)

*12. New York, The Metropolitan Museum of Art, 24.2.25 (Figure 42)

Type C
Anhydrite
Measurements: H. 5.4 cm, W. 8.8 cm, L. 12.2 cm
PROVENANCE: Excavated by John Garstang at Abydos, 1907;[64] formerly in the collection of the Reverend William MacGregor[65]

A double-duckling flask with the heads and necks of the birds curved to the side. The necks are not worked free

Figure 38. Head from a duck flask (Type B, cat. no. 8). From Lisht, Second Intermediate Period, Dynasty 17, ca.1635–1550 B.C. Anhydrite, with inlaid eyes. Ex–The Metropolitan Museum of Art (photo: after Terrace, *JARCE* 5 [1966] pl. XIX, fig. 16)

BIBLIOGRAPHY: Sotheby, Wilkinson and Hodge, London, *Catalogue of The MacGregor Collection of Egyptian Antiquities*, June 26–July 3, 1922, p. 135, lot 1018, pl. XXVI; Terrace, p. 61, BI, 7, pl. XXIV, fig. 27.

*13. Saint Petersburg, Hermitage, 5520 (Figure 43)

Type D
Anhydrite
Measurements: H. 11.5 cm, W. 15 cm, L. 20 cm
PROVENANCE: Formerly in the collection of Robert de Rustafjaell[67]

from the body and are shown feathered, in contrast to the plucked body, like cat. no. 6 (Figure 36).[66] The heads and beaks are long and narrow, and the sides of the beaks are recessed. The milk tooth is present on both beaks. The preserved eye inlays are small and rimmed in copper. The places where the vessel rested show evidence of wear.

Although this duck comes from Abydos, its similarity to the three other Type C examples that were found at Girgeh indicates a common workshop for all four pieces.

This is the largest anhydrite duck flask.[68] The ellipse-shaped body and the round head arching far from the body with only the tip of the beak touching the breast are both diagnostic for Type D. The eyes are inlaid. The wings are rounded at the wrist, indicating that the bird is a fledgling. The opening is surrounded by a sharp rim, which is found only on Type D flasks. A portion of the rim is broken away, and the head and neck of the duckling were broken away and reattached.

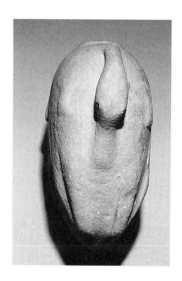
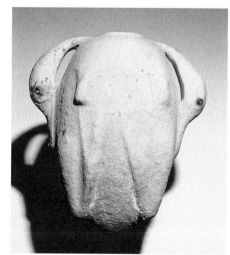
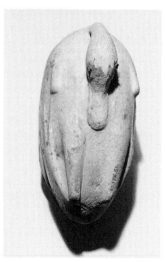
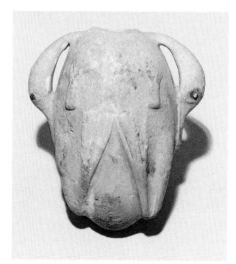

Figure 39a, b, c, d. Flask in the form of two ducks (Type C, cat. no. 9). Said to come from Girgeh, late Second Intermediate Period, Dynasty 17, ca. 1635–1550 B.C. Anhydrite, with inlaid eyes, L. 10.4 cm. The Metropolitan Museum of Art, Rogers Fund, 1910, 10.176.51

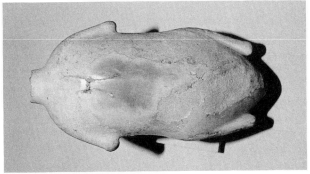

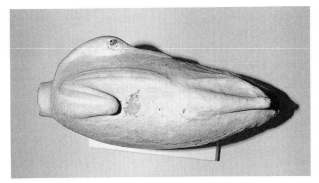

Figure 40a, b. Flask in the form of a duck with a long body (Type C, cat. no. 10). Said to come from Girgeh, late Second Intermediate Period, Dynasty 17, ca. 1635–1550 B.C. Anhydrite, with one inlaid eye, L. 14.7 cm. The Metropolitan Museum of Art, Rogers Fund, 1910, 10.176.50

This and the following flask are virtually identical.

BIBLIOGRAPHY: Sotheby, Wilkinson and Hodge, London, *Catalogue of the Remaining Part of the Valuable Collection of Egyptian Antiquities Formed by Robert de Rustafjaell, Esq.*, January 20, 1913, and four following days, p. 9, lot 103, pl. XIV; Kunsthaus Zürich, *Aus den Schatzkammern Eurasiens: Meisterwerke antiker Kunst*, exh. cat. (Zurich, 1993) pp. 316–317, cat. no. 162, with bibliography, ill. (the catalogue's authors were unaware of the Rustafjaell provenance).

14. Ex–Joseph Brummer Collection (Figure 44)

Type D
Anhydrite
Measurement: L. 19.1 cm
PROVENANCE: Formerly in the collections of Robert de Rustafjaell, Robert Woods Bliss (1937), and Joseph Brummer; present location not known

The second duckling flask from the Rustafjaell collection. Like the Saint Petersburg piece, this one is exceptionally large, with a round head and the neck arching far from the body. Only the tip of the beak touches the body.

BIBLIOGRAPHY: Sotheby, Wilkinson and Hodge, London, *Collection Robert de Rustafjaell*, January 20, 1913, p. 9, lot 102, pl. XIV; Parke-Bernet Galleries Inc., New York, *The Notable Art Collection Belonging to the Estate of the Late Joseph Brummer*, Part I, April 20–23, 1949, p. 9, lot 41, ill.; the provenance given there is N. Rustafjaell, London, 1913, and Robert Woods Bliss, Paris, 1937.

*15. London, British Museum 59243 (Figure 45)

Type D
Anhydrite
Measurements: H. 1.8 cm, W. 1.45 cm, L. 4.27 cm
PROVENANCE: Purchased in 1929. Probably part of the collection of Rev. William MacGregor

Duck head and part of neck. The eyes were inlaid. Like cat. nos. 13 and 14, the neck arches boldly, and the head is rounded. The break at the beak shows that only its tip touched the body, a further diagnostic feature of Type D.

This fragment may be the piece from the MacGregor collection that was sold in London at Sotheby's in 1922. The description in the catalogue reads, "also a Handle from another bowl, in the same stone, in the form of a swan's or goose's head and neck."[69]

BIBLIOGRAPHY: Terrace, p. 61, BI, 9. Probably the piece listed in Sotheby, Wilkinson and Hodge, London, *Catalogue of The MacGregor Collection of Egyptian Antiquities*, June 26–July 3, 1922, p. 135, as part of lot 1017.

Figure 41a, b. Flask in the form of a duckling with the head and neck turned to the side (Type C, cat. no. 11). Said to come from Girgeh, late Second Intermediate Period, Dynasty 17, ca. 1635–1550 B.C. Anhydrite, with inlaid eyes, L. 10 cm. The Metropolitan Museum of Art, Rogers Fund, 1912, 12.182.76

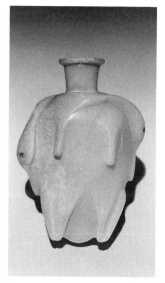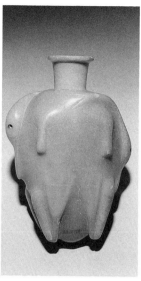

Figure 42. Double-duckling flask with the heads and necks turned to the side (Type C, cat. no. 12). From Abydos, late Second Intermediate Period, Dynasty 17, ca. 1635–1550 B.C. Anhydrite, with partially preserved eye inlays, L. 12.2 cm. The Metropolitan Museum of Art, Rogers Fund, 1924, 24.2.25

ABBREVIATIONS

Arnold—Dorothea Arnold, *An Egyptian Bestiary, MMAB,* Spring 1995

ASAE—Annales du Service des Antiquités de l'Égypte

Aston—Barbara G. Aston, *Ancient Egyptian Stone Vessels: Materials and Forms, Studien zur Archäologie und Geschichte Altägyptens,* Band 5 (Heidelberg, 1994)

Bourriau—Janine Bourriau, *Pharaohs and Mortals: Egyptian Art in the Middle Kingdom,* exhibition organized by the Fitzwilliam Museum (Cambridge, 1988)

CG—Catalogue Général des Antiquités Égyptiennes du Musée du Caire

JARCE—Journal of the American Research Center in Egypt

Kemp and Merrillees—Barry J. Kemp and Robert S. Merrillees, *Minoan Pottery in Second Millennium Egypt,* Deutsches Archäologisches Institut. Abteilung Kairo, Sonderschrift 7 (Mainz, 1980)

MDAIK—Mitteilungen des deutschen Archäologischen Instituts, Abteilung Kairo

Terrace—Edward L. B. Terrace, "Blue Marble" Plastic Vessels and Other Figures, *JARCE* 5 (1966) pp. 57–62, and pls. XIV-XXVIII.

ZÄS—Zeitschrift für ägyptische Sprache und Altertumskunde

ACKNOWLEDGMENTS

I thank Dorothea Arnold, Lila Acheson Wallace Curator in Charge, Department of Egyptian Art, The Metropolitan Museum of Art, for suggesting this article and discussing various aspects of it with me, and Marsha Hill, Curator, for her assistance at various stages during my work and for providing numerous details. I thank Richard Newman, Research Scientist, Department of Objects Conservation and Scientific Research, Museum of Fine Arts, Boston, whose analyses of organic residue taken from a broad sampling of blue-anhydrite containers in the Metropolitan Museum and the Museum of Fine Arts (Technical Report) have added immense interest and valuable information toward our understanding of the ancient use of these objects. I am also grateful to Janine Bourriau, the McDonald Institute for Archaeological Research, Cambridge University, England, for sharing her knowledge of Middle Kingdom material with me; to L. Joseph Stecher, Los Angeles, for editorial comments; to Georg Meurer for

Figure 43a, b. Large duckling flask (Type D, cat. no. 13). Second Intermediate Period, Dynasty 17, ca. 1635–1550 B.C. Anhydrite, with inlaid eyes, L. 20 cm. Saint Petersburg, Hermitage, 5520 (photo: Hermitage)

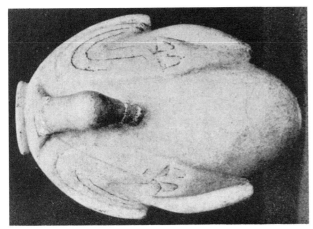

Figure 44. Large duckling flask (Type D, cat. no. 14). Second Intermediate Period, Dynasty 17, ca. 1635–1550 B.C. Anhydrite, with inlaid eyes, L. 19.1 cm. Ex–Joseph Brummer Collection (photo: after Parke-Bernet Galleries Inc., New York, *The Notable Art Collection Belonging to the Estate of the Late Joseph Brummer,* Part I, April 20–23, 1949, p. 9, lot 41)

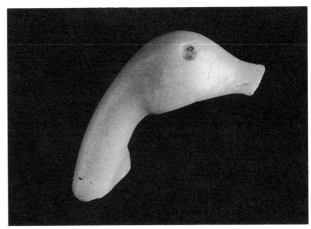

Figure 45. Head and neck from a duck flask (Type D, cat. no. 15). Second Intermediate Period, Dynasty 17, ca. 1635–1550 B.C. Anhydrite, eyes originally inlaid, L. 4.27 cm. London, British Museum 59243 (photo: courtesy of the Trustees of the British Museum)

assistance in Berlin; and to Diane Bergman (Wilbour Librarian) and Mary Gow (Assistant Librarian) of the Brooklyn Museum of Art, who made the Wilbour Library facilities available to me.

NOTES

1. The cosmetic arts in ancient Egypt are discussed by Rita E. Freed in Edward Brovarski, Susan K. Doll, Rita E. Freed et al., *Egypt's Golden Age: The Art of Living in the New Kingdom 1558–1085 B.C.*, exh. cat., Museum of Fine Arts, Boston (Boston, 1982) pp. 199–200.

2. Some objects generally classified as toilet articles may have served an additional or even a primary function as ritual implements. For the most recent discussion, see Arielle P. Kozloff in Arielle P. Kozloff and Betsy M. Bryan, *Egypt's Dazzling Sun: Amenhotep III and His World* (Cleveland, 1992) pp. 331–341. Numerous examples are illustrated in Jean Capart, *Primitive Art in Egypt* (London, 1905) figs. 75–78; Aston, p. 98.

3. Henry George Fischer, "Another Pithemorphic Vessel of the Sixth Dynasty," *JARCE* 30 (1993) pp. 1–9, discusses sixteen vessels in the form of monkeys. Three vessels bear cartouches of King Pepi I, Dynasty 6 (two mention the king's first jubilee). Other monkey vessels are inscribed with the names of his sons, one for Merenre, and five for Pepi II. To these may be added an uninscribed monkey vessel, without a baby, Munich, ÄS 1601, and a fragment with a baby only, Berlin 14404; Sylvia Schoske et al., *Schönheit–Abglanz der Göttlichkeit: Kosmetik im alten Ägypten,* Schriften aus der Ägyptischen Sammlung 5 (Munich, 1990) pp. 92–93, nos. 50 and 49, respectively.

4. Edward Terrace was the first to discuss anhydrite duck flasks as part of an article on anhydrite plastic vessels; *JARCE* 5 (1966) pp. 57–63, pls. XIV–XXVII.

To Terrace's list of duck vessels may be added: Private Collection (cat. no. 2); Strasbourg 1078 (cat. no. 4); Durham H. 2259 (cat. no. 6); E. L. B. Terrace (cat. no. 7); Saint Petersburg 5520 (cat. no. 13); Ex–Brummer Collection (cat. no. 14).

To Terrace's section termed "Others," listing blue-anhydrite vessels in forms other than monkeys or ducks, add: Cambridge, Fitzwilliam Museum (E.54.1937), a vessel embraced by a pair of vultures sharing shen signs in their talons, Bourriau, pp. 140–141, no. 142; Berlin 11554, a squat pot with cobras rising on opposite sides, their bodies encircling the base to create a ring, blue anhydrite, H. 2.5 cm; Schoske et al., *Schönheit,* pp. 106–107, no. 70; and a similar example, British Museum 12753, less finely worked, with the hoods of the cobras only, blue anhydrite, H. 4.12 cm, said to come from Thebes, unpublished.

5. The birds are usually identified as trussed ducks, but there is no visible sign of trussing.

6. Calcium sulfate $CaSo_4$ in its anhydrous form; Alfred Lucas, *Ancient Egyptian Materials and Industries* (London, 1989) rev. and enlarged by J. R. Harris, p. 413; Thierry De Putter and Christina Karlhausen, *Les Pierres utilisées dans la sculpture et l'architecture de l'Égypte pharaonique,* Connaissance de l'Égypte Ancienne 4 (Brussels, 1992) pp. 49–50; and Chris Pellant, *Steine und Minerale* (Ravensburg, 1994) p. 111. The composition, use, and date of anhydrite are discussed by Aston, pp. 51–53 (2.2.10). See also Kemp and Merrillees, p. 168; and Bourriau, p. 140.

7. Lucas, *Ancient Egyptian Materials and Industries,* p. 413.

8. Bourriau, pp. 142–143, discusses this problem.

9. MMA acc. no. 26.3.220, from Deir el-Bahri, Theban Tomb no. 313 (MMA tomb no. 510), blue anhydrite, H. 3 cm, W. 4.5 cm, D. 7 cm; Bertha Porter and Rosalind Moss, *Topographical Bibliography of Ancient Egyptian Hieroglyphic Texts, Reliefs, and Paintings,* I: *The Theban Necropolis,* Part I, *Private Tombs,* 2nd rev. ed. (Oxford, 1960) pp. 388–389, TT 313; Terrace, *JARCE* 5 (1966) pp. 58 and 62, D, 1, pl. XXVII. For Henenu and his tomb, see James P. Allen, "Some Theban Officials of the Early Middle Kingdom," *Studies in Honor of William*

Kelly Simpson I (Boston, 1996) pp. 10–12. I thank Marsha Hill, Curator, Department of Egyptian Art, MMA, for providing information on this object.

10. London, British Museum 24118, blue anhydrite, H. 3.98 cm, W. 4.29 cm, thickness 1.2 cm, purchased from Rev. William John Lottie, 1890; W. M. Flinders Petrie, *Diospolis Parva, the Cemeteries of Abadiyeh and Hu, 1898–99*, The Egypt Exploration Society, Excavation Memoir 20 (London, 1901) p. 42, mentioned in text; Henri Gauthier, *Le Livre des Rois d'Égypte, Recueil de Titres et Protocoles Royaux, Noms Propres de Rois, Reines, Princes, Princesses et Parents de Rois*, Tome II, *de la XIIIe à la Fin de la XVIIIe Dynastie*, Mémoires publiés par les Membres de l'Institut Francais d'Archéologie Orientale du Caire 18 (Cairo, 1912) p. 33, no. VIII; Terrace, *JARCE* 5 (1966) p. 58 (2).

W. Vivian Davies, Keeper, Department of Egyptian Antiquities, the British Museum, kindly permitted me to examine the blue-anhydrite objects in that collection. I thank Richard Parkinson, Curator, for providing details of those objects and the members of the department for their assistance.

11. Cairo JE 39567, blue anhydrite, H. 10 cm, from Dendera; Arthur E. P. B. Weigall, "Upper Egyptian Notes," *ASAE* 9 (1908) p. 107, no. 5, fig. 2; Aston, p. 52. I thank Christine Lilyquist, Lila Acheson Wallace Research Curator in Egyptology, MMA, for providing the Cairo Museum accession number.

12. Aston, p. 52.

13. The exceptions to this chronological distribution are a gold-trimmed vessel in the MMA (Figure 18) that belonged to a minor wife of Tuthmosis III (ca. 1479–1425 B.C.), New York, MMA 26.8.35a,b; Christine Lilyquist, *Egyptian Stone Vessels: Khian through Tuthmosis IV* (New York, 1995) p. 51, Q, ill.; and the head (H. 8.1 cm) and feet from a royal shawabti found in the tomb of Ramesses II (ca. 1279–1213 B.C.), Christian Leblanc, "Trois campagnes de fouille dans la tombe de Ramsès II. KV. 7—Vallée des rois—1993/1994/1995," *Memnonia, Bulletin édité par l'association pour la sauvegarde du Ramesseum* 7 (Paris-Giza, 1996) pp. 196–197, pls. L, LI b.

Two other pieces have been called anhydrite but are actually blue chalcedony: a bull-headed amulet datable to the Predynastic Period (ca. 3200–2960 B.C.), in Brussels, MRAH E 2335; De Putter and Karlshausen, *Les Pierres*, p. 50, pl. 4c; and an ethereal statuette that represents a daughter of Akhenaten (ca. 1349–1336 B.C.), in Berlin, 17951; Werner Kaiser et al., *Ägyptisches Museum Berlin* (Berlin, 1967) p. 68, no. 750, ill. I thank Dietrich Wildung, Director, Ägyptisches Museum und Papyrussammlung Staatliche Museen zu Berlin, for discussing the Berlin piece with me, and for suggesting that it and the Brussels amulet might be of chalcedony. For his publication of a small blue-chalcedony triad depicting Ramesses II and two deities in Marseilles, see Dietrich Wildung, "Ramses, die grosse Sonne Ägyptens," *ZÄS* 99 (1973) pp. 33–41, pl. IV.

14. This detail is similarly treated on Dynasty 18 dishes in the form of ducks; see, for example, Arnold, p. 28, no. 26.

15. I thank Richard Newman, Research Scientist, Department of Objects Conservation and Scientific Research, Museum of Fine Arts, Boston, for agreeing to undertake this project, and Susanna Gänsicke, Associate Conservator, for coordinating various details.

16. The single exception is the double-duck vessel (cat. no. 1; Figures 8, 31), which stands on the ankle joints.

17. Two cosmetic jars from the Dynasty 17 tomb of Queen Mentuhotep (ca. 1615 B.C.) at Dra Abu el-Naga are closed in this manner; Schoske et al., *Schönheit*, pp. 78–79, no. 32.

18. Janine D. Bourriau in Brovarski et al., *Egypt's Golden Age*, p. 103, no. 85, discusses a Dynasty 18 pottery vase with narrow neck that is sealed this way.

19. Paris, Louvre, E 11175bis; purchased, calcite, L. 22 cm, W. 11 cm, Diam. of spout 4.1 cm; Christiane Ziegler et al., *Museen der Welt: Der Louvre: die Ägyptische Sammlung* (Munich, 1992) p. 40, at the left in a group photograph. I thank Georg Meurer for bringing this object to my attention. Other examples include an alabaster flask in the form of a duck body from Beni Hasan, Tomb 684; see John Garstang, *The Burial Customs of Ancient Egypt As Illustrated by Tombs of the Middle Kingdom* (London, 1907) p. 118, fig. 111, who suggests it is early Dynasty 18 on the basis of the pottery found with it. See also Robert S. Merrillees, *The Cypriote Bronze Age Pottery Found in Egypt*, Studies in Mediterranean Archaeology 18 (Lund, 1968) pp. 107–108; a bag-shaped alabaster vessel with a duck-headed handle, found at Sedment, in locus 1300, a group of objects datable to various periods, W. M. Flinders Petrie and Guy Brunton, *Sedment* I, British School of Archaeology in Egypt and Egyptian Research Account 34 (London, 1924) p. 18, pls. XL, middle row left, XLI, no. 12. For Sedment locus 1300, see also Bourriau, p. 112, no. 98.

20. In contrast, vessels shaped as living birds are preserved from the Predynastic and Early Dynastic periods (ca. 3200–2800 B.C.); for example, Ali Abdel-Rahman Hassanain El-Khouli, *Egyptian Stone Vessels: Predynastic Period to Dynasty III, Typology and Analysis*, 3 vols. (Mainz, 1978) p. 738, pl. 139, N. A Tell el-Yahudiya jug in the shape of a live duck is datable to the Hyksos Period; Manfred Bietak et al., *Pharaonen und Fremde: Dynastien im Dunkel*, exh. cat., Historische Museum der Stadt Wien (Vienna, 1994) p. 231, no. 281 (New York, MMA 23.3.40).

21. By the New Kingdom, dishes in the form of food offerings occur frequently; they include plucked ducks, as well as ibex and oryx bound for slaughter; William H. Peck in Brovarski et al., *Egypt's Golden Age*, pp. 212–215, nos. 254–258.

22. Food-storage containers in the shape of fowl are documented from the Old Kingdom onward; for example, limestone food cases in the shape of plucked fowl from Dynasty 6 (ca. 2323–2150 B.C.), William C. Hayes, *The Scepter of Egypt: A Background for the Study of the Egyptian Antiquities in The Metropolitan Museum of Art*, Part I: *From the Earliest Times to the End of the Middle Kingdom* (New York, 1953) p. 119, fig. 73, MMA 37.6.2a,b and 37.6.5a,b; a lid for a duck-shaped container from a queen's burial beneath the pyramid of Amenemhat III (Dynasty 12, 1844–1797 B.C.) at Dahshur, Dieter Arnold, "Dahschur. Dritter Grabungsbericht," *MDAIK* 36 (1980) pl. 15. Related to these containers are model food offerings in the shape of plucked fowl, for example, a calcite duck discussed by Bourriau, p. 102, no. 87 (Edinburgh 1911.338).

23. For example, the statue of King Sebekemsaf I (ca. 1632–1618 B.C.) redated from Dynasty 13 to Dynasty 17 by W. Vivian Davies, *A Royal Statue Reattributed*, British Museum Occasional Papers 28 (London, 1981) pp. 1–56; and fine gold and electrum jewelry included in the burial of a woman at Qurna, W. M. Flinders Petrie, *Qurneh*, British School of Archaeology in Egypt and Egyptian Research Account 15 (London, 1909) pp. 6–10, pls. XXII–XXIX, and also discussed by Cyril Aldred, *Jewels of the Pharaohs, Egyptian Jewelry of the Dynastic Period* (New York, 1971) pp. 197–198, no. 48.

24. Weigall, "Upper Egyptian Notes," *ASAE* 9 (1908) p. 107, no. 5, fig. 2.

25. For a similarly shaped blue-anhydrite vessel with handles, see John Garstang, *El Arábah: A Cemetery of the Middle Kingdom; Survey of*

the Old Kingdom Temenos; Graffiti from the Temple of Sety, British School of Archaeology and Egyptian Research Account 6 (London, 1901) p. 7, pl. IX, Tomb 281, a disturbed burial.

26. Weigall, "Upper Egyptian Notes," p. 107.

27. Cobras were used in two instances to decorate eye-paint pots; see note 4.

28. For the development of stone-vessel shapes, consult Dorothea Arnold in Lexikon der Ägyptologie II, Wolfgang Helck and Wolfhart Westendorf, eds. (Wiesbaden, 1977) cols. 483–501.

29. The vessel inscribed for Sobekhotep IV of Dynasty 13 Cairo JE 39567, is similar in shape, see note 11, and Figure 17.

30. See Brovarski et al., Egypt's Golden Age, pp. 106 (91), 131–132 (126), 148–149 (150), for Dynasty 18 examples.

31. For the date of drop-shaped flasks, including other anhydrite examples, see Bourriau, p. 144, no. 150, and Lilyquist, Stone Vessels, pp. 61 and 14, figs. 149 and 11, respectively.

32. Abydos, T. E. Peet Tomb X. 52; T. Eric Peet, The Cemeteries of Abydos, Part II, 1911–12, The Egypt Exploration Fund, Excavation Memoir 34 (London, 1914) p. 61 (X. 52), pl. XIII, 14.

33. Kemp and Merrillees, p. 168.

34. Bourriau, p. 141. See also Aston, pp. 141–142.

35. Cairo CG 18506, from Thebes, blue anhydrite, H. 5 cm, Diam. of opening 6.7 cm; Terrace, JARCE 5 (1966) p. 62, BII, 2, pl. XXV, fig. 32; Friedrich W. von Bissing, Steingefässe, nos. 18065–18793, CG 15 (Vienna, 1907) pp. 102–103, pl. VIII.

36. Edinburgh, RSM 1909.527.33, blue anhydrite, H. 4 cm, Diam. 12 cm; Terrace, JARCE 5 (1966) p. 59, AI, 9, pl. XVIII, figs. 11–12.

Two pieces closely related to the Edinburgh monkey bowl are: MMA 30.8.139, blue anhydrite, H. 4 cm, Diam. 8.5 cm; Terrace, JARCE 5 (1966) p. 59, AI, 5, pl. XVI, fig. 7 (Figure 11); and Cairo Museum, JE 46403, blue anhydrite, Diam. 11 cm, from Abydos, Tomb E 237; Garstang, El Arábah, pp. 7–8, pl. IX; Terrace, JARCE 5 (1966) p. 59, AI, 7, pl. XVII, figs. 9, 10. On the basis of style, both pieces must be contemporaneous and most likely by the same artisan.

37. Petrie, Qurneh, p. 7, pls. XXII.9, XXV.

38. Ibid., p. 10.

39. Aldred, Jewels of the Pharaohs, pp. 197–198, no. 48.

40. Janine Bourriau in Studien zur altägyptischen Keramik, Dorothea Arnold, ed., Deutsches Archäologisches Institut. Abteilung Kairo, Sonderschrift 9 (Mainz, 1981) pp. 34–37, places it not later than the reign of Kamose (1555–1550 B.C.).

41. Aston, p. 52.

42. The E. L. B. Terrace group consists of 22 objects, predominantly faience figurines and model offerings said to be from a tomb at Lisht. They were recorded and photographed in the early 1970s and published by Kemp and Merrillees, pp. 165–166, pls. 23–26.

43. Now in Jerusalem, Israel Museum no. 91.71.241, H. 3.5 cm, W. 9.5 cm; Joan R. Mertens et al., "Ancient Art: Gifts from The Norbert Schimmel Collection," MMAB 49, 4 (1992) p. 63; Kemp and Merrillees, Second Millennium Egypt, p. 165, xvi; Jürgen Settgast and Ulrich Gehrig, Von Troja bis Amarna: The Norbert Schimmel Collection, New York (Mainz, 1978) no. 203; Terrace, JARCE 5 (1966) p. 59, AI, 1.

44. Kemp and Merrillees, p. 165.

45. Now in Jerusalem, Israel Museum no. 91.71.229; Mertens et al.,

"Ancient Art," MMAB 49, 4 (1992) p. 63; and Settgast and Gehrig, Von Troja bis Amarna, no. 199.

46. The coiffure is flat on the top, broad at the sides, and patterned as if tightly crimped. The back of the head is shaved except for two thick locks that lie against the shoulders, with a third lock at the back of the head. Geraldine Pinch, Votive Offerings to Hathor (Oxford, 1993) pp. 198–234, esp. pp. 199 and 211, discusses fertility figurines and classifies those wearing this hairstyle under her Type 1, d.

47. See, for example, Henry George Fischer, "The Mark of a Second Hand on Ancient Egyptian Antiquities," MMJ 9 (1974) p. 13, a female statuette excavated at Thebes, and Elisabeth Delange, Musée du Louvre: Catalogue des statues égyptiennes du Moyen Empire, 2060–1560 avant J.-C. (Paris, 1987) pp. 190–191, a limestone statuette (Paris, Louvre E 22454) inscribed for a nonroyal woman that is stylistically closely related. It may be derived from a similar hairstyle worn by terracotta figurines of the Hyksos Period.

48. J. Vandier d'Abbadie, Musée du Louvre, Département des Antiquités Égyptiennes: Catalogue des Objets de toilette égyptiens (Paris, 1972) pp. 102–103, no. 395, 166–167, no. 750.

49. Pinch, Votive Offerings to Hathor, pp. 199, 211.

50. Janine D. Bourriau in Lexikon der Ägyptologie V, Helck and Westendorf, eds.(1984) col. 365.

51. Cairo CG 18486, black serpentinite, H. 5.5 cm, W. at top 4 cm, inscribed for the "god's wife, great royal wife, Hatshepsut"; Lilyquist, Egyptian Stone Vessels, p. 50, cat. no. J, fig. 135. An exceptionally fine example is the shallow dish with a monkey as its handle in the Kofler collection; see William H. Peck in Brovarski et al., Egypt's Golden Age, p. 212, no. 253. Although a Late Period date for this piece has been suggested, cosmetic articles with monkeys are typical of Dynasty 18 and do not occur in this manner in the Late Period. The leash around the waist is a feature introduced during Dynasty 18, whereas in the Middle Kingdom, a collar is worn around the neck.

An anhydrite monkey holding a kohl tube, a cosmetic-vessel type characteristic of early Dynasty 18, adds support to this premise; Sotheby's, New York, Antiquities, Dec. 17, 1997, lot 39; H. 5.4 cm. The monkey's body is also hollowed.

52. For Dynasty 18 ivory and wood dishes and spoons in the shape of plucked ducks, see Vandier d'Abbadie, Catalogue des Objets de toilette égyptiens, pp. 31–33, cat. nos. 74–77; Arnold, p. 28, no. 26. I thank James Romano, Curator, Department of Egyptian, Classical, and Middle Eastern Art, The Brooklyn Museum of Art, for assistance obtaining photographs and statistics of objects in the museum collection.

53. See Alfred Hermann, "Das Motiv der Ente mit zurückgewendetem Kopfe im ägyptischen Kunstgewerbe," ZÄS 68 (1932) p. 92, for a discussion of the duck motif.

54. The provenance details are based on a note in Herbert E. Winlock's handwriting that accompanied the duck flask. Herbert E. Winlock (1884–1950), an American Egyptologist, excavated for the MMA between 1906 and 1931, was appointed curator in 1929, and director of the MMA in 1932; Dawson and Uphill, Who Was Who in Egyptology, The Egypt Exploration Society Special Publication 19, 3rd rev. ed., M. L. Bierbrier, ed. (London, 1995) pp. 448–449. I thank Marsha Hill for looking into this for me.

55. Sir Robert Ludwig Mond (1867–1938) was a British chemist and excavator. From 1902 to 1925 he worked clearing and recording Theban tombs, and also discovered a number of new ones;

Dawson and Uphill, *Who Was Who in Egyptology*, 3rd rev. ed., Bierbrier, ed. (1995), pp. 291–292.

56. London, British Museum 65267, found in an area of plundered tombs behind the Ramesseum; anhydrite, H. 6.9 cm, W. 7.2 cm, L. 11.48 cm, bequeathed by Sir Robert Ludwig Mond in 1939; Schemuel Yeivin, "The Mond Excavation at Luxor, Excavations behind the Ramesseum," University of Liverpool, *Annals of Archaeology and Anthropology Issued by the Institute of Archaeology*, J. P. Droop and T. E. Peet, eds. (London, 1926) XIII, p. 6, no. 4, pl. XI, fig. 5. Richard Parkinson is to be thanked for bringing this reference to my attention.

57. I thank the owners for permitting me to examine this flask and for permission to publish it.

58. Rita Freed, Curator, Department of Ancient Egyptian, Nubian, and Near Eastern Art, Museum of Fine Arts, Boston, to whom I am grateful for permission to publish this flask, kindly permitted me to examine it. I thank Peter Lacovara, Assistant Curator, for facilitating examination of the duck and arranging for the analysis of its contents.

59. Bourriau, p. 141.

60. Kemp and Merrillees, p. 168.

61. John Ruffle, Keeper, Oriental Museum, Durham, kindly provided information about the duck vessel and permission to publish it. I thank him for permitting me to examine the piece.

62. Kemp and Merrillees, p. 165.

63. See notes 46, 47.

64. Steven Snape, University of Liverpool, identified a photograph of a duck flask from Garstang's excavation (Abydos photo negative no. A580) as this piece.

65. Rev. William MacGregor (1848–1937) was a British collector whose fine collection of Egyptian antiquities was sold in 1922; Dawson and Uphill, *Who Was Who in Egyptology*, pp. 267–268.

66. This detail is often found on New Kingdom cosmetic articles; see, for example, Arnold, p. 28, no. 26, a pair of ivory cosmetic containers in the form of mallards.

67. Robert de Rustafjaell (ca. 1876–1943): "British-American collector and author; . . . lived for some time in Egypt as a geologist and mining engineer and formed a collection of Egyptian antiquities, mainly studying predynastic sites. . . . his collections were dispersed in three sales at Sothebys in 1906, 1913, and 1915"; Dawson and Uphill, *Who Was Who in Egyptology*, p. 368.

68. Andray Bolshakov, Keeper, Hermitage, kindly examined this duck flask for me and provided its statistics. I thank him for arranging for photographing the duck and for permission to publish it.

69. The other piece mentioned in the lot is an elaborate blue-anhydrite bowl decorated with ducks, their wings embracing the sides, which is on loan from the Guennol Collection to the Brooklyn Museum. The piece was found at Esna in a rock cut tomb (153E). The two deposits in the tomb were undisturbed. Other stone cosmetic vessels found with the duck bowl are characteristic of the Second Intermediate Period; John Garstang, "Excavations at Hierakonpolis, at Esna, and in Nubia," *ASAE* 8 (1907) p. 142; Dorothy Downes, *The Excavations at Esna 1905–1906* (Warminster, 1974) pp. 4–7, fig. 7a, b, and p. 99.

Technical Report: Organic Residues from Egyptian Blue Anhydrite Duck Flasks and Other Anhydrite Vessels

RICHARD NEWMAN

Department of Objects Conservation and Scientific Research, Museum of Fine Arts, Boston

MANY CERAMIC AND STONE VESSELS now found in museum collections were originally made to hold organic materials, such as foodstuffs, cosmetics, and perfumes. These organic materials can penetrate into the walls of the vessels, so that residues of the original contents may actually survive even when there is no visible remnant of them. By using strong organic solvents, one can at least partially extract residues trapped in the ceramic or stone and then analyze the extracted compounds. An analysis cannot be expected to provide an accurate view of the original contents for many reasons. The solvent will not necessarily extract all types of organic materials, and the analytical technique utilized to identify the organic materials will not necessarily analyze all of the compounds found in the solvent extract. More important, aging results in the destruction of many organic materials and changes the compositions of others. Volatile components of the original contents may have been lost, and some components may also have been lost to the soil in which an object rested for an extended period of time prior to its excavation. Even given these limitations, analysis of the solvent extract provides a glimpse of the original contents.[1] This article presents analyses of solvent-extracted organic residues from sixteen anhydrite vessels. The extracts were analyzed by gas chromatography/mass spectrometry (GC/MS).[2]

Published studies of solvent extracts from ceramics frequently indicate that fatty acids are the major detectable compounds. Fatty acids occur in different types of materials, the major sources of which are vegetable oils and animal fats; fatty acids also occur in substantial amounts in beeswax. In fresh oils and fats, fatty acids are present mostly in the form of triglycerides. During aging, triglycerides can react to form larger polymeric molecules, or can break down into molecules, including free fatty acids and various smaller fragments. As a result of chemical reactions, the compositions of aged oils and fats are quite different from

those of their fresh counterparts.[3] The typical methods of analyzing aged oils and fats do not detect polymeric material; instead, only fatty acids and small breakdown products are actually analyzed. The fatty acids in oils and fats are of two general types, unsaturated and saturated. Aged materials contain saturated fatty acids, which are fairly nonreactive, perhaps with only small amounts of unsaturated fatty acids (which are very reactive) remaining. The types and relative amounts of saturated fatty acids vary to some extent between oils from different sources and fats. Since the saturated fatty acids do not appear to be altered to a great degree during aging, their proportions in an ancient oil or fat will resemble their proportions in the fresh material; thus analysis permits some speculation on possible original sources.[4]

Some other major components of many aged oils and fats are dibasic acids. These acids, which are not present in fresh oils and fats, form during aging. Their abundances, relative to the saturated fatty acids, are not the same in all aged oils and fats; they provide another piece of information on which speculation about original source materials can be based. Oils can be divided into three general types: drying, semi-drying, and nondrying. Thin films of drying oils rapidly solidify by chemical reactions when exposed to the air. These types of oils (which include linseed, walnut, and poppyseed) have been used for many centuries as binders in oil paints, but some (such as linseed) were known well before oil painting was developed. Semi-drying oils partially solidify, while nondrying oils do not form solid films. Dibasic acids (the major one of which is azelaic acid) are abundant in aged drying oils, relative to the remaining saturated fatty acids; dibasic acids are very minor components of aged nondrying oils when compared with the saturated fatty acids. Thus the relative amounts of dibasic and saturated fatty acids give some indication of general oil type, although a specific type may not be able to be identified. Aged animal fats contain mostly saturated fatty acids.

Many other compounds besides fatty acids can also be detected in solvent extracts and may shed further

© The Metropolitan Museum of Art 1998
METROPOLITAN MUSEUM JOURNAL 33

The notes for this article begin on page 51.

light on the original contents of the vessel. Cholesterol, for example, would suggest the presence of animal fat. If the vessel being tested originally contained perfume, some compounds from the fragrant materials used in formulating the perfume could still be present.

Since relatively small amounts of material are being extracted from the object, the possibility of contamination from conservation treatment or handling needs to be kept in mind. All of the objects analyzed were intact and did not appear to have been treated in any way. High-purity solvent and carefully cleaned vials were utilized so that contamination from these sources would be negligible. However, traces of phthalates were found in nearly all of the extracts. These are common plasticizers used in plastic bags and could have been transferred to the objects from bags in which the stone objects may have been stored.

Many of the samples contained dozens of easily detectable individual compounds, not all of which have been identified at the time of writing of this paper. Nearly all of the predominant compounds in all the samples have been identified. Not surprisingly, these are mostly fatty acids and dibasic acids. Small amounts of other materials (beeswax and natural plant resins) were found in some vessels. Natural resins could have been components of perfumes, which were often made by mixing fragrant substances in oil or fat. No other plant extracts were specifically identified in any of the samples from the anhydrite vessels.

DISCUSSION OF RESULTS

Table 1 summarizes the results. Objects are listed in order of decreasing azelaic acid (diC9) content: azelaic acid is the major dibasic acid found in aged oils. Some general comments on the results are given below. Individual objects are referred to by the letter given to them in Table 1. Chromatograms of some of the samples are shown in Figures 1 and 2.

Types of oils and fats. The high azelaic acid levels in a few samples suggest that they contained semi-drying or drying vegetable oils. Duck flask A, which has a very high azelaic acid level, almost certainly contained a drying oil, which could perhaps have been linseed oil. The ratio of palmitic (C16) to stearic (C18) acids in this sample (2.5) is somewhat higher than is considered typical for linseed oil, but much closer to that of linseed than other common drying oils. Three other objects (B, C, and D) have relatively high azelaic acid levels (0.4–0.5), suggesting that they contained drying

or perhaps semi-drying oil.

The other samples have low or negligible azelaic acid levels. These low levels suggest that the original contents were nondrying vegetable oils (olive oil is one example of such an oil), or possibly animal fat. The high amount of stearic acid found in two samples (J and O) is more suggestive of animal fat than of a vegetable oil. If animal in source, the possible source cannot be more specifically determined: for example, goat, sheep, beef, or goose is equally possible.

Palmitic and stearic acids are the major saturated fatty acids found in most oils and fats. Not surprisingly, they are the major ones found in nearly all these samples. Some samples contained rather large amounts of other saturated fatty acids. Six (G, H, I, K, L, and P) contained myristic (C14) acid at a level of 20 percent or more than of palmitic (C16) acid. Myristic acid is an important constituent of fish oils, and it is possible that these six objects contained such an oil. There does not appear to be any correlation between the type of oil or fat kept in a vessel and its shape: at least three different materials appear ot have been kept in the four duck flasks (A, G, H, and O) whose contents have been analyzed.

It also needs to be kept in mind that more than one type of oil or fat may have been stored in an object. Two of the objects (E and N) had more than one chamber in which material could be stored. In the case of both objects, extracts from the separate chambers were similar, suggesting that both chambers had been used to store the same material.

Natural resins. Very small amounts of one or two compounds that are found in aged conifer resins were detected in about half of the vessels (A, B, E, G, I, N, and P).[5] The most likely source of these compounds is a resin from a pine, larch, or fir tree. In one sample (N, sample from R chamber), a small amount of a third compound (sandaracopimaric acid) was also detected.[6] This compound is an abundant one in sandarac resin, as well as resins from juniper and cypress trees. It seems possible that two different resins were present in this vessel.

Beeswax. Samples from three objects (B, E, and N) may have contained beeswax.[7]

SUMMARY

With one exception (N), all the vessels appear to have contained an oil or fat. While specific types of oils cannot be identified, the analyses indicate that more than one type was involved. Some almost certainly con-

tained a drying oil, but most contained nondrying oils (or animal fat). In nearly half the objects that contained oil or fat, a conifer resin of some type (most likely pine, larch, or fir) was also found. One object contained beeswax and probably two types of conifer resins (N). It is not certain that this object contained oil or fat. Two other objects contained beeswax and a conifer resin, along with some oil (B and E).

NOTES

1. Some recent studies of different types of organic residues in ceramics include the following: W. R. Biers, K. O. Gerhardt, and R. A. Braniff, "Lost Scents: Investigations of Corinthian 'Plastic' Vases by Gas Chromatography-Mass Spectrometry," *MASCA Research Papers in Science and Archaeology* 11 (1994) 59 pp.; S. Charters, R. Evershed, P. Blinkhorn, and V. Denham, "Evidence for the Mixing of Fats and Waxes in Archaeological Ceramics," *Archaeometry* 37 (1995) pp. 113–127; S. Charters, R. Evershed, L. Goad, A. Leyden, P. Blinkhorn, and V. Denham, "Quantification and Distribution of Lipid in Archaeological Ceramics: Implications for Sampling Potsherds for Organic Residue Analysis and the Classification of Vessel Use," *Archaeometry* 35 (1993) pp. 211–223.

2. Several milliliters of GC/MS-grade methylene chloride were swished around the inside of the object, then transferred to a 2- or 5-ml sample vial and the solvent evaporated to dryness. The dried residue, which usually included substantial inorganic material, was then mixed with 150–200 µl of a transesterification reagent, (m-trifluoromethylphenyl) trimethylammonium hydroxide, 0.2 N in methanol. The vial was capped and the solution heated to 50°C. for about five hours. The analyses were carried out the following day by gas chromatography/mass spectrometry (GC/MS). Usually 1 µl of the solution was injected into the instrument; if this proved to be too concentrated, a second run was carried out using a ~0.3 µl injection. Analyses were carried out on a Hewlett Packard 5890 capillary GC with an HP 5971A mass selective detector (MSD). Instrumental conditions were as follows: injection port temperature, 275°C., split/splitless inlet, operated in split mode (ratio–20:1); MSD interface temperature, 280°C.; oven program, 100°C. to 300°C. at 10°/minute. Column: Supleco PTE-5, 30 meter, 0.25 mm ID, 0.25 µm film thickness. The mass spectrometer was operated in scan mode, from 50–550 amu. Peaks were identified by their mass spectra, with reference to the Wiley Reference Library of Mass Spectra and various standards run in the laboratory.

3. J. S. Mills and R. White, *The Organic Chemistry of Museum Objects* (London, 2nd ed., 1994) pp. 34–45.

4. Attempts at identification are most likely to be successful if fairly substantial residues actually survive. One example is E. Morgan, C. Edwards and S. Pepper, "Analysis of the Fatty Debris from the Wreck of a Basque Whaling Ship at Red Bay, Labrador," *Archaeometry* 34 (1992) pp. 129–134. As this study shows, the saturated fatty acid composition of aged fats and oils also changes with aging, at least under certain conditions, and this means that the overall saturated fatty acid composition of an aged fat or oil cannot be expected to be precisely that of the fresh fat or oil from which it derived. How extensive the changes will be, however, cannot be predicted for most samples, including the extracts analyzed in the present project.

5. The specific compounds detected were the methyl esters of dehydroabietic acid and 7-oxodehydroabietic acid (results for individual samples are listed in Table 1). Both compounds are products of the oxidation of abietic acid. Abietic acid is found in many resins, particularly from the conifer family. Resins from trees of the Pinaceae family of the conifer group order (a family that includes pines, larches, spruces, and firs) are widespread and all contain important amounts of abietic acid. Abietic oxidation products may be all that remain readily analyzable in aged conifer resins (see Mills and White, *The Organic Chemistry of Museum Objects*, p. 100).

6. The specific compound detected is the methyl ester of sandaracopimaric acid. This compound is a major nonpolymeric component of resins from the Cupressaceae family of the conifer order, a family that includes *Tetraclinis articulata* (which produces the resin known as sandarac), as well as cypress and juniper trees. Of these, sandarac, from northern Africa, probably would have been the type most readily available in ancient Egypt. Little is known about the composition of highly aged resins from this genus, although the presence of sandaracopimaric acid in a 600-year-old resin varnish on an Italian painting has been taken as evidence for the presence of sandarac resin in the varnish (J. Dunkerton, J. Kirby, and R. White, "Varnish and Early Italian Tempera Paintings," in J. Mills and P. Smith, eds., *Cleaning, Retouching and Coatings* [London, 1990] pp. 63–69).

7. Beeswax that has been saponified, as was the case in the analyses carried out here, contains a large amount of palmitic acid and much smaller amounts of stearic acid and several others. Also present are straight-chain hydrocarbons and long-chain alcohols (the latter not readily analyzable by the particular procedure utilized here). The pattern of hydrocarbons and fatty acids with 20 or more carbon atoms is fairly distinctive for beeswax and permits its presence to be detected even when oils or fats are also present (see, for example, J. Mills and R. White, "The Mediums used by George Stubbs: Some Further Studies," *National Gallery Technical Bulletin* 9 [1985] pp. 60–64). A ratio of palmitic to stearic acid that is considerably lower than that of beeswax suggests than an oil or fat was mixed with the beeswax. Significant amounts of dibasic acids would also point to the admixture of a drying or semidrying oil.

Table 1. Results of gas chromatography/mass spectrometry analyses of methylated methylene chloride extracts

Object	diC8	diC9	diC10	C14	C15	C16	C17	C18	C20	C22	C24	C26	Other compounds
Museum of Fine Arts, Boston													
A. *Duck flask (3)* 65.1749	0.33	1.67	0.09	0.04	<0.01	1.00	0.01	0.41	0.08	0.04	0.03		Conifer resin (note 1)
The Metropolitan Museum of Art, New York													
B. *Vessel* 12.182.74	0.22	0.51	0.05	0.06	0.01	1.00	0.01	0.20	0.03	0.03	0.07		Beeswax, conifer resin (note 2)
C. *Pot with monkeys* 07.228.93	0.16	0.45	0.04	0.08	0.04	1.00	0.03	0.34	0.04	0.03	0.05		(See note 3)
D. *Lentoid flask* 10.176.53	0.13	0.43		0.17		1.00		0.40					(See note 4)
E. *Two monkeys (jars)*													
12.182.77L	0.08	0.16	0.01	0.02	<0.01	1.00	<0.01	0.12	0.01	0.01	0.04	<0.01	Beeswax, conifer resin (note 5)
12.182.77R	0.04	0.10	<0.01	0.03	<0.01	1.00	0.01	0.17	0.02	0.02	<0.01	<0.01	Conifer resin (note 6)
F. *Pot with monkeys* 66.99.16	0.03	0.13		0.03	0.01	1.00	0.01	0.17	0.03	0.01	0.01		(See note 7)
G. *Duck flask (9)* 10.176.51		0.12		0.33	0.07	1.00	0.05	0.40	0.04				Conifer resin (note 8) C12 acid present
H. *Duck flask (12)* 24.2.25	0.05	0.10		0.26	0.07	1.00	0.05	0.62	0.06	0.08	0.04		(See note 9)
I. *Amphora* 10.176.46		0.06		0.36	0.10	1.00	0.07	0.44	0.05	0.04	0.07		Conifer resin (note 10) C12 acid present
J. *Fish flask* 10.176.52	0.02	0.05		0.08	0.03	1.00	0.06	3.50	0.05	0.02	0.01		(See note 11)
K. *Bag-shaped jar* 10.176.48		0.04		0.46	0.09	1.00	0.05	0.36	0.05				C12 acid present (note 12)
L. *Amphora* 11.150.29		0.04		0.20	0.05	1.00	0.04	0.55	0.03	0.02	0.02		C12 acid present (note 13)
M. *Spouted dish* 10.176.47		trace		0.11	0.09	1.00		0.30			trace		(See note 14)
N. *Pair of monkey jars*													
10.176.49L		trace		0.05		1.00		0.08			0.12		Beeswax, conifer resin (note 15)
10.176.49R		trace		0.08	0.02	1.00	0.01	0.18	0.02	0.03	0.09	0.03	Beeswax, conifer resin (note 16)
O. *Duck flask (10)* 10.176.50		trace		0.04	0.01	1.00	0.03	1.50	0.01				(See note 17)
P. *Large monkey jar* 10.176.54		trace		0.33	0.11	1.00	0.04	0.33	0.03	0.03	0.04		Conifer resin (note 18)

Specific objects are referred to in the text by the letter that precedes the name. The number in parentheses following the name corresponds to the catalogue in the accompanying paper by Biri Fay. Compounds whose relative abundances are shown are straight-chain fatty acids (identified by number of carbon atoms) and some dicarboxylic acids (identified by number of carbon atoms). The peak area of C_{16} (palmitic acid) is defined as 1.00 for all samples, and all other peak areas are relative to this. "Trace" indicates that a peak was present, but it was too small for reasonable quantification. If the box is empty, the compound was not detected. In the notes below, the range of straight-chain hydrocarbons, detected in many of the samples, is noted; "at similar abundances" means that odd-carbon number and even-carbon number hydrocarbons were equally abundant.

1. Methyl 7-oxodehydroabietate detected. Also detected: traces of odd- and even-number straight-chain hydrocarbons, at similar abundances; dimethyl o-phthalate (contaminant).

2. Methyl 7-oxodehydroabietate detected. Also detected: odd- and even-number hydrocarbons (C_{21}–C_{33}), odd-numbered ones much more abundant, maximizing at C_{27}; C_{20}, C_{22}, C_{24} (most abundant), and C_{26} fatty acids.

3. Odd- and even-number hydrocarbons (C_{23}–C_{31}) detected (maximizing at C_{27}, odd ones somewhat more abundant than even ones). Also detected: dimethyl o- and p-phthalates (contaminants). Two major peaks with retention times somewhat less than that of methyl palmitate were not identified (contaminants?).

4. Traces of hydrocarbons and dimethyl o-phthalate (contaminant) detected.

5. Methyl 7-oxodehydroabietate detected. Also detected: odd- and even-number hydrocarbons (C_{23}–C_{30}, odd ones more abundant, maximizing at C_{27}).

6. Methyl 7-oxodehydroabietate detected. A phthalate (contaminant) was detected (tentatively identified as bis[2-ethylhexyl]phthalate).

7. Also detected: monounsaturated C_{18} fatty acids (abundance ~ 0.3 that of stearic acid).

8. Methyl dehydroabietate detected. Also detected: traces of odd- and even-number hydrocarbons (C_{22}–C_{28}), at similar abundances; dimethyl o-phthalate (contaminant). C_{12} (lauric) acid abundant (C_{12} acid/C_{16} acid = 0.19).

9. Odd- and even-number hydrocarbons detected (C_{21}–C_{28}), odd ones slightly more abundant, maximizing at ~ C_{22}–C_{25}. Also detected: dimethyl o-phthalate (contaminant).

10. Methyl 7-oxodehydroabietate detected. Also detected: odd- and even-number hydrocarbons in the range C_{19}–C_{25}, maximizing at C_{21}. Also detected: dimethyl o-phthalate (contaminant). C_{12} (lauric) acid abundant (C_{12} acid/C_{16} acid = 0.26). Also detected: hydroxy- and oxo-fatty acids (not specifically identified).

11. Traces of hydrocarbons and dimethyl o-phthalate (contaminant) detected.

12. Odd- and even-number hydrocarbons detected (C_{19}–C_{27}), at similar abundances, maximizing at C_{21}–C_{22}. Also detected: dimethyl o-phthalate (contaminant); 9,10-anthraquinone. C_{12} (lauric) acid abundant (C_{12} acid/C_{16} acid = 0.49).

13. Odd- and even-number hydrocarbons detected (C_{21}–C_{30}), at similar abundances, maximizing ~ C_{22}–C_{23}. Also detected: dimethyl o-phthalate (contaminant). C_{12} (lauric) acid abundant (C_{12} acid/C_{16} acid = 0.13).

14. Odd- and even-number hydrocarbons (C_{22}–C_{30}, at similar abundances) detected. Also detected: dimethyl o- and p-phthalates (contaminants).

15. Methyl dehydroabietate and methyl 7-oxodehydroabietate detected. Also detected: odd- and even-number hydrocarbons (C_{22}–C_{31}), odd ones somewhat more abundant than even ones, maximizing at C_{27}. Straight-chain alcohols (>C_{20}) tentatively detected. Dimethyl p-phthalate and much lower amount of dimethyl o-phthalate (contaminants) detected.

16. Methyl sandaracopimarate, methyl dehydroabietate and methyl 7-oxodehydroabietate detected. Also detected: odd-number hydrocarbons (C_{22}–C_{29}), at similar abundances, maximizing at C_{27}. Branched fatty acids detected, as well as, apparently, dicarboxylic acids (C_{24} and higher). Dimethyl o- and p-phthalates (contaminants) also present.

17. Odd- and even-number hydrocarbons detected (C_{22}–C_{31}), at similar abundances, maximizing ~ C_{27}–C_{30}. Also detected: dimethyl o-phthalate (contaminant).

18. Methyl dehydroabietate detected. Also detected: odd- and even-number hydrocarbons (C_{21}–C_{29}), odd ones slightly more abundant, maximizing at C_{25}. Dimethyl o- and p-phthalates (contaminants) also detected.

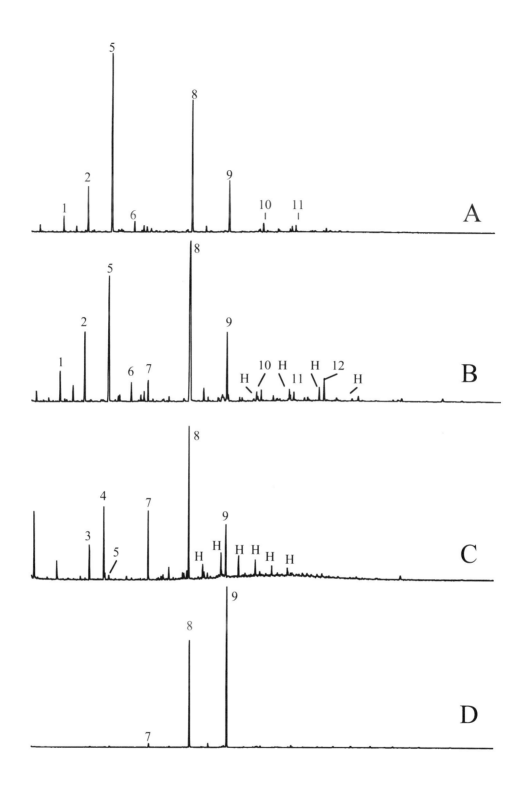

Figure 1. Total ion chromatograms of solvent extracts from four anhydrite vessels. Specific objects are identified by the letter references given in Table 1.(A) duck flask A; (B) vessel B; (C) bag-shaped jar K; (D) duck flask O. The horizontal axis is retention time (shown in each case is the region from 5 to 30 minutes). The vertical axis is abundance (total ion current); the scale for each chromatogram has been adjusted for ease of comparison. Some of the specific compounds in each chromatogram have been labeled. All acidic compounds were analyzed as methyl esters. Peaks 1, 2, 5, and 6 are dicarboxylic acids: 1, heptanedioic acid (diC7, pimelic acid); 2, octanedioic acid (diC8, suberic acid); 5, nonanedioic acid (diC9, azelaic acid); 6, decanedioic acid (diC10, sebacic acid). Peak 3 is o-phthalic acid, a contaminant. Peaks 4, 7–12 are straight-chain saturated fatty acids: 4, lauric (C12) acid; 7, myristic (C14) acid; 8, palmitic (C16) acid; 9, stearic (C18) acid; 10, eicosanoic acid (C20, arachidic acid); 11, docosanoic acid (C22, behenic acid); 12, tetracosanoic (C24) acid. Peaks labeled "H" are straight-chain hydrocarbons.

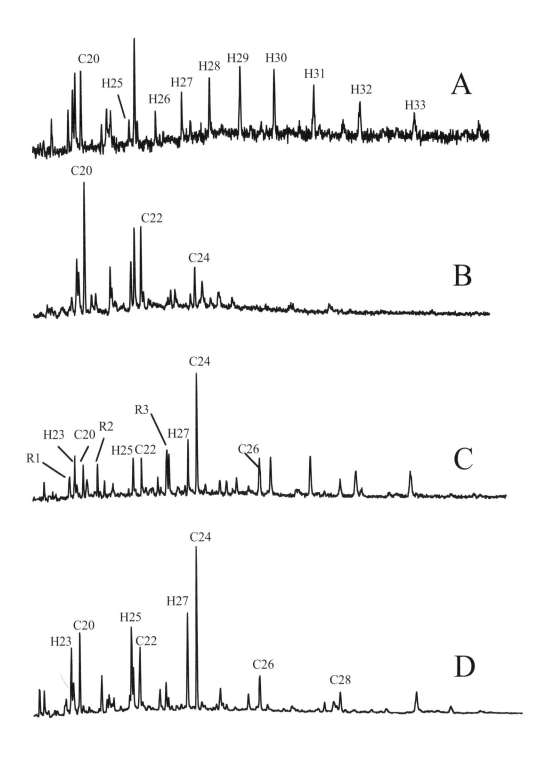

Figure 2. Details of total ion chromatograms of solvent extracts from four stone vessels. Specific objects are identified by the letter references given in Table 1. (A) duck flask O; (B) duck flask A; (C) pair of monkey jars N, sample R; (D) vessel B. The horizontal axis is retention time (16–30 minutes). The vertical axis is abundance (total ion current); the scale for each chromatogram has been adjusted for ease of comparison. Some of the specific compounds have been labeled. All acidic compounds were analyzed as methyl esters. Fatty acids are labeled with "C" followed by the number of carbon atoms in the specific compound. Straight-chain hydrocarbons are labeled with "H," again followed by the number of carbon atoms in the compound. Peak R1 is sandaracopimaric acid; R2, dehydroabietic acid; R3, 7-oxodehydroabietic acid.

Reliefs from the Tomb of the Vizier Nespakashuty: Reconstruction, Iconography, and Style

ELENA PISCHIKOVA

Research Assistant, Department of Egyptian Art, The Metropolitan Museum of Art

THIS ARTICLE IS DEVOTED TO the relief decoration of the tomb (Theban Tomb [TT] 312) built for the Vizier Nespakashuty D, called Nespakashuty in the text. His tomb was excavated by the Metropolitan Museum's Egyptian expedition in 1922–23. The fragmentary state of the decoration and the location of relief fragments in different museums have prevented scholars from publishing this important tomb before now. A two-year Andrew W. Mellon fellowship granted by the Metropolitan Museum made it possible for me to collect the fragments, study them, and reconstruct some scenes from the tomb.

NESPAKASHUTY AND HIS TOMB

The tomb of the vizier Nespakashuty, overseer of Upper Egypt under Psamtik I (664–610 B.C.), the first pharaoh of the Saite Twenty-sixth Dynasty, lies in western Thebes at Deir el-Bahri.[1] The tomb may be dated about 656–650 B.C. because Nespakashuty signed the Oracle Papyrus as the fourth witness in 651 B.C., in the fourteenth year of the reign of Psamtik I, which proves that he was then in office.[2] His titles, such as *mr ḥmw-nṯr jmn-rˁ nswt nṯrw* (Overseer of Priests of Amun-Re, King of Gods), *mr šmˁw* (Overseer of Upper Egypt), *mr niwt* (Overseer of the City), and *ṯ ɜty* (Vizier) show that in his day he was one of the greatest men of Thebes.[3]

The two best statues of Nespakashuty, now in the Cairo Museum, were found in the Karnak Cachette among a group of statues belonging to his family: a limestone, asymmetric squatting statue (JE 37000) and a graywacke squatting scribe statue with a wide striated wig (JE 36662).[4] The second statue is one of the finest early Saite sculptures known.

Nespakashuty's tomb belongs to the group made for high Late Period Theban officials, the earliest of which dates to the latter part of the Kushite Twenty-fifth

Dynasty (ca. 712–664 B.C.), although construction continued throughout the Saite Twenty-sixth Dynasty (664–525 B.C.). Nearly all these tombs lie in the Asasif necropolis, situated in a narrow desert plain that extends eastward from Hatshepsut's temple at Deir el-Bahri. Other Late Period tombs, mostly in a ruinous state, are dispersed over the Asasif necropolis to the south, and a few exceptional examples are cut into the limestone cliffs above.[5] These tombs include the largest private monuments ever built in Egypt; all of them had elaborate plans and were richly decorated with relief carving. The tombs of Mentuemhat (TT 34), Petamenophis (TT 33), Ibi (TT 36), Basa (TT 389), and Pabasa (TT 279) are still preserved.

The private Theban tomb relief of the Saite period is a subject of great significance in the history of Egyptian art, as the Twenty-fifth and succeeding Twenty-sixth Dynasties are periods of great artistic innovation. The Saite Dynasty, establishing its own style of reliefs and sculpture, influenced Egyptian art until the end of the Pharaonic Period. An important aspect of this artistic renewal was a widespread and systematic reference to the art of the past, a phenomenon often called archaism. Archaism in seventh-century Egypt exhibits itself in many ways—from the revival of the ancient types of scenes and canon of proportions to the precise copying of small details from older monuments. This relationship to the past is often recognized, but the exact sources of inspiration are difficult to determine. The situation is more advantageous in the Asasif necropolis. Theban sculptors of the Late Period were deeply influenced by the well-preserved reliefs and paintings found in the New Kingdom tombs and mortuary temples situated nearby. One can sometimes recognize specific examples of copying, which helps in establishing the mechanisms by which earlier patterns were reinterpreted by Late Period sculptors.

Although the Late Period Theban tombs reflect characteristic features in the development of Saite art, they also exhibit a great variety of subjects and styles from one tomb to another, and even within a single tomb. The rise of archaism in the relief decoration of late

The notes for this article begin on page 97.

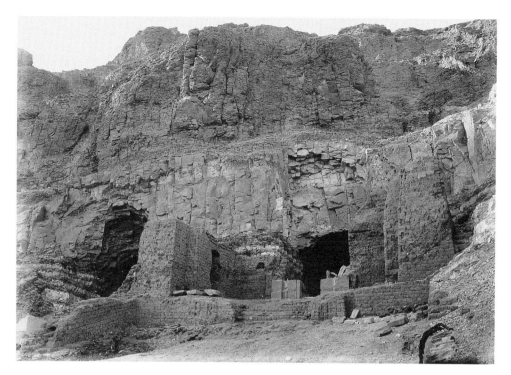

Figure 1. View onto the courtyard of Nespakashuty's tomb, 1922–23 (photo: Egyptian Expedition, neg. no. M4C 205)

Asasif tombs is easily understood. The construction of funerary monuments and stone-relief carving had diminished substantially at Thebes during the preceding Third Intermediate Period, so there was no direct tradition for constructing and decorating tombs. Therefore the subject and style of the relief decoration depended on the taste and wishes of the tomb owner or of the sculptors he employed, which makes each Late Period tomb a monument of unusual interest. Archaizing features are reflected in the decoration of the tomb of Nespakashuty, whose sculptors were obviously inspired not only by the Middle and New Kingdom Theban reliefs but also by the decoration of earlier Late Period Asasif tombs, including the tomb of Mentuemhat, some chapels of which had not yet been finished when the tomb of Nespakashuty was under construction.[6]

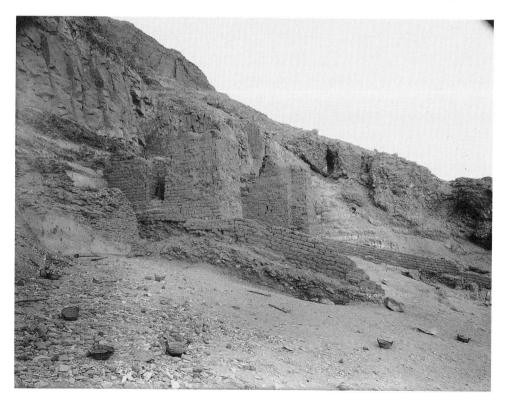

Figure 2. View of the pylon of Nespakashuty's tomb, 1922–23 (photo: Egyptian Expedition, neg. no. M4C 47)

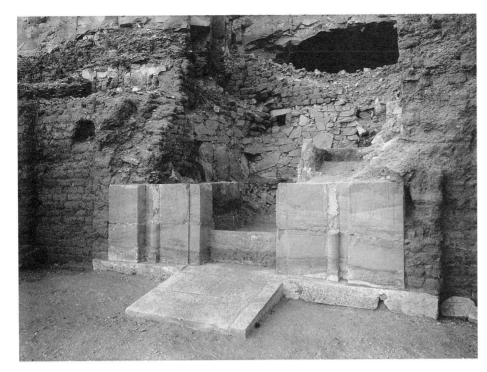

Nespakashuty's tomb was carved into the upper side of the cliff flanking the north side of the Asasif valley, whose primary functioning structure was still the causeway to the mortuary temple of Queen Hatshepsut of the Eighteenth Dynasty (Figure 1). The tomb is fitted into a row of much earlier tombs built for the high officials of the Eleventh and early Twelfth Dynasties: Khety (MMA 508, TT 311), Henenu (MMA 313, TT 313), Ipi (MMA 516, TT 315), Meru (MMA 517, TT 240), and others. Between the tombs of the overseer of the seal Khety and the steward Henenu lies the tomb of Nespakashuty, which shares its entrance court with an early Middle Kingdom tomb (MMA 509), whose owner is unknown because no decoration or inscriptions survive (Figure 2). The court and the entrance are larger than those of Khety and Henenu, which allowed James Allen to suggest that tomb MMA 509 was intended for an official of equally high rank, perhaps the Vizier Bebi, whose tomb has not yet been found.[7] Nespakashuty usurped an eastern portion of the court of the early Middle Kingdom tomb MMA 509 by cutting away the brick facade of the older tomb and building in its place a new mud-brick monumental pylon (thirteen meters wide) with arches. Sandstone slabs in sunk relief showing the seated Nespakashuty decorate the entrance (Figure 3), which leads to the ten-meter-long vaulted chapel that was richly decorated with reliefs carved in fine limestone (Figure 4). The relief decoration of the first chamber was never completed. The doorway on the north wall of the first chamber leads to a second chamber with six

Figure 4. The first chamber of the tomb as it was found by H. Winlock, 1922–23 (photo: Egyptian Expedition, neg. no. M4C 258)

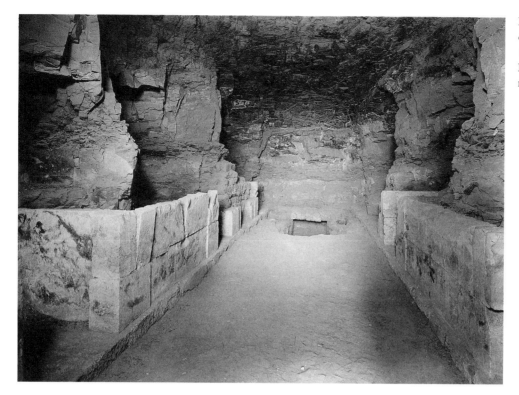

Figure 5. The second chamber of the tomb, 1922–23 (photo: Egyptian Expedition, neg. no. M7C 60)

side rooms, whose walls were lined with undecorated limestone slabs (Figure 5). Herbert Winlock suggested that there was a false door on the north wall of the second chamber.[8] Three of the side rooms were left unfinished. A stairway leads to the three-room burial crypt below. As the tomb's plan (Figure 6) shows its clear resemblance to the Middle Kingdom tombs, it is possible to assume that Nespakashuty was impressed by them and ordered a similar one.[9] Allen, however, has suggested another possibility: the ten-meter corridor forming the tomb's first chamber could have been cut initially for a family member or a dependent of the earlier Middle Kingdom tomb owner.[10] If this is so, Nespakashuty would have reused a corridor carved during the late Eleventh or early Twelfth Dynasty.

The tomb's unfinished state and modest size suggest that Nespakashuty had a short career and died quite young. Yet the choice of location seems puzzling. The Asasif valley floor was the official Theban necropolis of the time, with the tomb of Harwa (TT 37) and the huge, glamorous tombs of Petamenophis (TT 33) and Mentuemhat (TT 34) already under way. Nevertheless, the tomb of the Vizier Nespakashuty was placed on the side of the cliffs. Perhaps its location shows a special appreciation of the early Middle Kingdom.[11] The place that Nespakashuty chose for the tomb was the most desirable in the time of the reunification of Egypt after the First Intermediate Period because of the presence of the mortuary temple of Mentuhotep II in the valley of Deir el-Bahri.[12] The strong interest in early Middle Kingdom art that Nespakashuty's tomb demonstrates (see below) possibly reinforced his choice of burial in the old necropolis.[13] Another possible explanation is that although members of Nespakashuty's family held the office of the vizier of Upper Egypt for a long period of time, neither his grandfather Nespakashuty C nor his father, Nespamedu, ever moved to Thebes. They chose to stay in Tanis in the Delta and were buried at Abydos, the traditional necropolis of Thinite nobles, where the tomb of Nespamedu (D. 57) is one of the most elaborate.[14] It seems that Nespakashuty D, the fourth of this name (whose tomb is the subject of this article), was the first of that family to live in Thebes and be buried in the Theban Asasif necropolis. He may have meant to use the family cemetery in Abydos and changed his plans unexpectedly, which would explain the small size and unfinished state of his Theban tomb.[15]

EXCAVATION OF THE TOMB

The tomb of Nespakashuty was excavated by the Metropolitan Museum's Egyptian Expedition, led by H. E. Winlock in 1922–23.[16] The records of the expedition—photographs, tomb cards, notes, drawings, and letters—are housed in the archives of the Depart-

ment of Egyptian Art at the Metropolitan Museum. Photographic documentation is a major archival source for work on tomb reconstruction, and, fortunately, Harry Burton registered every fragment found in or around the tomb in five-by-seven and seven-by-nine-inch glass-negative photographs. Prints of these photographs were mounted on boards, numbered, and labeled at the time of the tomb's excavation.

The majority of the relief fragments were drawn after excavation. Only a few drawings were executed in the original size of the pieces;[17] most drawings were a 90 percent reduction, which explains why many details are missing. To provide accurate documentation in the present publication, some pieces were redrawn from the originals and some old drawings were corrected. Winlock's field records contain his first notes on the decoration of the tomb, precise measurements of the sandstone structure of the facade and brick pylon, and a description of the condition of the relief sculpture in situ. He found the facade reliefs badly shattered and noted that the relief decoration in the first chamber had fallen off the walls (see Figure 4). The probable explanation is in Winlock's 1923 notes: "There was a tremendous fire in the burial crypt. . . . the heat of the internal fire seems to have roasted the entire structure of the upper chapel, turning the lime . . . pink and baking the limestone walls until they are extremely brittle. . . . The result of the baking of the chapel walls has been that most of the structure has been reduced to an infinite number of small chips."

From a letter that Winlock wrote on February 14, 1926, to Albert Lythgoe, the Museum's curator of Egyptian art, we know that the expedition collected 115 boxes of relief fragments from the tomb of Nespakashuty and that it took about three weeks to pack them. "In spite of all our care I am afraid that some of these baked pieces will be shattered, but I don't see how we could help it unless we spend four or five times as much time as we did. Many of the fragments actually fell to pieces as we lifted them; therefore, do be charitable when you see their condition." The fragments were allotted to the Metropolitan Museum by the Egyptian authorities in the partition of finds and were shipped to New York in 1926. The well-preserved decoration of the entrance remained in situ.

Winlock's records indicate that a number of objects,

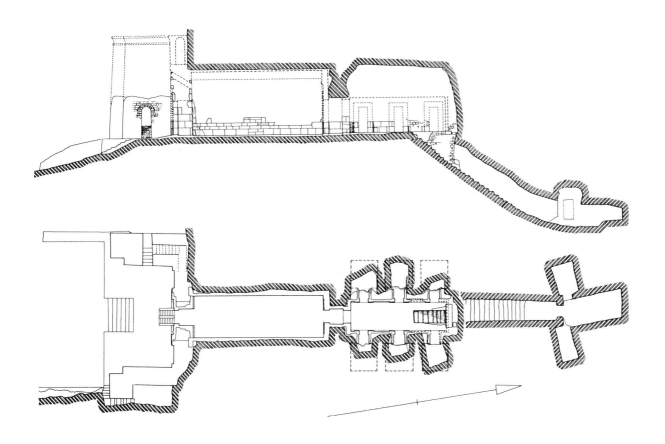

Figure 6. Plan of the tomb (drawing: Barry Girsh, after Lindsley F. Hall)

aside from the relief fragments, were found scattered loosely in the rubbish of the tomb's courtyard. Among them were fragments of Nespakashuty's outer coffin, artists' sketches on limestone chips, blue-faience inlays, and much evidence of the reuse of the tomb as late as the Coptic Period.

NESPAKASHUTY'S RELIEFS IN AMERICAN MUSEUMS

About twenty years after the excavation of the tomb of Nespakashuty, an attempt was made to piece together the relief decoration from the tomb at the Metropolitan Museum. Photographs and drawings from the mid-1940s show that this study resulted only in re-creating parts of the original walls. Less than ten years later, the Museum decided to retain only one fairly complete part of the west wall and deaccessioned most of the other fragments to other institutions (see Appendix).

Today, one of the largest sections of the east and west walls are in American museums. The Metropolitan Museum of Art owns sixty-three large fragments from the northern part of the west wall, which were installed in 1976 in gallery 22, where the art of the Twenty-sixth Dynasty is displayed.[18] The wall section comprises three registers, with scenes of the procession of offering bearers in the bottom and third registers and an episode from Nespakashuty's funeral in the second register—the barge bearing his coffin being towed across the river to the necropolis on the west bank. The funeral barge is accompanied by female mourners on other barges. In addition to this large section, the Museum retained two hundred and fifty small fragments, some of which are no larger than five to seven centimeters. Almost all of them were omitted from the first attempted reconstruction.

The Brooklyn Museum of Art owns a central and southern section of the west wall, which is a continuation of the Metropolitan Museum portion. The Brooklyn portion also shows the remains of three registers: the procession of offering bearers in the bottom register, the Abydos Pilgrimage (a sacred journey to the city of Osiris, a god of the afterlife) in the second register, and offering bearers with the sacred oil in the third.[19] A few blocks of the east wall, also now in Brooklyn, contain the remains of the offering bearers' procession in the bottom register and groups of male and female mourners in the second.[20]

The northern part of the east wall, with the representation of the funerary procession, is at the Oriental Institute Museum, Chicago.[21] The decorated northern door belongs to the Art Museum at Princeton University.[22] Many small fragments were acquired by other museums and private collectors (see Appendix).

DECORATIVE PROGRAM OF THE EAST AND WEST WALLS OF THE FIRST CHAMBER: HYPOTHETICAL RECONSTRUCTION (CHART 1, PAGE 90)

The reconstruction of the east and west walls of the first chamber of Nespakashuty's tomb is a complicated task for several reasons: the collapsed relief decoration was found scrambled on the floor; the tomb had also been used as a quarry for millennia. Furthermore, a comparison of two sets of photographs—excavation photographs taken in Egypt and a set made twenty years after the arrival of the reliefs at the Museum—shows that not all fragments found by Winlock came to New York.[23] It is thus necessary to consider fragments that at present are available only in Winlock's photographs. The photographs also document that some small Nespakashuty fragments that were deaccessioned by the Museum may be in private collections. Three fragments of the latter group were recently reacquired by the Metropolitan Museum (see Appendix). A thorough study of all available fragments has made it possible for us to add more pieces to the unpublished reconstruction made in the 1940s and to reexamine it. The main goal of this article, however, is to provide a better understanding of the iconography and style of the Nespakashuty tomb relief decoration based on selected scenes.

Yet another problem is the unfinished condition of the tomb reliefs. Some blocks present only preliminary drawings of figures and inscriptions; others have roughly carved outlines. Only a few of the fragments are completely finished reliefs, but their surface and interior details are clearly treated with great skill. The hard, compact limestone allowed crisp cutting and precise carving of details. The Theban creamy white limestone of which they were carved has an uneven concentration of iron oxides, which gives variable hues of pink to different slabs (contra Winlock cited above). Some fragments are not only of an intensive pink coloration but also have ruddy spots of rich color; these localized patches can be easily confused with the remains of paint marks.[24]

East wall

The east wall of the first chamber, which had been almost completed, is in better condition than the west wall. The east wall consists of eight registers. The bot-

tom register shows a procession of male and female offering bearers carrying offerings on their heads. The second register shows a funerary procession, rituals in front of a mummy, and the Opening of the Mouth ceremony. The third register depicts a slaughtering scene and a procession of male offering bearers with meat and fowl. The whole northern area of the upper part of the wall was occupied by a large-scale figure of Nespakashuty sitting on a chair in front of the offering table, an offering list, and offering rituals. Two sub-registers to the right show a procession of male offering bearers. Three top registers depict large-scale offerings.

West wall

The reconstruction of the west wall is complicated mostly because of its unfinished condition. The 1940s reconstruction of the wall was partly inaccurate because the ancient preliminary drawings on some blocks and photographs of missing fragments were ignored, leaving the northern part of the wall almost empty. Two photographs from the Winlock archive give important clues to the original composition of reliefs on the west wall.[25] One photograph shows an ancient drawing of the shoulder of a large male figure and a section of his necklace, as well as a register border behind him. The other shows a drawing of part of large-scale legs. These drawings are the only preserved remains of the large figure of the tomb owner that occupied the northern end of the west wall, which leads us to assume that the northern portions of the west-wall decoration constitute a mirror image of the east-wall representation of the seated tomb owner. The representation of this figure on the west wall remained unfinished because the whole northern section of the wall reached only the drawing stage. Excavation photographs also show the remnants of the drawings of the inscriptions that belong to the offering list and of a priest kneeling in front of an altar, a figure that is usually part of the offering composition placed below the offering list.[26] These drawings are clear evidence that the tomb owner was originally depicted sitting in front of the offering table with an offering list to the left and a scene of the offering rituals below.

The program of the decoration of the west wall was most likely similar to that of the east wall and probably consisted of eight registers. The bottom register shows a procession of the female and male bearers carrying offerings on their heads. The second register shows the Abydos Pilgrimage, the towing of the barge with the sarcophagus to the west bank of the Nile, and the beginning of the funerary procession. The third register shows the offering bearers bringing clothes, sacred

oil, fowl, and meat. In the northern area of the upper part of the west wall was the representation of the large figure of the tomb owner sitting in front of the offering list with the offering rituals below. The sub-registers showed the procession of offering bearers with animals and large-scale offerings, all preserved in fragmentary condition.

It can be concluded that the relief decoration of the east and west walls of the first chamber in the tomb of Nespakashuty consisted of three major subjects: the representation of the tomb owner, offering rituals, and funerary scenes.

MAJOR SCENES IN THE FIRST CHAMBER OF THE TOMB OF NESPAKASHUTY

REPRESENTATIONS OF NESPAKASHUTY

Fragments

1. The Art Museum, Princeton University, 50–127 (EP 1);[27]
2. Egyptian Department archives, MMA, neg. nos. M4C 262, 269, 292.

Description of the reconstructed scenes

Four relief fragments and two drawings belonging to two identical representations of Nespakashuty on the northern parts of the east and west walls of the first chamber survive. The carved fragments belong to the east wall, where his figure appeared to be finished. They show a section of chest and a hand holding a folded cloth, the elbow of a near arm, calves of two legs, and the bottom part of a chair's leg (Figure 7). Two ancient drawings belong to an unfinished figure of Nespakashuty on the west wall. Only the near shoulder and the calves of the legs are preserved (Figure 11). This incomplete material allows only a hypothetical reconstruction of his figure.

In both representations Nespakashuty is facing outward toward the offering list. He sits on a lion-legged chair and holds a folded cloth in the hand of his bent far arm. The near arm stretches toward the offering table (Figures 8–10). The head has not been preserved, but we can assume that he had a short or shoulder-length wig because there are no traces of the wig's lower edges on the shoulders. Nespakashuty wears a collar necklace and a double amulet. The remains of his garment also show that he wore a pelt vestment tied with an elaborate knot on his left shoulder. The ends of the straps forming the knot hang free over the necklace.

63

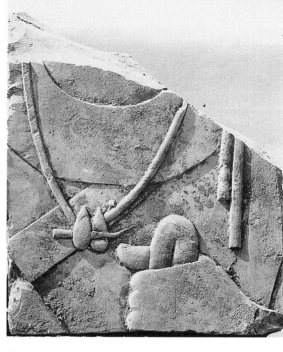

Figure 9. Relief fragment showing Nespakashuty's chest and one hand, 1922–23 (photo: Egyptian Expedition, neg. no. M4C 262)

Figure 7. Reconstruction of the figure of Nespakashuty from the north part of the east wall (drawing: Jo Wood, after Lindsley F. Hall)

Figure 8. Relief fragment showing a leg of Nespakashuty's throne, 1922–23. The Art Museum, Princeton University, 50–127 (EP 1) (photo: Egyptian Expedition, neg. no. M4C 292)

Figure 10. Relief fragment showing calves of Nespakashuty's legs, 1922–23 (photo: Egyptian Expedition, neg. no. M4C 269)

Iconographic and stylistic sources (see Chart 2, page 90)

Similar representations of a tomb owner wearing a pelt vestment have been known since the Third and Fourth Dynasties.[28] Nevertheless, Nespakashuty's image was most probably not derived from the Old Kingdom prototypes but was inspired by the corresponding contemporary images from the Asasif tombs of Mentuemhat[29] and Petamenophis.[30] On the relief from chapel C in situ and on the relief fragment at the Yale University Art Gallery, Mentuemhat is shown wearing a bag wig, a broad collar, a pelt vestment with a shoulder knot, and a double amulet. He holds a folded cloth in his near hand and both arms are outstretched toward the offering table. On the relief from the first court of his Asasif tomb he holds staffs in both hands. The representation of Mentuemhat could well have been copied for Nespakashuty, although a pose of Petamenophis with the far arm holding a folded cloth in front of the chest is closer to Nespakashuty.[31] It is possible that all of these roughly contemporaneous images had a common source, such as a pattern book.

The relief representations of Petamenophis and Mentuemhat provide help in the reconstruction of Nespakashuty's figure. Most likely, Nespakashuty sat on a chair with a short back support and wore a long kilt and a pelt vestment supported on his shoulder with an overlong, elaborate shoulder knot. It is probable that Nespakashuty's pelt vestment is similar to an iconographic version shown in the tomb of Mentuemhat,[32] as all later representations of tomb owners in the Asasif necropolis followed that of Mentuemhat.[33] One of the pronounced innovations in Mentuemhat's iconography is a transformation of the Old Kingdom narrow cloak edge into a wide chest band. The Old Kingdom edge ended with stripes forming a short knot that supports the cloak on the shoulder,[34] but during the Late Period the shoulder knot appears to have lost its practical function.[35] The knot became so long that it covered almost the whole shoulder and was obviously understood as a decorative element of the garment.[36] The long shoulder knot may be considered one of the hallmarks of the late Kushite–early Saite private relief style.[37] Another defining feature of this version of pelt vestment found in private tombs of the Twenty-fifth and Twenty-sixth Dynasties is the position of the paw lying on the shoulder of the tomb owner.[38] On Old Kingdom representations the paw hangs down, forming a kind of short sleeve.[39]

The existence of a pronounced Late Period tradition in the representation of the figure of a seated tomb owner makes it possible for us to reconstruct the figure of Nespakashuty quite accurately, despite its

Figure 11. Two fragments of the figure of Nespakashuty from the north part of the west wall, (photo: The Metropolitan Museum of Art, February 1948, neg. no. 140136)

fragmentary condition. This reconstruction is also supported by the better-preserved representations of Nespakashuty on the doorjambs of the facade[40] (Figures 12, 13). He is shown there wearing a bag wig, pelt vestment, and a short kilt, with his far arm bent in front of the chest.

OFFERING LIST AND OFFERING RITUALS

Fragments

1. Walters Art Gallery, Baltimore, 22.132, 22.329, 22.331;
2. Oriental Institute Museum, University of Chicago, OIM 18236;

Figure 12. Left doorjamb of the tomb in situ, 1922–23 (photo: Egyptian Expedition, neg. no. M7C 52)

3. The Denver Art Museum, 1949.7;
4. Columbia University, New York, COO. 1699. 1a, 1b, 1c, 2a, 2b, 2c, 2d, 3a, 3b;
5. MMA, 23.3.468, 1997.137.4;
6. The Art Museum, Princeton University, 50–127 (EP 2–6);
7. Egyptian Department archives, MMA, neg. nos. M4C 262, 263, 264, 269, 285, 286, 291, 293, 294, 297, 298, 301, 302, 308, 311, 324;
8. The Detroit Institute of Arts, 1993.55.

Description of the reconstructed scenes

The northern sections of the east and west walls in front of the seated figure of Nespakashuty are decorated with the representations of offering lists and offering rituals: a priest making libation, three kneeling priests, a priest sweeping out the footprints (a ritual called "bringing the foot"), three sub-registers with a procession of male offering bearers related to the offering list, and three subregisters with representations of large-scale offerings (Figure 16). Preserved fragments of the east wall show that the scene was completely finished. The parallel composition on the west wall was never completed and has survived only in a fragmentary condition.

Figure 13. Right doorjamb of the tomb in situ, 1922–23 (photo: Egyptian Expedition, neg. no. M7C 55)

66

This kind of offering scene has been known since the Old Kingdom[41] and was frequently represented in New Kingdom tombs.[42] The tradition was continued in the Late Period Asasif tombs of Mentuemhat,[43] Petamenophis,[44] Pabasa,[45] Basa,[46] and Ibi.[47]

Although the depiction of the seated Nespakashuty may well have been inspired by reliefs from Mentuemhat's tomb (see "Representations of Nespakashuty"), the rest of the composition appears to have had another source of inspiration. What is left of the offering list and the procession of offering bearers shows that the whole scene is an almost direct replica of the northern wall of the Southern Hall of Offerings in Hatshepsut's temple at Deir el-Bahri of the Eighteenth Dynasty.[48] The strong similarity between the Nespakashuty and Hatshepsut scenes is significant: in most cases, we can only suggest possible prototypes for Late Period reliefs. It is usually impossible to pinpoint the exact source of a traditional composition. Sometimes the source is lost or has not yet been found, which is why direct imitations of earlier models are particularly thought-provoking.

Figure 14. Relief fragment showing part of the figure of a male offering bearer in a short kilt. East wall. The Metropolitan Museum of Art, Rogers Fund, 1923, 23.3.468 (photo: Bill Barrette)

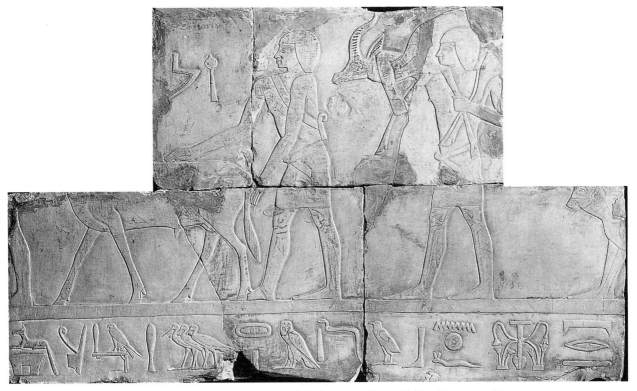

Figure 15. Relief fragment showing two offering bearers in plain short wigs. East wall. The Denver Art Museum, 1949.7

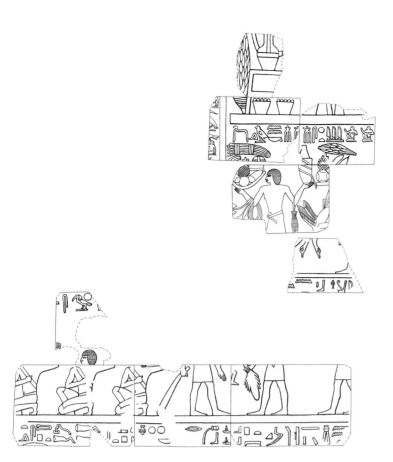

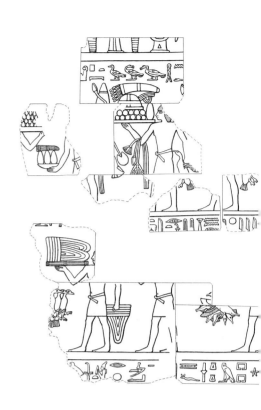

Figure 16a. Reconstruction of the middle part of the east wall of the tomb of Nespakashuty showing a procession of offering bearers (drawing: Jo Wood, and Jo Wood after Lindsley F. Hall)

Figure 16b. Middle part of the north wall in the Southern Hall of Offerings in Hatshepsut's temple at Deir el-Bahri (from E. Naville, *Temple of Deir el Bahari* IV [London, 1901] pls. 61, 62)

types; more probably, it was copied from the tomb of Harwa (TT 37), the first Late Period tomb in the Asasif, in which the relief decoration showed the influence of Old Kingdom prototypes.[51] The Late Period version of the Old Kingdom kilt is, however, slightly different: the free-hanging belt end goes behind the knot instead of in front of the knot, as in the Old Kingdom.

Instead of the universally seen short curly wig worn by Hatshepsut's offering bearers, the Nespakashuty reliefs show at least four different types of wigs: short plain, horizontally stepped, horizontally stepped with straight locks on the top and—the most elaborate one—a stepped, curly wig with straight locks on the top (Figures 15, 17, 18, 47).

The representation of the offerings is additional evidence of a new Saite style. All the offerings in the Nespakashuty reliefs are carved with great care and with a strong tendency to leave more space around each object and to depict them larger than those of the New Kingdom. Most of the offerings are at least twice as large as their prototypes. Late Period groups of objects are arranged with more completeness and symmetry. In Figure 19 one can see the basket with offerings carried by a bearer in the middle of the third register of the Hatshepsut temple offering composition and its counterpart in the tomb of Nespakashuty. The New Kingdom basket has a conical shape and its offerings consist of figs, two pieces of fruit of conventional form, small pieces of meat, bunches of grapes, and a melon covered with some onion. Nespakashuty's artist gave the basket a trapezoidal shape with a flat bottom. He kept most of the offerings but arranged them in geometrical order: the figs are rounded so that they form two straight rows between large pieces of round fruit; the melon has been replaced by a second bunch of grapes; and two bunches of symmetrically placed grapes form the support for the onion, which now lies horizontally.

In spite of the compositional and stylistic differences, the strong iconographical similarity between the Hatshepsut and Nespakashuty offering scenes is extremely helpful for the placement of some dispersed reliefs from Nespakashuty's tomb. Three fragments now in the Walters Art Gallery in Baltimore (22.329, 22.331, 22.132) were even assigned by G. Steindorff to the Eighteenth Dynasty[52] (see their description in the Appendix). The fragment number 22.331 was registered by Winlock and shown in his excavation photograph (Figure 20).[53] The position of its counterpart at the end of the middle subregister of the Hatshepsut offering composition shows the possible location of this fragment in the Nespakashuty scene.[54] Relief number 22.329, although not recorded by Winlock, joins two small fragments shown in another of his excavation photographs (Figure 21).[55] The offering bearer's reconstructed figure has a direct parallel in the Hatshepsut temple.[56] It must be placed in the same position as its counterpart: in the fourth register to the right of the offering list under the bottom row of the large-scale offerings.[57]

SLAUGHTERING SCENE

Fragments

1. MMA, 23.3.468 (EP 4, 5);
2. Egyptian Department archives, MMA, neg. nos. M4C 319, 283, 321.

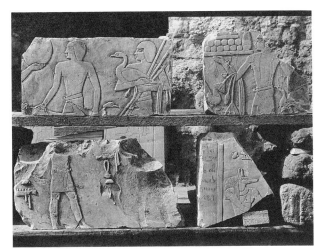

Figure 20. Four reliefs from Nespakashuty's tomb, 1922–23 (photo: Egyptian Expedition, neg. no. M4C 301)

Figure 21. Four reliefs from the tomb, 1922–23 (photo: Egyptian Expedition, neg. no. M4C 294)

Figure 22. Relief fragment showing two workmen slaughtering a bull, 1922–23 (photo: Egyptian Expedition, neg. no. M4C 283)

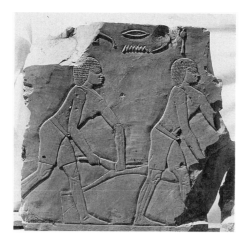

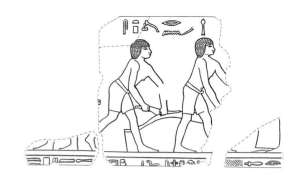

Figure 23b. Reconstruction of the slaughtering scene from the east wall of the tomb of Nespakashuty (drawing: Jo Wood, and Jo Wood after Lindsley F. Hall)

Description of the reconstructed scenes

Thirteen preserved fragments show four groups of butchers binding sacrificial animals with a long rope and cutting parts for offerings (Figure 23b). The men wear short kilts and short curly wigs with straight locks on the top. As far as we can now perceive, four bulls were represented, three bulls lying on their backs and one on its stomach.

Iconographic and stylistic sources

The slaughtering scene that formed part of the bottom register of a large offering composition was partially inspired by an equivalent scene on the east wall of the

Southern Hall of Offerings in Hatshepsut's temple (Figure 23a).[58] A similar scene in the tomb of Mentuemhat was also based on the Hatshepsut prototype, but Nespakashuty's scene is evidently closer to the Eighteenth-Dynasty reliefs.[59] The Mentuemhat and Nespakashuty artists used different parts of Hatshepsut's composition, which clearly indicates that the Nespakashuty sculptors copied directly from Deir el-Bahri reliefs and did not receive inspiration from the Mentuemhat artists. In Nespakashuty's tomb, butchers are shown in the process of binding the bulls with a rope, a replica of two groups of workmen that form the left end of two bottom registers in Hatshepsut's temple. Mentuemhat's sculptors copied

Figure 23a. Slaughtering scene on the east wall in the Southern Hall of Offerings in Hatshepsut's temple at Deir el-Bahri (from Naville, *Temple of Deir el Bahari* IV, pl. 57)

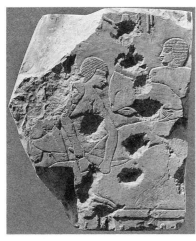

Figure 24. Relief fragment showing two workmen slaughtering a bull, 1922–23 (photo: Egyptian Expedition, neg. no. M4C 321)

Figure 25. Relief fragment showing remains of the figures of two workmen. East wall. The Metropolitan Museum of Art, Rogers Fund, 1923, 23.3.468 (photo: Bill Barrette)

Figure 26. Relief fragment showing the hand of a workman holding a bull's leg. East wall. The Metropolitan Museum of Art, Rogers Fund, 1923, 23.3.468 (photo: Bill Barrette)

the groups of workmen slaughtering bound bulls shown in the middle of three of the bottom registers of Hatshepsut's temple.

These two compositions reflect two different iconographic versions of a traditional slaughtering scene in Egyptian art: Mentuemhat's illustrates the pure New Kingdom tradition;[60] Nespakashuty's is based on the Old and Middle Kingdom iconography reflected in Hatshepsut's temple.[61] It is possible that Nespakashuty's choice was reinforced by the influence of the early Middle Kingdom monuments in the immediate neighborhood.[62] Following the early Middle Kingdom tradition, Nespakashuty's third group of butchers includes a workman approaching a bull from the side of its head and cutting its neck.

The first group from the left is closest to Hatshepsut's relief version, but the bull's front leg is shown half its normal size and without a hoof, a detail reflecting

Middle Kingdom tradition. The fourth, less well preserved group is a libation scene in which water is poured directly on a bull's cut throat (Figures 25, 26).[63] The most unusual part of the scene is the second group, in which a bull is shown on its stomach; this iconography is uncommon in New Kingdom art but was popular at Meir and Bersha during the Middle Kingdom.[64] Nespakashuty's composition, combining a few different iconographic versions, could have influenced the sculptors working later in the tomb of Basa in the Asasif. According to the remains of Basa's relief decoration, the slaughtering scene was copied from Nespakashuty's tomb.[65] At least two sculptors worked on this scene in Nespakashuty's tomb: the first and second groups show a graphic style with sharp lines and heavy modeling (Figure 22), while the third group was produced in lower relief with a more elegant line and less modeling (Figure 24).

Figure 27. Reconstruction of the procession of offering bearers and funeral rituals from the west wall of the tomb of Nespakashuty (drawing: Jo Wood)

74

Figure 28. Procession of offering bearers. West wall, 1922–23. Brooklyn Museum of Art, 52. 131.8, 9, 14 (photo: courtesy Brooklyn Museum of Art, neg. no. KKK)

PROCESSIONS OF OFFERING BEARERS IN THE BOTTOM REGISTERS OF THE EAST AND WEST WALLS

Fragments

1. MMA, 23.3.468, 23.3.468 (EP 2, 3) 1997.137.6;
2. Oriental Institute Museum, University of Chicago, OIM 18236;
3. Brooklyn Museum of Art, New York 52.131.1–32 and 68.1;
4. The Art Museum, Princeton University, 50–127 (EP 5, 7);
5. The Fitzwilliam Museum, University of Cambridge E.GA.3001.1943.

Description of the reconstructed scenes

Male and female offering bearers were depicted in the bottom registers of the east and west walls in the first chamber of Nespakashuty's tomb (Figure 27). Both compositions are preserved only in fragments. The southern part of the procession on the west wall was left unfinished in preliminary drawings or carved only around the outlines of the figures. All the offering bearers carry offerings on their heads, and some lead animals. The men wear short kilts and short curly wigs. The women wear traditional plain tripartite wigs, plain-collar necklaces, and long tight-fitting ankle-length dresses with straps that form a trapezoidal neckline.

Figure 29. Relief fragment showing the unfinished figure of a female offering bearer. West wall. The Metropolitan Museum of Art, Rogers Fund, 1923, 23.3.468 (photo: Bill Barrette)

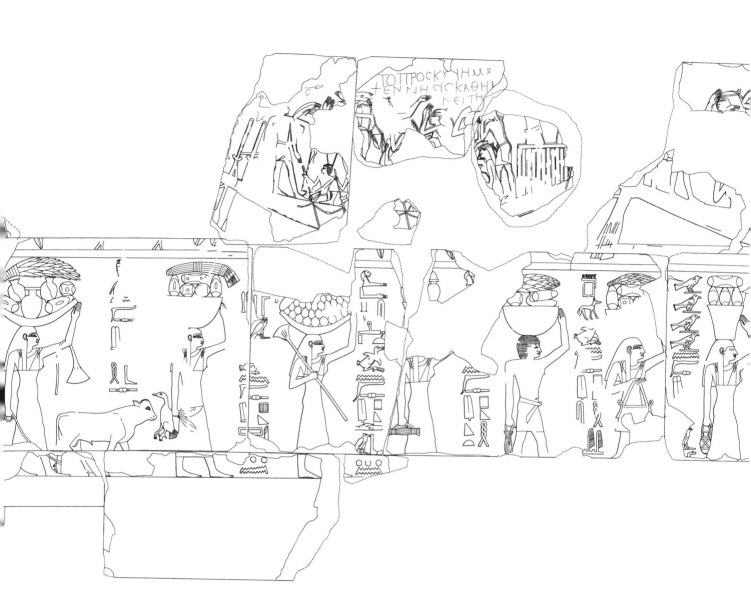

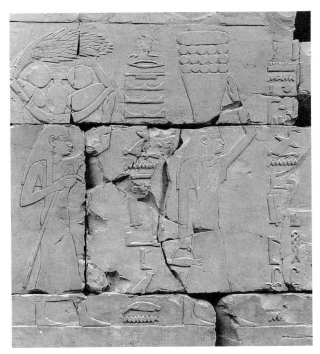

Figure 30. Relief fragment showing two figures of female offering bearers. West wall. The Metropolitan Museum of Art, Rogers Fund, 1923, 23.3.468 (photo: Bill Barrette)

The dresses are supported on the shoulders by knotted shoulder straps.[66] A short inscription in front of each figure lists the offerings and Nespakashuty's titles and name.

Iconographic and stylistic sources

The offering bearers in both scenes are depicted in the traditional manner of estate personifications.[67] This type of composition is found as early as the Fourth Dynasty and first appeared in royal complexes.[68] Despite its general similarity to Old Kingdom prototypes, this part of the tomb's decoration could have been inspired by a corresponding composition in Mentuemhat's tomb, nine fragments of which are preserved.[69] In contrast to Mentuemhat's, Nespakashuty's composition shows both female and male offering bearers (Figure 28).[70] Nevertheless, two features of the scene provide clear evidence that the composition was copied from Mentuemhat's tomb.

First, female offering bearers are depicted with the near leg forward crossing in front of the far leg (Figure 29).[71] Representation of the near leg forward is not attested in the Twenty-fifth Dynasty tombs in Thebes.[72] This feature first appears in the tomb of Mentuemhat, then in the tomb of Nespakashuty, and later in several other Late Period Asasif tombs. The second significant feature is the presence of strap knots on the female dresses (Figure 30). In the Old Kingdom, knots of this type appeared mostly in royal complexes on the garments of fecundity figures and estate personifications or as a feature of royal and divine garments.[73] To the best of my knowledge, the earliest representation of this strap knot appears on Narmer's garment on his famous palette.[74] But figures personifying estates in the Old Kingdom private tombs usually wear dresses with flat, smooth straps without knots.[75] After a long interval this knot reappears as an archaizing feature in Third Intermediate Period reliefs, again mostly on royal and divine garments and occasionally on dresses worn by private women.[76] The first representation of the strap knot on the garment of offering bearers in a private tomb is found in that of Mentuemhat. This feature became part of the Late Period Theban necropolis tradition and, starting with Nespakashuty, was repeated in every Asasif tomb.[77] It seems likely that this particular feature of subsidiary figures' garments in private tombs was inspired not by Old Kingdom royal reliefs but by a local Theban tradition of Third Intermediate Period royal art.

Specific features

Although most probably inspired by a scene from the tomb of Mentuemhat, the version in Nespakashuty's tomb shows some unusual features of its own. What is

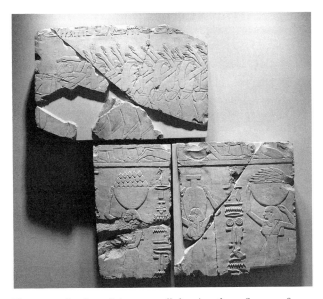

Figure 31. Section of the east wall showing three figures of offering bearers and female mourners. East wall. Brooklyn Museum of Art, 52.131.3, 24, 25 (photo: courtesy Brooklyn Museum of Art, neg. no. BBB)

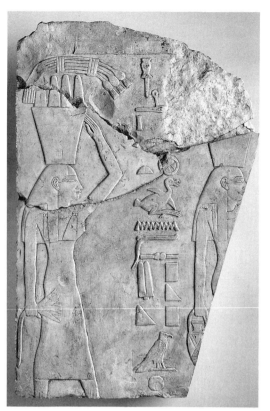

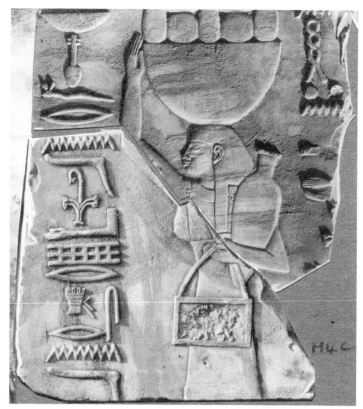

Figure 32. Relief fragment showing two figures of female offering bearers. West wall. The Metropolitan Museum of Art, Purchase, Lila Acheson Wallace Gift, 1997, 1997.137.6 (photo: Bill Barrette)

Figure 33. Relief fragment showing an offering bearer with a hedgehog. East wall, 1922–23. Oriental Institute Museum, University of Chicago, 18236 (photo: Egyptian Expedition, neg. no. M4C 259)

quite extraordinary in this type of composition is an image of a female offering bearer who balances offerings not on her head but on both shoulders using both arms to hold the offerings in place (Figure 31).[78] This positioning of a large jar is very unusual in Egyptian art. To my knowledge, there are no parallels to this figure among earlier representations of offering bearers: the usual Egyptian position for the offerings is on one shoulder.[79] The positioning of offerings on both shoulders is found only in Eighteenth-Dynasty representations of foreigners bringing tribute.[80] The possibility that such figures of foreigners were used as prototypes for the Nespakashuty representation is given further weight by another unusual feature visible in the remains of the female mourners in the second register of the same fragment. The mourners wear wraparound, calf-length skirts instead of the traditional pleated dresses or long skirts supported by belts with fringed ends. A similar wraparound garment appears on foreigners in the New Kingdom tomb decoration.[81] It may have a Canaanite origin[82] (see "Funerary Rituals and Procession," page 80). The fragment described

above is the only known example of a Late Period Theban tomb relief indicating the influence of the New Kingdom representation of foreigners. At the same time we do not know if Nespakashuty's artist identified the country of origin of this garment or even recognized it as a foreign one.

Traditional long narrow dresses worn by female offering bearers were also shown slightly differently than those in Mentuemhat's reliefs. V-neck dresses were replaced by dresses having a trapezoidal neckline (Figure 32). While Mentuemhat's iconographic version developed from the Old Kingdom tradition, Nespakashuty's variation of the same dress followed the Middle Kingdom models.[83] The Mentuemhat and Nespakashuty sculptors could have also been inspired by the Kushite monuments where both types of necklines are found.[84]

Another detail of unusual interest is a depiction of a hedgehog as an offering (Figure 33).[85] Very few examples of this are known among ancient Egyptian tomb reliefs. Nespakashuty's relief is one of three known Saite examples and the only one found in the Theban area.[86]

78

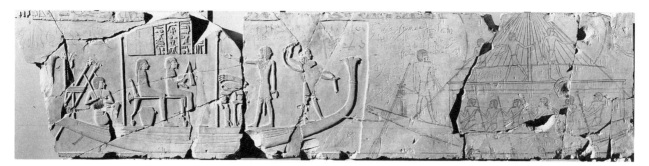

Figure 34. Central section of the west wall showing a scene of the Abydos pilgrimage. Brooklyn Museum of Art, 52.131.1G, H, I (photo: courtesy Brooklyn Museum of Art, neg. no. H)

Abydos Pilgrimage

Fragments

1. Brooklyn Museum of Art 52.131.1G, H, I, 13–15;
2. MMA, 23.3.468.

Description of the reconstructed scenes

The Abydos Pilgrimage occupies the second register of the southern part of the west wall. It consists of two traditional parts: the first two boats on their way to Abydos and two boats on the return from Abydos.

The first pair of boats (a sailing boat and a ritual papyrus *nsmt*-boat) heading to the north are shown being rowed rather than under sail. The fragments of the first boat show five sailors and parts of the figure of an overseer brandishing his flail over the crew's heads. The second pair of boats illustrates the return by sail from Abydos (Figure 34). The representation of the sailing boat exists in a preliminary drawing that shows three sailors unfurling the sail, the captain at the prow giving orders to the steersman at the helm, and the rest of the crew rowing. Most New Kingdom examples show the sailors dropping their oars while one of them leans over the side to fill a jug with water.[87]

The traditional composition is here reversed. Usually, a boat with sailors is represented to the right of the ritual boat so that they both go to the right and the second pair goes to the left. On the Nespakashuty relief the boats change places and the direction of movement.

Iconographic and stylistic sources

Nespakashuty's version is again close to Eighteenth-Dynasty prototypes. The closest parallels are the corresponding scenes in the tombs of Puimre (TT 39), Amenemhet (TT 82), and Nebamune (TT 17).[88] The Mentuemhat scene, which reflects a New Kingdom iconography of the Abydos Pilgrimage also influenced Nespakashuty's composition.[89]

The representation of Nespakashuty and his wife on a boat is very similar to its counterpart in the tomb of Mentuemhat.[90] Both are shown as wrapped figures seated on a lion-legged seat. Her arms are not visible, while Nespakashuty's far hand holding a flail is placed above the near oversize one. He wears a bag wig, and his wife is shown in a tripartite wig, the front lock of which is not represented.[91] It has been suggested that these figures depict mummiform statues of the tomb

Figure 35. Nespakashuty and his wife Ketykety in the boat. Brooklyn Museum of Art, 52.131.15 (photo: courtesy Brooklyn Museum of Art, neg. no. EE)

owner and his wife.[92] In the tomb of Ibi, a sledge under the figure of the tomb owner and his wife leaves no doubt that statues were represented.[93]

Specific features

A distinctive feature in the representation of Nespakashuty on a ritual boat is the appearance of braces on the chests of the tomb owner and his wife (Figure 35). They wear collars with hanging beads and beneath them two crossed leather braces, usually found among the chest wrappings of mummies beginning in the Twenty-first Dynasty. Representations of such braces on mummiform deities are known as early as the Seventeenth Dynasty,[94] and from the Eighteenth Dynasty on they became common.[95] Beginning in the Twenty-first Dynasty the braces appear on mummy representations and presumably had a symbolic function indicating that the deceased was equal to the gods.[96]

The richest source for representations of mummies shown with braces is Twenty-first Dynasty papyri, in which the braces appear on figures of two major types: mummiform gods (gods of the netherworld,[97] the four sons of Horus,[98] or Osiris[99]) and mummies of private people.[100]

The depiction of the braces on the figures of Nespakashuty and his wife denotes that seated mummies are represented; the iconography of seated mummiform figures decorated with a collar necklace and braces may recall images of Osiris.[101] To my knowledge, there are no parallels among the New Kingdom or Late Period representations. Even when figures appear mummiform, they do not have the braces, identifying them as mummies. Jan Assmann has reconstructed the figures of Basa and his wife with braces, as in the Nespakashuty reliefs, although there is no evidence for such a reconstruction.[102] It is more likely that Basa chose a more traditional version of the representation of a tomb owner in the pilgrimage boat, such as that shown in Mentuemhat's tomb and later repeated in the tombs of Ibi and Pabasa.

Nespakashuty's lion-legged chair with an open back is also exceptional for an Abydos Pilgrimage scene.[103] Its back support has an angled batten from the seat to the curved top rail and a strut joined to it.[104] This type of chair was frequently represented during the Middle and New Kingdom, as a chair for a tomb owner seated in front of an offering table.[105] A Late Period addition to this type of chair is a large papyrus umbel at the back of the seat.[106] Nespakashuty's chair type did not become traditional for the Late Period Theban Abydos Pilgrimage scene: every one displays a different type of chair.[107]

The remains of a cabin with a curved roof above the figures of Nespakashuty and his wife indicate a shape similar to New Kingdom prototypes.[108] Fragments of a head in an elaborate wig and of a vessel with burning incense show that there was a priest performing rituals in front of the seated couple. The empty space between Nespakashuty and the priest is large enough to contain a traditional offering table. Representations of a priest making offerings in front of the deceased on a pilgrimage boat became traditional in Late Period Theban tombs.[109]

FUNERARY RITUALS AND PROCESSION

Fragments

1. MMA, 23.3.468, 23.3.468 (EP 1);
2. Egyptian Department archives, MMA, neg. no. M4C 271;
3. Brooklyn Museum of Art 52.131.2, 3;
4. Oriental Institute Museum, University of Chicago, 18236.

Description of the reconstructed scenes

To the right of the Abydos Pilgrimage in the second register of the west wall four more boats were represented: a boat towing the barge with the sarcophagus to the necropolis on the west bank of the Nile and two others carrying female mourners. The fragment showing the stern of the last boat in the register also shows remains of an elbow and a hand of a large-scale figure (see Figure 27). There is no doubt that the large figure of a mourner or probably a few mourners were represented near the boat. To the right of the mourners two booths with offerings are depicted. Remains of feet to the right indicate that the rest of the second register was probably filled with a representation of the funerary procession. Fragments of ten figures carrying furniture, clothes, and weapons in the funerary procession on the west wall have survived. The funerary procession and rituals continue on the east wall. They include male and female mourners, dragging the coffin, bearers of funerary equipment, an Opening of the Mouth ceremony, and the goddess of the West.

Iconographic and stylistic sources

The funerary procession and associated rites seen in Nespakashuty's tomb are basically similar to the corresponding scene in the tomb of Mentuemhat.[110]

Figure 36. Southern section of the west wall showing a funerary procession. The Metropolitan Museum of Art reconstruction, 1947–48 (photo: The Metropolitan Museum of Art, February 1948, neg. no. 139273)

However, Nespakashuty's procession is more modest and contains elements that do not correspond to Mentuemhat's composition. It is possible that Nespakashuty's scene was strongly influenced by Ramesside period examples.[111] The reduction of the number of represented scenes to a few rituals and exclusion of the majority of previously depicted episodes recalls Ramesside precedents.[112] Ninteenth-Dynasty funeral scenes occupied far less space than funerary processions of their predecessors concentrating on men carrying funerary equipment, sledges bearing the body of the deceased, and male and female mourners. Precursors of this reduced version are found in the tombs dating just before the Amarna period, for instance in the tombs of Nebamun and Ipuki, and Ramose.[113]

It is, however, difficult to find the direct source for Nespakashuty's funerary procession. The closest parallel is a painting in the tomb of Nebamun and Ipuki (TT 181), which dates to the reign of Amenhotep III or IV, foreshadowing the Ramesside model of the funerary procession.[114] There is a great similarity between some parts of the funerary procession in the tombs of Nespakashuty and of Nebamun and Ipuki. This allows the suggestion that the artists who decorated the tomb of Nespakashuty could have visited the earlier tomb. The clearest evidence is a figure of an offering bearer carrying a pair of sandals, a small bag, and a chest (Figure 36). This is a traditional choice of offerings for the Eighteenth Dynasty, but they usually appear in different combinations.[115] In the tomb of Nebamun and Ipuki the offering bearer with the sandals looks exactly the same as his counterpart on the west wall in Nespakashuty's tomb. The near outstretched arm holds a small bag, the sandals hang on the arm, and the far arm supports a chair on his head.[116] Another figure behind him might also have been inspired by the painting in the tomb of Nebamun and Ipuki: an offering bearer carrying a vase stand with four vessels for sacred oil. Two vessels are preserved on the fragment from the tomb of Nespakashuty, perhaps the only ones originally represented there. On the northern part of the east wall of Nespakashuty's tomb a similar figure carries a stand with two vessels, which are larger than those from the New Kingdom and are decorated with big lotus flowers on the top. Only parts of two other figures in front of the file are preserved. An elbow of the second man shows that his near arm was raised. If similar to the

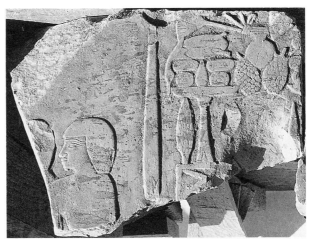

Figure 37. Relief fragment showing a funeral booth. West wall, 1922–23 (photo: Egyptian Expedition, neg. no. M4C 271)

Figure 38. Relief fragment showing two female offering bearers. West wall. The Metropolitan Museum of Art, Rogers Fund, 1923, 23.3.468 (photo: Bill Barrette)

Figure 39. Relief fragments showing female mourners in a boat. West wall. The Metropolitan Museum of Art, Rogers Fund, 1923, 23.3.468 (photo: Bill Barrette)

Nebamun and Ipuki painting, these figures might carry a lion-legged bed. Another figure with an outstretched arm may carry two wooden boxes for canopic jars on a tray. A similar figure on the opposite east wall is shown carrying a tray with two boxes. Compared with their New Kingdom precedents, these boxes are much larger, causing the bearer to support the tray on his shoulder. However, there are a few offering bearers carrying weapons who are not present in the tomb of Nebamun and Ipuki but are represented in many other Eighteenth-Dynasty tombs.[117]

Some of the funerary rites depicted in Nespakashuty's tomb, such as funeral booths with priests in them, were also possibly inspired by a painting in the tomb of Nebamun and Ipuki (Figure 37). The preserved booth fragments from Nespakashuty's tomb show the base of a column and remnants of four vase stands, a small offering table with five loaves of bread, two bunches of grapes, lettuce, and lotus flowers. According to the small scale of the booths, there were two of them represented, one above the other. The Nebamun and Ipuki have a similar composition: two booths with papyrus-shaped columns at the front side placed one above another and next to the mourners.[118]

As mentioned above, some parts of the composition were inspired by the decoration in Mentuemhat's tomb. The iconography of the expressive scene showing female mourners in two boats in Nespakashuty's tomb is so close to the respective scene in the tomb of Mentuemhat that it was most likely adapted from it with some changes and reductions.[119] There are fewer figures in Nespakashuty's tomb, and they are depicted in slightly different poses. In the Mentuemhat reliefs most of the mourners are shown with their arms bent above the heads, while in Nespakashuty's reliefs the arms are usually placed in front of the faces (Figures 38, 39). Nespakashuty's sculptors, however, directly repeated the most expressive of Mentuemhat's mourners, the one with the arms raised up high.[120]

Specific features

On the west wall of Nespakashuty's tomb eight boats are represented in one register: four boats of the Abydos Pilgrimage and four of the Last Journey to the West. The combination of these two scenes in one register is very unusual. In Mentuemhat's tomb they are contained on the same wall but separated from each other. The Abydos Pilgrimage occupies the bottom register, while the barks with the mourners and the scene of the towing of the barge laden with the sarcophagus to the west bank of the Nile were placed at the top. The combination of two compositions in one might be explained by a desire to use space in the most rational way. The only decorated chamber in Nespakashuty's tomb is much smaller than the space available for reliefs in Mentuemhat's tomb, and representations of ships need a wide register. The idea of placing all the boats in one line may be attributed to the aesthetic sense of the Nespakashuty sculptor: eight boats in one row with their repeated oars and sails look rhythmical. A similar combination of the Abydos Pilgrimage and the Last Journey to the West (six boats in two subregisters) appears in Pabasa's tomb.[121] As Pabasa's tomb was decorated almost fifty years later, it could have been influenced by the relief decoration in the tomb of Nespakashuty.

One figure in the Nespakashuty funerary procession was exceptional. On the relief fragment one can still see a hand holding an offering table with the lower parts of two mummiform statuettes on it, while lotus flowers and buds hang down from the table (Figure 40). The mummiform figurines must represent the pharaoh in the red crown; such figurines are usually carried in New Kingdom representations of funerary processions.[122] A similar representation was placed on the opposite east wall in Nespakashuty's tomb and in the later tomb of Ibi (Figure 41).[123] Quite unusual is the combination of the statuettes with the lotus flowers that hang from the table. Such hanging flowers are strongly associated with the iconography of fecundity figures, which, with specific types of offerings, had been traditionally a part of the decoration of royal complexes since the Old Kingdom. Nespakashuty's sculptors could have seen them in Hatshepsut's temple at Deir el-Bahri.[124] Rare Late Period royal examples of fecundity figures are known from the Taharka reliefs at Karnak and from two copies of Sahure's temple reliefs on two naoi of Amasis.[125] On the Old Kingdom examples and their Late Period copies, ꜥnḫ and wꜣs signs, or (rarely) bunches of blooms of the heraldic plants of Upper and Lower Egypt, were shown hanging from a table.[126] It seems that Nespakashuty's artists followed Eighteenth- and Nineteenth-Dynasty parallels, showing fecundity figures with lotus or papyrus flowers on long stems.[127] As fecundity figures were mostly part of royal temple decoration, examples in private tombs are very rare. The tomb of Nespakashuty is the only known Late Period example of their appearance in a private tomb.

The six surviving representations of the male mourners on the southern part of the east wall wear an unusual garment (Figure 42). The long plain kilts and short wigs are probably a result of the influence of tombs from the Ramesside period, when represen-

Figure 40. Relief fragment with a fecundity figure. West wall, 1922–23 (photo: Egyptian Expedition, neg. no. 140120)

tations of male mourners became popular.[128] The depiction of male mourners before Dynasty 19 is exceptional.[129] Ramesside tomb reliefs usually show large groups of male mourners wearing elaborate garments: long pleated kilts and shirts. In most cases they have shaved heads.[130] The first representation of male mourners in the Late Period tombs occurs in the tomb of Mentuemhat, where remnants of four of them are preserved.[131] They wear short plain wigs but their garments are not visible. Later, representation of male mourners became a Theban necropolis tradition.[132] In the tomb of Pabasa they wear pleated kilts, in the tomb of Basa archaic short kilts, and in the tomb of Ibi double kilts. Only in Nespakashuty's tomb do they wear long plain kilts.

The exceptional character of the garment of the female mourners has already been discussed (see "Processions of Offering Bearers," page 76) (Figure 43). A long diagonally wrapped skirt leaving the upper part of the body bare does not occur on mourners in any other New Kingdom or Late Period tombs.[133] This wraparound garment of Canaanite or Syro-Palestinian origin recalls foreign dresses as depicted in the New Kingdom.[134]

Nespakashuty's artists clearly did not follow a single tradition or pattern, but they combined small details from different periods. While using mainly Ramesside prototypes for the representation of funerary rites, they added some details and figures following an earlier tradition. Another example of combining different iconographic traditions is a scene of the coffin being dragged,

Figure 41. Relief fragment with two participants of the funerary procession. East wall, 1922–23. Oriental Institute Museum, University of Chicago; 18236; (photo: Egyptian Expedition, neg. no. M4C 281)

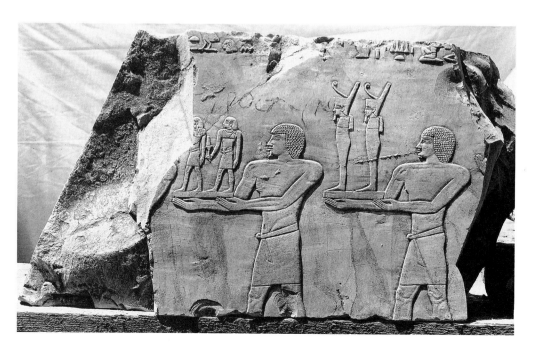

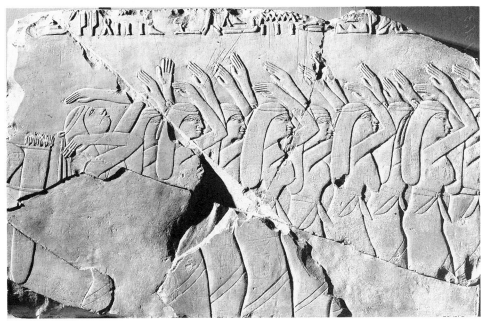

Figure 42. Southern section of the east wall with offering bearers and male mourners, 1922–23. Brooklyn Museum of Art, 52.131.2, 26–31 (photo: courtesy Brooklyn Museum of Art, neg. no. DDD)

Figure 43. Relief fragment with female mourners. East wall, 1922–23. Brooklyn Museum of Art, 52.131.3 (photo: courtesy Brooklyn Museum of Art, neg. no. Q)

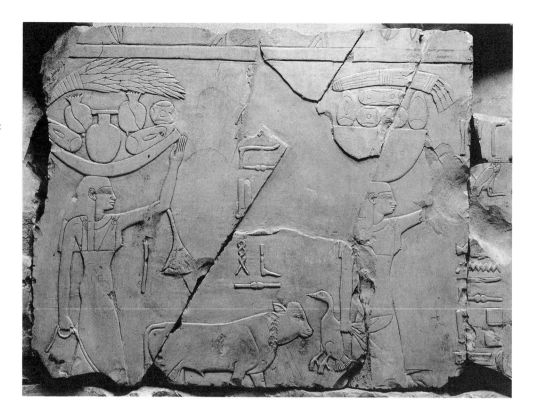

Figure 44. Relief fragment showing two female offering bearers. West wall. The Metropolitan Museum of Art, Rogers Fund, 1923, 23.3.468 (photo: Bill Barrette)

which shows it in a kiosk decorated with the hieroglyphic signs $ḏd$ and tit (Isis knot). The kiosk is placed on a sledge being dragged by bulls. This iconography is traditional for the Nineteenth Dynasty, but additional representations of a few men inside the kiosk belong to the time of Hatshepsut and Tuthmosis III.[135]

The tomb of Nespakashuty shows the shortest version of the funerary rites among the Late Period Asasif tombs. Many episodes seen in the tomb of Mentuemhat were not represented. The later tombs of Ibi and Basa show more similarity to Mentuemhat's composition.[136]

Two Sculptors of the Reliefs in Nespakashuty's Tomb

The decoration of Nespakashuty's tomb is executed in raised relief with gently rounded edges. Its surface is relatively unmodeled with only a few small incised details that were carefully carved. Approximately half of the relief decoration was completed. The preserved parts remain in a fragmentary condition. Nevertheless, one can suggest that at least two sculptors (or groups of sculptors) worked on the reliefs. With some reservations they may be called the sculptors of the east and the west walls. The difference in their individual manners is especially noticeable in the representation of the offering bearers in the bottom register of the two walls.

The middle section of the bottom register on the west wall shows the tomb's most elaborate style (Figure 44). The figures are executed in bold relief with rounded edges. Female figures are slim and elegant with small exposed breasts, narrow shoulders, thin waists, nicely carved feet, and gently curving, elongated fingers. Numerous small incised details are executed with great care and diligence. The combination of the flat, almost unmodeled surface of the dresses and decorative details evokes a style of the Eleventh Dynasty.[137]

The offering bearers from the east wall and the southern part of the west wall are executed in more shallow relief (Figure 45). The figures are proportionally heavier and wider in waists and shoulders. Their exposed breasts are full and supported by the upper edge of the dress. Their feet are flat; fingers are straight and short. The relief surface on the east wall is left almost undecorated with even fewer incised details. These features are closer to the earlier models from the Twelfth Dynasty.[138] It is also possible that this simple but delicate style was derived from the reliefs of the first half of the Eighteenth Dynasty, themselves based on early Twelfth-Dynasty Theban monuments.[139]

The most distinctive traits in Nespakashuty's reliefs are the facial features of minor figures: the exaggerated, narrow, slightly slanted eyes pointed down, the upper eyelid rims ending in cosmetic lines, raised eye-

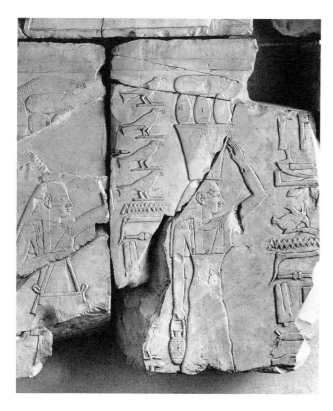

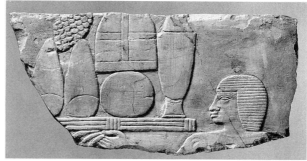

Figure 45. Relief fragment showing two female offering bearers. West wall. The Metropolitan Museum of Art, Rogers Fund, 1923, 23.3.468 (photo: Bill Barrette)

Figure 46. Relief fragment showing the head of a male offering bearer. East wall. The Metropolitan Museum of Art, Purchase, Lila Acheson Wallace Gift, 1997, 1997.137.4 (photo: Bill

brows, long noses, thick and sharply defined lips squared at the corner, and firm, overshot chins (Figures 46, 47). These faces bear a remarkable resemblance to the Theban facial style of the Eleventh Dynasty.[140]

Because of its exceptional location for a Late Period tomb high up on the cliff at Deir el-Bahri, the tomb of Nespakashuty is surrounded by early Middle Kingdom tombs, and the reliefs directly reflect early Middle Kingdom stylistic prototypes. It seems that an especially important source of inspiration were reliefs in the tomb of Queen Neferu (TT 319) of the Eleventh Dynasty.[141] It is highly probable that Nespakashuty's sculptors had the opportunity to visit the tomb of Neferu. Although the Hatshepsut temple porch was built across its entrance, a narrow tunnel was erected that descended from the upper court of the temple to the entrance of Neferu's tomb.[142]

The narrow eyes of the figures in the Nespakashuty reliefs also reflect the development of a facial type of the Late Theban necropolis from the Kushite to the Saite styles, with a tendency to decrease the size of the eye by making it narrower. The shape of the eyes in Nespakashuty's reliefs contrasts with the wider eyes seen on the minor figures in the tomb of Mentuemhat whose facial type could have been inspired by the representations in nearby tombs of the Eighteenth Dynasty or the monuments of the Twenty-fifth Dynasty.[143]

The individual styles discussed above are also dis-

tinct in two versions of a common facial type. The faces on the west wall look well proportioned: eyes are fully rimmed and the iris and pupil are indicated. The faces on the east wall have huge, almost grotesque noses. Eyes are not rimmed or only an upper rim is indicated; the iris is not shown.

Representations of objects and of minor details are also important in designating an individual style. Small objects can be considered a hallmark of an individual hand. There is a pronounced difference in the representation of offerings on the east and west walls. The sculptor of the west wall, who liked minor decorative details, depicts arc-shaped baskets with a pile of different offerings, which are organized symmetrically. The sculptor of the east wall prefers semicircular or tall baskets with plain surfaces that show only one or very few offerings represented in a large scale, usually a head of lettuce or a few loaves of bread or a pile of homogeneous offerings that look solid. Even the rendering of the same object by the different sculptors is modified. For example, a head of lettuce in a basket on the east wall is large and rigid, with sharp ends on the leaves. A head of lettuce on the west wall is in a compact, one-piece form: it is small and looks soft.

Not only completed parts of the reliefs but even preliminary drawings demonstrate the different stylistic variations. A comparison of two preliminary drawings of male offering bearers shows a pronounced difference in proportions and in the treatment of the body.

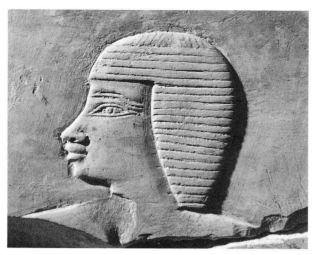

Figure 47. The head of a priest. East wall. The Detroit Institute of Arts, Founders Society Purchase, Walter Buhl Ford II Fund, 1993.55 (photo: courtesy The Detroit Institute of Arts)

One fragment in the Metropolitan Museum shows a slim, elegantly proportioned figure whose legs have no indication of muscles. Its style reflects the influence of the Hatshepsut temple reliefs (Figure 48). A fragment from the Brooklyn Museum shows a figure with heavy proportions and over-muscled legs, which demonstrate the influence of the Theban Kushite style based on Old Kingdom art (Figure 49).[144]

An interesting drawing is a recent acquisition of the Museum's Department of Egyptian Art (see Appendix). It shows a fat herdsman feeding an ibex (Figure 50). It is impossible to name a direct prototype for this scene, as representations of ibex are frequent in Old and Middle Kingdom tomb reliefs,[145] and the gesture of feeding has been well known since the Old Kingdom.[146] Also, the representation of minor figures of workmen as fat people is an old tradition in Egyptian art.[147] All these prototypes together may have influenced the draftsmen of Nespakashuty. This unfinished fragment also clearly demonstrates a technique of Nespakashuty's artists. Every figure was drawn twice; the preliminary drawing was roughly done with thick brush marks in a pale reddish color. At this stage the draftsmen determined the position of the figure on the wall, its proportions, and its general attitude. The second drawing made with a thin brush was more sophisticated. Elegant, curved brushmarks outline all the details for the sculptors to carve out. The quality of this drawing reveals the hand of a real master.

Although modest and unfinished, the relief decora-

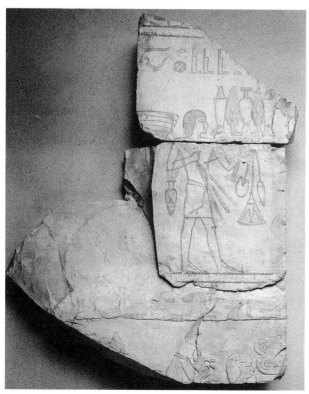

Figure 48. Limestone block showing the unfinished figure of the male offering bearer. West wall. The Metropolitan Museum of Art, Rogers Fund, 1923, 23.3.468 (photo: Bill Barrette)

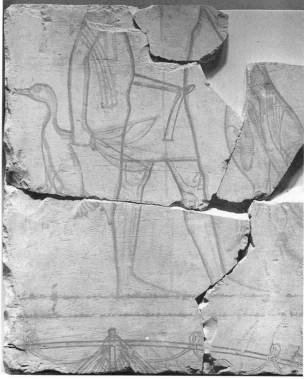

Figure 49. Limestone block showing the unfinished figure of the male offering bearer. West wall. Brooklyn Museum of Art, 52.131.22 (photo: courtesy Brooklyn Museum of Art)

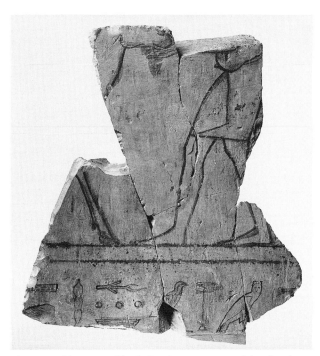

Figure 50. Limestone block showing remnants of the drawing of a male figure with an ibex. West wall. The Metropolitan Museum of Art, Purchase, Lila Acheson Wallace Gift, 1997, 1997.137.5 (photo: Bill Barrette)

tion of the tomb of Nespakashuty demonstrates a wide range of stylistic and iconographic variations. It owes much to the earlier tombs of the Asasif necropolis, which can be explained by direct copying, using the same so-called pattern books, or even employing some of the artists who could have worked for Mentuemhat. Nevertheless, Nespakashuty's tomb is not simply a small version of the immense, richly decorated tombs of his predecessors. Some features of its reliefs, such as certain details and scenes are not to be found in earlier or later Asasif tombs. Perhaps they were not included in pattern books but were selected by Nespakashuty's artists, revealing an individual approach to composing scenes.

Iconographically, Nespakashuty's artists created a version of relief decoration for a small tomb. The choice of the scenes shows which of them were considered most important. Furthermore, their layout on the walls, which shows both a practical and an aesthetic sensibility, was appreciated by the sculptors who worked in later tombs. Some of the compositional inventions of Nespakashuty's sculptors were influential for later tombs, even of a large size. Stylistically, Nespakashuty's reliefs, which were influenced by the early Eighteenth Dynasty, Twenth-fifth Dynasty royal art, and Asasif private tomb reliefs, owe a lot to the early Middle Kingdom Theban style. The unfinished state of the tomb reliefs adds to our knowledge of the process of Late Period relief carving.

ABBREVIATIONS

CdÉ—Chronique d'Égypte
GM—Göttinger Miszellen
JARCE—Journal of the American Research Center in Egypt
*LÄ—*Wolfgang Helck, Eberhard Otto, and Wolfgang Westendorf, eds., *Lexikon der Ägyptologie* (Wiesbaden, 1975–76) 6 vols.
MDAIK—Mitteilungen des deutschen Archäologischen Instituts, Abteilung Kairo
PM—Bertha Porter and Rosalind Moss, *Topographical Bibliography of Ancient Egyptian Hieroglyphic Texts, Reliefs, and Paintings,* I: *The Theban Necropolis,* Part I: Private Tombs (Oxford, 1960)

ACKNOWLEDGMENTS

In addition to support from the Andrew W. Mellon Foundation, the project was also sponsored by Mr. and Mrs. Jack Josephson, Mr. and Mrs. Theodore Halkedis, Mrs. Emma Swan Hall, and Mr. Alan May. I wish to express my deep gratitude to Dorothea Arnold, Lila Acheson Wallace Curator of Egyptian Art, for her encouragement, support, and supervision. I also want to thank Dieter Arnold, James Allen, Susan Allen, Marsha Hill, Catherine Roehrig, and Adela Oppenheim of the Department of Egyptian Art, The Metropolitan Museum of Art, for their help during the research and writing of this manuscript and for their valuable suggestions. In addition, I am indebted to staff members of the many museums that provided information and photographs, some of which have been incorporated into this study.

CHART 1. ICONOGRAPHIC AND STYLISTIC SOURCES OF THE NEPSKASHUTY TOMB RELIEF DECORATION

Sources / Scenes in the tomb	Tomb of Mentuemhat (TT 34)	Other Late Period tombs	Early Middle Kingdom tomb reliefs	Hatshepsut temple reliefs	Eighteenth Dynasty private tombs	Ramesside private tombs
Representatins of Nespakashuty	X	X				
Offering list and offering rituals		X	X	X		
Slaughtering scene			X	X		
Processions of offering bearers in the bottom register	X		X		X	
Abydos Pilgrimage	X				X	
Funerary rituals and procession	X				X	X

CHART 2. RELIEF DECORATION OF THE EAST AND WEST WALLS OF THE FIRST CHAMBER IN THE TOMB OF NEPAKASHUTY

East wall

North

8 Seated	Offering	Large-scale offerings		
7		Large-scale offerings		
6		Large-scale offerings		
5 Nepakashuty	List	Male offering bearers		
4 Offering rituals		Male offering bearers		
3 Offering bearers with meat and fowl			Slaughtering scene	Offering bearers with cattle
2 Opening of the Mouth	Rituals in front of the mummy		Funerary procession	
1 (bottom register)		Procession of offering bearers		

West wall

North

8 Large-scale offerings		Offering	Seated
7 Large-scale offerings			
6 Large-scale offerings			
5 Male offering bearers		List	Nespakashuty
4 Male offering bearers			Offering rituals
3 Offering bearers with sacred oil, clothes, fowl and meat			
2 Abydos Pilgrimage	Last Journey to the West	Funerary procession	
1 (bottom register)	Procession of offering bearers		

90

Appendix: Catalogue of the Dispersed Relief Fragments from the Tomb of Nespakashuty Included in this Article

Baltimore

Walters Art Gallery

22.216 Fragment of the ritual scene

DESCRIPTION: Relief fragment showing a priest performing an "Opening of the mouth" ritual. He makes libations from a ritual jar with his far arm and holds another vessel with burning incense in his near hand. He wears a long kilt, a leopard skin and a short horizontally striated wig with vertical locks on the top. He has long, narrow fully rimmed eyes, small mouth and a short beard. There is a stand with special tools for the opening of the mouth behind him. Traces of the inscription are seen above his head: *[š] hr . . . ḏd mdw jn . . . sm jm(j)[ḫnt] [rdjtš]ᶜ ḥr . . .* ("[putting] sand on [. . .]. Recitation by the *sem* and *jmj-[ḫnt]* ("priest").
LOCATION IN THE TOMB: The northern part of the east wall
MEASUREMENTS: H. 33.5 cm, W. 35.5 cm
CONDITION: Large chips at edges, inscription looks deliberately damaged, long vertical chisel marks are seen on the upper part of the inscription.
PROVENANCE: Purchased in 1929
BIBLIOGRAPHY: E. Pischikova, "Four Reliefs from the Tomb of Nespakashuty (TT 312) in the Walters Art Gallery, Baltimore," *Journal of the Walters Art Gallery* (1998) (forthcoming).
COMMENT: This relief fragment was found by Winlock together with the other tomb reliefs in 1922 and recorded on the field photograph that is now in Egyptian Department archives, MMA, neg. no. M4C 326. The Walters Art Gallery dated the fragment to the Old Kingdom. The relief is executed in a very gentle, sophisticated style. All details are carefully treated. Fingers are very long with nails indicated, which is unusual.

22.329 Fragment of the offering composition (Figures 16, 20)

DESCRIPTION: Relief depicts an offering bearer, facing left who lifts a basket with offerings and a wine jar in his raised hands. He wears a short kilt and a short, horizontally stepped wig. He has natural eyebrows and rimless eyes. At his right, the offerings of a missing bearer are shown; they consist of a fowl and a tray containing bread and grapes.
LOCATION IN THE TOMB: Fifth register of the east wall next to the offering list
MEASUREMENTS: H. 19.5 cm, W. 29 cm

CONDITION: Blackened with smoke; the lower left part of the relief looks deliberately cut.
PROVENANCE: Purchased in 1930; said to be from Luxor. The Walters Art Gallery records show that it is probably derived from Deir el-Bahri.
BIBLIOGRAPHY: G. Steindorff, *Catalogue of the Egyptian Sculpture in the Walters Art Gallery* (Baltimore, 1946) no. 240, p. 72, pl. 40.
COMMENT: The fragment was dated to Dynasty 18 by Steindorff. It joins two other fragments of the east wall recorded by Winlock (neg. no. M4C 294).

22.331 Fragment of the offering procession (Figures 16, 21)

DESCRIPTION: Relief shows two left facing offering bearers. Only the hand of a third bearer, holding a round jar, is visible in the upper right corner. One bearer leads a bull by his far hand, and carries a fowl by its wings in the other. The second bearer clasps a fowl with both arms, while holding three papyrus stems and a lotus bouquet. Both wear short belted kilts and plain wigs that cover their ears. The faces have plastically rounded eyebrows and fully rimmed eyes.
LOCATION IN THE TOMB: Fifth register of the east wall
MEASUREMENTS: H. 19 cm, W. 38 cm
CONDITION: Some chips at the edges and on the surface
PROVENANCE: Purchased in 1931; said to be from Deir el-Bahri
BIBLIOGRAPHY: G. Steindorff, *Catalogue of the Egyptian Sculpture in the Walters Art Gallery* (Baltimore, 1946) p. 73, no. 243, pl. 43.
COMMENT: Steindorff attributed this relief fragment to Dynasty 18. It was recorded by Winlock on the field photograph together with a fragment from the Brooklyn Museum of Art, no. 52.131.17, in 1922 (neg. no. M4C 301).

22.132 Fragment of the head of a priest

DESCRIPTION: Relief fragment of the head and shoulders of a man wearing an elaborate short stepped wig with straight locks on the top. The face has plastically rounded eyebrows, long, slanted fully rimmed eyes with long cosmetic lines, long nose, full lips, and short chin. The iris and pupil are indicated.
LOCATION IN THE TOMB: Fourth register of the east wall below the offering list
MEASUREMENTS: H. 8 cm, W. 9.5 cm
PROVENANCE: Purchased in 1930; said to be from Deir el-Bahri
CONDITION: The edges seems to be deliberately cut, small chips on the surface.
BIBLIOGRAPHY: G. Steindorff, *Catalogue of the Egyptian Sculpture in the Walters Art Gallery* (Baltimore, 1946) no. 251, p. 74, pl. 40.
COMMENT: Steindorff dated the fragment to Dynasty 18.

Brooklyn, New York

Brooklyn Museum of Art

52.131.1–32 and 68.1 (Figures 28, 31, 34, 35, 42, 43, 49)

DESCRIPTION: A section of the west wall shows the remains of three registers: the procession of offering bearers in the bottom register; Abydos pilgrimage in the second register, and offering bearers with the sacred oil in the third register. A section of the east wall shows offering bearers in the bottom register, and a group of mourners in the second register.

LOCATION IN THE TOMB: Central and southern sections of the west and east walls

BIBLIOGRAPHY: *Five Years of Collecting of Egyptian Art: 1951–1956* (New York, 1956) pp. 32–33, no. 35, pls. 56–59; R. Fazzini, et al, *Ancient Egyptian Art in The Brooklyn Museum* (New York, 1989) no. 73.

Cambridge

The Fitzwilliam Museum
University of Cambridge

E.GA.3001.1943 Fragment of the offering procession

DESCRIPTION: The relief shows remnants of a female offering bearer figure. Only the back part of the wig and a semicircular basket with figs is preserved. The inscription on the right part of the fragment says: "grapes of the priest of . . . gardens of the scribe of the temple of"

LOCATION IN THE TOMB: Bottom register of the east wall

MEASUREMENTS: H. 38.5 cm, W. 26.5 cm

CONDITION: Assembled from two pieces; some chips at edges and on the surface

PROVENANCE: Bequest of Gayer-Anderson, 1943

Chicago

Oriental Institute Museum
University of Chicago

OIM 18236 Fragments of the offering and funerary processions (Figures 33, 41)

DESCRIPTION: A section of the east wall shows three registers. The bottom one contains a procession of eight offering bearers facing left: three males and five females. Men wear short kilts and short, horizontally striated wigs. Women wear tripartite wigs and long tight dresses with shoulder knots. All of them support baskets with offerings on their heads. The second register contains figures of seven participants in the funerary procession. The first two wear long kilts, the other five wear short ones. Six of them wear elaborate short curly wigs with straight locks

on the top. The last one wears a shoulder-length plain wig. The first offering bearer carries a long *Stabstrauss*; the second, a chest; the third and fourth, vase stands with vessels for the sacred oil; the fifth, a tray with two statuettes; the sixth, two mummiform statuettes in red crowns; the seventh, two boxes for canopic jars. The third register contains six figures of priests bringing fowl and parts of a bull. They wear short kilts and short curly wigs with straight locks on the top. The northern part of the section shows the remains of the "Opening of the Mouth."

LOCATION IN THE TOMB: Northern part of the east wall

CONDITION: Assembled from thirty-two fragments

PROVENANCE: Acquired from The Metropolitan Museum of Art, 1950

Denver, Colorado

The Denver Art Museum

1949.7 Four fragments with the offering of the animals (Figures 15, 16)

DESCRIPTION: Four blocks showing two offering bearers with animals attached together.

1. The arm of an offering bearer and the back of a bull are shown on this fragment. The inscription above says *mzhd* ("orix").

2. Torsos of the two offering bearers facing left are shown on this fragment. They wear plain kilts and short plain wigs. The first one has a sash across the far shoulder and chest. The second offering bearer carries an antelope on his shoulders. Their faces with fully rimmed eyes, plastic eyebrows and deep nasa-labial furrows are well modeled.

3. The third fragment shows the legs of a bull and of a herdsman, whose legs are well modeled. The muscles and toe nails are indicated.

4. The fourth fragment shows the legs of a second offering bearer and a leg of the man following him. A far leg of the third offering bearer is seen behind a bull or cow which he leads. Only the muzzle and a front leg of the animal is preserved.

An inscription along the lower border of the representation says: . . . *jnpw n ḥm-ḥrw ḥm bꜣw nḫn m ḏd-mdw wbn.f zmꜣ pt r tꜣ* . . . ("... Anubis, for the Horus-priest and priest of the Ba's of Nekhen, reciting: May he rise; may the sky be joined to the earth").

LOCATION IN THE TOMB: The fourth register of the east wall

MEASUREMENTS: H. 41.6 cm, W. 68.6 cm

CONDITION: The second and third blocks were assembled from two fragments. All four blocks have chips at the edges. The neck of the antelope on the second block has modern reconstruction.

PROVENANCE: Acquired from an anonymous donor through an exchange with The Metropolitan Museum of Art, 1949

COMMENT: These four original blocks are installed in the Denver Art Museum with two additional blocks (upper right and upper left) that are modern reconstructions.

Detroit, Michigan

The Detroit Institute of Arts

1993.55 Fragment of the ritual scene (Figure 47)

DESCRIPTION: A relief fragment shows a priest pouring libations from a ritual vessel over the head of a second kneeling priest; only his wig is preserved. Both wear short horizontally striated wigs. The first priest has a narrow, slanted fully rimmed eye, plastic eyebrow, long nose, full lips, and short chin. On the left side of the fragment the outstretched arm of a third priest is visible.
LOCATION IN THE TOMB: Third register of the east wall below an offering list
MEASUREMENTS: H. 16 cm, W. 30 cm
CONDITION: Assembled from four fragments; large chips on the surface
PROVENANCE: Founders Society Purchase, Walter Buhl Ford II Fund, 1993

New York

Miriam and Ira D. Wallach Art Gallery
Office of Art Properties
Columbia University
in the City of New York

COO. 1699. 1a, 1b, 1c Fragments of the offering procession (Figures 16, 17)

DESCRIPTION: The relief shows two male offering bearers facing left. The first one holds a wine jar twined by a vine. The second man carries a piece of meat and a loaf of bread in a basket. Remnants of offerings carried by the third offering bearer are visible on the right side of the block. They consist of a fowl and a bunch of onions in a wide basket. The offering bearers wear short plain kilts and short horizontally striated wigs.
LOCATION IN THE TOMB: Fourth register of the east wall
MEASUREMENTS: H. 35 cm, W. 42 cm
CONDITION: Assembled from three fragments, numerous chips at edges
PROVENANCE: Acquired from The Metropolitan Museum of Art, 1950
COMMENT: The fragment is a copy of the relief from the north wall of the Southern Hall of Offerings in the Hatshepsut Temple at Deir el-Bahri.

COO. 1699. 2a, 2b, 2c, 2d Fragment of the bringing of sacred oil

DESCRIPTION: The remains of two offering bearers bringing vessels with sacred oil can be seen. Only the head of the first offering bearer is preserved. He wears a short, curly, elaborate wig. His face with a fully rimmed eye, plastic eyebrow and long nose is well modeled. He carries a tray with two bags of eye paint on it. Only remnants of the second offering bearer bags are visible. A preliminary drawing of the inscription executed in red paint is seen above them.
LOCATION IN THE TOMB: Fourth register of the east wall
MEASUREMENTS: H. 14 cm, W. 30 cm
CONDITION: Assembled from four pieces; unfinished and executed partly in red paint
PROVENANCE: Acquired from The Metropolitan Museum of Art, 1950
COMMENT: This fragment fits Brooklyn Museum of Art fragment number 52.131.17.

COO. 1699. 3a, 3b Fragment of the offering procession (Figure 16)

DESCRIPTION: The upper part of the offerings carried by the offering bearers facing left. The top of the short striated wig and a plastic eyebrow of the first offering bearer are visible. A large wine jar twined by a lotus flower is seen in front of him. The offerings of the second offering bearer consist of three loaves of bread (one rectangular and two round), a piece of meat, a grape and a bunch of onions. The remains of the inscription is above the representation. It says: . . . n.k z3tw qm3.n.f rnp(t) nb [. . .] (". . . for you the ground; he has created all vegetation . . .").
LOCATION IN THE TOMB: Fourth register of the east wall
MEASUREMENTS: H. 17.5 cm, W. 35 cm
CONDITION: Assembled from two pieces; some chips on the surface
PROVENANCE: Acquired from The Metropolitan Museum of Art, 1950
COMMENT: This fragment, like COO. 1699. 1a, 1b, 1c, is a direct copy from the Hatshepsut Temple at Deir el-Bahri.

New York

Department of Egyptian Art
The Metropolitan Museum of Art

23.3.468 (EP 1) Fragment of the funerary procession

DESCRIPTION: The back part of a male body and three overlapping arms holding a rope are all that now remain from what was probably three male figures dragging a sledge with a coffin or canopic jars. They wear short kilts.

The representation is executed in very low relief, almost without minor details. Only thumb nails are indicated.

LOCATION IN THE TOMB: Second register of the east wall

MEASUREMENTS: H. 13.5 cm, W. 3.4 cm

CONDITION: Assembled from three fragments; two large chips at the edges

PROVENANCE: Excavated by The Metropolitan Museum of Art Egyptian expedition led by H. Winlock in 1922–23

COMMENT: The location of the fragment in the tomb is determined by the representation of three overlapping arms. Funerary procession is the only composition in the tomb where such a group is possible. The similar version of this scene occurs in later Asasif tombs, for example, in that of Iby (K. von Kuhlmann and W. Schenkel, Das *Grab des Ibi*, [Mainz, 1983] pl. 62) and Basa (J. Assmann, Das *Grab des Basa* [Mainz, 1973] pl. 29).

23.3.468 (EP 2) Fragment of the offering procession (Figure 27)

DESCRIPTION: This fragment shows the right shoulder, bent arm, and elaborate curled wig of the male figure facing right. He holds an object with a round top, only a small part of which is visible. The remains of a basket are seen on his head.

LOCATION IN THE TOMB: Bottom register of the west wall

MEASUREMENTS: H. 15.5 cm, W. 4.5 cm

CONDITION: A fragment of a broken block; original edges have not survived.

PROVENANCE: Excavated by The Metropolitan Museum of Art Egyptian expedition led by H. Winlock in 1922–23

COMMENT: The remains of the wide basket for offerings on the head of the man show that this piece is a fragment of a figure from the bottom register. It is the only register in the tomb where the offering bearers carry offerings on their heads according the Old Kingdom tradition. An object with a round top in his near hand might be the remains of the leash of an offering animal.

23.3.468 (EP 3) Fragment of the offering procession (Figure 27)

DESCRIPTION: Only the hip area of the male figure facing right is preserved. A narrow object hangs over his short kilt. The figure is executed in low relief; only one knee is modeled.

LOCATION IN THE TOMB: Bottom register of the west wall

MEASUREMENTS: H. 15 cm, W. at bottom 6.4 cm, W. at top 1 cm

CONDITION: Edges are fractured.

PROVENANCE: Excavated by The Metropolitan Museum of Art Egyptian expedition led by H. Winlock in 1922–23.

COMMENT: It might be assumed that the narrow object hanging over the man's kilt is the long stem of the lotus flower that he hold in his hand. The closest parallel is a female offering bearer with a flower, from the bottom register of the west wall of the tomb of Nespakashuty.

23.3.468 (EP 4) Fragment of a slaughtering scene (Figures 23b, 26

DESCRIPTION: Only a hand holding a bull's leg and a rope is preserved. The fingers are visible and well modeled; nails are indicated. A thumb is the nearest finger to the bull's hoof.

LOCATION IN THE TOMB: Third register of the east wall

MEASUREMENTS: H. 9.5 cm, W. 10 cm

CONDITION: Large chips at edges; the lower left part is deliberately cut.

PROVENANCE: Excavated by The Metropolitan Museum of Art Egyptian expedition led by H. Winlock in 1922–23

COMMENT: At first glance it would seem that the fragment belongs to the offering bearer figure carrying a bull's leg. At the same time, in most cases, only the back of a hand is visible. Some times if fingers of a hand clasping the bull's leg are in full view, the pinkie is the finger nearest to the hoof. The only composition in which this hand position fits is a slaughtering scene.

23.3.468 (EP 5) Fragment of a slaughtering scene (Figures 23b, 25)

DESCRIPTION: The remains of two heads facing opposite are preserved here; they wear elaborate curled wigs with straight locks on the top. A rope loop is seen between them.

LOCATION IN THE TOMB: Third register of the east wall

MEASUREMENTS: H. 10 cm, W. 16 cm

CONDITION: The edges are fractured; chips on the surface.

PROVENANCE: Excavated by The Metropolitan Museum of Art Egyptian expedition led by H. Winlock in 1922–23.

COMMENT: The only three areas in the tomb all on the east wall where wigs of this kind occur are: a group of priests performing offering rituals below the offering list, offering bearers bringing sacred oil in the fourth register, and a slaughtering scene in the third register.

23.3.468 (EP 6) Fragment with a stern of a boat (Figure 27)

DESCRIPTION: The lower part of a male figure standing in the aftercastle is visible. A completely finished large scale elbow and a hand are shown to the right. The figure of a sailor and an aftercastle are left unfinished; only outlines were carved.

LOCATION IN THE TOMB: Second register of the west wall

MEASUREMENTS: H. 15 cm, W. 16, 5 cm

CONDITION: Some chips at edges

PROVENANCE: Excavated by The Metropolitan Museum of Art Egyptian Expedition led by H. Winlock in 1922–23.

23.3.468 (EP 7) Fragment of a male torso (Figure 27)

DESCRIPTION: Only the upper part of the male torso

and two arms are preserved; his far arm was raised.
LOCATION IN THE TOMB: The third register of the west wall
MEASUREMENTS: H. 4 cm, W. 15 cm
CONDITION: Small chips at edges and on the surface
PROVENANCE: Excavated by The Metropolitan Museum of Art Egyptian expedition led by H.Winlock in 1922–23.

23.3.468 Fragment of the offerings

DESCRIPTION: The fragment shows the remains of large-scale offerings: a wine jar entwined by a lotus flower stem with a bud at the end; a lettuce and a fowl with elaborately decorated wings and tail. A register border is visible above the representation.
LOCATION IN THE TOMB: Seventh register of the east wall
MEASUREMENTS: H. 14 cm, W. 35 cm
CONDITION: Small chips at edges; entire surface covered with cellulose nitrate adhesive
PROVENANCE: Excavated by The Metropolitan Museum of Art Egyptian expedition led by H. Winlock in 1922–23
COMMENT: The fragment was on loan to the Touch Collection in the MMA Education Department from 1983 to 1995.

1997.137.4 Fragment of the offering procession (Figures 16, 46)

DESCRIPTION: Relief fragment showing the head and shoulders of a man in a short horizontally striated wig; a tray with a pile of offerings rests on his shoulder.
LOCATION IN THE TOMB: Fifth register on the east wall
MEASUREMENTS: H. 4, 5 cm, W. 9, 7 cm
CONDITION: Assembled from two fragments, small chips at the edges covered with cellulose nitrate adhesive
PROVENANCE: Excavated by The Metropolitan Museum of Art Egyptian expedition led by H. Winlock in 1922–23, deaccessioned in 1948, purchased in 1997 as a Lila Acheson Wallace Gift

1997.137.5 Fragment with a herdsman (Figure 50)

DESCRIPTION: Drawing for relief showing a herdsman with an ibex
LOCATION IN THE TOMB: Fifth register of the west wall
MEASUREMENTS: H. 28 cm, W. 27, 5 cm
CONDITION: Assembled from three fragments; small chips at the edges
PROVENANCE: Excavated by The Metropolitan Museum of Art Egyptian expedition led by H. Winlock in 1922–23, deaccessioned in 1948; purchased in 1997 as a Lila Acheson Wallace Gift
COMMENT: The inscription in red pigment under the representation says: m ḫ3w nbw nḏm ("with every sweet flower").

1997.137.6 Fragment with two offering bearers (Figures 27, 32)

DESCRIPTION: Relief fragment with two female offering bearers
LOCATION IN THE TOMB: Bottom register of the west wall
MEASUREMENTS: H. 45 cm, W. 29, 2 cm
CONDITION: Small chips at the edges
PROVENANCE: Excavated by The Metropolitan Museum of Art Egyptian expedition led by H.Winlock in 1922–23, deaccessioned in 1948; purchased in 1997 as a Lila Acheson Wallace Gift
COMMENT: [n] smr wᶜty imr niwt ṯ3ty Ns-p-ḳ3–šwty ("for the sole companion, mayor, vizier Nespakashuty").

Princeton, New Jersey

The Art Museum, Princeton University

50–127 (EP 1) Fragment of Nespakashuty's chair. (Figures 7, 8)

DESCRIPTION: Raised relief fragment of the lower part of the front leg of Nespakashuty's lion legged chair. Only part of the lion paw standing on the frustrum is preserved. The frustrum is turned up on the wide side. Below the register's border remnants of offerings are seen.
LOCATION IN THE TOMB: Northern part of the east wall
MEASUREMENTS: H. 25.5 cm, W. 11 cm
CONDITION: Some chips at edges
PROVENANCE: Acquired from The Metropolitan Museum of Art, 1950
COMMENT: So far, this is the only fragment found of a representation of the tomb owner; it shows that the figure of Nespakashuty was executed in a much higher relief than all other parts of the tomb decoration.

50–127 (EP 2) Fragment of an offering procession (Figure 16)

DESCRIPTION: Raised relief fragment with the legs of a cow facing left and the feet of two attendants. At the right is a sign n.
LOCATION IN THE TOMB: Bottom register of the west wall
MEASUREMENTS: H. 30 cm, W. 44.5 cm
CONDITION: Some chips at edges and on the surface
PROVENANCE: Acquired from The Metropolitan Museum of Art, 1950
COMMENT: The original position of this fragment in the bottom register of the wall is defined by its lower part. Twenty –five centimeters of surface below the baseline, with the vertical chisel marks, is the lower border of the east and west walls.

50–127 (EP 3) Fragment of an offering procession (Figure 16)

DESCRIPTION: Raised relief fragment of two registers.

The upper register shows a far leg of the offering bearer and an oversized lotus blossom. The lower register shows the remnants of an inscription: only two signs *i* and *mn*, are preserved.

LOCATION IN THE TOMB: Third register of the east wall
MEASUREMENT: H. 20 cm; W. 10 cm
CONDITION: Some chips at edges and on the surface
PROVENANCE: Acquired from The Metropolitan Museum of Art, 1950

50–127 (EP 4) Fragment of an offering procession (Figure 16)

DESCRIPTION: Relief fragment of two registers. The upper one shows the legs of an offering bearer facing right; The lower one contains the remains of the inscription: *ḫtmtj-bjtj smr [wˁtj ḫ]n[tj . . .]*("royal seal bearer, [unique] friend, [foremost of . . .]")
LOCATION IN THE TOMB: Third register of the east wall
MEASUREMENTS: H. 26 cm, W. 31 cm
CONDITION: A large chip on the right side of the lower register
PROVENANCE: Acquired from The Metropolitan Museum of Art, 1950

50–127 (EP 5) Fragment of the offering procession with animals (Figure 16)

DESCRIPTION: A relief fragment shows the foot of an offering bearer and the three legs of the cow with a lead attached to its back leg. A surface below the baseline is left uncurved. The relief is finished except for the right and bottom border lines, which are marked with red paint.
LOCATION IN THE TOMB: Bottom register of the west wall, next to the right border
MEASUREMENTS: H. 25 cm, W. 34 cm
CONDITION: Some chips at edges; vertical chisel marks on the surface, traces of red paint
PROVENANCE: Acquired from The Metropolitan Museum of Art, 1950

50–127 (EP 6) Three relief fragments of the offering procession (Figure 16)

DESCRIPTION: The relief assembled from several pieces shows bits of three figures of offering bearers. Only the torso of the first one is preserved; his near arm is stretched forward. The arm of the second supports a tray with a pile of figs. The far arm of the third holds a bowl with three loaves of bread and a bunch of onions.
LOCATION IN THE TOMB: Third register of the east wall
MEASUREMENTS: H. 13 cm, W, 21.5 cm
CONDITION: The surface of the right part of the fragment is badly damaged.
PROVENANCE: Acquired from The Metropolitan

Museum of Art, 1950
COMMENT: The left fragment is attached to the group in the wrong way. The representation on it was considered as the body of the person carrying figs on the second fragment; as both show the near arms of the offering bearer, they cannot be part of one figure.

50–127 (EP 7) Relief fragment with two offering bearers (Figure 27)

DESCRIPTION: Two female offering bearers facing right. The first one supports a large semicircular bowl with loaves of bread on her head; the second woman carries a basket of berries in her near hand and supports a high basket on her head with her far hand. Between them are remains of the inscription. Only Nespakashuty's name is visible. The remains of the upper register are seen at the top.
LOCATION IN THE TOMB: The bottom register of the west wall
MEASUREMENTS: H. 41 cm, W. 40 cm
CONDITION: Surface is badly damaged; numerous ships on the surface
PROVENANCE: Acquired from The Metropolitan Museum of Art in 1950

50–127 (EP 8) Fragment of offerings

DESCRIPTION: It shows large-scale offerings: remains of two stands with wide baskets. The basket to the left is full of loaves of bread. One more loaf of bread and a bunch of grapes are shown on the right. Relief is shallow with well defined contours and a flat surface. In the representation of grapes each one is carefully curved around.
LOCATION IN THE TOMB: Fifth register of the east wall
MEASUREMENTS: H. 15.5 cm; W. 29.5 cm
CONDITION: Some chips on the edges
PROVENANCE: Acquired from The Metropolitan Museum of Art, 1950
COMMENT: Three upper registers of the east wall that show piles of large-scale offerings were executed by two different sculptors. The treatment of small details such as the style of the representation of a bunch of grapes is important for determining the individual sculptor.

50–127 (EP 9) Fragment of offerings

DESCRIPTION: The upper border of the upper register of the east wall is shown here. The remains of large-scale offerings are seen: a head of lettuce, the upper part of a melon, and a loaf of bread. The offerings are executed in a very low relief.
LOCATION IN THE TOMB: Upper register of the east wall
MEASUREMENTS: H. 10.5 cm, W. 40 cm
CONDITION: Some chips on the edges; some smoke blackening
PROVENANCE: Acquired from The Metropolitan Museum of Art, 1950

NOTES

1. For a list of documents mentioning the Vizier Nespakashuty ("D," according to Kitchen), see K. A. Kitchen, *The Third Intermediate Period in Egypt (1100–650 B.C.)* (Warminster, 1986) pp. 512, 598, 604. To distinguish Nespakashuty from his namesakes, see H. de Meulenaere, "La Famille des viziers Nespamedou et Nespakachouty," *CdÉ* 38 (1963) pp. 71–73, fig. 1; G. Vittmann, *Priester und Beamte* (Vienna, 1978) pp. 3, 91, 144, 149, 154–159, 168, 190, 196–197, 200.

2. It is now known as Brooklyn Oracle Papyrus, no. 47.218.3. See R. A. Parker, *A Saite Oracle Papyrus from Thebes in The Brooklyn Museum* (Providence, 1962) p. 15; Herman de Meulenaere, "Trois Viziers," *CdÉ* 33 (1958) pp. 197–201; E. Russmann, "Relief Decoration in Theban Private Tombs of the Twenty-fifth and Twenty-sixth Dynasties: Its Origins and Development, with particular reference to the tomb of Harwa (TT 37)," Ph.D. diss., New York University (1992) pp. 448–451.

3. Nespakashuty D belonged to a prominent Thinite family who received an office of the vizier that had been held by Mentuemhat's family since the beginning of Dynasty 25. The first member of the family to be appointed vizier was Nespakashuty's grandfather Nespakashuty C, who passed it on to his son Nespamedu, Nespakashuty's father. Nespakashuty D was the third vizier in the family. It has been suggested that "the transfer of the office to a Thinite family was part of an attempt to redistribute power in Upper Egypt as a whole"; see A. Leahy, "Nespamedu, 'King' of Thinis," *GM* 35 (1979) pp. 33–36. H. de M[eulenaere], "Nespamedu," *LÄ* IV (1983) cols. 463–464; H. de Meulenaere, "Notes de prospographie thébaine," *CdÉ* 53 (1978) pp. 229–231.

4. For the color illustrations, see Edna R. Russmann, *Egyptian Sculpture* (Austin, 1989) figs. 82, 83, pp. 179–181. Another known statue of Nespakashuty, composed of two fragments, shows him kneeling with a Hathor sistrum (British Museum, BM 1132 + 1225); see Meulenaere, "La Famille des viziers," pp. 73–76.

5. Diethelm Eigner, *Die monumentalen Grabbauten der Spätzeit in der thebanischen Nekropole* (Vienna, 1984) p. 50, pl. 27B, fig. 26.

6. According to Edna Russmann, "the walls on the north side of the second court and the portico at the west end of the first court were decorated in two variants of Twenty-fifth Dynasty style. The reliefs on the north, south, and east facades of the first court and in the first room can be assigned, on stylistic grounds, to the early Twenty-sixth Dynasty," in E. Russmann, "Relief Decoration in the Tomb of Mentuemhat (TT 34)," *JARCE* 31 (1994) p. 17.

7. James Allen, "Some Theban Officials of the Early Middle Kingdom," *Studies in Honor of William Kelly Simpson* (Boston, 1996) I, p. 20.

8. H. E. Winlock's field notes contain an explanation of this suggestion on p. 6: "The north end of the room above the doorway was bridged by two sandstone slabs. In the room were found a few fragments suggesting a false door, unsculptured. Except for the roll over the door, nothing definite could be identified. We have supposed, however, that this false door was erected on the sandstone slabs at the back of the room."

9. Eigner, *Monumentalen Grabbauten*, p. 50, fig. 26. Winlock suggested that Nespakashuty, "seeing the imposing ruins of the fifteen-hundred-year-old Eleventh Dynasty tombs on the hillside, ordered his engineers to make the like for him." See H. E. Winlock, *Excavations at Deir el Bahri 1911–1931* (New York, 1942) p. 82.

10. James Allen elaborated on this concept in a conversation on Sept. 22, 1997. The examples of the early Middle Kingdom tombs with the attached corridors, he suggested, are the tomb of the Vizier Ipi with the "little tombs of the family and the vassals of the great man quarried out of the rock" and the chancellor Meketra's tomb with the attached tombs of his dependents Intef, Wah, and beside them three tombs of dependents at the sides of the courtyard. See also Winlock, *Excavations*, pp. 19, 29–30, 55, figs. 2, 6.

11. Conversation with Marsha Hill, Aug. 1, 1997.

12. "The tombs of Khety and Henenu lie on either side of MMA 509. The owners of these three tombs were clearly honored with the most favorable position in the row, closest to the king. MMA 509 clearly had the most advantageous position with respect to the royal mortuary temple," from Allen, "Some Theban Officials," pp. 20–21.

13. The temple of Mentuhotep II was regarded as holy up to the end of Dynasty 19. Even though it was used as a quarry after the time of Rameses II, enough remained to discern his location and greatness. The destruction of the temple was presumably stopped by the time of Dynasty 21 when Deir el-Bahri was again used as a necropolis; see E. Naville, *The XIth Dynasty Temple at Deir el-Bahari* (London, 1907) I, p. 16. For the history of the necropolis during the Late Period, see Eigner, *Monumentalen Grabbauten*, pp. 21–28.

14. A. Leahy, "Nespamedu, 'King' of Thinis," *GM* 35 (1979) p. 33. Leahy assumed that a difficult personal relationship with Mentuemhat could be a factor that kept Nespakashuty's family in Thinis.

15. Presumably, he moved to Thebes with his mother, Irterau, who was a chief attendant of the divine consort Nitokris. She was buried in Asasif (TT 390), PM I, 1, pp. 440–441, plan, p. 438.

16. H. E. Winlock, "The Museum's Excavations at Thebes," *MMAB* 18 (1923) II: The Egyptian Expedition, 1922–23, pp. 20–23, 25, figs. 16–17; idem, *Excavations*, pp. 81–83.

17. The drawings were not signed, but their style suggested to Dieter Arnold that they were made by Lindsley F. Hall, who illustrated some of Winlock's publications. For example, see H. Winlock, *Bas-Relief from the Temple of Ramses I at Abydos* (New York, 1921).

18. Acc. no. 23.3.468. Only a few MMA relief fragments are published; see *The Metropolitan Museum of Art Guide* (New York, 1983) no. 44, p. 104.

19. My convention of numbering registers from the bottom to the top is required by the state of the tomb.

20. Acc. no. 52.131.1–32 and 68.1; *Five Years of Collecting Egyptian Art: 1951–1956* (New York, 1956) pp. 32–33, no. 35, pls. 56–59; Richard A. Fazzini et al., *Ancient Egyptian Art in The Brooklyn Museum* (New York, 1989) no. 73; W. S. Smith, *The Art and Architecture of Ancient Egypt* (New Haven, London, 1981) p. 410, fig. 403.

21. Acc. no. 18236; unpublished.

22. Acc. no. 50–127; unpublished. The door has never been installed in the university museum.

23. Presumably, some of the fragments may still be in the tomb, but this could not be ascertained because of the collapse of the ceiling (author's observation, March 1998).

24. The observation of the stone was done by Ann Heywood, associate conservator in the Department of Objects Conservation, MMA.

25. Egyptian Department archives, MMA, neg. no. 140136.

26. Ibid., neg. no. 140135.

27. EP numbers are temporary sub-numbers assigned to the

single fragments inside the acc. nos. MMA 23.3.468 and Princeton University 50–127.

28. See, for example, the wooden panel of Hesira, in Cairo; the stela of Wepemnofret, University of California; the stela of Rahotep, British Museum; the relief from the tomb of Sennuwka, Museum of Fine Arts, Boston: William Stevenson Smith, *A History of Egyptian Sculpture and Painting in the Old Kingdom* (London, 1946) pls. 32, 33, 45.

29. Gerry D. Scott III, *Ancient Egyptian Art at Yale* (New Haven, 1986) no. 77; Jean Leclant, *Montuemhat quatrième prophète d'Amun, prince de la ville* (Cairo, 1961) pl. LXI; Russmann, "Relief Decoration in the Tomb of Mentuemhat (TT 34)," pp. 5, 6; figs. 2b, 3.

30. J. Dümichen, *Grabpalast des Patuamenap in der thebanischen Nekropolis* (Leipzig, 1884) pls. III, V.

31. Ibid., pls. V, XIII.

32. Numerous Old Kingdom representations of tomb owners in a pelt vestment are known. To my knowledge, the first depiction of this garment is found on the Narmer palette; see J. Pirenne, *Histoire de la civilisation de l'Égypte ancienne* (Brussels, 1961) pp. 28, 332. For the Old Kingdom examples, see C. von Vandersleyen, *Das alte Ägypten* (Berlin, 1975) pl. XIX, figs. 245, 246, 276.

33. K. von Kuhlmann and W. Schenkel, *Das Grab des Ibi, Obergutsverwalters der Gottesgemahlin des Amun (thebanisches Grab Nr. 36)* (Mainz, 1983) pl. 49; J. Assmann, *Das Grab des Basa (Nr. 389) in der thebanischen Nekropole* (Mainz, 1973) pl. 9.

34. The clearest example showing the functional character of the shoulder knot is a painted relief from the tomb of Merib in Berlin: *Ägyptisches Museum* (Berlin, 1991) no. 13, p. 23. The stripes and the knot are painted red, which reveals how it was attached to the cloak.

35. The loss of the practical functions by the represented objects of daily life is a characteristic feature of Late Period art; see Elena Pischikova, "Mistakes in the Representation of Objects of Daily Life in Saite Reliefs," *GM* 139 (1994) pp. 69–92.

36. The loss of the practical sense of the knot is illustrated by the representation of Ibi and his wife sitting on a chair; see Kuhlmann and Schenkel, *Grab des Ibi*, pl. 49. The depiction shows a knot tied over the wife's hand as she embraces her husband. However, Old Kingdom parallels show a wife embracing her husband over the knot; see N. Davies, *Rock Tombs of Sheikh Said* (London, 1901), pl. IV.

37. For example, an archaizing stela from the Cleveland Museum of Art, no. 3949.20, was first published as an Old Kingdom stela; see *The Bulletin of The Cleveland Museum of Art* 12 (1925) pp. 145, 147–148. Bernard V. Bothmer republished the stela as the Dynasty 26 relief in Bothmer, *Egyptian Sculpture of the Late Period*, Brooklyn Museum (New York, 1960) no. 24, pl. 22, fig. 50, p. 28. The relief shows a tomb owner sitting before the offering table. He wears a pelt vestment with a knot. As Bothmer noted, "This date is indicated not only by the inscription at the upper right but also by details such as the inverted frustum under the chair legs." The length of the knot and its position on the shoulder can also be used as an indication of the late origin of the piece.

38. There is another depiction of a pelt vestment in the tomb of Nespakashuty, on a priest from a scene of the Abydos Pilgrimage; see R. Fazzini et al., *Ancient Egyptian Art in The Brooklyn Museum*, cat. no. 73. For the later tombs, see Kuhlmann and Schenkel, *Grab des Ibi*, S 112; Assmann, *Grab des Basa*, pl. 27. Royal iconography was based on Old Kingdom prototypes; see R. A. Fazzini, *Egypt Dynasty XXII–XXV* (Leiden/New York, 1988) pl. XL, 1.

39. For an Old Kingdom parallel, see the representation of Ptahhotep in K. Lange and M. Hirmer, *Egypt: Architecture, Sculpture, Painting in Three Thousand Years* (London, 1961) fig. 72.

40. Fragment in situ. Photograph in Egyptian Department archives, MMA, neg. no. M7C 53.

41. For example, see W. K. Simpson, *The Mastabas of Qar and Idu (G 7101 and G 7102)* (Boston, 1976) figs. 22, 23; D. Dunham and W. K. Simpson, *The Mastaba of Queen Meresyankh III (G 7530–7540)* (Boston, 1974) fig. 9; W. K. Simpson, *The Mastabas of Kawab, Khafkhufu I and II (G 7110-20, 7130-40)* (Boston, 1978) fig. 47; idem, *The Offering Chapel of Kaemnofret in the Museum of Fine Arts, Boston* (Boston, 1982) pp. 110–114, pls. C, D.

42. PM (1972) TT 48, p. 88; TT 66, p. 137, TT 78, p. 155, TT 81, p. 162.

43. Russmann, "Relief Decoration in the Tomb of Mentuemhat (TT 34)," figs. 2a, 2b.

44. Dümichen, *Grabpalast des Patuamenap*, pl. IV.

45. Egyptian Department archives, MMA, neg. nos. T 725, T 728.

46. Assmann, *Grab des Basa*, pls. 18, 21, 22.

47. Kuhlmann and Schenkel, *Grab des Ibi*, pls. 51, 54–56.

48. E. Naville, *Temple of Deir el Bahari* IV (London, 1901) pls. 111, 112.

49. G. Robins, *Proportion and Style in Ancient Egyptian Art* (Austin, 1994) pp. 160–165. Following M. Bietak and E. Reiser-Haslauer, Robins mentions that the transition from the old 18-square grid to the new 21-square grid can already be seen in the tomb of Mentuemhat. "If figures of the twenty-fifth and twenty-six dynasties are analyzed on an 18-square grid, we find the proportions are no longer as in the New Kingdom, but that they have reverted to those found in the Old and Middle Kingdoms. In addition, the limbs and shoulder width in the New Kingdom figures tend to be more slender than in the old models. Thus the lengthening of the body above the waist, the shortness of the legs, and the general stockiness result from a reversion to pre-New Kingdom proportions, not from any change of the grids."

50. E. Staehelin, *Untersuchungen zur ägyptischen Tracht im Alten Reich* (Berlin, 1966) pl. XXI, 4.

51. Edna R. Russmann, "Harwa as Precursor of Mentuemhat," *Artibus Aegypti: Studia in Honorem Bernardi V. Bothmer* (Brussels, 1983) pp. 140–141.

52. G. Steindorff, *Catalogue of the Egyptian Sculpture in the Walters Art Gallery* (Baltimore, 1946) cat. nos. 240, 243, 251, pp. 72–74, pls. 40, 43.

53. Egyptian Department archives, MMA, neg. no. M4C 301.

54. For the Hatshepsut offering bearer, see Naville, *Temple of Deir el Bahari*, pl. 112.

55. Egyptian Department archives, MMA, neg. no. M4C 302.

56. Naville, *Temple of Deir el Bahari*, pl. 112.

57. For the more information on the Baltimore fragments, see E. Pischikova, "Four Reliefs from the tomb of Nespakashuty (TT 312) in the Walters Art Gallery," *The Walters Art Gallery Bulletin* (forthcoming).

58. Naville, *Temple of Deir el Bahari*, pl. 107.

59. For the Hatshepsut temple, see Naville, *Temple of Deir el Bahari*, pl. 107. For the tomb of Mentuemhat, see Peter der Manuelian,

Living in the Past: Studies in Archaism of the Egyptian Twenty-six Dynasty (London/New York, 1994) p. 131, fig. 9A.

60. For the New Kingdom tombs see J. Vandier, *Manuel d'archéologie égyptienne* V (Paris, 1969) figs. 130, 134, 136.

61. For the Old Kingdom slaughtering scenes, see W. K. Simpson, *Giza Mastabas* (Boston, 1980) IV, pl. XXI, a, b; idem, *The Mastabas of Kawab, Khafkhufu I and II* (Boston, 1978) fig. 49; Mohamed Saleh, *Three Old-Kingdom Tombs at Thebes* (Mainz, 1977) pl. 10.

62. I am grateful to Dieter Arnold for showing me unpublished drawings of relief fragments from the temple of Mentuhotep II and discussing this question with me. Although the remains of the slaughtering scene from the Dynasty 11 Temple of Mentuhotep Nebhepetre show the Old Kingdom iconographic version with butchers binding a bull, it is questionable that Nespakashuty's sculptors could see it, as the temple was destroyed during the Ramesside period. It is more likely that they saw only private tomb decorations that were influenced by the royal temple. For Middle Kingdom private tombs, see E. Delange, *Catalogue des statues égyptiennes du Moyen Empire (2060–1560 avant J.-C.)* (Paris, 1987).

63. For New Kingdom parallels, see Vandier *Manuel* V, figs. 130, 2; 135.

64. For the Middle Kingdom, see ibid., figs. 90, 95, 108, 6-8. Rare examples from the New Kingdom are also known, see D. J. Brewer, *Domestic Plants and Animals. The Egyptian Origins* (Warminster, 1994) fig. 7.10.

65. J. Assmann in his publication of Basa's tomb mentions that he does not know any parallel to Basa's slaughtering scene. It is understandable because the slaughtering scene from Nespakashuty's tomb was unpublished; see Assmann, *Grab des Basa*, pp. 102–103, pls. 21,1; 22.

66. For the description of the strap knot an its specific shape, see Staehelin, *Untersuchungen zur ägyptischen Tracht*, pp. 166–169, pl. XLIII, fig. 69.

67. Personifications of estates always carry offering containers on their heads and support them with their far arms.

68. For the earliest examples, see reliefs of the Low Temple of the Bent Pyramid at Dashur and reliefs from the mortuary complex of Cheops that were reused in the Dynasty 12 pyramid of Amenemhat I at Lisht, in W. S. Smith, *The Art and Architecture of Ancient Egypt* (London, 1990), p. 77, figs. 68, 68a; p. 99, fig. 93.

69. For the procession of offering bearers in the west portico behind the first court in Mentuemhat's tomb, see P. de Manuelian, "An Essay in Reconstruction: Two Registers from the Tomb of Mentuemhat at Thebes (no. 34)," *MDAIK* 39 (1983) pp. 131–150, pls. 26, 27, 29–31.

70. Although the Old Kingdom examples mostly show female offering bearers, the representation of both female and male bearers in one procession is also known since Dynasty 4. See the cult chamber of the mastaba of Queen Meresankh III in H. W. Müller, *Ägyptische Kunst* (Frankfurt am Main, 1970) p. 31. There is also a second procession with both female and male offering bearers in Chapel E in Mentuemhat's tomb that could have inspired Nespakashuty's sculptors, but it is executed in sunk relief and very different in style and details; see Russmann, "Relief Decoration in the Tomb of Mentuemhat (TT 34)," p. 7, fig. 7.

71. We can discuss only female figures because the leg position of the male figures is unclear.

72. Russmann, "Relief Decoration in the Tomb of Mentuemhat (TT 34)," p. 8, no. 44.

73. For parallels, see the Fertility scene from Sahura Temple at Abysir in Smith, *A History of Egyptian Sculpture*, pl. 53a, nn. 46, 51. Identical knots can occasionally be seen on belts of male private statues; see J. Vandier, *Manuel d'archéologie égyptienne* III (Paris, 1958) pls. XVI, 5; XVII, 5, 6.

74. Smith, *A History of Egyptian Sculpture*, pl. 29. This shoulder knot kept its significance as a feature of the royal garment in the Middle Kingdom; see a relief of Senwosret I with the god Atum in the Cairo Museum in Lange and Hirmer, *Egypt: Architecture, Sculpture, Painting*, fig. 94. It is seen occasionally in the New Kingdom; see the tomb of Sety I in C. Nims, *Thebes of the Pharaohs* (New York, 1965) p. 176.

75. For the tomb of Ti, see G. Steindorff, *Das Grab des Ti* (Leipzig, 1913) pl. 113; for the tomb of Ptahhotep and Akhethotep, see N. de G. Davies, *The Mastaba of Ptahhetep and Akhethetep at Saqqara* (London, 1901) pls. XV, XVI.

76. For a shoulder knot as a feature of male corselet straps and Divine Consorts' dresses, see Dynasty 25 representation of Amun-Re at Karnak in B. de Gryse, *Karnak* (Brussels, 1984) p. 67. For royal images, see a faience plaque of King Iuput from Thebes, ca. 735 B.C., in C. Aldred, *Egyptian Art* (London, 1980) fig. 174, p. 212. For private reliefs, see the representation of Mentuemhat and his wife Shepenmut in Edna Russmann, "Mentuemhat's Kushite Wife (Further Remarks on the Decoration of the Tomb of Mentuemhat, 2)," *JARCE* 34 (1997) p. 23, fig. 1.

77. For the later tombs, see the tomb of Ibi in Kuhlmann and Schenkel, *Grab des Ibi*, pl. 26. It is very possible that in the Old Kingdom the shoulder knot had a ritual symbolic meaning that was forgotten in the Late Period.

78. Brooklyn Museum of Art, 52.131.1–32; see Fazzini et al., *Ancient Egyptian Art in The Brooklyn Museum*, cat. no. 73.

79. Vandier, *Manuel* V, pp. 117–131.

80. See the examples of Syrians bringing tributes in the tomb of Rekhmire (TT 100) in N. de G. Davies, *Painting from the Tomb of Rekhmi-Re at Thebes* (New York, 1935) pls. X, XI, XI, XXII.

81. See, for example, J. Vandier, *Manuel d'archéologie égyptienne* IV (Paris, 1964) fig. 318.

82. D. Redford, *The Akhnaten Temple Project* (Toronto, 1988) p. 14, pl. 7, 1.

83. For the Old Kingdom examples, see Y. Harpur, *Decoration in Egyptian Tombs of the Old Kingdom* (London/New York, 1987) figs. 174, 177, 188, 540. For Dynasty 11, see fragments from the tomb of Neferu in W. K. Simpson, "The Middle Kingdom in Egypt: Some Recent Acquisitions," *Bulletin of the Museum of Fine Arts* 72 (1974) p. 106, fig. 7.

84. Fazzini, *Egypt Dynasty XXII–XXV*, pls. X, 1; XXI, 1; XXVI, XXIX, 1.

85. Oriental Institute Museum, University of Chicago, 18236.

86. V. von Droste, *Der Igel im alten Ägypten* (Hildesheim, 1980) cat. nos. 43–45, pp. 92–93, pl. III, 43.

87. For the tomb of Amenemhet (TT 82), see N. de G. Davies and A. Gardiner, *The Tomb of Amenemhet (No. 82)* (London, 1915) pl. XII; for the tomb of Nebamun, see Vandier, *Manuel* V, p. 1004, fig. 384.

88. For the New Kingdom tombs, see Vandier, *Manuel* V, pp. 957, 1004, fig. 384; Davies and Gardiner, *Tomb of Amenemhet*, pl. XII.

89. For the tomb of Mentuemhat, see H. W. Müller, "Der 'Stadtfurst von Theben' Mentemhet," *Munchener Jahrbuch der bilden-den Kunst* 26 (1975) fig. 11, p. 18. There is no doubt that Mentuemhat's reliefs started the inner necropolis tradition for the representation of the Abydos Pilgrimage; the reliefs in the tombs of Nespakashuty, Ibi, Basa, and Pabasa were influenced by Mentuemhat's tomb.

90. Russmann, "Mentuemhat's Kushite Wife," pp. 25–26, fig. 2.

91. According to the iconography of the composition, Nespakashuty's tomb was included in the so-called Middle Group (*Mittleren Gruppe*) together with Dynasty 18 tombs and the tomb of Ibi of Dynasty 26; see H. A[ltenmuller], *LÄ* I, pp. 42–45. One of the characteristic features of this group, when compared to other Middle Kingdom scenes, is that the representation of a mummy in a ritual boat has been substituted for a statue of the deceased in a naos-shaped shrine.

92. Fazzini et al., *Ancient Egyptian Art in The Brooklyn Museum*, no. 74. According to Fazzini's description, "The register below represents the deceased Vizier and his wife Ketjketj, or statues of them, making mythical voyages to and from Abydos."

93. Kuhlmann and Schenkel, *Grab des Ibi*, p. 195, pl. 65. In n. 1140 Schenkel pointed out the similarity of the representation of the Abydos Pilgrimage in the tombs of Mentuemhat and Ibi. He noted that the representation of a sledge under the statue of the tomb owner on the ritual boat is a unique detail.

94. W. F. Petrie, *Abydos* (London, 1903) II, pl. XXXII, 3.

95. M. Werbrouck, *Les Pleureuses dans L'Égypte ancienne* (Brussels, 1938) p. 103, fig. 57; A. Lhote and J. Vandier, *La Peinture égyptienne* (Paris, 1954) fig. 157.

96. B. L. Goff, *Symbols of Ancient Egypt in the Late Period* (Paris/New York, 1979) p. 103.

97. A. Piankoff, *Mythological Papyri* (New York, 1957), nos. 4, 7, 12, 15, 24, 25. No. 4, Papyrus of Nesi-Khonsu A, shows seven gods of the first seven pylons of the netherworld, illustrating chapters 145 and 146 of the Book of the Dead. No. 7, Papyrus of Tent-diu-Mut, shows four standing mummiform divinities of the netherworld: the first has the feather of Truth for a head, the second has two serpents, the third a cobra, and the fourth is jackal-headed. On No. 12, Papyrus of Bak-en-Mut, eight seated gods of the netherworld are seen above the back of the serpent. No. 15, Papyrus of Ta-udja-Re, shows four gods inside shrines. No. 24, Papyrus of Gaut-Sushen A, depicts four seated gods holding knives. No. 25, Papyrus of Pa-Neb-en-Kemet-Nekht, shows eleven mummiform gods wearing the feathers of Truth on their heads.

98. Ibid., nos. 2, 7, 18. They all show standing or sitting mummiform figures of the four sons of Horus.

99. Ibid., nos. 2, 4, 10, 15, 25. The mummiform figure of Osiris wearing the Atef crown is usually represented with braces on its chest. No. 10, Papyrus of Pa-di-Amon, shows the iconography closest to the Nespakashuty tomb relief: Osiris is represented in a shrine enclosed in a pavilion with an open door.

100. Ibid., nos. 17, 24, 27. No. 17, Papyrus of Khonsu-mes B, shows the mummy of the deceased on a lion-shaped couch. Papyrus no. 27 shows a lotus barge on which a mummy on a draped catafalque lies between two feathers.

101. For the New Kingdom and Late Period images of Osiris on stelae, see, for example, C. Barbotin et al., *Musée Granet. Collection Egyptienne* (Aix-en-Provence, 1995) pp. 50–51, 56–59, 64–71.

102. Assmann, *Grab des Basa*, pp. 119–120, fig. 42, pl. XXIX.

103. Earlier examples of the Abydos Pilgrimage show two major types of chairs: in the New Kingdom the lion-legged chairs with plain vertical short back support without a papyrus flower: for the tombs of Puimre, Kenamun, Amenemhat (TT 82), Nebamun, see Vandier, *Manuel* V, pp. 957, 966, 987, 1004, figs. 368, 369, 380, 384. For the tombs of Kaemhet and Sennofer, see Wreszinski, *Atlas zur altägyptische Kulturgeschichte* (Leipzig, 1923) I, pls. 207, 208, 308. For the Middle Kingdom block-throne, see the tomb of Sehetepibre, see Vandier, *Manuel* V, p. 918, fig. 344, 2.

104. G. Killen, *Ancient Egyptian Furniture* (Warminster, 1980) I, pp. 54–56, figs. 28.3, 28.5. All the illustrated examples date from the Middle Kingdom when they first appear.

105. For example, see the tomb of Nebamun (TT 90) in N. de G. Davies, *The Tomb of Two Officials* (London, 1923) pl. XXI.

106. It might be considered an innovation and a characteristic feature of the seventh-century reliefs. See, for example, the representation of a tomb owner in the tomb of Ibi (TT 36) in Kuhlmann and Schenkel, *Grab des Ibi*, pl. 13. See also Bothmer, *Egyptian Sculpture of the Late Period*, no. 6, p. 7. Bothmer noted: "The later character of the relief is evident from the papyrus blossom, which is much more dainty than the sturdy examples of the Middle Kingdom chairs."

107. A lion-legged chair with a short vertical back without a blossom is in the tomb of Mentuemhat; see Müller, "Der 'Stadtfurst' Mentemhet," fig. 11, p. 18; Russmann, "Mentuemhat's Kushite Wife," p. 25, fig. 2; the same type of chair with a blossom and a block-throne in the tomb of Ibi is in Kuhlmann and Schenkel, *Grab des Ibi*, pl. 65; Pabasa's tomb shows Nespakashuty's type of chair. It is very possible that the Pabasa sculptor was influenced by Nespakashuty's; see Egyptian Department archives, neg. no. T 725.

108. The Mentuemhat reliefs show another type of awning with an architrave and a horizontal roof.

109. This feature was pointed out by Müller in his description of the tomb of Mentuemhat; see Müller, "Der 'Stadtfurst' Mentemhet," p. 19. This motif first appeared in the New Kingdom Dynasty 18 tombs, for example, in the tomb of Sennefer; see Vandier, *Manuel* V, pl. XLV, fig. 361.

110. Müller, "Der 'Stadtfurst' Mentemhet," pp. 31–32, fig. 26.

111. For the Ramesside parallels, see P. Barthelmess, *Der Übergang ins Jenseits in den thebanischen Beamtengräbern der Ramessidenzeit* (Heidelberg, 1992) pls. 3, 4.

112. Describing the characteristic features of the Ramesside type of funerary procession, Davies remarked, "In the Ramesside period, the funerary cortege, consisting only of the mourners accompanying the bier and the bearers of the offerings, moves towards the door of a tomb before which the mummy is set up"; see N. de G. Davies, *The Tomb of Two Sculptors at Thebes* (New York, 1925) p. 39.

113. N. Strudwick, *The Tombs of Amenhotep, Khnummose, and Amenmose at Thebes (nos. 294, 253, and 254)* (Oxford, 1996) p. 75.

114. Davies, *Tomb of Two Sculptors*, p. 39.

115. For example, in the tomb of Kenamun (TT 93) the sandals are shown hanging on the far, banded arm of an offering bearer, who carries a spear in his far hand and a chair in his near hand; see C. K. Wilkinson and M. Hill, *Egyptian Wall Painting. The Metropolitan Museum of Art's Collection of Facsimiles* (New York, 1983) p. 108. In the

tomb of User (TT 21) an offering bearer who carries a chair and weapons does not have sandals; see N. de G. Davies, *Five Theban Tombs* (London, 1913) pl. XXI. There are only two examples of numerous variations of offering bearers with funerary equipment; no two repeat each other.

116. Davies, *Tomb of Two Sculptors*, pl. XXIV.

117. For example, Davies, *Five Theban Tombs*, pl. XXI; N. de G. Davies, *The Tomb of Puyemre at Thebes* (New York, 1922) I, pl. IX.

118. Davies, *Tomb of Two Sculptors*, pl. XIX. The representation of funeral booths in this tomb is different from later tradition; they were rarely found in pre-Ramesside tombs. For the representation of booths in the New Kingdom, see M. A.-Q. Muhammed, *The Development of the Funerary Beliefs and Practices Displayed in the Private Tombs of the New Kingdom at Thebes* (Cairo, 1957) p. 165; G. Martin, *The Memphite Tomb of Horemheb, Commander-in-Chief of Tutankhamun* (London, 1989) p. 192, pl. 124.

119. Müller, "Der 'Stadtfurst' Mentemhet," pp. 31–32, fig. 26.

120. The representation of the mourners in boats reflect mostly the Dynasty 19 tradition; see Werbrouck, *Les Pleureuses*, pp. 32–33, fig. 18; p. 82, fig. 50. Only a few Dynasty 19 examples are known; the first example is in the tomb of Menna (TT 69). Although Mentuemhat's sculptors visited the Menna tomb, they were not inspired by this modest composition of only three mourners, see Vandier, *Manuel* V, pl. XLV, fig. 353, 1.

121. Egyptian Department archives, MMA, neg. nos. T 725, T 732, T 733.

122. Davies and Gardiner, *Tomb of Amenhotep*, cat. no. 82, p. 50, pl. XI.

123. Kuhlmann and Schenkel, *Grab des Ibi*, pl. 65.

124. Naville, *Temple of Deir el Bahari* pl. 110.

125. For Karnak reliefs, see J. Leclant, *Recherches sur les monuments thébains de la XXVᵉ dynastie dite éthiopienne* (Cairo, 1965) pl. 50; for the naoi of Amasis in Louvre D 29 and Leiden AM 107, see J. Beines, "The Destruction of the Pyramid Temple of Sahure," *GM* 4 (1973) pp. 9–14.

126. Baines, *Fecundity Figures*, p. 109.

127. For the Temple of Amenhotep III at Wadi el Sebua, see ibid., p. 162, figs. 100, 101. For the Temple of Ramses III at Karnak, see ibid., p. 324, fig. 184.

128. For Theban tombs TT 138, TT 259, TT 19, TT 31, TT 23, TT 255, TT 159, TT 14, see Barthelmess, *Übergang ins Jenseits*, pls. 3, 4.

129. To my knowledge, representations of male mourners in the tombs of Ankh-ma-hor at Saqqara and Idou at Giza are the only ones dated to the Old Kingdom; see Werbrouck, *Les Pleureuses*, p. 17, fig. 2; p. 134, figs. 76, 77. Reliefs from these two Memphite Dynasty 6 tombs show groups of male mourners wearing short kilts and short wigs. In the New Kingdom male mourners first appear in the tomb of Horemheb at Saqqara, where soldiers are seen lamenting the death of the general; see Martin, *Memphite Tomb of Horemheb*, pl. 125.

130. TT 19, TT 341: Bartelmess, *Übergang ins Jenseits*, pl. 3.

131. For the Cleveland Museum relief no. 51.282, see Manuelian, *Living in the Past*, fig. 3.

132. For the tomb of Pabasa (TT 286), see photographs in the MMA Egyptian Department archives T 725, T 729; for the tomb of Ibi (TT 36), see Kuhlmann and Schenkel, *Grab des Ibi*, pl. 62; for the tomb of Basa (TT 389), see Assmann, *Grab des Basa*, pl. 29.

133. The representation of female mourners as a close group of overlapping figures is known in private reliefs from the beginning of Dynasty 18 and continues into Dynasty 19; see Werbrouck, *Les Pleureuses*, figs. 4, 10, 12, 17; Davies, *Tomb of Two Sculptors*, pl. XXIV; idem, *The Tomb of Nefer-hotep at Thebes* (New York, 1933) I, pp. 28–31. The women are usually shown in pleated dresses knotted at the front.

134. Redford, *Akhnaten Temple Project*, p. 14, pl. 7, 1; Martin, *Memphite Tomb of Horemheb*, fig. 69, pl. 80.

135. For tombs TT 126, TT 123, TT 127, TT 100, see J. Setthast, *Untersuchungen zu altägyptischen Bestattungsdarstellungen* (Hamburg/New York, 1963) pl. 3.

136. For Ibi, see Kuhlmann and Schenkel, *Grab des Ibi*, pls. 63, 64; for Basa, see Assmann, *Grab des Basa*, pl. 29.

137. For the tomb of Neferu, see PM I, 1, pp. 391–393; for the illustration, see Aldred, *Egyptian Art*, fig. 69.

138. See, for example, D. Wildung, *Sesostris und Amenemhet: Ägypten im Mittleren Reich* (Munich, 1984) fig. 60.

139. See, for example, a relief from the reign of Hatshepsut or Tuthmosis III in B. V. Bothmer, *Antiquities from the Collection of Christos G. Bastis* (Mainz, 1988) cat. no. 4, p. 15.

140. The closest parallel is the representation of the ritual procession from the tomb of Neferu; see Scott, *Ancient Egyptian Art at Yale*, cat. no. 26, p. 58; for Dynasty 11 private relief, see W. Hayes, *The Scepter of Egypt* (New York, 1990) I, fig. 101, p. 165.

141. PM I, 1, pp. 391–393.

142. H. E. Winlock called this tunnel "the ancient tourists' passage"; see Winlock, *Excavations at Deir el Bahri*, pp. 102–104.

143. Bothmer, *Antiquities*, no. 15, pp. 44–46.

144. For an example of the Kushite relief with male figures that reflects the Old Kingdom style, see Dynasty 25 reliefs at Karnak in Gryse, *Karnak*, pls. 10, 11.

145. W. J. Darby, P. Ghaliougui, and L. Grivetti, *Food: The Gift of Osiris* (London/New York/San Francisco, 1977) I, pp. 225–228.

146. Harpur, *Decoration in Egyptian Tombs of the Old Kingdom*, fig. 27; Smith, *History of Egyptian Sculpture*, pls. 47, b; 49, a. The relief from tomb G 5110 is the closest parallel known to me.

147. For the Old Kingdom, see Smith, *History of Egyptian Sculpture*, fig. 187; for the Middle Kingdom, see L. Klebs, *Die Reliefs und Malerein des mittleren Reiches* (Heidelberg, 1922) pl. 97; for the New Kingdom, see idem, *Die Relief und Malereien des neuen Reiches* (Heidelberg, 1934) pls. 5–7.

Dendur: The Six-Hundred-Forty-Third Stone

GABRIELE and JOCHEN HALLOF

University of Würzburg

Dedicated to our father and father-in-law Josef Hallof (1926–1998)

AMONG THE EGYPTOLOGICAL COLLECTIONS list-
ed in the *Multilingual Egyptological Thesaurus* is
the Petrological and Oriental Collection of the
Monastery at Banz.[1] Banz is a small village of a little
more than one thousand inhabitants located on the
banks of the river Main, in a wide valley cut by the river
through the Jura Mountains millions of years ago. For
almost eight hundred years, the village was the prop-
erty of the prince-bishops of Bamberg, who founded a
monastery on the hill of Banz in 1114. Between 1698
and 1719 the monastery, which had fallen into disre-
pair, was rebuilt by Leonhard Dientzenhofer
(1660–1707), his brother Johann (1663–1726), and
Balthasar Neumann (1687–1753), creator of the
Würzburg Residence. The present appearance of the
building, whose yellowish sandstone is visible at a con-
siderable distance, dates from this time. Like the great
pilgrimage church of Vierzehnheiligen, also built by
Neumann in the mid-eighteenth century and located
on the opposite (southern) bank of the river Main, the
monastery can be said to be a pearl of the Frankish
Baroque.

The Banz monastery was secularized in 1803, and
eleven years later it was purchased by Duke Wilhelm of
Bavaria as his summer residence. During this time its
petrological collection was founded, with fossils that
had been discovered on the slopes of the Main valley
in the immediate vicinity of Banz. The Banz Oriental
Collection, however, was assembled decades later by
Duke Maximilian of Bavaria (1808–1888), grandson
of Duke Wilhelm of Bavaria and father of Empress
Elisabeth of Austria (1837–1898), during his 1838
voyage to the Middle East.

Maximilian undertook that voyage following the
deaths of his grandfather Wilhelm and his father, Duke
Pius August von Birkenfeld-Gelnhausen (1786–1837)
in an effort to forget his personal grief.[2] He tried to
travel incognito under the name Banz but was only
partly successful.[3] The duke was accompanied by

Friedrich Carl, Baron von Busek (1801–1866); his
brother Carl Theodor, Baron von Busek (1803–
1860)[4]; Captain Theodor Hügler, a "court-gentleman"
of Heusler; his private physician, Dr. Baier;[5] the com-
poser Johann Petzmaier (1803–1884); and the court-
painter Heinrich von Mayr (1806–1871).

The travelers began their journey on New Year's Day
1838. Starting by coach in Munich, they proceeded
through Innsbruck and the Brenner Pass to Verona.
There they changed to a mailboat, which brought the
duke's party via Venice, Trieste, and Corfu to Alexan-
dria. From there they drove on nonstop to Cairo, where
three *dahabiyas* (sailing houseboats) were waiting to
serve as their home for the next few months. Equipped
with the necessary *firmans* (official permits) granted by
the viceroy Muhammad Ali (1769–1894), the party
reached the southernmost point of their trip, the
Second Cataract of the Nile, two months later. Maxi-
milian remarked in his report with pride that he was the
first Bavarian to set foot on the stones of Abu Sir.[6]

On the way back to Cairo the party witnessed the
opening of a tomb. Unfortunately, it is not evident
from the duke's report whether the mummy in the col-
lection at Banz came from this "excavation." From
Cairo the duke visited Christian holy places in Syria,
purchased four slaves (whom he later baptized in
Bavaria), and returned with his traveling party via
Malta and Naples to Munich, where he arrived on
September 17, 1838.

Two of the travelers published accounts of their
experiences and impressions: Duke Maximilian[7] and
Heinrich von Mayr.[8] Carl Theodor, Baron von Busek,
painted a number of watercolors on the trip, only
recently published (see note 4). In none of these
reports, however, is there any information about the
souvenirs and curiosities collected during the trip—
the mummy of a young woman, three mummies'
heads, various animal mummies, shawabtis, stones,
and stone fragments—which are housed today in the
Banz Petrological and Oriental Collection. It is there-
fore impossible to know who collected the objects and
under what circumstances they were purchased.[9] For

METROPOLITAN MUSEUM JOURNAL 33

The notes for this article begin on page 107.

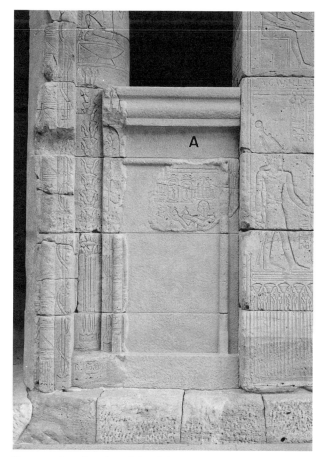

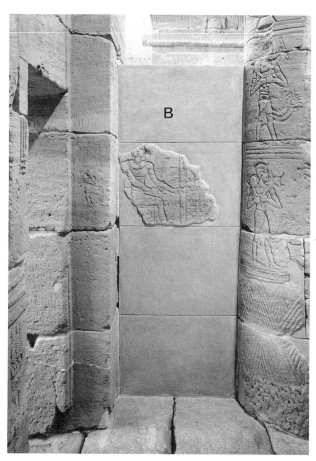

Figure 1. Exterior view of the right screen wall of the temple of Dendur in the Sackler Wing, showing the position of the newly discovered block (A). Early Roman Period, ca. 15 B.C. Aeolian sandstone, length of gateway and temple 25 m. The Metropolitan Museum of Art, Given to the United States by Egypt in 1965, awarded to The Metropolitan Museum of Art, 1967, and installed in the Sackler Wing in 1978, 68.154

Figure 2. Interior view of the right screen wall of the temple of Dendur showing the position of the newly discovered block (B)

an appropriate presentation, a room "in the oriental style" (probably pseudo-Egyptian) was installed by the duke in the Banz monastery. Today visitors can still admire the collection surrounded by furniture of the mid-nineteenth century, as well as by old prints and the original wallpaper. Even the handwritten labels of the last century are still there, although they do not give the kind of information modern visitors like to have.

Among the curiosities on display is a block of reddish sandstone, which attracts the visitor's attention because of its size (42 cm high by 53 cm wide). On its front a frieze of ten rearing uraei with sun-disks on their heads (17 cm high) can be seen in raised relief.[10] They are shown above stylized palm fronds, which form the cavetto. The right border of the palm fronds is flanked by a cobra wearing a red crown and sitting on top of a papyrus umbel, looking left.

The back of the block, which was carved in sunk relief, shows at its top the left half of a winged sun-disk.[11] Below the sun-disk are two cartouches with the king's title:

nswt-biti nb t3wi PR-ʿ3, z3 rʿ nb hʿw PR-ʿ3 "King of Upper and Lower Egypt, Lord of the Two Lands, 'Pharaoh,' Son of Re, Lord of Diadems 'Pharaoh.'"

The king identified by this title must have stood to the right, probably presenting an offering to a god facing him since the Atef-crown of this god is shown on the left and the god's name is given in two columns of text engraved in front of him:

(1) *dd-mdw (j)n wsjr hsy ʿ3 m [...]* (2) *p-dj-jst z3 qwpr [...]*
(1) "Recitation by the Osiris, the highly praised one in [...], (2) Pedesi, son of Kuper [...]."

This information makes it possible for us to know with certainty the provenance of this block and even its precise original location.

- Material (reddish sandstone) indicates that the block must derive from the Nubian area.
- The contents (a ritual scene) tell us that the block was part of a temple.
- The inscription with the name of the god Pedesi restricts the possible provenance of the block to a single monument, the temple of Dendur, since the god Pedesi is known only from this temple.[12]
- As the symbol of Lower Egypt, the uraeus with the red crown is found on the northern part of the temple. For the axis of Dendur this means the right side of a relief-decorated architectural element.[13] The orientation of the snake to the left further limits the possible placement of the block to the right border of a wall.
- This wall must have had an upper border in the form of a cavetto with a frieze of uraei above it. Cavettos can be found in temples on pylons, roofs, and screen walls.[14] Of these elements in the temple of Dendur, only the two screen walls of the temple facade are not intact. The block in Banz must belong to this incomplete section.
- Since the snake with the red crown is preserved on the left (southern) screen wall, the block must belong to the other, right (northern) screen wall.

From these data the block in the Banz Petrological and Oriental Collection can be identified as the right upper border block of the right screen wall of the temple of Dendur.

The temple of Dendur was erected by the Roman emperor Augustus (63 B.C.–A.D.14) and dedicated to the local gods Pedesi and Pihor. For unknown reasons the decoration of the monument was never finished.

Several travelers in the last century produced views of the temple (e.g., Norden in 1737,[15] Legh in 1816,[16] and Roberts in 1838[17]). These views do not show the screen wall intact, either to the left or to the right of the entrance to the pronaos, but they do record a heap of blocks lying between the entrance of the temple and its pylon.[18] A. M. Blackman published the complete temple as part of the survey of the documentation of Nubian antiquities threatened with flooding by the raising of the old Aswan dam, which took place between 1907 and 1912. On plate 33 of his publication, Blackman illustrates a fragment that he assigned

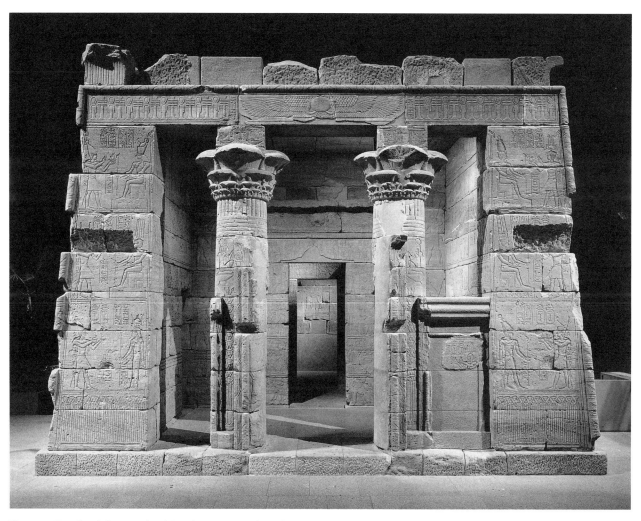

Figure 3. Facade of the temple of Dendur as restored in The Metropolitan Museum of Art before the discovery of the missing block of the right screen wall

provisionally to the southern screen wall, but he gives no information about the provenance of this block.[19] Most likely it was found in front of the temple entrance as debris was being cleared away from the space between the court and the pylon during the photographic documentation of the temple, as one can see on Blackman's plates 31 and 32.

Blackman's fragment was set in the right screen wall during the reconstruction of the temple by the Centre d'Études et de Documentation sur l'Ancienne Égypte, after the temple was rescued in 1962 from the new threat of flooding created by the construction of the High Dam, which had begun in 1960.[20] The stone at Banz can be placed directly above this block, and the northern (right) screen wall can now be fully reconstructed. It consisted of four courses, with a total height of 1.83 meters and a width of 72 centimeters. On the outside the pharaoh is shown offering wine to Pedesi or Pihor, and above this scene is a cavetto with a frieze of uraei. Unfortunately, the newly discovered

block at Banz does not contribute to the identification of the god.

On the inside wall, however, it is now possible to identify clearly the actors of the ritual scene. The king stands in front of the seated god Pedesi and presents flowers to him. This action is described by the line of text in front of the king, in which he addresses the following words to the god:

ḥnk.j n.k zšn nb pr ᵓmᵓ tȝ "I offer you every lotus flower that emerges (from) the earth."

106

Above the scene is the winged sun-disk, whose span can be calculated as 72 centimeters, which is exactly the width of the screen wall.

Pedesi's headdress—Atef crown with uraeus on a short wig—appears several times in the Dendur temple.[22] The inscription in front of Pedesi can be completed on the basis of parallels as follows:[23]

(1) *dd-mdw (j)n wsjr ḥsy ꜥꜣ m-[ḥnw ḥrt-ntr]* (2) *p-dj-jst zꜣ qwpr [mꜣꜥ ḫrw]* [24] (1) "Recitation by the Osiris, the highly praised one in [the necropolis], (2) Pedesi, son of Kuper, [justified]."

The traveling party of Duke Maximilian visited the ruins of the temple of Dendur twice: on March 21, 1838, and on April 3, 1838. In both cases the block was not mentioned in the duke's brief diary-style reports. Under March 21 is the following entry:[25] "The night of this day we spent close to the temple of Meroe,[26] which I just had enough time to visit since the sun had just set. The remains are not very big. The drawings on the wall in pretty good condition. We were right on the Tropic of Cancer." Even shorter is the entry for April 3: "In the evening I visited again the temple of Meroe." Nevertheless, this was probably the day on which the Banz block began its journey to Europe.

To visit the temple today requires a trip to New York City, where the temple has been re-erected in the Sackler Wing of The Metropolitan Museum of Art. The temple was offered as a gift to the United States of America by the goverment of the Arab Republic of Egypt in 1965, and three years later, 642 blocks were shipped from Nubia to New York. More than a century earlier the six-hundred-forty-third block had already traveled in a more or less informal fashion to a small village in Germany, where it passed unnoticed in a curiosity cabinet until now.

NOTES

1. Dirk van der Plas, ed., *Multilingual Egyptological Thesaurus*, PIREI 11 (Utrecht, 1996) p. 18.

2. "Maximilian, Herzog in Baiern," *Allgemeine Deutsche Biographie* 52 (1906) pp. 258–270.

3. Aloys Dreyer, *Herzog Maximilian in Bayern, der erlauchte Freund und Förderer des Zitherspiels und der Gebirgspoesie* (Munich, 1909) p. 18.

4. See *Eine Reise nach dem Orient mit Herzog Max in Bayern 1838 und weitere Reisen des Freiherrn Carl Theodor von Busek (1803–1860)*, exh. cat., Kunstkabinett Dagmar Fleischmann (Munich, n.d.) pp. 7–12.

5. Baier was the only member of the traveling party who did not return home. He died in Syria.

6. Herzog Maximilian in Bayern, *Wanderungen nach dem Orient im Jahre 1838* (Munich, 1839) p. 133. This event took place on March 3, 1838.

7. Ibid. This entertaining and exciting traveler's report went through several editions. The description of the pharaonic monuments, however, plays only a minor role in it.

8. Heinrich von Mayr, *Malerische Ansichten aus dem Orient, gesammelt auf der Reise Seiner Hoheit des Herrn Herzogs Maximilian in Bayern im Jahre MDCCCXXXVIII, herausgegeben und Ihrer königlichen Hoheit der Frau Herzogin Louise in Bayern in tiefster Ehrfurcht gewidmet von Heinr. v. Mayr* (Munich, n.d.). This publication reproduces the watercolors of Mayr accompanied by short discussion. Both travelers' reports may be added to those included in the book of Martin R. Kalfatovic, *Nile Notes of a Howaddji: A Bibliography of Travelers' Tales from Egypt, from the Earliest Time to 1918* (London, 1992).

9. It is possible that the initiative came from Heinrich von Mayr, who designed an oriental kiosk after his return to Bavaria and equipped it with fabrics, tools, and ethnographical objects of all kinds from his private collection: see "Heinrich von Mayr," *Allgemeine Deutsche Bibliographie* 21 (repr. Berlin, 1970) p. 140. The kiosk was later purchased from the king of Württemberg for the "Wilhelma," his summer residence in Stuttgart.

10. Bernhard Kästle, *Petrefaktensammlung Kloster Banz. Versteinerungen und Orientalische Sammlung*, Bayerische Museen 17 (Munich/Zurich, 1992) p. 79, fig. 1.

11. Ibid., p. 79, fig. 2.

12. We owe this information to the database of more than 8,500 ritual scenes of the Greco-Roman Period, established under the direction of Professor Beinlich at the University of Würzburg.

13. See Dieter Arnold, *Die Tempel Ägyptens. Götterwohnungen, Kultstätten, Baudenkmäler* (Zurich, 1992) p. 42.

14. Ibid., pp. 15–16, 61–62.

15. Hassan El-Achirie, *Le temple de Dandour I. Architecture*, Centre d'Études et de Documentation sur l'Ancienne Égypte. Collection Scientifique (Cairo, 1972) pl. 28.

16. Ibid., frontis.

17. *Ägypten gestern und heute. Lithographien und Reisetagebuch von David Roberts* (Erlangen, 1996) pp. 56–57.

18. This accumulation of blocks can best be seen in Norden's drawing: El-Achirie, *Le temple de Dandour* I, pl. 28.

19. Alyward Manley Blackman, *The Temple of Dendûr*, Les temples immergés de la Nubie (Cairo, 1911) p. 21 and pl. 33.

20. F. Ibrahim and Christian Leblanc, *Le temple de Dandour* III. *Planches photographiques et indices*, Centre d'Études et de Documentation sur l'Ancienne Égypte. Collection Scientifique (Cairo, 1975) pl. 30.

21. This reading after *Valeurs phonétiques des signes hiéroglyphiques d'époque gréco-romaine* (Montpellier, 1988) p. 403, nos. 183–185.

22. This headdress was most probably characteristic for Pedesi: M. Aly et al., *Le temple de Dandour* II. *Dessins*, Centre d'Études et de Documentation sur l'Ancienne Égypte. Collection Scientifique (Cairo, 1979) pls. 37, 44, 50, 62, 67; see also pls. 7 and 65, where Pedesi is depicted without the ceremonial beard.

23. Blackman, *The Temple of Dendûr*, pp. 83, 92–93. For a possible restoration of the hieroglyphs, see Aly et al., *Le temple de Dandour* II, pl. 67. The restoration is relatively sure: only in this parallel are Pedesi's name and title written in such a way that the second line of text begins with the name, *pꜣ-dj-jst* as it does on the block at Banz.

24. The bottom of the *ḫrw*-sign can be seen on the fragment of

107

the screen wall: see Blackman, *The Temple of Dendûr*, pl. 33, 1.

25. Herzog Maximilian in Bayern, *Wanderungen*, p. 120.

26. This confusing name, which has nothing to do with the Sudanese site of Meroe, can also be found in the report of traveler Anton Prokesch-Osten, who called Dendur "Grab-Meroe": *Das Land zwischen den Katarakten des Nil, mit einer Karte, astronomisch bestimmt und aufgenommen im Jahre 1827 von A. Prokesch Ritter von Osten, k. k. Major* (Vienna, 1831) p. 102.

.

Silver-and-Gold Moche Artifacts from Loma Negra, Peru

DEBORAH SCHORSCH

Associate Conservator, Sherman Fairchild Center for Objects Conservation,
The Metropolitan Museum of Art

INTRODUCTION

COMPOSITE SILVER-AND-GOLD ORNAMENTS are known from various cultures throughout the ancient world; no culture in the Americas, however, appears to have indulged a taste for this visual, and presumably symbolic, juxtaposition as frequently as the Moche of northern Peru (ca. A.D. 100–800) (Figure 1). The emergence of a large corpus of Moche metallic artifacts in the last three decades has allowed archaeologists as well as historians of art and technology to recognize the Moche culture as the source of some of the most sophisticated metalwork ever produced in ancient America.[1] The particularly rich collection of Moche metalwork from Loma Negra in The Metropolitan Museum of Art serves as a fine starting point for investigations into the technical ingenuity that the Moche applied to the manufacture of these composite precious-metal ornaments.

The exploitation of metal in Peru had its very modest beginnings in the Initial Period.[2] The Early Horizon that followed was a period of pan-Andean unity based in part on what may have been the propagation of a religious cult identified with Chavín de Huántar, a major archaeological site in the northern highlands of Peru. Metalwork was still relatively rare during this period, and the extant artifacts are almost exclusively of gold. While Early Horizon objects entirely of silver are almost unknown, there are a few Chavín silver-and-gold pieces. The subsequent Early Intermediate Period, which is characterized by the development of regional cultures, witnessed the rise of the Moche people and their innovative metalworking practices. During the Early Intermediate Period the frequency and size of gold objects increased dramatically, and silver as well as copper came into widespread use.[3]

The consistent exploitation of silver in ancient Peru has been traditionally associated with the Chimú, a north coast culture centered in the Moche Valley in the Late Intermediate Period, but this outdated perception was based both on the misattribution of known artifacts and on the lack of metalwork dating to earlier periods. For example, many of the silver, or partly silver, objects formerly described as Chimú are now attributed to the Lambayeque culture (also called Sicán), which established itself in the valley of that name during the Middle Horizon. Other silver objects can be recognized as Vicús, a culture nearly contemporary to the Moche. Accidents of preservation and discovery can skew the archaeological record: in a review of the state of Peruvian archaeology in 1942

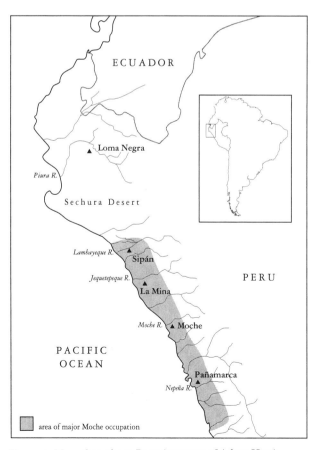

Figure 1. Map of northern Peru (courtesy of Adam Hart)

The notes for this article begin on page 132.

Figure 2. Nose ornament, Moche, from Loma Negra, Peru. Silver, W. 22 cm. The Metropolitan Museum of Art, The Michael C. Rockefeller Memorial Collection, Gift of Hugh Smith, by exchange, 1970, 1978.412.243

Alfred Kroeber wrote that contrary to popular opinion silver was used by the Moche but stated his belief that early silver was rare.[4] A few years later, in a chart summarizing the development of metallurgy in northern Peru, Samuel Lothrop described silver as present but rare in Chavín, Gallinazo, and Mochica (Moche) contexts.[5] As mentioned earlier, artifacts entirely of silver attributed to the Early Horizon Chavín culture are almost unknown, although there are a few examples of silver-and-gold composite pieces. Early Horizon metalworkers also used silver as an alloying metal: there are Chavín silver-based ternary alloys, where the three components are gold, silver and copper, which were used for solder,[6] and other man-made gold-based ternary alloys were employed for the fabrication of metal sheet.

Discoveries of the last forty years, having significantly increased the number of silver or partially silver artifacts that can be attributed to the Vicús and Moche cultures, demonstrate that the use of silver was so not uncommon in the Early Intermediate Period. An abundance of silver objects was recently found at a Moche site at Sipán.[7] In addition to the solid-silver-sheet nose ornaments from Loma Negra (see MMA 1978.412.243; Figure 2), a considerable number of artifacts from Loma Negra were made from silvered-copper sheet.[8] Again, one may mention the use by the Moche of ternary silver-based and intentionally alloyed ternary gold-based solders, as well as the intentional alloying of binary (gold-silver) alloys and ternary alloys (gold-silver-copper), the former for gilding copper substrates and the latter for use as sheet metal.

LOMA NEGRA AND THE DISCOVERY OF MOCHE METALWORK

The first opportunity to observe the enormous productivity and high level of expertise achieved by Moche metalworkers came in the late 1960s when tomb robbers discovered and looted a rich burial site that came to be known as Loma Negra, in the Vicús region of the Piura Valley on the far north coast of Peru (Figure 1).[9] During the early 1960s this area had been the focus of widespread illegal digging, and study of the objects recovered, supplemented by information gathered in professional salvage operations, led to the recognition of the Vicús culture.[10] Indigenous to the Piura River valley, the Vicús culture has been dated to the first half of the Early Intermediate Period.[11] Hundreds of artifacts recovered in the Vicús region, however, are attributed to the Moche, a people who flourished in the fertile river valleys far to the south on the other side of the inhospitable Sechura Desert, from about A.D. 100 to 800. The intensive agricultural activity undertaken by the Moche supported a highly stratified society with widespread commercial contacts.[12] Still, the discovery of Moche artifacts on the north side of the desert, far from the Moche cultural sphere as it was then defined, raised many questions. The relationships between the local Vicús culture and this Moche "outpost," and between the Piura Valley sites and Moche culture as a whole, have been considered by various scholars, but much remains to be clarified.[13]

In the early 1970s a project to document the Loma Negra material was undertaken at the former Museum of Primitive Art in New York. At that time hundreds of objects attributed to Loma Negra were catalogued by Anne-Louise Schaffer, under the supervision of Julie Jones, at that time curator of Precolumbian Art.[14] Subsequently, the Museum of Primitive Art was closed, and in 1978 and 1979 its collections, along with the Loma Negra Archive, were transferred to the Metropolitan Museum, where they are now housed in its Department of the Arts of Africa, Oceania, and the Americas.

The objects included in the Loma Negra Archive are almost exclusively metal, and nearly all were fashioned from hammered sheet, rather than cast.[15] The large number of metal objects relative to ceramic finds was noted by Hans-Dietrich Disselhoff as typical of the Vicús region,[16] but subsequent discoveries suggest that this may not be the case. When the archive was assembled, relatively few examples of other Moche works of art in metal were known, and archaeologists and art historians were perplexed by the new finds.[17] Not only were there no obvious parallels for certain individual

objects or types of objects, the sheer number of metal finds from a single context was overwhelming and difficult to explain.[18] Scholars were uncertain as to what type of site Loma Negra could represent because extremely metal-rich individual burials in the Andean region were largely unpublished.

Recent excavations in the Lambayeque Valley at Sipán, and the discovery of a rich Moche tomb in the Jequetepeque Valley at a site called La Mina, are providing analogous finds in terms of typology, style, quality, quantity, methods of manufacture, and context.[19] In 1987 attention was drawn to a cluster of eroded adobe pyramids at Sipán known as Huaca Rajada, when a number of high-quality Moche artifacts began to appear on the Peruvian art market. At the site it was discovered that grave robbers had penetrated and looted part of the burial of a high-status Moche male. Under the direction of Walter Alva of the Bruning Museum in the town of Lambayeque, the site has been the focus of ongoing scientific excavations and other significant tombs have been discovered.[20]

One year after the looting of the Sipán burial, grave robbers located an isolated elite tomb about fifty miles to the south at La Mina, near the site of Pacatnamú in the Jequetepeque Valley.[21] While the tomb was subsequently located and a salvage excavation undertaken, nearly all the precious-metal artifacts and sumptuous ceramics had already been removed.[22] These new discoveries led to a reevaluation of the Loma Negra corpus, and in 1992 an exhibition entitled "Loma Negra—A Peruvian Lord's Tomb" was presented in The Metropolitan Museum of Art.[23] Although their deposition context is lost, the Loma Negra artifacts can now be recognized as the grave goods of high-status Moche individuals buried in the Piura Valley.[24] The colloquium/workshop "Andean Royal Tombs, Works of Art in Metal,"organized in conjunction with the exhibition, elicited further thought and discussion about Moche metalwork from Loma Negra, Sipán, and La Mina.

Between 1979 and 1987 approximately four hundred artifacts documented in the Loma Negra Archive entered the collections of the Metropolitan Museum.[25] Among these objects are a sizable group made from unalloyed copper, including "crescents"[26] and a variety of relief plaques. Most of the artifacts—including personal ornaments, small figures of animals (particularly insects and crustaceans), disk ornaments, anthropomorphic and zoomorphic standards, and numerous relief plaques in a great variety of shapes—were made from gilded- or silvered-copper sheet. There are also more than twenty objects or fragments of objects, including plain and embellished nose ornaments, earflares, and flat or three-dimensional ornaments for attachment to substrates of other metals, that were made from solid gold sheet. A group of gold nose ornaments and two small gold figures (Figure 3) that were probably not manufactured locally are also associated with the finds.[27]

There are also a number of silver objects, primarily nose ornaments (Figure 2), known from Loma Negra. It is, however, the artifacts that combine silver and gold components or silver and gold surfaces using a variety of mechanical and metallurgical processes that constitute the most striking finds from Loma Negra, Sipán, and La Mina. The composite objects from Loma Negra that combine gold and silver sheet rather than gilded or silvered surfaces are limited to nose ornaments and

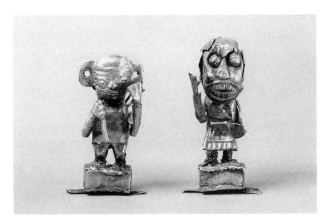

Figure 3. Anthropomorphic figures, from Loma Negra, Peru. Gold, H. 3.8 and 4.2 cm. The Metropolitan Museum of Art, The Michael C. Rockefeller Memorial Collection, Bequest of Nelson A. Rockefeller, 1979, 1979.206.1341,1342

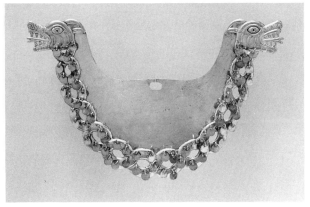

Figure 4. Nose ornament, Moche, from Loma Negra, Peru. Silver and gold, W. 20.8 cm. The upper portion of this ornament is silver sheet; the lower *ajouré* relief band is gold. The Metropolitan Museum of Art, The Michael C. Rockefeller Memorial Collection, Bequest of Nelson A. Rockefeller, 1979, 1979.206.1225

earflares (Figures 4–12), but additional types of artifacts that combine solid precious-metal sheets are known from Sipán and La Mina. Relative to the number of composite silver-and-gold objects of Moche manufacture, much effort went into developing methods used for combining the two metals. Several of these processes were already in use in Chavín times and many were employed simultaneously, if less frequently, by Vicús metalworkers; yet the innovative metallurgy of the Moche far exceeded the legacy they inherited, just as many of their technological innovations were not incorporated into the metalworking traditions of subsequent Andean cultures. Later Peruvian cultures continued to express an interest in the juxtaposition of gold and silver but none appears to have pursued this goal with the refinement and resourcefulness displayed by the Moche.

Two mechanical and three metallurgical methods were employed in the manufacture of composite works from Loma Negra in the Metropolitan Museum (see Appendix).[28] Three of these methods, and two additional ones, were observed on objects from Sipán. Most of these seven techniques appear to have been used in the manufacture of the objects from La Mina and possibly an eighth as well. Another method of combining gold and silver was used in the manufacture of an unprovenanced Moche nose ornament in the American Museum of Natural History, New York, and yet another method can be observed on an unprovenanced silver-and-gold figure of a llama in the Museo del Banco Wiese in Lima.[29] In some instances a combination of mechanical and metallurgical processes were used on a single artifact.

The research presented here is based on detailed technical examinations of thirteen composite objects from Loma Negra in the Metropolitan Museum.[30] The work was carried out in conjunction with an ongoing study of the Loma Negra corpus currently under way in the Sherman Fairchild Center for Objects Conservation.[31] The project was begun by Ellen Howe, initially in preparation for the Loma Negra exhibition and the colloquium/workshop "Andean Royal Tombs, Works of Art in Metal." Moreover, several unprovenanced Moche composite objects, and those attributed to other ancient Peruvian cultures, in the collections of the Metropolitan Museum, the American Museum of Natural History, New York, the National Museum of the American Indian, New York and Washington, D.C., and Dumbarton Oaks Research Library and Collections, Washington, D.C., were included in this investigation.

These objects, as well as two nose ornaments attributed to La Mina in a private collection, were examined under magnification and radiographed. Polished sections of joins were studied using a metallographic microscope, and elemental analysis of the sections and of microsamples were carried out using an energy-dispersive x-ray spectrometer attached to a scanning electron microscope (EDS/SEM).[32] Two of these sections were also analyzed using wave-dispersive x-ray spectroscopy (WDS) in conjunction with an electron microprobe.[33] In addition, a significant number of composite silver-and-gold objects from Sipán were examined under magnification.

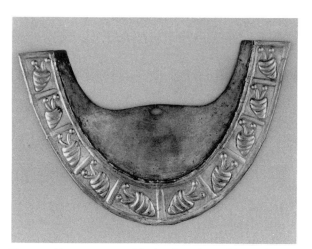

Figure 5. Nose ornament, Moche, from Loma Negra, Peru. Silver and gold, W. 19.9 cm. The upper portion of this ornament is silver sheet; the lower relief band is gold. The Metropolitan Museum of Art, The Michael C. Rockefeller Memorial Collection, Bequest of Nelson A. Rockefeller, 1979, 1979.206.1228 (photo: author)

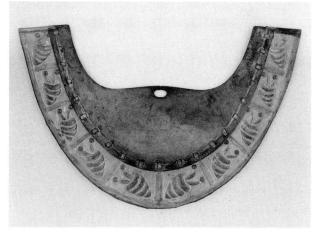

Figure 6. Reverse of silver-and-gold nose ornament in Figure 5, showing staples used for mechanical attachment (photo: author)

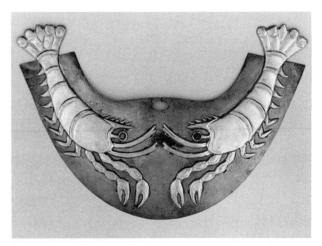

Figure 7. Nose ornament, Moche, from Loma Negra, Peru. Silver and gold, W. 18.7 cm. The ornament overall is silver sheet; the applied crayfish are gold. The Metropolitan Museum of Art, The Michael C. Rockefeller Memorial Collection, Bequest of Nelson A. Rockefeller, 1979, 1979.206.1236 (photo: author)

Figure 8. Reverse of silver-and-gold nose ornament in Figure 7, showing staples used for mechanical attachment (photo: author)

MECHANICAL JOINING METHODS

In ancient times metal joins were executed using mechanical, adhesive, or metallurgical methods. Mechanical joins are those where interlocking metal components are held in close physical proximity.[34] The largest number of composite silver-and-gold artifacts from Loma Negra were joined mechanically, which is consistent with the finds from the site as a whole, as mechanical joining was the predominant method used to assemble the approximately four hundred Loma Negra artifacts in the Metropolitan Museum fashioned from gold, silver, copper, silvered-copper, and gilded-copper sheet.[35] Mechanical joins are also found on composite silver-and-gold artifacts from Sipán[36] and La Mina.

I. The mechanical joins present on the Loma Negra objects generally rely on a series of rectangular tabs and slots; the tabs extend from the edges of one sheet of metal and are inserted into slots cut into a second sheet. For example, there are several nose ornaments made from hammered silver sheet with gold attachments. In one case a gold band with snails in low relief is joined in this manner to the bottom edge of the silver component (Figures 5, 6). In a second example the silver substrate is overlaid with two mirror-image gold crayfish in low relief (Figures 7, 8).

On all the composite nose ornaments in the Metropolitan Museum that were joined using mechanical means, the gold sheet was applied to or over the silver, but taken together with the objects of similar manu-

Figure 9. Pair of earflares, Moche, from Loma Negra, Peru. Silver and gold, Diam. 7.6 and 7.5 cm. The harpy eagles are sheet silver, the frontplates are gold; the backplates and the shafts are gilded copper. The Metropolitan Museum of Art, The Michael C. Rockefeller Memorial Collection, Bequest of Nelson A. Rockefeller, 1979, 1979.206.1245,1246

Figure 10. Pair of earflares, Moche, from Loma Negra, Peru. Silver and gold, Diam. 7.8 cm. The shafts, rims surrounding the frontals, and the warriors are gold sheet; the backplates of the frontals are silver; one third of the backplate on 1979.206.1241 is restored. The Metropolitan Museum of Art, The Michael C. Rockefeller Memorial Collection, Bequest of Nelson A. Rockefeller, 1979, 1979.206.1241,1242

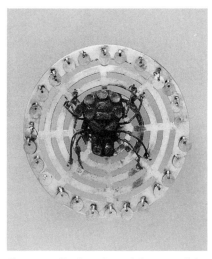

Figure 11. Pair of earflare frontals, Moche, from Loma Negra, Peru. Silver and gold, Diam. 8.4 cm. The spiders are silver sheet and wire; the webs and danglers are gold sheet. The Metropolitan Museum of Art, The Michael C. Rockefeller Memorial Collection, Bequest of Nelson A. Rockefeller, 1979, 1979.206.1240 (right), and National Museum of the American Indian, 24/3543 (left) (photo: author)

Figure 12. Earflare frontal shown at right in Figure 11. The Metropolitan Museum of Art, The Michael C. Rockefeller Memorial Collection, Bequest of Nelson A. Rockefeller, 1979, 1979.206.1240

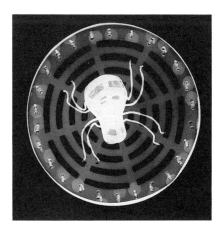

Figure 13. Radiograph of silver-and-gold earflare frontal in Figure 12 (photo: author)

Figure 14. Disk ornament, Moche, from Loma Negra, Peru. Silvered- and gilded-copper sheet, Diam. 28.2 cm. The owl and the outer band are gilded-copper sheet; the backplate is silvered copper. The Metropolitan Museum of Art, Bequest of Jane Costello Goldberg, from the collection of Arnold I. Goldberg, 1986, 1987.394.56

Figure 15. Radiograph of silvered- and gilded-copper disk ornament in Figure 14, showing A) tabs attaching body of owl to backplate and B) attachment of rod supporting head (photo: author)

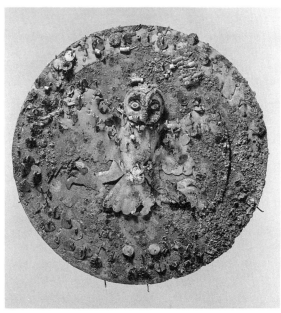

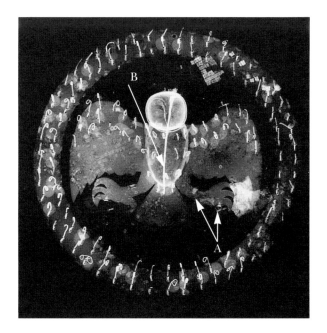

facture from other collections documented in the Loma Negra Archive, where silver was applied to gold, the nose ornaments demonstrate that for the Moche both gold and silver could function either as foreground or background. This flexibility can also be observed on the Loma Negra harpy eagle earflares (MMA 1979.206.1245,1246), each of which has a silver bird within a gold field (Figure 9),[37] and the warrior earflares (MMA 1979.206.1241,1242), where the metals used for image and ground are reversed (Figure 10), and on the large disk ornaments discussed below.

Mechanical joins were also used in the manufacture of the frontals from a pair of circular earflares divided between the Metropolitan Museum (MMA 1979.206.1240) and the National Museum of the American Indian (24/3543). Each frontal represents a silver spider in the center of a gold web (Figures 11, 12).[38] The spiders are three-dimensional, each having been formed from two raised sheets of silver that were pressure-fitted.[39] The legs are made from four round silver wires, each threaded through a pair of holes on opposite sides of the body (Figure 13). The wires were fitted into rectangular holes in the webs and flattened so as not to slip out, holding the spiders mechanically in place.

Silver-and-gold objects of Chavín manufacture are rare, and none is known to have used mechanical joining methods. Although Vicús composite objects are relatively common, mechanical joins are rare.[40]

II. The second Moche method of combining gold and silver is similar to the first insofar as it involves the assembly and mechanical attachment of metal sheets using tabs and wires. However, in this case the sheets are of copper with gilded or silvered surfaces. Close examination of Loma Negra artifacts in the Museum that were assembled from copper-sheet components has revealed that a considerable number use both gilded-copper and silvered-copper sheets.

Among these, the largest and the most impressive in terms of imagery are two disks that measure approximately twenty-six and twenty-eight centimeters in diameter. These disks, along with eight others from Loma Negra in the Metropolitan Museum are part of a cohesive but enigmatic group of objects found thus far only in the Vicús region. The disks have one or more hole(s) for suspension or attachment to a support, but their function is unknown.[41] As noted above, the use of gold and silver as both foreground and background characterizes the disks.

In the first case (MMA 1987.394.56) a background disk of "silvered" copper supports a gilded-copper owl assembled from several pieces of sheet (Figure 14).

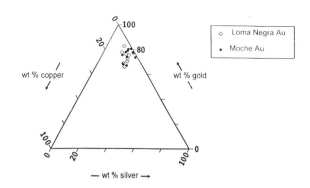

Figure 16. Ternary gold-silver-copper diagram plotting gold alloys from Loma Negra and other Moche contexts

Copper corrosion products that have migrated from the substrate obscure much of the disk's surfaces, but in radiographs it is possible to see that the wings lack the tabs that held the other parts of the body in place and would have flapped freely when the disk was moved (Figure 15). Its head, created entirely in the round, is mounted on a metal rod inserted into the body and attached to its inner surface and would have rotated from side to side. The outer edge of the disk is covered by a rim made from gilded-copper sheet. The

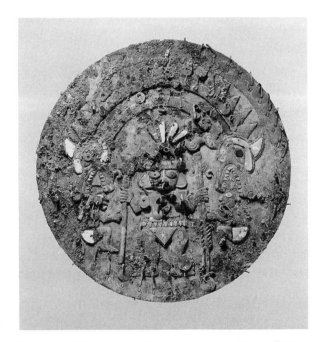

Figure 17. Disk ornament, Moche, from Loma Negra, Peru. Silvered- and gilded-copper sheet, Diam. 26.4 cm. The warrior, the "moon creature," and the outer band are silvered-copper sheet; the backplate is gilded copper. The Metropolitan Museum of Art, Bequest of Jane Costello Goldberg, from the collection of Arnold I. Goldberg, 1986, 1987.394.54

115

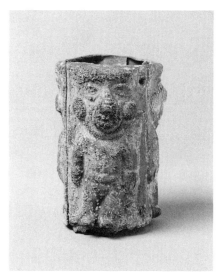

Figure 18. Staff head, Moche, from Loma Negra, Peru. Silvered- and gilded-copper sheet, H. 6.8 cm. The Metropolitan Museum of Art, The Michael C. Rockefeller Memorial Collection, Bequest of Nelson A. Rockefeller, 1979, 1979.206.1314

rim is anchored there with tabs and by the numerous flat gilded-copper wire strips*[42] supporting gilded-copper dangles,* which also would have swayed and jingled when the disk was moved. The gold surface layer examined in a section prepared from one of the attachment tabs on the owl contains 20.2 percent silver;[43] the ratio of gold to silver (ca. 4:1) is similar to that typically found in Moche ternary alloys (Figure 16).[44] The so-called silvered layer of the background contains 43.7 percent silver and 56.3 percent gold. Alloys of the same compositions prepared as standards indicate that the juxtaposed metals were relatively similar in color.[45]

The second disk (MMA 1987.394.54), which is embellished with shell-and-stone inlay, represents a warrior surmounted by a double-headed "moon creature" holding a prisoner by the hair in each of its jaws, all made from silvered-copper sheet* and mounted with tabs onto a gilded-copper disk (Figure 17). Here the rim, held in place by tabs and dangle wires, has a silvered surface. There are no moving parts other than a multitude of silvered-copper dangles.* With 25.8 percent silver, the ratio of gold to silver in the gilded layer of the background is lower (3:1) than found in the gold alloys typically used by the Moche; the silver-rich

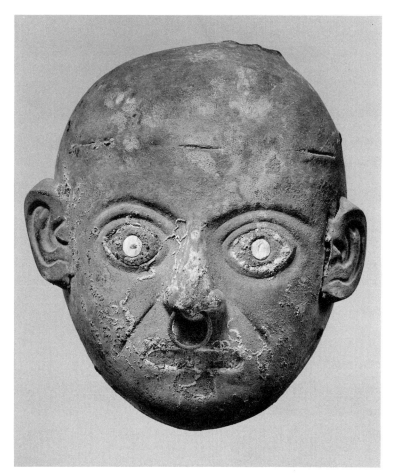

Figure 19. Mask, Moche, from Loma Negra, Peru. Copper, silvered- and gilded copper, H. 20.2 cm. The mask is made of copper sheet; the eyes and teeth are gilded copper; the ring is silvered copper. The Metropolitan Museum of Art, Bequest of Jane Costello Goldberg, from the collection of Arnold I. Goldberg, 1986, 1987.394.68

Figure 20. Bead in the shape of a human head, Moche, from Sipán, Peru. Gold, silver, and lapis lazuli, H.12.5 cm. The bead is made of gold sheet; the eyes are inlaid with silver sclerae and lapis-lazuli pupils. Lambayeque, Bruning Museum (photo from Alva and Donnan, *Royal Tombs*, fig. 23)

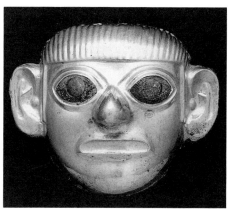

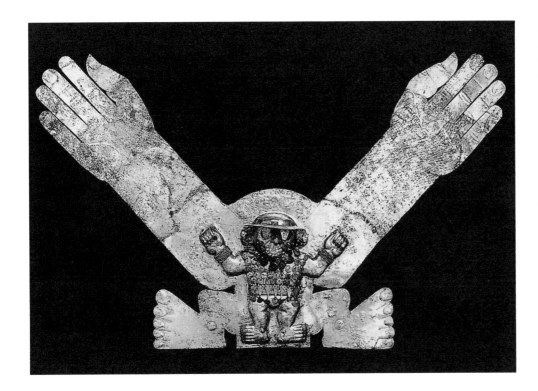

Figure 21. "Headless figure" ornament, Moche, from Sipán, Peru. Gilded-copper sheet and silver, H. 42.5 cm. The sheet is gilded copper and the finger and toenails are inlaid with silver. Lambayeque, Bruning Museum (photo from Alva and Donnan, *Royal Tombs*, fig. 66)

layer on the rim contains 44.5 percent gold.

In general, movement—be it tongues dangling from the jaws of foxes[46] or the rotating owl head and flapping wings described above, combined with the liberal use of dangles of every description—played an integral part in Moche metalwork. It seems that the ability of ancient Andean peoples to appreciate subtle differences in the gold–silver spectrum was more highly developed than ours,[47] but in the case of the two large gilded- and silvered-copper disks, the use of carefully chosen gold-and-silver alloys similar in color placed in close juxtaposition would have animated the surfaces and complemented the viewer's perception of the physical movement and sound inherent in their construction.[48]

A third object constructed from mechanically joined gilded- and silvered-copper sheets is a staff head (MMA 1979.206.1314) (Figure 18).[49] From the surviving components it appears that a relatively thin sheet of silvered copper* was hammered to form a cylinder and fitted onto a wooden staff. Attached to one end of the cylinder are two gilded-copper plaques* worked in relief, each spanning one-half of its circumference. Copper nails held the plaques and sheet onto the wooden core.[50]

Thus far, this method of combining gold and silver has not been reported on objects from other Moche contexts, but closer examination of the material from Sipán and elsewhere may reveal their existence. This method appears not to have been popular with Vicús metalworkers.[51]

ADHESIVE JOINING METHODS

III. Moche metalwork characteristically had inlays of nonmetallic materials, such as shell and stone. The inlays were held in place with a natural resin bulked with an inorganic material to increase its viscosity (Figure 17).[52] This adhesive method of attachment was also used for metal inlays and can be seen on, for example, a Loma Negra copper mask (MMA 1987.394.68) with eyes and teeth of gilded copper* (Figure 19). Although there are no known Loma Negra composite silver-and-gold examples, several objects from Sipán were made using this adhesive joining method. Frequently illustrated is one of several similar beads made from solid-gold sheet in the shape of a human head, whose eyes are inlaid with solid-silver scleras and lapis lazuli pupils (Figure 20). The silver inlays were cut or hammered to shape and adhered in place with resin. From Sipán there are also examples of gilded-copper sheet* that was inlaid with solid-silver-sheet inlay (Figure 21).[53]

METALLURGICAL JOINING METHODS

Metallurgical joins are those that bond metal components on an atomic scale to form a continuous piece, sometimes with the addition of an intermediate metal layer. Such joins are effective due to the interdiffusion of metal atoms within the two joined components, and generally require the application of heat. Heather

117

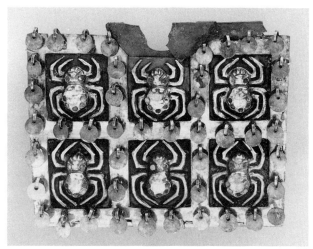

Figure 22. Nose ornament, Moche, from Loma Negra, Peru. Silver and gold, W. 8.6 cm. The spiders, the grid, and the danglers are gold sheet; the backplates are silver. The Metropolitan Museum of Art, The Michael C. Rockefeller Memorial Collection, Bequest of Nelson A. Rockefeller, 1979, 1979.206.1230

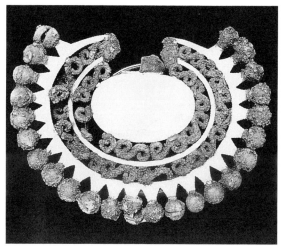

Figure 23. Nose ornament, Moche, from Sipán, Peru. Silver and gold, H. 4.0 cm. The gold components are made of sheet; they are soldered to silver wire and to hemispheres constructed from silver sheet. Lambayeque, Bruning Museum (photo from Alva and Donnan, *Royal Tombs*, fig. 223)

Figure 24. Effigy spoon, Chavín, from Chavín de Huántar(?), Peru, 400–200 B.C. Silver and gold, H. 11.1 cm. The figure and the spoon are constructed from gold sheets, the shell from two sheets of silver. Washington, D.C., Dumbarton Oaks B-440 (photo: Dumbarton Oaks Research Library and Collections)

Figure 25. Pin, Chavín, from Chongoyape, Peru. Silver and gold, L. ca. 5.5 cm. The head of the pin consists of two gold sheet hemispheres mounted onto a silver shaft. Washington, D.C., National Museum of the American Indian 16/1971M (photo: author)

Lechtman suggests that metallurgical joining techniques, such as soldering and brazing, were important stimuli to the development of alloys in the central Andes.[54]

IV. The overall examination of the artifacts from Loma Negra in the Metropolitan Museum revealed few instances of solder.[55] A nose ornament representing spiders on a web (MMA 1979.206.1230) (Figure 22) is the only instance where solder was chosen to assemble silver and gold components.[56] By contrast, solder appears to have been used more frequently on composite silver-and-gold artifacts from Sipán (Figure 23). Solder may have been used to join silver and gold components on two objects of the Early Horizon: a Chavín spoon with a man blowing into a conch shell in Dumbarton Oaks (B-440) (Figure 24)[57] and a small Chavín pin in the National Museum of the American Indian (16/1971M) (Figure 25).[58] Solder is rarely observed on silver-and-gold artifacts attributed to the Vicús culture.

The Loma Negra composite nose ornament on which solder was used consists of six gold spiders in low relief, each placed on an individual silver backplate, which was joined to the reverse of a rectangular gold grid (Figures 22, 26). The solder is readily visible in radiographs of the ornament; fully fused, it is evident from strings of fine radiotransparent bubbles present in radiopaque zones seen near the outlines of the spiders (Figure 27). The joining of the backplates to the grid is less delicate and was ultimately a less successful

Figure 26. Reverse of silver-and-gold nose ornament in Figure 22 (photo: author)

Figure 27. Radiograph of silver-and-gold nose ornament in Figure 22, to show A) fused solder; B) unfused pallion; C) location of a tab (now lost) and slot for attaching backplate onto grid (photo: author)

operation. Occasional patches of porosity, indicating where melting occurred, are clearly visible in the radiographs, but in many cases large pallions—or rectangular pieces of unfused solder—can also be observed. In some cases the edges of the pallions are visible between the backplate and the grid.[59] Apparently the maker of this ornament was concerned that the joins might fail: four tabs, no longer extant, originally extended from the top and bottom of each plate and were slotted into the grid. Soldering supplemented by tabs was also noted on each of a pair of three-

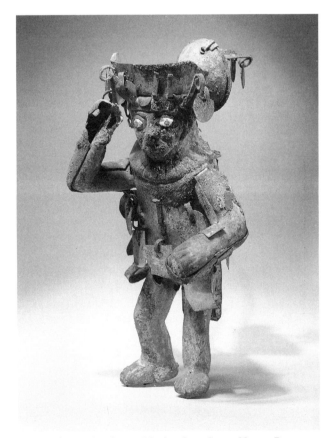

Figure 28. Warrior figure, Moche, from Loma Negra, Peru, Early Intermediate Period. Gilded copper sheet and shell(?), H. 12.0 cm. The Metropolitan Museum of Art, Gift of Jane Costello Goldberg, from the collection of Arnold I. Goldberg, 1981, 1981.450.32

Figure 29. Nose ornament, Moche, from Loma Negra, Peru, Early Intermediate Period. Silver and gold, W. 14.0 cm. The proper right half is gold sheet, the proper left silver. The Metropolitan Museum of Art, The Michael C. Rockefeller Memorial Collection, Bequest of Nelson A. Rockefeller, 1979, 1979.206.1332 (photo: author)

Figure 30. Nose ornament, Moche, from Sipán, Peru, Early Intermediate Period. Silver and gold, W. 8.5 cm. The proper right half is gold; only narrow strip of silver survives from proper left half. Lambayeque, Bruning Museum (photo from Alva and Donnan, *Royal Tombs*, fig. 160)

Figure 33. Nose ornament, Vicús, Peru, Early Intermediate Period. Silver and gold, W. 8.6 cm.; From the proper right, silver-and-gold sections alternate. New York, American Museum of Natural History, Department of Anthropology 41.2/8677 (photo: author)

dimensional warrior figures from Loma Negra (MMA 1981.450.31, 32) constructed from gilded-copper sheet[*] (Figure 28).[60]

V. Another metallurgical join observed on Moche artifacts can be described as a hammer-welded lap join. There is one hammer-welded nose ornament (MMA 1979.206.1332) from Loma Negra in the Metropolitan Museum (Figure 29) and at least one other documented in the Loma Negra Archive that was probably made in this manner.[61] Visual examinations carried out on the objects from Sipán indicate that the same technique was used in several cases (Figure 30). In terms of technical mastery and design the composite

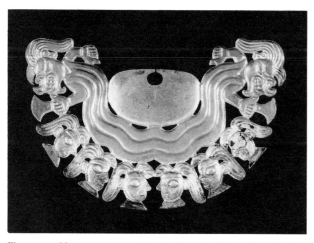

Figure 31. Nose ornament, Moche, from La Mina, Peru, Early Intermediate Period, Gold and silver, w. 13.3 cm. The upper oval section and warrior heads are silver sheet; the double headed serpent is gold. Private collection (photo: Diana Harvey)

Figure 32. Pectoral, Chavín, Peru. Silver and gold, H. ca. 14.6 cm, max. W. 47.0 cm. From the top, silver-rich and gold-rich strips alternate. New York, American Museum of Natural History, Department of Anthropology 41.0/3706 (photo: Judy Levinson)

Figure 34. Nose ornament, Vicús, Peru. Silver and gold, W. 3.6 cm. The proper right section is gold sheet; the proper left silver. Washington, D.C., National Museum of the American Indian 15/894 (photo: author)

Figure 35. Pair of earflares, Moche, Peru. Silver and gold, Diam. of shafts 5.2–5.3 cm. Right: frontal with alternating pie-shaped sections of gold and silver sheet; center: left and center: shafts. The Metropolitan Museum of Art, The Michael C. Rockefeller Memorial Collection, Bequest of Nelson A. Rockefeller, 1979, 1979.206.1175–1177

silver-and-gold *ajouré* nose ornaments attributed to La Mina (Figure 31) represent some of the most sophisticated Moche artifacts on which this method was used.[62]

A hammer-welding technique was apparently also employed for the manufacture of two pectorals in the American Museum of Natural History (41.0/3706, 41.0/3707) (Figure 32) that are attributed to the Chavín culture,[63] as well as for Vicús nose ornaments in the same collection (41.2/8677) (Figure 33) and in the National Museum of the American Indian (15/894, 15/895) (Figure 34). In fact, hammer-welding seems to have been quite popular with Vicús metalworkers.[64] Because only one hammer-welded object from Loma Negra was available for technical study, objects attributed to other ancient Peruvian cultures were examined in order to determine the physical

Figure 36. Radiograph of silver-and-gold nose ornament in Figure 29 (photo: author)

Figure 38. Detail of radiograph of silver-and-gold nose ornament in Figure 34; arrow indicates gold strip continuous with silver sheet component (photo: author)

Figure 37. Radiograph of silver-and-gold pectoral from Figure 32 (photo: author)

Figure 39. Radiograph of silver-and-gold nose ornament in Figure 33 (photo: author)

Figure 40. Polished section from hammer-welded join on silver-and-gold nose ornament in Figure 29, electron back-scattered photograph; the lighter area is gold sheet; the darker area is silver sheet (photo: Mark T. Wypyski)

Figure 41. Polished section from hammer-welded join on silver-and-gold earflare in Figure 35, electron back-scattered image; lighter areas are gold; the darker areas are silver (photo: Mark T. Wypyski)

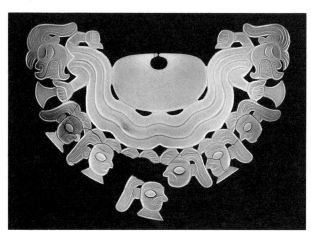

Figure 42. Radiograph of silver-and-gold nose ornament from Figure 31 (photo: author)

character of this type of join and to hypothesize how it was executed. In addition to the Vicús nose ornaments and Chavín pectorals, a pair of earflares in the Metropolitan Museum (MMA 1979.206.1175–1177) (Figure 35) attributed to the Moche culture and a pair of roundels in the American Museum of Natural History (41.2/6297) and a *tupu* in Dumbarton Oaks (B-472)[65] attributed to the Lambayeque culture were also examined.

A number of Vicús and Moche silver-and-gold composite nose ornaments were examined and radiographed at the Royal Ontario Museum in the mid-1970s in conjunction with a traveling exhibition of metal artifacts in the Museo Oro del Péru.[66] Tushingham, Franklin, and Toogood discounted soldering as a possible joining method and concluded that the ornaments had been welded without the introduction of a filler metal. In the radiographs they noted sharp junctures between the components and proposed that the joins had been executed, without overlapping the gold and silver sheets and without much hammering, through the action of heat. The authors also mentioned the presence of cracks along some of the joins but offered no explanation for their origin.

In radiographs of the Loma Negra and Vicús nose ornaments, the Moche earflares, the Lambayeque roundels and *tupu*, and the Chavín pectorals, the corresponding silver-and-gold components in each object exhibited drastically different opacities (Figures 36–39), such as had been observed by Tushingham, Franklin, and Toogood in objects of similar manufacture.[67] To confirm the supposition that these artifacts had been hammer-welded, metallographic sections were prepared from samples removed from joins on the Loma Negra nose ornament and from one of the Moche earflares. Pending further investigation, it appears that gold and silver sheets were assembled with slightly overlapped edges and alternately heated and hammered until adequate fusion occurred.

Certainly in viewing these sections (Figures 40, 41) it is obvious that the silver and gold components had been overlapped prior to joining. The metal sheets that were used for the Loma Negra nose ornament are quite thin, measuring about 0.2 millimeter near the join, while the metal at the join is nearly twice as thick. The Moche earflares are made from substantially thicker gold and silver sheets, the edges of which appear to have been beveled at the overlap, so that the joins are approximately the same thickness as the individual starting sheets. The abrupt junction between the gold and silver sheets, with their dramatically different radiopacities, tends to obscure features associated with the joins, but, in fact, a careful review of each

hammer weld in the radiographs reveals a narrow zone where the gold and silver sheets overlap. As a rule porosity, which is generally associated with melting, was not observed. The Chavín pectorals, the only exceptions, had isolated pores along the joins.

It is clear that the joins were annealed, because substantial interdiffusion of the gold and silver can be observed in the metal sections at relatively low magnifications; the distribution of the two metals on an atomic scale is confirmed with electron backscatter imaging and elemental dot mapping. On the section from the Moche earflare, in particular, long narrow peninsulas of gold penetrate the silver sheet on the other side of the join and vice versa, suggesting that the heating occurred repeatedly and in alternation with campaigns of hammering (Figure 41). Furthermore, there is evidence for considerable deformation by hammering, both at the joins and on the objects overall, subsequent to joining. The broad area of overlap between the gold and silver sheets of the Loma Negra nose ornament (Figure 40), for example, is due to extensive hammering at the joins, while the similarity in the pattern of hammer blows and changes in thickness in the gold and silver components, visible in the radiographs, also suggest that the final shaping and finishing were carried out after the components were joined (Figure 36). The joining of the gold and silver sheets prior to shaping the artifacts could also be established for both Vicús nose ornaments in the National Museum of the American Indian. In one case (15/894) (Figure 34), there is a vestigial strip of gold attached to the silver component, which indicates that the notch where the ornament was attached to the septum was cut and shaped after the two metals had been joined and hammered to form a slightly ovoid disk (Figure 38).

Cracks very close to the hammer-welded joins are visible in the radiographs. Their position parallel to the joins suggests that the cracks are due not to inadequate fusion but rather to subsequent stress to the join. In fact, the irregular black voids visible in the section from a join on one of the Moche earflares are cracks, also seen in section, that probably resulted when the flat band consisting of the four hammer-welded sections was hammered into a cylinder (Figure 41).

The radiographic images of the two hammer-welded La Mina nose ornaments are significantly different from those of the various other hammer-welded objects that were radiographed in this study and by Tushingham, Franklin, and Toogood. When taken with evidence acquired through other means of examination, these differences may point to a local variation in manufacture. For example, in correlating the radi-

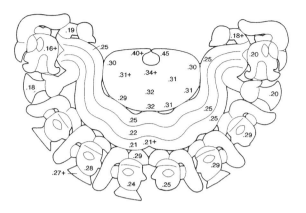

Figure 43. Drawing of silver-and-gold nose ornament in Figure 31, indicating sheet thicknesses (drawing by Barry Girsh)

ographic images of the hammer-welded ornaments, such as the nose ornament from Loma Negra (Figure 36), the Moche earflares, the Chavín pectorals (Figure 37), and the Vicús nose ornaments (Figures 38, 39), with measurements of sheet thicknesses, it is obvious that the corresponding silver and gold components were made from silver and gold sheets of similar thickness. However, the error of assuming that the lack of marked differences in the radiopacity of the different metal components means that an object was not hammer-welded is illustrated by a nose ornament attributed to La Mina (Figure 31). From top to bottom, the piece consists of an oval silver field, a gold serpent with two human heads, and a row of silver trophy heads. Whereas preliminary macroscopic examination of the ornament suggested that it had been made from gold and silver sheets joined by hammer-welding, this conclusion was at first discounted because the radiopacity is fairly consistent throughout the ornament except where changes in thickness were created by the repoussé and chasing, or on the edges, where it is obvious that the metal had been disproportionately thinned by hammering (Figure 42). The possibility that these ornaments had been made from gilded silver was briefly considered and rejected as being inconsistent with the radiographic evidence. Confirmed examples of gilded-silver Moche artifacts are extremely rare.[68]

Subsequent examination of broken edges within the silver component and of a metallographic sample removed from an exterior gold edge proved definitively that the ornament was made from solid-gold and solid-silver sheets. Detailed caliper measurements of numerous sites on the La Mina nose ornament (Figure

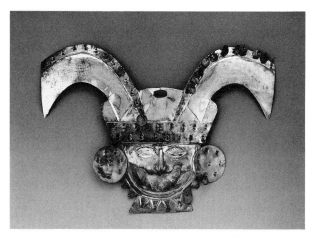

Figure 44. Nose ornament, Moche, from Loma Negra, Peru, Early Intermediate Period. Partially silvered gold sheet and silver sheet, W. 18.9 cm. The headband, the top edges of the feathers, the earflares, and the necklace are silvered gold; the nose ornament and danglers are silver sheet. The Metropolitan Museum of Art, The Michael C. Rockefeller Memorial Collection, Bequest of Nelson A. Rockefeller, 1979, 1979.206.1223

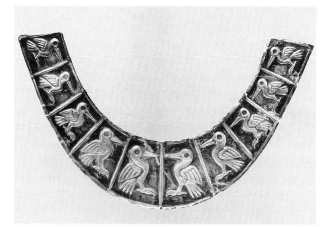

Figure 45. Band from nose ornament, Moche, from Loma Negra, Peru, Early Intermediate Period. Partially silvered gold sheet, W. 21.0 cm. The background fields are silvered gold; the birds and borders are gold. The Metropolitan Museum of Art, The Michael C. Rockefeller Memorial Collection, Bequest of Nelson A. Rockefeller, 1979, 1979.206.1226

Figure 46. Polished section of silvered-gold sheet from nose ornament in Figure 44; left: electron backscattered image; right: elemental dot maps of (from top to bottom) gold, copper, and silver (photo: Mark T. Wypyski and author)

43), together with the radiographs and visual examination of the object and its section, suggest that it was hammer-welded from components of different thicknesses. The silver sheet near the join is consistently thicker than the corresponding gold sheet, which might account for the fortuitously homogeneous radiopacity visible in the radiographs. A similar relationship between the measured thicknesses of the gold and silver sheets and their relative radiopacities was observed in the examination of the second composite silver-and-gold nose ornament attributed to La Mina.

Close examination of two hammer-welded ornaments from La Mina (see Figure 31) suggests that the following sequence of steps was used in their manufacture. First, gold and silver sheets were joined by alternating heating and hammering. This was followed by the execution of the relief decoration. The metal along the joins was then selectively removed to create negative spaces and the ornament was trimmed. Hammering to finish the edges and the polishing were the final steps. Evidence that the joining of the two metals was a preliminary step can be seen along internal and external edges of the ornament, where lengths of silver sheet have narrow gold borders, and vice versa.

Analysis of the silver and gold components from the Loma Negra hammer-welded ornament indicated that both are debased.[69] The composition of the gold sheet—which contains 19.3 percent silver and 5.2 percent copper—is typical for the Loma Negra gold alloys, as well as Moche gold in general (see Figure 16). The silver sheet contains 6.6 percent gold and 4.4 percent copper. Unfortunately this nose ornament was the only Loma Negra hammer-welded join available for analysis, but in all instances where silver-sheet samples from hammer-welded composite silver-and-gold artifacts were analyzed, they were found to contain amounts of gold and copper equal to or greater than what was detected for the Loma Negra example. It is interesting to note that the silver used on composite objects that employ other metallurgical means of attachment, i.e., soldering or silvering, also contain considerable additions of gold and copper.

The silver used for metallurgical joining processes differs distinctly in composition from the alloys used for Loma Negra artifacts without metallurgical joins. In the six cases where analyses were carried out on objects made entirely of silver sheet or on silver components mechanically joined to gold sheet, three were quite pure (0.7–1.1 percent copper, with no gold detected). The other three were found to contain 2.0–3.6 percent copper with, in one case, an additional 1.3 percent gold (also see Appendix).

The location and composition of silver sources used by the Moche have not, as yet, been investigated, but it is obvious that pure silver was available. It also seems quite likely that the Moche added gold and copper to silver to produce alloys not known to occur in nature,[70] and that they chose specific natural and artificial alloys for different cultural or practical reasons. In the six instances where the silver was employed in the manufacture of objects that do not have metallurgical joins, one must assume that melting point or other working properties related to the application of heat were not factors in the choice of metal.

Whereas the color of gold is altered by the presence of even small amounts of additional metals, changes in the color or sheen of silver are optically less evident even as moderate amounts of copper and gold are added.[71] Therefore it is conceivable that color did not greatly affect the decisions concerning the alloying of the silver used for the Loma Negra hammer-welded nose ornament. The different degree or quality of polish attainable on different alloys may have been a factor, but this question has not been investigated. Although the reason for choosing (and probably preparing) the silver alloy is not clear, the metal must have had some combination of physical—including visual—and mechanical properties that made it suitable for combining with gold.

In most cases, the corresponding silver and gold components of the hammer-welded objects studied have relatively similar melting points; on the Loma Negra nose ornament the gold and silver components melt at 960° and 920°C, respectively. How melting point might relate to the diffusion coefficients of the two metals at elevated temperatures, and the role of concentration gradients associated with specific pairs of alloys, remain to be considered. Other properties, such as the two metals' relative malleabilities, that might have affected their ability to maintain adequate physical proximity during heating may also have played a role in choosing the alloys.[72]

In view of the multitude of variables, it is interesting to consider the two pectorals in the American Museum of Natural History attributed to the Chavín culture (see Figure 32). Each pectoral consists of eight alternating gold and silver bands. Analysis of the bands indicates that they are all ternary alloys. The compositions of the artificially alloyed silver-rich bands on both ornaments are nearly identical, averaging about 54 percent silver, 39 percent gold, with the remainder copper. This alloy melts at about 950°C. The gold-rich bands on one of the pectorals (41.0/3706) average 67 percent gold, 20 percent silver, with the remainder copper,[73] which melts at approximately 880°C, while on the second piece (41.0/3707) the average composition of three of the gold-rich bands is 78 percent gold, 13 percent silver, with the remainder copper. The alloy melts at about 950°C, or at the same temperature as the alloy used for the silver-rich bands.[74] What is notable in the appearance of the pectorals is the similarity in the colors of the different alloys; the alternation of the bands is evident today because the silver-rich ones are tarnished; when viewing cleaned areas on the reverse of the pectorals or modern standards replicating the alloys used, one recognizes what great forethought and effort went into joining eight bands of metal that to our eyes are barely distinguishable visually.[75]

VI. There are two silvered-gold objects from Loma Negra in the Metropolitan Museum. The embellishment of Loma Negra objects through the application of silver onto a gold substrate was previously noted by Lapiner,[76] and by Lechtman, Erlij, and Barry Jr.,[77] but this phenomenon is generally unreported for Peruvian artifacts.[78] As a rule, silvered gold is rare in all cultural contexts because, if for no other reason, gold is generally regarded as the more precious or high-status metal.[79] Silver coatings on gold artifacts from Sipán and La Mina have not been confirmed thus far.

The first of the two silvered-gold artifacts is a nose ornament (MMA 1979.206.1223) that represents the head of a man wearing a feathered headdress and several pieces of jewelry (Figure 44). Both the obverse and reverse surfaces are gold, but on the obverse certain details—the earflares, the necklace, the headband, and the top border of the feathers—are silvered. The nose is a separate, raised sheet of gold attached mechanically with tabs, and the man's nose ornament and the dangles were cut from a solid silver sheet. The ornament is inserted into the septum of the nose and the dangles are suspended from silver wires, which are rectangular in section.

The second silvered-gold artifact (MMA 1979. 206. 1226) is a flat, curved band divided into ten trapezoidal fields, each containing a bird shown in profile (Figure 45). The birds are executed in low relief and

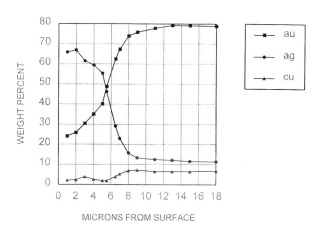

Figure 47. Polished section of silvered-gold sheet from nose ornament band in Figure 45, electron backscattered image; arrows indicate string of voids delineating interface between silver layer and gold substrate (photo: Mark T. Wypyski)

Figure 48. Electron microprobe analyses of silver, gold, and copper across section of silvered gold sheet from nose ornament in Figure 44

the fields are surrounded by raised borders. Once again only gold is visible on the surface of the reverse; on the obverse the birds and the borders are gold and the trapezoidal fields are silvered. Along the top edge are eleven small tabs that were used to attach the sheet to the upper half of a nose ornament, and when complete, the object would have been comparable in appearance to the snail nose ornament discussed earlier (see Figure 5).

Although visual examination and radiographic analysis were helpful in characterizing these ornaments, proof for their manufacture from partially silvered-gold sheet was obtained from the examination of polished sections. Viewed in section, the silver layers on the anthropomorphic nose ornament and the bird relief band are fairly irregular in thickness, averaging one and three microns, respectively. Scanning electron microscope elemental x-ray maps, electron backscatter images, and electron microprobe traces across the sections document the distribution of gold and silver (Figures 46–48). It is interesting to note a marked accumulation of silver in an angular irregularity on the surface of the gold in the section of the nose ornament (Figure 46).[80]

The structures observed in the etched metallographic sections indicate that in a later or final stage of manufacture, these artifacts were reheated sufficiently for the heavily cold-worked grains of the gold substrate to recrystallize and a certain degree of diffusion to occur. Unfortunately the silver coatings are far too thin for one to observe grain structure when using a conventional metallographic microscope, or other features that may be present.

Electron microprobe line scans across the silver–gold interfaces carried out on both sections indicate that the zone of diffusion is quite broad, particularly in relation to the thickness of the silver layer. On the section from the anthropomorphic nose ornament, where the discrete silver layer averages three microns in thickness, diffusion of substantial amounts of silver into the gold substrate occurred to an approximate depth of eight microns (Figure 48).[81]

At this time it remains unclear how these silver coatings were applied. It is obvious that neither depletion plating, which was widely used in pre-conquest South America to gild and silver copper substrates, nor electrochemical replacement plating, the mechanism proposed by Lechtman for the gilding and silvering of copper sheet from Loma Negra, could have been used to produce silver layers on gold. Mechanical joining also seems unlikely.

In the manufacture of the bird-relief band it is possible to recognize the following steps: the relief detail was chased into a sheet of gold cut to approximate the final shape; the obverse was silvered and then the raised areas—the birds and the borders—were abraded to reveal the gold beneath; the band was then cut to its proper size and attached with tabs to its corresponding top half. Evidence for these steps can be found in radiographs (Figure 49) and in a careful examination of the band's silvered and unsilvered surfaces. The gold areas are somewhat less radiopaque than the silvered-gold areas, but because of its extreme thinness (ca. one micron) and the low atomic weight of silver relative to that of gold, the silver layer is not responsible for the increased radiopacity. Caliper mea-

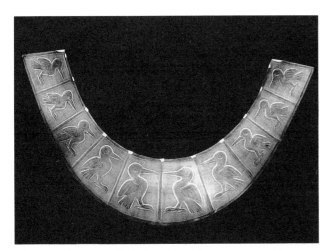

Figure 49. Radiograph of silvered-gold nose ornament band from Figure 45 (photo: author)

surements indicate that the silvered-gold sheet is thicker than the unsilvered sheet but by more than can be accounted for by the addition of one micron of silver. Some thinning of the raised areas, all of which are unsilvered gold, may be attributed to the chasing process, but other observations, including polishing scratches and small silver islands on the gold surfaces, suggest that the gold areas are thinner because they were abraded during the selective removal of patches of silver from an overall silver layer. Most convincing is the fact that the very top edge of the band and the tabs extending from it are silvered. If the silver layer had been applied locally, it is unlikely that a millimeter-wide strip adjacent to the gold border, or the tabs, would have been silvered; the presence of silver on the tabs implies that the layer had been applied to the entire obverse surface. Evidence of an overall application and selective removal of a silver layer on the anthropomorphic silvered-gold nose ornament was not observed.

An interesting and as yet unexplained phenomenon is the presence of mercury on the surface of the bird-relief band. Whereas mercury gilding, also called fire or amalgam gilding, was widely used in many ancient and historic Old World contexts, its use on objects from pre-conquest Peru has never been confirmed.[82] Amalgam silvering on gold is metallurgically possible, though it was rarely, if ever, carried out anywhere in the ancient world.[83] There are sources of elemental mercury in Peru, but it is not clear that they were exploited before the Spanish conquest.[84] However, the mineral cinnabar, a mercuric sulfide with the formula HgS_2, had widespread use as a pigment for painting

and during burial seems occasionally to have been sprinkled in powdered form on bodies of deceased individuals, or on the grave goods that accompanied them in death.[85]

In any event, as indicated by electron microprobe analysis of the section from the bird-relief band, mercury is present both in the rather spongy silver surface layer and concentrated in visually discrete structures on the surface itself, where minute specks of gold can be observed as well (Figure 50). Minimal amounts of mercury were detected in the gold substrate. In situ x-ray diffraction analysis of the surface of the band and elemental analysis of the section proved unsuccessful in identifying a mercury-containing compound.[86] Red pigment present on the surfaces of several pieces from Loma Negra has been identified as cinnabar, and it is possible that the mercury is due to the subsequent decay of cinnabar that had been sprinkled during burial onto the surface of the nose ornament to which this band belonged, or onto a neighboring object. The sublimation of cinnabar, which occurs at 583°C, would presumably leave a mercury residue on the surface; there is, however, nothing to suggest that the bird-relief band was heated after burial. Mercury independent of cinnabar was not detected on the silvered-gold nose ornament, nor on any other Moche object thus far analyzed.

VII. There is an unprovenanced Moche nose ornament in the American Museum of Natural History (41.2/8676) that was also made from partially silvered gold (Figure 51). In this case, because of the poor preservation of the silver layer, it is possible in many areas to observe the formerly silvered gold substrate and to gauge the thickness of the silver layer, which is significantly greater than those present on the two Loma Negra ornaments. The differences observed in both the macroscopic and radiographic features of the unprovenanced silvered-gold nose ornament on one hand and the two Loma Negra pieces described above point to the use of different working methods that led to a similar result.

It was noted above that the areas of silvered-gold sheet on the Loma Negra ornaments are slightly more radiopaque than gold areas, where it appears that a silver layer was intentionally abraded away. Exactly the opposite is true for the unprovenanced nose ornament, where the silvered-gold areas are considerably less radiopaque than the plain gold sheet (Figure 52). The unsilvered gold substrate is approximately 0.18 millimeter thick, while in the formerly silvered areas, where the silver has been lost due to corrosion and probably from a cleaning undertaken after the orna-

A B

B

Figure 50. Electron back-scatter photograph of polished section of silvered-gold sheet from nose ornament band in Figure 45, showing A) mercury "crystals" and B) gold particles (photo: Mark T. Wypyski)

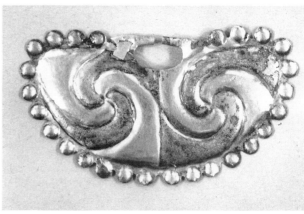

Figure 51. Nose ornament, Moche, Peru. Partially silvered gold sheet, W. 6.7 cm. Alternating swirls of unsilvered and silvered gold sheet. New York, American Museum of Natural History, Department of Anthropology 41.2/8670 (photo: author)

ment was retrieved from its burial place, the same gold sheet is an average of 0.15 millimeter thick. Intact silvered-gold areas are considerably thicker, measuring 0.24–0.25 millimeter. In this case it appears that the method of application involved the removal of gold from the surface before the application of the silver layer, rather than the application of an overall silver layer locally removed by abrasives. It is possible that the silver was applied as sheet and hammer-welded in place, or using a method related to the fusion and diffusion processes proposed by David Scott for the gild-

ing and silvering of some copper artifacts from Ecuador and Colombia.[87] In the absence of additional artifacts of this type that can be studied and analyzed in section, one must reserve all opinions.

VIII. There is a single example of precious metal inlays secured using metallurgical means that can be observed on one of a pair of silver-and-gold scepters from tomb 1 at Sipán. The substrate is the solid cast-silver shaft.[88] Gold has been inlaid in a series of spiraling channels cast and/or scored into two war clubs that

Figure 52. Radiograph of silvered-gold nose ornament in Figure 51. Areas of extreme radiopacity on border and below proper left nose prong correspond to ancient repairs. (photo: author)

Figure 53. Peanut bead necklace, Moche, Sipán, Peru. Silver and gold, L. of largest bead 9.0 cm. The five pairs on the proper right are gold; those on the left are silver. Lambayeque, Bruning Museum (photo from Alva and Donnan, *Royal Tombs*, fig. 96)

ornament the shaft. The surfaces of the gold inlays are globular and, for the most part, below the surface level of the silver substrate. In the few instances where the gold had been higher when first applied, it was smeared, apparently during manufacture, across the silver, so that the surfaces are now more or less flush. Minute amounts of gold were also applied to the convex silver surfaces of two "stones" shown in slings wrapped around the war clubs. In this case the gold does not appear globular, nor to have been set into a deep recess. It can be proposed that the gold inlay was applied in a semi-molten state, but a rigorous examination is necessary in order to discover the precise methods of application of both the gold inlays and overlays; the method used for the latter may be related to that used to apply silver to a gold surface on the unprovenanced nose ornament in the American Museum of Natural History described above and, in any case represents a rare, if small-scale, occurrence of gilded silver in Peru that predates the Lambayeque culture.

IX. One method for combining gold and silver used by the Moche seems, thus far, to be unique to La Mina. It appears on several similar gold zoomorphic trumpets, to which silver has been applied using two methods.[89] One method is inlay, probably of the first type, using an organic adhesive, described for the Sipán material, and the second appears to involve the fusion of silver strips onto the surface of the gold. A full examination of the trumpets would be necessary to determine the precise details of their manufacture.

DISCUSSION

It is clear that the visual juxtaposition of silver and gold was highly significant to the Moche. In addition to the use of gold and silver within a single composite work, gold and silver objects themselves were sometimes arranged to express a specific, dualistic relationship between the two metals. In Sipán tomb 1, excavated by the Bruning Museum, three pairs of objects in gold and silver versions—ingots, backflaps, and *tumis*— were placed on the proper right and proper left sides, respectively, of the deceased.[90] A similar right-left arrangement of pairs of gold-and-silver backflaps and bells was found at Sipán in tomb 3, the burial of a man believed to have held a similar position in the Moche hierarchy, but in an earlier period.[91] This phenomenon is thus far known only from Sipán because evidence for this type of arrangement, should it exist, can be ascertained only for artifacts obtained through excavation. The association of gold and silver with the right and left sides of the human body has also been observed on composite silver-and-gold objects, such as the famous peanut bead necklace from tomb 1 at Sipán (Figure 53) and on hammer-welded nose ornaments from Loma Negra (Figure 29) and Sipán,[92] and nose ornaments attributed to the Vicús culture (Figure 34).[93] Whereas the finds at Sipán suggest that in burial contexts at that site and/or for specific personages there was a symbolic association between gold and the right side of the human body, and silver with the left, compositionally most Moche composite objects are not bisected by a single vertical line of symmetry that separates two mirror-image fields of different color, nor are gold and silver limited to one side or the other of a central axis (see Figures 4, 5, 7, 9–11, 14, 17, 22, 31, 44, 45, 51).[94]

Viewed in terms of the effort and creativity that went into the manufacture of the composite artifacts discussed in this article, one might suggest that the interest of the Moche in the visual juxtaposition of gold and silver was unlimited. "Why juxtapose silver and gold on a single object?" "Why cover copper with a layer of gold?" "Why fashion an object of solid gold in one instance and the same object from gilt copper in another?" To these questions that Heather Lechtman posed while reflecting on the lectures presented at the colloquium/workshop "Andean Royal Tombs, Works of Art in Metal,"[95] one might add: Why devise so many methods of manufacture to create a specific visual effect? Are these sumptuous ornaments the work of a people for whom innovation, or variety, or the mastery of the physical world through the manipulation of raw matter, was a value of cultural significance? A preliminary examination of Vicús metalwork suggests that Vicús metalsmiths also depended on a considerable range of methods for combining gold and silver; perhaps this tendency or desire to juxtapose these metals embodies a specific level or quality of contact between the Moche and Vicús cultures; alternately, one might suggest that this technical and visual aesthetic is a development of the Early Intermediate Period in the north central Andes rather than a specifically Moche phenomenon. In considering this question one should look also to the composite silver-and-gold artifacts attributed to the problematic Frías culture, associated with a site of the same name in the highlands just northeast of Loma Negra and neighboring Vicús culture sites and thought to be contemporaneous in date.

Having adopted and developed these techniques, how did the Moche metalworker choose the method or methods that would be used in the manufacture of

a specific object? The evidence from the existing corpus of Moche metalwork suggests that there are regional variations in the types of objects executed in gold and silver, just as one observes that certain methods seem to be favored at one or another of the three main sites. What combination of various and interrelated factors, such as date of manufacture, local traditions, type and function of the artifact, social status of the owner, availability of resources, and working properties of materials, formed a preference for one manufacturing method over another? Our hope is that, with further study and thought, we might begin to assign cultural values to the different technological processes used to create these objects and thereby might explain a particular confluence of artifact and manufacture.

ACKNOWLEDGMENTS

I would like to thank James H. Frantz, conservator-in-charge of the Sherman Fairchild Center for Objects Conservation of the MMA, for his ongoing generous support of my research. I am indebted to Julie Jones, Department of the Arts of Africa, Oceania, and the Americas, MMA, and to Ellen G. Howe and Richard E. Stone of the Sherman Fairchild Center, for their time and expertise, which were essential for the formulation and execution of this research. Samantha Alderson, Sarah Nunberg, and Leesa Vere-Stevens all provided information about the Loma Negra material gleaned in the course of the examinations and conservation treatments they undertook during their internships at the Sherman Fairchild Center; George S. Wheeler carried out the open architecture x-ray diffraction analysis; and Mark T. Wypyski carried out numerous analyses for this research, offered his expertise in their interpretation, and provided electron back-scatter images and elemental dot maps. Lawrence Becker of the Worcester Art Museum and Heidi King of the Department of the Arts of Africa, Oceania and the Americas, MMA, repeatedly offered useful commentary and advice. Heather Lechtman of the Center for Materials Research for Archaeology and Ethnography at MIT provided much encouragement as well as stimulating discussion about Loma Negra and Sipán. In addition I must acknowledge an enormous debt to Lechtman's writings, which have established a theoretical basis for much of the contemplation that went into this article. I am grateful to Craig Morris, Judith Levinson, and Barbara Conklin (formerly) of the American Museum of Natural History; to Nancy Rosoff, Scott Merritt, and Mary Mooney of the National Museum of the American Indian; and to Elizabeth H. Boone and the late Carol Callaway, both formerly of Dumbarton Oaks, for generously facilitating the examination and loan of Peruvian metalwork in their care. Richard Newman of the Museum of Fine Arts, Boston, carried out electron-microscopic analyses. Ulrike Bunte of the Linden-Museum Stuttgart, Staatliches Museum für Völkerkunde, was kind enough to examine the Moche mask and its documentation on a moment's notice. My thanks go also to Christopher B. Donnan of the Fowler Museum of Cultural History at the University of California at Los Angeles for providing access to the Moche Archive, for facilitating my examination of metalwork from Sipán, and for answering my many queries on Moche culture. I enjoyed Walter and Susanne Alva's hospitality during a 1993 visit to Lambayeque. Thanks to Robert Baines of the Royal Melbourne Institute of Technology, who carried out preliminary hammer-welding replication experiments. Thanks also to other colleagues at the MMA: Adam Hart of the Design Department, Joshua Lee of the Department of Arms and Armor, Silvia Centeno of the Sherman Fairchild Center, Barry Girsh, formerly of the Department of Egyptian Art, Ross Day, Jeanette Schnell, Peter Blank (formerly), Katie Dowling (formerly), James Dowtin, and Donald Roberts of the Department of the Arts of Africa, Oceania and the Americas, and especially, Eileen Travell and Bruce J. Schwarz of the Photograph Studio, for their generous contributions.

Appendix: Composite Silver-and-Gold Artifacts from Loma Negra in The Metropolitan Museum of Art

I. Mechanical joining of silver and gold sheets

1979.206.1225
Silver nose ornament with applied gold double-headed dragon
W. 20.8 cm, H. 12.3 cm
Not analyzed
Figure 4

1979.206.1228
Silver nose ornament with applied gold-relief band
W. 19.9 cm, H. 12.6 cm
Analysis of silver component: 99.0% Ag, 1.0% Cu
Figures 5, 6

1979.206.1235 (not illustrated)
Silver nose ornament with applied gold snakes and relief trophy head
W. 9.1 cm, H. 7.1 cm
Analysis of silver component: 95.1% Ag, 1.3% Au, 3.6% Cu

1979.206.1236
Silver nose ornament with applied gold-relief crayfish
W. 18.7 cm, H. 12.3 cm
Analysis of silver component: 98.0% Ag, 2.0% Cu; of gold component: 76.3% Au, 17.0% Ag, 6.7% Cu
Figures 7, 8

1979.206.1240
(cf. National Museum of the American Indian 24/3543)
Earflare frontal in form of silver spider on gold web
Diam. 8.4 cm
Analysis of silver component: 97.2% Ag, 2.8% Cu; of gold component: 70.3% Au, 16.7% Ag, 13.0% Cu
Figures 11–13

1979.206.1241 (cf. 1979.206.1242)
Gold earflare with gold warrior figure on silver backplate
Diam. 7.8 cm, L. 8.1 cm
Not analyzed
Figure 10

1979.206.1242 (cf. 1979.206.1241)
Gold earflare with gold warrior figure on silver backplate
Diam. 7.8 cm, L. 8.1 cm
Not analyzed
Figure 10

1979.206.1245 (cf. 1979.206.1246)
Gold earflare with silver harpy eagle appliqué (backplate and cylinder shaft of depletion-gilded ternary alloy)
Diam. 7.6 cm, L. 10.0 cm
Not analyzed
Figure 9

1979.206.1246 (cf. 1979.206.1245)
Gold earflare with silver harpy eagle appliqué (backplate and cylinder shaft of depletion-gilded ternary alloy)
Diam. 7.5 cm, L. 10.8 cm
Analysis of gold component: 74% Au, 19% Ag, 7% Cu (Heather N. Lechtman, Antonieta Erlij, and Edward J. Barry Jr., who, in "New Perspectives on Moche Metallurgy; Techniques on Gilding Copper at Loma Negra, Northern Peru, " *American Antiquity* 47 [1982] p. 7)
Figure 9

1979.206.1247 (not illustrated)
Gold nose ornament frontal with stone inlays in form of Ai-Apec wearing a silver nose ornament
W. 9.6 cm, H. 6.9 cm
Analysis of gold component: 68.8% Au, 18.8% Ag, 12.4% Cu
Illustrated in Alan Lapiner, *Pre-Columbian Art of South America* (New York, 1976) fig. 382

II. Mechanical joining of gilded- and silvered-copper sheets (selected examples)

1979.206.1314
Staff head
H. 6.8 cm, Diam. 3.7 cm
Not analyzed
Figure 18

1987.394.54
Warrior and "moon creature" disk
Diam. 28.2 cm
Analysis of gold surface layer (backplate): 74.2% Au, 25.8% Ag; of silver surface layer (rim): 44.5% Ag, 55.5% Au
Figure 17

1987.394.56
Owl disk
Diam. 26.4 cm
Analysis of gold surface layer (owl): 79.8% Au, 20.2% Ag; of silver surface layer (backplate): 43.7% Ag, 56.3% Au
Figures 14, 15

III. Solid-gold and -silver sheets soldered with ternary alloy

1979.206.1230
Nose ornament in shape of a spiderweb
W. 8.6 cm, H. 6.6 cm
Analysis of silver component: 88.7% Ag, 6.1% Au, 5.2% Cu; of gold component: 66.0% Au, 13.1% Ag, 20.9% Cu; of solder: 52.8% Ag, 14.2% Au, 33.0% Cu
Figures 22, 26, 27

IV. Hammer-welded gold and silver sheets

1979.206.1332
Nose ornament
W. 14.0 cm, H. 10.7 cm
Analysis of silver component: 89.0% Ag, 6.6% Au, 4.4% Cu;
of gold component: 75.5% Au, 19.3% Ag, 5.2% Cu
Figures 29, 36

V. Partially silvered-gold sheet

1979.206.1223
Gold nose ornament in form of a man wearing a feathered
headdress (wearing mechanically joined silver-sheet nose
ornament)
W. 18.9 cm, H. 12.7 cm
Analysis of gold substrate: 78.0% Au, 13.3% Ag, 8.7% Cu; of
silver surface layer: 71.6% Ag, 23.5% Au, 4.9% Ag
Figure 44

1979.206.1226
Gold-relief band from nose ornament
W. 21.0 cm, H.12.0 cm
Analysis of gold substrate: 83.0% Au, 12.5% Ag, 4.5% Cu; of
silver surface layer: 56.9% Ag, 38.0% Au, 5.1% Cu
Figures 45, 49

NOTES

1. See Heather N. Lechtman, "Traditions and Style in Central Andean Metalworking," in *The Beginning of the Use of Metals and Alloys*, Robert Maddin, ed. (Cambridge, Mass., 1988) pp. 344–378, esp. p. 349, and Heather N. Lechtman, "Andean Value Systems and the Development of Prehistoric Metallurgy," *Technology and Culture* 25 (1984) pp. 1–36, esp. p. 15.

2. The following periods of central Andean prehistory and northern Peruvian cultures are discussed in this article: Initial Period (ca. 1800–ca. 900 B.C.); Early Horizon (ca. 900–ca. 200 B.C.); Early Intermediate Period (ca. 200 B.C.–ca. A.D. 600); Middle Horizon (ca. A.D. 600–ca. 1000); Late Intermediate Period (ca. 1000–ca. 1475); Late Horizon (ca. 1475–1534). The dates defining these periods and cultures are under constant revision; those cited here are found in Richard W. Keatinge, preface in *Peruvian Prehistory*, Richard W. Keatinge, ed. (Cambridge, Mass., 1988) pp. xiii–xvii; for other recent chronologies, see Michael E. Moseley, *The Incas and Their Ancestors* (London, 1992) pp. 16–21; Heather N. Lechtman, "The Andean World," in *Andean Art at Dumbarton Oaks*, 2 vols., Elizabeth Hill Boone, ed. (Washington, D.C., 1996) I, pp. 15–32, esp. table 1; and Karen O. Bruhns, *Ancient South America* (Cambridge, Mass., 1994) pp. 7–14.

3. The development of copper metallurgy, and particularly systems for gilding and silvering copper surfaces, while beyond the scope of this article, was a major technological development of the Early Intermediate Period.

4. Alfred L. Kroeber, *Peruvian Archaeology in 1942* (New York, 1944) pp. 57, 127–128.

5. Samuel K. Lothrop, "Gold Artifacts of Chavín Style," *American Antiquity* 16 (1950–51) pp. 226–240, esp. p. 235. Lothrop also mentions a few specimens of poorly documented Early Horizon Paracas silver said to have been found by Tello at Cerro Colorado in southern Peru; see Samuel K. Lothrop, "Gold and Silver from Southern Peru and Bolivia," *Journal of the Royal Anthropological Institute of Great Britain and Ireland* 67 (1937) pp. 305–325, esp. p. 306. Lechtman, in "Traditions and Style," p. 235, suggests that the use of silver dates at least as far back as ca. 700 B.C., at the beginning of the Early Horizon. The Gallinazo culture dates to the early years of the Early Intermediate Period and was centered in the Virú Valley, south of the Moche valley.

6. See notes 57, 60 below.

7. Walter Alva and Christopher B. Donnan, *The Royal Tombs of Sipán* (Los Angeles, 1993) figs. 27, 33, 36, etc.

8. Representative gilded- and silvered-copper objects from Loma Negra were studied by Heather N. Lechtman, Antonieta Erlij, and Edward J. Barry Jr., who, in "New Perspectives on Moche Metallurgy: Techniques of Gilding Copper at Loma Negra, Northern Peru," *American Antiquity* 47 (1982) pp. 3–30, hypothesized the use of an electrochemical replacement plating method on all of the artifacts examined with the exception of a pair of earflares, see note 37 below; see also Heather N. Lechtman, "A Precolumbian Technique for Electrochemical Replacement Plating of Gold and Silver on Objects of Copper," *Journal of Metals* 31 (1979) pp. 154–160; idem, "Pre-Columbian Surface Metallurgy," *Scientific American* 250 (1984) pp. 56–63; idem, "Andean Value Systems," pp. 14–21. A number of the gilded-copper objects from Sipán have been described as depletion gilded; see Christian Eckmann, "Gilding Processes and Surface

Treatment of Gold-Silver-Copper Alloys from the Royal Tomb of Sipán," paper presented at the colloquium/workshop "Andean Royal Tombs, Works of Art in Metal," May 10, 1993, MMA. There were apparently no silvered-copper artifacts among those from Sipán examined by Eckmann.

9. Alan Lapiner, *Pre-Columbian Art of South America* (New York, 1976) pp. 113–115; Julie Jones, "Mochica Works of Art in Metal: A Review," in *Pre-Columbian Metallurgy of South America*, A Conference at Dumbarton Oaks, Oct. 18–19, 1975, Elizabeth P. Benson, ed. (Washington, D.C., 1979) pp. 53–104; Hans-Dietrich Disselhoff, "Metallschmuck aus der Loma Negra, Vicús (Nord-Peru)," *Antike Welt* 3 (1972) pp. 43–53.

10. Hans-Dietrich Disselhoff, *Vicús, Eine neu entdeckte altperuanische Kultur*, Monumenta Americana VII (Berlin, 1971); Hans Horkheimer, *Vicús, Exposición auspiciada por la Universidad Técnica de Piura* (Lima, 1965); idem, "Vicús, Ausdrucksformen einer neu aufgefundenen Kultur,"*Archiv für Völkerkunde* 22 (1968) pp. 85–91.

11. Bruhns, *Ancient South America*, p. 13.

12. For a general introduction to Moche culture, see Alva and Donnan, *Royal Tombs*, pp. 13–25; Christopher B. Donnan, *Moche Art of Peru*, rev. ed. (Los Angeles, 1978). The dates cited here for the Moche culture are based on Donnan's work.

13. Horkheimer, *Vicús*; Disselhoff, "Metallschmuck"; Lechtman et al., "New Perspectives," pp. 3–7; Peter Kaulicke, "Moche, Vicús-Moche y el Mochica Temprano," *Bulletin de l'Institut Français d'Études Andines* 21 (1992) pp. 853–903; idem, "La Presencia mochica en el Alto Piura: problematica y propuestas," in *Moche: Propuestas y Perspectivas*, Actas del Primer Coloquio sobre la Cultura Moche, Trujillo, April 12–16, 1993, S. Uceda and E. Mujica, eds. (Lima, 1994) pp. 327–358; Bruhns, *Ancient South America*, pp. 327–358; Krzysztof Makowski, Christopher B. Donnan, Ivan Amaro Bullon, et al., *Vicús* (Lima, 1994).

14. Schaffer, a graduate student at the Institute of Fine Arts, New York University, was then an intern in the Museum of Primitive Art, New York.

15. See, for example, Lechtman, "Traditions and Style," p. 344. Based on the paucity of cast objects found at Sipán, a metal-rich Moche site in Lambayeque Valley discovered in 1987, this does not seem remarkable.

16. Disselhoff, "Metallschmuck," p. 46.

17. Jones, "Mochica."

18. Anne-Louise Schaffer, "Impressions in Metal: Reconstructing Burial Context at Loma Negra, Peru," in *Recent Studies in Andean Prehistory and Protohistory*, D. Peter Kvietok and Daniel H. Sandweiss, eds. (Ithaca, 1985) pp. 95–119.

19. To these examples of Andean burials of elite individuals one might add a tomb of the Lambayeque culture recently excavated at Huaca Loro; Isumi Shimada and Jo Ann Griffin, "Precious Metal Objects of the Middle Sicán," *Scientific American* 270 (1994) pp. 82–89.

20. Walter Alva, "Discovering the New World's Richest Unlooted Tomb," *National Geographic* 174 (1988) pp. 510–548; idem, "Splendors of the Moche: New Royal Tomb Unearthed," *National Geographic* 177 (1990) pp. 2–15; Alva and Donnan, *Royal Tombs*; Walter Alva, *Sipán* (Lima, 1994). Since the appearance of two full-length volumes describing the excavation of three major tombs, approximately ten more burials, far less rich in their contents, have been excavated at Huaca Rajada.

21. Christopher B. Donnan, "Splendors of the Moche: Masterworks of Art Reveal a Remarkable Pre-Inca World," *National Geographic* 177 (1990) pp. 17–33, esp. pp. 29–32; idem, "The Royal Moche Tomb at La Mina, Jequetepeque Valley," paper presented at "Andean Royal Tombs," MMA.

22. Some of the finds from this looted site are documented in the Moche Archive at the University of California at Los Angeles. A number of objects said to be from La Mina are illustrated in Christopher B. Donnan, "Oro en el arte moche," in *Oro del antiguo Perú*, Juan Antonio de Lavalle, ed. (Lima, 1993) pp. 119–193.

23. Julie Jones, "Loma Negra—A Peruvian Lord's Tomb," exh. pamphlet, Oct. 13, 1992–July 4, 1993, MMA (New York, 1992).

24. Julie Jones, "Welcome, and More on Loma Negra," paper presented at "Andean Royal Tombs," MMA.

25. The first portion of the Loma Negra corpus accessioned by the MMA came from the Museum of Primitive Art in 1979 as part of the Nelson A. Rockefeller Bequest. Loma Negra objects formerly in the Arnold I. Goldberg collection were donated to the MMA in several phases, starting in 1980. A number of Loma Negra artifacts are illustrated in Lapiner, *Pre-Columbian Art*, nos. 347, 349–355, 357–361, 363, 365–369, 376–382, 385–386, 388–397.

26. Crescent ornaments, which may be ceremonial axes, are known only from the Vicús region. Examples are illustrated in Disselhoff, "Metallschmuck," figs. 3–5, 8–10, 12, 15, 17, and in Lapiner, *Pre-Columbian Art*, nos. 347, 360, 361, 365.

27. Jones, "Welcome."

28. Nine additional composite objects or pairs of objects, and two components of gold that were used in composite constructions, all belonging to various private collections, were documented in the Loma Negra Archive in the early 1970s. Some composite silver-and-gold objects attributed to the Vicús culture in catalogues of the Museo Oro del Perú are now thought to have come from Loma Negra; see Miguel Mujica Gallo, *Catalogue Museo "Oro del Perú"* (Lima, 1970) e.g., nos. 16, 17. One Loma Negra composite silver-and-gold nose ornament in a private collection appears in Lapiner, *Pre-Columbian Art*, no. 397. See also note 61 below.

29. Illustrated in Daniel Levine, *L'Or des dieux, l'or des Andes*, exh. cat., Metz-Arsenal (Woippy, 1994) p. 41.

30. Deborah Schorsch, "Manufacturing Methods of Composite Gold and Silver Objects at Loma Negra," paper presented at "Andean Royal Tombs," MMA.

31. Ellen G. Howe, Deborah Schorsch, Mark T. Wypyski, Samantha Alderson, Sarah Nunberg, and Leesa Vere-Stevens, "Technical Overview of Loma Negra Metalwork," paper presented at "Andean Royal Tombs," MMA; Deborah Schorsch, Ellen G. Howe, and Mark T. Wypyski, "Moche Metalwork from Loma Negra, Manufacture and Aesthetics," *Boletín Museo del Oro* (forthcoming).

32. The analyses were carried out by Mark T. Wypyski on a Kevex model Delta IV energy-dispersive x-ray spectrometer with a modified Amray model 1000 (1600T) scanning electron microscope operating at a voltage of 30 kV. The data were quantified with Kevex software using MAGIC IV ZAF corrections for standardless analysis and are reported in relative weight percentages of elements detected.

33. The analyses were carried out by Richard Newman on a Cameca electron beam microprobe equipped with a Tracor-Northern 5502 energy-dispersive x-ray fluorescence system with stage automation at the Department of Earth and Planetary Sciences

of Harvard University. The microprobe was calibrated with gold, silver, copper, and cinnabar standards, and matrix corrections were carried out using ZAF (fundamental parameters) method.

34. Heather N. Lechtman and Arthur Steinberg, "Bronze Joining: A Study in Ancient Technology," in *Art and Technology: A Symposium on Classical Bronzes*, Suzannah Doeringer, David G. Mitten, and Arthur Steinberg, eds. (Cambridge, Mass., 1970) pp. 5–35. Mechanical joining processes are based on the production of metal components that can be hammered, crimped, bent, or tied in place, sometimes with the use of rivets, wires, and tabs. Two other possibilities exist: cast components can be designed so that they interlock after casting, or components can be cast together. Moche composite gold-and-silver artifacts were nearly always made from hammered rather than cast components, and only the first of the three mechanical methods outlined by Lechtman and Steinberg has been observed.

35. See Lechtman et al., "New Perspectives," p. 7, and Lechtman, "Traditions and Style," pp. 360–362. The entirely silver objects surviving from Loma Negra are simple nose ornaments whose manufacture did not require joining.

36. See Alva and Donnan, *Royal Tombs*, fig. 166.

37. The backplates of the frontals and the shafts are gilded-copper sheet, and the earflares are one of two pairs of objects from Loma Negra known to have depletion gilded components; Lechtman, "Andean Value Systems," fig. 5; Silvia A. Centeno and Deborah Schorsch, "The Charaterization of Gold Layers on Copper Artifacts from the Piura Valley (Peru) in the Early Intermediate Period," in *Gilded Metals*, Terry Drayman Weisser, ed. (forthcoming).

38. The MMA earflare frontal, while it was still in the Museum of Primitive Art, was described by Lapiner (*Pre-Columbian Art*, no. 380) as having a silvered-gold web, a misperception that probably arose from the presence of a grayish sulfide tarnish on the gold surface.

39. Pressure-fitting is a mechanical joining method that involves preparing metal-sheet components that can be hammered to fit tightly together without tabs, wires, etc.

40. An exception is a nose ornament in the National Museum of the American Indian (15/901) composed of a gold bead on a silver wire.

41. Most of the other eight disks from Loma Negra in the MMA are made of gilded copper. Two examples are illustrated in Lapiner, *Pre-Columbian Art*, nos. 363, 366. A number of disk ornaments not documented in the Loma Negra Archive are found in the American Museum of Natural History.

42. Surface layers on components marked with an asterisk were not analyzed.

43. This and other analyses of silvered and gilded surfaces presumed to be applied by electrochemical deposition were normalized by the subtraction of copper, which, in such cases, would be present almost exclusively due to the migration of copper from the substrate during burial; see Centeno and Schorsch, "Oro y Plata."

44. The data plotted in Figure 16 derive from SEM analyses carried out at the MMA Sherman Fairchild Center for Objects Conservation and from published analyses that appear in Salvador Rovira, "Pre-Hispanic Goldwork from the Museo de América, Madrid: A New Set of Analysis," in *Archaeometry of Pre-Columbian Sites and Artifacts: Proceedings of a Symposium Organized by the UCLA Institute of Archaeology and the Getty Conservation Institute, Los Angeles, March 23–27, 1992*, David A. Scott and Pieter Meyers, eds. (Malibu, 1994) pp. 323–350, and in Kroeber, *Peruvian Archaeology*, p. 132. For these

and other analyses subsequently carried out at the Sherman Fairchild Center, see Schorsch et al., "Manufacture and Aesthetics."

45. See the Chavín pectorals discussed on page 125.

46. Jones, "Mochica," figs. 19, 20; Schorsch et al., "Manufacture and Aesthetics."

47. Heather Lechtman has written extensively about the significance of color in ancient Peruvian metalwork.

48. A similar effect, attained through the juxtaposition of plain and textured surfaces that have different reflective properties and therefore appear to be of slightly different colors, can be observed on a Loma Negra gilded-copper openwork disk, decorated with concentric bands of sea creatures (MMA 1987.384.46); Schorsch et al., "Manufacture and Aesthetics."

49. The metal is erroneously described as copper sheet in Lechtman et al., "New Perspectives," p. 6.

50. A sample of wood removed from the inside of this artifact provided a carbon-14 date of A.D. 295 ± 95 years; Lechtman et al., "New Perspectives," p. 5.

51. A mask in a private collection attributed to the Vicús culture is described as having been made from mirror-image gilded- and silvered-copper sheets joined with a metal "staple"; see Museum zu Allerheiligen, *Idole Masken Menschen: Frühe Kulturen, Alte Welt und Neue Welt*, exh. cat. (Schaffhausen, 1992) no. 5.18.

52. Attempts to identify natural resins used on artifacts from Loma Negra have thus far proved unsuccessful.

53. A method of inlay more familiar to students of Old World metallurgy appears much later and becomes widespread in Peru only in Inka times. In that case the metal to be inlaid is formed or cut to size and hammered into existing channels; see Julie Jones, *Art of Empire: The Inca of Peru*, exh. cat., Museum of Primitive Art (New York, 1964) fig. 38.

54. Heather N. Lechtman, "The Central Andes: Metallurgy without Iron," in *Coming of the Age of Iron*, Theodore Wertime and James D. Muhly, eds. (New Haven, 1980) pp. 267–334, esp. p. 286; Lechtman, "Traditions and Style," p. 360.

55. Howe et al., "Technical Overview"; of the hundreds examined, nine individual objects or pairs of objects were found to have been joined with solder. With the exception of the silver-and-gold composite nose ornament discussed here, these examples were made from gold or gilded-copper sheet. As used in this essay, the term soldering refers to high-temperature, or hard, soldering, which is generally referred to as brazing in the metallurgical industry; see Deborah Schorsch, "Copper Ewers of Early Dynastic and Old Kingdom Egypt—An Investigation of the Art of Smithing in Antiquity," *Mitteilungen des Deutschen Archäologischen Instituts Abteilung Kairo* 48 (1992) pp. 146–159, esp. p. 152.

56. Two composite nose ornaments not in the MMA that are known from photographs in the Loma Negra Archive are also likely to have been assembled with solder.

57. Solder was used to join some gold components to each other and may well also have been used for gold-to-silver joins; Lechtman, "Bimetallic Effigy Spoon" (cat. entry), in *Andean Art at Dumbarton Oaks* I, pp. 55–66.

58. Samuel K. Lothrop, "Gold Ornaments of Chavín Style from Peru," *American Antiquity* 6 (1940–41) pp. 250–262, esp. pp. 258–260, pl. xxc. Solder is not visible in the radiographs of the pin, neither on gold-to-gold or gold-to-silver joins. The joins may have

been produced by fusing, which is executed at elevated temperatures without the introduction of a filler metal.

59. Compare Lechtman, "Traditions and Style," p. 263.

60. A sample of the solder used to join one of the backplates to the web from the nose ornament was analyzed and found to contain 52.8% silver, 33.0% copper, and 14.2% gold. The composition of the solder used on the Loma Negra gilded-copper warrior figures is entirely different, containing 48.5% gold, 27.7% silver, and the remainder copper (Howe et al., "Technical Overview"). Copper-silver solders have also been noted on Moche gold objects (Lechtman et al., "New Perspectives," pp. 38–42), as has the use of both gold- and silver-based soldering alloys on Chavín gold (Lechtman, "The Central Andes," p. 286). At the present time there are too few analyses of Moche solders to compare with these data or to evaluate what combination of factors, aesthetic and practical, affected their formulation.

61. In addition, not included in the archive is a hammer-welded Loma Negra nose ornament in the American Museum of Natural History (41.2/6983).

62. Donnan, "Oro," figs. 127, 128, 130, 131.

63. These pectorals were formerly thought to be of the later Chimú period; Pliny E. Goddard, "Peruvian Gold of the Chimú Kingdom," Natural History 21 (1920) pp. 447–452.

64. See esp. Mujica Gallo, "Oro del Perú," nos. 3326, 3328–3330, 3332, 3353, 3359, 3420, 3431; A. D. Tushingham, Ursula M. Franklin, and Christopher Toogood, Studies in Ancient Peruvian Metalworking, History, Art and Technology Monograph 3 (Toronto, 1976) nos. 24, 32, 34, 42, 43; Makowski et al., Vicús, figs. 120, 466, 477.

65. Lechtman in The Andean World, pp. 207–210; a tupu is a pin used for securing clothing.

66. A. D. Tushingham, Kent C. Day, and Léo Rosshandler, Gold for the Gods, exh. cat., Royal Ontario Museum (Toronto, 1979); see Tushingham et al., Ancient Peruvian Metalworking, pp. 20–24.

67. Tushingham et al., Ancient Peruvian Metalworking, figs. 72, 74, 76.

68. One such example, a scepter from Sipán, is discussed on pages 128–129.

69. Objects were sampled on outer edges away from hammer-welded joins so that the analyses more or less reflect the metal as originally formulated and unaffected by diffusion that occurred at the joins.

70. Georg Peterson, Minéria y metalurgia en el antiguo Perú, Arquelógias, Publicaciones del Instituto de Investigaciones Antropologias 12 (Lima, 1970); Noel H. Gale and Zofia A. Stos-Gale, "Ancient Egyptian Silver," Journal of Egyptian Archaeology 67 (1981) pp. 103–115, esp. p. 114.

71. Ernst Drost and Jürgen Haußelt, "Uses of Gold in Jewellery," Interdisciplinary Science Reviews 17 (1992) pp. 271–280, fig. 1.

72. Preliminary hammer-welding replication experiments were undertaken by Robert Baines during his residency at the Sherman Fairchild Center.

73. This average is based on the analysis of three of the four gold-rich bands.

74. The fourth gold-rich band contains about 85% gold, which raises the melting point to approximately 975°C.

75. These pectorals are discussed by Lechtman in Benson, Dumbarton Oaks, p. 74 and no. 29.

76. Lapiner, Pre-Columbian Art, nos. 380, 393; see note 38.

77. Lechtman et al., "New Perspectives," p. 7; see also Lechtman, "Andean Value Systems," fig. 6.

78. The famous mask from Huaca de la Luna in the Linden-Museum Stuttgart Staatliches Museum für Völkerkunde (119–156) is described in a recent publication as partially silvered gold; Donnan, "Oro," p. 124. The piece had been previously published by other scholars as gilded and painted copper (e.g., Jones, "Mochica," p. 70), which was reconfirmed by Ulrike Bunte of the Linden-Museum, who recently examined the mask (Bunte, personal communication with author). Visual examination of a specific type of composite silver-and-gold Vicús nose ornaments indicates that they were partially silvered, but as yet no analyses have been undertaken. There is a partially silvered gold bowl, attributed to the Huari culture of the Middle Horizon, in the Museo Nacional de Arqueologiá, Antropologiá y Historia in Lima.

79. P. Andrew Lins, "A History of Metal Coatings on Metals Pre-1800 AD (unpublished manuscript, 1974; British Museum Department of Scientific Research Reference Library 669 [031]) p. 20, cites an unusual case of an oblong piece of gold wrapped in silver sheet from predynastic Egypt. Several authors have noted Chinese amalgam silvered bronzes that have a gold layer between the silver and the bronze. It has recently been suggested that the presence of a gold layer improves the adhesion of the silver; Kilian Anheuser, "An Investigation of Amalgam Gilding and Silvering on Metalwork" (Ph.D. diss., University of Oxford, 1996) p. 14.

80. The large patch of copper visible in the elemental dot map corresponds to the presence of copper corrosion products on the inner surfaces of the irregularity.

81. All microprobe analyses were carried out with a point beam. An area of approximately three microns in diameter generates the x-rays detected in a single analysis. Therefore, as most of the successive points analyzed are only 0.5–2.0 microns apart, there is considerable overlap.

82. V. P. Oehm, Investigaciones sobre minéria y metalurgia en el Perú prehispánico, Bonner Amerikanische Studien 12 (Bonn, 1984) p. 47.

83. Lins, "Metal Coatings," p. 30; for mercury silvering on base metal substrates, see Susan La Niece, "Silvering," in Metal Plating and Patination, Susan La Niece and Paul T. Craddock, eds. (London, 1993) pp. 201–210; see also note 79 above.

84. Peterson, Minéria y Metalurgia, pp. 55, 87.

85. In Moche burials traces of a red pigment that has not been analyzed are often found on the frontal bones and eye orbits of the deceased, and a unique case where the floor of a Moche tomb was covered with red pigment, also unidentified, was found in Sipán; Alva and Donnan, Royal Tombs, pp. 91, 215.

86. The scans were carried out on a Phillips 1710 open architecture diffractometer using copper radiation. No crystalline phases were detected.

87. David A. Scott, "Fusion Gilding and Foil Gilding in Pre-Hispanic Colombia and Ecuador," in Precolumbian American Metallurgy, Clemencia Plazas, ed. (Bogota, 1985) pp. 307–326, and idem, "Gold and Silver Coatings over Copper: An Examination of Some Artefacts from Ecuador and Colombia," Archaeometry 28 (1986) pp. 33–50.

88. Alva and Donnan, Royal Tombs, pp. 96–100, figs. 101–104; solder was the means of attaching the gold scepter to the silver handle. It is unclear if the second scepter (Donnan, "Oro," fig. 117) also had gold inlay.

89. These trumpets are documented only in the Moche Archive (UCLA).

90. Alva and Donnan, *Royal Tombs*, pp. 221–223; *tumis* are a type of blade.

91. Ibid., p. 221, figs. 230, 231.

92. For example, in tomb 2 at Sipán in the burial of a man who has been tentatively identified as a "Bird Priest," a gold-and-silver nose ornament and a composite backflap were placed so that their gold and silver halves corresponded to the right and left sides of the deceased's body; Alva and Donnan, *Royal Tombs*, pp. 148–160, 163–165, figs. 160 (left), 166.

93. Composite nose ornaments of this type are occasionally worn by Moche and Vicús personages represented in clay vessels; see Lapiner, *Pre-Columbian Art*, nos. 445, 451; Christopher B. Donnan, *Ceramics of Ancient Peru* (Los Angeles, 1992) cat. no. 121.

94. Furthermore, adherence to strict right and left placements of gold and silver artifacts, respectively, around the body of the deceased in burials is not observed. A pair of nose ornaments, one of gold and the second of silver, was found one on top of the other on the right side of the deceased's cranium, believed to be a "Warrior Priest," in tomb 3 at Sipán; Alva, *Sipán*, figs. 72, 74.

95. Heather N. Lechtman, "Additional Perspectives on Moche Metallurgy," paper presented at "Andean Royal Tombs," MMA.

The Medici-Tornabuoni *Desco da Parto* in Context[1]

JACQUELINE MARIE MUSACCHIO

Trinity University, San Antonio, Texas

T HE BIRTH OF A CHILD was much desired and often lavishly celebrated in Renaissance Italy. During this period, large families were valued for demographic, economic, and political reasons. In many cases, these celebrations were magnified by an awareness of the inherent dangers any successful birth had to overcome. A significant percentage of deaths among young married women was associated with childbearing, and an equally large number of infants died within days of birth.[2] This situation resulted in the production and use of numerous objects to encourage, celebrate, and commemorate childbirth. Although relatively few such objects survive today, we can learn about them from contemporaneous household inventories. These objects retained their birth-related identity, signified by their common designation *da parto*, years after the actual event.[3] The typical Renaissance birth chamber was elaborately furnished with embroidered sheets and pillows, painted tables and birthing chairs, and ornate tablecloths. New mothers wore special clothing and head coverings, and distinctive mantles, swaddling clothes, and gowns were made for babies to wear at baptism.

From the evidence it seems that members of most social classes used childbirth objects. Naturally, the wealthiest families had the most impressive array. For example, Francesco Inghirammi, an employee of the Medici bank, was a very wealthy man at his death in 1470.[4] He left seven children, ranging in age from a few months to twelve years; the inventory of his estate in Florence included two painted birth trays, a box containing birth charms, a birth mantle, two sets of embroidered birth sheets, two embroidered birth pillows, and a birthing chair.[5] However, not every consumer had the financial resources of Inghirammi. As a result, birth objects were available in a variety of price ranges. In 1551 the estate of a blacksmith in Livorno included six embroidered pillowcases of soft white linen for use during confinement.[6] The employer of a servant woman in Florence gave her clothing, chick-

ens, and wine when she was pregnant in 1476.[7] And throughout the fifteenth century the Ceppo, a charitable foundation in Prato, purchased candies, nuts, and candles for various poor families on the occasions of births and baptisms, stating in their records that it was done "for the love of God."[8]

Many of these childbirth objects are known to us primarily through documentary evidence. But one important type of childbirth object does survive today: the painted wooden tray, usually referred to as a *desco da parto*, which is best exemplified by the Medici-Tornabuoni tray in the Metropolitan Museum (Figures 1, 2).[9] Evidence indicates that this tray was made to celebrate the birth of Lorenzo di Piero de' Medici, known as *il Magnifico*, who ruled the city of Florence from 1469 to 1492. The tray was painted by the prolific Florentine artist Giovanni di Ser Giovanni, known as Scheggia (1406–1486), and it seems to have been presented by Piero di Cosimo de' Medici to his wife, Lucrezia di Giovanni Tornabuoni, at Lorenzo's birth in 1449. Lorenzo was the firstborn son, and as such his birth must have been lavishly celebrated with the full range of childbirth objects favored at that time. Until this century, none of these was thought to survive; the vast majority of the objects were ephemeral and have long since disappeared. However, in 1905, Aby Warburg used the inventory of Medici possessions made at Lorenzo's death to establish that the childbirth tray listed in Lorenzo's room was in fact the Museum's tray, which was then in the collection of the New-York Historical Society.[10] This inventory listed "a round childbirth tray painted with the Triumph of Fame" in Lorenzo's personal quarters, valued at ten florins.[11] Further details regarding its provenance, unknown until now, appear below.

Household inventories regularly listed painted childbirth trays during this period. They were relatively common objects, so no further description or reference to figural content was provided. This very fact emphasizes the unusual qualities of the Medici-Tornabuoni tray, since its iconography was so precisely identified in Lorenzo's inventory. As the inventory states, the front of the tray depicts the Triumph of

METROPOLITAN MUSEUM JOURNAL 33

The notes for this article begin on page 147.

Figure 1. Giovanni di Ser Giovanni (1406–1486). *The Triumph of Fame* (front of a childbirth tray), ca. 1448. Tempera, silver, and gold on wood, Diam. 92.7 cm. The Metropolitan Museum of Art, Purchase in memory of Sir John Pope-Hennessy: Rogers Fund, The Annenberg Foundation, Drue Heinz Foundation, Annette de la Renta, Mr. and Mrs. Frank E. Richardson, and The Vincent Astor Foundation Gifts, Wrightsman and Gwynne Andrews Funds, special funds, and Gift of the children of Mrs. Harry Payne Whitney, Gift of Mr. and Mrs. Joshua Logan, and other gifts and bequests, by exchange, 1995, 1995.7

Fame, largely based on both Boccaccio's *Amorosa visione* (1342) and Petrarch's *Trionfi* (1354–74), two vernacular texts popular during the Renaissance.[12] The growing humanist interest in classically inspired literature, and its dissemination in both manuscript and printed form, led to the prominence of this type of secular iconography on domestic objects like marriage chests and birth trays. As triumphal images were often utilized as moral examples, their representation on domestic art was particularly relevant. Several child-

birth trays, in fact, were painted with individual triumphs.[13] But the composition on the front of the Medici-Tornabuoni tray is different from that of any other childbirth tray and even slightly different from other representations of the subject.[14] In fact, the Triumph of Fame is usually represented on domestic art in a series with other triumphs, rather than by itself.

That is clearly not the case with the Museum's tray, since the image is entirely autonomous. It is carefully constructed according to the newly promulgated

Figure 2. Verso of Figure 1, showing device of Piero de' Medici with the Medici and Tornabuoni coats of arms

tenets of linear perspective. In the center is a fantastically articulated pedestal, which combines disparate elements of classical architecture to render a complex pastiche structure. On top of the pedestal is a fluted globe, no doubt meant to signify the orb of the world. This globe may take the place of the mandorla within which the figure of Fame often stood in more traditional representations of the subject.[15] The use of the mandorla followed Boccaccio's description in *Amorosa visione*, which read,

And among the other things which I noticed there
around about this supreme
lady, in her magnanimous breast
the enemy of death, was a perfect circle
rotating lofty and round,
from beneath her feet and over her head.
I do not believe there can be anything
in the whole world, town or country, domestic
 or foreign,
which would not appear within that circle.[16]

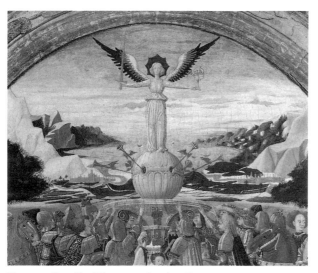

Figure 3. Detail of Figure 1, showing Fame

Figure 4. Detail of Figure 1, showing frame

But the circular shape of the Medici-Tornabuoni tray itself may have worked here as Boccaccio's "perfect circle," encompassing everything painted on this tray—both nature and humankind—within the orbit of Fame.

The globe is punctuated by six portholes, and from these project six winged trumpets, a feature common to earlier representations of the subject. The globe supports a winged figure of Fame (Figure 3), whose stiff frontal pose, hieratic posture, and serious expression are strikingly medieval in inspiration, in contrast to the innovative architectural construction on which she stands. Her arms are outstretched, and she holds a sword in her right hand and a statuette of a cupid in her left.[17] Because of the high platform, Fame dominates the surrounding figures and landscape and stands outlined against the distant mountains, river, sea, and sky. On each side of her, set into the landscape, is a walled city, and around her are twenty-eight knights and men on horseback, fourteen on each side, dressed in a variety of flamboyant clothing and armor. Unlike other versions of the Triumph of Fame, the men are not identified by individual labels. But their worth as men of virtue and renown is clear by their appearance and by their proximity to the figure of Fame herself. Those closest to the platform raise their right hand to Fame, in order to become part of her themselves.[18] Those farthest away observe the action with a more detached calm. At the base of the platform are two retainers, one centrally placed and staring out at the viewer, the other barely visible because of the cluster of men on horseback.[19] In the immediate foreground, which is dotted with tufted plants and

striped with different grasses, are three rather ungainly hounds, one white, one black, and one a rich brown.

The reverse of the Medici-Tornabuoni tray is dominated by Piero de' Medici's prominent personal device, composed of a diamond ring, three feathers, and a scroll inscribed with the motto "Semper." The diamond ring with feathers had been used by Cosimo de' Medici, Piero's father and Lorenzo's grandfather, but Piero added several details to make the device his own. He incorporated the colors of the Theological Virtues (red, green, and white) into the feathers, and added his motto to the arrangement. The Medici-Tornabuoni tray seems to be the earliest example of this complete device.[20] On each side of the device, near the top of the tray, is a coat of arms. On the left are the eight red *palle*, or balls, of the Medici, and on the right is the rampant lion of the Tornabuoni. The obvious dynastic message on the reverse is continued by the garland of red, green, and white feathers on the elaborate front frame (Figure 4).

Despite the extremely high quality and historical interest of this tray, childbirth trays in general have remained relatively unknown. Surviving examples and documentary citations indicate that these wooden trays were of several distinct types. The first and best-known type is the painted tray, which initially appeared about 1370, in the first generation after the Black Death, and continued to be used through the third quarter of the sixteenth century.[21] The Medici-Tornabuoni tray is an example of this type. Although statistical evidence is not conclusive, inventories suggest that nearly half of late-fourteenth- and fifteenth-century households had at least one of this type of birth tray among their

possessions.[22]

In fact, wooden childbirth trays, like the other birth-related objects mentioned earlier, were part of birth celebrations at almost every level of Renaissance society. The Medici were following a well-established tradition popular even in families of much lesser economic means. The main evidence we have regarding this tradition is the numerous wooden trays that have survived. But equally important evidence for the presence and the popularity of the childbirth tray comes from the inventories in the Florentine Magistrato dei Pupilli, the government agency that inventoried and processed the estates of deceased citizens for the protection of their minor heirs.[23] These sources, combined with occasional literary, documentary, and artistic references, can reveal a great deal about the role, appearance, production, and patronage of these trays in Renaissance Italy.

The primary role of the childbirth tray was, above all, utilitarian: it was used to carry food and gifts into the confinement chamber and to hold items at the new mother's bedside.[24] In his *Lives of the Most Excellent Architects, Painters, and Sculptors*, Vasari described a drawing made by the painter Francesco Salviati (1510–1563) in the early 1540s, which was used "to paint on one of those round panels on which one carries food to confined women."[25] Descriptions in inventories confirm Vasari's statement that these trays were actually employed and were not simply decorative accessories; they were occasionally identified as trays for women to use during their stay in bed after childbirth.[26] Such a tray often appeared in painted scenes of confinement. In Paolo Uccello's fresco of the Birth of the Virgin, the attendant carries a tray to the mother's bedside; on the tray, which is draped with a white, embroidered cloth, are two carafes of wine, no doubt to fortify the new mother following labor (Figure 5).[27] Images on several surviving childbirth trays also indicate their use. One tray shows a mother sitting up in bed to receive guests with a draped tray on the coverlet beside her (Figure 6). The use of special cloth covers to protect the painted surface reinforced the importance of these objects to the childbirth ritual. Documents further confirm this practice; several inventories cite special covers to protect—and, no doubt, enhance—the trays.[28] These accessories indicate the high esteem in which childbirth trays were held by contemporaries.

We can learn much about the production of birth trays by a close physical examination. Most surviving examples measure between fifty and sixty centimeters in diameter.[29] Although contemporary inventories do not provide exact measurements, a standard is implied when the clerk described a tray as large or small.[30] Their size probably made it easy to construct them

Figure 5. Paolo Uccello (1397–1475). *The Birth of the Virgin*, ca. 1436. Fresco. Prato, Cathedral (photo: Alinari/Art Resource, N.Y.)

from a combination of smaller wood remnants available in the workshop.[31] Furthermore, it appears that shapes were standardized. The earliest surviving trays are twelve-sided or sixteen-sided. But documentary evidence suggests that round birth trays appeared by the late fourteenth century, although the earliest example dates from about 1430.[32]

According to both surviving examples and documentary evidence, the early trays were painted with

Figure 6. Bartolommeo di Fruosino (1366/69–1441). *Confinement Room Scene* (front of a childbirth tray), 1428. Tempera, gilt, and silver on panel. Private collection (on loan to The Metropolitan Museum of Art)

141

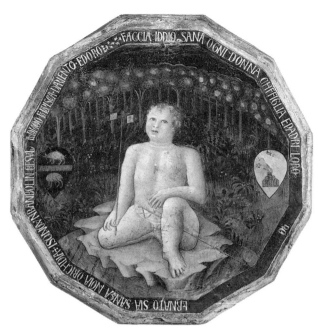

Figure 7. Verso of Figure 6

tempera on both sides and usually had gilt frames or moldings.[33] The frames were attached to one or both sides of the tray. Evidence of paint overlap on intact frames and the painted outlines visible on trays that have had their frames removed indicate that the trays were painted with their frames already attached. Although this procedure made the panels unwieldy, it was practical, since the painted surface would be damaged if the

Figure 8. Detail of Figure 2

frame was attached later.[34] Frames prevented damage to the painted surface when the tray was hung on a wall or rested on a surface, and their raised edges kept small objects from falling off when they were carried. As a result, the frames were subject to considerable stress, and only a few original examples survive. Very few of these are known to have hooks in them, but it seems logical that the trays would hang on the wall in this manner. The Medici-Tornabuoni tray has the remains of a broken hook in the top of its frame, on the reverse (Figure 8). There is no such device on the recto, which implies that the reverse of the tray was not necessarily meant for prolonged display.[35] In fact, it is clear from the entry in the Medici inventory, which specifies only the triumphal scene, that the Museum's tray was hanging front forward at the time of Lorenzo's death.

More specific information about the production and sale of childbirth trays is rare. The Medici-Tornabuoni tray is attributed to Scheggia, the brother of Masaccio and a skilled artist in his own right, who painted a number of other birth trays and marriage chest panels.[36] Although Scheggia executed several religious panels and sacred frescoes, he is best known today for his domestic, secular paintings. His formal training was with the painter Bicci di Lorenzo, as well as, more informally, with his brother, with whom he lived for an extended period of time.[37] Scheggia was also somewhat influenced by Domenico Veneziano, as can be seen in certain features of this birth tray.[38] But Scheggia was not the only painter who executed childbirth objects; others can be associated, for example, with Masaccio, Neri di Bicci, and Pontormo.[39] Indeed, Vasari stated that no early Renaissance artist looked upon furniture painting as a shameful activity.[40]

Inventories and painted representations indicate that the often elaborate interiors of Renaissance homes contained a wealth of objects, some entirely unknown to us today.[41] To furnish these homes expediently and affordably, most consumers had to turn to a variety of sources. There were a significant number of artists who produced uncommissioned objects in quantities to sell on the open market, displaying different kinds of ready-made paintings and sculpture in their shops for examination and purchase by the public.[42] The tradition of stock production was surprisingly strong for domestic art, and childbirth objects were no exception. There must have been a considerable demand for birth trays, since childbirth was a regular and a widely celebrated event. Most birth trays do appear to have been made for the open market. For example, in 1383, the wool dealer Benedetto degli Albizzi purchased several paintings, including two small birth

trays, from the workshop of a deceased painter and then sold them at a profit. The fact that there were completed but unclaimed trays in this painter's shop when he died indicates that they were executed with no specific buyer in mind.[43] This was no doubt common; in his *ricordanze*, Neri di Bicci described a painted birth tray made at his own expense as a stock item.[44]

Given this sort of testimony, as well as the evidence of the trays themselves, it is probable that the majority of childbirth trays were workshop productions, executed in multiples according to patterns in loose sheets or model books. The availability of these patterns would have facilitated the reuse of specific motifs within the workshop. The iconographic range for birth trays was relatively limited, and almost all known trays can fit into specific categories. Similar serial production is evident in the marriage chest panels and devotional images from Apollonio di Giovanni and Marco del Buono's popular shop, which was a major source for domestic furnishings of all types in the fifteenth century.[45] Motifs were taken from various sources and adapted as necessary to each composition. With this piecemeal method, a shop could keep a staff large enough to complete commissions during busy periods, yet still have work to do in slower times.[46] Designs were also passed between shops, a practice that is especially noticeable in the group of childbirth trays that illustrate Petrarch's Triumph of Love. Several of these trays feature similar motifs, even though they originated in different workshops.[47]

Standardization of this sort guaranteed that the customers received what they wanted. The addition of small coats of arms at purchase time was all that was necessary to particularize many of these stock childbirth trays. The small heraldic shields were usually placed to the sides of the main scenes, or in an otherwise unobtrusive position. In a tray by Bartolommeo di Fruosino, on loan to the Metropolitan Museum, there are small heraldic shields on both the front and back, as well as a small inscription on the front with the date (Figures 6, 7). Such inconspicuous locations allowed for the insertion of heraldic devices with minimal difficulty once the tray was purchased. Coats of arms loudly proclaim one of the major reasons behind the birth celebrations and the trays themselves: the new child, who extended the lineage, with the two coats of arms representing the *parentado* between the two families.[48]

Of course, not everyone purchased birth trays from stock supplies. Some buyers resorted to secondhand dealers.[49] We know that Niccolò Strozzi bought a secondhand birth tray for his wife, Francesca, who was eight months pregnant, for a mere seven lire.[50] At the same time, but from another dealer, Strozzi bought Francesca a pink nightshirt lined in white fur and a small mantle for their newborn.[51] Clearly, the sale of all kinds of childbirth objects through secondhand dealers was quite common, although payment records are rare. Sometimes, Pupilli inventories would provide a valuation of individual estate items for sale purposes. But it is often difficult to determine if the object was sold at that price or simply appraised for accounting purposes. Nevertheless, the most inexpensive tray listed in the Pupilli was valued at a mere ten soldi in 1418,[52] while the costliest was valued at three florins in 1441.[53]

The wide range of prices and the constant demand indicate an active market in both stock and secondhand trays. But the wealthier Renaissance patrons must have commissioned their childbirth trays directly. One of the better-known cases appears in the workshop ledger of Apollonio di Giovanni and Marco del Buono.[54] This ledger includes a reference to Giovanni di Amerigo Benci's request in 1453 for a round birth tray painted with the story of Solomon and Sheba, which cost him nine florins.[55] But surely this was not a great expense for Benci; he was the general manager for the Medici bank from 1440 to his death in 1455, and as a close colleague of the Medici he was a similarly ostentatious patron of the arts.[56] In fact, with the example of Piero, less than five years earlier, commissioning an elaborate and unique tray for the birth of his son, Benci may have felt a certain degree of pressure to commission a similarly impressive tray for a birth in his own family.[57] Because this was a special commission, the nine florins Benci paid was considerably more than he would have had to spend otherwise.

It is within this context that we must consider the Medici-Tornabuoni birth tray. Like Giovanni Benci, Piero di Cosimo de' Medici was not the type of man who purchased his art on the open market or from the secondhand dealers. He was, instead, a significant and influential art patron, and one with an obvious desire for expensive and glorifying effects.[58] Francis Ames-Lewis has characterized Piero's taste during this period as one focused on delicate surfaces, rich details, bright color, and specific Medicean symbols.[59] All four characteristics can be seen quite clearly in the Museum's tray, which must have been commissioned by late 1448 to be ready for Lorenzo's birth on New Year's Day, 1449. The finely detailed composition on the front is carefully designed according to linear perspective, the colors are brilliant, and the gilding is extensive. This tray, which is about thirty centimeters wider than most surviving trays, was constructed in an extravagant fashion, making it much too expensive a

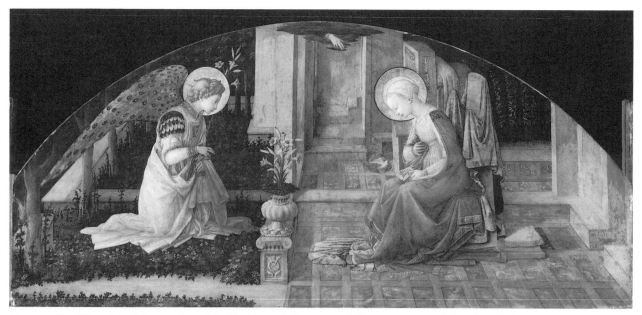

Figure 9. Fra Filippo Lippi (ca. 1406–1469). *The Annunciation*, ca. 1448. Tempera on panel. London, National Gallery

venture for a mere stock item. And the large-scale device and coats of arms make a deliberate reference to Medicean pride and lineage.

In fact, Piero's public commissions, including the tabernacles in San Miniato and Santissima Annunziata, always incorporate his devices and the family coat of arms into the design. He had a great desire to extol his lineage in this public manner.[60] But, as the Medici-Tornabuoni tray indicates, he also wanted to surround himself with objects emphasizing that lineage—and its prominence—in his own domestic space. Piero seems to have exhibited these same interests in the commission of Fra Filippo Lippi's *Annunciation*, which includes his device of a diamond ring surrounding three feathers on the low balustrade between the figures (Figure 9).[61] Lippi's painting was probably intended for a room of the Medici palace where it would have been seen by visitors, rendering the dynastic significance of the device unmistakable.[62]

There is considerable further evidence for associating this childbirth tray with Lorenzo de' Medici's birth. The image of the Triumph of Fame is unique among both surviving and documented childbirth trays, implying that it was used in this case by special request. Clearly, the image of Fame was an appropriate subject for a child destined to be the leader of the city of Florence. And, in fact, it is possible that the numerous schematic walled cities in the background signified Medici dominion over surrounding lands in Tuscany. The iconography of these childbirth trays was not mere gratuitous ornamentation. Each subject must have had a special meaning to contemporaries, although its nu-

ances are often lost to us today.[63] In several cases, the same subjects were depicted on both marriage chests and birth trays, a logical overlap, given the very intimate link between the two events in Renaissance thought.[64]

There seems to have been a close connection between this subject and Scheggia as well. An intriguing group of four curved panels attributed to Scheggia also illustrates *Trionfi*. In this case, there is an individual panel for the Triumph of Love, Fame, Death, and Eternity.[65] These panels, dated to about 1450, probably made up part of a piece of furniture that has since been dismantled. But the depiction of the Triumph of Fame on this panel differs considerably from its depiction on the Medici-Tornabuoni birth tray (Figure 10). On the panel, the figures are arranged in a frieze facing right. The white-robed figure of Fame is surrounded by a mandorla and seated on a chariot, which is pulled, as Petrarch specified, by elephants. The chariot is surrounded by both male and female figures, some of whom are labeled for easier identification. Fame holds a sword in her right hand and a large book in her left. Certain details, such as the horses with their elaborate caparisons, the clumps of grass, the winged trumpets, and the high-waisted white robe of Fame, are depicted in both the panel and the birth tray. But the tray is considerably more innovative and detailed, and it stands on its own as an independent entity, rather than as a part of a continuous processional image that is carried through more than one panel.

Piero de' Medici is also known to have had a particular fondness for *Trionfi*. A letter from the artist Matteo de' Pasti indicates that Piero commissioned an

144

illuminated manuscript of Petrarch's *Trionfi* sometime in 1441.[66] At this time, Piero was beginning to accumulate important texts for his library; this may have been one of the first. Both the 1456 and 1464 inventories of Piero's estate included such a volume covered in green velvet and closed with silver fastenings.[67] This reference has been associated with a manuscript in Paris, now unfortunately missing its illuminations.[68]

But Piero's interest in triumphs went beyond the actual texts. To celebrate his wedding to Lucrezia Tornabuoni in 1448, he seems to have purchased a pair of marriage chests painted with a series of triumphs. These chests were apparently passed down to Lorenzo; just such a pair was recorded in Lorenzo's room at his death.[69] The two panels now in the Isabella Stewart Gardner Museum in Boston, attributed to Francesco Pesellino (1422–1457), probably came from this pair (Figure 11).[70] These panels show evidence that they were originally from the front of marriage chests. Their size corresponds to the long, low format used for marriage chests at this time, and each one has visible damage in the central top area, most likely from keys that once hung from the now-removed locks that secured their contents. One of the panels depicts the Triumphs of Love, Chastity, and Death, and the other depicts the Triumphs of Fame, Time, and Eternity. All but Eternity share a continuous landscape background, as if the triumphal carts are in a ceremonial parade.[71]

Taken together, these factors point to Piero de' Medici as the patron of the Museum's tray. He was certainly able to afford such an unusually large and carefully executed object, with its ostentatious metallic leaf and finely detailed figural scene. His Petrarchan manuscripts and marriage chests prove that he was particularly fond of the subject, and his personal devices decorate both the front and the back of the tray. Although evidence for the purchase of birth trays is extremely rare, as a proud father Piero would have

Figure 10. Giovanni di Ser Giovanni. *The Triumph of Fame*, ca. 1450. Tempera on panel. Florence, Palazzo Davanzati (photo: Alinari/Art Resource, N.Y.)

been the perfect patron for this tray.[72] So Piero had the means, the interest, and the desire to celebrate his firstborn son in the most appropriate manner possible, according to popular custom.

Whether for sentimental, aesthetic, or even political reasons, it is clear that Lorenzo continued to value the birth tray given to his mother on the occasion of his birth. It was hanging in his room when he died in 1492, at the age of forty-three. Childbirth trays were usually listed in inventories alongside paintings or works of art that hung on the wall or rested in small niches; one gets the impression that the clerk simply listed all the works of art in the order he saw them as he looked around the room.[73] And, in fact, Lorenzo's tray is listed between two paintings, apparently topographical views of the Holy Land and of Spain (both valued at several florins less than the tray), which implies that it hung on a wall between the two, with its heraldic side hidden from view.[74] This would explain

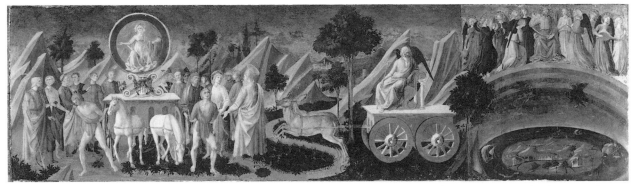

Figure 11. Francesco Pesellino (1422–1457). *The Triumphs of Fame, Time, and Eternity* (panel from a marriage chest), ca. 1448. Tempera on chestnut wood. Boston, Isabella Stewart Gardner Museum (photo: Isabella Stewart Gardner Museum)

why the clerk did not describe the elaborate device in any way; he simply did not see it.[75]

This birth tray was in Lorenzo's room long after his own birth, his mother's death, and even the birth of his own children and the death of his wife. But this was not unusual. Birth trays remained in the home for a long period of time, pre-, post-, and even in-place-of-partum. Documents indicate that childless couples had birth trays.[76] Many homes even had more than one.[77] Most families kept their trays for decades; years after a child was born, these trays were still a significant part of the household furnishings, which could be handed down from generation to generation.[78] Judging from the great number of documented households that had these trays, one can assume that many have been lost in the intervening centuries. Some of these must have been the ones described in contemporaneous inventories as bad, used, or broken; in 1426, Salvestro di Francesco's estate even included a tray that was described as *tristo*, or sad.[79] An object so damaged that it was described as sad in 1426 would hardly have survived to the present day. But these descriptions of condition are important; they suggest that the trays were valued as dynastic reminders that were still worth having in the household (and worth assessing) even when they were in very poor condition. The presence of Lorenzo's birth tray in his personal quarters at his death can therefore be explained as popular custom.

The Medici family was under a great deal of strain following Lorenzo's death. His twenty-two-year-old son, Piero, was largely incompetent as a ruler and quickly alienated the Florentines with his excessive, indulgent behavior. The continual condemnation by the Dominican friar Girolamo Savonarola furthered popular animosity and in 1494 after a series of disastrous decisions, Piero and his family were exiled from the city of Florence.

A year after this exile and the confiscation of their remaining possessions, the new Florentine government held a sale of Medici property. There were surprisingly few contemporaneous references to this event. The pharmacist Luca Landucci made note of this sale, which took place at Orsanmichele during the summer of 1495. In his usual philosophical manner, Landucci observed that the great wealth of objects revealed "what fortune may do in this transitory life, or rather divine permission, to the end that man may recognize that all comes from God, who gives and takes away."[80] Surely, seeing the treasures of the Medici family for sale would have made the reflective Florentine citizens a bit more cautious overall. Others, of course, were not so philosophical as Landucci. They looked at the sale as an excellent way to build up their own collections. Alessandro Gondi noted in his account book that he purchased a beautiful marble Madonna at this sale for an excellent price.[81]

Government officials kept careful accounts of this sale, which raised a considerable amount of money. The accounts indicate that the Medici-Tornabuoni tray was bought by a gentleman named Ser Bartolomeo di Bambello for slightly more than three florins.[82] In the three years since Lorenzo's death, and with the subsequent change in government, the tray had depreciated by more than two-thirds. Without the original commission document, we may never know how much Piero paid for the tray. But the inventory of 1492 does reveal that, over forty years after it was made, the tray was valued at the not insignificant sum of ten florins. The price Ser Bartolomeo paid was in accord with prices paid for other secondhand birth trays in the late fifteenth century. Given its elaborate nature, it would seem that the Museum's tray was a relative bargain. It is likely that the negative associations of the Medici family helped bring down the value by 1495.

Shortly after Ser Bartolomeo di Bambello purchased the Medici-Tornabuoni tray, surviving examples and documentary evidence indicate that the production of painted trays declined considerably. But the birth tray as a genre of domestic art did not disappear. A few were made, and many were still mentioned in household inventories throughout the sixteenth century, no doubt objects handed down from generation to generation. The Museum's tray was no exception. When Ser Bartolomeo di Bambello died in 1543, his estate was handled by the Magistrato dei Pupilli, a typical occurrence if minor heirs were involved. In June of that year the tray was specifically consigned to his widow, Lucrezia.[83] Like many widows, she received a variety of household goods, perhaps as partial retribution for her dowry, perhaps as a way to allow her to set up a new home. The consignment of this birth tray to Lucrezia kept it separate from the wider group of goods from which Pupilli officials pulled salable objects to raise money to settle the estate's debts.[84] And perhaps the Pupilli officials, noting its extravagance, assigned the tray to Lucrezia so that she could protect it for Ser Bartolomeo's heirs. By this date, nearly fifty years after the Medici sale, the tray had lost its immediate identification with that family and was described only perfunctorily, as a round, painted, childbirth tray.

The Medici-Tornabuoni tray remained in Ser Bartolomeo di Bambello's family for at least one more generation. Sometime after 1543 it was passed on to Ser Bartolomeo's heir, his son Jacopo. This probably

occurred at Lucrezia's death or at Jacopo's marriage; the records do not reveal the exact date. However, when Jacopo himself died in 1579, the inventory of his estate revealed that he left a round birth tray painted with a hunting scene.[85] This tray is surely the Museum's tray, with its iconography misconstrued. Painted childbirth trays were relatively rare in the late sixteenth century; by that time, it had become more typical to use inlaid or plain wooden trays, or even maiolica wares.[86] Painted birth trays had become so common and standardized in the fifteenth century that it perhaps sufficed to state their presence in inventories, without describing their iconography.[87] But in the sixteenth century, when painted trays became much rarer and perhaps more of a curiosity, it was necessary to describe them in greater detail.[88] As a result, the Medici-Tornabuoni tray was worthy of special note in the otherwise routine inventory of Jacopo's estate. Because it was so unusual, the Pupilli officials attempted, albeit inaccurately, to identify the iconography.

This error is understandable; the figures on the front of the Museum's tray are on horseback, armored and armed, and dogs occupy the front plane, suggesting a hunting scene. But this mistake indicates two important facts. First, the officials were obviously unfamiliar with Boccaccio and Petrarch, whose texts were not as popular as they had been a century earlier. And second, Jacopo's family, a member of which would have been present when the inventory of his estate was conducted, may not have known either the subject or the origin of the tray. This would not be unusual; after all, more than a century had passed since its production, and over eighty years since Ser Bartolomeo di Bambello purchased it at the Medici sale. It had become a family heirloom, but its provenance and iconography were presumably forgotten. As a result, the tray was singled out by the Pupilli officials as something worthy of more than a cursory description, even though they did not know exactly what they were describing.

The Medici-Tornabuoni birth tray is clearly a special case, and its unique nature rendered it identifiable through several transfers of ownership. Nevertheless, there are no known references to its whereabouts between 1579 and 1801. Presumably it remained in Florence, perhaps in the possession of further descendants of Ser Bartolomeo di Bambello. During the eighteenth and nineteenth centuries a great many ancient Italian families sold off valuable objects from their ancestral collections to pay bills and settle debts. The market for early Italian painting, in particular, was quite strong. And an object as spectacular as this tray would surely be an attractive acquisition; it is likely that it changed hands during this period.

The tray is documented in Florence again by 1801, in the collection of Abbé Rimani. It was sold to the collector Alexis-François Artaud de Montor of Paris about this date. He published the tray in 1811 and 1843 as, oddly enough, a painting by Giotto.[89] Artaud de Montor died in 1849; his estate went to auction in 1851, when the Medici-Tornabuoni tray was sold to Thomas Jefferson Bryan of New York.[90] Bryan donated it to the New-York Historical Society in 1867, where it remained until the society deaccessioned it in 1995.

As the example of this tray indicates, the production and use of childbirth trays was a long-standing custom that had strong roots in the ideology of post-plague Italy. The popularity of such elaborate and oftentimes costly objects to encourage, celebrate, and commemorate childbirth emphasizes the importance of the event to the Renaissance family in a tangible and revealing manner.

ACKNOWLEDGMENTS

For the technical examination of trays in their care, I was assisted by Keith Christiansen, The Metropolitan Museum of Art; Norman Muller, The Art Museum, Princeton University; and Carol Sawyer and Bruce Suffield, Virginia Museum of Fine Arts.

NOTES

1. This article arose from my dissertation, "The Art & Ritual of Childbirth in Renaissance Italy" (Ph.D. diss., Princeton University, 1995). Unless otherwise stated, all manuscript citations are from the Archivio di Stato, Florence, and all transcriptions and translations are my own.

2. D. Herlihy and C. Klapisch-Zuber, *Tuscans and Their Families. A Study of the Florentine Catasto of 1427* (New Haven, 1985) pp. 274–279.

3. For example, at his death in 1475, Andrea Bucelli's estate included "3 paia di schodelle di maiolicha da donna di parto"; at this date, his children were fifteen and sixteen years old (*Magistrato dei Pupilli avanti il Principato* [henceforth *MPAP*] vol. 172, 336r).

4. Much of his wealth came from his involvement in the Medici bank; see R. de Roover, *The Rise and Decline of the Medici Bank 1397–1494* (Cambridge, 1963) pp. 17, 71–72, 235.

5. *MPAP*, vol. 173, 265r–274r.

6. *Magistrato dei Pupilli del Principato* (henceforth *MPP*) vol. 2650, 153v: "3 paia di federe sottile da parto di lino con sue reticelle biancha."

7. *Carte strozziane*, ser. V, vol. 1751, 125r: "e non le contiamo nulla pane e vino e pollastri e pipioni logoro a Nuovoli nel suo parto." For

more information on this particular case, see J. M. Musacchio, "Pregnancy and Poultry in Renaissance Italy," *Source* 16 (1997) pp. 7–8.

8. Archivio di Stato, Prato, *Ceppi*, vol. 211, 32 right: "Giuliano d'Anbruogio speziale . . . E de'avere a dì 15 di novembre [1440] soldi tredici per una libra di chandele li dettono per lo amore di Dio a Monna Checha del Ghuazerino."

9. Major bibliography for this important tray is listed in Sotheby's New York, Jan. 12, 1995, lot 69. The historiography of birth trays in general is relatively limited. The earliest studies treated the trays as charming novelties; see U. Rossi, "I deschi da parto," *Archivio storico dell'arte* 3 (1890) pp. 78–79, and E. Müntz, "Les plateaux d'accouchées et la peinture sur meubles du XIVe au XVIe siècle," *Fondation Eugène Piot. Monuments et mémoires* 1 (1894) pp. 203–232. Subsequent publications included birth trays within the larger category of Renaissance painted furnishings; primary among these is P. Schubring, *Cassoni: Truhen und Truhenbilder der italienischen Frührenaissance* (Leipzig, 1915 and 1923). The only monographic treatment of childbirth trays as an independent genre is M. E. Fitzgerald's "Deschi da Parto: Florentine Birth Trays of the Quattrocento" (Ph.D. diss., Syracuse University, 1986), which includes a summary catalogue. See also D. C. Ahl, "Renaissance Birth Salvers and the Richmond *Judgement of Solomon*," *Studies in Iconography* 7 (1981) pp. 157–174. I was not able to consult C. De Carli, *I deschi da parto e la pittura del primo rinascimento toscano* (Turin, 1997), while preparing this manuscript.

10. A. Warburg, "Della impresa amorose nelle più antiche incisione fiorentine," *Rivista d'arte* 3 (1905) p. 5.

11. M. Spallanzani and G. G. Bertelà, eds., *Libro d'inventario dei beni di Lorenzo il Magnifico* (Florence, 1992) p. 27 ("uno descho tondo da parto dipintovi il trionfo della fama"). The fact that the tray was found in Lorenzo's rooms signified his intimate connection to it and all but excluded the possibility that the tray was commissioned for the birth of his younger brother Giuliano in 1453.

12. On the prevalence of these texts, see C. Bec, *Les livres des Florentins (1413–1608)* (Florence, 1984). Copies were widely owned; for example, in 1497, Lorenzo Tornabuoni's estate included "1º libro de' Trionfi del Petrarcha" (*MPAP*, vol. 181, 141v). Coincidentally, Lorenzo was the son of Giovanni Tornabuoni, Piero de' Medici's brother-in-law.

13. For the link between this theme and marriage and childbirth, see A. Jacobson-Schutte, "Trionfi delle donne: rovesciamento dei ruoli nella Firenze rinascimentale," *Quaderni storici* 44(1980) pp. 474–496.

14. For triumph iconography in Renaissance art, see G. Carandente, *I trionfi nel primo Rinascimento* (Turin, 1963), M. Salmi, "*I Trionfi* e il *De viris illustribus* nell'arte del primo Rinascimento," *Atti dei Convegni Lincei* 10 (1976) pp. 23–47, and L. S. Malke, "Contributo alle figurazioni dei Trionfi e del Canzoniere del Petrarca," *Commentari* 28 (1977) pp. 236–261. E. Callmann recently compiled a list of Boccaccian themes in Italian painting, which includes triumph images within the larger group; see E. Callmann, "Subjects from Boccaccio in Italian Painting, 1375–1525," *Studi sul Boccaccio* 23 (1995) pp. 19–78, esp. 41–46.

15. For examples, see D. C. Shorr, "Some Notes on the Iconography of Petrarch's *Triumph of Fame*," *Art Bulletin* 20 (1938) pp. 100–107.

16. G. Boccaccio, *Amorosa visione*, R. Hollander, T. Hampton, and M. Frankel, trans. (Hanover, 1986) pp. 28–29.

17. This statuette, although common in representations of the Triumph of Fame, may be a mistranslation; see Shorr, "Some Notes," p. 104, but also E. Callmann, *Apollonio di Giovanni* (London, 1974) p. 12.

18. To link this gesture to Boccaccio's text, see Shorr, "Some Notes," p. 104.

19. Although rather disheveled and barefoot, these two young men are not the shackled prisoners who often appear in such scenes and are discussed in D. C. Shorr, "The Identification of the Captives in Petrarch's *Triumph of Fame*," *Die graphischen Künste* 2 (1937) pp. 41–44.

20. For Medici devices, see F. Ames-Lewis, "Early Medicean Devices," *Journal of the Warburg and Courtauld Institutes* 42 (1979) pp. 122–143, and, most recently, F. Cardini, "Le insegne Laurenziane," in *Le tems revient. 'l tempo si rinuova. Feste e spettacoli nella Firenze di Lorenzo il Magnifico*, P. Ventrone, ed. (Florence, 1992) pp. 55–74.

21. The later types are described in Musacchio, "Art & Ritual," pp. 116–128.

22. D. C. Ahl found a birth tray in almost 42 percent of the predominantly 15th-century inventories she examined; see Ahl, "Renaissance Birth Salvers," p. 158. My own archival research seems to indicate an even higher percentage; however, the repetition of many of the inventories throughout several volumes of the Pupilli and across many years makes it difficult to provide a definitive number.

23. For the statutes defining the Pupilli during this period, see F. Morandini, "Statuti e ordinamenti dell'Ufficio dei Pupilli et Adulti nel periodo della Repubblica Fiorentina (1388–1534)," *Archivio storico Italiano* 113 (1955) pp. 522–551; 114 (1956) pp. 92–117; 115 (1957) pp. 87–104.

24. There is no evidence to support the common assumption that trays were made in celebration of a marriage. In my examination of inventories and account books from a wide variety of social and economic backgrounds, I never encountered a *desco da nozze*. Marriage was celebrated with an extensive range of objects, but trays were not among them. Occasionally, however, birth trays were included in the list of a new couple's domestic furnishings. In 1493, Tommaso and Bartolommea Minerbetti gave their son Andrea and his bride, Maria, a number of items to set up their new home, including a round painted birth tray with a gold frame; see G. Biagio, *Due corredi di nuziali fiorentini 1320–1493 da un libro di ricordanze dei Minerbetti* (Florence, 1899) p. 19. But this tray was specified as a birth tray, even at the marriage, and may have been presented to the new couple for its talismanic properties; see J. M. Musacchio, "Imaginative Conceptions in Renaissance Italy," in *Picturing Women in Renaissance and Baroque Italy*, S. M. Grieco and G. Johnson, eds. (Cambridge, 1997) pp. 42–60.

25. G. Vasari, *Le vite de' più eccellenti pittori, scultori, ed architettori*, G. Milanesi, ed. (Florence, 1882) VII, pp. 20–21 ("per dipignerlo in un di que tondi nei quali si porta da mangiare alle donne di parto").

26. For example, in 1413, the estate of Maestro Tommaso di Maestro Donati included "unum deschum ad usum mulierum in partu" (*MPAP*, vol. 24, 207r).

27. Both Michele Savonarola and Paolo da Certaldo recommend-

ed fragrant and digestible white wines for pregnant women; see M. Savonarola, *Il trattato ginecologico-pediatrico in volgare. Ad mulieres ferrarienses de regimine pregnantium et noviter natorum usque ad septennium*, L. Belloni, ed. (Milan, 1952) p. 131, and P. da Certaldo, *Libro di buoni costumi*, A. Schiaffini, ed. (Florence, 1945) p. 125.

28. For example, in 1593, the estate of Andrea Cianno had "uno tondo da donne di parto anticho con sua coperta di pano verde" (*MPP*, vol. 2656, 859v). Furthermore, the clerk who made the inventory of Lorenzo Vanni's estate in 1429 took care to note the presence of "1° descho da parto senza inviltura," suggesting that cloth covers were normally expected with childbirth trays (*MPAP*, vol. 160, 422r).

29. The smallest tray is the unframed *Amorous Hunt* at the Yale University Art Gallery (48.7 cm), while the largest is the elaborately framed Medici-Tornabuoni tray (92.7 cm). Dimensions are problematic, however; many trays no longer have their original frames, while others have no frames at all.

30. For example, in 1423 Andrea Mazuoli's estate included "1° deschetto da parto" and "1° descho da parto" (*MPAP*, vol. 39, 223r), which implies that the first tray was smaller than the second.

31. An X-ray examination of a tray at The Art Museum, Princeton University, shows that it was made from two pieces of wood. The join goes from the bottom left corner diagonally up to the right, adding on only a small piece. This neat, dowel-less join was covered by four strips of a light, open-weave cloth and would have been braced by the original frame or molding.

32. In 1388 Filippo Quartucci's estate had "1 tavola tonda da parto" (*MPAP*, vol. 4, 138r). For the earliest round tray, see L. Berti and A. Paolucci, *L'Eta di Masaccio. Il primo quattrocento a Firenze* (Milan, 1990) pp. 102–103. The relation between tondi and birth trays is discussed in R. J. M. Olson, "Lost and Partially Found: The Tondo, a Significant Florentine Art Form, in Documents of the Renaissance," *Artibus et historiae* 14 (1993) p. 34. There must have been considerable freedom with shapes, however; in 1418 Arrigo Rondinelli's estate included "uno desco da parto quadro" (*MPAP*, vol. 28, 255v).

33. For example, in 1404 the estate of Lorenzo Schiattini included "uno descho da parto messo ad'oro fine" (*MPAP*, vol. 15, 184v).

34. Marriage chests were also constructed in their entirety before they were painted; see Callmann, *Apollonio di Giovanni*, p. 27. This practice was adopted from monumental altarpiece production techniques; see D. Bomford et al., *Art in the Making. Italian Painting before 1400* (London, 1989).

35. The same is true for another tray by Scheggia, now at the Virginia Museum of Fine Arts. This tray has a nail surmounted by a ring driven into the frame. Examination indicates that this device was inserted before the linen ground was laid on the back of the panel, making it an integral part of the panel.

36. The identity of this artist was merged with the Master of the Adimari Cassone, also known as the Master of Fucecchio, by Luciano Bellosi in 1969; see L. Bellosi, D. Lotti, and A. Matteoli, *Mostra d'arte sacra della diocesi di San Miniato* (San Miniato, 1969) pp. 56–57. His oeuvre was compiled largely by R. Longhi, "Fatti di Masolino e di Masaccio," *Critica d'arte* 5 (1940) p. 187, and G. Pudelko, "Studien über Domenico Veneziano," *Mitteilungen des kunsthistorischen Institutes in Florenz* 4 (1934) pp. 163–164. Scheggia's

work with intarsia is outlined by M. Haines, *La Sacrestia delle Messe del Duomo di Firenze* (Florence, 1983) pp. 107–108. For documentary references to Scheggia, see J. Beck, *Masaccio. The Documents* (Locust Valley, N. Y., 1978) pp. 5–12, 19, 24–29; U. Procacci, "Le portate al catasto di Giovanni di Ser Giovanni detto lo Scheggia," *Rivista d'arte* 37 (1984) pp. 235–257; and M. Haines, "Nota sulla discendenza di Giovanni di Ser Giovanni," *Rivista d'arte* 37 (1984) pp. 257–268.

The Medici inventory of 1492 also includes a three-part *spalliera* painted by Scheggia with the story of Lorenzo de' Medici's joust; see Spallanzani and Bertelà, *Libro d'inventario*, p. 73. It is probably safe to assume that this refers to the joust of 1469, which Luigi Pulci commemorated with his famous poem. This *spalliera*, unfortunately, does not seem to survive. But its appearance may have been similar to Uccello's three panels of the *Battle of San Romano* (ca. 1450), which served as *spalliere* in Lorenzo's own bedchamber. The 1492 inventory describes both Scheggia's panels and Uccello's panels as positioned high on the wall, framed in gold, and set apart by thin colonnettes. For the most recent discussion of Uccello's panels, see F. and S. Borsi, *Paolo Uccello*, E. Powell, trans. (New York, 1994) pp. 307–312.

37. See F. Zeri, "Un appunto su Tommaso di Ser Giovanni, detto Masaccio, e suo fratello, Giovanni di Ser Giovanni, detto Scheggia," *Prospettiva* 33–36 (1983–84) pp. 56–58, for an example of the artistic interchange between the two brothers.

38. The tray was associated with Domenico most recently by C. Eisler, "A Window on Domenico Veneziano at Santa Croce," in *Scritti di storia dell'arte in onore di Federico Zeri*, M. Natale, ed. (Milan, 1984) p. 131.

39. For the tray attributed to Masaccio, see L. Berti and R. Foggi, *Masaccio. Catalogo completo dei dipinti* (Florence, 1989) pp. 197–201. Neri di Bicci listed two trays in his *ricordanze*; see N. di Bicci, *Le ricordanze*, B. Santi, ed. (Pisa, 1976) pp. 167–168, 175. Pontormo executed two birth bowls depicting the naming of John the Baptist; see A. Bruschi, *Un Pontormo ritrovato. Il desco da parto Ughi-Antinori, già della collezione Elia Volpi* (Florence, 1992).

40. Vasari, *Le vite*, II, p. 149. Vasari also described how Ghirlandaio instructed his apprentices to paint baskets for women; see ibid., III, pp. 269–270.

41. Several scholars have dealt with this problem. See A. Schiaparelli, *La casa fiorentina e i suoi arredi nei secoli XIV e XV*, M. Sframeli and L. Pagnotta, eds. (Florence, 1983); J. K. Lydecker, "The Domestic Setting of the Arts in Renaissance Florence" (Ph.D. diss., The Johns Hopkins University, 1987); and P. Thornton, *The Italian Renaissance Interior 1400–1600* (New York, 1991).

42. See B. Cole, "The Interior Decoration of the Palazzo Datini in Prato," *Mitteilungen des kunsthistorischen Institutes in Florenz* 13 (1967) p. 61; and F. Sacchetti, *Il trecentonovelle*, A. Lanza, ed. (Florence, 1984) pp. 166–172. The anonymous 15th-century carnival song of the Florentine sculptors also implies this practice; see C. Singleton, ed., *Canti carnascialeschi* (Bari, 1936) p. 10.

43. G. Corti, "Sul commercio dei quadri a Firenze verso la fine del secolo XIV," *Commentari* 22 (1971) p. 89.

44. Neri di Bicci, *Le ricordanze*, pp. 167–168.

45. Callmann, *Apollonio di Giovanni*, pp. 30–35.

46. E. Callmann, "Apollonio di Giovanni and Painting for the Early Renaissance Room," *Antichità viva* 27 (1988) p. 12. Evidence

indicates that this workshop executed the majority of the chest before a specific order was received; see Callmann, *Apollonio di Giovanni*, pp. 25–38.

47. See the discussion in Callmann, *Apollonio di Giovanni*, pp. 36–37, 58–59.

48. The use of small heraldic shields was common in domestic art, indicative of the open-market origin of many of these objects. They are found, for example, on some of the stucco and terracotta Madonna and Child reliefs associated with Lorenzo Ghiberti's workshop; for a partial list, see J. Harris, ed., *The Mount Holyoke College Art Museum: Handbook of the Collection* (South Hadley, Mass. 1984) p. 22.

49. Several trays have anachronistic coats of arms, which were probably repainted when ownership changed. Buying used goods and repainting them was a cheaper option than purchasing a new object outright. For an example of this, see C. M. Kauffmann, *Catalogue of Foreign Paintings* (London, 1973) I, pp. 13–14.

50. *Carte strozziane*, ser. IV, vol. 71, 22v.

51. Ibid.

52. *MPAP*, vol. 28, 283v.

53. *MPAP*, vol. 61, 153r. For information on the value of the florin, which varies by 14 soldi in the period between these two valuations, see R. A. Goldthwaite, *The Building of Renaissance Florence: An Economic and Social History* (Baltimore, 1980) p. 430.

54. The ledger is transcribed in Callmann, *Apollonio di Giovanni*, pp. 76–81. It exists today as an incomplete 17th-century copy of a lost document; evidence for this is provided in Callmann, "Apollonio di Giovanni and Painting."

55. Callmann, *Apollonio di Giovanni*, p. 79. This tray does not survive today; however, for further information about the use of this particular subject on domestic art, see C. C. Wilson, *Italian Paintings XIV–XVI Centuries in the Museum of Fine Arts, Houston* (Houston, 1996) pp. 214–229.

56. For information on Benci, see de Roover, *Rise and Decline*, pp. 57–58, and F. Ames-Lewis, "Art in the Service of the Family: The Taste and Patronage of Piero di Cosimo de' Medici," in *Piero de' Medici "il Gottoso" (1416–1469)*, A. Beyer and B. Boucher, eds. (Berlin, 1993) p. 209.

57. Benci may have been buying the tray for a pregnant daughter, since he had purchased a pair of marriage chests to celebrate the wedding of a daughter a year earlier; see Callmann, *Apollonio di Giovanni*, p. 79.

58. Piero's art patronage was first analyzed in E. H. Gombrich, "The Early Medici as Patrons of Art," in *Italian Renaissance Studies*, E. F. Jacob, ed. (London, 1960) pp. 279–311. For recent studies on Piero, see the essays in Beyer and Boucher, *Piero de' Medici*.

59. Ames-Lewis, "Art in the Service," p. 209.

60. See, in particular, Ames-Lewis, ibid., and L. Gnocchi, "Le preferenze artistiche di Piero di Cosimo de' Medici," *Artibus et historiae* 18 (1988) pp. 41–78.

61. Ames-Lewis, "Art in the Service," esp. pp. 209–217.

62. M. Davies and, more recently, F. Ames-Lewis have suggested that Lippi's *Annunciation* may also be associated with the birth of Lorenzo di Piero de' Medici, which places it in an interesting relationship with the Medici-Tornabuoni birth tray. See M. Davies, "Fra Filippo Lippi's *Annunciation* and *Seven Saints*," *Critica d'arte* 8 (1950) p. 360, and Ames-Lewis, "Art in the Service," pp. 216–217.

63. Vasari implied as much in regard to 16th-century wooden trays when he described Francesco Salviati's drawing for a birth tray. According to Vasari, the complex iconography of Salviati's drawing, which incorporated the ages of man and the temple of Athena, shows that "for newborns one should above all else pray for knowledge and goodness" (Vasari, *Le vite*, VII, p. 21: "ai nati figliuoli si doverebbe innanzi ad ogni altra cosa pregare sapienza e bontà").

64. For information on Renaissance marriage, see esp. C. Klapisch-Zuber, *Women, Family, and Ritual in Renaissance Italy*, L. G. Cochrane, trans. (Chicago, 1985), and A. Molho, *Marriage Alliance in Late Medieval Florence* (Cambridge, 1994).

65. G. Landolfi, "I 'Trionfi' petrarcheschi di Palazzo Davanzati: un esercizio di lettura iconografica," *Antichità viva* 32 (1993) pp. 5–17.

66. This letter was first published by G. Milanesi, "Lettere d'artisti italiani dei secoli XIV e XV," *Il Buonarroti* 4 (1869) pp. 78–79. An English translation is in D. S. Chambers, *Patrons and Artists in the Italian Renaissance* (London, 1970) pp. 94–95. Although Matteo does not specify exactly what medium he is working in, F. Ames-Lewis has presented a convincing case analysis that Matteo was, in fact, illuminating one of the earliest manuscripts for Piero de' Medici's library; see F. Ames-Lewis, "Matteo de' Pasti and the Use of Powdered Gold," *Mitteilungen des kunsthistorischen Institutes in Florenz* 28 (1984) pp. 351–362.

67. See M. Spallanzani, ed., *Inventari medicei, 1417–1465: Giovanni di Bicci, Cosimo e Lorenzo di Giovanni, Piero di Cosimo* (Florence, 1996) pp. 113, 117, 157. There were two illustrated *Trionfi* in Lorenzo's estate at his death, perhaps representing the volumes Piero owned and then passed to his son; see Spallanzani and Bertelà, *Libro d'inventario*, pp. 49, 50.

68. F. Ames-Lewis, "The Library and Manuscripts of Piero di Cosimo de' Medici," (Ph.D. diss., Courtauld Institute, London, 1977) pp. 336–337.

69. Spallanzani and Bertelà, *Libro d'inventario*, p. 26.

70. For these panels, see P. Hendy, *European and American Paintings in the Isabella Stewart Gardner Museum* (Boston, 1974) pp. 176–178. Both panels have been cut down, now measuring a maximum of 158 cm, while 3.5 braccia would be 204 cm. There is no mention of these panels in the incomplete inventories that exist of Piero's possessions during his lifetime. But we know that Piero patronized Pesellino, and we know that Piero appreciated this particular iconography. Furthermore, Pesellino died in 1457, well before Lorenzo de' Medici would have been an active art patron. So it is quite likely that this pair of chests was made for Piero and Lucrezia's wedding and passed on to Lorenzo with the death of his parents.

71. This was often the case; see B. Witthoft, "Marriage Rituals and Marriage Chests in Quattrocento Florence," *Artibus et historiae* 5 (1982) pp. 43–59.

72. The case of Giovanni Benci mentioned earlier seems to be an example of a grandfather purchasing a birth tray. But there is no reason to believe that the Medici-Tornabuoni tray was ordered by Cosimo de' Medici, Piero's father, since the device on the reverse of this tray was used first by Piero.

73. Such a process is described in Lydecker, "The Domestic Setting," p. 22.

74. Spallanzani and Bertelà, *Libro d'inventario*, pp. 26–27.

75. This was often the case; there are relatively few references in inventories to the reverse images on childbirth trays.

76. In the late 14th century Francesco and Margarita Datini of Prato had a birth tray, but they had no legitimate children; see I. Origo, *The Merchant of Prato. Daily Life in a Medieval Italian Village* (London, 1992) pp. 233–234. In my examination of Archivio di Stato, Prato, *Archivio Datini*, 236, the collection of various Datini inventories from ca. 1390–1405 that Origo consulted, I found reference to one birth tray, although Origo states that the Datini had two. There is evidence that the Datini valued this tray; an undated notation made alongside one reference stated that they brought the tray with them to Florence while living there temporarily.

77. For example, in 1469, Piero Cioni's estate included "1ª tavoleta da dona di parto dipintta vechia" and "1ª tavoletta da dona di parto dipinta nuova" (*MPAP*, vol. 173, 201v). Many inventories, in fact, record more than one tray, contradicting the traditional assumption that the birth tray was offered only at the birth of the firstborn; see M. Wackernagel, *The World of the Florentine Renaissance Artist*, A. Luchs, trans. (Princeton, 1981) p. 168.

78. In 1487, Marco Parenti consigned, along with other household items, "uno desco da parto dipinto" to his son Piero and Piero's wife, Onesta (*Carte strozziane*, ser. II, vol. 17 bis, 79r).

79. *MPAP*, vol. 44, 257v: "1 descho da parto tristo."

80. L. Landucci, *Florentine Diary from 1450 to 1516*, A. de Rosen Jervis, trans. (London, 1927) p. 93.

81. *Carte Gondi*, vol. 33, 116 left. In 1506 an inventory of Alessandro's home recorded six different Madonna statuettes, but the Medici one is not specified, indicating that it lost its associations with the exiled family almost immediately; see *Carte Gondi*, vol. 36, 247.

82. *Medico avanti il Principato*, vol. 121, 357r: "A Ser Bartolomeo di Bambelo. 1 tondo da parto dipintovi su il Trionfo della Fama (fiorini 3.6.8)."

83. *MPP*, vol. 2663, 336r: "1º tondo da donna di parte dipinto."

84. These activities are outlined in Morandini, "Statuti e ordinamenti."

85. *MPP*, vol. 2647, 594v: "uno tondo da donna di parto dipintovi una caccia."

86. For a discussion of these later manifestations, see Musacchio, "The Art & Ritual," pp. 116–163.

87. In fact, the earliest known references to iconography are in the Medici inventory, which cited, along with the *Triumph of Fame* tray, a lost tray with a battle scene by Masaccio, and two other trays specified only as painted and, in one case, round (Spallanzani and Bertelà, *Libro d'inventario*, pp. 80, 104, 152). Because this inventory was undertaken partly to indicate the vast wealth of the Medici, it was especially detailed; other inventories were considerably more prosaic.

88. In the hundreds of household inventories examined, the only references to iconography that I have found date from the 16th century. In addition to the Medici-Tornabuoni tray in Jacopo di Bartolomeo di Bambello's estate, there was "1º tondo da parto dipintovi dirento Cupido" in 1540 (*MPP*, vol. 2648, 525r) and "1º tondo di legno da donne di parto con 6 figure dipinte" in 1581 (*MPP*, vol. 2655, 141v). In 1518 the estate of Alessandro Rinuccini included a round birth tray painted with a Roman history scene; see C. Klapisch-Zuber, "Les femmes dans les rituels de l'alliance et de la naissance à Florence," in *Riti e rituali nelle società medievali*, J. Chiffoleau et al., eds. (Spoleto, 1994) p. 17. Each of these cursory descriptions reveals little about the actual appearance of a particular tray, although each does describe a popular surviving type.

89. See A. F. Artaud de Montor, *Considérations sur l'état de la peinture en Italie* (Paris, 1811) pp. 80–82, and idem, *Peintres primitifs* (Paris, 1843) pp. 34–36.

90. Place de la Bourse, Paris, Jan. 16–17, 1851, lot 57.

A Stained-Glass Window from Flavigny-sur-Moselle

ARIANE ISLER-DE JONGH

Department of History in Art, University of Victoria

RESEARCH UNDERTAKEN BY the Canadian Committee of the Corpus Vitrearum Medii Aevi (CVMA) has led to the rediscovery of a stained-glass window that was considered lost but is actually in a private collection in British Columbia. The window comes from the former Priory Church of Saint-Firmin in Flavigny-sur-Moselle and represents the Creation of the World and the Expulsion from Paradise (Figure 1).[1] In the present article, I intend to examine this window in relation to those remaining of the original cycle in which it was included and to place the cycle in the cultural and religious context of its time. Two other windows and four medallions of this series are in The Metropolitan Museum of Art.

Flavigny-sur-Moselle is located in Lorraine, a few kilometers south of Nancy. A Benedictine priory dedicated to Saint Firmin was founded there in the tenth century.[2] The original Romanesque chapel underwent several modifications over the centuries, the most important one being the construction of a western bell tower in the twelfth century. A portal was added in 1732 (Figure 2). Little is known of the priory's history until the end of the fifteenth century, by which time the monastic community appears to have been greatly reduced, following the general decline during the period. In 1510 Wary de Lucy was named commendatory prior, succeeding his uncle Barthélemy de Lucy, and he held the priorate until his death in 1557. Unlike many commendatory priors, Wary de Lucy resided at his priory, although according to Chanoine Dedenon he led the easy life of a grand humanist noble.[3] Between 1525 and 1530, he planned the reconstruction of the church,[4] preserving only the western bell tower. He entrusted Valentin Bousch, a stained-glass painter established at Metz, to execute seven windows in the choir between 1531 and 1533.

During the French Revolution, the priory was secularized, but it was bought back, after the Restoration of 1814, by the Benedictine nuns of Saint-Eustase, who had occupied the abbey of Vergaville (Moselle) before the Revolution. In 1904, however, fearing the consequences of the new law of separation of church and state, the nuns decided to emigrate to Italy, and they sold most of the church furnishings, including the four stained-glass windows that had survived from the ensemble decorating the choir of the church.

Three of these windows (Windows 1, 3, 5; see Figure 3)[5] were still in France in 1907, when they were mentioned and illustrated in a French publication.[6] They were apparently shipped to North America sometime before World War I. The fourth one, the Crucifixion window (Window 2), now in the Church of Saint Joseph in Stockbridge, Massachusetts, was known to have been in a private collection in New York in 1913. Windows 1 and 3 and four medallions were bought by the Metropolitan Museum in 1917.[7] The Creation window was not part of that group and was considered lost. In fact, the four medallions in the Metropolitan were originally in the window containing the Creation (see notes 20 and 24 below), two in the tracery compartments and two in the decorative console at the base of the lancets. It is hoped that further study of sales catalogues will elucidate the history of the British Columbian glass prior to its purchase in 1952, but so far we have no information (see note 1).

In a 1994 article Michel Hérold presented the first scholarly study devoted to Valentin Bousch.[8] In the eighteenth century, this artist was already considered to be one of Lorraine's finest glass painters of the first half of the sixteenth century.[9] Not much is known about his apprenticeship. He was born in or near Strasbourg,[10] and he seems to have acquired solid training before arriving at Saint-Nicolas-de-Port, near Nancy, in 1514. As archival documents published by Abbé Jacques Choux in 1973[11] have encouraged more recent research, especially within the French Corpus Vitrearum project,[12] we shall limit ourselves in this essay to an overview of Valentin Bousch's activities before he started working on the Flavigny windows.

Notarial documents published by Abbé Choux, supplemented by careful studies of the church's surviving windows, prove that Bousch ran a large and active workshop after he settled in Saint-Nicolas-de-Port.[13] The

The notes for this article begin on page 165.

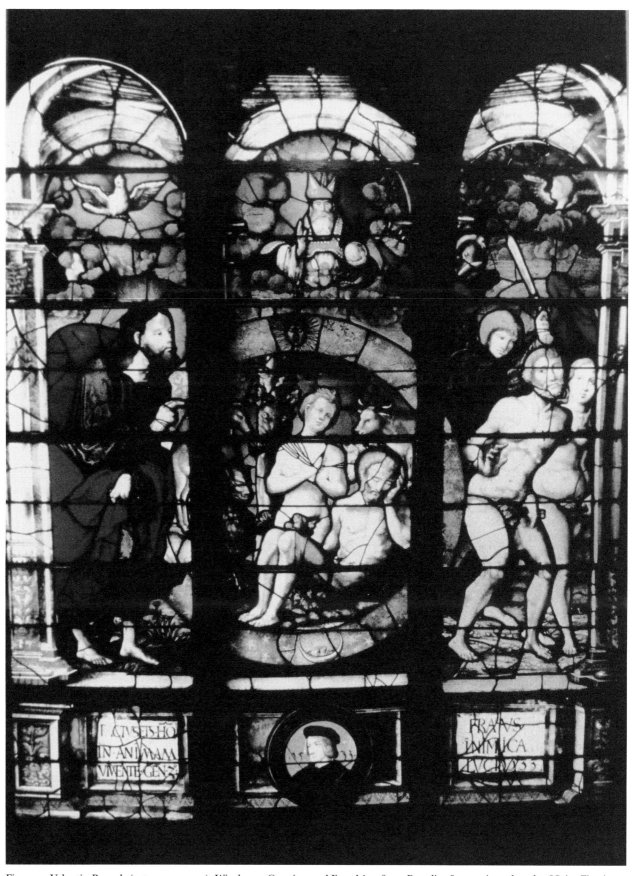

Figure 1. Valentin Bousch (act. 1514–1541). Window 5: Creation and Expulsion from Paradise from priory church of Saint-Firmin, Flavigny-sur-Moselle, 1533. Langley, British Columbia, private collection (montage of photographs by Chester Goosen)

Figure 2. Priory church of Saint-Firmin, Flavigny-sur-Moselle, tower porch and facade (photo: Michel Hérold)

Figure 3. Priory church of Saint-Firmin, Flavigny-sur-Moselle, plan and distribution of choir windows (after a plan from Nancy, Bibliothèque Municipale, Fonds Abel, *carton 152*)

evolution of his style can thus be traced over a crucial period in his development. The character of his work passes from "[des] figures élégantes et statiques . . . disposées sous des dais arborescents caractéristiques du gothique tardif"[14] to an approach to representation in which the rendering of volumes and movement, quite often set within the depth of three-dimensional space, is depicted within Renaissance architectural frames. "Clarté, monumentalité, vigueur quasi sculpturale [en] sont . . . les caractères les plus notables."[15] It is also during this period that, in 1518, Valentin Bousch created the apse windows for the church of Varangéville. They were destroyed, but in an old photograph of the Crucifixion window there, one can see his new sense of pictorial depth.[16]

In 1520 Bousch moved his workshop to Metz, where he had received a sizable commission for stained glass in the newly reconstructed cathedral of Saint-Étienne.[17] He married and lived there until his death in 1541. His many works for the cathedral are well documented: he produced thirteen very large windows

over two campaigns, one from 1520 to 1528, the other from 1534 to 1539. But patronage conditions were not the same as in Saint-Nicolas-de-Port: while the many and diverse donors there had been free to determine their own programs—narrative series, single scenes, large or small figures—the cathedral chapter of Metz was now the sole authority, imposing an iconographically and stylistically coherent program.[18] Despite such constraints, the art of Valentin Bousch would gain in strength and achieve full mastery in the very large facade window of the south transept (33.25 × 12.75 m): large, sumptuously treated figures, animated in a quasi-dancing rhythm, are grouped in pairs in a complex but rigorous architectural frame, forming a sort of *Sacra Conversazione*.[19]

Between 1528 and 1534, when Valentin Bousch was not working on new windows for the cathedral, he was executing other commissions in and around Metz. The most important of these was undoubtedly Wary de Lucy's choir windows commissioned for the newly reconstructed priory church at Flavigny-sur-Moselle.

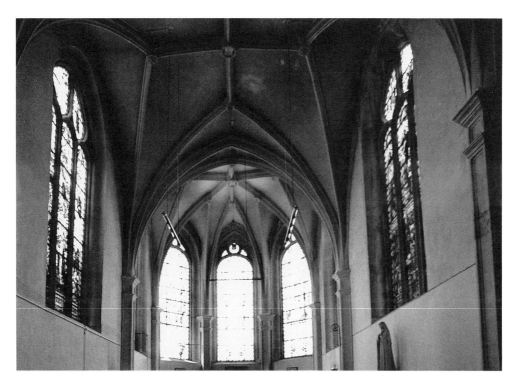

The young prior's choice of a glazier is easily explained by his family connections: at Flavigny, he had succeeded his uncle Barthélemy, who was also commendatory prior of Saint-Nicolas-de-Port, where he had been succeeded by Pierre de Lucy, another close relative, who is mentioned as being active between 1515 and 1529. As we have seen, Bousch worked at Saint-Nicolas-de-Port from 1514 until his move to Metz in 1520. Wary de Lucy was thus able to appreciate the growing talents of a master glass painter, whose Strasbourg origins could only have added prestige to an important commission.

The Flavigny choir has seven windows: in the western bay, two large windows of three lancets under a pointed arch face each other; to the east are five narrower one-lancet windows, two in the straight bay, the other three closing the apse. The tracery heads are relatively simple, consisting of two large, pointed lobes above the lancets of the large western windows and smaller compartments at the top of the five other windows (Figure 4).

The stained glass from the single-lancet windows measures 361.2 × 160.2 centimeters, including the predella and decorative console, while the stained glass of the three lancets from Window 5 each measure 300 × 86 centimeters, including the predella. The difference in height is explained in part by the different dimensions of the tracery compartments and also by the loss in Window 5 of the decorative console, which is still incorporated into the bases of the other windows. Two

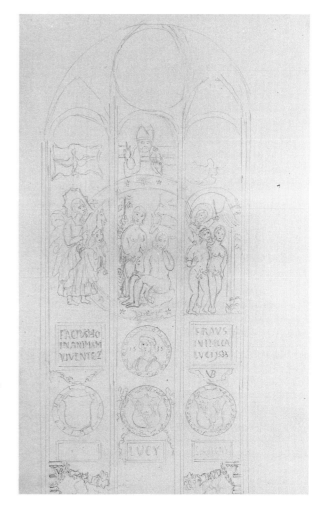

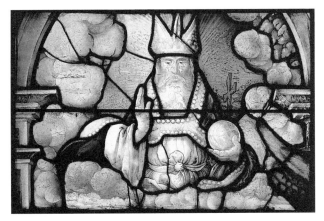

Figure 6. Window 5: panel 6b: God the Father, from priory church of Saint-Firmin, Flavigny-sur-Moselle (photo: Chester Goosen)

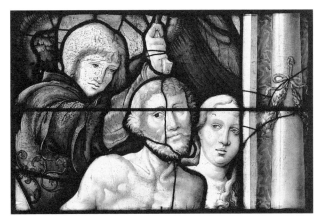

Figure 7. Window 5, panel 5c: heads of angel, Adam, and Eve, from priory church of Saint-Firmin, Flavigny-sur-Moselle (photo: Chester Goosen)

heraldic medallions from the console survive and are now in the Metropolitan Museum:[20] they depict the arms of Savigny and Craincourt. Fortunately, the intact console is partially documented in two drawings of the 1880s in the municipal library of Nancy (Figure 5):[21] they show Savigny in the middle, Craincourt on the right, and possibly Toulon on the left. These three families are related to the Lucy family: Claude de Craincourt and Jeanne de Savigny were respectively the mother and grandmother of Wary de Lucy.[22]

The main subject of this essay is the stained-glass window depicting the Creation of the World and the Expulsion from Paradise (Figure 1). In the left lancet the Word, in the form of Christ, introduces the subject, with a characteristically rhetorical gesture. Above him a cherub and the dove of the Holy Spirit can be seen. In the middle lancet God the Father, crowned and mitered (the miter's points placed laterally), contemplates his work (Figure 6): a circle represents the firmament, with stars, sun, and moon; inside the circle, four animals flanking a tree look toward the sleeping Adam, with Eve rising from his side: on the left, there are a lion and a stag; on the right, an ox and an ass. In the right lancet we see Adam and Eve being expelled from paradise by the archangel Gabriel brandishing a large sword (Figure 7), while the serpent, coiled around the tree, surveys the scene and a cherub floats in the sky above (Figure 8).

The whole scene is staged in an architectural setting in the form of a "loggia," whose pilasters echo the church's own pilasters[23] and whose base frames a predella in three parts: in the center, a medallion contains a bust-length portrait of the donor, Wary de Lucy, and the date, 1533; on the left the verse of Genesis illustrated in the glass, "FACTUS-ETS[sic]-HO-IN-ANIMAM-VIVENTE-GEN-2"; on the right the prior's motto, "FRAUS

INIMICA LUCI-1533."

The main colors of the pot-metal glass used in the window are a beautiful red for Christ's mantle, part of God's cope, and the archangel's wings; dark blue for Christ's tunic; and deep violet decorated with a damask pattern painted in silver stain for the archangel's garment. The background makes use of a luminous, fairly light blue, on which billowing clouds are defined in grisaille washes (Figure 8). Bousch uses tonal variations in the blue glass to animate the sky, producing atmospheric effects. Faces and body parts, as well as the architectural setting, are treated in grisaille and silver stain on white glass. Some details in green, mauve, or yellow pot-metal glass add to the diversity of the palette.

To complete the original appearance of the Creation window, one should visualize in the tracery the two medallions now in the Metropolitan, catalogued as "evangelists."[24] They are, in fact, two prophets, as

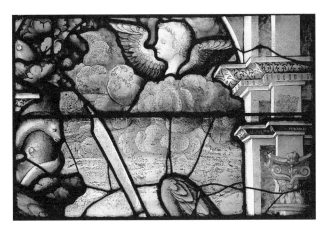

Figure 8. Window 5c, panel 6c: serpent and cherub, from priory church of Saint-Firmin, Flavigny-sur-Moselle (photo: Chester Goosen)

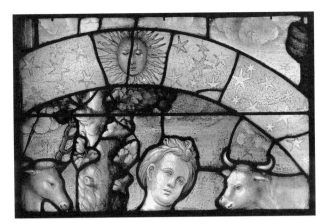

Figure 9. Window 5, panel 5b: head of Eve and circle of the heavens, from priory church of Saint-Firmin, Flavigny-sur-Moselle (photo: Chester Goosen)

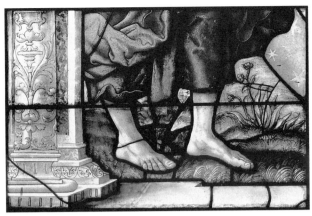

Figure 10. Window 5, panel 3a: feet of Christ, from priory church of Saint-Firmin, Flavigny-sur-Moselle (photo: Chester Goosen)

documented in papers found in the municipal library in Nancy.[25] We shall discuss their identities later.

The pictorial composition[26] has a very strong impact, thanks to the counterpoint provided by the intense and luminous areas of colored glass playing off the dominant white glass painted in silver stain and grisaille; the light blue background serves as a unifying effect. However, closer analysis reveals that the brushwork is an essential element of the pictorial impact. Opaque line work is used in moderation: lines are seldom very thick but can sometimes be solid enough to be mistaken for lead line, as becomes evident when one makes rubbings. Figure modeling is achieved through grisaille washes of different tones, sometimes worked over with a stiff brush to provide texture without hatching. Hatching is used, however, on tree trunks which are painted in a watercolorist style, with details picked out in darker tones to achieve a highly

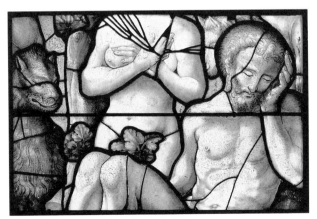

Figure 11. Window 5, panel 4b: torsos of Eve and Adam, from priory church of Saint-Firmin, Flavigny-sur-Moselle (photo: Chester Goosen)

naturalistic effect (Figure 9). There is relatively little stick work: some can be seen in the grass under Christ's feet (Figure 10), in halos, in the orphreys of God the Father's cope, and in the outline of Gabriel's turned-up sleeves. The eyes are drawn with very delicate white strokes picked out with a stick or a needle.

Silver stain is used with great mastery and adds to the effect of modeling. Hair and beards are treated with very thin "comma" strokes, either black or white, using a thin brush or needle, alternatively, on a background of silver stain with a wash of grisaille (Figures 7, 11). Silver stain is also used, as mentioned earlier, to decorate the archangel's violet robe. In the predella the portrait of Wary de Lucy is surrounded by a wreath cut in blue glass, with touches of silver stain that create green leaves incorporated into the foliage. Furthermore—and this is a technique that does not appear to be found at Saint-Nicolas-de-Port—silver stain is used to modify tones of green, thus obtaining variations from olive green to bronze. This remarkable effect can be observed, for instance, on the garments of the prophet in the left lobe of the tracery, one of the two prophets now in the Metropolitan Museum (see Figures 24, 25).

The leading network structures the entire image, enclosing surfaces of glass masterfully cut in large pieces adapted to the forms of the subject.[27] We have found no instances of jeweling (a technique consisting of drilling a hole in the glass and inserting a piece of another color, secured by leading; also called "chef d'oeuvre"), but some cuts, notably around Eve's fig leaf in the central lancet, are quite daring.

The general composition and architectural integration are also remarkable, particularly in comparisons with the other remaining windows in the Flavigny

Figure 12. Angel from the Assumption of the Virgin, ca. 1514–20, window 23 from Church of Saint-Nicolas, Saint-Nicolas-de-Port (photo: Michel Hérold)

Figure 13. Donor Evrard Marlier, 1527, window 16 from Cathedral of Saint-Étienne, Metz (photo: Michel Hérold)

Figure 14. Saint Matthew (detail), 1538, window 205 from Cathedral of Saint-Étienne, Metz (photo: Michel Hérold)

cycle. The stone mullions between the lancets function as a first screen opening onto the scene. Behind it, the large circle of the firmament extends beyond the central lancet on both sides and takes its place inside the "loggia" represented in the painted architectural setting. This painted setting, while echoing that of the church, already presents signs of a certain decorative Mannerism (Figures 8, 10). The general composition of the window also includes the two prophets seen in the tracery; they lean against an entablature incorporated into the painted architectural setting, as if they were on a balcony, observing and commenting on the scene below.

Comparison with other windows executed by Valentin Bousch brings out some interesting points. First, given the size of the church at Flavigny, the stained glass was not seen from a great distance. The closest comparison is with the lower windows in Saint-Nicolas-de-Port, where conditions are relatively similar, as can be seen in the window of the Assumption of the Virgin (Window 23), in which the same painting technique can be observed in the faces of the Virgin and the angel supporting her on the right (panels 1c and 2c, Figure 12), as well as in the lower window done during the first campaign in Saint-Étienne Cathedral—for example, the donor Evrard Marlier in Window 16 (Figure 13) of the Virgin and Child in Window 26 (Figure 15). The situation is clearly quite different when we consider the higher windows, particularly those executed during the second campaign at Metz. Although the elements of the painting technique are the same, the contrasts are much stronger, and thick black lines and white strokes picked out in stick work dominate the overall design (Figure 14).

One should not fail to observe the comparison

Figure 15. Virgin and Child (detail), 1526–27, window 26 from Cathedral of Saint-Étienne, Metz (photo: Michel Hérold)

between the anatomy of the extraordinary Saint Sebastian in Saint-Nicolas-de-Port (Window 113, panels 2c to 4c, Figure 16) and that of the left-hand figure in the Flavigny Flood window (Window 3, Figure 21), as well as the face of Saint John in the Stockbridge Crucifixion window (Window 2, Figure 23).[28]

The Strasbourg origin of Valentin Bousch is obviously very important. During his formative years, he must have been in contact with Rhenish stained-glass painters and with the art of southern Germany.[29] His

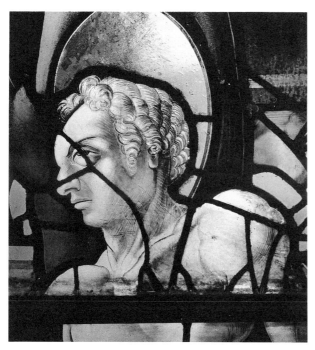

Figure 16. Saint Sebastian (detail), ca. 1518, window 113 from Church of Saint-Nicolas, Saint-Nicolas-de-Port (photo: Michel Hérold)

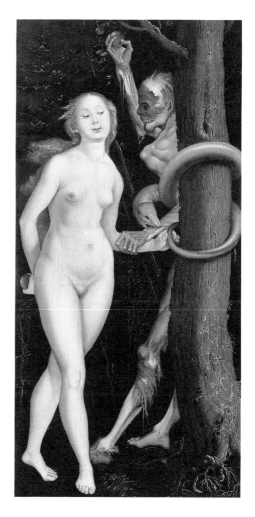

Figure 17. Hans Baldung Grien (German,1484/85–1545). *Eve, the Serpent and Death*, ca. 1512. Ottawa, National Gallery of Canada (photo: National Gallery of Canada)

Figure 18. Window 5, panel 2b: donor, Wary de Lucy, from priory church of Saint-Firmin, Flavigny-sur-Moselle (photo: Chester Goosen)

style is often associated with that of Hans Baldung Grien, whose family had settled in Strasbourg early in the sixteenth century. Baldung, after his apprenticeship and his *Wanderjahre*, during which he spent some time in Dürer's workshop in Nuremberg, was back in Strasbourg between 1509 and 1512; it was probably during this period that contacts and exchanges between the two young artists took place. Some comparisons can be found, starting with the "entrechat" pose of Baldung's Eve in the National Gallery, Ottawa[30] (Figure 17), which is very similar to Bousch's Flavigny Eve when she is expelled from Paradise. But an even more striking similarity that exists between the face of Eve in the same part of the Flavigny window and that of some of Baldung's female faces[31] has to be reconsidered, because the authenticity of the Flavigny piece is problematic.[32]

Some of Bousch's details also invite comparison with Rhenish works. In the portrait of the donor, Wary de Lucy, in the center of the predella (Figure 18), the drawing of the heavily lidded eyes, with pronounced eyebrows and eyelashes, is similar to that of one of the saints in Window 205 in the Cathedral of Saint-Etienne

in Metz, dated 1538 (Figure 14). The same specific eye details, as well as the very graphic treatment of faces, can be found in some figures in the windows of the north nave aisle of the Cologne cathedral (n XXI–XXV) dating from the early sixteenth century.[33]

Nevertheless, by the time Valentin Bousch came to work at Flavigny, he had been established for almost twenty years in Lorraine, where contacts with northern France and Flanders were quite strong. He had been able to integrate the influences he had encountered into a style of his own: highly distinctive faces, narrative animated by movement, an expressionistic emphasis on moments of crisis, as in the scene of the Flood (Window 3, Figure 21) or in the group of Saint John supporting the Virgin at the foot of the cross (Window 2, Figure 23);[34] and in the remarkable combination of intensity and serenity, seen in the face of Christ as He introduces and explains the program of the stained-glass cycle (Figure 19). In the Flavigny windows Bousch attained complete mastery of his art and explored all its possibilities.

Over many centuries, the subject of the Creation of the World has often given rise to representations of complex cosmologies.[35] But at Flavigny the simple circle of stars depicted by Bousch, with the sun at the summit and the moon at the bottom, is simply related to popular iconographic tradition, as can be found in the *Shepherds' Calendar* of 1496.[36] The Creation of Eve and the position of the sleeping Adam (reversed) can be compared with the same scene in the stained glass of the cathedral at Châlons-sur-Marne (Window 40, south nave aisle, dated 1506 or 1516); the Expulsion from Paradise is also very similar to that window.

An interesting comparison can be made with the Creation illustrated in the Lübeck Bible of 1494, in which God appears in his glory, surrounded by angels, as with outstretched arms he embraces the whole of Creation, which is arranged in concentric circles around the Garden of Eden, where we see the birth of Eve, blessed by Christ as Creator[37] (Figure 20). But in the Flavigny window Christ stands outside the circle of Creation. He is part of the Trinity, with the dove of the Holy Spirit establishing the visual connection with God the Father, and is also the embodiment of the divine will and love: "In the beginning was the Word."[38] Situated as he is in the first lancet, Christ introduces the whole program of stained glass in the choir, much of which is known through the other surviving windows: The Flood (Figure 21), Moses Presenting the Tables of the Law (Figure 22) and the Crucifixion (Figure 23).

It is known from documents that the three windows completing the cycle in the choir of Flavigny had

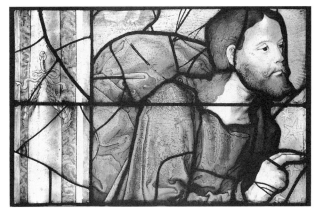

Figure 19. Window 5, panel 5a: detail of Christ, from priory church of Saint-Firmin, Flavigny-sur-Moselle (photo: Chester Goosen)

already disappeared by 1850. In 1875, however, in response to an inquiry about the religious furnishing in the diocese, the parish priest compiled a list of the windows, based on the reminiscences of the convent's chaplain: the Creation, the Flood, Sinai, Bethlehem, the Calvary, the Pentecost, and the Last Judgment.[39] One can, of course, have doubts about a list established after a twenty-five-year interval, and other hypotheses have since been suggested, but it would seem, by referring to the choir's layout, that the program cited in 1875 can be generally accepted, although we shall propose a possible variation.

The choir of Flavigny is illuminated, as we have seen, by seven windows culminating in pointed arches, the two westernmost having the dimensions of the Creation window, the other five those of the windows preserved in the United States. Thus we would have had, facing each other in the western bay, the Creation on the north side (Window 5) and the Last Judgment on the south (Window 6). Between the Creation and the axial window were the two windows now in the Metropolitan Museum, namely the Flood (Window 3) and Moses Bringing the Tables of the Law (Window 1). In the stone tracery at the summit of the axial window (Window 0), there still remained in 1877 a figure of God the Father; one can deduce from this that the subject of the lancet below might have been a Nativity, as the chaplain recalled, but another possibility might be an Annunciation. The latter is a stronger supposition, considering the very special devotion directed to this subject by the Lorraine ducal family, a devotion that found resonances through the whole duchy, as can be seen, for instance, at Saint-Nicolas-de-Port, where it is represented many times, and in particular, in the axial choir window.[40]

On the south side, the first window to the right of the

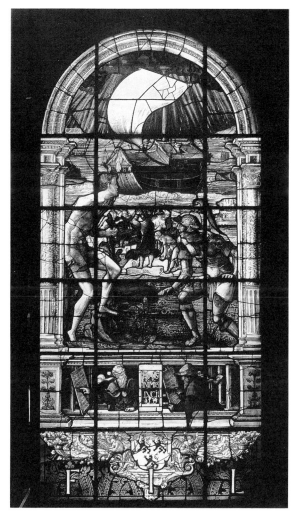

Figure 20. First page of Genesis from the Lübeck Bible, printed by Steffan Arndes, 1494. Leipzig, Universitätsbibliothek, Signatur Biblia 204 (from H. Kunze, *Geschichte der Buchillustration in Deutschland* [Leipzig, 1975])

Figure 21. Window 3: The Flood, 1531, from priory church of Saint-Firmin, Flavigny-sur-Moselle. The Metropolitan Museum of Art, Purchase, Joseph Pulitzer Bequest, 1917, 17.40.2

axial one (Window 2) would have been the Crucifixion. Various subjects have been proposed for Window 4: the Last Supper, the Supper at Emmaus, the Pentecost (as in the chaplain's list), or the Resurrection. Since, in 1877, there was still a Paschal Lamb in the stone tracery of this window, and if we assume that it was in its original location, the event depicted below should have taken place after the Crucifixion, thus eliminating the Last Supper from consideration. Then the last window in the cycle would be the Last Judgment, facing the Creation.

The documents in the Nancy municipal library to which we have already referred (see notes 21 and 25) also describe the subjects in the tracery of the other windows: in Window 3 (above the Flood) was a phoenix; in Window 1 (above Moses), the dove of the Holy Spirit; and above the Crucifixion in Window 2 was a pelican. Each of the predellas of these three windows

features two bust-length figures who appear to be prophets,[41] presenting biblical texts pertaining to each respective subject. Below the Crucifixion, however, the figure on the right looks younger than the other and could be Saint John the Evangelist offering a verse of his Gospel.

As for the two prophets observing the Creation from their "balcony," the author of the same document claimed to recognize them as Moses and Elijah.[42] We prefer to see them as Moses (Figure 24) and Isaiah (Figure 25), as their presence supports the very condensed narrative of the first window. Indeed, Isaiah, on the right, refers to his vision of God in his glory, surrounded by seraphim (Isaiah 6:1–4); he seems also to point to the animals, peacefully attending Eve's birth. Of course they are not the wolf and the lamb or the leopard and the kid mentioned in his prophecy (Isaiah 11:6–7 and 65:25), but the lion and the stag of

162

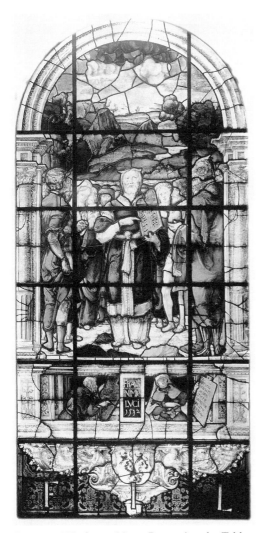

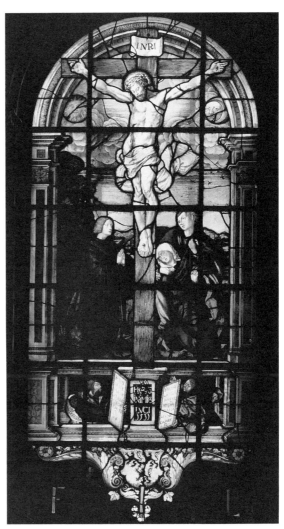

Figure 22. Window 1: Moses Presenting the Tables of the Law, 1532, from Saint-Firmin. The Metropolitan Museum of Art, Purchase, Joseph Pulitzer Bequest, 1917, 17.40.1

Figure 23. Window 2: Crucifixion, 1531, from Saint-Firmin. Stockbridge, Massachusetts, Church of Saint Joseph (photo: Leland A. Cook)

Figure 24. Window 5, tracery panel 1ab: Moses, 1533, from Saint-Firmin. The Metropolitan Museum of Art, Purchase, Joseph Pulitzer Bequest, 1917, 17.40.3

Figure 25. Window 5, tracery panel 1bc: Isaiah, 1533, from Saint-Firmin. The Metropolitan Museum of Art, Purchase, Joseph Pulitzer Bequest, 1917, 17.40.4

Figure 26. Window 5: diagram of panel numbering

Flavigny, symbols of majestic valor and piety respectively, who live together in peace in the Garden of Eden. Moses, for his part, points down toward the other side of the scene to the ox and the ass, which herald the Nativity of Christ.

Thus we can propose that the entire Flavigny cycle illustrates the destiny of humanity in its relationship to God. The program, based exclusively on the Old and New Testaments, reflects the Christian humanism of the time. There are no themes drawn from apocryphal texts or from Jacobus de Voragine's *Golden Legend*. In this context, the primordial position of the Word, in the person of Christ, takes on its full importance: he introduces not simply the first window of the Creation, but the whole cycle that follows as well.

Most of the authors writing on Flavigny and its stained-glass windows have mentioned that the period during which they were created, between 1531 and 1533, was "troubled by the dissemination of Protestant ideas."[43] It appears necessary, however, to set the commission in its immediate historical context and to see how far questions provoked by new ideas might find an echo in the Flavigny cycle.

Geographically, Lorraine lies between regions where these new Protestant ideas were emerging and would eventually bring about the Reformation: in France lively intellectual exchanges between humanists spread even to the entourage of François I, while in the German countries the movement initiated by Luther's teachings would soon develop along more radical lines, particularly with the Anabaptists. Their excesses may have had repercussions in Lorraine until Duke Antoine's victory, between the towns of Salerne and Selestat, over the *rustauds,* the peasants in revolt who had spread from the south of Germany. In the end, owing to the strong influence of the ducal family, especially on the upper classes, the duchy remained Catholic. Nevertheless, in the early years of the Reformation, between 1520 and 1530 and even later, Metz and Saint-Nicolas-de-Port had active Protestant communities that were in close contact with Strasbourg, which in 1530 would join the Protestant princes in the Augsburg Confession.

In Metz, according to historian Georges Viard, "the field had been prepared in 1519–20 by a small circle of humanists gathered around Cornelius Agrippa, while he was residing in the city. It included parish priests, physicians, lawyers, a few artisans, the bookseller Jacques. They read Lefèvre d'Étaples [ca. 1450–1537], Erasmus, and Luther. Occasionally there would be public debates, but these did not really lead to popular enthusiasm. Nevertheless the municipal authorities were alarmed and, in 1521, they forbade the purchase of Luther's books."[44] Furthermore, between 1523 and 1525 many preachers of these new ideas had met with such success that the authorities reacted violently against them: some preachers were expelled and some were executed, often after such horrible torture that rioting ensued. The contemporary correspondence of the Strasbourg reformer Martin Bucer, Erasmus, and other reformers[45] attests that the Metz events were closely observed and commented upon. Erasmus, in particular, supported the rebellious canon Pierre Toussain, a friend of Guillaume Farel.[46] But in about 1530 there was still hope that the flagrant abuses of the church and the sclerosis that had befallen medieval scholasticism could be corrected by needed reforms. The diffusion of Erasmus's Christian humanism, the conciliatory efforts of Martin Bucer, and the influence of Lefèvre d'Étaples in France were giving strength to the dissemination of ideas based on a new reading of the Scriptures in the original texts. Some

authors tend to minimize the importance of the movement in Metz and in Saint-Nicolas-de-Port,[47] but it seems quite reasonable to assume that the creators of the Flavigny cycle—the patron and the artist—were aware of the new ideas.

Among the main points discussed in these humanist circles were the doctrine of predestination, as opposed to that of free will, which was a source of conflict between Erasmus and Luther; the definition of the Word as God's self-revelation, by which the redemptive action of Christ was made known to humankind, and the source of which is to be found in the Scriptures; the doctrine of the Eucharist, in which the theory of transubstantiation, defined by a decree of the Fourth Lateran Council (1215), was confronted both with that of consubstantiation proposed by Luther, according to which Christ is really present in the bread and the wine of Holy Communion, and with the theory of the symbolic character of the Sacrament, supported by Zwingli. Also debated was the principle of the Trinity, which the Anabaptists denied.

In the program of the Flavigny windows, we are first presented with Christ expressing the divine Word and the affirmation of the Trinity, with the dove of the Holy Spirit visually connecting him with God the Father; then the fate of fallen mankind, expelled from paradise, punished by the Flood, saved first by God's Law brought down by Moses, then by the New Alliance through the Crucifixion.

Some details in the Creation window raise further questions. The story of the Creation is significantly shortened if we compare it, for instance, with the window in Châlons-sur-Marne mentioned above, in which the narrative extends through eight episodes. Why is the Temptation not represented according to the tradition (see Figure 8; it is merely suggested by the presence of the serpent, half hidden in the tree, looking on at the Expulsion)? Why is Eve, whose birth is shown in the very center of the composition, rising from Adam's side, already wearing a fig leaf? Was she born a sinner? Her hands crossed over her breast evoke the gesture of humility of the Annunciate Virgin in the Ghent Altarpiece, but her left hand freeing her right breast might also suggest a nursing Mother of Christ.[48]

One cannot help thinking that the author of the program was influenced by the doctrine of predestination at a time when, between 1530 and 1535, these ideas were passionately debated, despite the early repressions of the 1520s, which would be fiercely resumed in Metz only in 1543. It should indeed be emphasized that the iconography of this window is highly exceptional in character. As for the whole cycle, despite the absence of the three missing windows, it can be pro-

posed that Valentin Bousch might well have known of the new ideas in Metz and probably stayed in contact with Strasbourg. Working for a very enlightened patron, he had a greater freedom of composition and interpretation than he had at Saint-Nicolas-de-Port or Metz. The main point, however, is certainly that the program was established by a humanist who was well aware of the general debates of his time and who tried to demonstrate that the essential character of Christianity is compatible with a reformed Catholicism, as proposed by Erasmus, a humanist solution that would be abandoned after the Council of Trent.

It should be hoped that further research will shed more light on the personality of Wary de Lucy, who lived through these difficult times and transmitted to us his interpretation of them.

ACKNOWLEDGMENTS

Many thanks are due to Michel Hérold, who generously allowed me to use his archival research on Flavigny and who enriched my understanding of the subject through our lively discussions. This essay is also a posthumous homage to Jane Hayward, who first drew our attention to the existence of the private collection in British Columbia. The photographs of the Creation window were taken by Chester Goosen. I wish also to acknowledge the invaluable help of James Bugslag, who revised the English version of my text, and of Gwladys Downs, who read the final version. Lastly, the present owners should be thanked for their friendly collaboration.

NOTES

1. This stained-glass window was bought in 1952 from a son of William Randolph Hearst, a year after the latter's death. At that time the present owner took a few notes from Hearst's "private catalogue," but these give only a brief description of the window, without any mention of provenance; however, he recalls having heard Hearst say that he had bought it in Sens. This information remains sketchy and ought to be investigated. The window did not appear in the 1941 sales catalogue of the Hearst collections. The problem of knowing how and when it came to the United States and, in particular, when and where it was bought by Hearst, remains unresolved.

2. The priory is now a medical institution, thus acknowledging in a secular setting its original dedication, since Saint Firmin is revered as a healer.

3. A benefice *in commendam* is bestowed upon a secular ecclesiastic or a layman (commendatory) with enjoyment of its revenues for

life. "Barthélemy de Lucy, abbé de Saint-Arnoul de Metz, . . . possédait aussi le prieuré de Saint-Nicolas-de-Port" (Abbé Jacques Choux, "Valentin Bousch à Saint-Nicolas-de-Port et à Flavigny," *Le Pays Lorrain* 3 [1973] p. 165). When, shortly before his death, Barthélemy resigned his benefice at Flavigny in favor of his nephew Wary de Lucy, the latter was only nine years old; his father managed the priory until he came of age (Chanoine A. Dedenon, *Histoire du prieuré benedictin de Flavigny-sur-Moselle* [Nancy, 1936] pp. 72–73). On the decline of the community and on what is known of the life of Wary de Lucy, see ibid., where he is described as a nobleman who cared about the well-being of the villagers who were his dependents. In 1529 he was also appointed an apostolic protonotary (see Nancy, Bibliothèque Municipale, Fonds Abel, *carton* 73, f. 8).

4. His coat of arms on the keystone of the choir marks the completion of the building. Dedenon (*Histoire du prieuré*, pp. 70–72) notes similarities in the architectural decoration (trapezoidal molded pilasters, prismatic vault ribs) with that of the Cordeliers church in Nancy, a foundation of the dukes of Lorraine. Since the Cordeliers church, according to tradition, was considered to have been built between 1480 and 1487, Dedenon concludes that the reconstruction of Flavigny was the work of Barthélemy de Lucy. Pertinent texts were included in Michel Hérold, "Les Vitraux disparus de l'Église des Cordeliers à Nancy," *Bulletin monumental* 142-II (1984) pp. 159–172. Sylvain Bertoldi, "L'Église des Cordeliers de Nancy: un monument du XV^e ou du XVI^e siècle?" *Lotharingia* (1990) II, pp. 271–285, on the basis of a thorough stylistic analysis, supported by archival documents, has shown that the Cordeliers church dates in large part from 1520–25 and that Flavigny must be dated later.

5. Two plans of the priory are known, one dated "vers 1760," the other undated but entitled "Préventorium . . . ," thus dating it after the nuns had left. Both are so imprecise concerning the church that they are not as useful for locating and numbering the windows as a rough sketch plan in Nancy (Bibliothèque Municipale, Fonds Abel, *carton* 152), dated in the 1880s, which we have used here.

6. Edmond des Robert, "Trois vitraux du prieuré de Flavigny-sur-Moselle," *Bulletin mensuel de la Société d'archéologie lorraine* (August–September 1907) pp. 213–214, cited by Léon Germain de Maidy, "Sur les anciens vitraux de Flavigny," *Bulletin de la Société d'archéologie lorraine* (1927) p. 58. Two of the windows (nos. 3, 5) are also illustrated in Dedenon, *Histoire du prieuré*.

7. They were bought from Jacques Seligmann, the same dealer who sold the Crucifixion window to Thomas Fortune Ryan of New York in 1913. For the stained glass in this series now in the United States, see Madeline H. Caviness et al., *Stained Glass before 1700 in American Collections: New England and New York* (Corpus Vitrearum Checklist I), Studies in the History of Art, Monograph Series I, vol. 15 (Washington, D.C., 1985) pp. 154–156; idem, *Stained Glass before 1700 in American Collections: Midwestern and Western States* (Corpus Vitrearum Checklist III), Studies in the History of Art, Monograph Series I, vol. 28 (Washington, D.C., 1989). See also "Vitraux déplacés," in *Le Vitrail en Lorraine* (Nancy, 1983) p. 401.

8. Michel Hérold, "Valentin Bousch, l'un 'Des Peintres sur verre qui se distinguèrent au seizième siècle,'" *Revue de l'art* 103 (1994) pp. 53–67.

9. Ibid., p. 53 and nn. 1–3.

10. Ibid., p. 54 and n. 15.

11. Choux, "Valentin Bousch," pp. 157–170.

12. Michel Hérold and Françoise Gatouillat, *Les Vitraux de Lorraine et d'Alsace*, C.V. Recensement des vitraux anciens de la France (1994); Michel Hérold, *Les Vitraux de Saint-Nicolas-de-Port*, C.V. France VIII/1 (Paris, 1993).

13. Choux, "Valentin Bousch," pp. 158–161.

14. Hérold, "Valentin Bousch, l'un 'Des Peintres,'" p. 58.

15. Ibid., p. 56.

16. Ibid., p. 58.

17. He was given the office of cathedral glazier in 1518 (ibid., p. 59).

18. Ibid., p. 60.

19. Ibid., p. 61.

20. MMA, Department of European Sculpture and Decorative Arts, acc. nos. 17.40.6, 5: Savigny, gules three lions rampant or; Craincourt, argent two lions passant gardant gules, crowned or.

21. Nancy, Bibliothèque Municipale, Fonds Abel, *cartons* 73, f. 4, and 152. The drawing (Figure 5) shows a decorative console under the heraldic medallions. In the absence of material evidence, we have numbered the panels according to the existing dispersed pieces (Figure 26): thus Savigny would be lancet b, panel 1, and Craincourt lancet c, panel 1.

22. See de Maidy, "Sur les anciens vitraux," p. 77: Toulon, azure a cross argent couped in chief by a label or.

23. For the relationship with the Cordeliers church in Nancy, see note 4 above.

24. "Two Evangelists," MMA, acc. no. 17.40.3,4. See also Caviness, C.V. Checklist I, p. 155. These two pieces, originally in the form of elongated lobes, were cut down at an unknown date to form two circular medallions.

25. Nancy, Bibliothèque Municipale, Fonds Abel, *carton* 73, f. 21.

26. Although we were able to make a thorough visual study of the Flavigny windows now in the United States, thanks to the collaboration of our American colleagues, this essay is mainly concerned with the stained-glass window in Canada. I shall refer to relevant features of the other windows only when they are pertinent, as they will later be treated in greater depth by the American Corpus Vitrearum project.

27. A diagram of the original leading structure has been drawn up, based on rubbings of the glass and on close observation, and forms the basis for a study of the glass cutting at Flavigny by James Bugslag (see following article). The few instances of restoration that we have observed will be reported in detail in the final publication of the Canadian Corpus Vitrearum.

28. Hérold, *Les Vitraux*, pp. 57 and 63.

29. When he died in 1541, Bousch's will showed that he owned drawings or prints by Dürer ("pourtraictures d'Albert") and a few Italian paintings. See Hérold, "Valentin Bousch," p. 65.

30. See Robert A. Koch, *Hans Baldung Grien—Eve, le serpent et la pomme*, exh. cat., National Gallery of Canada (Ottawa, 1974); A. Kent Hieatt, "Eve as reason in a tradition of allegorical interpretation of the Fall," *Journal of the Warburg and Courtauld Institutes* 43 (1980) pp. 221–226.

31. See, for instance, Baldung's *Virgin with Grapes* (dated 1534), Berlin, Staatliche Museen Preussischer Kulturbesitz, Gemäldegalerie, in Hans Körner, "Hans Baldung *Muttergottes mit der Weintraube*," *Pantheon* 46 (1988) pp. 50–60; or his *Three Graces* (dated 1541–44), in the Prado, in James H. Marrow and Alan Shestack, *Hans Baldung Grien—Prints and Drawings*, exh. cat., Yale University Art Gallery (New Haven, 1981) figs. 32, 33.

32. On closer observation, the glass does not appear to be of the same quality as its surroundings, being very smooth and of a slightly different tone; moreover, the drawing seems crisper than in the rest of the window and sprinkled with a "bloom," which imitates corrosion. A couple of pieces in the painted arches crowning the lancets could also be instances of restoration. The drawing of this head of Eve is of remarkable quality, but its authenticity is doubtful until it undergoes further analysis, in particular the checking of edges of the glass.

33. Herbert Rode attributes this stained glass to one or more workshops working in the circle of the Master of the "Heilige Sippe" and of the Master of Saint Séverin, both of whom had connections with Flanders. See H. Rode, *Die mittelalterlichen Glasmalereien des Kölner Domes*, C.V. R.F.A. IV/I (Berlin, 1974); see esp. the face of Saint Sebastian, Window n XXII 3 c, pl. 221.

34. There is an interesting comparison to be made between this group and a sculpture of the same subject, Saint John Supporting the Virgin, in the Entombment in the Church of Pont-à-Mousson (Meurthe-et-Moselle).

35. Some examples from 15th-century Italy come to mind: Masaccio's fresco in Santa Maria del Carmine in Florence (1425), Ghiberti's Doors of Paradise, also in Florence (1428–52), or Giovanni di Paolo's predella (ca. 1445) in the Robert Lehman Collection of the MMA. For an iconographic study of the Creation, see Barbara Bronder, "Das Bild der Schöpfung und Neuschöpfung der Welt als *orbis quadratus*," *Frühmittelalterliche Studien* 6 (1972) pp. 188–210.

36. See also Choux, "Valentin Bousch," p. 166 and nn. 24, 25.

37. See Horst Kunze, *Geschichte der Buchillustration in Deutschland* (Leipzig, 1975) esp. pp. 314–318 and ill. pp. 226–232.

38. Earlier Italian examples of this can be found, particularly in the late-12th- and early-13th-century mosaics in the Palatine chapel, Palermo, and in Monreale Cathedral, or in San Marco in Venice, but in these representations Christ introduces each scene of the Creation as the Creator; this is especially evident in the scene of the Expulsion from Paradise in San Marco, where He pushes Adam and Eve out of the gate. On the Pauline tradition of "Christ logos" in representations of the Creation, see Hans Martin von Erffa, *Ikonologie der Genesis* (Munich, 1989) I, pp. 45–46.

39. De Maidy, "Sur les anciens vitraux, pp. 74–75.

40. Hérold, *Les Vitraux*, p. 135.

41. De Maidy ("Sur les anciens vitraux," p. 59) thinks that they are authors, perhaps Benedictine monks, engaged in the study of biblical literature: "il s'agit d'écrivains quelconques, peut-être des moines bénédictins, appliqués à l'étude de la littérature biblique."

42. "Enfin dans les lobes deux personnages de dimensions disproportionnées à l'espace qu'ils occupent paraissent assis dans la posture d'hommes qui écrivent sur des tablettes qu'ils ont devant eux. . . . Nous supposons qu'ils représentent Moïse et Elie qui ont figuré à côté du Seigneur dans le mystère de la Transfiguration." Nancy, Bibliothèque Municipale, Fonds Abel, *carton* 73, f. 21.

43. De Maidy, "Sur les anciens vitraux," p. 76 (author's translation).

44. Georges Viard, "La Renaissance, l'Humanisme et les débuts de la Réforme—1450–1550," in René Taveneaux, *La Vie religieuse*, Encyclopédie Illustrée de la Lorraine (Nancy, 1988) p. 105 (author's translation).

45. A. L. Herminjard, *Correspondence des Réformateurs dans les pays de langue française* I: 1512–26, II: 1527–32 (Geneva/Paris, 1866–72; repr., 1965).

46. Ibid., II, pp. 153–154, letter no. 247 (Sept. 3, 1528).

47. Particularly Bernard Roussel, cited by Viard, "La Renaissance," p. 104.

48. On the theme "Eve–Mary," see von Erffa, *Ikonologie der Genesis* I, pp. 211–216.

Valentin Bousch's Artistic Practice in the Stained Glass of Flavigny-sur-Moselle

JAMES BUGSLAG

Assistant Professor, School of Art, University of Manitoba

T HE REMAINING GLASS from the priory church at Flavigny-sur-Moselle forms the crowning achievement of Valentin Bousch, a renowned Renaissance artist. That his surviving oeuvre comprises works solely in the medium of stained glass is indicative of both the high valuation still placed on that medium during the first half of the sixteenth century and Bousch's consummate technical command of glazing practice. His earlier work at Saint-Nicolas-de-Port has recently benefited from the fundamental research of Michel Hérold,[1] who has also compiled the fullest biography of the artist.[2] Bousch's work at the Cathedral of Saint-Étienne in Metz has been studied as well,[3] but the stained glass of Flavigny-sur-Moselle has yet to receive comparable attention.[4] Part of the reason is undoubtedly that it is not only displaced but also divided among various North American collections. The combined attention of several national committees of the Corpus Vitrearum Medii Aevi (CVMA), however, together with the generous cooperation of The Metropolitan Museum of Art in New York, a private collector in British Columbia, and the Church of Saint Joseph in Stockbridge, Massachusetts, is creating new possibilities for the study of the Flavigny glass.[5] What is beginning to emerge is the profile of an exceptional artist whose work develops from the late Gothic environment of Germanic art characteristic of the Strasbourg region toward the new canons of artistic value inspired by Italy and usually subsumed under the Renaissance umbrella.[6] The purpose of this essay is to contribute to a fuller understanding of Valentin Bousch by investigating aspects of the artistic practice of his workshop at Flavigny-sur-Moselle and, in comparing them with his earlier work, to give an indication of his growth as an artist. Bousch must be considered not simply as a

glazier but as an artist whose works played a substantial role in redefining the artistic values of his time.

The starting point of this research was a close examination of the Flavigny Creation window (Figure 1) by the Canadian Committee of the Corpus Vitrearum, of which I am a member. Among other things, this study established the current leading network of the window, which was later used to attempt a re-creation of the original leading network. Subsequently, the Flood and Moses windows (Figures 21, 22) and the two prophet medallions in the Metropolitan Museum (Figures 24, 25) were studied at close range on a scaffold.[7] This analysis has helped to highlight some remarkable glass cutting and painting, as well as some related aspects of Valentin Bousch's working methods. These make clear that Bousch exhibited a virtuoso command of technique, bringing him into clearer focus as an artistic personality and allowing closer insight into the demands of a Renaissance glazier's workshop.

Much of the following analysis focuses on glass cutting, although we do not know how the Bousch workshop cut its glass. Most glass cutting before the Renaissance was done with a hot iron, which was run over the cut line; then the glass was doused in water, in order to crack it along that line. The edge would then be refined with a grozing iron. At a later time, a faceted diamond began to be used for glass cutting, and little effort has yet been directed toward investigating exactly when this change took place. Writers are usually content to cite Jean-Jacques Gruber's statement that diamond cutting was in use by the mid-sixteenth century, but it is mentioned as early as the second half of the fourteenth century in the treatise of Antonio da Pisa.[8] The earliest documentary evidence for a diamond glass cutter, however, dates from 1635, in the inventory of the deceased Parisian glazier Nicolas Chamus.[9] Evidence for earlier usage must necessarily come from the examination of the glass itself in its unleaded state, and so far there is little evidence that such analysis has been carried out, or at least published.[10]

In the fifteenth century, window glass was becoming thinner and being produced in larger and larger

Figures 1–26 referred to here are illustrated in the article by Ariane Isler-de Jongh, which begins on page 153 of this *Journal*.

The notes for this article begin on page 180.

pieces, as well. It may also be significant that, according to Guy-Michel Leproux, white glass is harder than colored glass,[11] because throughout the fifteenth century French stained glass is characterized by large areas of white glass, which is used extensively—for canopies, figures, and garments—and is cut in regular rectilinear pieces.[12] It was increasingly expected of a glazier, however, that he be capable of more difficult cutting. As Leproux writes, candidates for membership in the Paris glaziers' guild (formed in 1467) were required to submit a small panel of stained glass as a "masterpiece" and were also required to make some delicate cuts of glass in the workshop of one of the jurors.[13]

The extent of such guild practice is difficult to determine, but it is certain that Valentin Bousch knew how to make extremely difficult cuts, as he himself made—or directed someone in his workshop to make—some remarkable cuts in the Flavigny windows. These are seldom obvious, however, since they nearly always served a pictorial end, rather than advertising themselves as overt displays of craft skill. One of the most obvious instances is in the roundel of the prophet Isaiah, formerly one of the tracery compartments above the Creation window and now in the Metropolitan Museum (Figure 25). The blue sky piece in front of Isaiah's face has been delicately cut to create an extremely narrow indentation to fit the prophet's yellow pen. This indentation must have presented difficulties comparable to jeweling (*coupure en chef d'oeuvre*), yet it is used here not to evoke a rich sense of materiality but to contribute toward a concentrated image of the prophet writing, perhaps following a model from another medium (models will be discussed below). Cuts of this degree of difficulty, one may speculate, were subject to frequent breakage, necessitating repeated attempts and thus increasing the costs of both labor and materials. Such cuts also weaken pieces of glass considerably, and they are often difficult to identify now because of subsequent breaks that have been repaired by mending leads. In the central lancet of the Creation window, for instance, in the lower torso of Eve (Figure 11), the two small leads to either side of her fig leaf are mending leads, masking the fact that an extraordinary indentation was required in this large piece of glass. Originally, this would have left, particularly at the right, a very narrow isthmus in the glass; it is understandable that the piece subsequently cracked there. And in the panel near the top of the same lancet, the cutting around God the Father presents many difficult cuts (Figure 6): I believe that the two yellow areas flanking His head originally constituted single pieces, as well as His crown, which now contains only one obvious mending lead, and the

orphreys of His cope, in which the right-hand and bottom edges were also made in a single piece.

Such virtuoso cutting would have been noticed by a knowledgeable observer in the 1530s—and recognized as an expensive procedure. Besides breakage and labor costs, as mentioned above, the more deep cuts into a piece of glass, particularly on a large piece, the more waste there would have been. Cost is certainly likely to have been a factor here, for the donor, Wary de Lucy, paid for the glazing of not one but seven windows—a large and undoubtedly expensive commission by any standard. And if my analysis of Bousch's approach to the project is correct, it would appear that the donor wanted to spare no expense.

It was not, however, just to create a lavish product that Bousch made use of his virtuoso glass cutting at Flavigny. He used glass cutting in combination with his painting practice with the intention of creating painterly effects that sometimes flew in the face of established glazing practice. Such "obvious" glazing practices as jeweling were completely avoided at Flavigny, as was engraving.[14] Bousch consistently approached his Flavigny works with the sensibility of a painter rather than a glazier, and it is surely significant that documented references to him characterize him as a painter.[15]

One of Bousch's major concerns at Flavigny was to minimize the intrusive effect of lead lines, and he accomplished this by a number of means. Glass cutting played a very active role in defining the character of Renaissance stained glass. There had been a tendency during the fifteenth century for glass to be cut in large geometric shapes that, particularly in canopies, created a leading network with a paneled effect, in which the leads are relatively unrelated to the contours depicted in the glass. Bousch was certainly aware of this practice, for it is strongly exemplified in his earlier Window 210 in the south transept of Metz Cathedral, dating from 1528.[16] In general, such a paneled effect was superseded only gradually in the sixteenth century, but its complete abandonment at Flavigny can be seen as a sharp change in Bousch's workshop practice; in fact, it is one of many changes in artistic practice noticeable in the Flavigny glass, a topic to which I shall return shortly. Even though many large pieces of glass were used at Flavigny, the lead lines follow contours in the imagery much more scrupulously, which resulted in many more irregular cuts. A paneled effect was still being created by some glaziers at this time, but it is nowhere to be found in the Flavigny Creation window.[17]

Not only did Bousch attempt to limit the positioning of his lead lines to major contours, but this aspect of his approach to the placement of leads also meshes

effectively with his painting style. As Jean-Jacques Gruber so nicely put it, grisaille in Bousch's hands takes on the character of a pigment.[18] He built up grisaille on his glass not in flat, uniform densities but with a fluidity of tone that may have depended on new binding agents in his grisaille mixture: gum arabic and even, it would appear, oil were utilized by this time, rather than the traditional wine, urine, or vinegar.[19] Bousch probably also used combinations of iron- and copper-based grisaille, an increasingly common procedure at this time.[20] In any case, he often deployed his painting materials in combinations to create a remarkable variety of tones and textures. Thus, in the Flood window (Figures 21, 27) the ark exhibits a wide range of brown and yellow tones, as does the helmet of the right-hand foreground figure, even though both were painted on white glass. In oil painting, armor had long featured the effects of light on highly reflective metal surfaces; that had not been the case in stained glass, however, and no glass painter better captured the effect than Valentin Bousch has here.

As well as making use of a variety of painting materials, Bousch also used a variety of brushes to apply his grisaille and a variety of stick work to remove it. Application and removal are often combined in Bousch's heads to create a painterly effect that is unsurpassed in the medium of stained glass (see Figure 12). In this respect, the Flavigny glass, as in so many other aspects, can be seen as the culmination of Bousch's development. The parallel hatchings that enlivened the shadows in many of his earlier works at Saint-Nicolas-de-Port are gone now. Although hatching was a widely disseminated practice among glass painters, at Flavigny Bousch was capable of producing a tremendously nuanced range of shadows, from light to deep, by means of continuously graded washes. The darkest shadows, at a distance, are indistinguishable from lead lines, and the two are often found together. The effect is particularly noticeable in Christ's draperies in the left light of the Creation window (Figure 1). Even in a relatively close view, the dark shadows of Christ's purple robe, just above his red mantle, are so disposed that the lead line that follows the border between the two colors is almost completely invisible. The same is true of the dark clouds at the top of the Flood window. Elsewhere, lead lines follow contours where they are often indistinguishable from thick lines nearby painted in grisaille. In the Flood window, the ark and its rigging contain many such cleverly concealed lead lines. Cut lines, it would appear, were always placed so as to optimize pictorial values.

Bousch's attempt to limit cuts and lead lines to major contours was subject to a number of technical

Figure 27. Detail of foreground nude and ark from Window 3 in Figure 21 (photo: James Bugslag)

Figure 28. Detail of heads from Window 1 in Figure 22 (photo: James Bugslag)

considerations. Obviously, the borders between different colors of glass must be leaded, whether a strong contour is wanted or not. Bousch, however, sought to reduce such difficulties in his initial design work by orchestrating forms in a way that minimized unwanted effects. In the Moses window, for instance (Figure 28), he frequently painted several heads on the same piece of glass, so regularly, in fact, that he may have been trying to subvert the normal expectations of stained glass, in which heads were usually surrounded by a prominent lead line and hence graphically isolated from both body and surroundings. Another strategy can be seen in the Crucifixion window (Figure 23). Following the lead line between the green foliage of the trees at left and the sky above, the blue sky piece has a serrated opaque profile painted along its lower edge, which successfully masks the presence of the adjacent lead line. Similarly, opaque radial rays emanate in both directions from the lead line separating Christ's halo

Figure 29. Detail of the figure of Christ from Window 2 in Figure 23 (photo: James Bugslag)

Figure 30. Transfiguration of Christ, 1514–20, window 111 from Church of Saint-Nicolas, Saint-Nicolas-de-Port (photo: Michel Hérold)

from the cross and the sky, considerably toning down the presence of the lead line.

Bousch also made use of his varied painting techniques to obviate the necessity for changes in the color of the glass. By applying light, overall grisaille washes, he could approximate the midtone of a color, leaving the unpainted glass to form the highlights and denser washes to create shadows. With the addition of silver stain, he often created the effect of a whole palette on a single color of glass, as in the green "earth" pieces (see Figure 10). There are even passages, particularly in the Flood window (Figure 21), where Bousch appears to have attempted to break through the coloristic limitations of pot-metal glass by painting a single object on two contiguous pieces of differently colored glass. The plant in the central foreground begins on a piece of green glass defining a grassy bank and continues above

on a piece of light blue glass defining the water beyond it; silver stain has been applied to the light blue piece, creating a greenish yellow, in an attempt to harmonize the color of the plant on two differently colored pieces of glass.[21] The same principle has been used to different effect in the left-hand foreground figure, in which the toes of the right foot are depicted on blue glass to register their immersion in the rising floodwaters.

A related consideration in the limitation of obtrusive cut lines was the size of glass pieces available to Bousch. Some of his pieces are very large indeed;[22] these are particularly noticeable in his nude figures, where lead lines would be especially intrusive, as can be seen by the unfortunate number of mending leads that are now so obvious in these figures. In order to minimize size limitations, Bousch has tried once again to use major contours to his advantage. This is perhaps most

notable in the Crucifixion window in the important and highly visible figure of Christ (Figure 29). Although the presence of mending leads makes the original leading network uncertain, it would appear that Christ's whole upper torso was formed from a single huge piece of white glass; the only lead lines interrupting the upper part of Christ's body in this panel may well have been two at the shoulder joints and that following the rather darkly shaded beard. In the panel below, positive advantage has been taken of the lead lines, which separate the white body pieces from the same-colored loincloth. In the Creation window the central figure of Adam (Figure 11) has a lead line following the contour between his chest and forearm, and Eve, above, likewise has a lead line following the underside of her forearms; in both cases, Bousch has differentiated the shading of the adjacent pieces of same-colored glass, which not only contributes to the modeling of the figure but also considerably subdues the presence of the lead line.

Another way that Bousch tried to overcome the limitations even of the fairly large pieces of glass available to him was to make the best of a set of intrusive lines over which he had little control: namely, stone mullions, the iron armatures of his panels, and the horizontal saddle bars that originally cut across each panel. The three narrow lancets of the Creation window are separated by mullions (Figure 1). Within each lancet the rectangular panels measure 30 inches wide by 17½ inches high, or about 76 by 44½ centimeters, and the saddle bars are uniformly central in each panel.[23] The other three surviving windows are wide single lancets requiring two vertical armatures; with the five horizontal armatures, these form an obvious linear grid in front of the pictorial field (Figures 21–23).[24] This tendency to avoid lead lines by aligning cuts with such necessary interruptions is still obvious for the limits of the panels, but not for the saddle bars, because all of the original ones have disappeared. The armatures of the Creation window, however, are now provided with modern saddle bars.[25]

In all the rectangular panels of the Creation window, there is now only one saddle bar, located roughly in the middle of the panel. What leads me to believe that a single saddle bar in each panel was initially anticipated by Bousch is the frequency with which he made use of this inevitable interruption to his overall pictorial effect to place a lead line. A remarkable instance of this practice can still be seen in the central figure of Adam (Figure 11), where an invisible lead, aligned with the saddle bar, separates Adam's head from his torso, whereas his left arm and shoulder form a single piece. And the framing pilaster segments of each side panel

are regularly composed of two rectangular pieces of glass, joined by a horizontal cut in the center, so that the lead aligns with the saddle bar. This practice is also used extensively in the bottom donor panels.

Although the alignment of cut lines with saddle bars appears to have been more or less widespread in the sixteenth century, Bousch's use of it here is distinctive. Where single saddle bars are used elsewhere, the height of the panels is usually much lower than at Flavigny, resulting in many more panel divisions. For panels with proportions comparable to those of Flavigny, it would appear to have been common practice to use two saddle bars for each panel, dividing the panel into thirds. In both arrangements, there were usually more horizontal divisions in the window than is seen here. Bousch was able to reduce the intrusive effects of his combined panel divisions and saddle bars to a minimum, and thus his practice of aligning lead lines with a saddle bar does more than simply allow the use of much smaller pieces of glass: the effects are eminently pictorial.

Although no other windows have retained saddle bars, I believe that Bousch originally made allowance for central saddle bars in all of them.[26] This is most obvious in the Flood window (Figure 21). In its present state, the horizontal lead line in the sail of the ark is highly visible, whereas the one through the body of the ark is less so because of its darker color; but in both cases these cuts appear designed to be aligned with a saddle bar. Even more remarkable in this respect is the monumental nude figure seen at the left. Although the compositions of all three of the single broad lancets from Flavigny ignore the iron armatures that divide them into separate panels (other than to avoid interruptions of major pictorial elements), the positioning of the nude figure seems purposefully engineered to further de-emphasize this obtrusive linear grid. The upper body is conspicuously located on four adjacent panels, and there are parts of this figure in six different panels: thus the figure competes for visual prominence with several armatures, and the powerful conceptual unity of the human body deflects perceptual attention from the regular geometric lines that interrupt it. The figure is also strategically placed to obviate the intrusive use of leads. Horizontal lead lines cut through its waist and right calf, in both cases almost in the center of either panel, where they would have been hidden by the saddle bars. Remarkable as it may seem, with the saddle bars in place, and taking account of its division into panels, there may originally have been no other leads interrupting the entire huge figure.

The lead lines beneath the saddle bars are obviously the result of straight cuts, which elsewhere at Flavigny

are largely limited to the vertical pilasters at the sides of the windows and ground strips at the bottom of each scene. Apart from these instances, Bousch has deliberately avoided straight cuts, except where a straight contour is to be depicted. This is particularly noticeable in the arches at the tops of the lancets in the Creation window (Figure 1). These broad expanses of fictive masonry, all making use of the same color of glass, are larger than could be accommodated by a single piece of glass, and there was no way that Bousch could hide the inevitable lead lines, or adapt them to contours. So he used uneven, slightly wavy cut lines in these sections, which makes it almost impossible, without examining the unleaded pieces, to determine which leads are original and which are mending leads. Bousch may even have meant these lead lines to resemble mending leads (an eye practiced in looking at stained glass would naturally tend not to consider them as part of the intended visual effect). Even today, with so many intrusive mending leads intervening, we can still see the tremendous beauty and pictorial sophistication of the Flavigny windows.[27] It is reasonable to assume that Bousch's artistry would have been both recognized and valued at the time, for Giorgio Vasari, writing later in the sixteenth century, singles out these same considerations when he admires the work of one of Bousch's most distinguished contemporaries, Guillaume de Marcillat, who "worked out the cartoons for his stained glass with such care . . . that he succeeded in disposing the leading network and the armatures, in combination with the figures and draperies, in a way that they were not noticed."[28]

The execution of this stained glass presents such a carefully worked-out coordination of pictorial forms, leading, painting techniques, and division into panels with their saddle bars, that Bousch, in designing the windows, probably made use of a design of a type commonly surviving from this period, in which the composition is adapted to mullion and panel divisions.[29] Such a drawing would have been necessary in order to adapt Bousch's pictorial intentions to the technical limitations of interruptive elements, such as mullions, panel edges, saddle bars, and lead lines. These considerations, in turn, would have been formalized and refined in the subsequent cartoons made from them, as the Vasari quote suggests. There are very few passages in the Flavigny windows in which pictorial forms clash at all with these elements. In the right lancet of the Creation window, however, a saddle bar now cuts right across Adam's face and the top of Eve's head (Figure 7). This apparent awkwardness may have been due to the compositional difficulty of fitting three heads into a single panel. Such instances are noticeably absent

elsewhere in the Flavigny glass, and it is doubtful that Bousch would have condoned the present saddle bar. In all likelihood, to avoid pictorial interruptions, the saddle bar was originally shaped around the heads.[30] Shaped saddle bars were widely used at the time, and some glaziers used them so extensively that it can be considered a limitation of their compositional abilities. The minimal necessity of their use at Flavigny is yet another testimony to the remarkable talents of Valentin Bousch and makes the careful working out of the overall arrangements in preliminary drawings even more likely.

The coordination that such a design drawing can provide would have been doubly important to Bousch because of his approach to composition. One need only recall the changes that Michel Hérold has traced in Bousch's career—from a basically fifteenth-century idiom to one of the new Renaissance, or even Mannerism—to see that Bousch was a well-informed and up-to-date artist. He made use of models, which included not only other stained glass but also prints, drawings, paintings, certainly architecture, and perhaps even sculpture. It is worthwhile to consider that Bousch was also a painter of panels in oil-based paint, as well as a glass painter, and that his knowledge of Hans Baldung Grien's oeuvre gave him the example of an artist who, while not a glazier himself, was a painter, printmaker and designer of stained glass.[31] Beyond specific iconographic models, Bousch relied for many formal elements of his work on compositional models from other media and contexts. Such compositional elements and pictorial effects from other media have been harmoniously combined in the Flavigny windows by means of Bousch's considerable technical abilities.

The inspiration of prints and drawings in the composition of stained glass has recently been brilliantly demonstrated by Hartmut Scholz.[32] Although he focused on artistic practice in the city of Nuremberg, his study provides a compelling methodological model for further research in other regions. Much work remains to be undertaken in Europe as a whole, but considerable research has begun for Lorraine, where the inspiration of prints has been noted in stained glass dating to as early as the 1450s.[33] However, the copying process was never straightforward. Even in a relatively literal case, the stained-glass designer often had to adapt models from other media to a pictorial field of substantially different shape, scale, and proportions. Moreover, the graphic effects of the print medium are not directly translatable into stained glass. Besides the addition of color, techniques such as stippling and cross-hatching cannot simply be blown up to a huge scale, and the necessary presence of lead lines joining relatively small

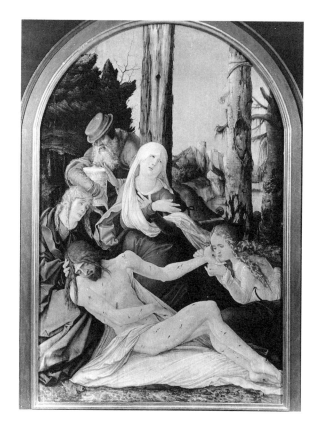

Figure 31. Hans Baldung Grien. *Lamentation*, 1512. Berlin, Gemäldegalerie (Photo: Alinari/Art Resource)

Figure 32. Anonymous Italian (Padua). *Hercules and the Giants.* Engraving, late 15th century (photo: © The British Museum)

pieces of glass both affects the graphic definition of the work and obviates large areas of plain background.

Bousch's earliest productions give evidence of a fairly broad knowledge of other works, especially paintings and prints. Hérold has mentioned many reflections of prints in Bousch's glazing campaign at Saint-Nicolas-de-Port between 1514 and 1520, which is the earliest known period of his work. Most characteristic, perhaps, is the Transfiguration in Window 111 (Figure 30), in which the figures of Saint Peter and Saint John are seemingly drawn from two different woodcuts by Albrecht Dürer, and the foliage above Saint John may have been inspired by yet another woodcut,[34] but rather than copy a composition verbatim, Bousch has used his knowledge of Dürer's prints to build up an image of his own and adapted it to the requirements of a particular glazing project. In Hérold's words, he has "assimilated" the language of prints rather than merely copying them[35] (prints were easily disseminated, and their use by artists was ubiquitous by this time). Besides Bousch's familiarity with the works of Hans Baldung Grien, Hérold has signaled telling similarities between Bousch's 1524 Annunciation in Window 3 of Metz Cathedral and Grünewald's Isenheim Altarpiece of about 1512–16.[36] Once again, this is not a literal copy, and elements have been freely transposed. A relationship with Grünewald may also be surmised for Bousch's distinctive head of Saint Mary Magdalen in

Window 16 of Metz Cathedral (1526–27).[37] He may also have known the work of Lucas Cranach the Elder. In the destroyed axial window at Varangéville and in Window 219 at Saint-Nicolas-de-Port, Bousch depicts an off-center Crucifixion featuring an obliquely set cross. Although Dürer also makes use of this rare oblique setting, as in his Seven Sorrows of the Virgin Altarpiece made for the chapel of Wittenberg Castle in 1496, Bousch's Varangéville Crucifixion also includes a tree very much like those in Cranach's 1503 Crucifixion, now in Munich.[38] The creativity with which Bousch used visual models may open specific attributions to question, but on balance, it cannot be doubted that he had a wide knowledge of a variety of media.

As is understandable, given Bousch's probable Strasbourg origins, his earlier output relates strongly to Rhenish and German works. This is not true, however, at Flavigny, where Germanic sources are overshadowed by Neoclassical Italianate elements, which were not entirely new to Bousch's oeuvre. In his architectural framing components at both Saint-Nicolas-de-Port and Metz Cathedral, for instance, classical detailing had already begun to replace foliated and/or Gothic elements.[39] At Flavigny the balance tips dramatically toward substantially new sources. This is most evident in the Flood window, with its monumental foreground nude and inverted composition. Yet Bousch did not abandon his earlier inspirations, and

the designs for these windows must be considered a novel combination of older and newer sources.

However much we can see continuities in his models, Bousch seems to have been making a conscious effort to create something new. The novelties in this project are as telling as the discarded previous practices (his abandonment of hatching and new approaches to leading have already been dealt with above). The damask patterns, which formed such a prominent impression in Bousch's earlier work, are considerably toned down at Flavigny. They form no part in his narrative scenes and are apparent only as backgrounds of the prophet figures below each scene and of the decorative consoles at the bottom of each window.[40] Gothic and foliate elements in his frames are also conspicuous by their absence here.

Even where his earlier, largely Germanic compositional sources are still apparent, Bousch appears to be using them in a new way. This is particularly clear in the Creation window (Figure 1). The close iconographic similarities between the printed Creation scene from the Lübeck Bible of 1494 (Figure 20) and the Flavigny window have been noted elsewhere.[41] Bousch no longer simply copies the print, but he selectively takes some of its parts and combines them with other pictorial elements. Baldung Grien may have acted as an intermediary here, for in his rather sketchy, small woodcut of *Created Man Still with God* from Ulrich Pinder's *Der beschlossene gart des rosenkrantz marie* published in Nuremberg in 1505, there is a similar suggestion of a circular form for the created world.[42]

Baldung Grien's print does not present a very close formal correspondence with the Creation window, certainly not so close as the Lübeck Bible, but the effect of heavenly figures appearing amid thick clouds is included in the window. Indeed, using rays of light that stream out from around the three persons of the Trinity and that completely replace halos is a graphic effect that Bousch has transferred from prints to stained glass (Figure 6). Such auras of light can also be found in Dürer's prints, and it is known that Bousch owned prints or drawings by Dürer.[43] To this graphic *Versatzstück*, however, Bousch has added a strongly contrasting coloristic element. He had used such clouds before to surround Moses and Elijah in the Transfiguration window (Figure 30) at Saint-Nicolas-de-Port (1514–20) and in the Crucifixion window at Varangéville (1518), but in neither case did the clouds have such a painterly sense of monumental plasticity and at Flavigny we may be seeing the influence of panel painting. Certainly, this is an effect that Baldung Grien used occasionally in his panels, such as in his *Lamentation* of 1512 (Figure 31).[44] Although he has not included

radiating rays of light, the powerful juxtaposition of the dark, sculptural clouds and the more diaphanous gold ground creates similarly strong and dramatic contours between the two zones, contours that are strengthened by lead lines in Bousch's window.

Baldung Grien's *Lamentation* also includes a dove that is very close to the one in the Creation window; however, such doves can be seen not just in Baldung Grien's work but also in Dürer's and later in Nuremberg stained glass as well.[45] In Baldung Grien's Saint John Altarpiece of about 1520[46] there is not only a dove but cherubs formed of winged heads, which also appear in Bousch's window. There is perhaps a little more indication of recessive landscape background here than in Baldung Grien's *Lamentation*, but in both, the clouds and golden aura within largely close off the background, focusing the composition on figures near the picture plane, just as in Bousch's window. It can be said that in Baldung Grien's panels and in Bousch's Creation window, "the closeness of plastic form to the picture plane imparts a [strong] emotionalism of movement and color."[47] In contrast to the sense of three-dimensional pictorial space evident in the surrounding architecture of the Creation window, there is remarkably little deep space around the figures. This contrasts with the Flood window (Figure 21).

Valentin Bousch was very familiar with prints, especially with those of Baldung Grien, and this gives us an indication of Bousch's approach to composition. As a designer, Bousch's approach may have paralleled that of Baldung. Previous to his arrival in Strasbourg in about 1505, Baldung Grien had served his apprenticeship under Dürer in Nuremberg, where he had also designed stained glass for the Veit Hirschvogel workshop, whose work Bousch would have known from its *Adoration of the Magi* at Saint-Nicolas-de-Port.[48] Hartmut Scholz has recently shown how thoroughly designers working for that workshop amalgamated design elements from other windows, from previously existing cartoons, and from prints, often readapting figures for different iconographic purposes and combining diverse elements into a new cohesiveness.[49] Valentin Bousch worked in similar ways, as can be noted in the central figure of Eve (Figures 1, 9, 11) in the Creation window. As Eve rises from Adam's side, she looks up into the heavens and folds her arms across her breast. Such a pose and gesture are distinctive, but very few other examples exist in images of the Creation of Eve.[50] The pose is more common in other iconographic contexts at this time, particularly in portrayals of the Virgin, where the gesture indicates her humble acceptance of God's will—it is used in scenes of the Coronation of the Virgin, the Assumption,

the Annunciation, the Crucifixion, and even the Lamentation (Figure 31). In the context of a highly naturalistic nude Eve, already provided with her fig leaf, the gesture suggests a curious ambivalence between modesty and eroticism rather than humility.[51] This figure, the central focus of the Creation window, has been adapted from very different iconographic circumstances.

The figure of Adam, too, may have evolved similarly. It is certainly typical to show him asleep while Eve emerges from his side, but here his particular pose, with knees drawn up exposing the contours of his haunches, while his torso twists into a more frontal attitude, is distinctive. This Adam, as well as the general composition of the whole central group, quite strongly reflects the figures of Christ and the Virgin in Baldung Grien's Berlin *Lamentation* panel (Figure 31). This is not surprising, considering the connections already surmised between Bousch and Baldung Grien, but what is surprising are the convincing, more distinctly Mannerist comparisons that can also be made with this figure. It is strangely paralleled, for instance, in a work such as Rosso Fiorentino's later *Pietà* panel.[52] Through the wide dissemination of prints among glaziers by this time, it would not be out of the question for a glass painter working in Metz, as was Valentin Bousch, to be familiar with the works of Rosso or even of Raphael.[53] Adam's pose, in fact, can be found quite commonly in the school of Fontainebleau.[54] This is certainly not the only Mannerist resemblance in the Flavigny glass, and it is entirely characteristic that we cannot too hastily decide between the influence of Baldung Grien and more directly Italianate sources. In general, the Mannerist cast of the Flavigny glass cannot be doubted. But Bousch has to a great extent anticipated, rather than been inspired by, the school of Fontainebleau.

Mannerist influence must have been reaching Bousch from elsewhere, and Antwerp presents one strong possibility. That was certainly the case with sculpture being produced in Lorraine at that time. However, the wide dissemination of prints makes geographical influences difficult to pinpoint. Bousch's use of Mannerist elements is entirely in harmony with his approach to the design of the Flavigny windows: large figures, close to the picture plane, not at all frontal or static, but turning freely in space and often displaying a torsioned pose or an exquisitely "mannered" gesture, and his dramatic use of the nude figure.

As has been said above, Mannerism is most apparent in the Flood window (Figure 21). The idea of embedding the main subject in the middle distance and flanking it by large foreground figures is essentially a new one. This sort of inverted composition was being pioneered among the group of artists known as the Antwerp Mannerists. That one of the foreground figures is a gigantic nude is nothing less than astounding in a church window. Bousch had done nudes before, for instance, in his Saint Sebastian at Saint-Nicolas-de-Port,[55] but always with a decorous loincloth and with a clear iconographic rationale. Here, this remarkable nude announces the window, and perhaps the series, as Art, independent of the religious significance of the program. This daring overall composition is part of a synthetic narrative in which two moments are combined. The foreground shows the rising floodwaters, with the ark already afloat in the middle distance and torrents of rain bursting from looming storm clouds. Yet a dove is being launched from a hatch in the roof of the ark. Where these distinct elements of Bousch's composition came from is a larger question than can be dealt with here, but it is apparent that this design results from a combination of the new and the old.

The crouching figure in the right foreground is indicative of this mixture of sources. Although the figure is suitably torsioned to give a Mannerist effect, it is hard to find equivalents for such a crouching pose among the Antwerp Mannerists, or at Fontainebleau, or in Italian Mannerist works. The pose is closer (to use an extreme example) to Erasmus Grasser's *Morris Dancers* of 1480; comparable poses can often be seen in northern prints, and while Bousch was perhaps drawing on different aspects of his former stock of models, he was not entirely dependent here on new ones. The fanciful classical armor worn by the figure, however, is something new and depended on models that Bousch had not previously used.[56] We can compare it with the rather more conventional armor of his several Saint Georges at Saint-Nicolas-de-Port.[57] All of Bousch's helmets and armor in the Flavigny glass are similarly fantastic, and along with such exotic costumes as that of Saint Barbara from the Church of Sainte-Barbe, their sources point strongly to Antwerp.[58]

The Antwerp Mannerists were redefining the use of the nude, and though Bousch's lithe and nimble nude foreground figure in the Flood window has little in common with Jan Gossaert's chunky specimens, he was perhaps also inspired by Antwerp artists. Yet, we know from his will that he possessed Italian prints and/or drawings, and Italy was the source for the most accomplished and artistically interesting nudes made at this time, a fact that was undoubtedly known to Bousch. In the large nude of the Flood window the distended, almost anamorphic distortion of the shoulder is initially perplexing, but it has tremendous diagnostic potential (Figure 27): Bousch seems far more confi-

dent in his use of strictly artistic models than in his understanding of human anatomy, since comparable distortions can be observed in contemporary prints. A close example can be seen in an anonymous late-fifteenth-century Paduan engraving, *Hercules and the Giants* (Figure 32).[59] The distended shoulder of the left foreground figure is combined with a comparably misunderstood collarbone, which curves back on itself in the form of a somewhat elastic tubular shape, just as in Bousch's nude in the Flood window (a similar collarbone can be seen in the figure of Adam in the Creation window). This lack of understanding of the human body is not surprising, given Bousch's training and early practice and his liminal place in the artistic developments of his time. Although northern artists such as Dürer were drawing from the nude figure, albeit with some hesitancy, it would appear that the practice was not yet general, and the lack of sophistication in depicting the human body is all the more surprising here, considering Bousch's prominent use of it.

The novelty of placing nude figures in the foreground, as in the Flood window, where it serves no central iconographic function, would certainly have been noticed by contemporary audiences, and must reflect a distinctive choice on the part of the patron. Some viewers might have questioned the decorum of a graphically depicted nude figure looming over the monks' stalls, but it must have had the support, and undoubtedly the encouragement, of Bousch's patron. Whatever motivations Wary de Lucy might have had in selecting or authorizing the program in general and the iconographic treatment of the individual subjects, it would seem that he was also interested in making apparent his cultural allegiances as a patron. That he would have sanctioned such anatomical naïveté from his chosen artist, however, points to a shared distance in their enthusiasms for the new art from its sources, and once again highlights the tremendous novelty of Bousch's artistic accomplishments in his designs for the Flavigny glass.

What is perplexing here, given the almost emblematic novelty of the Flood window, is that it is not matched in the windows around it. The Crucifixion (Figure 23) is altogether more conventional, and while parallels for the composition of the Moses window (Figure 22) are not easy to find, it offers no hint of the compositional daring of the Flood. The centralized figure of Moses is hemmed in by crowds of Israelites in a curiously static, even iconic, arrangement. Despite the exotic touch offered by the fanciful classical helmets of the two large flanking figures, the lack of movement,

of foreground depth, and of narrative is striking. Perhaps Bousch was stumped for models. Old Testament imagery was not as common in sixteenth-century stained glass as hagiographic or New Testament subject matter. Certainly, the unusually young Moses, with his close-cropped beard and horns, stands out from the iconographic norm and is unlike other, more standard Moses figures that Bousch used elsewhere (see Figures 24, 28).[60] Much work still needs to be done to analyze the synthetic compositions in these windows and their diverse sources. It seems sufficient here to define the problem. Bousch's wide knowledge of art was still expanding—to a point where he had gone far beyond the style and practice in which he had been trained. His compositions give evidence of a careful and erudite selection of elements, which have been combined into essentially new compositions. Bousch was seemingly not one of the growing number of glaziers who commonly worked from a videmus supplied by the patron, without input into the design process.

In order to make a strong case for such a knowledgeable and synthetic approach to design on the part of Valentin Bousch, it would be desirable to identify more of his specific sources. But the above comparisons are at least indicative of Bousch's working method as a designer. In addition, many Mannerist works that invite comparison with the Flavigny windows, particularly from Fontainebleau, seem to date from after the early 1530s, when the windows were made. This points out how close Bousch was to the cutting edge of artistic change in this part of northern Europe. Art historians are not used to considering glass painters as important artistic innovators, but it seems increasingly appropriate to judge Valentin Bousch in this way.

Moreover, Bousch's innovations depended on a considerable body of technical skills and workshop practices. Just as each of the surviving Flavigny windows displays a somewhat distinct approach to design, the windows also exhibit an impressive variety of painting techniques and technical considerations. The Moses window, for instance, stands out by the frequency and variety with which more than one head is painted on a single piece of glass. The Flood window experiments with painting objects on adjacent pieces of differently colored glass. Christ in the Crucifixion window features an individual approach to figure painting, very unlike other nudes in Bousch's oeuvre (see below). And the supernatural lighting effects in the Creation window occur nowhere else in the series.

Bousch's treatment of clouds provides an excellent

point of reference to compare his technical procedures in all the surviving Flavigny windows. Clouds appear in all four windows, and their forms reveal different technical handling in each. The well-defined plastic, cumulo-nimbus clouds of the Creation window (Figures 1, 6) emphasize the bursts of supernatural light breaking through them; this is achieved through smoothly modulated grisaille washes, creating a highly sculptural sense of modeling, and contours in which opaque strokes are often mirrored with stick-work highlights. In the Crucifixion window, however (Figure 23), such clouds are combined with wisps of stratus clouds to produce a more expansive space and a gentler ambience (despite the conventional depictions of the sun and moon to either side of the cross). The clouds in the Moses window (Figure 22), cumulus combined with stratus, are altogether more somber, and Bousch has used white and three different tones of blue glass, modified with grisaille washes, to create a continuous gradation of tone from light to very dark. The storm clouds of the Flood window (Figure 21) also make use of different tones of blue glass, and the painting techniques include jagged areas of opaque grisaille, which, added to the painted effects of torrential rain, provide a suitably ominous setting for the destruction of sinful humanity. Thus, each window achieves different cloud effects through different painting and glazing techniques, and comparable differences of technique between the Flavigny windows abound. The Flood window, for instance, uniquely displays beautiful, almost calligraphic painted waves in the flood waters (Figure 27).[61] Once again, their graphic definition suggests more the assimilation than the copying of the print media. The amount of technical invention in these windows is amazing. It points to a highly flexible workshop, over which, as Hérold has already observed, Bousch exercised strict control, thus producing at Flavigny a homogeneous ensemble.

This characteristic of the Bousch atelier creates a methodological problem in the analysis of the Flavigny glass. The question of identifying hands within the Flavigny workshop is complicated both by its use of a wide range of models and by its experimental technical character in general. The heads and nude figures, in particular, require much more careful study. Two problems are worth noting. In the Creation window the head of Eve in the right lancet is an extremely high-quality restoration (Figure 7); the crispness of the grisaille and the presence of minutely painted "bloom" to emulate the effects of corrosion can be seen, however, only on very close examination under ideal conditions. The extent of such restoration in the other Flavigny

windows remains to be determined,[62] and the research planned by the American Committee of the CVMA may change considerably our picture of Bousch's range of practice. Perhaps an even greater problem is posed by the figure of Christ in the Crucifixion window (Figure 29). The canonical proportions and accomplished anatomical detailing of the body contrast with Bousch's other nudes, and the painting style lacks the smoothly modulated grisaille washes characteristic of his other heads and flesh parts. Here, facial features are built up in a manner that resembles drawing rather than painting, and the definition of the hair lacks both silver stain and the matte grisaille tones of, for instance, the hair of the donor figure kneeling at the foot of the cross. If the figure of Christ is indeed by Bousch—a possibility that must be called into question, pending detailed examination—its antecedent is doubtless a specific model used not only to provide a compositional element but also to serve as the basis for singular and adventuresome technical experiment.

Whatever problems still await resolution, the general picture of Valentin Bousch's artistic practice is clear. His considerable technical skill and creativity as a glazier was a necessary factor in turning his design energy into stained glass, yet he used a painter's sensibility to fuse his design sources into an extraordinarily accomplished whole. In both his painting and his cutting of glass, Bousch was a virtuoso craftsman who was able to manipulate traditional skills to radically new effect. In fact, even though he is known primarily as a glass painter, his proclivity toward panel painting strongly influenced both his glass-painting techniques and his approach to glass cutting. The size of the pieces Bousch used, the relative amount of waste in such large, irregular pieces, and the very difficult nature of many of his cuts must have increased the costs enormously.[63] No expense, it would seem, was spared in the creation of forceful pictorial effects. And to the same end, Bousch also pushed his materials close to their structural limits. When one considers that new lead-drawing mills were creating thinner but less structurally supportive leads and that many of Bousch's cuts resulted in such delicate, breakable pieces, one wonders whether he might have had a presentiment that one day his magnificent work would have to be viewed through a screen of mending leads. It seems entirely possible that the prospect of creating such a dazzling pictorial accomplishment in the Flavigny windows outweighed practical, long-term considerations and that Valentin Bousch went about as far as a glazier could go in bringing a new and exciting vision to the medium of stained glass.

ACKNOWLEDGMENTS

Without the generosity, encouragement, and help of Ariane Isler-de Jongh, this article could never have been written. I take full responsibility, however, for the opinions expressed and for any errors that may have slipped in.

NOTES

1. Michel Hérold, *Les Vitraux de Saint-Nicolas-de-Port*, CVMA France VIII/1 (Paris, 1993).

2. Michel Hérold, "Valentin Bousch, l'un 'Des Peintres sur verre qui se distinguèrent au seizième siècle,'" *Revue de l'art* 103 (1994) pp. 53–67. See also Abbé Jacques Choux, "Valentin Bousch à Saint-Nicolas-de-Port et à Flavigny," *Le Pays Lorrain* 3 (1973) pp. 157–170.

3. Marcel Aubert and Jean-Jacques Gruber, *La Cathédrale de Metz* (Paris, 1931) pp. 215–248, pls. XXXIV–L; Michel Hérold, "Les vitraux de la cathédrale de Metz," *Congrès archéologique de France, 149e session, 1991* (Paris, 1995) pp. 477–494. On Bousch's now-destroyed stained glass in the Church of Saint-Gorgon at Varangéville, see Choux, "Valentin Bousch," pp. 166–168. On the work attributed to him at Génicourt-sur-Meuse, see Michel Hérold, "L'Église de Génicourt-sur-Meuse et ses vitraux," *Congrès archéologique de France, 149e session, 1991* (Paris, 1995) pp. 121–138.

4. Hérold, "Valentin Bousch," p. 53: "les verrières de Flavigny-sur-Moselle . . . ne soulèvent guère l'attention." See, however, the article by Ariane Isler-de Jongh, "A Stained-Glass Window from Flavigny-sur-Moselle," in this volume.

5. I would like, particularly, to acknowledge the tremendous help and hospitality of the private collectors in British Columbia for opening their home to the Canadian Committee of the CVMA, of Jessie McNab in facilitating my research at the MMA, and of Father Perrault and Margaret Drake for allowing access to the Church of Saint Joseph, Stockbridge, Mass.

6. For a more nuanced characterization of the dramatic change from Gothic to Renaissance style in France, see Henri Zerner, *L'Art de la Renaissance en France. L'invention du classicisme* (Paris, 1996).

7. Unfortunately, it was not possible for me to see the Crucifixion window in Saint Joseph's Church (Figure 23) from a scaffold; my observations of it were made with binoculars from the floor of the church.

8. On diamond cutting, see Jean-Jacques Gruber, "Technique," in Marcel Aubert et al., *Le Vitrail français* (Paris, 1958) pp. 55–82; and Jean Lafond, *Le Vitrail. Origines, techniques, destinées*, 3rd ed., Françoise Perrot, ed. (Lyons, 1988) pp. 46–49. For a transcription of the original Italian and a simultaneous translation into German of the treatise of Antonio da Pisa, see Robert Bruck, "Der Tractat des Meisters Antonio von Pisa über die Glasmalerei," in *Repertorium für Kunstwissenschaft* (1902) XXV, pp. 240–269, esp. pp. 264–265.

9. Documented by Guy-Michel Leproux, *Recherches sur les peintres-verriers parisiens de la Renaissance (1540–1620)*, École Pratique des Hautes Études—IV^e section, Sciences historiques et philologiques, V, Hautes études médiévales et modernes, 62 (Geneva, 1988) pp. 52–54.

10. Since the edges of diamond-cut pieces would still usually have been grozed, evidence for the technique of the initial cut may be largely erased by the application of the grozing iron.

11. Leproux, *Recherches*, p. 53.

12. See Claire Desmeules, "Le Passage du moyen âge à la Renaissance dans le vitrail: étude du réseau de plomb," unpublished M.A. thesis, Université Laval (Quebec City, 1988). I would like to thank Roland Sanfaçon for alerting me to this work.

13. Leproux, *Recherches*, p. 13.

14. This is particularly pertinent, since Hérold has identified in Bousch's work at Saint-Nicolas-de-Port one of the earliest known instances of acid etching; see Hérold, *Les Vitraux de Saint-Nicolas-de-Port*, p. 57; see also Lafond, *Le Vitrail*, p. 64. But see note 20 for Bousch's possible use of sanguine.

15. Hérold, *Les Vitraux de Saint-Nicolas-de-Port*, pp. 207–208; in surviving apprenticeship contracts, Bousch promises to teach "l'art et science tant de pincture que de verrierie" (Annexe 7, p. 208) and "l'art et science de peintrerie tant sur voyre que autrement etc." (Annexe 9, p. 208). Bousch's will, moreover, mentions panel paintings done by him.

16. Hérold, "Les vitraux de la cathédrale de Metz," pp. 484, 487.

17. It is possible that financial considerations played a role in determining such a paneled effect. In contrast to Bousch's approach at Flavigny, this would necessitate far fewer difficult cuts and far less waste, thus decreasing both material and labor costs. This kind of situation could explain how Bousch was capable of both approaches to glazing: it may have been a factor determined by the financial commitment of the commissioner and perhaps even specified in the terms of Bousch's contracts.

18. Gruber, "Technique," p. 69.

19. Leproux, *Recherches*, p. 54.

20. Further technical examination is necessary to determine whether Bousch also may occasionally have used sanguine, in combination with grisaille and silver stain. Although I have not been able to examine it closely, the blood flowing from Christ's side in the Crucifixion window is very likely sanguine. Below, in the figure of David, a clasp on his garments features red and white on the same piece; this, too, might be sanguine, but it is possibly an etched piece of flashed red glass.

21. A similar extension of foliage onto a differently colored piece of glass was probably intended, as well, for the plant grasped by the left-hand foreground figure, but the fronds drawn on the hand piece currently appear unpainted. The possibility exists that these fronds may initially have been cold painted, but even close examination of the piece may not be enough to verify this, as cold paint can flake off so thoroughly. The possibility of cold paint was suggested to me by a paper read at the XIXth International Colloquium of the CVMA in Kraków in May 1998 by Lisa Pilosi, "On the Occurrence of Cold Paints on Silver-stained Roundels in the The Metropolitan Museum of Art."

22. In his will, Bousch bequeathed 400 *liens* of white glass to the glazier Antonin; Pierre Le Vieil, *L'Art de la peinture sur verre et de la vitrerie* (1774; repr. Geneva, 1973) p. 44. According to Hérold, "Valentin Bousch," pp. 64, 67 n. 68, a *lien* is a measure equivalent to three sheets of glass, each measuring approximately 0.88×0.42 m; he cites as authority G. Rose-Villequey, *Verre et verriers de Lorraine au début des Temps modernes* (Paris, 1971) p. 175. The same source makes clear that Lorraine was a prominent glass-making region; see Michel

Hérold, "Les Verriers de Lorraine à la fin du Moyen Age au temps de la Renaissance (1431–1552). Approche documentaire," *Bulletin monumental* 145 (1987) pp. 87–106.

23. The top panels are not rectangular but terminate in a round arch. Although the metal frame in which the window is now located is modern, it undoubtedly reflects the original arrangement. It should be noted that the top panel in the center lancet is currently installed in reverse.

24. The dimensions of the Flood window are 361.2 × 160.2 cm (142 × 63 in.) and those of the Moses window are 303.1 × 168.2 cm (119 × 66 in.); see Madeline H. Caviness et al., *Stained Glass before 1700 in American Collections: New England and New York* (Corpus Vitrearum Checklist I), Studies in the History of Art, Monograph Series I, vol. 15 (Washington, D.C., 1985) pp. 154–155. The height of the four central registers in the Flood window is ca. 55.4 cm (21 13/16 in.). The width of the outer panels is ca. 41.6 cm (16⅜ in.), and that of the central panels ca. 102.2 cm (40¼ in.). The latter dimensions were taken from scaffolding erected in situ in the MMA and may not be entirely accurate. The dimensions of the Crucifixion window are 361.2 × 168.2 cm (142 × 66 in.); see Madeline H. Caviness et al., *Stained Glass before 1700 in American Collections: Midwestern and Western States* (Corpus Vitrearum Checklist III), Studies in the History of Art, Monograph Series I, vol. 28 (Washington, D.C., 1989) pp. 251–252.

25. There are no saddle bars in the top register of arched panels. For the other panels, the saddle bars are located on the interior side of the glass, which was probably the original arrangement, as most low windows from this period have interior saddle bars. Lafond, *Le Vitrail*, p. 70, indicates that low windows were usually installed from the interior, while clerestory windows were installed from the exterior. See also Nicole Blondel, *Le Vitrail* (Paris, 1993) "Vergettes," pp. 132–133, and "Pose des panneaux," p. 349.

26. In the irregular top panels, either the saddle bars were considerably below center or two were planned initially.

27. A rare opportunity to see 15th- and 16th-century stained glass without the usual screen of mending leads has been provided by recent restoration campaigns in Bourges Cathedral, in which many mending leads were removed. The glass-cutting in the Jacques Coeur chapel (Window 25) stands out in its complexity and pictorial qualities, but even here, two saddle bars per panel were planned.

28. Quoted in Blondel, *Le Vitrail*, p. 126.

29. For the use of such drawings, see most recently Hartmut Scholz, *Entwurf und Ausführung: Werkstattpraxis in der Nürnberger Glasmalerei der Dürerzeit*, CVMA Deutschland Studien I (Berlin, 1991) esp. p. 136. There is no commonly accepted name for such drawings: *modello* is sometimes used, but use of *videmus* should be limited to drawings attached to glazing contracts. See Hilary G. Wayment, "The Great Windows of King's College Chapel and the Meaning of the Word 'Videmus,'" *Proceedings of the Cambridge Antiquarian Society* 69 (1979) pp. 53–69; and William W. Robinson and Martha Wolff, "The Function of Drawings in the Netherlands in the Sixteenth Century," in *The Age of Bruegel: Netherlandish Drawings in the Sixteenth Century*, John Oliver Hand et al., eds. (Washington, D.C./Cambridge, 1986) pp. 25–40, esp. 32–34.

30. Blondel, *Le Vitrail*, pp. 132–133, mentions the "*vergette de contour*," but it does not appear to have been systematically studied.

31. Michel Hérold, "Valentin Bousch." This virtuosity was becoming widespread and was also applicable to, among others, Albrecht Dürer in Germany and Dirk Vellert and Pieter Coeck van Aelst in Flanders. Vellert and perhaps Coeck, like Bousch, also produced stained glass.

32. Scholz, *Entwurf und Ausführung*.

33. Of the eight Passion scenes now in Window 5 of the Church of Saint Martin in Metz, dating ca. 1450–60, seven were clearly modeled on engravings by Master E.S. (Lehrs 41–47); see Abbé Jacques Choux, "Le Vitrail lorrain au Moyen Age et à la Renaissance," in *Le Vitrail en Lorraine du XII^e au XX^e siècle*, exh. cat. (Pont-à-Mousson, 1983) pp. 33–72, esp. pp. 42–44.

34. Hérold, *Les Vitraux de Saint-Nicolas-de-Port*, pp. 63, 173, relates the figure of Saint James to that of Joachim in Dürer's *Annunciation to Joachim* (Bartsch 78, ca. 1504), Saint John to the figure of the same saint in Dürer's *Adoration of the Lamb*, from his *Apocalypse* series (Bartsch 67, ca. 1496–97), and the foliage above Saint John to that in Dürer's *Nativity* (Bartsch 2, 1504). It might also be noted that the figure of Moses is comparable to the same figure in Jan Provoost's 1525 *Last Judgment* altarpiece (Bruges, Groeningemuseum); see the entry on Provoost by Els Vermandere, *Dictionary of Art* (London/New York, 1996) vol. 25, pp. 668–669; Dirk de Vos, *Groeningemuseum, Bruges: The Complete Collection* (Bruges, 1983) pp. 46–47.

35. Hérold, "Valentin Bousch," p. 68.

36. Hérold, "Les vitraux de la cathédrale de Metz," p. 490.

37. See Hérold, *Les Vitraux de Saint-Nicolas-de-Port*, fig. 54.

38. On Cranach's work and its relation to Dürer, see Werner Schade, *Cranach: A Family of Master Painters*, Helen Sebba, trans. (New York, 1980) pp.19–20. The Crucifixion in the west window of Saint-Nicolas-de-Port is displaced, and may have originally come from a composition comparable to a cartoon for a stained-glass window in the Hermitage in Saint Petersburg attributed by Marlier to Pieter Coeck van Aelst, depicting a donor kneeling in front of an altar; see Georges Marlier, *Pierre Coeck d'Alost* (Brussels, 1966) p. 358 and fig. 299.

39. The architectural definition of the classical framing elements at Flavigny is distinctly simpler than many of the fussy and elaborately decorated frames Bousch used earlier. They are now much closer to the style of Renaissance architecture being built in Lorraine at the time. It would seem that Bousch's patrons were drawn to this new style of architecture, which was used in several churches for which he supplied the stained glass, including Saint-Nicolas-de-Port and Flavigny itself. Some of the painted detailing on horizontal moldings, however, suggests links with Dirk Vellert in Antwerp; see, for example, the painted cyma recta moldings in Vellert's *Man of Sorrows* altarpiece (Brussels, Musée de L'Assistance Publique) ill. in Max J. Friedländer, *Early Netherlandish Painting* (Leiden/Brussels, 1975) XII, p. 30, pl. 71.

40. The console of the Creation window has not survived. Although the consoles of the other three windows have survived, only the Crucifixion window in Stockbridge shows the console mounted with the window (Figure 23); the two consoles in the MMA are in storage, and only the registers above are currently on display.

41. See Isler-de Jongh, "A Stained-Glass Window."

42. 8. Buch, fol. 146r. See Matthias Mende, *Hans Baldung Grien, Das graphische Werk. Vollständig Bildkatalog des Einzelholzschnitte, Buchillustrationen und Kupferstiche* (Unterschneidheim, 1978) fig. 111.

43. Hérold, "Valentin Bousch," p. 65.

44. Berlin, Gemäldegalerie, cat. no. 603B.

45. See, most recently, Scholz, *Entwurf und Ausführung*.

46. Frankfurt, Städelsches Kunstinstitut.

47. Charles D. Cuttler, *Northern Painting from Pucelle to Breugel* (New York, 1968) p. 390.

48. Now in Window 113; see Hérold, *Les Vitraux de Saint-Nicolas-de-Port*, pp. 46–49, 177–184.

49. Scholz, *Entwurf und Ausführung*, passim.

50. The only previous example known to me is in an early-13th-century English psalter (Munich, Staatsbibl., Clm. 835, fol. 8r); see Nigel Morgan, *Early Gothic Manuscripts, 1190–1250, A Survey of Manuscripts Illuminated in the British Isles* (London, 1982) IV, pt. 1, no. 23, pp. 68–71. A photograph of folio 8r is on file at the Princeton Index of Christian Art.

51. Compare the nude figure of Eve with a fig leaf with those in contemporaneous images of the tree of life and death; see Ernst Guldan, *Eva und Maria: Eine Antithese als Bildmotiv* (Graz/Cologne, 1966) passim.

52. Paris, Musée du Louvre, inv. no. 1485.

53. Guy-Michel Leproux, *Vitraux parisiens de la Renaissance* (Paris, 1993) p. 150, gives the comparable example of Nicolas Pinaigrier's "*pourtraict*" of the Descent from the Cross window in the Church of Saint-Étienne-du-Mont in Paris, which was based on a print by Marcantonio Raimondi (Bartsch 32).

54. See, for instance, the engraving of the *Nymph of Fontainebleau*, Paris, Bibliothèque Nationale, Cabinet des Estampes, L.400. Another, perhaps less close parallel for Adam's figure is Rosso's copy of Michelangelo's *Leda* (London, Royal Academy). Rosso had been working for King Francis I at Fontainebleau since 1530, and by the 1540s, with the addition of Primaticcio, Fontainebleau would exercise a tremendous influence on French art. In particular, as Leproux has shown, Fontainebleau eventually exercised a considerable influence on stained-glass design in Paris; see Leproux, *Recherches*, pp. 57–58.

55. Window 113, panels 2c, 3c, and 4c, dating to 1514–20; see Michel Hérold, *Les vitraux de Saint-Nicolas-de-Port*, pp. 180, 182–183, pl. XXVI.

56. Similar fanciful armor can be seen, for instance, in an early-16th-century design drawing for a secular window depicting Mucius Scaevola; see Michel Hérold, "Dans les coulisses de l'atelier: modèles et patrons à grandeur," in Leproux, *Vitraux parisiens de la Renaissance*, pp. 172–177, esp. 177. There are also examples in 16th-century Belgian stained glass. I would like to thank Ariane Isler-de Jongh for these references.

57. Saint George is found in Windows 18, 20, 106, and 108; see also the armor depicted in the Funeral of the Virgin in Window 23. All the windows date from 1514–20. Remarkably, Bousch returned to more conventional armor in his later work in Metz Cathedral; see his Saint Michael and Saint George, both of 1539, in Window 203. This conservatism can presumably be accounted for in terms of the intervention of Bousch's patrons.

58. The Church of Sainte-Barbe was destroyed, and the remaining glass is now located in Window 8 of Metz Cathedral; see Hérold, "Les vitraux de la cathédrale de Metz," pp. 487–488. For a fairly close comparison with Saint Barbara's costume, see the Saint Catherine in Jan Gossaert's *Holy Family Triptych with Saint Catherine and Saint Barbara* (Lisbon, Museu Nacional de Arte Antiga). Another close comparison is the sculpture of Saint Barbara (ca. 1525–30) in the church of La Madeleine, Troyes; the Troyes school of sculpture was also instrumental at that time in bringing new Renaissance artistic ideas to northern France.

59. See David Landau and Peter Parshall, *The Renaissance Print 1470–1550* (New Haven/London, 1994) fig. 77. I would like to thank Claire Labrecque for alerting me to this print.

60. Compare, for instance, the Moses in Bousch's Transfiguration in Window 111 at Saint-Nicolas-de-Port, ca. 1514–20, and the later Moses and the Brazen Serpent in Window 203, dating from 1539.

61. These seem to be related to graphic effects from prints, particularly those associated with the Antwerp Mannerists. See, for example, the sky effects in the works of Master I♀V, e.g., *Landscape with Saint John the Evangelist* and *Saint Anthony the Hermit*, probably 1530s; for illustrations of these works, see Bruce Davis, *Mannerist Prints: International Style in the 16th Century*, exh. cat. (Los Angeles, 1988) no. 87.

62. Thanks are due to Virginia Raguin for help with identifying the restorations in the Creation window. Examination of the Moses window from a scaffold suggests that much of the left part of the arch is modern restoration, and there are many stopgaps and several reversed pieces in the Prophet panels below.

63. The cost of the Flavigny glass is unknown. Documented prices paid to Bousch for his work elsewhere are all surprisingly low; see Hérold, "Les Verriers de Lorraine," pp. 90 and 100 nn. 18, 19. Rather than reflecting the market value of Bousch's talent, however, the low prices may have been a constraint imposed on Bousch by some of his patrons and which affected the sort of work he was able to do. It is impossible to imagine similar prices for the Flavigny glass.

The Tapestry Weaver and the King:
Philippe Behagle and Louis XIV

EDITH A. STANDEN

Curator Emeritus, Department of European Sculpture and Decorative Arts,
The Metropolitan Museum of Art

PHILIPPE BEHAGLE (1641–1705) was appointed director of the tapestry manufactory at Beauvais in 1684, twenty years after it had been set up by Louis XIV's minister, Jean Baptiste Colbert, with a local man, Louis Hinart, in charge; the stated purpose of the enterprise, like that of many others created by Colbert, was "se passer de recourir aux Etrangers pour les choses nécessaires à l'usage et à la commodité" of the king's subjects. One clause in Hinart's contract had authorized him to place the royal arms on the entrances of all the buildings of the manufactory, along with the words "Manufacture royale de Tapisseries."[1]

Purchases of tapestries from Hinart by the king are recorded in the royal accounts—254 items, mostly low-priced verdures and landscapes with small figures;[2] there are no records of how many were sold elsewhere, although the names of a number of buyers are known.[3] The king was certainly the principal customer until Colbert's death in 1683, when Hinart, who was in financial difficulties, retired. The choice of Behagle to succeed him was made by Colbert's successor, Louvois, who evidently favored this Flemish weaver. Daniel Cronström, writing from Paris to the Swedish architect Nicodemus Tessin in Stockholm about French tapestries on January 7, 1695, mentions this interest: "Vous serez peut estre estonné de m'entendre préfèrer Beauvais, dont il ne sortoit autrefois que des ordeures, aux Gobelins, mais vous n'en serez . . . que Mr. de Louvois a tiré des meilleurs ouvriers des Gobelins pour y establir une manufacture avec beaucoup de soin."[4] (The Gobelins were closed at this time to save money for the king's wars.) Louvois was presumably responsible for what must have been the most glorious day in Behagle's life, commemorated by an inscription on a stone plaque on a garden wall at the manufactory: "Le Roy Louis XIV s'est reposé sous cet ombrage en 1686. Le sieur Behagle était alors directeur de la Manufacture."[5]

METROPOLITAN MUSEUM JOURNAL 33

The manufactory during Behagle's directorship was prolific, at least in the early years; a figure of about 1,300 pieces or more has been estimated for 1684 to 1690.[6] Three documents are known that name the subject of the sets produced there. Two of them are lists of tapestries given as payment for debts. One document, dated April 4, 1689, includes pieces representing "grotesques à petits personnages," "oiseaux de la Ménagerie" (Louis XIV's zoo), and verdures;[7] the second, of August 19, 1690, names *Metamorphoses*, with large figures and with small ones, *Cephalus and Procris*, *Psyche*, and verdures; the *Metamorphoses* with large figures are said to be from designs by Sève and Houasse.[8] The third document is one drawn up by Behagle, probably in 1700, boasting about the tapestries he had sold very profitably to very important people but complaining bitterly that, for want of sufficient funds to hold his products in storage, he had been forced to sell many at a loss. He lists sets called "Histoire de metamorphauce," "tenture grotesque fines" and "communs," and "Chinoise faict par quatre illustre peintre [*sic*]."[9]

Among the tapestries that Behagle said he had sold profitably, "sur lequel pris, j'ay gagné plus d'un tiers," was the first entry in the memorandum, a set made for the apartments of the duke and duchess of Maine at Marly, "que Sa Majesté a trouvé belle et bien fabriqué." The *Journal du Garde Meuble* records the delivery of these pieces in June 1700; they were sets of "Verdures et paysages à petit personnages . . . dessin de la hire," *Metamorphoses*, and a verdure set "représentant divers sujets, comme voyageurs de compâgne, festes de village, et divertissements de compâgne."[10] They are very similarly described in the royal inventory entries for 1701.[11]

The *Grotesques* (the distinction between "fine" and "commun" has not been ascertained) seem to have been the most popular of the subjects named in these documents; more than 150 examples are known to exist.[12] Louis XIV owned a set of six, described in the royal inventory as by "Béhagle . . . sur un fonds de laine feuille-morte."[13] The Metropolitan Museum of

The notes for this article begin on page 200.

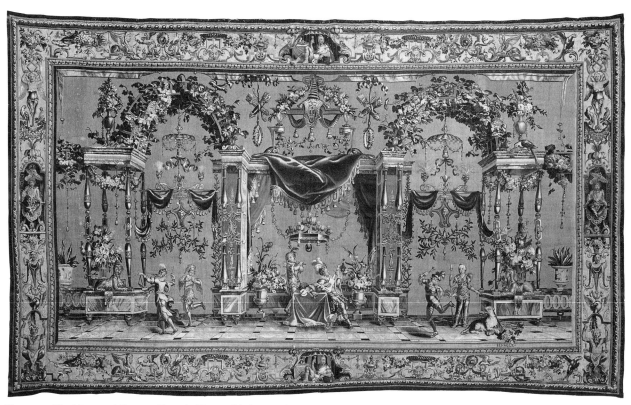

Figure 1. *Musicians and Dancers.* French (Beauvais), late 17th or early 18th century. Wool and silk tapestry, 300 × 508 cm. The Metropolitan Museum of Art, Gift of John M. Schiff, 1977, 1977.437.2

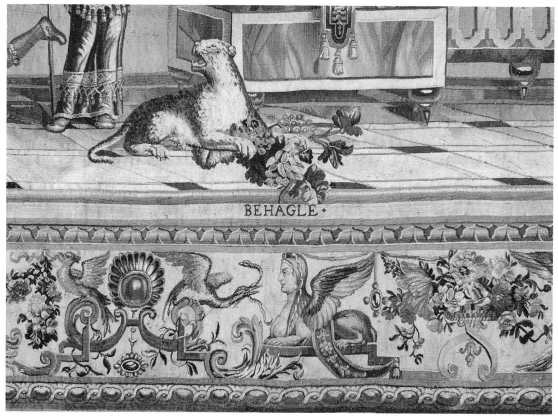

Figure 2. Mark of Philippe Behagle. Detail of Figure 1

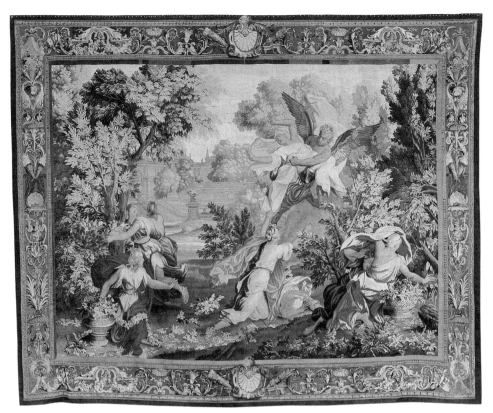

Figure 3. *Boreas and Orithyia.* French (Beauvais), late 17th or early 18th century. Wool, silk, and metal thread tapestry, 358 × 452 cm. The Metropolitan Museum of Art, Gift of Francis L. Kellogg, 1977, 1977.435

Art has a set of five, one of which has Behagle's name in the border (Figures 1, 2), as well as a single piece from another set.[14] Behagle does not name the designer of this series, but he is known from other sources to have been Jean-Baptiste Monnoyer.[15] The innovative character of the design, which anticipates the fancifulness and gaiety of the Rococo, has been frequently commented upon.

The particularly imaginative and elegant chinoiserie border to the Metropolitan Museum set of the *Grotesques* (also found in other examples) may be after Guy Vernansal, a painter at the Gobelins[16] who made the cartoons after Jean Berain for the borders of the *Battles of Charles VI of Sweden*, woven by Behagle in 1695–99.[17] Vernansal's name appears on several panels of the *Story of the Emperor of China*, so that he is presumably one of the "four illustrious painters" to whom Behagle attributed his "Chinoise." The Metropolitan Museum owns an *Audience of the Emperor* from this frequently woven series.[18]

Other Beauvais tapestries in the Metropolitan woven while Behagle was the director are upholstery panels for chairs known to have been made in 1691–96; they are the earliest securely dated surviving examples of the tapestry-woven upholstery *en suite* with wall hangings that was to become a specialty of the manufactory.[19] The *Boreas and Orithyia* from the *Metamorphoses* (Figure 3) was designed, according to Behagle's memorandum, by René Antoine Houasse (ca. 1645–1710)

and either Gilbert de Sève or his brother Pierre before 1690, but the cartoon continued to be woven until 1730.[20] The design, like those of the other pieces in the series, is highly competent and effective, admirably adapted to the technical demands of the medium. A *Stag Hunt*, also in the Metropolitan Museum, has no manufacturer's or city marks, but it is close to other hunting scenes with Behagle's name.[21]

Behagle sold many tapestries to Louis XIV; most were verdures and landscapes, but they included *Grotesques, Metamorphoses, Ports de Mer,* and "*Teniers.*"[22] One series closely connected with the king is not listed in the inventories or mentioned in Behagle's documents: the *Conquests of Louis XIV.* Four pieces of a set with the arms of the comte de Toulouse are at Versailles; they have no marks, but other examples show Behagle's name.[23] Two pieces of another set with similar borders are included in a mixed group of six tapestries owned by the J. B. Speed Art Museum in Louisville, Kentucky;[24] each of these has the inserted coat of arms (Figure 4) in the upper border of Heinrich, Graf von Brühl (1700–1762), the virtual ruler of Saxony after the death of Augustus the Strong in 1738 until the occupation of the country by Frederick the Great in 1759.[25]

Brühl (Figure 5) is known to art historians primarily as the director of the Meissen porcelain manufactory and the owner, at no cost to himself, of an enormous number of its products. Chief among these

Figure 4. Arms of Heinrich, Graf von Brühl. Detail of Figure 7

Figure 5. *Heinrich, Graf von Brühl*. Print by Zucchi (1704–1779) after Torelli, 48.3 × 35.6 cm. The Metropolitan Museum of Art, The Elisha Whittelsey Collection, The Elisha Whittelsey Fund, 1951, 51.501.2701

is the huge Swan Service, designed for him and with his arms on every piece (Figure 6). He did, however, make substantial collections of other works of art.[26] Tapestries are recorded as among his possessions, but little is known of them. The most spectacular may have been a set of the Gobelins *Months of Lucas*, the ninth weaving (1737–40). On the advice of the French representative in Dresden, the set was given to Brühl in 1746; in 1768 it was acquired from his estate for the royal palace.[27] A large Aubusson landscape with his unmistakable coat of arms was on the London art market in 1986.[28] Another landscape with the arms, perhaps made in Beauvais, was owned by a descendant in 1928,[29] and four other tapestries related to the Louisville pieces are known. One is in the Mobilier National, Paris (Figure 20); two are in the Virginia Museum of Fine Arts, Richmond (Figures 12, 18), and one was sold in Paris in 1912.

The two pieces in Richmond and the six Louisville tapestries were in the collection of Lord Amherst of Hackney, Didlington Hall, Norfolk, and were sold at Christie's, London, on December 11, 1908, as lot 92. They were said to have come from Moritzburg, Saxony, a castle owned by the Elector Augustus III. All were described as of much the same height, two panels being very wide and one of medium width (all now in Louisville) and five narrow uprights (three in Louisville). One wide panel is said to show the queen of

France seated in a carriage while Louis XIV received the homage of the burghers of Dole. The inscription on the tapestry (Figure 7) refers to the garrison of the captured town and gives the date of the event, June 16, 1674. The tapestry of medium width, which is illustrated in the sale catalogue, also has an inscription stating that it shows the siege of the town of Doesburg to Louis XIV on June 21, 1672 (Figure 8). The six other tapestries represent "Louis XIV surrounded by various allegorical figures."[30] A tapestry with the same coat of arms and borders in the Mobilier National, Paris, is mentioned. All the Amherst tapestries came into the hands of the New York dealers P. W. French & Co., who lent the *Doesburg* panel to an exhibition in San Francisco in 1922.[31] The two tapestries from the sale that are not in Louisville are those in the Virginia Museum of Fine Arts, Richmond; they are versions of two pieces in Louisville, but the Brühl arms have been removed.[32]

The *Dole* and *Doesburg* tapestries are from the series known as the *Conquests of Louis XIV*. Their borders, with long inscriptions in elaborate cartouches, are like those of the four pieces of the set at Versailles, and the central scenes are similar, except that the *Dole* made for the comte de Toulouse tactfully does not include the carriage with the queen and she is not mentioned in the inscription (the count was the son of Louis XIV and Madame de Montespan). The designs of both sub-

186

Figure 6. Arms of Brühl impaling Kolowrat-Krakowska (his wife). Detail of dish from the Swan Service. German (Meissen), ca. 1737–41. Hard paste porcelain, Diam. 33.7 cm. The Metropolitan Museum of Art, Gift of Rosenberg and Stiebel, Inc., 1948, 48.165

jects have been shown to be derived from prints by Sebastien Le Clerc.[33] *Doesburg* depicts the king and two companions, very awkwardly crammed in behind him, who appear on the far right of the print, with the fortified city in the distance. This part of the print was also used for the *Almanach royale* of 1677 (Figure 9), which, however, commemorated a different hero and a different victory.[34] The Brühl arms, as has been mentioned, are also found on another tapestry of this set, *Messina secourue par le duc de Vivonne*, sold at the Hôtel Drouot, Paris, on March 11 and 12, 1912, no. 212. All the victories of the *Conquests* were won in 1672–78, the period of Louis XIV's second invasion of the Low Countries, known as the Dutch War.[35]

The other four tapestries with the Brühl arms at Louisville are from another series celebrating Louis XIV woven by Behagle, but it was not made at Beauvais or in Paris. The borders resemble those of the *Conquests*, but they lack the cartouches with long inscriptions, have fleurs-de-lis instead of monograms in the corners, and include small birds and masks among the scrolling foliage. Three of them have the name "P. Behagle" beside a city mark, the tower of

Figure 7. *The King at Dole.* French, 17th century. Wool, silk, and metal thread tapestry, 477 × 595 cm. Louisville, J. B. Speed Art Museum

Figure 8. *The Siege of Doesburg*. French, 17th century. Wool, silk, and metal thread tapestry, 480 × 353 cm. Louisville, J. B. Speed Art Museum

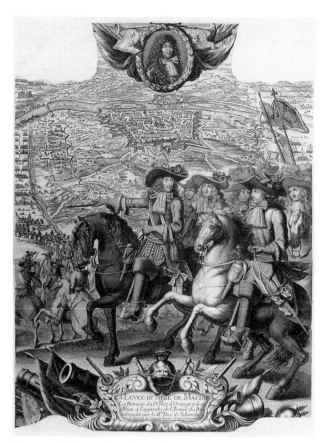

Figure 9. *L'Almanach royal pour l'année MDCLXXII*. Print, 85 × 90 cm. Paris, Bibliothèque Nationale, Cabinet des Estampes, Ob[5] 1677

Tournai (Figure 10).[36] The prominent fleurs-de-lis in the lower corners of these four pieces emphasize the French origin of the set and date it to the period when the city was French, 1667 to 1709. Behagle, as has been mentioned, went to Beauvais in 1684, so it is clear that these four Brühl tapestries were made in Tournai between 1667 and 1684.

Figure 10. Marks of Tournai and Philippe Behagle. Detail of Figure 22

Behagle was born in Oudenaarde in 1641 and was presumably trained there as a tapestry weaver.[37] In 1660 he was at what was shortly to become the Gobelins manufactory in Paris; he was married in the local church in 1669. In the next year he was paid 1,000 livres, a substantial sum, by the royal treasury for "un tableau en tapisserie très-fine qu'il a faict, représentant le chasteau de Fontainebleau."[38] He returned in 1672 to Oudenaarde, then under French rule, which ensured that its products were not banned from entering France and had a workshop there; he and his partner, Jean Baert, made tapestries for two of Louis XIV's mistresses. In 1677 he was at the head of another workshop in Tournai, with fifty employees. It is not surprising that he would write in 1695: "J'ay passé une partie de ma jeunesse a etablir des manufactures par ordre de sa Majesté."[39]

In 1678 Behagle signed a six-year contract with the authorities at Tournai, saying that he had established a "manufacture de tapisseries d'haute lisse des plus fines et exquisses qu'il s'enfabrique dans les Pays Bas";[40] apparently he was confident that his Gobelins expertise would surpass the skill of the previous holder of

his position, Jan Oedins, who had obtained a similar contract in 1671.[41] He was granted a salary of 200 écus a year, but when, at the end of the six years, he asked for a raise, it was refused and, under orders from Colbert, he went to Beauvais. In the French royal accounts concerning this move, Behagle is called "marchand tapissier de Tournay."[42] His work before 1684 has been little discussed.[43]

Tournai in 1677 was a flourishing French city. It had been captured in June 1667 by Louis XIV with the army led by his great general Marshall Turenne. As in most of the other Flemish towns, the citizens put up little resistance and the Spanish garrison scarcely more. The siege lasted only a few days and only four lives were lost. As Madame de Sévigné wrote, "le roi s'amusait à prendre la Flandre,"[44] and the medal commemorating the capture of Tournai has the motto,

"Fecit miracula ludens."[45] The king made a triumphant entry and came back a month later with the queen, for whose hereditary rights, as he claimed, he had taken much of Flanders from its Spanish rulers;[46] he was also accompanied on this visit to the conquered Flemish cities by two mistresses (La Vallière and Montespan), his brother, the dauphin (a child of seven), 3,200 horsemen, 300 carriages, and all the trappings needed for display and splendor.[47] The city had been the capital of the Frankish kings. La Fontaine, speaking in the name of the city, wrote:

J'étais ville des Francs: je le suis des François.
Un vainqueur, sous qui tout succombe,
Sut à ce premier joug ranger ma liberté.
Ce qu'on crut mon malheur fait ma félicité;
Aux efforts de Louis je dus d'abord me rendre.[48]

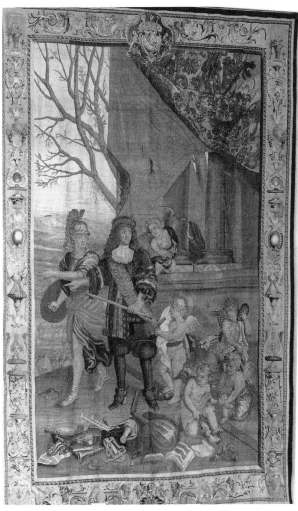

Figure 11. *Louis XIV Leaving for War*. French (Tournai), ca. 1680. Wool, silk, and metal thread tapestry, 458 × 267 cm. Louisville, J. B. Speed Art Museum

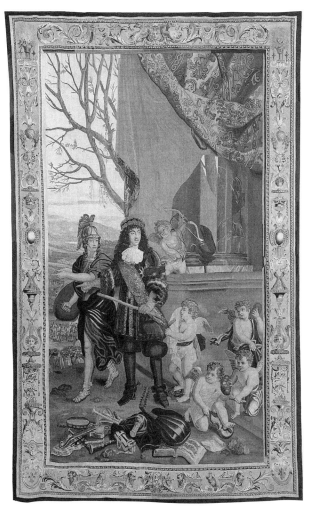

Figure 12. *Louis XIV Leaving for War*. French (Tournai), ca. 1680. Wool, silk, and metal thread tapestry, 465 × 285 cm. Richmond, Virginia Museum of Fine Arts, Bequest of Virginia V. G. Millhiser (photo: Ron Jennings, © Virginia Museum of Fine Arts)

189

Figure 13. Adam Frans van der Meulen (1632–1690). *Leafless Tree*. Drawing, 105 × 75.5 cm. Paris, Mobilier National

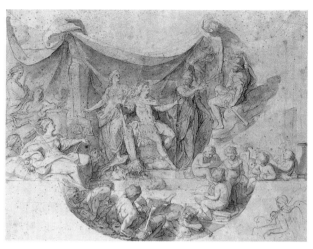

Figure 14. Charles Le Brun (1619–1690). *Le Roi gouverne par lui-même*. Drawing, 41.1 × 50.5 cm. Paris, Musée du Louvre (photo: Réunion des Musées Nationaux)

With his chief minister, Colbert, Louis XIV conferred great benefits on the city of Tournai. A local historian has written: "La ville devient ainsi un centre politique, militaire, judiciare et administratif de la plus haute importance. Economiquement, une grande activité y règne, soutenue par Colbert et une Chambre de Commerce s'y crée (1678)."[49] This was the year of Behagle's contract. It is not surprising that the only known tapestries marked as made by this weaver in this city glorify Louis XIV.

One of the signed Tournai tapestries in Louisville is *Louis XIV Leaving for War* (Figure 11). The version in Richmond has almost exactly the same composition and borders, a mask replacing the Brühl arms, but with no city or weaver's marks (Figure 12).[49] The king, in contemporary civilian dress, wears an unusual small, brown fur hat, as if prepared for winter weather. He has an elaborate gold-embroidered baldric supporting his sword and holds a baton in one hand while pointing to the right with the other. Beside him, the goddess Minerva, grasping a shield, imitates his gesture. The tree with bare boughs above her can be com-

pared to a large drawing by Adam Frans van der Meulen (1632–1690) in the Mobilier National, Paris (Figure 13).[51] Similar bare boughs are seen in the *Prise de Dole* of the Gobelins *History of the King* series;[52] this city was captured in February 1668. It was considered extraordinary for Louis XIV to go to the battlefront in winter, when, as was written in the *Gazette*, "en cette Saison tous les autres Princes ne s'appliquent qu'aux Plaisirs."[53] Troops can be seen in the distance. On a ledge behind the king a cupid aims his bow away from the monarch, and below him three small winged children play with a mask; a fourth seizes the king's sword hilt as if to detain him and holds up a cloth to wipe away a tear. A pile of musical instruments lies at the king's feet in the foreground.[54]

The symbolism is clear. Minerva, the goddess of wisdom and war, leads the king away from peaceful

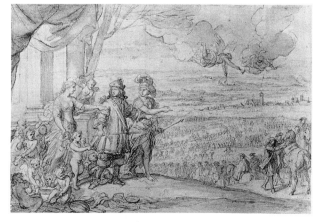

Figure 15. Le Brun workshop. *Louis XIV partant pour la guerre*. Drawing, 32 × 48 cm. Paris, Musée du Louvre (photo: Réunion des Musées Nationaux)

delights, such as music and the theater. She plays the same role, adopting the same stance, in a drawing by Charles Le Brun in the Louvre (Figure 14).[55] This is a preliminary study for the central scene on the ceiling of the Grande Galerie (the Galerie des Glaces) at Versailles that shows Louis XIV taking power into his own hands in 1661.[56] In the drawing Minerva's raised hand points in the direction in which she advances and also to the figure of Mars on a cloud. Below, as in other related drawings, are children occupied with the arts and sciences: one holds a globe, one reads, and one draws a portrait.[57] In the final version on the ceiling they have returned to being as frivolous as they are in the tapestry. As a contemporary writer stated, "Tout le bas du Tableau est rempli de jeunes Enfants nus, qui expriment en cent manieres differentes le Jeu, le Bal, la Musique, la Chasse, les Festes, les Carrousels, et tous les autres divertissemens de la Cour. Cela se passe aux pieds du Monarque, qui n'en paroist aucunement touché." He accounted for the presence of the goddess Hymen in the scene by saying that "on estoit encore dans les réjouissances du mariage du Roy."[58] In the Louvre drawing she wears a crown and holds a scepter and presumably represents the queen herself.

But the king, Minerva (carrying a spear instead of a shield), a cupid, playing children, musical instruments, distant troops, and even the drapery, columns, and leafless tree of the tapestry appear on the left side of another Louvre drawing from the Le Brun workshop (Figure 15).[59] This, however, also includes a lightly clad, attractive young woman, perhaps Venus, who places her left hand on the king's arm as if to restrain him and gestures with her right hand toward the children and their playthings at her feet. She has disappeared completely from the tapestry, which also has fewer children.

This drawing, called *Louis XIV partant pour la guerre*, and four others were listed by Gaston Brière as a set under the somewhat romantic title of a *Projet d'une Histoire galante du Roi*, attributed to Van der Meulen.[60] A better title might be the *Devolution War Drawings*, since the woman who appears in all of them is presumably the queen; the Spanish Netherlands "devolved" upon her rather than upon her half-brother, Charles II of Spain, according to a Flemish law of inheritance cited by the lawyers of Louis XIV.[61] She, the king (in Roman armor), and the most prominent child of the drawing, who here might represent the dauphin, with the departing troops in the background, are also found in another drawing (large and squared up for transfer) from the Le Brun workshop in the Louvre (Figure 16).[62]

This disappearance of the young woman from the

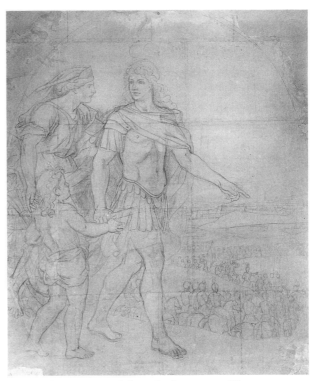

Figure 16. Le Brun workshop. *La Guerre contre l'Espagne pour les droits de la reine*. Drawing, 235 × 200 cm. Paris, Musée du Louvre (photo: Réunion des Musées Nationaux)

tapestries woven between 1677 and 1684 shows that by the time the tapestry was woven the queen was no longer important. The Dutch War of 1672–78 was not connected with her, and it was about to reach a successful conclusion: an heir to the throne had been born and the king began to recognize his illegitimate children. Jennifer Montagu has pointed out that the signing of the treaty of Nijmegen in 1678 led to the decision to depict the king's victories on the ceiling of the Grande Galerie; she has written that, with a single exception, "one human individual, and one only appears in each scene: the King."[63] Minerva in the related drawings and the paintings represents the king's wisdom and expertise in war; no other human beings are needed. Once this principle had been established, all the drawings showing the queen in an active role would have become politically incorrect.

Another Louisville tapestry with Behagle's name and the Tournai mark, *Louis XIV Crowned by Victory*, shows the end of the story (Figure 17). The king, now in imperial Roman costume, with a huge brown wig, has returned to triumph. He holds a commander's baton and a wreath of flowers and sits in what is apparently a chariot, ready for the procession. His feet rest on a cannon and a plumed helmet. A winged Victory

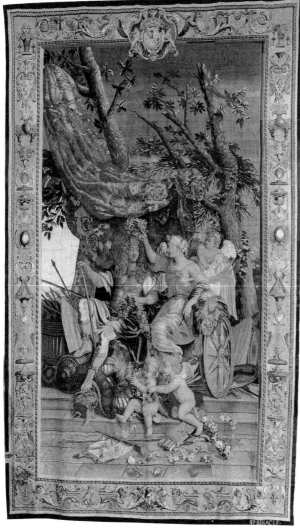

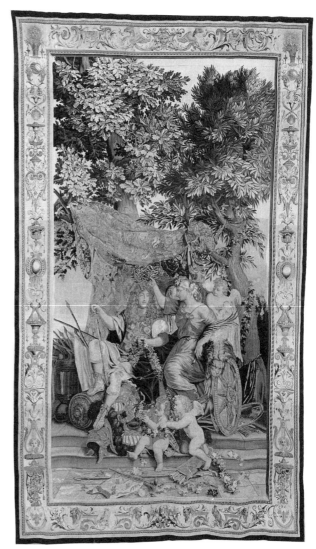

Figure 17. *Louis XIV Crowned by Victory*. French (Tournai), ca. 1680. Wool, silk, and metal thread tapestry, 477 × 279 cm. Louisville, J. B. Speed Art Museum

Figure 18. *Louis XIV Crowned by Victory*. French (Tournai), ca. 1680. Wool and silk tapestry, 488 × 274 cm. Richmond, Virginia Museum of Fine Arts, Bequest of Virginia V. G. Millhiser (photo: Ron Jennings, © Virginia Museum of Fine Arts)

beside him raises a laurel wreath over his head and rests one arm on a lion's skin, a palm frond in the crook of her elbow. A winged child behind her puts his hand on one of her wings and two more on the steps below play with flowers and discarded weapons. A banner at their feet shows fleurs-de-lis.

The same composition is seen in the unsigned tapestry in Richmond (Figure 18).[64] Though an almost exact replica of the lower half of the scene, it is markedly different above, where lush foliage replaces the bare, broken tree trunks and scanty leaves of the Louisville tapestry, as if summer had arrived with victory. No drawing has been found that can be closely associated with the tapestries, although there are some points of resemblance between them and one in the *Histoire galante* group (Figure 19).[65] The king, in

Figure 19. Le Brun workshop. *Le Roi sur un char*. Drawing, 26 × 35 cm. Paris, Musée du Louvre (photo: Réunion des Musées Nationaux)

192

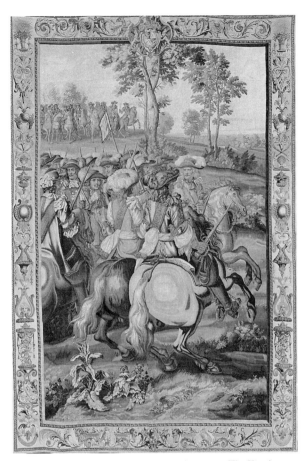

Figure 20. *Le Depart de Turenne pour la guerre (The King's Cavalry).* French (Tournai), ca. 1680. Wool, silk, and metal thread tapestry, 450 × 300 cm. Paris, Mobilier National

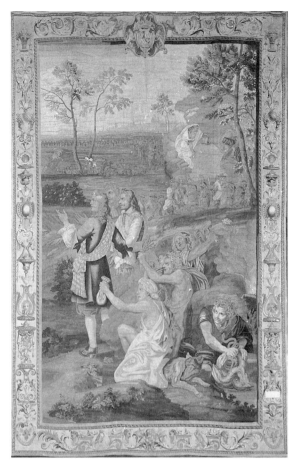

Figure 21. *Louis XIV Accepting the Surrender of a City.* French (Tournai), ca. 1680. Wool, silk, and metal thread tapestry, 465 × 649 cm. Louisville, J. B. Speed Art Museum

Roman costume and a wig, is seated in a somewhat similar pose on a chariot, and some of the winged children can be compared to their counterparts in the tapestries. The plumed helmet under the king's feet in the latter is being held over his head in the drawing, and the scene is surrounded by drapery and trees in all the versions.

But another drawing in the Louvre is clearly the source for three Brühl tapestries, one in the Mobilier National and two in Louisville (Figures 20–22). One of the latter pair has Behagle's name and the Tournai mark. The composition of the drawing (Figure 23)[66] has been divided to make three panels of tapestry. The horseman in the foreground on the left appears in both the drawing and the tapestry in Paris (Figure 20),[67] but the figures farther to the left, very slightly sketched in the drawing, are replaced in the tapestry by two repetitions of the first rider, with differently colored horses and costumes. This rider is also close to

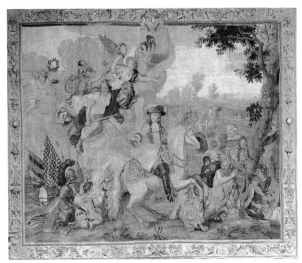

Figure 22. *The Welcome Given to the King.* French (Tournai), ca. 1680. Wool, silk, and metal thread tapestry, 485 x 312 cm. Louisville, J. B. Speed Art Museum

193

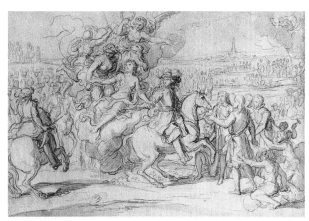

Figure 23. Le Brun workshop. *Louis XIV au siège d'une ville.* Drawing, 28 × 40 cm. Paris, Musée du Louvre (photo: Réunion des Musées Nationaux)

Figure 24. Adam Frans van der Meulen. *Louis XIV Before Douai.* Drawing, 29.5 × 40.9 cm. The Metropolitan Museum of Art, Rogers Fund, 1908, 08.227.8

Figure 25. Le Brun. *Marshall Turenne.* Oil on canvas, 67 × 52 cm. Versailles, Musée National (photo: Réunion des Musées Nationaux)

the one furthest to the right in a Van der Meulen drawing in the Metropolitan Museum, *Louis XIV Before Douai* (Figure 24);[68] Douai was taken by the king in July 1667. In the tapestry the rider seen full-face with white plumes in his hat has the features of Turenne, as shown in the well-known portrait by Le Brun at Versailles (Figure 25);[69] the tapestry has therefore been called *The Marshall* or *The Departure of Turenne for the War*; another title might be *The King's Cavalry*. The significance of the likeness is somewhat diminished by the fact that the same features are given to all the other visible faces of the group.

The central section of the drawing has been used for the larger of the two Louisville tapestries, for which a suitable name could be *Louis XIV Accepting the Surrender of a City* (Figure 21).[70] A prominent figure in

the drawing, however, has been removed and replaced in the tapestry by a very awkward blank space, possibly a reweaving: the young woman or goddess who floats on a cloud behind the mounted king. She places her right hand on the sword-bearing hand of a figure in the air behind her, while her left holds a leafy twig, perhaps an olive branch. Her function is obvious: she is restraining the spirit of war and urging clemency and peaceful benevolence. She might represent the queen, like the young women in the so-called *Histoire galante* drawings.

The allegorical beings above this figure have been preserved in the tapestry and some can be compared to other drawings from the Le Brun workshop. The winged woman raising a wreath is like the chief figure in a sketch of Dawn (Figure 26), made for a ceiling painting in a pavilion at Colbert's château of Sceaux, completed by 1677,[71] and the woman seen from behind appears in drawing called *Louis XIV à la tête de son armée* (Figure 27).[72] She is also reminiscent of a soldier in a Le Brun drawing for the Grande Galerie[73] and a background figure on the right in Antoine Coysevox's relief after Le Brun, the *Triumph of Louis XIV*, at Versailles (Figure 28). The subsidiary figures in this work were described in the *Mercure galant* of December 1682 as "la Victoire, la Valeur et la Renommée";[74] these names may well be given to the three main flying figures in the tapestry. The boy in the air behind them is like the torchbearer in the Dawn drawing.

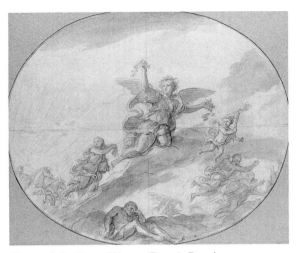

Figure 26. Le Brun. *L'Aurore* (Dawn). Drawing, 30 × 40 cm. Paris, Musée du Louvre (photo: Réunion des Musées Nationaux)

Figure 27. Le Brun workshop. *Louis XIV à la tête de son armée.* Drawing, 42 × 54 cm. Paris, Musée du Louvre (photo: Réunion des Musées Nationaux)

There is one curious difference in this part of the design between the drawing of the complete subject (Figure 23) and the tapestry (Figure 21). The feeble lion in the air of the drawing has been replaced by a much more realistic and ferocious beast. This animal is very close to one in a Le Brun drawing, *La Force* (Figure 29), used for a statue executed by Jean Raon about 1681.[75] The lion of the complete drawing and the tapestry is presumably the companion of the warlike woman with a drawn sword. The small boy kneeling on the ground on the left in the tapestry beside a pile of banners, armor, and weapons does not appear in the drawing; his function is not clear and a source for him has not been located.

Louis XIV on horseback in the center, however, has been closely copied from the figure in the drawing (Figure 23). The horse has been given more harness and decorated trappings, and there is a crouching, disconsolate lion under its raised front legs, presumably a symbol of defeated Spain.[76] Both king and horse can be found in the often repeated portrait by Le Brun's pupil René Antoine Houasse at Versailles (Figure 30).[77]

The figures at the right in the Louvre drawing (Figure 23) are apparently some citizens of the conquered city come to greet the king. The foremost figure, identified as an important person by his conspicuous sash, seems to introduce the humble suppliants, one of whom wears an old-fashioned ruff and a roll of fab-

Figure 28. Antoine Coysevox (1640–1720). *Triumph of Louis XIV,* ca. 1681–83. Stucco relief, H. 392 cm. Versailles, Musée National (photo: Réunion des Musées Nationaux)

Figure 29. Le Brun. *La Force*. Drawing, 292 × 134 cm. Paris, Musée du Louvre (photo: Réunion des Musées Nationaux)

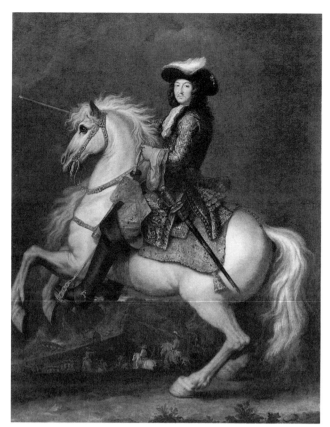

Figure 30. René Antoine Houasse (ca. 1645–1710). *Louis XIV on Horseback*. Oil on canvas, 255 × 200 cm. Versailles, Musée National (photo: Réunion des Musées Nationaux)

ric at his shoulder, suggesting a Spanish costume.[78] Behind the raised forelegs of the king's horse is a small, cowering boy holding a rabbit or hare; he is presumably a personification of Fear.[79] At the right are three ugly allegorical beings crouching on low-lying clouds, apparently trying to hold the citizens back. A troop of approaching horsemen appears in the distance and a city is seen on the horizon.

A much more elaborate version of this scene is shown on the two tapestries in Louisville (Figures 21, 22). The second, smaller piece could be called *The Welcome Given to the King*; it has Behagle's name and the Tournai mark. One real person appears in the group on the right in the larger tapestry (Figure 21), a bearded old man in old-fashioned costume, holding out his hat to the king. Two more are shown in the *Welcome* (Figure 22). The important man wearing a conspicuous sash with a gold fringe is like his counterpart in the drawing but is more richly dressed, with a purple coat and red heels. The man behind him also wears an old-fashioned costume. The long line of distant horsemen in the tapestry is very lightly indicated in the drawing, and the figures in the sky are unlike their counterparts; part of the tapestry here seems to have been rewoven. A distant city is visible on the horizon in both versions of the scene.

But the evil personifications are more clearly defined in the tapestries than are their counterparts in the drawing. There are three on the far right of the drawing who appear in *The Welcome Given to the King*, looming out of a pale brown cloud, but they now have attributes that identify them. The foremost figure wears a gold turban and holds a golden moneybag; she has a wolf behind her and is Avarice, as described by Cesare Ripa.[80] Beyond her is a being who, in the drawing, reaches out to clutch one of the men greeting the king, and in the tapestry holds a bunch of twigs and grasps a cock; she is Jealousy.[81] These two figures are very similar in both drawing and tapestry, except for the attributes, which are largely missing in the drawing. The third, most distant figure, however, is hardly visible in the drawing but is large and clear in the tapestry. She holds a hammer in both, but in the tapestry she also raises a bunch of nails; she is Necessity, in the sense of "needs must," something that cannot be avoided, not of want or poverty.[82] The evil being in the

lower right corner of the tapestry has snakes for hair and is taking more snakes from a bag; he must represent something malevolent.[83] A Le Brun drawing shows a very similar head with snakes (Figure 31).[84]

The personifications on the right side of the tapestry *Louis XIV Accepting the Surrender of a City* (Figure 21) are not in the drawing of the complete scene (Figure 23). They are very crowded and conspicuously less well designed than those of *The Welcome Given to the King* (Figure 22), perhaps because the painter of the tapestry cartoon had no drawing to guide him. They are led by a man who cringes in terror away from the hooves of the king's horse. His open mouth and staring eyes are reminiscent of a Le Brun drawing in the Louvre (Figure 32), which is inscribed "Leffroy,"[85] He has a peacock-feather crown and a large peacock stands beside him, symbols identifying him as Pride;[86] perhaps his attitude and expression illustrate the downfall of proud enemies when confronted by the king of France. Above him is a dark blue cloak covered with pink masks worn by a scarcely visible figure holding up a bundle of burning straw; she is Falsehood.[87] Beside this figure are two heads—one old, one young—a hand holding a mask, and another with two hearts; this is a single entity, Fraud.[88] The seated man in the lower right corner has a bird on his head, smoke pours from his mouth, and he grasps with both hands a child in swaddling clothes. The bird is a nightingale, and the man is about to drown the baby; he is Cruelty.[89]

This highly allegorical depiction of the surrender of a conquered city is strikingly different from the realistic, conventional representation of the surrender of Tournai to Louis XIV shown in a print after Van der Meulen (Figure 33).[90] The cathedral, with its distinctive five steeples above the central tower, is seen in the background, and the city fathers, in dignified robes, kneel before the king, the foremost presenting the keys to the city on a platter. Their subservient postures and simple dress would certainly not have suited the grand personage in *The Welcome Given to the King* (Figure 22). There are no supernatural or symbolic beings on the ground or in the sky. The lavish use of personifications in the tapestries can be compared to the similar wealth of symbolic figures in the set of drawings called by Brière a *Mythological History of the King*; some of these are identified by inscriptions as *Diligence, Sagesse, Secret, Prévoyance, Soin, Mansuétude, Châtiment, Fraude, Orgeuil, Crainte,* and *Soumission*;[91] some are suitable qualities for the conqueror, others for the conquered.

Figure 31. Le Brun. *Head with Snakes*. Drawing. Location unknown (photo: courtesy Witt Library, Courtauld Institute of Art, London)

Figure 32. Le Brun. *La Frayeur*. Drawing, 20 × 16 cm. Paris, Musée du Louvre (photo: Réunion des Musées Nationaux)

Figure 33. Jan de Huchtenburgh, after Van der Meulen. *Surrender of Tournai.* Print, 9 × 13 cm. Munich, Staatliche Graphische Sammlung

Figure 34. Adam Frans van der Meulen. *Louis XIV Before Tournai.* Drawing, 30.3 × 41.9 cm. The Metropolitan Museum of Art, Rogers Fund, 1908, 08.227.9

The four tapestries in Louisville and the one in Paris show the only subjects known of the Tournai series, which can be called the *Glorification of Louis XIV.* This is an unusual number for a set. The two near-replicas of Louisville designs in Richmond would normally suggest a second weaving, but the facts that they all came much later into the possession of the Graf von Brühl and that three tapestries of the *Conquests of Louis XIV,* perhaps made in Beauvais, were added to them make up a large set, suggest that the *Glorification* tapestries remained Behagle's property for some time; his 1684 contract included payment for the cost of transportation from Tournai to Beauvais of "les tapisseries, laines, soies et métiers."[92] But why had Behagle undertaken such an ambitious project and why did he repeat two of the designs? Nothing is known of his agreement with the city except the amount of his salary; perhaps he had hoped for a commission, or even two, for a suitable expression of loyalty to the French crown. A similar idea occurred to the city fathers of Lille in 1684: they approved the cartoon of a tapestry to be hung in their meeting place, the king's arms in the center and those of the city in the corners, but they were unable to pay for weaving.[93] Perhaps having so many costly objects left on his hands was an additional inducement for Behagle's move to Beauvais; by this date, however, such a series would have been hard to sell in France. The most glorious years of Louis XIV were over.[94]

The *Glorification* tapestries, as has been shown, can be dated to 1677–84; perhaps they were begun in the first enthusiasm when Behagle received his contract in 1678. How the cartoons were provided can only be guessed at. As has been indicated, the designer must

have had access to many drawings in the Le Brun and Van der Meulen studios at the Gobelins. Behagle presumably had friends at the manufactory from his twelve years there, 1660 to 1672. This was a period of great achievement at the Gobelins. In 1660 it was still a private enterprise run by two Flemings, but after the fall of the overambitious minister Fouquet in 1661 it was set up by Colbert as a royal establishment and its period of splendor began. The king's first visit was in 1662, and the famous Gobelins tapestry of this event shows how much had already been achieved. Behagle's presence on this great occasion can surely be taken for granted.

Behagle must have known well the many tapestry series after Le Brun and probably wove parts of them. They all celebrate the grandeur of the king: the *Elements* (first weaving finished 1666–69),[95] the *Maisons royales* (1668–81),[96] the *History of Alexander* (1666–80),[97] and, especially pertinent for the idea of the *Glorification,* the *History of the King.* Le Brun was working on the designs of this last series in 1662, and the first pieces were put on the loom in 1665.[98] Behagle could well have asked a friend at the manufactory to send him designs for an appropriate series of similar inspiration to be woven in Tournai, and this friend might have remembered some ten-year-old preliminary sketches that had never been used.

Both Le Brun and Van der Meulen had studios at the Gobelins. When the contents of Le Brun's studio were taken over by the king after the artist's death in 1690, they included nearly 3,000 drawings, many by assistants,[99] all of them now in the Louvre. The 223 drawings from Van der Meulen's workshop, including

some by other hands, went to the Gobelins, where he had died eight months after Le Brun.[100] Both artists had visited Tournai when it was captured, and both may be supposed to have been sympathetic when asked for ideas for a tapestry series glorifying Louis XIV; neither, of course, could have been expected to provide specific drawings himself. The spirit of camaraderie at the manufactory was described in an article in the *Mercure galant* of 1673: "Ils prennent tous ensemble d'honnestes divertissements, et se traitent les uns les autres, ce que les empêche d'aller faire la débauche autre part: c'est une des raisons pour lesquelles on les a tous logez ensemble."[101]

The full-sized cartoons would probably not have been sent to Tournai from Paris; one may imagine drawings, *petits patrons* or larger versions, cribbed from many different sources. There are, however, elements in the tapestries that have not been related to any known drawings. One very conspicuous addition is the wealth of allegorical beings that have been added in their entirety to *Louis XIV Accepting the Surrender of a City* and in part to *The Welcome Given to the King* (Figures 21, 22). Though present only as vague malignancies in the related drawing (Figure 23), the figures are for the most part well integrated into the designs of the tapestries and can be supposed to have been included in the *petits patrons*. As previously shown, they can be identified as Avarice, Jealousy, Necessity (what is unavoidable), Pride, Falsehood, Fraud, and Cruelty. Could these figures have been placed on the tapestries as a comment on the political situation in Tournai ten years after its capture by Louis XIV? The Flemish cities were well treated by their new rulers, but France was much closer than Spain, and its regulations were more stringent and more effectively enforced. "Le Roi ne veut pas que ces gens-là s'accoutument à raissoner sur les ordres qu'il reçoivent," wrote the French minister Louvois in 1671.[102] Some markets for industrial products had been cut off and some citizens had lived more comfortably under the slack Spanish regime. Spanish secret agents after the conquest found some willing hearers.[103] Could Behagle have wanted to demonstrate his loyalty by representing very graphically the vices of an antiFrench minority in Tournai? The actual conquest of the city a decade earlier, as commemorated in a drawing by Van der Meulen in The Metropolitan Museum of Art (Figure 34),[104] was not important to the newcomer Behagle. The prominent position, dignified bearing, and rich costume of the foremost man in *The Welcome Given to the King* suggest that he represents an important, pro-French citizen of Tournai at the time when the tapestries were made. His lack of a sword shows that he is not a nobleman or army officer. The disappearance of the boy with the rabbit of the drawing could indicate that the good citizens of a French Tournai had no reason to fear the king of France.

Another marked difference between tapestries and drawings is found in *Louis XIV Leaving for War* (Figures 11, 15) and *Louis XIV Accepting the Surrender of a City* (Figures 21, 23). This is the disappearance of the nymph or goddess who represents the queen. In *Louis XIV Leaving for War* this has been skillfully effected, but her absence from *Louis XIV Accepting the Surrender of a City* has an awkward appearance. If the space that she would have filled is a reweaving, perhaps she was removed at the manufactory because she now detracted from the glory of the king, who needed no outside

Figure 35. François Bonnemer (1637–1689) and François Verdier (1651–1730), after Van der Meulen. *Passage du Rhin.* Painted silk, 413 × 645 cm. Paris, Mobilier National

encouragement to incline him to benignity. As has been suggested, all the drawings containing the figure representing the queen must refer to the Devolution War of 1667–68. Ten years later such a figure had become meaningless—the king must stand alone, uninfluenced by any other being.

There are too many artists who were working at the Gobelins, both when Behagle was there and ten years later, for any attribution of the *petits patrons* of the Tournai *Glorification* tapestries to be more than hesitantly suggested. Some, including Vernansal and the Sève brothers, have been mentioned as providing designs for his work at Beauvais. Another possibility is François Bonnemer (1637–1689), who specialized in paintings on silk; he was at the Gobelins in 1673[105] and was very active there in 1675–88. But it is the borders of one of Bonnemer's paintings on silk, the *Marche de la cavalerie commandée par Condé* from the set of the *Passage du Rhin*, made at the Gobelins in 1682–84 (Figure 35), that suggest another artist. Bonnemer's central scenes are after Van der Meulen, but the borders are described in an inventory of cartoons taken after Le Brun's death where they are said to be: "huit enfans dessinez pour les tapisseries sur moire [the painted silks], par le s. Verdier d'après led. deffunt s. Le Brun . . . et autres sujets, qui ont servi à peindre lesd. tapisseries sur moire, par led. s. Verdier, qui ont été retouchez dud. deffunt s. Le Brun."[106] The two winged boys standing in the vertical borders of the *Marche de la cavalerie* are very similar to the child next to the king in *Louis XIV Leaving for War* (Figure 11). The one on the left of the silk panel is in profile like the boy in the tapestry; the one on the right has his legs in the same position, and both have the belt round the waist as their only clothing. François Verdier (1651–1720) was very close to Le Brun, who bequeathed to him and Houasse "tous ses desseins et bosses"; the king appropriated most of these.[107] Verdier was paid for ornamental designs at the Gobelins in 1671[108] and was very active there in the 1680s.[109] The flying allegorical figures in Van der Meulen's cartoon of the *Crossing of the Rhine* in Versailles are believed to be by Verdier; they can be compared to those in the drawing *Louis XIV au siège d'une ville* (Figure 23).[110]

Behagle did not list the *Glorification* tapestries in the records of his payments for debts, nor did he include them in the memorandum of his successful sales. It is possible that, once he had moved to Beauvais, he was not proud of them. As a Gobelins worker, he well knew that good design is as essential to a tapestry as good materials and workmanship; he was clearly justifiably proud of the artists he would call on at Beauvais. The Tournai tapestries, with designs inexpertly adapted from unrelated drawings, are not as good as the best Beauvais work (cf. Figures 1, 3), a fact of which Behagle must have been aware.

One can only hazard a guess as to how such a conglomeration of ten disparate tapestries, not of the finest quality, the seven Tournai pieces of the *Glorification* (two being repetitions) and three *Conquests of Louis XIV,* came, fifty or sixty years after they had been woven, into the possession of Graf von Brühl. The strange mixture of subjects, the different borders, and the remoteness in time of the scenes depicted, do not speak well of the taste and discrimination of the purchaser—perhaps he thought he was buying a recent weaving of the Gobelins *History of the King.*[111] One can only suppose that all the tapestries were in storage at Beauvais when an order was received at the manufactory for a large set wanted immediately by a distant customer. Here was a splendid opportunity to dispose profitably of some outdated merchandise. Brühl's arms were hastily added and the shipment thankfully dispatched. But the addition of the arms has enabled a rare set to be identified, and Behagle's persistent loyalty to Louis XIV has been strikingly confirmed.

NOTES

1. Roger-Armand Weigert, "Les Commencements de la Manufacture royale de Beauvais, 1664–1705," *Gazette des Beaux-Arts*, 6th ser., vol. 64 (Dec. 1964) pp. 332, 334.

2. Jean Coural and Chantal Gastinel-Coural, *Beauvais, Manufacture nationale de Tapisserie* (Paris, 1992) pp. 11, 13.

3. Some were used as diplomatic gifts to perhaps less sophisticated recipients, such as the Russian and Algerian ambassadors and an unknown monarch listed as the "roi Darde (Guinea)" (Coural, *Beauvais*, p. 13).

4. *Les relations artistiques entre la France et la Suède, 1693–1718. Nicodème Tessin le jeune et Daniel Cronström correspondance* (Stockholm, 1964) p. 67.

5. Jules Badin, *La Manufacture de Tapisseries de Beauvais depuis ses origines jusqu'à nos jours* (Paris, 1909) p. 9. At Colbert's express request, the king had visited the manufactory on his way to the wars in Flanders in 1670, when he bought several tapestries, and in 1680. Hinart later recorded his wish to represent the "actions héroiques" of the king (Coural, *Beauvais*, p. 11, nn. 19, 21) but never did so.

6. Bertrand Jestaz, "The Beauvais Manufactory in 1690," *Acts of the Tapestry Symposium, November 1976, The Fine Arts Museums of San Francisco* (San Francisco, 1979) p. 188.

7. Heinrich Göbel, *Wandteppiche*, II: *Die romanischen Länder* (Leipzig, 1928) I, pp. 213, 214.

8. Jestaz, "Beauvais Manufactory," p. 187. The author believes that tapestries made by Hinart might have been included in these lists, but Coural (*Beauvais*, p. 19 n. 18) considers it more probable that

tapestries made by Behagle before he went to Beauvais were listed.

9. Badin, *Manufacture de Tapisseries*, pp. 12, 13.

10. I am indebted to Dr. Betsy Rosasco for the transcription of these entries in the *Journal du Garde Meuble*, Arch. nat., o'3307, fol. 189, nos. 178, 179.

11. Jules Guiffrey, *Inventaire géneral des Meubles de la Couronne* (Paris, 1899) I, pp. 363, 364.

12. Roger-Amand Weigert, "Les Grotesques de Beauvais," *Hyphé* 1 (1946) p. 69.

13. Guiffrey, *Inventaire général*, p. 361.

14. Edith Appleton Standen, *European Post-Medieval Tapestries and Related Hangings in The Metropolitan Museum of Art* (New York, 1985) II, no. 64a–f, pp. 441–458.

15. Ibid., p. 442.

16. He made a copy of Le Brun's *History of Alexander* for *basse lisse* looms, woven ca. 1670–80, and was paid for other work in 1701 (Maurice Fenaille, *État général des Tapisseries de la Manufacture du Gobelins* III, pt. 1 [Paris, 1904] pp. 100, 167).

17. Ibid. VI, (1923) pp. 6, 7.

18. Standen, *European Post-Medieval Tapestries*, no. 66, pp. 461–468. The designs continued to be woven after Behagle's death in 1705. A set of six pieces made for the comte de Toulouse is in the J. Paul Getty Museum, Los Angeles; one has Vernansal's name and two have Behagle's (Charissa Bremer-David, *French Tapestries in the J. Paul Getty Museum* [Los Angeles, 1997] cat. no. 9, pp. 80–97).

19. Edith A. Standen, "Some Beauvais Tapestries Related to Berain," *Acts of the Tapestry Symposium, November 1976. The Fine Arts Museums of San Francisco* (San Francisco, 1979) pp. 212–216.

20. Standen, *European Post-Medieval Tapestries*, no. 67, pp. 469–477. To the list of subjects given here can probably be added a *Hippomenes and Atalanta* in a private collection (*Tapisseries françaises des XVIIe et XVIIIe siècles*, exh. cat., Galerie du Théatre Municipal [Brive, 1989] no. 11). The Sève brothers worked at the Gobelins making cartoons after Le Brun, Poussin, and Raphael (Fenaille, *État général*, II [1903] pp. 69, 74, 100, 186, 268).

21. Standen, *European Post-Medieval Tapestries*, no. 68, pp. 473, 474.

22. Guiffrey, *Inventaire général*, pp. 358, 359, 361–364. All are recorded as in the royal collection by 1701; none is listed among the pieces added by 1714.

23. Roger-Armand Weigert, "Remarques sur les Conquêtes de Louis XIV tissées par Behagle, *Bulletin de la Société de l'Histoire de l'Art français* (1932) pp. 280–289; Daniel Meyer, "Les Conquêtes de Louis XIV," *Revue du Louvre* (1970) pp. 155–164; the Versailles set is dated after 1703 and is thought to have been made in Behagle's Paris workshop. It was exhibited at the "Splendor of Versailles," Jackson, Miss., 1998; see exh. cat., pp. 136–145, entry by Xavier Salmon.

24. *Handbook of the Preston Satterthwaite Collection, The J. B. Speed Memorial Museum, Louisville*, n.d., n.p.; the tapestries, called Beauvais, are listed as *The King and Mars, The King at Dole* (illus.), *The Siege of Doesburg, Louis XIV Vanquishes Evil, The Triumph of Louis XIV*, and *Louis XIV Crowned by the Goddess of Victory* (illus.); *Glorious Horsement: Equestrian Art in Europe*, exh. cat., Springfield Museum of Fine Arts and Louisville, J. B. Speed Memorial Museum (Springfield, 1981–82) cat. no. 83 (*Siege of Doesburg*), cat. no. 84 (*Triumph of Louis XIV*); called Beauvais, woven by Philippe Behagle after Jean Baptiste Marin, 1690–1720.

25. The arms have been described by Dr. Helmut Nickel in a private letter: "The first and fourth quarterings refer to Brühl's title; they are halved of gold and red, overlaid by a crowned double-eagle, half black and half white (party per pale of Or and gules, a crowned double-eagle overall, party of sable and argent). This is a combination of the arms of the Empire: in Gold a black crowned double-eagle, and the royal arms of Poland (as sponsor): in Red a crowned silver eagle. The second and third quarterings: in Blue a silver chevron (*azure, a chevron argent*) are the family arms of Brühl." The three crests are: 1, tail of peacock; 2, an eagle of the shield; 3, a chapeau pyramidal from the Saxony arms *or* surmounted by three peacock feathers. The supporters are two crowned lions (J.B. Rietstap, *Armorial Général* [Baltimore, 1978] p. 316).

26. Aladár Boroviczény, *Graf von Brühl. Der Medici, Richelieu und Rothschild seiner Zeit* (Zürich, 1928) pp. 360–363, 383–394 (Brühl is said to have owned "herrlichen französichen Gobelins"); Rainer Rückert, *Biographische Daten des Meissener Manufacturisten des 18. Jahrhunderts* (Munich, 1990) pp. 267, 268; Gerald Heres, *Dresdener Kunstsammlungen im 18. Jahrhunderts* (Leipzig, 1991) pp. 99–130. Brühl had an agent in Paris called Huet who purchased a writing table for him in 1749 for 2400 livres (Hans Huth, "Two French writing-tables," *Burlington Magazine* 72 [1938] p. 81).

27. Fenaille, *État général*, II, pp. 358, 359, pls. facing pp. 356, 358, 360. The set is listed in the inventory of 1765, taken after Brühl's death, as "No. 8, 1000 Ther. Zwölf stuck Haut de Lice zu Tapeten, die Jahren-Zeiten vorstellend." (I am indebted to Iris Kretschmann for this reference.) All the *Months* except *April* were in the Royal Palace (the Residenz Museum) in 1900. *April* is in the Louvre (Château de Coppet, *Les Gobelins*, exh. cat. [1962] no. 47). *November* is in the Hermitage Museum, Saint Petersburg (N. Biroukova, *Les Tapisseries françaises de la fin du XV^e au XX^e siècle dans les collections de l'Hermitage* [Leningrad, 1974] no. 27).

28. Simon Franses, *European Tapestries, 1450–1750. A catalogue of recent acquisitions* (London, 1986) pp. 35–38, no. 8. Another piece of the set is said to be in Haneberg Castle, Södermanland, Sweden.

29. Boroviczény, *Graf von Brühl*, pl. facing p. 397.

30. Christie, Manson & Woods, London, Dec. 11, 1908, lot 92, p. 21.

31. Phyllis Ackerman, *Catalogue of the Retrospective Loan Exhibition of European Tapestries in the San Francisco Museum of Art* (San Francisco, 1922) cat. no. 52, called Beauvais, 1685–1711.

32. I am indebted to Dr. Alice Zrebiec for an account of the Amherst tapestries when they were owned by French & Co. The Richmond tapestries are recorded as repaired in 1926 and the coat of arms on *Louis XIV Crowned by Victory* as removed in 1928. Lengthening and reweaving may also have taken place at this time (information kindly provided by Thomas Campbell).

33. Meyer, "Conquêtes," pp. 157, 158, figs. 3, 4.

34. *Creating French Culture—Treasures from the Bibliothèque Nationale de France*, exh. cat. (New Haven/London, 1995) cat. no. 120. The victory is the raising of the siege of Maastricht, and the chief character is presumably the army commander named in the inscription, the duc de Schomberg.

35. The *Messina* of the Toulouse set is owned by Edmond de Rothschild. For the victories of the Dutch War, see François Bluche, *Louis XIV*, Marc Greengrass, trans. (New York, 1990) pp. 248–261.

36. A single tower appears on the arms of the city (Françoise Thomas and Jacques Nazet, eds., *Tournai, une ville, un fleuve*

[Tournai, 1995] pp. 47, 147); Weigert, "Remarques," pp. 283–288 (the author describes, but does not illustrate, the tapestries with Brühl arms, then owned by P. W. French & Co., and concludes: "Behagle a établi deux séries de *Conquêtes de Louis XIV*, l'une à Tournai, à tendances allégoriques, et l'autre strictement historique, executée à la Manufacture de Beauvais"). The Christie's sale catalogue does not mention the marks, but one was recorded by W. G. Thomson, *A History of Tapestry from the Earliest Times until the Present Day* (London, 1930) p. 407. Few tapestries with the Tournai mark have been published, but two 16th-century examples were shown in an exhibition at Roubaix in 1911 (Eugène J. Soil de Moriamé, *Les anciennes industries d'art tournaisiennes à l'exposition de 1911* [Tournai, 1912] p. 193).

37. Elsa Vandermeersch-Lantmeeters, "Kunstenaarsfamilies in Oudenaarde IV. De familie Behagle I," *Handelingen van de Geschieden Oudeidkundige Kring van Oudenaarde* 30 (1993) pp. 201, 204. (I am indebted to Dr. Ingrid De Meûter for supplying me with this publication.)

38. Jules Guiffrey, *Comptes des Bâtiments du Roi sous le règne de Louis XIV* (Paris, 1881) I, col. 366.

39. Coural, *Beauvais*, p. 24.

40. Quoted in Eugène Justin Soil de Moriamé, *Les Tapisseries de Tournai et les haute lisseurs de cette ville* (Tournai, 1882) p. 66. The city archives, described as "les plus riches de Belgique," were completely destroyed in May 1940 (Thomas and Nazet, *Tournai*, p. 20).

41. Dora Heinz, *Europäische Tapisseriekunst der 17 und 18. Jahrhunderts* (Vienna, 1995) p. 90.

42. Guiffrey, *Comptes des Bâtiments*, II, col. 403. Colbert's successor, Louvois, was less generous but in general confirmed Behagle's privileges (Coural, *Beauvais*, p. 17).

43. Weigert's identification of some of the tapestries with Brühl arms (see note 34) is the only unquestionable attribution. A "Teniers" *Cardplayers* with Behagle's name from a set of six pieces is illustrated in Heinrich Göbel, *Wandteppiche*, I: *Die Niederlande* (Leipzig, 1923) pl. 410, as an Oudenaarde work of about 1670, but the author in his *Wandteppiche*, II: *Die romanischen Länder* (Leipzig, 1928), p. 217, describes the set as made in Beauvais about 1685, illustrating another piece (II, pl. 217). This attribution is supported by H. C. Marillier, *Handbook to the Teniers Tapestries* (London, 1932) p. 97. A supposed portrait of Louis XIV's *intendant* in Flanders, Dugué de Bagnols, was exhibited in Tournai in 1911 with a tentative attribution to Behagle's manufactory in that city (Soil de Moriamé, *Les anciennes industries*, p. 192).

44. Quoted in Victor Champier, *L'Art dans les Flandres françaises aux XVII^e et XVIII^e siècles après les conquêtes de Louis XIV* (Roubaix, 1926) p. 31.

45. A. P. de Mirimonde, "Une vue inédite de Tournai par David Teniers le Jeune," *Musées Royaux des Beaux-Arts de Belgique Bulletin* 10 (1961) p. 109. A project for flooding the approaches to the city was considered, but had to be abandoned because of a drought (Thomas and Nazet, *Tournai*, pp. 189, 192).

46. For the origins of the Devolution, or Queen's, War, see Bluche, *Louis XIV*, pp. 239, 244.

47. Alexandre de Saint-Leger, *Histoire de Lille* (Lille, 1942) p. 267.

48. Quoted in Jean-Pierre Néraudau, *L'Olympe du Roi-Soleil* (Paris, 1986) p. 82. The poem is a translation of a Latin inscription made as a label for a painting. Chilperic II, king of the Franks, was supposed to have given a diploma to Tournai Cathedral in 716 (Thomas and Nazet, *Tournai*, p. 121).

49. Paul Rolland, *Tournai tel qu'il fut* (Brussels, 1947) p. 38; idem, *Louis XIV et Tournai* (Brussels, 1944) p. 5. The author states that the first *Conquests* tapestries were woven by Behagle in Tournai in 1677. The somewhat inept designs of the series and the fact that these were adapted from prints, rather than from works by the illustrious painters that Behagle quoted so proudly for his Beauvais weavings, lend some credibility to this supposition.

50. The Louisville tapestry has been called *The King and Mars*, but the deity is clearly feminine. The Richmond tapestry (acc. no. 65.38.6) is called *Minerva Summoning Louis XIV to Arms* (*Guide to the Virginia Museum*, n.p., n.d., p. 40).

51. Laure C.-Starcky, *Dessins de Van der Meulen et de son atelier*, exh. cat., Mobilier National (Paris, 1988) p. 201, cat. no. 205, illus. The drawing is squared up for transfer. A very similar tree appears in the painting, the *View of Dole in 1668*, at Versaille, but this is only 48 cm high (Wolfgang Schulz, "Adam François van der Meulen und seine Condé-Ansichten," *Musée Royale des Beaux-Arts de Belgique Bulletin* 23–29 [1974–80] p. 260, fig. 11). It is also close to the tree on the right side of the tapestry *Le Mois de décembre, le château de Monceaux* in the *Maisons royales* series, first woven in 1668 (Bremer-David, *French Tapestries*, p. 27, no. 16).

52. Daniel Meyer, *L'Histoire du Roy* (Paris, 1980) p. 119, pl. 15. The event shown has a very cold and windy setting.

53. Quoted in Fabian Stein, *Charles Le Brun. La Tenture de l'Histoire du Roy* (Worms, 1985) p. 106.

54. These have been kindly identified by Dr. Laurence Libin as a tambourine, violin or treble viol, bagpipe (*cornemuse*), lute, oboe, recorder, flute, another violinlike instrument (probably a quinton) and its bow, and a couple of other woodwinds.

55. Jules Guiffrey and Pierre Marcel, *Inventaire général des Dessins du Musées du Louvre et du Musée de Versailles* (Paris, 1913) VII, no. 5805, inv. 27691. Called *Le roi gouverne par lui-même*.

56. Robert W. Berger, *Versailles, the Château of Louis XIV* (University Park / London, 1985) p. 54, fig. 93. The drawing is said to be possibly Le Brun's project for the painting shown to the king in 1678. On the finished ceiling Minerva plays a less active part; the gods now no longer influence the king; they merely assist or congratulate him (Alain Mérot in *Triomphe et Mort du Héros*, exh. cat. [Lyon, 1988] cat. no. 5, *Le Roi arme sur terre et sur mer*, sketch for the third compartment of the Grande Galerie, 1678–79, Musée d'Art et d'Histoire, Auxerre). The name "Galerie des Glaces" seems to have been first used in the second half of the 19th century (Béatrix Saule, *Versailles triomphant, une journée de Louis XIV* [Paris, 1996] p. 186, no. 1).

57. Robert W. Hartley, "The Allegory of Versailles: Then and Now," *Laurels* 52, no. 1 (Spring 1981) pp. 16, 17.

58. [Pierre Rainssant], *Explication des tableaux de la galerie de Versailles et des deux salons* (Versailles, 1687) pp. 3, 4. The marriage took place in 1660.

59. Guiffrey and Marcel, *Inventaire*, no. 6300, inv. 27694. Dr. Lydia Beauvais, now engaged in cataloguing the Le Brun drawings at the Louvre, has kindly informed me that the main figures and the landscape are by Van der Meulen and the distant figures in the sky, one of whom is Bellona, can be attributed to Le Brun.

60. Gaston Brière, "Van der Meulen, collaborateur de Le Brun,"

Bulletin de l'Histoire de l'Art français (1930) p. 153. The drawings listed as forming this series are 1. *Le départ pour la guerre* (Figure 15); 2. *Le retour du vainqueur* (illustrated in Stein, *Charles Le Brun*, pl. 64); 3. *Vénus et les Amours*; 4. *Le roi, en Mars, est sur un char* (Figure 19); 5. *Le roi, à cheval, est visé par deux Amours*. Stein (*Charles Le Brun*, p. 307) shows that nos. 3 and 5 were originally a single piece. In discussing some of the drawings (pp. 304–309), he attributes the landscapes to Van der Meulen and states that the figures are based on sketches by Le Brun.

61. Stein, *Charles Le Brun*, p. 174. The author writes: "Nur zu dieser Zeit spielte Maria Theresa in Propaganda und Panegyrik eine Rolle." To this group of drawings might be added *Louis XIV au siège d'une ville* (Figure 23), listed by Brière among the drawings for a "suite mythologique de l'Histoire du Roi," but containing the goddess. Possibly two drawings attributed to Le Brun in the National Gallery of Scotland (D1805, D1806), called the *Triumph of Louis XIV* and *Louis XIV Receiving Ambassadors*, could also be connected, although the woman in them is somewhat older and more fully clothed. She has no crown, but can be compared to the queen in the Grande Galerie drawing (Figure 14).

62. Guiffrey and Marcel, *Inventaire*, no. 5735, inv. 29909. Called "La guerre contre l'Espagne pour les droits de la reine."

63. Jennifer Montagu, "Le Brun's early designs for the Grande Galerie and some comments on the drawings," *Gazette des Beaux-Arts*, 6th ser., vol. 120 (Nov. 1992) pp. 195–206. The author states that, to her knowledge, this type of allegorical history had never been used before.

64. Acc. no. 65.38.7. Göbel, *Die romanischen Länder*, pp. 216, 217, fig. 213. Called Beauvais, ca. 1690. The illustration shows the Brühl arms in the upper border that were later removed (see note 31).

65. Guiffrey and Marcel, *Inventaire*, no. 63389, inv. 26469; Brière, "Van der Meulen," p. 153, *Le Roi, en Mars, est sur un char*.

66. Guiffrey and Marcel, *Inventaire*, no. 6326, inv. 29622 (called *Louis XIV à la tête de son armée*); Brière, "Van der Meulen," p. 157 (described as "Louis XIV au siège d'une ville, sujet indeterminé"; the drawing is placed among the group called *Projet d'une suite mythologique de l'Histoire du Roi*, the result of a collaboration between Le Brun and Van der Meulen, the allegorical figures perhaps executed by François Verdier, "sous la dicté de Le Brun"); Stein, *Charles Le Brun*, pp. 168, 169, 297, cat. no. xxx, fig. 59 (called *Ludwig XIV. schont ein Stadt*, attributed to Van der Meulen and described as of uncertain utilization, not part of the *Histoire du Roy mit eingefügten Allegorien* (pp. 152–159); Starcky, *Dessins de Van der Meulen*, p. 29 (called *Histoire du roi avec figures allégoriques*; the *Histoire galante* and the *Histoire allégorique* of Brière are considered by this author to be arbitrary groups of untitled drawings). Dr. Lydia Beauvais has kindly sent me her description of this drawing, which she calls *Louis XIV à la tête de son armée retenu par la Paix*, a reference to the negotiations for peace begun at Doesburg in 1672. She attributes the foreground figures to Le Brun, the distant scene to Van der Meulen, and has identified two cartoon fragments (inv. 29847/47 recto and verso, H. 1200 cm, W. 530 cm) showing part of the king and of the woman with a wreath above (Victory). These have been pricked for transfer but cannot have been used for the cartoon at the Tournai manufactory as they do not correspond exactly to the same details in the tapestry.

67. Göbel, *Die romanischen Länder*, pp. 216, 217, fig. 215; Alfred Darcel, *Les Tapisseries décoratives du Garde-Meuble* (Paris, 1881) pl. 33; the tapestry is said to have been acquired "sous le dernier Empire."

68. Jacob Bean, *15th–18th Century French Drawings in The Metropolitan Museum of Art* (New York, 1986) cat. no. 188, p. 175.

69. Very similar portraits of Turenne are found in the tapestries of the *Meeting of the Kings* and others of the Gobelins *History of the King* series (Daniel Meyer, *L'Histoire du Roy* [Paris, 1980] pp. 26, 46, 82). A drawing in the reverse direction to the Versailles sketch was in the Mme V . . . sale, at the Hôtel Drouot, Paris, March 25, 1975, no. 68.

70. The tapestry has been called *Louis XIV with Banished Evils* or *Louis XIV Saves the City from Evil*. It does not include the usual offering at a surrender of the keys of the city (see Figure 33).

71. Guiffrey and Marcel, *Inventaire*, no. 5885, inv. 27685; Henry Jouin, *Charles Le Brun et les arts sous Louis XIV* (Paris, 1889) p. 304. "Quinze cartons de figures et animaux du pavillon de l'Aurore de Sceaux" were listed as in Le Brun's studio at the Gobelins in the inventory taken after his death (Jules Guiffrey, ed., "Inventaires des tableaux et desseins . . . ," *Nouvelles Archives de l'Art français*, 2nd ser., vol. 4 [1883] p. 140).

72. Guiffrey and Marcel, *Inventaire*, no. 6325, inv. 29624. The presence of a goddess in a chariot drawn by swans suggests that this drawing could be part of the so-called *Histoire galante* group.

73. Jennifer Montagu, *The Expression of the Passions: The Origin and Influence of Charles Le Brun's* Conference sur l'expression géneral et particulière (New Haven / London, 1994) p. 44, fig. 76.

74. Quoted in Guy Kuraszewski, "La cheminée au Salon de la Guerre au Château de Versailles," *Bulletin de la Société de l'Histoire de l'Art français* (1974) p. 63.

75. Guiffrey and Marcel, *Inventaire*, no. 6009, inv. 29786; François Souchal, "Les statues aux façades du Château de Versailles," *Gazette des Beaux-Arts*, 3rd ser., vol. 79 (Feb. 1972) p. 91, fig. 94. The lion of this drawing and of the tapestry also appears on the cartoon fragment inv. 29847/47 verso (see note 65).

76. As in a number of works by Le Brun, e.g., *Le Brun à Versailles*, exh. cat., Musée du Louvre (Paris, 1985–86) cat. nos. 6, 74.

77. Claude Constans, *Musée National de Versailles. Les Peintures* (Paris, 1995) cat. no. 2677. Other versions are in Arras, Dijon, Perpignan, Troyes, Lisbon, and Vaux-le-Vicomte. An example was sold at Sotheby's, London, July 4, 1990, no. 211. The Versailles painting is said to date from about 1769 and to be perhaps after a drawing by Le Brun (Ch. Maumené and Louis d'Harcourt, "Iconographie des rois de France. Seconde partie," *Archives de l'Art français* 16 [1931] pp. 64, 65, no. 67). The portrait of the king that Colbert gave to the city of Tournai in 1668 is attributed to Le Brun and Van der Meulen; it shows the king in civilian dress on horseback facing right, with troops in the distance but is not close to the tapestry or to the related drawing (Le Bailey de Telleghem, *Musée des Beaux-Arts, Tournai* [Brussels, 1979] pp. 56–57).

78. Both the ruff and the shoulder roll are worn by figures representing Spain in engraved almanachs of 1678 and 1680 (Maxime Préaud, *Les effets du Soleil. Almanachs du régime de Louis XIV*, exh. cat., Musée du Louvre [Paris, 1995] cat. nos. 17, 18); Stein, *Charles Le Brun*, p. 168, describes the group in the drawing as: "Gezeigt ist Ludwig XIV. zu Pferde, dem zwei Offiziere von rechts kommend zwei Abgeordnete in spanischen Tracht vorführen."

79. A rabbit is held by a woman representing Timidity in a Le Brun drawing used for a painting in the Grande Galerie (Montagu, *Expression of the Passions*, p. 45, fig. 76).

80. Cesare Ripa, *Iconologia*, Piero Buscaroli, ed. (Milan, 1992) (reprint of a second edition, 1603), p. 32. Avarita is described as having beside her "un lupo magrissimo" and as holding "una borsa legata e stretta."

81. Ibid., pp. 156, 157. Gelosia holds a cock because "quest animale e gelosissimo, vigilante, e accorto. . . . Il mazzo della spina dimostra i fastidi pugentissimi de geloso." A Dutch edition of the *Iconologia* of 1644 (reprint 1971) p. 177, identifies a person with these attributes as "Impietà, Godloosbeyt . . . hebbende Eesels ooren, en in haer rechten hand eenen Haen, in de flincker een tack van een stekelige dooren" (quotation kindly provided by Dr. Alice Zrebiec). Impietà in the Italian edition (p. 183) holds a hippopotamus and mistreats a pelican. Though Louis XIV was accused of impiety because he tolerated Protestantism (until the revocation of the Edict of Nantes), heresy was not a likely problem in Flanders. Tournai has been described as a "bastion de la Contre-Réforme" (Thomas and Nazet, *Tournai*, p. 27).

82. Ripa, *Iconologia*, pp. 312, 313; Necessità, "che non posse stare altrimenti." J. Baudoin, *Iconologie* (Paris, 1644) p. 125, quotes the proverb, "*Le clou est enfoncé*, dont il n'est plus temps de conseiller d'une affaire, qui se trouve déjà faite."

83. Personifications in Ripa (pp. 100, 200) with snakes in their hair include Invidia (Envy) and Discordia, but neither is described as holding snakes. Invidia can have a snake wound round her breasts and her hand on a hydra, but Discordia has no snakes except those in her hair.

84. The drawing is known from a photograph in the Witt Library of the Courtauld Institute, London; it has no indication of the location of the original. The photograph was given to the library by Anthony Blunt, with the attribution to Le Brun.

85. Guiffrey and Marcel, *Inventaire*, no. 6497, inv. 27327. It "goes back to an early idea for the Persian fleeing in the foreground of *The Battle of Arbela*" (Montagu, *Expression of the Passions*, pp. 149, 150, fig. 193), which was first woven as a tapestry in 1663. Another version was owned by Colnaghi in 1996 (*An Exhibition of Master Drawings*, Colnaghi [New York / London, 1996] no. 23).

86. Ripa, *Iconologia*, p. 434. Superbia holds a peacock in one hand and a looking glass in the other.

87. Ibid., pp. 45, 46, Bugia. The masks should be interspersed with tongues; the burning straw, quickly extinguished, illustrates how Falsehood "presto nasce, e presto muore."

88. Ibid., pp. 150, 151, Fraude.

89. Ibid., p. 83. Crudeltà "in cima del capo habbia un rosignolo, e con ambi le mani affoghi un fanciullo nella fasce." No explanation is given for the nightingale; the cruel fate of Philomena is perhaps the reason for the appearance of the bird.

90. Helge Seifert, *Zum Ruhme der Helden. Historien- und Genremalerie Beständen der Alten Pinakothek*, exh. cat., Alte Pinakothek (Munich, 1993) p. 310, fig. 27. A drawing by Van der Meulen in the Mobilier National shows the same central figures, but not the city in the background (Starcky, *Dessins de Van der Meulen*, no. 186, illus.). A drawing of a similar event attributed to the circle of Van der Meulen is in the Pierpont Morgan Library; the conqueror is not Louis XIV and the keys are presented by bald-headed men wearing coats with long dangling sleeves (Felice Stampfle, *Netherlandish Drawings of the Fifteenth and Sixteenth Centuries and Flemish Drawings of the Seventeenth and Eighteenth Centuries in the Pierpont Morgan Library* [New York, 1991] no. 290).

91. Brière, "Van der Meulen," p. 152.

92. Roger Armand Weigert, "La Manufacture de Beauvais à la fin du XVIIIe siècle. Deux documents inédits relatifs à l'installation de Behagle (1684)," *Pro Arte. Revue internationale d'art ancien et contemporain*, 8th year, no. 78 (Geneva, 1949) p. 220. Thirty carts were needed for the transportation (Coural, *Beauvais*, p. 28, n. 7).

93. A. Mabille de Poncheville, *Lille-en-Flandre des origines à nos jours* (Lille, 1951) p. 121.

94. The year 1680 is said to have marked the zenith of Louis XIV's reign (Bluche, *Louis XIV*, pp. 262, 263).

95. Fenaille, *État général*, II, pp. 66, 68. *The Elements* set in the Royal Palace, Turin, some pieces of which have Behagle's name, are reversed versions of the Gobelins series after Le Brun (Jestaz, "Beauvais Manufactory," p. 188), indicating that Behagle, when at Beauvais, could obtain Gobelins designs. Another instance is the set of the *Acts of the Apostles*, the cartoons of which were sent from the Gobelins to Beauvais about 1692 (Coural, *Beauvais*, p. 21).

96. Fenaille, *État général*, II, p. 163. The series includes a *Fontainebleau*, which may have provided the model for Behagle's single piece bought by the king in 1668.

97. Ibid., p. 184.

98. Ibid., p. 159. The battles and conquered towns of the Gobelins series date from the Devolution War or earlier. A *Siege of Tournai* is included.

99. Lydia Beauvais and André Le Prat, "Un carton de Le Brun reconstitué. La figure de l'*Afrique* pour l'Escalier des Ambassadeurs à Versailles," *Revue du Louvre* (1995) p. 67. The number of his assistants at the Gobelins has been estimated at over 60 (Jouin, *Charles Le Brun*, p. 160).

100. Jean Coural in *La Route du Nord. Van der Meulen. Dessins et soies peintes*, exh. cat., Galerie nationale de la Tapisserie (Beauvais, 1991) p. 4.

101. Quoted in Jouin, *Charles Le Brun*, p. 235.

102. Quoted in Albert Croquez, *L'Intendance de le Flandre Wallonne sous Louis XIV (1667–1707)* (Lille, 1912) p. 102.

103. For the reactions of the citizens of the conquered Flemish cities to Louis XIV's generally conciliatory policy, see Bluche, *Louis XIV*, pp. 330–332.

104. Bean, *15th–18th Century French Drawings*, no. 189.

105. Chantal Gastinel-Coural, "La Tenture du Passage du Rhin," in *La Route du Nord*. He also painted "deux grands tableaux à l'huile" for *Chancelleries* woven in Beauvais (Coural, *Beauvais*, p. 21), which suggests a connection with Behagle.

106. Quoted in ibid., p. 27, no. 9. For Verdier, see also note 65.

107. Guiffrey, "Scellés et inventaires," p. 144, no. 1.

108. *Nouvelles Archives de l'Art français*, 3rd ser., vol. 12 (1896) p. 422, citing the *Revue de l'Art Français ancien et moderne* VII, p. 155.

109. Fenaille, *État général*, II, pp. 168, 267, 268, 324.

110. Stein, *Charles Le Brun*, pp. 276–282. The author illustrates two related studies by Verdier (figs. 41, 43) that support this attribution.

111. The sixth and seventh sets were on the Gobelins looms from 1729 to 1741 (Fenaille, *État général*, II, pp. 123–125).

A Note on *Abraham Banishing Hagar* by Giambattista Tiepolo

ELFRIEDE R. KNAUER

Dedicated to Cornelia and Josef Delz

I N 1996 THE THREE-HUNDREDTH ANNIVERSARY of the birth of Giambattista Tiepolo was celebrated with a spate of exhibitions and conferences all over Europe and in the United States where the most note-worthy presentation took place at The Metropolitan Museum of Art in New York. These events engendered a large number of catalogues, studies, archival investigations, new attributions, and reviews. They also led to the identification of some previously unknown works by the painter and much fresh insight into his oeuvre and working methods.[1]

The purpose of this note is to reconsider suggestions made regarding the subject matter and the titles ascribed to an enigmatic but powerful early painting by the artist. This canvas, once in the Rasini collection in Milan, was first published by Antonio Morassi, who called it *Abraham Banishing Hagar* (Figure 1).[2] Keith Christiansen accepts the title but adds a question mark,[3] which indicates some doubt about the designation, and his uncertainty seems justified. He—right-ly—also rejects two more recent suggestions that seem even less convincing than Morassi's reference to Genesis 16:6–8. In 1987 Bernard Aikema proffered "The Sacrifice of Polyxena at the Tomb of Achilles" as a title,[4] while in 1993 Massimo Gemin and Filippo Pedrocco maintained that the scene depicts the banishment of Vashti, the wife of Ahasuerus, the Persian king who ordered her to appear before his guests. Vashti's refusal to do so led to her expulsion.[5] Un-happy with these hypotheses, Christiansen assumes that Tiepolo's use of a recondite source inhibits the understanding of the paintings subject. The latest contribution to the debate is George Knox's unconvincing alternative: Mordecai at the palace gate beseeching Esther to offer herself to Ahasuerus. "This scenario, though not described in so many words in Esther, 2, covers all the main points: the magnificent palace gate-way, the insistent gesture of Mordecai pointing indoors, and the emotional prostration of Esther."[6]

© The Metropolitan Museum of Art 1998
METROPOLITAN MUSEUM JOURNAL 33

Only a careful study of the given realia in this paint-ing will lead to a more plausible title. With the excep-tion of Michael Levey,[7] all those concerned seem to misread the data somewhat. He is the only art histori-an to describe correctly the building in the scene—how-ever, again without coming to persuasive conclusions. "At the base of a strange, huge drum-like structure (with its bas-relief, more classical-seeming than Bibli-cal) a heavily draped aged priest or sage gesticulates over the prostrate, imploring body of a woman, while two figures look on, one indifferently, the other as though anxious to intercede. Penitence, perhaps, is what the woman's pose suggests." He concludes: "The originali-ty of the treatment is striking, and that is only under-lined if the subject really *is* the Expulsion of Hagar."

Little remains to be added to this description. That the structure is circular—its curve receding into the shadows of the background on the left—is confirmed by its rounded foundation in the lower right of the painting, which serves as a platform for the draped male and the prostrate woman, who beseechingly touches his right foot. A marble string course defines the base of the terracotta-colored building at shoulder height and ends at the projecting straight, noncurvilinear frame of the doorway, of which only the left part is vis-ible. Its pedestal is decorated with a marble relief that depicts a youthful male facing right; a figure of uncer-tain sex behind him looking back toward a tree hung with drapery; and a wooden pail stands on the ground. The figures may be busying themselves with a sacrifice, although part of the altar is obscured by the two young women who crouch in front of the bas-relief. Over it a carved wave pattern embellishes the ledge on which double pilasters rest. These—together with an identi-cal set at the right of the door but outside the picture—must be thought of as supporting the gateway's pediment. Three plain steps lead up to the dark interior of the building. The billowing smoke that emerges from an ornate brazier at the front is sooty and does not seem to rise up straight and clean, as might be expected.

There is no visual reference to an oriental or bibli-

The notes for this article begin on page 209.

Figure 1, Giambattista Tiepolo (1696–1770). *Abraham Banishing Hagar.* Oil on canvas, 96 × 136 cm. Private collection (photo: courtesy MMA)

cal ambience; instead, everything points to a classical setting. If we follow the pictorial cues supplied by the painter, the subject reveals itself almost as a matter of course. The literary background of Tiepolo's contemporaries (ours is so sadly remiss) must have enabled them to recognize the scene without any difficulty, the visual allusions being unequivocally clear. The classical sources that were then available refer to the circular temple of Vesta in the Forum Romanum. The very ancient cult that centered on the family hearth and gods (Penates) had been officially elevated to a state worship by imperial times.[8] Ovid's *Fasti* 6.280–318 give a vivid description of the goddess Vesta, of her cult—because she was a virgin she required chaste servants—and of the shape of the building that Ovid calls a tholus (6.282).[9] Excavations had not yet started in the Campo Vaccino in Tiepolo's day,[10] and the sanctuary's actual shape, circular and ringed with columns, was not known. However, Tiepolo may have seen coins depicting it (Figure 2).[11] Venice could pride itself on one of the finest assemblages of Classical antiquities, ever since Cardinal Domenico Grimani, followed by Giovanni Grimani, patriarch of Aquileia, willed their

collections to the city in 1523 and 1586 respectively. Tiepolo must have been aware of these treasures and used them. The coins invariably show the tholus with a conical roof, its doorway framed by two columns on either side; this was a pictorial convention to evoke the peristyle familiar to the Roman viewer, but it was unknown to Tiepolo. He therefore omits it but provides the drumlike structure with a stately porch and flanking double pilasters. The brazier in the painting not only attests to the sacred character of the building but, as we shall see, is its actual focus. The old man who peremptorily points into the sanctuary, while sternly talking down to the young prostrate woman, wears sandals and the classical garb of a Roman priest officiating. In early Rome, it was the king (rex) who served as the main priest at religious functions. The name *Rex sacrorum* and the position survived throughout the Republic.[12] With their heads covered ritually, priests presided over the sacrificial rites.[13] This framework allows me to suggest passages from Ovid's *Fasti* and from Plutarch's *Lives* as the major sources of Tiepolo's painting. Let me quote the "historian" first, in his *Life of Romulus*:

Figure 2. Roman coins with the temple of Vesta. No. 1, Neronian; no. 2, Vespasianic; no. 3, Tiberian
(photo: from *LIMC*, V, 2, s.v. Hestia Vesta)

The kings of Alba reigned in lineal descent from Aeneas, and the succession devolved at length upon two brothers, Numitor and Amulius. Amulius proposed to divide things into two equal shares, and set as equivalent to the kingdom the treasure and gold that were brought from Troy. Numitor chose the kingdom; but Amulius, having the money, and being able to do more with that than Numitor, took his kingdom from him with great ease, and, fearing lest his daughter might have children, made her a Vestal, bound in that condition forever to live a single and maiden life. This lady some call Ilia, others Rhea, and others Silvia; however, not long after, she was, contrary to the established laws of the Vestals, discovered to be with child, and should have suffered the most cruel punishment [to be buried alive], had not Antho, the king's daughter, mediated with her father for her; nevertheless, she was confined, and debarred all company, that she might not be delivered without the king's knowledge. In time she brought forth two boys, of more than human size and beauty, whom Amulius, becoming yet more alarmed, commanded a servant to take and cast away.

We may stop here, since the future of these boys—who were nursed by a she-wolf, who restored the kingdom to Numitor and founded the city of Rome—is well known. In Rome the wolf was a creature sacred to Mars and this "gave credit to what the mother of the children said, that their father was the god Mars; though some say that it was a mistake put upon her by Amulius, who himself had come to her dressed up in armour"(!)[14] The poet's version is more circumstantial. The story of Rhea Silvia is the major subject of *Fasti*, book 3.

Tiepolo has compressed the events into a single scene full of passion and drama: Amulius, the king, priest, and uncle of Ilia or Rhea Silvia, who had forced her to become a vestal virgin, has just learned of her pregnancy and threatens to put her to the gruesome death reserved for delinquent virginal priestesses. The goddess Vesta is offended by what has transpired. The smudgy smoke from the brazier signals a dying fire.

"Silvia fit mater . . . / ara deae certe tremuit pariente ministra/et subiit cineres territa flamma suos."[15] Antho, the king's daughter (who is mentioned only in Plutarch's tale), intercedes on behalf of her cousin—the indirect light on her face enlarges her eyes dramatically—while her maid looks on impassively. The sanctuary is not located in the busy Forum but in a dark glen. Tiepolo, aware of Ovid's description,[16] may also have seen reliefs of Rhea Silvia and Mars on Roman sarcophagi or on mosaics (Figure 3), which place the scene on the wooded banks of the Tiber.[17] The background in his painting may indicate this specific site, and the women wear classicizing robes. However,

Figure 3. *Mars and Rhea Silvia on the Banks of the Tiber*. Roman mosaic from Ostia, second century A.D. (photo: from *LIMC*, VII, 2, s.v. Rea Silva, no. 6)

Figure 4. Ciro Ferri (1634?–1689). *The Vestals,* 1666. Oil on canvas, 148 × 194 cm. Rome, Palazzo Spada (photo: from Lo Bianco, *Pietro da Cortona,* no. 87)

Tiepolo was not familiar with the very distinct head-dress of the vestal virgins; it consisted of multiple woolen bands worn under a veil (as attested by excavated statues and reliefs).[18]

So much for the painting's iconography, which apparently has no counterpart. Not surprisingly, however, another artist—and surely not the only one—had already met the challenge of Ovid's compelling tale, but his rendition remained unacknowledged due to our unfamiliarity with the classics. Ciro Ferri (1634?–1689), the devoted collaborator of Pietro da Cortona (1596–1669), who completed many unfinished projects after the master's death, painted a large canvas while busy on a commission of Pietro's in Bergamo in 1666 (Figure 4). The provenance of the picture, entitled *The Vestals,* is well documented.[19] The works of Ferri lack the grandiose and balanced sweep of Pietro's creations, but he successfully emulated his master's astounding versatility. In this picture, Ferri leads us into the tholus, crowded with animated groups of adults and children, as Vesta was the protector of the family and the hearth. In an island of stillness in the center, there is an elaborate golden altar (together with a thronelike chair and a tall ewer, which exhibit Ferri's talents as sculptor and goldsmith) with a vestal virgin standing behind it. The focus, however, is on the seated young priestess, undoubtedly Rhea Silvia, who drapes the end of her large veil over her abdomen and looks, half thoughtful, half surprised, at the strange shapes of the flames, while sooty smoke wells up from a reluctant fire. The vestal virgin who tries to rekindle it has to protect her face from the acrid smoke. This is

Figure 5. Giandomenico Tiepolo (1727–1804). Red-and-white chalk drawing of a seated man, *capite velato.* Stuttgart, Graphische Sammlung der Staatsgalerie Stuttgart, inv. no. 1456 (photo: from *Tiepolo* [Stuttgart, 1970] no. 148)

not the solemn standard sacrifice for Vesta, but rather the sign of the goddess's horror and indignation at the discovery of Rhea Silvia's pregnancy. Because of the unrecognized iconography of the scene, the catalogue entry censures the painter for perceived shortcomings. Ironically, the words used by its author to denigrate the work's general atmosphere actually confirm the intentions of the painter. What is seen as an error by the modern critic turns out to be the artist's triumph.[20]

In Tiepolo's picture scholars have searched for parallel poses, and a number have been pinpointed as being typical of the painter's youthful work, specifically prostrate figures.[21] As a matter of course, Giambattista's son Domenico shared motifs with his father. The garb of Domenico's seated man, *capite velato* and wearing sandals (Figure 5), much resembles Amulius's garb in our painting.[22]

In conclusion, one would like to ask whether the rare subject might have been a special commission. It has been suggested, though tentatively, that the picture belonged to a set—recorded by Da Canal in 1732—painted by young Giambattista for the home of Doge Giovanni Corner (r. 1709–22).[23] Corner's tenure covered a phase of unprecedented gloom in the history of the once proud Republic.[24] Though deeply religious, the scion of one of the oldest and most respected patrician families in Venice may have felt the need to enhance the standing and morale of his house by trying to connect it to figures out of Roman history. Decorating palaces in such a manner was not unusual in seventeenth- and eighteenth-century Venice.[25] It was a tradition of long standing among the Venetian nobility to appropriate Trojan and Roman ancestors, and our painting may have functioned as such.[26]

NOTES

1. For a summary of these activities, see George Knox, "1996: The Tiepolo Year," *Kunstchronik* 50, 1 (1997) pp. 1–7. The latest comprehensive catalogue of the painter's work is by Massimo Gemin and Filippo Pedrocco, *Giambattista Tiepolo: I dipinti. Opera completa* (Venice, 1993); for a review, see S. Loire, *Kunstchronik* 50, 1 (1997) pp. 23–32. Gemin and Pedrocco's work and the catalogue edited and partly written by Keith Christiansen, *Giambattista Tiepolo: 1696–1770*, exh. cat., MMA (New York, 1996), serve as a basis for this study.

2. Antonio Morassi, "An Unknown Early Work by Giambattista Tiepolo," *Burlington Magazine* 70 (Feb. 1937) p. 53.

3. Cat. no. 8 in Christiansen, *Tiepolo*.

4. Bernard Aikema, "Quattro note su G. B. Tiepolo giovane," *Mitteilungen des Kunsthistorischen Instituts in Florenz* 31 (1987) pp. 441–454, esp. p. 452. Aikema believes that Ovid's *Metamorphoses* XIII, ll. 447–480, is the source.

5. See Christiansen, *Tiepolo*, cat. no. 27 and chap. 1, n. 101.

6. *Apollo* (Nov. 1996) p. 53.

7. Michael Levey, *Giambattista Tiepolo: His Life and His Art* (New Haven/London, 1986) pp. 12–14.

8. K. Latte, *Römische Religionsgeschichte*, Handbuch der Altertumswissenschaft 5, 1 (Munich, 1960) chaps. 6: "Religion der Gemeinde," and 8: "Die Pontifikalreligion." *Enciclopedia dell'arte antica classica e orientale* (Rome, 1966) VII, pp. 1148ff., s.v. Vesta (G. Carettoni). For Vesta, see also E. Simon, *Die Götter der Römer* (Munich, 1990); for the capital punishment inflicted upon guilty vestal virgins, see F. Hampl, "Zum Ritus des Lebendigbegrabens von Vestalinnen," *Festschrift für R. Muth* (Innsbruck, 1983) pp. 165–182; M. Beard, "Re-reading (Vestal) virginity," in *Women in Antiquity: New Assessments* (London/New York, 1995) pp. 166–175, and the report on Session 313: "Proximity to Powers: The Vestal Virginis in Imperial Rome" at the 99th Annual Meeting of America, *American Journal of Archaeology* 102, 2, (April 1998) pp. 389–391. See also S. Ribichini, "La vergine del focolare," *ARCHEO* XIII, 12 (Dec. 1997) pp. 116–118.

9. See Ovid's *Fasti*, Sir J. G. Frazer, trans. (London/New York, 1931) pp. 338–343. Architects and artists must have been familiar with the meaning of the word *tholus* (Greek Θόλος) since the late 15th century when the first printed editions of Vitruvius's *De architectura* appeared; see his discussion of the word, 4.8.3.

10. See R. Lanciani, *The Ruins and Excavations of Ancient Rome* (Boston/New York, 1897) pp. 221–224; idem, *Rovine e scavi di Roma anticha*, E. Rodríguez-Almeida, trans. (Rome, 1985) pp. 203–205; E. Nash, *Pictorial Dictionary of Ancient Rome* (New York, 1962) II, pp. 505–509, s.v. Aedes Vestae. Excavations were conducted in 1883 and 1889–1900; the tholus was partially restored in 1930.

11. See *Lexicon Iconographicum Mythologiae Classicae* (hereafter *LIMC*) V, 1 and 2 (Zurich/Munich, 1990) p. 417, s.v. Hestia/Vesta, nos. 43ff.; 46 (T. Fischer-Hansen). See also Nash, *Pictorial Dictionary*, pp. 511–513, s.v. Vesta in Domo Palatina.

12. However, his role was largely ceremonial and he ranked below the all-powerful pontifex maximus. Augustus assumed the office of pontifex maximus in perpetuity, as did all his successors. See *Der Kleine Pauly: Lexikon der Antike* 4 (Munich, 1972) pp. 1046–1048, s.v. Pontifex (K. Ziegler), also Latte, *Römische Religionsgeschichte*, Appendix I. "Die römischen Priesterschaften," p. 394. Latte surmises that the king originally kept a vestal virgin in his house to watch over the sacred hearth.

13. For depictions of priests officiating, see Latte, *Römische Religionsgeschichte*, figs. 23, 27ff. The grandest example of the pontifex maximus officiating is the over-lifesize statue of Augustus from the Via Labicana in the Museo delle Terme; see W. Helbig, *Führer durch die öffentlichen Sammlungen klassischer Altertümer in Rom, Die Staatlichen Sammlungen, Museo Nazionale Romano (Thermenmuseum), Museo Nazionale di Villa Giulia*, 4th ed., H. Speier, ed. (Tübingen, 1969) no. 2300, pp. 216–218 (H. v. Heintze). For the formula *capite velato* frequently used to describe priestly persons at sacrifice whose toga or veil covered the back of their heads, see *Thesaurus Linguae Latinae* III (Leipzig, 1907) pp. 387[74]–388[21], s.v. caput. In Cicero's *De natura deorum* 2.3.10, it designates the head as being completely covered, including the face, when men performed the rare act of *devotio*, or self-immolation. The references to this habit in Roman literature were not lost upon Renaissance and Baroque artists; the *capita velata* of the Roman priests and of Publius Decius Mus in Rubens's 1616 series depicting the fateful divination, the consul's

devotio, victory, and death in the battle against the Latins (Livy, 8.6–10) constitutes its most splendid manifestation. For the paintings, intended as cartoons for tapestries, in the collection of the prince of Liechtenstein in Vaduz, see R. Baumstark, *Tod und Sieg des römischen Konsuls Decius Mus* (Vaduz, 1988).

14. Plutarch, *The Lives of the Noble Grecians and Romans*, trans. by John Dryden and rev. by A. H. Clough (New York, no date) pp. 24ff. For a recent study of the background of the myth of the founding twins, see T. P. Wiseman, *Remus: A Roman Myth* (Cambridge, 1995).

15. Ovid, *Fasti* 3.45, 47ff: "Silvia became a mother . . . certainly the altar of the goddess trembled, when her priestess was brought to bed, and the terrified flame sank under its own ashes." Should we see in the curious gap that has opened between the thick marble relief and the actual body of the tholus the result of the earthquake described by Ovid?

16. *Fasti* 3.11–24.

17. See *LIMC,* VII, 1 and 2 (Zurich/Munich, 1994) pp. 615–620, s.v. Rea Silvia (M. Hauer-Prost), nos. 6 (fig. 3), 7–9; 11, 20–25a. The scene is also depicted on gems and on reliefs. Figure 3 is a Hadrianic mosaic from Ostia. For a late Republican depiction, see the paintings from the sepulchrum Statiliorum et Aliorum on the Esquiline with legends of Troy and Romulus in the Museo delle Terme, Rome; see Helbig, *Altertümer in Rom*, no. 2489, pp. 461–464 (B. Andreae); for illustrations, see Nash, *Pictorial Dictionary*, pp. 360–365. For sarcophagi, see C. Robert, *Die antiken Sarkophagreliefs* III, 2 (Berlin, 1904) nos. 188, 188a (Palazzo Mattei and Vatican), pp. 190–192, and H. Sichtermann, *Die antiken Sarkophagreliefs* 12, 2. *Die mythologischen Sarkophage* (Berlin, 1992) pl. 6,1, cat. no. 10.

18. The headdress consists of the *suffibulum,* or veil, and the *infulae,* a sextuple string of wool worn as a headband; see *Enciclopedia dell'arte,* p. 1148. For a sculpture of a vestal, see Latte, *Römische Religiongeschichte,* fig. 32. Busts of Vesta herself, with veiled head, appear on Roman coins, see e.g., *LIMC,* nos. 48, 50ff. See also Nash, *Pictorial Dictionary,* s.v. Vesta in Domo Palatina.

19. See A. Lo Bianco, ed., *Pietro da Cortona, 1597–1669,* exh. cat. (Milan, 1997) pp. 229–234, for Ferri's career and cat. no. 87; 148 × 194 cm, Rome, Galleria Spada. The picture was painted for the Grand Duchess Vittoria della Rovere, wife of Ferdinando II de' Medici, and passed into the Spada collection in 1698. See also *The Dictionary of Art* 11 (1996) s.v. Ferri, Ciro, nos. 22–25 (S. Prosperi Valenti Rodinò), where the painting's title is given as *Vestal Virgins Tending the Sacred Flame.* The stature of Ciro Ferri may enjoy some reevaluation after the Rome exhibition; see S. Pepper, *The Art Newpaper* 77 (Jan. 1998) p. 14.

20. ". . . ma la grazia delle figure femminili, il guizzo vivace dei fanciulli, le torsioni violente che turbano l'equilibrio compositivo della scena *non ricevono adeguata valorizzazione dalla tavolozza cromatica* adottata dal Ferri in questo dipinto, *appesantice la grazia dei personaggi, blocca in un atmosfera affocata il dinamismo della composizione*" (my italics); see Lo Bianco, *Pietro da Cortona*, no. 87, p. 420.

21. See Morassi, "An Unknown Early Work," p. 53. In addition, Morassi thought he could decipher a signature and an indistinct date (1717 or 1719) on the piece of wood next to the brazier. No trace of it is visible today, and Christiansen, *Tiepolo,* pp. 74ff., convincingly places the painting in the early 1720s. See also W. L. Barcham, *The Religious Paintings of Giambattista Tiepolo: Piety and Tradition in Eighteenth Century Venice* (Oxford, 1989) pp. 39, 42ff., for

further parallels in Tiepolo's work, and also for references to 16th-century artists providing models for poses, e.g., Tintoretto and Titian. Such adaptations were customary and commendable. Recumbent figures, male or female, facing us or seen from behind, mostly placed in the foreground, however, are to be found not only in the youthful work but throughout the career of both Giambattista and Giandomenico Tiepolo. (They are preceded in this by their slightly senior contemporary Giovanni Battista Piazzetta [1683–1754].) A Mannerist conceit is transformed by them to define space in a fresh and vigorous way. Rhea Silvia's despairing prostration is strangely reminiscent of an anonymous drawing in the Albertina, traditionally ascribed to Perino del Vaga; see V. Birke and J. Kertész, *Die Italienischen Zeichnungen der Albertina. Generalverzeichnis Bd. I* (Vienna/Cologne/Weimar, 1992) p. 262, inv. no. 463. It shows a woman in a very similar posture; at her right, on the ground, is a crying, naked baby boy. Is she Hagar?

22. See *Tiepolo: Zeichnungen von Giambattista, Domenico und Lorenzo Tiepolo aus der Graphischen Sammlung der Staatsgalerie Stuttgart,* Sept. 20–Nov. 30, 1970, Stuttgarter Galerieverein e.V. Graphische Sammlung Staatsgalerie Stuttgart, cat. no. 148, pp. 128ff., where another version is referred to.

23. Aikema (above, n. 4) p. 452, cites Vincenzo da Canal's life of Tiepolo's teacher, *Vita di Gregorio Lazzarini* (Venice, 1732), in the 1809 Venice edition of G. A. Moschini, XXXII, where we are told that Giambattista "fu pittore del Doge Cornaro a S. Polo, nella cui ricca abitazione presidieva alla distribuzione delle cose pittoriche, oltre all'avervi fatto più sovra-porte con ritratti e quadri di buon gusto." The relatively small dimensions of our picture (96 × 136 cm), and its implicit invitation to be viewed "di sotto in sù," suggest to Aikema that it might have been intended for one of the doors—of similar width—in the *piano nobile* of Palazzo Corner. Two related portraits were identified sometime ago: E. Martini, "I ritratti di Ca' Cornaro di G. B. Tiepolo giovane," *Notizie da Palazzo Albani III,* I (1972) p. 34[5] (not accessible to me), Aikema, "Quattro note," p. 454.[21] They were exhibited in Venice and New York, see Christiansen, *Tiepolo,* cat. nos. 3a, b: For Doge Giovanni II Corner (1647–1722), Tiepolo's patron who commissioned the paintings, and Doge Marco Corner (ca. 1286–1368), during whose tenure (1365–68) Guariento of Bologna painted the *Incoronazione di Maria* in the Sala del Maggior Consiglio in the palace of the Doges, destroyed by fire in 1577, see the respective entries by E. Martini and F. Pedrocco.

24. See *Dizionario Biografico degli Italiani* (Rome, 1983) XXIX, pp. 234–236, s.v. Corner, Giovanni. Born in 1647, Giovanni was elected doge in 1709 and died in 1722. The peace of Passarowitz concluded the Venetian-Turkish war of 1714–18. Venice lost the Morea and the Aegean islands, while Austria, the ally and real victor, won territories along the Danube and on the Adriatic coast.

25. See B. Aikema, "La decorazione di Palazzo Barbaro-Curtis a Venezia fino alla metà del settecento," *Arte Veneta* 41 (1987) pp. 147–153. Scenes from the lives of virtuous men and women from ancient history were apparently combined with portraits of family members. Giambattista's contribution to the main salone, *The Apotheosis of the Barbaro Family* (1750), is in the MMA. See Christiansen, *Tiepolo,* cat. no. 21a; for the rest of Tiepolo's set, see cat. nos. 21b–d. Ciro Ferri's *Vestals* attests to the subject as entirely acceptable.

26. See H. Buchthal, *Historia Troiana: Studies in the History of Mediaeval Secular Illustration* (London, 1971) esp. pp. 59–67.

Tiepolo, Henry James, and Edith Wharton

ROSELLA MAMOLI ZORZI

Ca' Foscari University of Venice

THIS ESSAY EXAMINES the different reactions of Henry James and Edith Wharton to Giambattista Tiepolo (1696–1770), the only American novelists to write at any length on the painter in the late nineteenth and early twentieth centuries. Their work reflects the changing and complex story of Tiepolo's fortune in the English-speaking world.

The story of the Venetian painter's reputation in the nineteenth century is actually quite complicated. Although connoisseurs and wealthy collectors never stopped buying Tiepolos,[1] the taste for Neoclassical works had begun to affect the painter's reputation while he was at the Spanish court in Madrid, where Raphael Mengs (1728–1779) had begun to eclipse him.[2] Leading Neoclassical figures such as Antonio Canova and Dominique Vivant Denon, however, owned some Tiepolos,[3] and famous eighteenth-century travelers such as Cochin or Goethe seemed to admire the artist, at least partly.[4] In the English-speaking world, Ruskin's mid-nineteenth-century anathema of what he called the "Grotesque Renaissance," which included the eighteenth century, literally led him to forbid *looking* at Tiepolo. In general, when James was writing in the 1870s, the previous century was still considered a century of decadence,[5] although French painters and critics did praise Tiepolo.[6] These artists and writers included Delacroix,[7] whom James greatly admired.

In 1872 Henry James (1843–1916) went to the opening of an exhibition of paintings, "in a new and handsome gallery, masked by one of the residential brown-stone fronts of Fifth Avenue."[8] This was the new Metropolitan Museum of Art, then in the Dodsworth Building, formerly Mr. Allen Dodsworth's Dancing Academy, at 681 Fifth Avenue, between Fifty-third and Fifty-fourth Streets. James, at the time a young man of twenty-eight, was to become famous for his novels—from *The Portrait of a Lady* (1881) to *The Wings of the Dove* (1902)—stories, critical essays, and prefaces to the New York edition (1907–9) of his works, but not for his plays. At this point, young James was also review-

ing exhibitions, and his articles were published in such journals as the *Atlantic Monthly*, the *North American Review, The Nation*, and later *The Galaxy*, the *New York Tribune*, and others.

The "1871 Purchase" exhibited 174 paintings, bought by William T. Blodgett,[9] a member of the executive committee of the new Museum, an abolitionist and the founder of the *Nation*. He had resigned from business because of ill health and had gone to Europe, where he bought three private collections for a particularly good price ($116,180.27) because of the aftermath of the Franco-Prussian War. He offered the works of art to the Museum. After some discussion—because Mr. Blodgett[10] had not consulted the trustees about his purchase—the collections were bought and exhibited to the public.

In writing about the opening, Henry James declared that if the exhibition had "no gem of the first magnitude," it had only a "few specimens" that were "decidedly valueless." He practically ignored the "half-dozen indifferent examples of archaic masters," which he never liked in any case. (Late in life James remembered going to see those "angular saints and seraphs . . . black Madonnas and obscure Bambinos"[11] as a young boy, in the evening, with his parents, at the Bryan Gallery of Christian Art, entrance 25 cents.)

James then described a Rubens with faint enthusiasm and was more inspired by a Jacob Jordaens, a Gaspard de Crayer (whose color he compared with that of Veronese), a few portraits by van Dyck, the "masterpiece of inelegant vigour," *Malle Babbe of Haarlem*[12] by Frans Hals, and several other Flemish paintings.

In the exhibition there were three small Tiepolos, of which he wrote:

An Italian master, whatever his individual worth, possesses this grace as a matter of course. . . . With how little genuine strength it may occasionally be allied, may be seen in the three small specimens of that tardy fruit of the Venetian efflorescence, G. B. Tiepolo. *Sincerity, and even sense,* with this florid master of breezy drapery and fastidious *pose, is on its last legs;* but he retains the instinct of bril-

© The Metropolitan Museum of Art 1998
METROPOLITAN MUSEUM JOURNAL 33

The notes for this article begin on page 226.

Figure 1. Giambattista Tiepolo (1696–1770). *The Investiture of Bishop Harold as Duke of Franconia.* Oil sketch, 71.8 x 51.4 cm. The Metropolitan Museum of Art, Purchase, 1871, 71.121

liant and elegant arrangement. He offers a desperately faint but not unmusical echo from the azure-hearted ceilings of Paul Veronese. Elegance for elegance, however, we prefer that of the small Sassoferrato, the usual Sanctissima Virgo . . . [my italics].[13]

The three Tiepolos James saw were the *Investiture of Bishop Harold as Duke of Franconia* (Figure 1),[14] the Metropolitan Museum's oil sketch for one of the great frescoes in Würzburg at the time known as the *Triumph of Ferdinand III*; the *Sacrifice of Abraham*, an oil sketch now attributed to Giandomenico,[15] not to Giambattista; and the *Crowning of Thorns*, later attributed to Jacopo Guarana.[16] The "small Sassoferrato" was a nineteenth-century copy.

James partly admired the elegance of the "three small specimens," but the true meaning of this passage is clear: he stressed Tiepolo's lack of "sincerity" ("Sincerity, and even sense . . . is on its last legs"). Even the metaphors alluding to flowering ("tardy fruit," "efflorescence," "florid") are not purely positive, as "efflorescence" refers not only to the actual flowering but also to its culmination, just before spoiling. If there is an echo of Veronese in Tiepolo, this is certainly "not unmusical" but it is also "desperately faint": what lies behind this comment regarding lack of truth or sincerity in art is clearly Ruskin's judgment, then still strongly influential, which linked the finest art to the religion of the society in which the artist was active.

For many years Ruskin's well-known *Stones of Venice* (1851–53) was regarded as the bible by all English-speaking travelers who went to Venice and contemplated its paintings. It was the leading guidebook for James when he had first visited Venice in 1869. We know from his letters to his brother William[17] that Ruskin's *Venetian Index,* which James followed almost verbatim, led him to discover Tintoretto and to admire Veronese and Titian, but it contained no comment on Tiepolo. James's views on Ruskin's greatness as an art critic are quite explicit over these early years, between 1869 and 1872.[18]

Ruskin's veto on the eighteenth century—as well as the seventeenth—was to prove influential. The only comment that Ruskin made about Tiepolo can be found in a late work, *Saint Mark's Rest* (1884), where he mentions the two paintings in Sant'Alvise.[19] James's lack of appreciation of Tiepolo in 1872 is not at all surprising, for Ruskin's diktat affected him and most other contemporary English and American writers and critics.

In the English-speaking world, moreover, Sir Joshua Reynolds's general strictures on Venetian art were not forgotten. The painter and critic actually loved Venetian painting, but he felt obliged to criticize it in his public lectures. Referring mainly to Veronese, Reynolds wrote that Venetian art was "a tale told by an ideot [*sic*], full of sound and fury, signifying nothing."[20] Actually, Reynolds was criticizing the Venetian mannerism of the Cinquecento, not Tiepolo; but there was an undercurrent of suspicion that an art that "gave pleasure to the eye or the senses" was too sensual and morally lax for the English.

Therefore, because of Reynolds's influence and that of Ruskin later, and due to the general lack of appreciation for eighteenth-century works, Tiepolo was not well regarded in the nineteenth century. A change in taste would eventually take place also in the English-speaking world, but certainly more slowly than in French culture, as James's and Wharton's different reactions testify.

One blatant, pre-Ruskin example of "blindness" to Tiepolo is Washington Irving, who spent several months in Madrid and described at length his 1842 visit to the queen of Spain. Irving lingered and waited for the queen in the royal palace, and though he mentioned waiting in the royal halls, he did not seem to notice the great Tiepolo ceilings in the palace: the *Apotheosis of the Spanish Monarchy* (Figure 2) in the

Figure 2. Giambattista Tiepolo. *The Apotheosis of the Spanish Monarchy*. Fresco. Madrid, Palacio Real (photo: Palacio Real)

saleta, the *Glory of Spain* in the throne room, the *Apotheosis of Aeneas* in the guardroom.[21]

Another traveler, Samuel F. B. Morse, the American painter, now better known as the inventor of the telegraph, went to Venice in 1831. He spent several weeks there, but did not make a single reference to Tiepolo.[22] James De Veaux, another American painter, stayed more than three months in Venice in 1843, copying works by Veronese. He did visit the church of the Scalzi—where at the time Tiepolo's immense fresco ceiling of the *Transport of the Holy House of Loreto* (see Figure 3) could be seen—but he commented only on the "surfeit of marbles" in the interior[23] and did not even mention the ceiling.

After Ruskin's condemnation of anything that belonged to the "Grotesque Renaissance,"[24] Tiepolo was deliberately overlooked as a product of the forbidden eighteenth century, and thus nineteenth-century American travelers to Venice would ignore the gorgeous ceilings of the Scalzi, the Gesuati, the Ca' Rezzonico, or the Antony and Cleopatra cycle in the Palazzo Labia.

English-language guidebooks were of no help when it came to Tiepolo's frescoes: Murray's *Handbook* for 1860 did mention those in the Villa Valmarana ai Nani, in Vicenza, but made no reference to the ones in Palazzo Labia (the building was described as "much dilapidated"), while it listed carefully the paintings in the Manfrin collection.[25]

When Henry James wrote his review of the 1872 exhibition, New Yorkers had already had several opportunities to see Tiepolo, or at least what were described as Tiepolo paintings and etchings. As early as 1830 Richard Abraham, an Englishman whose London address was in Bond Street, had exhibited a "finished sketch" by Tiepolo, at the American Academy of Fine Arts. It was described as follows:

This beautiful cabinet specimen represents the presentation of banners, after a conquest, to one of the Roman emperors, who is seated on his throne under a triumphal arch, the grouping of figures on each side of which, is admirable; the foreshortening of the two musicians in the foreground is inimitable; the drawing is perfect, the casting of the draperies, the grandeur of the colouring, the distribution of the lights and shadows, and the bold, free, and spirited pencilling is not inferior to P. Veronese.[26]

Which painting this may have been (a "finished sketch")—no size is indicated—is open to conjecture, but the description allows us to identify the subject, the *Investiture of Bishop Harold* (see Figure 1).[27] Whether it was a copy or the oil sketch that the Metropolitan Museum later acquired with the 1871 Purchase does

not seem to be documented. The exhibition that included it ran from March 20 to November 20, 1830, and this success was apparently due also to a scandal: the somewhat shady Mr. Abraham was put in jail in New York because he had passed off copies as originals. After making "some compromise," he was allowed to exhibit the collection he had brought from London.[28]

In 1874 and 1876 several supposed Tiepolos were shown in the Metropolitan Museum: a *Virgin with Saint Joseph*, belonging to a Mrs. Cooledge [*sic*], and a *Saint Helen Conducting Constantine to Heaven*, belonging to a Mrs. W. Tilden.[29] It is difficult to identify these as paintings, drawings, etchings, or copies.[30] One can only surmise that the name "Tiepolo" was known by some Americans, because a few works were attributed to him. However, Tiepolo's oeuvre did not have much impact on the American imagination, providing no source material for novels or stories, as had the *Beatrice Cenci* by the "divine Guido." No Tiepolo really impressed Henry James; the writer did not base any story on a Tiepolo painting, although he later wrote about the artist.

In an 1892 story, "Collaboration," as noted by Adeline Tintner,[31] James used a Tiepolo ceiling to embellish the Paris studio of a painter (the narrator of the story). The studio is described as a center of cosmopolitan sophistication:

The air is international as only Parisian air can be; women, I surmise, think they look well in it; they come also because they fancy they are doing something bohemian. . . . the old heraldic cushions on the divans, embossed with rusty gold, are favourable to expansion and contraction—that of course of contracting parties— and the Italian brocade on the walls appeals to one's highest feelings. Music makes its home there—though I confess I am not quite the master of that house, and when it is going on in a truly receptive hush I enjoy the way my company leans back and gazes through the thin smoke of cigarettes up at the distant Tiepolo in the almost palatial ceiling. I make sure the piano, the tobacco and the tea are all of the best.[32]

As it is seen through a haze of smoke, the Tiepolo ceiling hardly receives its due. It is used by the writer merely to impart the atmosphere of a sophisticated and modish world. The story centers on the suspect "collaboration" of the painter and a musician to write something that lies outside the expected and genteel rules of society, but it is clear that it is their artistic achievement that really counts. However, the title has also a negative nuance, as the protagonists are a French painter and a German musician who cooperate ("collaborate") while their patriotic friends deplore their association because of the Franco-Prussian War of 1870.[33]

Figure 3. Giambattista Tiepolo. *The Miracle of the Holy House of Loreto.* Oil sketch, 124 x 85 cm. Venice, Gallerie dell'Accademia (photo: Gallerie dell'Accademia)

In a preface, published in 1908, James recalled being in Venice and writing *A London Life:*

I remember being not long before [1888] at work upon it, remember in fact beginning it, in one of the wonderful faded back rooms of an old Venetian palace, *a room with a pompous Tiepolo ceiling* [Figure 4], and walls of pale-green damask, slightly shredded and patched, which, on a warm morning, looked into the shade of a court where a high outer staircase, strikingly bold, yet strikingly relaxed, held together one scarcely knew how; where Gothic windows broke out, on discolored blanks of wall, at quite arbitrary levels, and where above all the strong Venetian voice, full of history and humanity and waking perpetual echoes, seemed to say more in ten warm words, of whatever tone, than twenty pages of one's cold prose [my italics].[34]

I have quoted this passage at length because I think it reveals vividly James's fascination with Venetian art, architecture, and history. The palace, the Palazzo Barbaro at S. Vidal on the Grand Canal, was the home of Daniel and Ariana Curtis, where the novelist was a

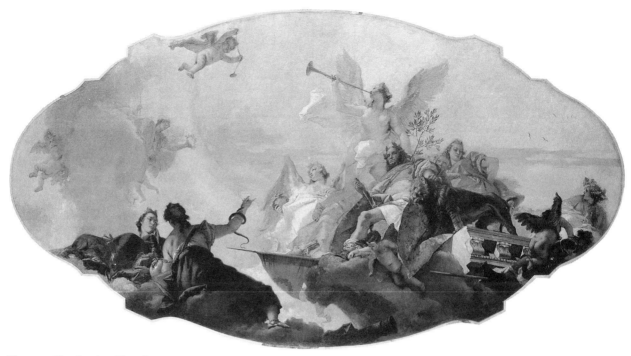

Figure 4. Giambattista Tiepolo. *The Glorification of the Barbaro Family.* Oil on canvas, 243.8 x 466.7 cm. The Metropolitan Museum of Art, Anonymous Gift, in memory of Oliver H. Payne, 1923, 23.128

frequent guest from 1887 onward. The palace still stands, with its strikingly bold yet strikingly relaxed open-air stone staircase, Gothic windows, and echoes of the history of the Barbaro family, which gave the palace its name and splendor, with its stuccowork and the eighteenth-century Piazzetta and Ricci in the salon portrayed by Sargent. It was the "germ" from which James derived his imaginary creation of Palazzo Leporelli, where Milly Theale, in *The Wings of the Dove,* decides to live and die.

What concerns us here is the power of Venice on James's imagination and the reference to the "pompous Tiepolo ceiling" that he remembered. However, this ceiling was no longer in situ when James visited, as it had been sold in 1866,[35] not by the Curtises, who bought the palace in December 1885, but by former owners. The sale of the Barbaro and its contents was a fate shared by many Venetian palaces in the course of the nineteenth century, after the fall of the Venetian Republic. For example, the large-scale Roman-history subjects that are at the Metropolitan Museum and at the Hermitage came from the ballroom of Palazzo Dolfin. They were also sold in 1870.[36]

James does not seem to have realized that the Tiepolo ceiling painting, known as the *Apotheosis of the Barbaro Family* (now called *Fame, Power, Nobility*),[37] was not the real thing, but simply a copy of the one that had been sold. What matters here, however, is the

definition of the painting. In James's vocabulary "pompous" was hardly a positive adjective, and it is a word to which we will soon return. James's attitude toward Tiepolo at the beginning of the century does not seem to have changed much from his writings of some thirty years earlier, even if his appreciation of the eighteenth century, and of such painters as Longhi, had undergone a revision.

What is somewhat surprising is not James's doubt of Tiepolo's "sincerity" in 1872 but his continued reservations about the ceiling—the pompous Tiepolo ceiling—as late as the early 1900s, when Ruskin's views were less important and when Tiepolo was admired after the celebrations of the 1896 bicentenary.[38]

Despite James's fascination with Venetian architecture and painting, Tiepolo never worked on the writer's imagination as had Titian's *Sacred and Profane Love* in "Traveling Companions,"[39] Veronese's *Queen of Shebah Before King Solomon* and Bronzino's *Lucrezia Panciatichi* in *The Wings of the Dove,* or the great cycles of his beloved Tintoretto throughout his oeuvre.

Tiepolo, with his breezy beauty, his bare-breasted queens and nymphs and goddesses, seems to have been overly joyous and sensuous for James's Puritan imagination. If James's stories and novels concerning art and artists represent an imposing contribution to a genre, Tiepolo is not an influential figure in his work.

As mentioned above, "Collaboration" came out in 1892, a time of a renewed interest in Tiepolo. It is tempting to link James's story to an important event that took place in Paris—just a little later, 1893[49]—but which is worth mentioning in regard to Tiepolo's standing. At that time, Nélie Jacquemart, a well-known portrait painter, who had married Édouard André, a wealthy banker, bought several Tiepolo frescoes and moved them to their new mansion on boulevard Haussmann. The Andrés were offered, and bought, the frescoes of Villa Contarini at La Mira.[41] Their subject, and its connection with French history, seemed ideal for these buyers: the fresco cycle represents King Henry III's arrival at the villa, on his way back from Poland in 1574. The king is shown on the steps of the villa, against a background of boats on the Brenta, as Procuratore Contarini (the owner of the mansion) welcomes the king. In the original arrangement of the frescoes, a balustrade had been painted all around the ceiling, from which the painted guests looked down to admire the royal visitor. Because of the French subject, Henri de Chennevières, writing in the *Gazette des Beaux-Arts* in 1896, praised the Andrés as benefactors of France. Of course, de Chennevières also fully realized the artistic importance of the purchase,[42] since he was one of the first critics to relaunch the cult of Tiepolo.

As noted earlier, the real turning of the tide by English-speaking writers came late, after fin de siècle theories of art for art's sake had spread, when critics reacted against Ruskin's theories, and there was a general reevaluation of the eighteenth century. In an 1893 essay John Addington Symonds (1840–1893), the author of *The History of the Renaissance in Italy* (1875–86), was the first English writer to analyze a Tiepolo in detail: the *Last Communion of Saint Lucy* (Figure 5), in the church of SS. Apostoli.[43] Among other things he raised the issue of the response by non-Catholic viewers when confronted with scenes of gory martyrdom, a point that Mrs. Anna Jameson, quite famous as an art critic in the nineteenth century, had also made.[44]

One American writer had proclaimed as early as 1878 "Tiepelo [*sic*] is my artist,"[45] but one cannot say that this declaration led to anything, such as essays or works of fiction based on Tiepolo. This writer, the pretended "innocent abroad," Mark Twain, was much less "innocent" and ignorant than he wanted to appear, as is quite clear from his journals, in which it is evident that he had read Ruskin.

Edith Wharton (1862–1937) is the first American writer to admire Tiepolo and allow all the beauty and joy of his world to enter her imagination. As regards Tiepolo, Wharton is ahead of James, freer in her appreciation, freer also than Symonds, whom she had read. Wharton's admiration for Tiepolo must also be placed within the reevaluation of Tiepolo mentioned above and within the more restricted but highly innovative circle of her friends. Wharton, a friend of Vernon Lee, as was James, had read her book on the eighteenth century and was also influenced by other works by German art historians such as that by Cornelius Gurlitt, who enthusiastically described not only the Villa Valmarana but the church of the Scalzi, the Rezzonico and Labia palaces,[46] and by the 1898 guidebook *Gsell-Fels* (in Dr. Meyer's Reisebücher—Ober Italien), in which the Scalzi ceiling is discussed in detail.[47] Ruskin's harsh condemnation does not seem

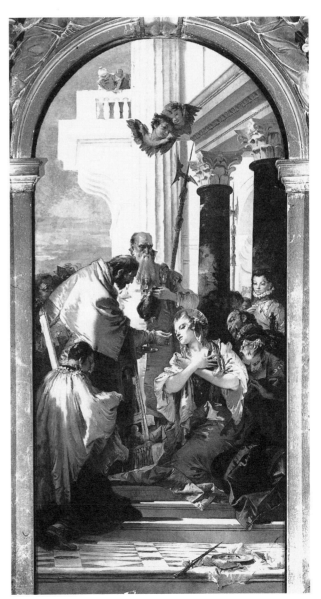

Figure 5. Giambattista Tiepolo. *The Last Communion of Saint Lucy.* Oil on canvas, 222 x 101 cm. Venice, SS. Apostoli (photo: Böhm)

to have penetrated the German world.

Wharton was also a close friend of Mary and Bernard Berenson's. The writer may have read the critic's 1896 essay,[48] and one might imagine his possible influence on her. However, this seems unlikely because when Wharton and the Berensons met in March 1903 in Florence, they initially loathed each other, and they became friends after 1909.[49] Only at a later date did she acknowledge learning from Berenson.

Berenson's admiration of Tiepolo was somewhat qualified, as he noted "the lack of that simplicity and candour which never failed Paolo [Veronese]."[50] He lamented that Tiepolo showed his audience such a "pompous and haughty" word.[51] The world "pompous" is the same word that James had used to describe the Palazzo Barbaro ceiling. Among the many purchases Berenson suggested to Isabella Stewart Gardner, he never mentioned a Tiepolo, although he did write to her about Mme André's *Arrival of Henry III*: "Her finest possession is a really beautiful staircase which she has built to set off the gorgeous Tiepolo frescoes that she got from the Villa Pisani."[52]

If Berenson modified his limited appreciation of Tiepolo in later years, Edith Wharton showed no reservations from the very beginning. In "Picturesque Milan" (first published in 1903) Wharton began her essay with an overt "defense" of the city as worth seeing, defying the "conspiracy of silence" caused by Ruskin and his followers. Wharton had read and loved Ruskin's *Stones of Venice* and *Mornings in Florence*, given to her by her father in 1881[53] but had reacted to the critic's views:

[Milan] is rich in all that makes the indigenous beauty of Italy, as opposed to the pseudo-Gothicisms, the trans-Alpine points and pinnacles, which Ruskin taught a submissive generation of art critics to regard as the typical expression of the Italian spirit. The guidebooks, long accustomed to draw their Liebig's extract of art from the pages of this school of critics, have kept the tradition alive by dwelling only on the monuments which conform to perpendicular ideas, and by apologetic allusions to the "monotony" and "regularity" of Milan—as though endeavouring to placate the traveller for its not looking like Florence or Siena![54]

In this essay on Milan, Wharton mentioned some of the critics who helped her shake off Ruskin's hatred for the "Grotesque Renaissance" and appreciate the seventeenth and eighteenth centuries. Among the critics she mentions are J. W. Anderson, Ebe, and Gurlitt again,[55] Franchetti (on Bernini), and "the recent volume on Tiepolo in the Knackfuss series of Künstler-Monographien."[56]

When Wharton went to see the wonderful Tiepolo fresco in the Palazzo Clerici, she described it as follows:

Yet Milan is not dependent on the seasons for this mid-summer magic of light and colour. For dark days it keeps its store of warmth and brightness hidden behind palace walls and in the cold dusk of church and cloister. Summer in all its throbbing heat has been imprisoned by Tiepolo in the great ceiling of the Palazzo Clerici: that revel of gods and demigods, and mortals of all lands and races, who advance with linked hands out of the rosy vapours of dawn.[57]

In this short description Wharton seems to capture all the magic of Tiepolo's art, and wholly to appreciate the gods, demigods, and mortals of all lands and races without any concern about Tiepolo's "falsity" or possible immorality.

In Milan, Rome, and Venice, Wharton looked at art with a fresh eye. She even theorized on the traveler's need to renew his perception of art, often over-described in guidebooks, to shed new light on hackneyed subjects. She explored this topic in the final essay of *Italian Backgrounds*, describing the planes of "devotional pictures of the early Renaissance" as follows: "The foreground is conventional. Its personages—saints, angels, and Holy Family—are the direct descendants of a long line of similar figures."[58] She adds that the background, with the landscapes of the Lombard plains, the Tuscan hills, or the "fantastic serrated . . . Friulian Alps" is the "real picture."

She finds that Italy is also divided into planes: "The foreground is the property of the guide-book and of its product, the mechanical sight-seer; the background, that of the dawdler, the dreamer, and the serious student of Italy."[59] Wharton clearly belonged to the group of dawdlers or "passionate pilgrims." To enjoy the foreground, where "paintings, statues and buildings" have "stiffened into symbols," "one must let in the open air of an observation detached from tradition."[60]

Tiepolo, in Venice, is seen as part of the city's background, like all the eighteenth century:

In Venice the foreground is Byzantine-Gothic, with an admixture of early Renaissance. It extends from the church of Torcello to the canvasses of Tintoretto. This foreground has been celebrated in literature with a vehemence and profusion which have projected it still farther into the public consciousness, and more completely obscured the fact that there is another Venice, the Venice of the eighteenth century.

Wharton clearly had in mind Ruskin's forceful prose celebrating Tintoretto and his campaign to preserve Tiepolo's paintings. When Ruskin started writing

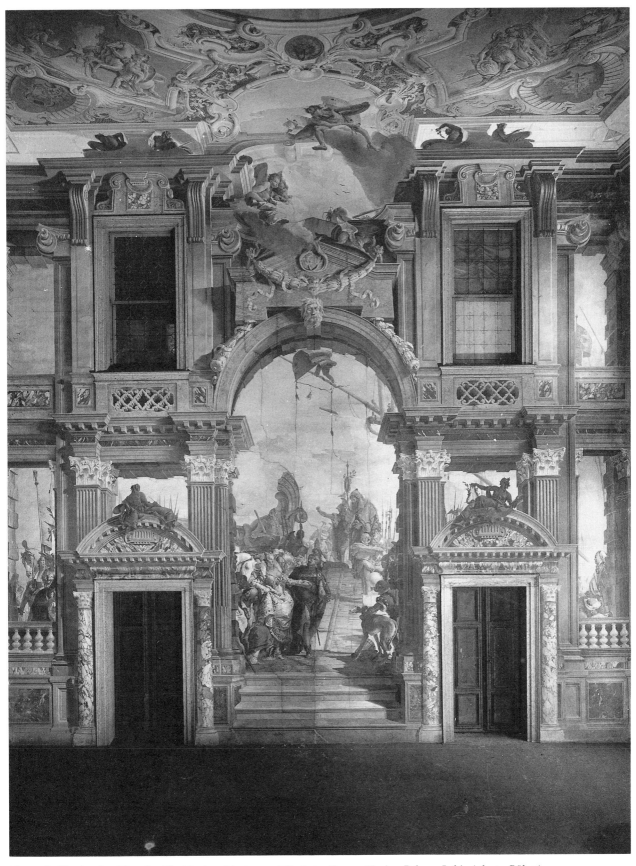

Figure 6. Giambattista Tiepolo. *The Meeting of Antony and Cleopatra*. Fresco. Venice, Palazzo Labia (photo: Böhm)

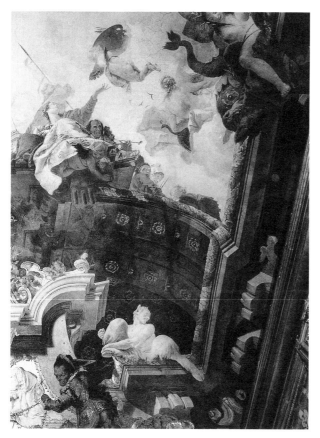

Figure 7. Giambattista Tiepolo. *The Course of the Sun*, detail showing Maenads and Satyrs. Fresco. Milan, Palazzo Clerici (photo: Palazzo Clerici)

about the great Tintorettos of the Scuola di San Rocco in 1846, they were sadly neglected and doomed to destruction because of the rain that seeped in through the roof and onto the canvases themselves.

Wharton was not only able to enjoy Tiepolo's frescoes, but she could also fully appreciate the spirit of eighteenth-century Venice:

It is instructive to note that the Venice of that day [the eighteenth century] had no galleries and no museums. Travellers did not go there to be edified, but to be amused; and one may fancy with what relief a young nobleman on the grand tour, sated with the marbles of Rome and the canvasses of Parma and Bologna, turned aside for a moment to a city where enjoyment was the only art and life the only object of study. But while travellers were flocking to Venice to see its carnival and gaming-rooms, its public festivals and private casini, a generation of artists were at work brushing in the gay background of the scene. . . . Longhena and his pupils were the architects of this bright mise en scène, Tiepolo was its great scene-painter. . . . [61]

It is as if Wharton expressed in her appreciation of eighteenth-century Venice[62] a joie de vivre that she

herself had rediscovered, finding her true identity as a writer, escaping from the stifling conventions of the New York society she was to portray so bitterly and accurately the following year in *The House of Mirth* (1904) and later in *The Age of Innocence* (1920). It is interesting that Lily Bart, in *The House of Mirth*, chooses not to dress up as Tiepolo's Cleopatra, in the much-discussed scene of the tableaux vivants, but rather as Reynolds's Mrs. Lloyd.[63]

One seems to sense a sort of personal identification with a world where freedom and enjoyment were celebrated, a world that did not exclude sexual and sensual relationships, a world that the dark and oppressive atmosphere of the Victorian nineteenth century could not tolerate or admire.

Wharton was able to appreciate the Gesuati ceiling, the wonderful Palazzo Labia frescoes, and the Scalzi ceiling, the one De Veaux had not bothered to look at:

On the soaring vault of the Scalzi . . . the great painter of atmosphere, the first of plein-airists, was required to depict the transportation of the Holy House from Palestine to Loreto. That Tiepolo, with his love of ethereal distances, and of cloud-like hues melting into thin air, should have accepted the task of representing a stone house borne through the sky by angels, shows a rare sense of mastery; that he achieved the feat without disaster justifies the audacity of the attempt. Tiepolo was above all a lover of open spaces. He liked to suspend his fluttering groups in great pellucid reaches of sky, and the vast ceiling of the Scalzi gave him an exceptional opportunity for the development of this effect. The result is that the angels, whirling along the Virgin's house with a vehemence which makes it seem a mere feather in the rush of their flight, appear to be sweeping through measureless heights of air above an unroofed building. The architectural propriety of such a trompe l'oeil is not only open to criticism but perhaps quite indefensible; yet, given the demand for this particular illusion, who but Tiepolo could have produced it [see Figure 3]?[64]

Wharton's description renders the beauty of a ceiling that now exists only in words because it was destroyed by an Austrian bomb in 1915. She recalled it again much later, when, in *The Glimpses of the Moon* (1922), Wharton's male protagonist meets a young woman under the "celestial vortex" of the Scalzi church ceiling.[65]

Wharton noted similar enchanting aerial effects in the ceiling of the Gesuati at the Zattere, where she noticed that guidebooks likened the Virgin Mary to "a noble Venetian lady of the painter's day." "No doubt she does. It is impossible to form an intelligent estimate of Tiepolo's genius without remembering that the Catholicism of his time was a religion of bon ton, which aimed to make its noble devotees as much at

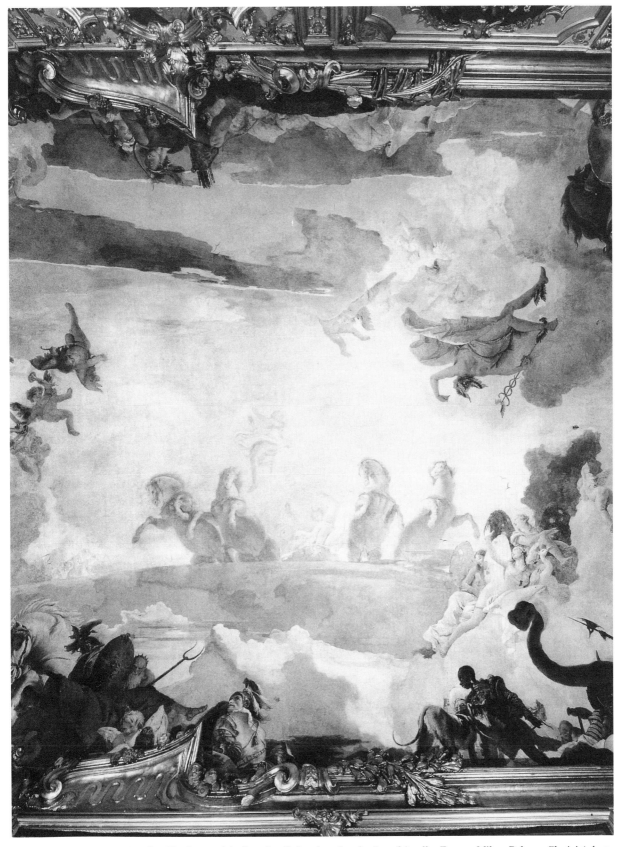

Figure 8. Giambattista Tiepolo. *The Course of the Sun*, detail showing the chariot of Apollo. Fresco. Milan, Palazzo Clerici (photo: Palazzo Clerici)

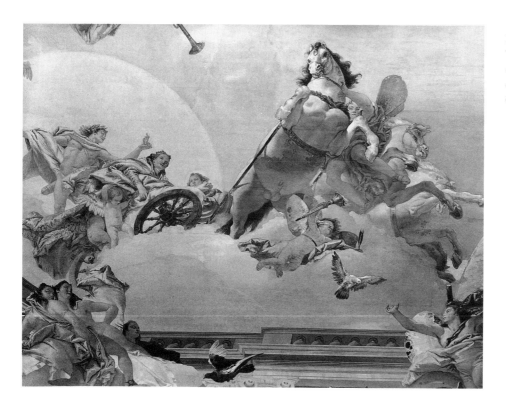

Figure 9. Giambattista Tiepolo. *Wedding Allegory*, detail. Fresco. Venice, Museo del Settecento Veneziano, Ca' Rezzonico (photo: Cacco)

home in church as in the drawing-room."[66] Yet, "by sheer force of technique," Wharton continued, Tiepolo "contrived to impart to his great religious pictures a glow of the supernatural splendour" that Dante's Paradise might well have described.

Moving on to discuss Tiepolo's secular paintings, Wharton emphasized his special gift in depicting "worldly pageants." In the Palazzo Labia the painter found "an unequalled opportunity for the exercise of this side of his talent." And:

Here, in the lofty salon of the piano nobile, he painted the loves of Antony and Cleopatra transposed in the key of modern patrician life. He first covered the walls with an architectural improvisation of porticoes, loggias and colonnades, which might have been erected to celebrate the "triumph" of some magnificent Este or Gonzaga. In this splendid setting he placed two great scenes: Cleopatra melting the pearl, and Antony and Cleopatra landing from their barge; while every gallery, balcony and flight of steps is filled with courtiers, pages and soldiers, with dwarfs and blackamoors holding hounds in leash, and waiting-maids and lacqueys leaning down to see the pageant [see Figure 6].[67]

It is interesting that Wharton admired the decorative side of the Labia frescoes, but did not stop there: Cleopatra is immediately referred to as "Royal Egypt," in Shakespeare's words, and it is his tragedy that comes to Wharton's mind when looking at the frescoes. If she describes in splendid prose the richness of Tiepolo's

figures and gowns, she stresses how "one may recall Shakespeare under these rouged and powdered Venetians"; in other words, the beauty of the paintings does not prevail over the dramatic perception of the story as painted by Tiepolo: "Still more Shakespearean is the scene of the pearl. Cleopatra, enthroned in state at the banqueting table, lifts one hand to drop the jewel into her goblet, and in her gesture and her smile are summed up all the cruel graces of the 'false soul of Egypt.'"

Whatever "falsity" could be attributed to the artist, it is now a question of how he consciously uses it to tell a tragic and powerful royal story. For Wharton, Tiepolo is "the direct descendant of Titian and Veronese" and of "the radiant majesty of the Venetian cinquecento." Her admiration of Tiepolo knows no bounds. She wrote on his paintings in *Italian Backgrounds*, documented some of her impressions in *Italian Villas and Their Gardens* and in her first novel. When she went to Venice, she stopped en route at Stra to see the Villa Pisani frescoes, and later wrote about its "most riotously splendid ceiling."[68]

In *The Valley of Decision* (1902),[69] a book that is a ragbag of themes and forms—a novel as historical as it is political—the story is set in eighteenth-century Italy. The book was very successful, but Henry James was right when he concluded his appreciation of the novel by telling Wharton, "Do New York!" However, in this long and rather clumsy first novel, she seems to find her true, creative voice when describing an imaginary

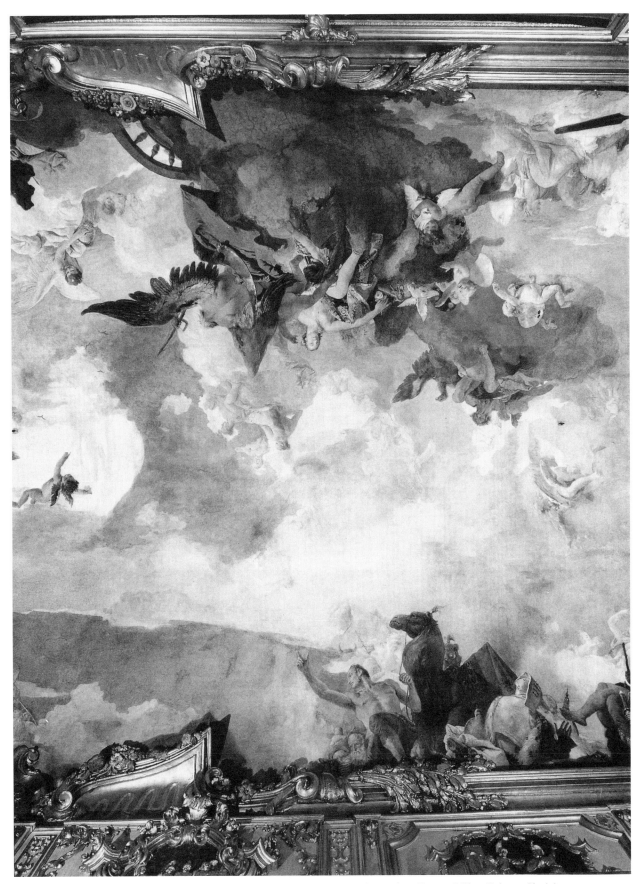

Figure 10. Giambattista Tiepolo. *The Course of the Sun*, detail showing the dromedary. Fresco. Milan, Palazzo Clerici
(photo: Palazzo Clerici)

Tiepolo. Although Wharton had prepared herself carefully by reading a number of works, including Vernon Lee's *Studies of the Eighteenth-Century in Italy* and books she had borrowed from Charles Eliot Norton, such as significant eighteenth-century memoirs by Goldoni, Lorenzo da Ponte, and Casanova,[70] her rendering of period Venice is fairly stereotyped.[71] This was not applicable to Wharton's description of an imaginary Tiepolo fresco in the villa where her protagonists meet. The prose suddenly seems to soar, like a flying angel in a Tiepolo ceiling:

When the curtain fell the Procuratoressa led the company to the circular saloon which, as in most villas of the Venetian mainland, formed the central point of the house. . . . His [Odo's] eye . . . was soon drawn . . . to the ceiling which overarched the dancers with what seemed like an Olympian revel reflected in the sunset clouds. Over the gilt balustrade surmounting the cornice lolled the figures of fauns, bacchantes, nereids and tritons, hovered over by a cloud of amorini blown like rose-leaves across a rosy sky, while in the center of the dome Apollo burst in his chariot through the mists of dawn, escorted by a fantastic procession of the human races. These alien subjects of the sun—a fur-clad Laplander, a turbaned figure on a dromedary, a blackamoor and a plumed American Indian—were in turn surrounded by a rout of Maenads and Silenuses, whose flushed advance was checked by the breaking of cool green waves, through

Figure 11. Giambattista Tiepolo. Detail of *The Meeting of Cleopatra and Antony* in Figure 6 (photo: Böhm)

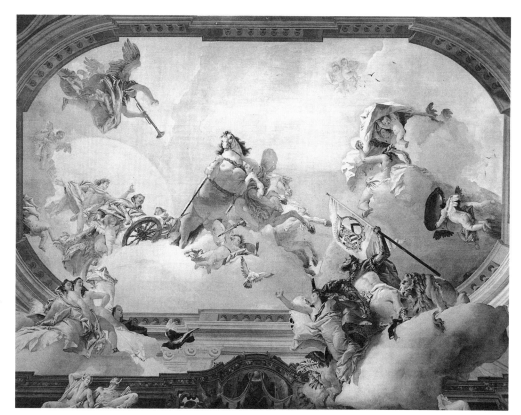

Figure 12. Giambattista Tiepolo. *Wedding Allegory.* Fresco. Venice, Museo del Settecento Veneziano, Ca' Rezzonico (photo: Ca' Rezzonico)

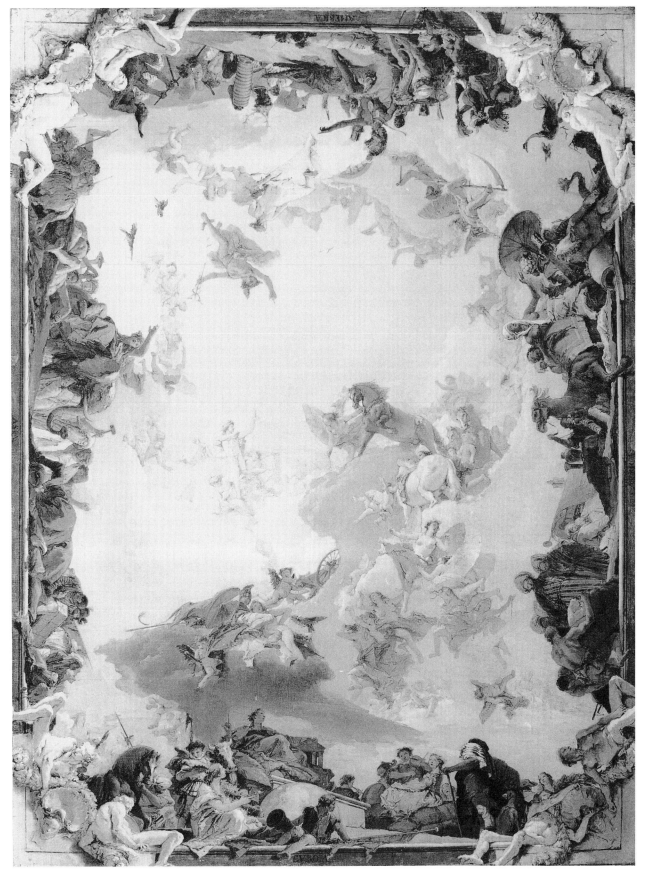

Figure 13. Giambattista Tiepolo. *Apollo and the Four Continents* (modello for fresco, Residenz, Würzburg). Oil on canvas, 185.4 x 139.4 cm. The Metropolitan Museum of Art, Gift of Mr. and Mrs. Charles Wrightsman, 1977, 1977.1.3

which boys wreathed with coral and seaweed disported themselves among shoals of flashing dolphins. It was as if the genius of Pleasure had poured all the riches of his inexhaustible realm on the heads of the revelers below.[72]

In this description—where one cannot identify a specific Tiepolo fresco—many impressions of different frescoes have acted on the writer's imagination: the plumed Indian, the gilded cornice, the Maenads and Satyrs (Figure 7) of Palazzo Clerici and of Villa Pisani at Stra; the chariot of Apollo bursting through the mist in Palazzo Clerici (Figure 8) and Ca' Rezzonico (Figure 9); the dromedary (Figure 10), the waves, and the coral of Palazzo Clerici; the blackamoor of Palazzo Labia (Figure 11) and Villa Valmarana. But one can also think of other famous frescoes by Tiepolo: the chariot in the monumental Würzburg fresco, *Apollo Leading Beatrix of Burgundy to the Genius of the German Nation*, the plumed Indian and the dromedary in the allegories of the four continents (Olympus and the Continents, see Figure 13), also in Würzburg,[73] not to mention the usual *amorini* (Figure 12) and blackamoors.

In *The Valley of Decision* Wharton seems to paint, in words, her own personal Tiepolo fresco, a pure product of her imagination, a verbal firework inspired by Tiepolo's visual fireworks.[74]

NOTES

1. See Francis Haskell, "Tiepolo e gli artisti del secolo XIX," in *Sensibilità e razionalità nel settecento*, Vittore Branca, ed. (Florence, 1967) II, pp. 481–497. In the 1850s the Rothschilds bought a large fresco, described first by Henri de Chennevières in *Les Tiepolo* (Paris, 1898), apparently from Palazzo Vecchia in Vicenza and moved it to their Château de Ferrières. See George Knox, *Giambattista and Domenico Tiepolo: A Study and Catalogue Raisonné of the Chalk Drawings* (Oxford, 1980) I, p. 24. I am grateful to George Knox for having called my attention to English and American collectors. For the various albums of the Cheney collection, bought between 1842 and 1852, see George Knox, "Description and Provenance of the Cheney Album," in *Catalogue of the Tiepolo Drawings in the Victoria and Albert Museum* (London, 1975) pp. 3–9. James Jackson Jarves owned the drawings *Five Angels* (now in the MMA) and *Three Allegorical Figures on the Clouds*; see nn.1 and 92 in Bernard Aikema, *Tiepolo and His Circle, Drawings in American Collections* (Cambridge, Mass., 1996).

2. Antonio Morassi, *G. B. Tiepolo* (London, 1955) p. 3. See also Keith Christiansen on Mengs and Neoclassicism, "L''infiammata poetica fantasia' di Giambattista Tiepolo," in *1696–1996 Giambattista Tiepolo* (Milan, 1996) p. 275, and Terisio Pignatti, "Giambattista Tiepolo: Life and Art," in Terisio Pignatti and Filippo Pedrocco, *Giambattista Tiepolo: Venetian Itineraries* (Venice, 1996) p. 39.

3. See Haskell, "Tiepolo e gli artisti."

4. Charles-Nicolas Cochin admired the Tiepolos in the Gesuati,

although with some reservation (p. 88/141); he praised the "manière" of Tiepolo at the Scalzi but found "la couleur . . . dure, maniérée et monotone, et les ombres . . . trop égales" (p. 117/148); in the comparison between Tiepolo and Piazzetta he praised the former: "le plus beau génie et la couleur la plus agréable, la plus grande facilité et le pinceau le plus flatteur" (p. 159/159), *Voyage d'Italie; ou, Recueil de notes sur les ouvrages de peinture et de sculpture qu'on voit dans les principales villes d'Italie* (Geneva, 1972 repr. of 1758 ed.). In 1786 Goethe wrote: "Heut sah ich die Villa Valmarana die Tiepolo dekorirt und allen seinen Tugenden und Fehlern freyen Lauf gelassen hat. Der hohe Styl gelang ihm nicht wie die natürliche, und in diesem letzten sind köstliche Sachen da, im Ganzen aber als Dekoration gar fröhlich und brav," in *Sämliche Werke*. II. Abteilung, K. Eibl et al., eds., *Italien im Schatten der Revolution. Briefe, Tagebücher und Gespräche von 3. September 1786 bis 12. Juni 1794* (Frankfurt, 1991) p. 72. Goethe also admired the Gesuati ceiling, although, as Adriano Mariuz points out, he did not distinguish between the two hands of Giambattista and Giandomenico but he did detect two styles: "con acume critico poco comune distingueva due stili: conferendo la palma a quello 'naturale' egli riconosceva implicitamente la maggiore modernità di Giandomenico," in Adriano Mariuz, *Giandomenico Tiepolo* (Venice, 1971) p. 54; see chap. 1 on the relationship with Neoclassicism.

5. In *The Handbook of Painting* based on Franz T. Kugler, rewritten by Gustav F. Waagen, and then Joseph A. Crowe, a popular handbook with English-speaking readers, book 6 of the second volume (in the 1874 edition) is significantly called "The Decline of Art, 1700–1810." But in Venice admiration of Tiepolo never died out; see Antonio Berti, *Elogio di Gio. Batta Tiepolo* (Venice, 1856) and a few years later the work of Urbani de Gheltoff (1879).

6. Hippolyte Taine wrote with mixed feelings on Tiepolo: "le dernier des décorateurs de plafonds, Tiepolo, est un maniériste qui, dans ses tableaux religieux, cherche le mélodrame, et qui, de parti pris, éparpille ses personnages, de manière à donner à ses scènes l'aspect d'un volcan en éruption," *Voyage en Italie* (Paris, 1914) II, p. 301. A few years earlier, Théophile Gautier, who found the style of the Scalzi church horrible, actually praised the interior: "les plafonds à fresque, de Tiepoletto et Lazzarini, d'un ton gai, léger, clair, où dominent le rose et l'azur, conviendraient merveilleusement à une salle de bal ou de théâtre. Cela devait être charmant, plein de petits abbés poudrés et de belles dames, au temps de Casanova et du Cardinal de Bernis, pendant une messe en musique de Porpora, avec les violons et les chœurs de la Fenice," *Voyage en Italie* (Paris, 1876) p. 262. We should also remember the Goncourts' study of the Settecento, *L'Art du dix-huitième siècle* (1873).

7. "Il y a des nouveaux Tiepolo qui sont des merveilles" wrote Delacroix to his friend Pierret (1832-34), *Correspondance générale d'Eugène Delacroix, 1804–1837* (Paris, 1935) I, p. 354.

8. Henry James, "The Metropolitan Museum's 1871 Purchase," in *The Painter's Eye. Notes and Essays on the Pictorial Arts*, John Sweeney, ed. (London, 1956) p. 52 ("Unsigned notes. Originally printed in the *Atlantic Monthly*, June 1872," ibid., p. 5).

9. William T. Blodgett "also collected American and European art. He had made history in 1859 by paying $10,000 for Frederic Church's *Heart of the Andes*." He offered the 174 pictures he had bought in Europe for $116,180.27; see Howard Hibbard, *The Metropolitan Museum of Art* (New York, 1980) p. 9. He was helped in the 1871 purchase by John Taylor Johnston, president of the MMA. Johnston was also a collector and opened his house to the public on Thursday afternoons, see Winifred Howe, *A History of the Metropolitan*

Museum of Art (New York, 1913) I, pp. 134–136.

10. Ibid., p. 134.

11. Henry James, *A Small Boy and Others*, F. W. Dupee, ed. (Princeton, 1983) p. 152.

12. In both the *Atlantic Monthly* and the book, the title is *Hille Bobbe of Haarlem*; see James, *Painter's Eye*, p. 55.

13. Henry James, "The 1871 Purchase," p. 58. James goes on to praise Teniers and other Flemish painters, quoting "two examples of that forlorn straggler in the march of Venetian art, Francesco Guardi. A Tiepolo of landscape we may call this gentleman"(p. 65). In contemporary newspaper reviews Tiepolo was never mentioned, but there was general approbation for the Flemish painters. There was also a constant appreciation of the "authenticity" of the collection, guaranteed by Étienne Le Roy, of the Brussels Museum, who had actually helped Mr. Blodgett in the purchase.

14. Filippo Pedrocco and Massimo Gemin, *Giambattista Tiepolo: I dipinti. Opera completa* (Venice, 1993) cat. no. 414a.

15. Federico Zeri, with Elizabeth Gardner, *Italian Paintings: A Catalogue of the Collection of The Metropolitan Museum of Art* (New York, 1973) II, p. 66. See also Harry B. Wehle, *A Catalogue of Italian, Spanish, and Byzantine Paintings* (New York, 1940) pp. 282, 288, where the two paintings are specifically identified as part of the 1871 purchase. The *Sacrifice of Abraham* came from the collection of the duchesse de Berry.

16. As for the Sassoferrato and the "third Tiepolo," I owe the identifications to the kindness of Keith Christiansen, curator of European Paintings at the MMA: the Sassoferrato of the 1871 purchase, from the Castelbarco collection, was sold by the Museum at the Parke Bernet Galleries (June 7, 1956). The third Tiepolo, attributed later to Guarana, was sold at Sotheby Parke Bernet on Jan. 8, 1981; again, I am grateful to Keith Christiansen for this information.

17. Henry James, *Letters 1843–1875*, Leon Edel, ed. (Cambridge, Mass. 1974), and Leon Edel, *Henry James. The Untried Years* (Philadelphia/New York, 1953) pp. 301–302; Viola Hopkins Winner, *Henry James and the Visual Arts* (Charlottesville, Va., 1970) pp. 19–21, 28–30; Henry James, *Lettere da Palazzo Barbaro*, Rosella Mamoli Zorzi, ed. (Milan, 1989).

18. See, for example, the beginning of the essay "An English Critic of French Painting, 1868," where James shows he is quite conscious of the influence of Ruskin and the reactions against him, *The Painter's Eye*, pp. 33–34. On the influence of Ruskin in the United States, see Roger B. Stein, *John Ruskin and Aesthetic Thought in America 1840–1900* (Cambridge, Mass., 1967).

19. Ruskin described, and took issue with, the ceiling of the church of S. Alvise, and also with its two Tiepolos (*Ascent to the Calvary* and the *Flagellation*):

[The roof] of S. Alvise is little more than a caricature of the mean passion for perspective, which was the first effect of "science" joining itself with art. And under it, by strange coincidence, there are also two notable pieces of plausible modern sentiment,—celebrated pieces by Tiepolo. He is virtually the beginner of Modernism: these two pictures of his are exactly like what a first-rate Parisian Academy student would do, setting himself to conceive the sentiment of Christ's flagellation, after having read unlimited quantities of George Sand and Dumas. It is well that they chance to be here: look thoroughly at them and their dramatic chiaroscuros for a little time, observing that no face is without some expression of crime or pain, and that everything is always put dark against light, or light against dark. Then return to the entrance

of the church, where under the gallery, frameless and neglected, hang eight old pictures" (John Ruskin, *St. Mark's Rest: The History of Venice* [Sunnyside, Kent, 1887] p. 30).

20. Sir Joshua Reynolds, *Discourses on Art*, Robert R. Wark, ed. (New Haven/London, 1959) IV, p. 64.

21. Washington Irving, *Letters III, 1839–1845*, Ralph M. Aderman, Herbert L. Kleinfeld, and Jennifer S. Banks, eds. (Boston, 1982) pp. 269–273.

22. Samuel F. B. Morse, *Letters and Journals*, Edward L. Morse, ed. (Boston, 1914; repr., 1972) I, pp. 269–273.

23. James De Veaux, letter in Robert W. Gibbes, *A Memoir of James De Veaux* (Columbia, S.C., 1846) p. 181. De Veaux died of tuberculosis in Rome, in 1844, at the age of 33.

24. See John Ruskin, *The Stones of Venice* (London, 1925) III, chap. 3, which has the same title.

25. Murray's *Handbook for Travellers in Northern Italy* (London, 1860) p. 359. It describes at length the church of the Scalzi, but there is no mention of the Tiepolo ceiling (ibid., p. 371). The 1879 Baedeker *(Italy. Handbook for Travellers. Northern Italy)* does not mention the Tiepolos in Ca' Rezzonico, the Scalzi, or Udine, while it mentions Tiepolo in the Palazzo Labia. The 1899 edition, instead, refers to Tiepolo's ceiling in the Scalzi. Mueller's *Venice: Her Art Treasures and Historical Associations*, published in Venice (1885), in English, mentions the Palazzo Labia frescoes, but makes no reference to the Scalzi ceiling (in spite of the detailed description of the interior marbles and statues on p. 159), and there is no mention of the Tiepolos in the Ca' Rezzonico (p. 144). When Pen Browning bought the whole Palazzo Rezzonico in 1888, his father, Robert, was enthusiastic and included in the list of bargains two Tiepolo ceilings; (*Letters of the Brownings to George Barrett*, Paul Landis and Ronald E. Freeman, eds. [Champaign, Ill., 1958] p. 45).

The Manfrin collection was an 18th-century private collection of over 400 pictures and included Giorgione's *Tempest*; it was open to the public and was listed in every guidebook; it was dispersed in the 19th century; see *Catalogo dei Quadri esistenti nella Galleria Manfrin in Venezia* (n.p., n.d.); Giulio Lecomte, *Venezia* (Venice, 1844) pp. 275–286; and Francis Haskell, *Patrons and Painters* (New Haven, 1980) pp. 379–381.

26. *The National Museum of American Art's Index to American Art Exhibition Catalogues from the Beginning through the 1876 Centennial Year*, James L. Yarnall and William H. Gerdts, comps. (Boston, 1986) V, cat. no. 89617.

27. As for its owner, the catalogue adds: "This beautiful painting adorned the collection of J. Taylor Esq. of England." No Tiepolo is listed in the Christie's sale catalogue of April 26, 1787, documenting the sale of "a most Capital and Valuable Collection of Pictures, . . . the property of Sir John Taylor, brought from his house in Hill Street, Berkeley Square." I would like to thank Dr. Lotte Hellinga of the British Library and Margaret L. Ford of Christie's, London, for providing me with the documentation.

28. Carrie J. Rebora, *The American Academy of the Fine Arts, New York, 1802–1842* (Ann Arbor, Mich., 1990) II, pp. 392–394.

29. *American Art Index*, cat. nos. 89621, 89609.

30. Other paintings attributed to Tiepolo were *Brennus in Rome, Cleopatra Drinking the Pearl Dissolved in the Wine*, and *Judith with the Head of Holofernes*, the subject of which can be identified with the *Judith Showing the People the Head of Holofernes*, in the Rossello Collection in Milan. See Pedrocco and Gemin, *Giambattista Tiepolo*,

cat. no. 54, 37 x 48 cm; for other paintings attributed to Tiepolo listed in the *American Art's Index*, see "Tiepolo." A *Jacob and Esau* belonging to C. C. Perkins was exhibited in Boston in 1856; see *The Boston Athenaeum Index 1827–1876*, Robert F. Perkins Jr. and William J. Gavin II, eds. (Boston, 1980) p. 141.

31. Adeline Tintner, *Henry James and the Lust of the Eyes* (Baton Rouge/London, 1993) p. 144. Tintner also correctly suggests that Tiepolo's Palazzo Labia fresco lies behind James's description of alighting from the gondola, compared with Cleopatra's disembarking from her barge, in the 1899 essay "Two Old Houses and Three Young Women" (ibid., p. 145). See chap. 11, "Rococo Venice and Longhi," for James's relation with the 18th century.

32. "Collaboration;" in *The Complete Tales of Henry James,* Leon Edel, ed. (London, 1963) VIII, p. 407.

33. Mr. Blodgett's purchase, made during the Franco-Prussian War (Howe, *A History of the Metropolitan Museum of Art*, p. 136) may have had something to do with James's choice of chronology.

34. Preface (*The Spoils of Poynton, A London Life, The Chaperon*), in *Prefaces to the New York Edition*, in *Literary Criticism*, Leon Edel, ed., with the assistance of Mark Wilson (New York, 1984) p. 1152. For the other Tiepolo ovals in the "cameron," see Andrea Bayer, "Le decorazioni per Ca' Barbaro," in *1696–1996 Giambattista Tiepolo*, pp. 157–166, and Diane De Grazia in Diane De Grazia and Eric Garbeson, *The Collections of the National Gallery of Art, Systematic Catalogue: Italian Paintings of the Seventeenth and Eighteenth Century* (Washington, D.C., 1996) pp. 265–272.

35. Pedrocco and Gemin, *Giambattista Tiepolo*, p. 408.

36. Ibid., p. 258.

37. Ibid., p. 408.

38. See the 1896 exh. cat., *Mostra Tiepolesca*, Attilio Centelli, ed. (Venice, 1896), where the list of critics includes Zanetti, Longhi, G. A. Meyer, Ticozzi, De Boni, Siret, Blanc, and Paul Leroy, in addition to Giuseppe Urbani de Gheltoff, the author of *Tiepolo e la sua famiglia* (Venice, 1879), Pompeo Molmenti, who had published *Il Carpaccio e il Tiepolo* (Turin, 1885), and the two then forthcoming works of Henri de Chennevières and Buisson (p. 26).

39. Rosella Mamoli Zorzi, "Titian and XIX-Century American Writers," in *Annali di Ca' Foscari* XXX, 1–2 (1991) pp. 196–197.

40. Adriano Mariuz, "Giambattista Tiepolo: 'il vero mago della pittura,'" in *1696–1996 Giambattista Tiepolo*, p. 3.

41. On the Jacquemart-André purchase of the frescoes, see Henri de Chennevières, "Les Tiepolo de l'Hôtel Édouard André," in *Gazette des Beaux Arts* 15 (Jan. 1, 1896). For other purchases, they bought from the same antique dealers from whom Isabella Stewart Gardner, among others, bought Venetian Gothic windows or 18th-century chairs: the names of the antiques dealers Rietti, Richetti, and Guggenheim recur frequently, along with those of famous Florentine antique dealers. The Jacquemart-Andrés also bought at the Paris auctions and in various European cities. I would like to thank the curator of the Musée Jacquemart-André, M. Nicolas Sainte Fare Garnot, and the curator of the Musée Jacquemart-André of Chaalis, M. Robert-Henri Bautier, for generously giving me access to their archives.

42. "Jamais peut-être dans son oeuvre pourtant surabondante de gaietés d'âme et de brosse, Tiepolo ne donne davantage la sensation de la peinture heureuse de peindre et devenue le besoin d'un esprit et d'un oeil obsédés de la ligne et du ton, comme le musicien l'est de sa libre chanson. La qualité du coloris participe de la joie, plus spéciale encore, de cette composition," ibid., p. 126.

43. John A. Symonds, "On an Altar-Piece by Tiepolo," in *In the Key of Blue and Other Essays* (London, 1893). Symonds's interest in the artist dated back at least ten years, when he had written to Horatio F. Brown inquiring about the Tiepolos at the Villa Contarini, which he had learned about while reading Maxime du Camp's *Souvenirs littéraires*. (See *Letters and Papers of John Addington Symonds*, Horatio F. Brown, ed. [London, 1923] p. 161). The frescoes Symonds inquired about were the very cycle of frescoes the Jacquemart-Andrés bought just a few years later. Maxime du Camp wrote: "Je m'intéressais aux Tiepolo; j'avais contemplé tous ceux que garde la ville, depuis le Portement de la Croix, qui est à Sant' Alvise, jusqu' à l'Antoine et à la Cléopatre du palais Labia; j'allais sur la Brenta afin de voir la grande fresque représentant l'entrée de Henri III à Venise, qu'il a peinte . . . la villa Pisani et que l'on a trop retouchée. . . ." *Souvenirs littéraires* (Paris, 1892) II, p. 160. On Symonds's essay, see Haskell, "Tiepolo e gli artisti," pp. 495–497, and John R. Hale, *England and the Italian Renaissance* (London, 1954) chap. 8. Symonds admired Edmund Gosse's studies in the 18th century and also translated Carlo Gozzi's *Useless Memoirs* (1888). On Symonds's background and friendships, see Phyllis Grosskurth, *John Addington Symonds: A Biography* (London, 1964).

44. Anna Jameson, *Sacred and Legendary Art* (London, 1851; 1848) p. 612.

45. Mark Twain wrote, "But Tiepelo [*sic*] is my artist. In that palace near the Bella [*sic*] Arti in that chapel of San Giovanni e Paolo—& in the Jesuit church where the marbles are, these are all beautiful" (Aug.–Oct. 1878). The palace near the Belle Arti could be Ca' Rezzonico. The only Jesuit church in Venice does not have a Tiepolo: Twain might be referring to the Gesuati church. The chapel in SS. Giovanni e Paolo might be a reference to the Ospedaletto, near, not in, SS. Giovanni e Paolo. Twain, however, is usually accurate in his Venetian references. See Mark Twain, *Notebooks and Journals 1877–1883*, II, Frederick Anderson, Lin Salamo, and Bernard L. Stein, eds. (Berkeley, 1975) p. 205. See also Rosella Mamoli Zorzi, "Tintoretto e gli angloamericani nell'Ottocento," in *Annali di Ca' Foscari* XXV, 1–2 (1996) pp. 216–219.

46. See Edith Wharton, *Italian Villas and Their Gardens*, ill. by Maxwell Parrish (London, 1904); the reference on p. 232 is to Cornelius Gurlitt's *Geschichte des Barockstiles in Italien* (Stuttgart, 1887).

47. In *Gsell-Fels* (Leipzig/Vienna, 1898, 6th ed.), the Scalzi Tiepolo is described as follows: "An der Spiegeldecke eines der genialsten und farbenprächtigsten Freskogemälde von Giambattista Tiepolo, die Translation des Hauses der Maria nach Loreto, sein Jubelgesang in sich vollendeter venezianischer Dekorativkunst. (Hier tritt Tiepolos Kunst, der silberklaren Venezianischen Luft die Farbe zu entlocken, besonders glänzend hervor)," p. 282.

48. Berenson wrote on Tiepolo in *The Italian Painters of the Renaissance* (London, 1952) I, p. 35. Although it was initially published in 1896, he added, "N.B. Written in 1894!" at the end of the essay.

49. R. W. B. Lewis, *Edith Wharton: A Biography* (New York, 1985) p. 269.

50. Berenson, *Italian Painters of the Renaissance*, I, p. 35.

51. *Illustrazione italiana* 6 (June 1951) p. 58.

52. Berenson wrote that the frescoes were from Stra, rather than La Mira; letter of June 28, 1898, in *The Letters of Bernard Berenson and Isabella Stewart Gardner 1887–1924*, with correspondence by Mary Berenson, Rollin Van N. Hadley, ed. (Boston, 1987) p. 142. Isabella

Stewart Gardner, however, did buy a Tiepolo, the oil sketch for the Würzburg *Wedding of Barbarossa*, following the suggestion of Ralph Curtis; see *Guide to the Collection* (Boston, 1976) p. 67. On Ralph Curtis's advice to buy the painting in April 1901 through her Paris agent I. Robert, see Philip Hendy, *European and American Paintings in the Isabella Stewart Gardner Museum* (Boston, 1974) p. 249.

53. Eleanor Dwight, *Edith Wharton. An Extraordinary Life* (New York, 1994) p. 28.

54. Edith Wharton, "Picturesque Milan," in *Italian Backgrounds* (New York, 1927) pp. 155–156. As regards Milan, the visit to Palazzo Clerici may have been suggested by Enrico Boito, Verdi's librettist, whose brother, Camillo, wrote a long, appreciative essay on Tiepolo in 1881, although it was limited to the Villa Valmarana frescoes (*Gite d'artista* [Milan, 1884]). Enrico's "powerful protection" had "opened the doors of some little-known villas of the Brianza and the Naviglio"; see Edith Wharton, *A Backward Glance* (New York, 1964) p. 135.

55. Cornelius Gurlitt described the Scalzi ceiling: "Die Hauptsache aber ist an derselben Tiepolos farbenglänzendes, meisterhaft leichtes und schwungvolles Bild: 'Engel tragen das Haus der Maria nach Loretto,'" *Geschichte des Barock-Styles in Italien* (Stuttgart, 1887) p. 312. Describing Palazzo Rezzonico, he wrote: "Tiepolos glänzende Phantasie erfüllte sie die innere Eintheilung der Treppe mit dem Sonnenscheinen seiner wunderbar heiteren Kunst" (p. 317), and on the Palazzo Labia: "In denselben aber schuf ein phantasiereicherer Künstler eine noch grossartigere Architektur, erweiterte Tiepolo die Wände durch meisterhaft behandelte, perspektivisch gemalte Prachtbauten und erfüllte diese mit einer Schilderung der Kleopatra, im Warheit aber mit dem Bilde der lebensfrohen Welt der im letzten Glanze strahlenden Republik" (p. 326).

56. Wharton also read Jacob Burckhardt, whose *Cicerone* admits the talent of some 18th-century artists: "Anche più tardi vi furono pittori di talento che si irrobustirono all'esempio di Paolo creando qualche opera di notevole importanza. Così il Lazzarini, l'Angeli, il Fiumani ed anche il Tiepolo" (*Il Cicerone*, intro. by Federico Pfister [Florence, 1952] p. 1079). The first edition is dated 1855, but the book was written in 1853–54.

57. Wharton, "Picturesque Milan," in *Italian Backgrounds*, pp. 163–164

58. Wharton, "Italian Backgrounds, "in ibid., p. 173.

59. Ibid., p. 177.

60. Ibid., p. 178.

61. Ibid., pp. 190–191.

62. A poem by Wharton, "The Last Giustiniani," was set in 18th-century Venice, *Scribner's* (Oct. 1889) pp. 405–406, and Lewis, *Edith Wharton*, pp. 60–61.

63. On this particular painting see Judith Fryer, "Reading Mrs. Lloyd," in *Edith Wharton: New Critical Essays*, Alfred Bendixen and A. Zilversmit, eds. (New York, 1992), and Elaine Showalter, "The Death of the Lady (Novelist): Wharton's *House of Mirth*," in ibid. On the novel, see Cynthia Griffin Wolff, "Lily Bart and Masquerade Inscribed in the Female Mode," in *Wretched Exotic. Essays on Edith Wharton and Europe*, Katherine Jolin and Alan Price, eds. (New York, 1993) pp. 279–280. See also Candace Waid, *Edith Wharton, Letters from the Underworld* (Chapel Hill, N.C., 1991).

64. Wharton, "Italian Backgrounds," in *Italian Backgrounds*, pp. 193–194.

65. Edith Wharton, *The Glimpses of the Moon* (New York, 1922) p. 91. In the novel, the old view of people "principled against the effete art of Tiepolo and all his contemporaries" is played out against the admiration now expressed by different characters, ibid., p. 125.

66. Wharton, "Italian Backgrounds," in *Italian Backgrounds*, p. 195.

67. Ibid., pp. 196–197.

68. Wharton, *Italian Villas and Their Gardens*, p. 244. In her description of this ceiling Wharton seems to have captured the essence of Tiepolo's painting as defined by Svetlana Alpers—the idea that the fresco must be seen by a viewer moving in space; see Svetlana Alpers and Michael Bandaxall, *Tiepolo and the Pictorial Intelligence* (New Haven, 1994).

69. On this novel, see William L. Vance, "*The Valley of Decision*. Edith Wharton's Italian Mask," and Millicent Bell, introduction in *The Cambridge Companion to Edith Wharton*, Millicent Bell, ed. (Cambridge, 1995) pp. 169–198; Gianfranca Balestra, "Italian Foregrounds and Backgrounds in *The Valley of Decision*," in *Edith Wharton Review* 9, I (1992) pp. 12–14, 27; Janet Goodwin, *Edith Wharton: Traveler in the Land of Letters* (New York, 1990), and Dwight, *An Extraordinary Life*, p. 285.

70. On Wharton's sources, see her own *Backward Glance*, pp. 67, 70–71, 91, 102, 128, 130; see also Gianfranca Balestra, "Il Settecento italiano di Edith Wharton," in *Il "Passeggere" italiano: Saggi sulle letterature di lingua inglese in onore di Sergio Rossi*, Renzo Crivelli and Luigi Sampietro, eds. (Rome, 1994) pp. 389–395, and Lewis, *Edith Wharton*, passim.

71. On the representation of Venice and the differences among the various descriptions, see Rosella Mamoli Zorzi, "The Representation of Venice vs. the Representation of Places in Central Europe," in *Images of Central Europe in Travelogues and Fiction by North American Writers*, Waldemar Zacharasiewicz, ed. (Tübingen, 1995) pp. 128–137.

72. Wharton, *The Valley of Decision* (New York, 1914) p. 392.

73. Wharton did go to Würzburg, but only later, in Dec. 1909, to see "the longed-for Tiepolos at the Prince Bishop's Palace," as she wrote to Sara Norton on Dec. 2, 1909 (*The Letters of Edith Wharton*, R. W. B. Lewis, ed. [London, 1988] p. 194). She must have written a letter to Henry James on the subject, as he replied that he had followed her, "leaping with you breathless from Schiller to Tiepolo—through all that Gothicry of Augsburg, Würzburg, *und so weiter*" (*The Letters of Henry James*, Leon Edel, ed. [Cambridge, Mass., 1984] IV, p. 538). This 1909 visit might be linked to her friendship with Berenson.

74. Charles Blanc, in his "Les Tiepolo" in *Histoire des peintres de toutes les Écoles: École vénitienne* (Paris, 1868) had used the metaphor of fireworks but with a very different meaning: "doué, animé au plus haut du feu pittoresque, plein de facilité, d'abondance et de verve; mais, à vrai dire, ce feu n'est qu'un feu d'artifice; cette abondance tient plus au tempérament qu'à l'esprit; cette facilité dégénère en intempérance; cette verve, si fertile en images, est stérile en sentiments et en idées, et parce qu'elle ne vient pas de l'âme du peintre, elle ne dit rien à l'âme du spectateur" (p. 1).

The Bowes Family of Streatlam Castle and Gibside and Its Collections

MARGARET WILLS AND HOWARD COUTTS

LTHOUGH MANY OF THE ANCIENT British noble and aristocratic families survive into the twentieth century, their collections have often been reduced or dispersed across the world. In turn, their original historical and artistic context may be lost as they lose their link with the people who first bought or commissioned them. This article looks at the collections of one historic British family, the Bowes family of County Durham, who were once major landowners and industrialists in the north of England. Although the direct male line died out in the eighteenth century, enough survives of their collections in Britain and the United States to give an idea of their artistic tastes and social aspirations. Some of their most outstanding objects have come to rest in The Metropolitan Museum of Art, and these—when considered with other objects they owned and their relationship to the family's history—can be seen as a part of a pattern of luxury spending and social display by a family determined to make its mark in Georgian society.

The Bowes family was one of the most influential landed families in County Durham in northeast England. Its name and the coat of arms (three bows) perhaps indicate that the family originally headed a company of bowmen or archers in the service of William the Conqueror at the castle of Bowes on the North Yorkshire border. In about 1310 Sir Adam Bowes married Alice Trayne, heiress of Streatlam Castle, County Durham, which remained the family seat until the nineteenth century. William Bowes, Adam's grandson, fought in France and was knighted there in 1356, while other family members helped to police the border between Scotland and England. In the Tudor period Sir George Bowes was loyal to Queen Elizabeth I during the Rising of the North in 1569, and he was rewarded with leases for lead mines. His heroic defense of Barnard Castle nearby and his part in suppressing the Rising are recorded from old family documents in Sir Cuthbert Sharp's *Memorials of the Rebellion of 1569* (1840).[1] The family gained power and influence during the seventeenth century and continued its relationship with Barnard Castle; a simple silver wine cup (Figure 1) in the Bowes Museum, inscribed "Barnard Castle The 14 April 1635," probably commemorates the retirement of Sir Talbot Bowes from the Head Stewardship of the castle in 1635. Barnard Castle was subsequently ruined during the English civil war (1642–49); it survives today as a picturesque ruin overlooking the River Tees, although a town of the same name flourishes in its shadow.

William Bowes (1656–1706), great-grandson of Sir George Bowes, went to Trinity College, Cambridge, in 1672 and was admitted to Gray's Inn that same year. William was elected member of Parliament for County Durham five times in the period up to 1705. In 1684 he was knighted by Charles II at Whitehall, which may have been a purchased honor. For his bride he sought the hand of Elizabeth Blakiston of Gibside, a country estate in the north of England west of County Durham, near Newcastle (the Blakistons had become the owners of Gibside through marriage in 1534, and a new house was built between 1603 and 1620). Inventories made in 1573 and 1608 can be found in the Strathmore archive in the Durham Record Office,[2] and, although little of the furnishings have survived, a superb gold cup and cover now in the Victoria and Albert Museum (Figure 2) by Jacob Bodendick, London, 1675, bears the Bowes-Blakiston coat of arms and Blakiston crest of a cock and is listed in the family's possession in the early eighteenth century. The origin of the cup is not precisely known, but it has been conjectured that the cup is a racing prize won later by Sir William, who kept a stud farm at Streatlam Castle.[3]

The marriage contracts between Sir William Bowes and Elizabeth Blakiston linked two well-known families and sought to provide a certain status for Sir William and an assured future for his bride. In January 1693 an agreement was signed with Sir Francis Blakiston, the bride's father, which gave Gibside Manor, its collieries and lands, to his daughter Elizabeth, in return for certain provisions for Sir Francis and his other daughter, Jane.[4] A later contract of August 1693 went into greater detail of the property involved and mentioned

© The Metropolitan Museum of Art 1998
METROPOLITAN MUSEUM JOURNAL 33

The notes for this article begin on page 242.

Figure 1. Wine cup, inscribed "Barnard Castle The 14 April 1635." Maker unknown. Silver, H. 25.6 cm. County Durham, The Bowes Museum, Barnard Castle X.4596 (photo: The Bowes Museum)

Figure 2. Covered cup, engraved with the Bowes-Blakiston arms, by Jacob Bodendick (London), 1675. Gold, H. 14.75 cm. London, Victoria & Albert Museum M.63.1993 (photo: © The Board of Trustees of the Victoria & Albert Museum)

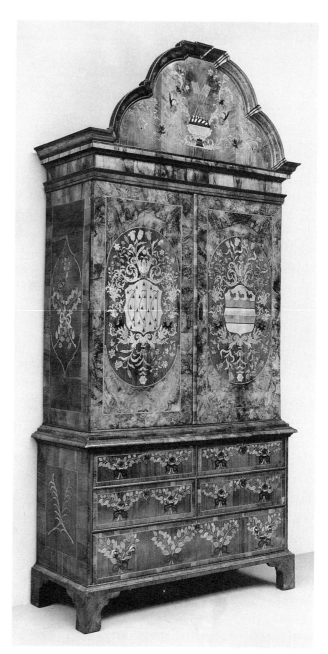

Figure 3. Cabinet, inlaid with the coats of arms of Bowes and Blakiston. English, after 1693. The Metropolitan Museum of Art, Rogers Fund, 1931, 31.86

that Sir Francis could live at Gibside for life. His wife, Anne, was also provided for, while his daughter Jane was to have a dowry of £6,000 if she married with the consent of her parents. Their goods, chattels, and furniture were to be in trust for life for Sir Francis and Dame Anne.[5] The marriage of Sir William Bowes and Elizabeth Blakiston took place in St. Mary's Church, Barnard Castle, on August 17, 1693, and with it a new phase in the fortunes of the Bowes family began. This date must mark the terminus post quem of the

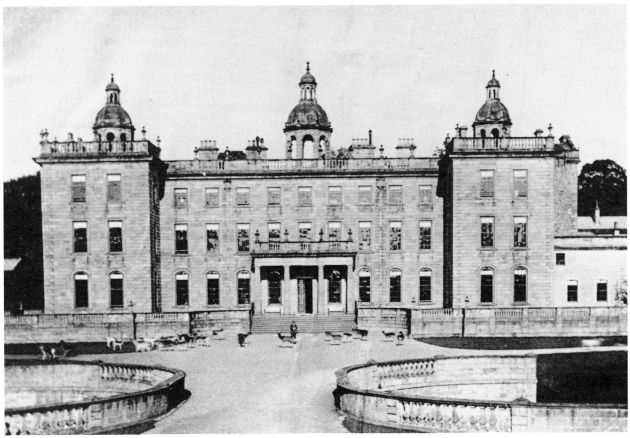

Figure 4. Photograph of Streatlam Castle, County Durham, as rebuilt by William Blakiston Bowes in the early 18th century. The cupolas and the portico were added by John Bowes (1811–1885)

remarkable large cabinet veneered with the Bowes-Blakiston arms, acquired by the Metropolitan Museum in 1931 (Figure 3). The piece consists of a large cupboard with drawers over a chest of drawers, the whole magnificently veneered with floral marquetry and the coats of arms of the two families on the doors. On the pediment is the Bowes crest of six inverted arrows. It is similar in design and execution to a cabinet in the Victoria and Albert Museum inlaid with the arms of George Lawson of Harsley Castle, Yorkshire, and his wife, Margaret Trotter of Skelton Castle, Yorkshire, suggesting a common northern origin for these two pieces of superb craftsmanship.[6] We do not know which craftsman made these pieces, but records imply that the Bowes family favored the city of Newcastle on the northeast coast for the purchase of luxury goods when not in London.

Ten children were born of this marriage, and eight of them, four boys and four girls, survived childhood. The youngest boy, John, died of smallpox in 1714. Lady Bowes was left to bring up her family after the death of her husband in 1706, and she took charge of the Gibside property on the death of her father in 1713 and

until her eldest son, William Blakiston, came of age in 1718. The Blakiston family was rich in lands but had not exploited the coal that lay beneath them, and Lady Bowes took over the running of the coal interests. She was involved in disputes with other coal owners, as she suspected that they had extracted too much coal for the safety of her mines.

William Blakiston Bowes, the heir to Streatlam and Gibside, preferred London life to that in the country, and in 1716 there was a staff of eleven servants at the Bowes family town house in Queen's Square, Westminster, London. William was sent to Europe on the Grand Tour and also trained in the techniques of coal mining, where the family's greatest wealth lay. He largely rebuilt and refurnished the family home of Streatlam Castle, changing it from a square, forbidding castle into a vast and rather daunting Georgian edifice, whose thick internal walls revealed its original purpose as a northern stronghold (Figure 4). The exact date of his work is not known, but the leaden spouts there bore the dates 1717, 1720, and 1721.[7] The interior was laid out in the fashionable style, with a series of paneled rooms enfilade and suites of plain

233

Figure 5. Mirror with silvered frame. English, ca. 1717–21. From Streatlam Castle, where it hung between the windows of the drawing room. 270 x 75 cm. Liverpool, The Walker Art Gallery, on loan to The Bowes Museum, Barnard Castle (photo: The Bowes Museum)

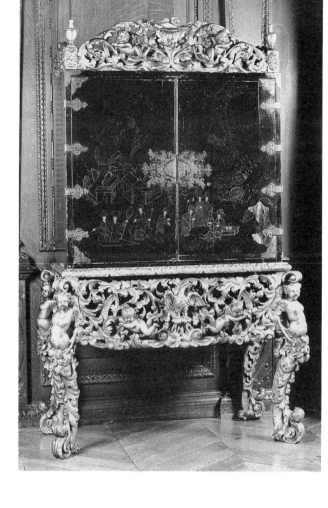

Figure 6. Japanned cabinet on stand. English, ca. 1700. 186 x 117 x 61 cm. From Streatlam Castle or Gibside. Liverpool, The Walker Art Gallery, on loan to The Bowes Museum, Barnard Castle (photo: The Bowes Museum)

and upholstered chairs, mirrors, and lacquered cabinets, some of which survive the dispersal of the contents in the 1920s (Figures 5, 6).[8] A well-known suite of embroidered upholstered chairs, with the Bowes crest, must date from this refurnishing (Figure 7).[9] The crest is contained within a lozenge, suggesting a spinster's or widow's arms, and it may be that the suite was commissioned by Lady Bowes before William attained his majority. Certainly a nineteenth-century inventory (1832–70) of Streatlam Castle records that his descendant John Bowes refurnished the state bed in white satin and red stuff, "exactly as they were put up in 1717 by Mr. Blakiston Bowes," an unusually precise date that would tally well with the style of objects.[10] Most spectacular among the family possessions must have been some magnificent silver, including a silver-gilt ewer and basin by the court goldsmith David Willaume, today in the collection of Her Majesty Queen Elizabeth the Queen Mother (Figure 9). It dates from the year of William's majority in 1718 and would have been part of a collection of plate that he

assembled in order to advertise his wealth and status in his search for a bride.[11]

Although William Blakiston wished to marry, he was not successful and died intestate at the age of twenty-four in 1721. He was succeeded by the second son, Thomas, who died suddenly, apparently of a fit, in 1722, and then by the youngest remaining son, George Bowes (Figure 8), who had joined the army and had become a captain in General Wade's regiment. George resigned his commission in order to devote himself to family affairs and the running of his estates. He presented two handsome silver flagons to St. Mary's, Whickham, near Gibside, in the same year that he succeeded to his property. They are engraved "Ex dono Georgii Bowes, Armiger. Anno Domini 1722" and were no doubt given in gratitude for his inheritance.[12]

Unlike his eldest brother, George Bowes did not care for life in London. Later he wrote from Gibside, "I must own I was greatly tir[e]d of London, not only from a dislike of Town's life, but from a just aversion to the scandalous Measures of the last Winters Campaign."[13]

However, he did wish to become a member of Parliament and have the influence that that entailed. This meant residing in London from November to June if he were to attend regularly. His first attempt to enter Parliament as a member for Berwick in 1723 was thwarted by a quarrel with William Cotesworth, an influential coal owner, and it was not until 1727 that George Bowes succeeded in gaining one of the two seats for County Durham. Through his attempts to enter Parliament, Bowes met Thomas Robinson, who was knighted by George II in 1731. He was an amateur architect, a follower of Lord Burlington's, and had traveled widely over Europe. It seems likely that he gave Bowes his first lessons in architecture and encouraged him to subscribe to the most influential architecture books of the day, William Kent's *Designs of Inigo Jones* (1727), James Gibbs's *Book of Architecture* (1728), and Isaac Ware's edition of Palladio's *The Four Books of Architecture* (1738). Robinson was the owner of Rokeby Park, a few miles from Streatlam Castle, which he had built in the Palladian style in 1725–30.

Discussions about George Bowes's marriage had

Figure 8. Enoch Seeman the Younger (British, 1694–1744). *George Bowes.* Oil on canvas. Payment for the portrait is recorded in Mrs. Bowes's accounts for April 27, 1745. Glamis Castle (photo: courtesy of Kinghorne and Strathmore estates)

begun as early as 1720, when his future bride, Eleanor Verney, sole heiress of Lord Willoughby de Broke of Compton Verney, was only ten. If she were to marry

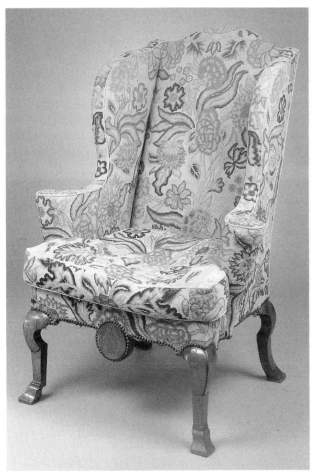

Figure 7. Chair with embroidered cover, with the Bowes coat of arms. English, ca. 1717. Location unknown (photo: courtesy of Sotheby's New York)

Figure 9. Silver-gilt ewer and basin by David Willaume (London), 1718. H. of ewer 33 cm. Diam. of basin 68 cm. London, Collection of Her Majesty Queen Elizabeth the Queen Mother (photo: reproduced by gracious permission of Her Majesty Queen Elizabeth the Queen Mother)

Figure 10. Silver teakettle and stand engraved with the Bowes coat of arms with Verney in pretense, by Simon Pantin (British, d. 1731), 1724. Silver, H. 103.5 cm. The Metropolitan Museum of Art, Gift of Irwin Untermyer, 1968, 68.141.81

Figure 11. Upholstered chair. English, ca. 1735. Walnut, partly gilt with pewter inlay, H. 106 cm. The Metropolitan Museum of Art, Rogers Fund, 1931, 31.86

after the age of fourteen, she would come into the sum of £15,000, and the marriage duly took place after her fourteenth birthday on October 1, 1724. In spite of the monetary aspect of the match, George Bowes was very much in love with his young bride, who was as beautiful as she was learned. It was this marriage that must have led to the family's acquisition of an elegant silver teakettle of 1724 by the London maker Simon Pantin, which was donated to the Metropolitan Museum with its original tall tripod silver stand (Figure 10). This is a rare feature of such wares and suggests that George Bowes hoped his wife would entertain in some style. It

Figure 12. *Gibside from the South*, engraving by Samuel Rawle after a watercolor by J. M. W. Turner (British, 1775–1851) for Robert Surtees's *History of Durham* (1816–23). The view shows clearly the James Paine chapel on the left and the column of Liberty on the right, with the Jacobean house in the middle distance. County Durham, The Bowes Museum, Barnard Castle 1983.35 (photo: The Bowes Museum)

is engraved with the Bowes–Blakiston arms with those of Verney "in pretence" (superimposed to indicate marriage to an heiress or last female representative of a noble family).[14] It must have superseded a similar, but plainer, teakettle and stand by the Newcastle maker Francis Batty of 1722, today in the collection of Her Majesty Queen Elizabeth the Queen Mother.[15]

Sadly, Eleanor Bowes died two and a half months after the marriage. Horace Walpole's gossip was that the bride "was said to die of the violence of the Bridegroom's embraces,"[16] and Lady Mary Wortley Montagu, the famous bluestocking, wrote a poem about her death beginning:

Hail, happy bride, for thou art truly blest?
Three months of rapture, crown'd with endless rest.[17]

As with most marriages among those with lands or money at that time, the marriage settlement was highly important. It was revoked, and Bowes had to pay back the £15,000 dowry plus £750 interest. However, the kettle and stand were retained, presumably as George Bowes's personal property, and feature in lists of family plate throughout the eighteenth and nineteenth centuries.

Bowes was now twenty-three, the owner of vast estates and already a widower. If his young wife had lived, it is likely that the Jacobean house at Gibside would have been replaced by a Palladian mansion. George Bowes was a successful businessman and in 1726 formed an agreement with his neighbors the Wortleys and the Liddells to restrict the coal trade in their own interests, forming a cartel known as the Grand Allies or Alliance. He became mayor of Hartlepool and of Durham in 1732, having presented a still-surviving statue of Neptune to the marketplace in Durham in 1730. He also paid for paneling in the town hall in 1751.

However, his main pastime was replanning the landscape of his mother's house at Gibside. The house was three stories high, with five bays of mullioned windows and a plain slate roof, and it stood above a steep drop to the River Derwent and water meadow below. It had been completed in 1620 and was by now rather old-fashioned, with the main dining room in the former Great Chamber on the first floor and some of the bedrooms located opposite. There were more bedrooms on the second floor, and garrets above, largely for servant use. Bowes began to modernize the house by putting in sash windows. His real interest, however, was the layout of the grounds, and under his supervision the nineteen Gibside walks were engineered according to designs by Stephen Switzer in 1731 and 1732. They provided points of interest on strolls through the

Figure 13. Mirror with gilded frame with the Bowes crest of interlaced arrows. English, ca. 1740. 175 x 100 cm. Liverpool, The Walker Art Gallery, on loan to The Bowes Museum, Barnard Castle (photo: The Bowes Museum)

grounds by members of the family and their guests, especially when there was a newly completed building to visit. His mother-in-law, Mrs. Verney, visited in 1734, after extensive repaneling and refurnishing by the Newcastle cabinetmaker James Bickerdike had taken place.[18] The bathhouse above the river was begun after Switzer's second visit to Gibside and completed in 1736, in time for a visit by the 3rd Duke of Cleveland, a descendant of Charles II, on April 6, 1737. Entertainments were given for the company at Durham, and a barge bore the duke and his wife to Tynemouth Light House, accompanied by a customs house boat and a town boat. Here there was further entertainment.[19] The walnut armchair with applied pewter ornament in the Metropolitan Museum (Figure 11), stylistically datable to about 1735, perhaps coincides with one of the visits. More buildings were undertaken, usually one at a time, as funds permitted. The New Coach Road (1738–40) was an engineering feat through difficult terrain, and the new stables (1747–51) were conveniently placed for access to the house. The banqueting house (1741–45) was a Gothic Revival belvedere from

Figure 14. Porcelain plate. Chelsea. Diam. 23 cm. County Durham, The Bowes Museum, Barnard Castle X3372 (photo: The Bowes Museum)

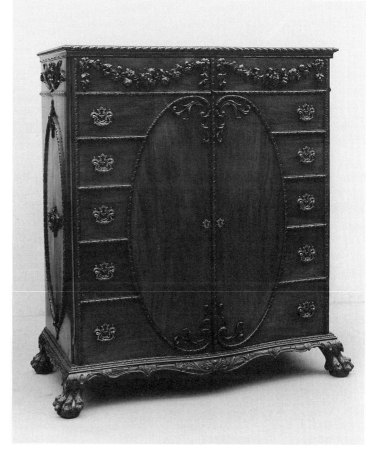

Figure 15. Mahogany clothespress marked "GIBSIDE," attributed to Vile and Cobb, ca. 1756. 143.2 x 126.2 x 67.2 cm. The Metropolitan Museum of Art, Gift of Morris Loeb, 1956, 56.125

which to view the whole estate. The 140-foot column bearing a statue of Liberty (1750–57) could be seen from the lower Derwent valley. It formed a culminating point for the Grand Avenue (1746–49), the western end of which was terminated by James Paine's Chapel, begun in 1760, the year of George Bowes's death (Figure 12).[20]

With all his activities in Parliament, as a coal owner, and running his estate, Bowes did not have much time to devote to refurnishing Gibside House. There is a solitary record of a couch being bought from William Hallet in 1739.[21] However, no further interior furnishing seems to have been done at Gibside until 1743, when George Bowes remarried and set about refurbishing Gibside in a manner suitable for his new bride. The London furniture maker William Greer provided mahogany and other furnishings to the value of £432.6.4.[22] These are recorded as being in the drawing and dining rooms in the Gibside inventory of December 1743, where they seem to have displaced walnut furniture sent on to the lesser rooms. The account book for this period in the Bowes Museum records purchases of jewelry, a silver tureen from the great Rococo silversmith Peter Archambo (£39.11.0), and further silver plate from "Mr. Nevill" and the

Countess of Essex to the enormous sum of £545.3.0. Sadly, none of this survives, but a Palladian-style mirror with the Bowes coat of arms would seem to date from this second wave of furnishment. It is one of a set of four, now split among the Metropolitan Museum, the Walker Art Gallery, Liverpool (currently on loan to the Bowes Museum; Figure 13), and the Rosenbach Foundation, Philadelphia.[23] With its severe architectural character and pedimented frame, it is in the latest Palladian taste, and the four must have decorated one of the main rooms in Gibside or the Bowes's town house in London.

George Bowes married Mary Gilbert on June 14, 1743. She was the heiress of Edward Gilbert of St. Paul's Walden Bury, Hertfordshire, and also had property in London as part of her dowry. They seem to have set about entertaining in a manner befitting their grand position. An evocative description of entertainment at Gibside during their marriage survives in the letters of the husband of Lady Mary Wortley Montagu of Denton Hall, Northumberland, in July 1753. He wrote: "I dined this day sennight at Gibside; it was one of the finest summer days I ever saw. . . . All the gentlemen are planting and adorning their Seats, but nothing comes up to the grandeur and magnificence of what Mr.

Bowes has done, and is a-doing. I ought not to omit telling you that he has already erected upon a rising ground a gothick building which he calls a Banquetting room, in which the night before there was a concert of Musick, at which Jordain and an Italian woman performed, whom Mrs. Lane brought with her from Bramham Moor [Bramham Park, North Yorkshire] from which she came in a day."[24] From Gibside, visits were made to dine with neighbors, such as the Ellisons at Park House, Gateshead, the Liddells at Eslington Park, Northumberland, and Bowes's brother-in-law Thomas Liddell at Newton, County Durham. These friends were usually engaged in the coal trade and sometimes had family connections. Visits were also made to the York races and Lord Burlington's Assembly Rooms there, with lodgings taken at York for the event, as well as the races at Newmarket in August 1756.

With this marriage the family seems determined to have their presence felt in London. Their London town house on Conduit Street was replaced by one in fashionable Grosvenor Square, rented from 1758 to 1759, first at number 13, then at number 40. As staging posts Bowes had already rented Ledston Hall, Yorkshire, and Newstead Abbey, Nottinghamshire, the ancestral home of the Byrons, in order to break the long journey between Gibside and London. Mary Bowes's accounts of expenditure survive for the years 1743–63 and form a fascinating account of fashionable spending in London.[25] They record her visits to Drury Lane Playhouse and the opera, as well as to benefit performances for Mrs. Woffington, Colley Cibber, and David Garrick. Her companion was often Miss Chalenor, the sister-in-law of Bowes's eldest sister, Anne. In 1755 Mary Bowes also visited Ranelagh, the pleasure gardens in London, where her husband's old friend Sir Thomas Robinson was master of ceremonies.

She began a collection of old master pictures, buying works attributed to Rubens,[26] still in the family, and others at a public auction in Pall Mall in January 1749. She also bought a set of prints of Marriage à la Mode direct from the painter William Hogarth in April 1746, less than a year after their completion.[27] She made numerous and continuous purchases from many of the fashionable London dealers and makers of fine furniture and porcelain, including "Dresden" (Meissen), Derby, Bow, and Chelsea. A set of Chelsea botanical plates in the Bowes Museum, bequeathed in 1878 with much other eighteenth-century porcelain by John Bowes's cousin Susan Davidson, may be survivors of two sets of "plates with plants" bought from the Chelsea sales of 1758 and 1759 (Figure 14).[28] Mary Bowes also bought from the fashionable furniture maker John Cobb in 1756,[29] who was famous not only for the quality of his furniture, made in association with his partner William Vile, but also for his "haughty behaviour," which included appearing in his workshops "in full dress of the most superb and costly kind" when giving orders to his workmen.[30] This payment may relate to the large Rococo mahogany clothespress once attributed to William Vile in the Metropolitan Museum marked "GIBSIDE" (Figure 15).[31] Its carved decoration is similar to that on an elaborate bookcase supplied by Vile to the royal family in 1762. Her greatest expenditure, however, was on the drawing room at Gibside, for which £1,000 was given by her father in April 1760. Some drawings survive that suggest the incorporation of large pictures from the collection, and a new chimneypiece was commissioned from the sculptor Thomas Carter. It may be noted that there was nothing "extravagant" about her spending, and everything was of good quality, suitable to the family's elevated and established position, rather than ostentatiously grand or expensive; in this the Boweses contrast with magnates such as Sir Lawrence Dundas[32] and Sir Watkin Williams-Wynn,[33] who commissioned fashionable architects to design their furniture and imported French tapestries and Continental porcelain in abundance, presumably to make a great splash in London society.

Meanwhile, other members of George Bowes's family had not been idle, and George Bowes's sister Elizabeth had bought and refurnished a house in Durham town in 1758. This was in addition to the family home in South Bailey, near the cathedral. She seems to have set about refurnishing it, and a pair of fine Rococo mirrors have appeared on the New York art market with a provenance from this house (Figure 16).[34] They must date from about 1760, as they are recorded in an inventory of that year, although Elizabeth herself had died in 1759 and the house was rented out for a number of years.[35]

Into this prosperous and discerning family Mary Eleanor, the only child of George and Mary Bowes, was born on February 24, 1749. Bowes received a letter of congratulations from Captain William Fitzthomas dated March 2, 1748: "What tho' it be'nt a Boy, the same Material will produce one, be industrious & apply yourself closely to the Business, & I warrent your success." He continued: "at least your blood, if not your Name will be transmitted to Posterity." He also mentioned a relative of his, who had some connection with the Bowes family and might be encouraged to take the name of Bowes and make a match of it.[36]

Mary Eleanor was born when her father was nearly fifty and perhaps unused to young children. She seems

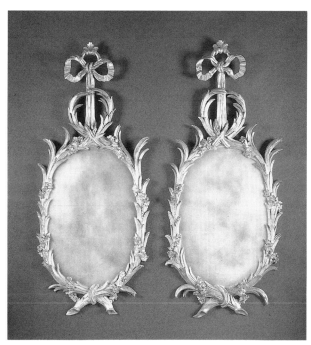

Figure 16. Pair of mirrors with gilt frames, from Elizabeth Bowes's town house in Durham (now the County Hotel). English, ca. 1760. 147 x 64.6 cm (photo: courtesy of Sotheby's New York)

Figure 17. J. C. Dillman Engleheart (British, 1783–1862), after George Engleheart (1752–1829). *Mary Eleanor Bowes.* Miniature, watercolor on ivory, H. 6 cm. County Durham, The Bowes Museum, Barnard Castle 1975-48 (Min 86) (photo: The Bowes Museum)

to have been treated as a young adult rather than a child, with great attention paid to learning and accomplishments. Her father would show her off to his friends reciting long speeches from Ovid's *Metamorphoses* and poems by Milton. She received lessons in music from the Newcastle composer Charles Avison and other lessons, including dancing and drawing, while for recreation she went to children's balls. Her favorite dances were given by the earl and countess of Northumberland for children from the age of five to fourteen. George Bowes died in 1760, leaving her a rich heiress, "the greatest heiress perhaps in Europe, and ugly in proportion" (Figure 17), according to Lord Chesterfield.[37]

Unfortunately, Mary Eleanor had little judgment of human nature. In 1767, at the age of eighteen, she married John Lyon, the 9th Earl of Strathmore, of Glamis Castle, Angus, Scotland, but they turned out to be temperamentally unsuited to each other. There exists a Chinese porcelain tea set with the Bowes arms that must date from just before this marriage, as it shows her coat of arms in a lozenge, the symbol for spinsters or widows (Figure 18). This contrasts with another Chinese porcelain service at Glamis Castle with the Bowes Lyon arms, which must date from after the marriage.

The marriage to the 9th Earl of Strathmore took a year and a half to arrange. One of the conditions of George Bowes's will was that anyone marrying his daughter, or succeeding to Gibside, would have to take the name of Bowes. This was at first not agreeable to Lord Strathmore, and there were also money matters to be arranged. The couple had five children, three boys and two girls, the eldest of whom was at first disliked by his mother.

The 9th Earl of Strathmore died of consumption in 1776 en route to Lisbon seeking a cure. The marriage had not been a happy one, and Mary Eleanor enjoyed her new freedom. She had an affair with George Grey, and, while expecting his child, suddenly married Andrew Robinson Stoney, an adventurer who had already maltreated and hastened the death of his wealthy first wife. He had wooed Mary Eleanor with a fake duel. Once married, Stoney sought to gain possession of the rents from the estate and tried to force her to make her property over to him. After ten years' struggle in the courts, she obtained a divorce and, in return for a pension, transferred the estate to her eldest son, John, the 10th Earl of Strathmore.[38]

In these unpropitious circumstances, there were few changes at Gibside, although Mary Eleanor had erected a magnificent greenhouse between 1772 and 1775 to cater to her interest in plants. She commissioned the

botanist William Paterson to collect specimens during his voyage to the Cape of Good Hope in 1774–79, and these were contained in an elegant Neoclassical cabinet, veneered in burr elm and kingwood, complete with pipes and taps in the legs. The front is decorated with carved boxwood cameos of artistic and scientific figures including Apollo, Homer, Pope, and Shakespeare, indicating the learned nature of its function.[39] The cabinet must have been a unique commission, specially designed and made, although nothing can be traced in the family accounts relating to its construction. The cabinet survived, minus its plants, into the twentieth century with some adaptations, and was bought by the Bowes Museum in 1961 (Figure 19).

Mary Eleanor's eldest son, John Bowes, the 10th Earl, made good the depredations of his stepfather and restored Gibside as nearly as possible to what his grandfather had planned, a place of interest and delight. However, he failed to marry for many years, owing to a liaison with Lady Tyrconnel of Seaton Delaval on the bleak Northumbrian coast. She was a great beauty, six years his senior, with an easygoing husband, and she became a constant visitor to Gibside. However, Lady Tyrconnel was suffering from consumption and her condition varied, but remedies were useless and she died at Gibside on October 8, 1800. Lord Strathmore was left in much the situation as George Bowes when his first wife died, and he too turned to Gibside for consolation and employment. Gibside House was too large for his needs as a young bachelor. The top floor was removed and a heavy castellated parapet erected to hide the pitched roof. In 1812 the chapel designed by James Paine was nearly complete and was consecrated. John Dobson (1787–

Figure 19. Botanical-specimen cabinet, English, ca. 1780. Veneered in walnut and kingwood with applied boxwood cameos framed in mahogany, 136 x 76 x 47 cm. County Durham, The Bowes Museum, Barnard Castle FW 56 (photo: The Bowes Museum)

Figure 18. Chinese porcelain teapot with the arms of Bowes, ca. 1767. H. 16 cm. County Durham, The Bowes Museum, Barnard Castle X.4439 (photo: The Bowes Museum)

1865) designed a new wing for Gibside House consisting of a two-story greenhouse, but this was rejected and the Earl of Strathmore returned to live at Streatlam Castle, the ancient seat of the Bowes. Here he formed a liaison with a village girl, Mary Millner, who gave birth to a son, John Bowes Bowes, in London in 1811.

The 10th Earl seems to have done little to the interiors at Gibside and Streatlam, other than adding some elegant suites of chairs, and was presumably happy with the furnishings ordered by his grandfather.[40] He did, nevertheless, buy a large quantity of plate from Rundell and Bridge between 1797 and 1801.[41] They would have contrasted with a utilitarian Wedgwood blue-and-white service that was perhaps used when Mary Millner attended dinner after her arrival at Streatlam

Castle in 1813, although never when other guests were present. It was transferred to the Bowes Museum by his son in 1882. His greatest coup, however, was the purchase of three watercolors by J. M. W. Turner, executed when he was in the northeast on a commission to paint Raby Castle for the Duke of Cleveland. Turner wrote to his friend James Holworthy on November 21, 1817, that "Lord Strathmore called at Raby and took me away north"[42] and the result was three watercolors, two of Gibside and one of another family property at Hylton Castle, one of which (*Gibside from the South*) was engraved by Samuel Rawle for Surtees's *History of Durham* (1816–23) (Figure 12).[43]

The 10th Earl tried to legitimize his infant son by marrying Mary Millner on the day before he died in 1820, but the courts decided that his claim to the Scottish title and estates was not valid, as his father had never resided in Scotland, and the title passed to the 10th Earl's brother Thomas, who became the 11th Earl of Strathmore, from whom Her Majesty Queen Elizabeth the Queen Mother, the Patron of the Friends of The Bowes Museum, is descended. However, the infant John Bowes Bowes (eventually contracted to John Bowes) was left with an entailed interest in the Bowes family properties in County Durham, which made him a very rich man. He maintained the family estates in good order but spent increasing periods of time in Paris, where he married an actress, Joséphine Coffin-Chevalier, who was the guiding force behind the founding of the Bowes Museum in their home town of Barnard Castle, which opened in 1892.[44] On his death in 1885 the Durham properties reverted to the Strathmore family, who now took on the surname Bowes Lyon. After World War I they withdrew from the Streatlam and Gibside estates, and a number of family pieces came on the market into the collections of the Metropolitan Museum and the Bowes Museum, as well as other collections. A room in Glamis Castle, Angus, is furnished with family pieces, including a seventeenth-century armorial chimney-piece from Gibside. Although Streatlam is now demolished and Gibside survives as a shell in the care of the National Trust, enough exists of their collections to suggest something of the wealth and magnificence of one of the leading families of the north of England.

ACKNOWLEDGMENTS

The authors would like to thank the Kinghorne and Strathmore estates for permission to quote from the family papers currently housed in the Durham County Record Office (D/St/D to Z).

NOTES

1. The location of the original documents is given in Joan Auld, "A Glamis Miscellany," *Archives* XIV, no. 63, pp. 131–140.

2. See Jennifer Gill, *Streatlam and Gibside: The Bowes and Strathmore Families in County Durham,* Durham Record Office, 1980, p. 28.

3. Philippa Glanville, "The Bowes Gold Cup: A Stuart Race Prize?," *Burlington Magazine* 137 (June 1995) pp. 387–390.

4. Durham Record Office, Strathmore Papers, D/St/D5/1/57.

5. Durham Record Office, Strathmore Papers, D/St/D5/1/59.

6. Preston Remington, "The Bowes-Blakiston Cabinet from Streatlam Castle," *MMAB* 26, no. 11 (Nov. 1931) pp. 264–267. The Trotter-Lawson cabinet is discussed and illustrated in Christopher Wilk, ed., *Western Furniture 1350 to the Present Day in the Victoria and Albert Museum* (London, 1996) pp. 80–81.

7. These dates are given in *Proceedings of the Society of Antiquaries, Newcastle-upon-Tyne,* no. 37 (1888) p. 381. However, the first date of 1719 is given by John Bowes, *Streatlam Castle in the County of Durham* (London, 1880) p. 13, and the catalogue of the sale of remaining contents and fittings held at Streatlam Castle by Perry & Phillips Ltd., Bridgenorth, Salop, on May 24–26, 1927.

8. Streatlam Castle and its contents were discussed and illustrated in *Country Life* 38 (Dec. 18, 1915) pp. 836–843.

9. R. Edwards and Percy Maquoid, *The Dictionary of English Furniture* (London, 1954) I, p. 258, fig. 98; the set sold at Parke-Bernet New York, Nov. 3–5, 1960, lot 370; a single chair sold at Sotheby's New York, Oct. 16, 1993, lot 308.

10. This supposition seems to be borne out by the volume of Bowes letters in the British Library (Add. Ms 40747), in which William writes twice (March 13, 1717/18, and April 24, 1718) to his mother from London, mentioning chairs and beds that he is sending to her in Durham. There is also a letter of 1720 to a prospective father-in-law in which he describes his assets, including £1,600 of silver, and mentions renovations at Streatlam and Gibside.

11. A related stand of the same date and by the same maker is in the Museum of Fine Arts, Boston. Other Bowes silver of the early 18th century includes a teapot and stand by John Leach of 1709 (*Christie's Review of the Year,* 1960–62, p. 34), and a coffeepot by John Bache of 1724 (sold at Christie's, July 12, 1989, lot 197).

12. A plain silver punch bowl (Newcastle, 1725) that he gave to the Newcastle Company of Bakers and Brewers ca.1736 is now in the Bowes Museum (1984.5).

13. Durham Record Office, Londonderry Papers, D/Lo/F743 (14) June 10, 1744.

14. "A Unique Ensemble," *Connoisseur* (Aug. 1955) p. 27; Yvonne Hackenbroch, *English and Other Silver in the Irwin Untermyer Collection* (New York, rev. ed., 1969) p. 72, figs.138, 139. See also *Queen Charlotte's Loan Exhibition of Old Silver,* Seaford House (London, 1929) pl. 43 (tripod stand only).

15. See John Cornforth, *Queen Elizabeth the Queen Mother at Clarence House* (London, 1996) p. 53, which also illustrates other pieces of family silver today in Her Majesty's collection.

16. G. Sherburn, "Walpole's Marginalia in Additions to Pope (1776)," *Huntingdon Library Quarterly* 1 (1938) p. 482, no. 171.

17. Robert Halsband, *The Life of Lady Wortley Montagu* (Oxford, 1956) p. 123.

18. Durham Record Office, Strathmore Papers, D/St/E5/5/2.

19. John Gloag and Yvonne Hackenbroch, *English Furniture with Some Other Furniture of Other Countries in the Irwin Untermyer Collection* (London, 1958) figs. 109, 110, and p. 25.

20. For a fuller account of the garden buildings at Gibside, see Margaret Wills, *Gibside and the Bowes Family* (Newcastle upon Tyne, 1995).

21. Durham Record Office, Strathmore Papers, D/St/E5/8/10. The couch was possibly recovered by John Bowes in 1845; see D/St/E15/7/3.

22. Sarah Medlam, "William Greer at Gibside," *Furniture History* (1990) pp.143–156.

23. Information in MMA files, courtesy of John Cornforth.

24. Emily J. Climenson, *Elizabeth Montagu. The Queen of the Blue-Stockings. Her Correspondence from 1720 to 1761* (London, 1906) pp. 36–37.

25. Durham Record Office, Strathmore Papers, D/St/E15/5/96 to 100 and D/St/E12/11.

26. In fact, a version of Franz Snyders's *Fruit Market* now in the Hermitage, Saint Petersburg (see Susan Koslow, *Snyders* [Antwerp, 1996] p. 17).

27. April 26, 1746: "Paid Mr. Hogarth the Painter for Six Prints of Marriage a la Mode being ye second Payment 10/6d"; May 20, 1746: "Paid Elias Shadows bill for framing six Prints of Marriage à la Mode £1/18." They were subsequently recorded in the "Sotts Hall" (the drunkard's hall or gaming room) at Gibside in the inventory of 1761.

28. March 11, 1758: "Pd at y. Chelsea sale for 12 Plates with Plants £5 & four small Baskets for Fruit £2.5.0"; April 10, 1759: "Pd at ye Chelsea sale for 12 Plates with Plants £5.17.6d & 12 Plates less [?] £5.7.6d."

29. Nov. 30, 1756: "Paid Mr. Cobb Cabinet Makers for a Mahogany tea chest 12/-; Paid ditto for ditto a Mahogany table with a drawer in it 15/-; Paid for a large Mahogany chest of drawers to th[e] ap. [?] Maho[gan]y Night table £6.10s"; Feb. 15, 1758: "Pd Mr.Cobb Upholdersher y.Balance of his Bill in bill on Child [Mrs.

Bowes's banker] £61.18.9d." Further payments to Cobb for 1754–57 are recorded in Medlam, "William Greer at Gibside," p. 155.

30. J. T. Smith, *Nollekens and His Times* (London, 1829) II, p. 243, quoted in Geoffrey Beard and Christopher Gilbert, *Dictionary of English Furniture Makers 1660–1840* (London, 1986) p. 182.

31. Anthony Coleridge, *Chippendale Furniture* (London, 1968) p. 22, fig. 11.

32. For the Dundas collection, see the special issue of *Apollo* (Sept. 1967).

33. Oliver Fairclough, "Sir Watkin Williams-Wynn and Robert Adam: Commissions for Silver 1768–80," *Burlington Magazine* 137 (June 1995) pp. 376–386.

34. Sold at Sotheby's, New York, Oct. 13, 1994, lot 479.

35. Durham Record Office, Strathmore Papers, D/St/E8/9 to 13.

36. British Library, Add. Ms 40748, Bowes MS, pp. 103–104.

37. Bonamy Dobré, ed., *The Letters of Philip Dormer Stanhope 4th Earl of Chesterfield*, VI (London, 1932) no. 2480, pp. 2795–2796.

38. Her life story is described in Ralph Arnold, *The Unhappy Countess* (London, 1957).

39. Identifications are due to Gertrude Seidmann, Oxford.

40. A pair of Regency armchairs from Gibside was sold at Sotheby's, London, July 4, 1997, lot 85.

41. This included tureens, dinner plates, ice buckets, and a centerpiece (D/St/C1/10/16–17). The Bowes family silver was sold at Christies, London, Dec. 8, 1948, but the catalogue descriptions are too imprecise to enable many identifications to be made. A set of dinner plates with the 10th earl's arms by James Young, London, 1791, from the 1948 sale (lot 78) was sold at Christie's, April 30, 1996, lot 63.

42. John Gage, *Collected Correspondence of J. M. W. Turner* (Oxford, 1980) p. 71.

43. Andrew Wilton, *Turner* (London, 1979) nos. 556, 557.

44. See Charles Hardy, *John Bowes and the Bowes Museum* (Bishop Auckland, 1970); see Elizabeth Conran et al., *The Bowes Museum* (London, 1992).

The Porcelain Decoration of Ignaz Bottengruber

MAUREEN CASSIDY-GEIGER

Curator, The Arnhold Collection

THE METROPOLITAN MUSEUM OF ART OWNS A number of pieces of porcelain with decoration attributed to Ignaz Bottengruber, an independent porcelain painter, or so-termed *Hausmaler*, whose painting on porcelain is distinguished by its rich allegorical content and lyrical Baroque style. In the 1720s he resided in the Silesian city of Breslau, and his work for one notable patron, the collector Dr. Johannes Georgius Pauli (d. 1736), was documented by Dr. Johann Christian Kundmann (1684–1751), the chronicler of that city's outstanding *Kunst- und Raritäten-Cabinets*. In 1723 Kundmann praised Bottengruber's painting on porcelain as superior to that of another local *Hausmaler*, Ignaz Preissler (1676–1741), who worked in a different palette and more formalized style: "darauf in Bresslau erstlich Herr Preussler nur grau in grau oder schwarze Gemählde gemacht, ietzo aber verrichtet dieses Herr Pottengruber mit allen bunten Farben, und zwar in solcher Perfection, als es sonst niemals allhier geschehen worden."[1]

While Bottengruber's works have remained collectors' items, almost nothing is known about the painter beyond what was recorded by Kundmann. Gustav E. Pazaurek, who brought the *Hausmaler* to prominence in 1925 with the publication of his landmark two-volume work, *Die Deutsche Fayence- und Porzellan-Hausmaler*,[2] located a record for the 1721 baptism of Bottengruber's son Johannes. He had already published this information in 1902, in the only comprehensive study of the artist.[3] Kundmann's published accounts of the libraries and so-called collector's cabinets in Breslau therefore remain the primary record of Bottengruber's activity.

Breslau (now Wrocław), an important Catholic university city and a center for trade and transport in the region, was home to twelve notable *Kunst- und Raritäten-Cabinets*, or "Museums," which Kundmann describes in detail in the *Promtuarium rerum naturalium et artificialium Vratislaviense* of 1726.[4] Two references to Bottengruber appear in the entry on the collection belonging to Dr. Pauli. Cited under the category *Picturae*, among works with generous attributions to a range of notable Renaissance and later artists, an album of watercolors of local birds by Bottengruber is singled out for mention, followed by his porcelains: "2.) Aviarium Silesiae ad naturalem sere similitudinem expressum, colore aqueo a *Bottengrubero*. 3.) Diversa instructa vasorum porcellaniorum eleganter pictorum & encausticorum a *Bottengrubero*."[5]

The circumstances of Bottengruber's employment by Pauli were published by Kundmann in 1741, with comments and an excursus that are useful to this essay.[6] The son of Dr. Matthäus Pauli, personal physician to Friedrich Augustus I of Saxony (later Augustus the Strong), Johannes Pauli undertook a period of travel and study after settling in Breslau as a young man. A trip to Paris provided the opportunity, if not the impetus, to amass a large collection of important books, drawings, and prints from various sources. It may have been Pauli's erudition, as much as the richness of his library, that inspired the elaborate iconography of Bottengruber's programs, which were doubtless intended to interest and amuse his patron's like-minded friends. For example, on a tankard painted with subjects after Bruegel and his circle, a monkey holds open a book inscribed with the instructions "Redeunt Saturnia Regna: RISUM seneatis Amici," a reference to Virgil's *Eclogues* (Figures 1, 2).[7]

Bottengruber seems to have worked exclusively for Pauli and lived under his auspices for several years, in the manner of a court artist. He was initially commissioned to produce the avian watercolors singled out by Kundmann, which were eventually sold to a man named Schumacher. Otherwise, Bottengruber painted on porcelain, firing the enamel decoration in a muffle kiln. The decoration of one bowl much coveted by Kundmann, who once had the opportunity to buy it but did not because of its high price, was described as a bacchic festival and may be one of the two known waste-bowls painted with renderings of *The Triumph of Bacchus* after Maerten-Jacobsz van Veen, called Heems-

© The Metropolitan Museum of Art 1998
METROPOLITAN MUSEUM JOURNAL 33

The notes for this article begin on page 258.

Figure 1. Tankard. Decoration attributed to Ignaz Bottengruber, Breslau, ca. 1726. Hard-paste DuPaquier (Vienna) porcelain. H. 10.3 cm. Nuremberg, Germanisches Nationalmuseum, Ke 799 (photo: Germanisches Nationalmuseum)

Figure 3. Waste-bowl. Decorated by Ignaz Bottengruber, signed and dated Vienna, 1730. Hard-paste DuPaquier (Vienna) porcelain. Diam. 17 cm. Vienna, Österreichisches Museum für angewandte Kunst, Ke 6077 (photo: Pazaurek, "Ignaz Bottengruber," p. 150)

246

Figure 2. Alternate view of Figure 1 (photo: Germanisches Nationalmuseum)

kerk (1498–1574) (Figures 3, 4).[8]

At some point, Dr. Pauli dabbled in alchemy and formulated a "universal cure," which proved fatal to a number of his test patients. Because of this catastrophe, he fled to Danzig (now Gdansk, Poland), where he lived under an assumed name until his death in 1736. He left instructions that his collection be sold to cover his debts, with the exception of a number of books that he left to his only son.

A small number of porcelains signed and dated by Bottengruber help document the Breslau years and indicate a subsequent period of activity in Vienna. He painted on blank porcelain from the Meissen and DuPaquier factories or on Chinese porcelain (Figure 5).[9] He commonly placed a signature or initials on the

Figure 4. Underside of Figure 3 showing signature "IABottengruber Siles:/f. Viennae 1730" (photo: *Sammlung des Freiherrn Adalbert von Lanna Prag* [Lepke, 1909])

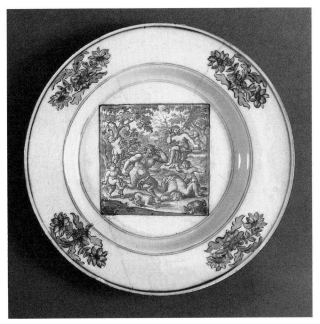

Figure 5. Plate. Decorated by Ignaz Bottengruber, signed and dated Breslau, March 1728. Hard-paste Chinese porcelain. Diam. 20.9 cm. Stuttgart, Württembergisches Landesmuseum, G 25,17 (photo: Württembergisches Landesmuseum)

Figure 6. Underside of Figure 5 showing signature: "Wratisl A 1728/ Mens: Mart./ IABottengruber f" (photo: Württembergisches Landesmuseum)

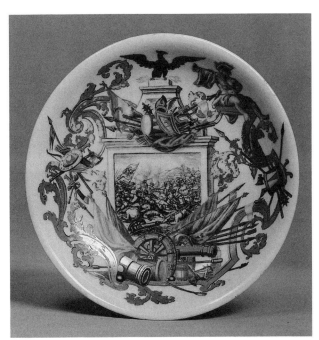

Figure 7. Saucer. Decorated by Ignaz Bottengruber, signed and dated Breslau, 1726. Hard-paste DuPaquier (Vienna) porcelain. Diam. 4⅞ in. The Metropolitan Museum of Art, Gift of R. Thornton Wilson, in memory of Florence Ellsworth Wilson, 1950, 50.211.18

Figure 9. Johann August Corvinus after a painting by Georg Philipp Rugendas and ornament by Abraham Drentwett, *Belagerung und Eroberung der Festung Dendermonde* from the set entitled *Repraesentatio Belli ob Successionem in Rego Hispanico . . .* , published by Jeremias Wolff (Augsburg, after 1714). Engraving, 44.1 × 37.6 cm trimmed. The New York Public Library, MEOI+ Decker, pl. 27 (photo: New York Public Library)

Figure 8. Underside of Figure 7 showing signature: "IAB f. Wrat:/ 1726"

Figure 10. Teabowl and saucer. Decorated by Ignaz Bottengruber, signed "IAB f: Wrat: 1726," Breslau, 1726. Hard-paste DuPaquier (Vienna) porcelain. H. teabowl 4.2 cm; Diam. saucer 12.4 cm. Hamburg, Museum für Kunst und Gewerbe (photo: Museum für Kunst und Gewerbe)

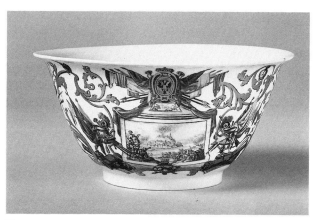

Figure 12. Waste-bowl. Decorated by Ignaz Bottengruber, Breslau, 1726. Hard-paste DuPaquier (Vienna) porcelain. H. 8.3 cm; Diam. 17.4 cm. Hamburg, Museum für Kunst und Gewerbe, 1878,221 (photo: Museum für Kunst und Gewerbe)

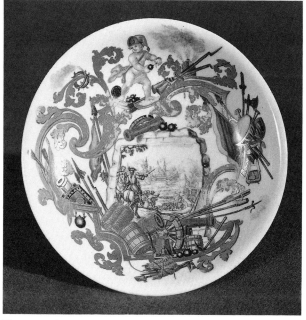

Figure 11. Saucer. Decorated by Ignaz Bottengruber, Breslau, 1726. Hard-paste DuPaquier (Vienna) porcelain. Diam. 12.8 cm. Nuremberg, Germanisches Nationalmuseum, LGA 5166 (photo: Germanisches Nationalmuseum)

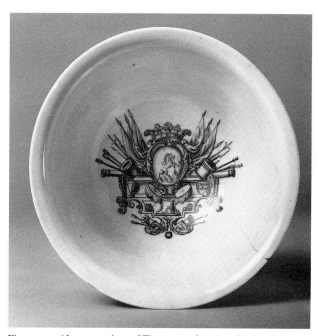

Figure 13. Alternate view of Figure 12 showing the inside (photo: Museum für Kunst und Gewerbe)

reverse, often including the year and name of the place where the pieces were painted. Some of these are signed with an abbreviation of *Wratislaviense*, the Latin name for Breslau, and are dated 1726, 1727, or 1728 (Figures 6, 8).[10] There are also pieces inscribed on the underside *Viennae* and dated 1730, placing the artist in that city in that year (Figures 3, 4, 50).

The Museum owns a signed and dated saucer from a tea service painted in Breslau in 1726 (Figures 7, 8). The subject of the decoration, the Austrian victory over the Turks, was extremely popular in the regions threatened for centuries by the Ottomans. The entab-

lature in the center features a battle scene in the manner of Georg Philipp Rugendas (1666–1742), rendered in violet monochrome, with the Austrian eagle appearing in the tableau and atop the pediment. The thick gold foliate strapwork inside the rim supports large and small military trophies painted in polychrome, as well as a putto with military attributes. Bottengruber was able to assimilate a range of sources when devising such a program, influenced as much by French ornament prints as by the elaborate commemorative series published by Jeremias Wolff after 1714 to recognize the important battles of the War of the Spanish Succession

248

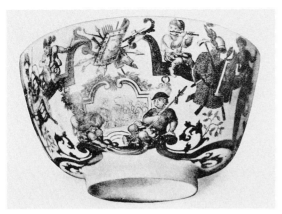

Figure 14. Waste-bowl. Decorated by Ignaz Bottengruber, signed "IA. Bottengruber f. Wratisl. 1727," Breslau, 1727. Hard-paste DuPaquier (Vienna) porcelain (?). H. 8 cm; Diam. 15 cm. Dresden, Porzellansammlung, Staatliche Kunstsammlungen (photo: Pazaurek, "Ignaz Bottengruber," p. 146)

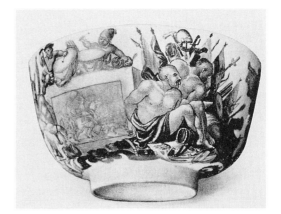

Figure 15. Alternate view of Figure 14 (photo: Pazaurek, "Ignaz Bottengruber," p. 146)

(Figures 9, 23, 24).[11] The decoration of other known parts of the service follows the same general format (Figures 10–12). The placement of trophies on the inside or underside of bowls and saucers is typically Bottengruber (Figure 13).

Bottengruber devised a related program for another service, painted in 1727. The chief distinction is that, in the later service, the putti are fully clothed (Figures 14, 15). The Museum owns a bottle decorated en suite that copies the decoration on another Bottengruber bottle almost verbatim, except for the addition of the coat of arms on one side (Figures 16, 17). Long attributed to Bottengruber, the bottle has a very different style of painting and must be assigned

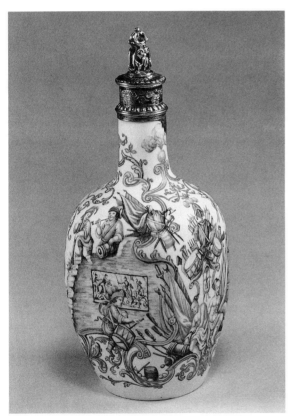

Figure 16. Square bottle. Decoration attributed to Ignaz Preissler, ca. 1731. Hard-paste DuPaquier (Vienna) porcelain. H. with cover 45.2 cm. The Metropolitan Museum of Art, Gift of Irwin Untermyer, 1964, 64.101.233ab

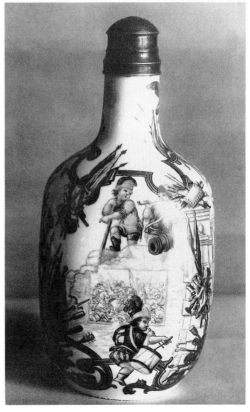

Figure 17. Square bottle. Decoration attributed to Ignaz Bottengruber, ca. 1727. Hard-paste DuPaquier (Vienna) porcelain. Hamburg, formerly Tillmann Collection; destroyed (photo: Karin Kiemer)

Figure 18. Waste-bowl. Decoration attributed to Ignaz Bottengruber, Breslau, ca. 1725–30. Hard-paste DuPaquier (Vienna) porcelain. Diam. 19.3 cm. Toronto, The George R. Gardiner Museum of Ceramic Art, G 83.1.734 (photo: The George Gardiner Museum)

Figure 19. Teabowl and saucer. Decoration attributed to Ignaz Bottengruber, ca. 1725–30. Hard-paste DuPaquier (Vienna) porcelain. H. teabowl 4.5 cm; Diam. saucer 13 cm. Toronto, The George R. Gardiner Museum of Ceramic Art, G 83.1.733 (photo: The George Gardiner Museum)

Figure 20. Saucer. Decoration attributed to Ignaz Preissler, Breslau, ca. 1720–25. Hard-paste Meissen porcelain. Diam. 8.3 cm. The Metropolitan Museum of Art, Gift of Irwin Untermyer, 1964, 64.101.240

Figure 21. Saucer. Decorated by Ignaz Bottengruber, Breslau, ca. 1728. Signed "Bottengr f." Hard-paste DuPaquier (Vienna) porcelain. Diam. 13.3 cm. The Metropolitan Museum of Art, The Lesley and Emma Sheafer Collection, Bequest of Emma A. Sheafer, 1973, 1974.356.548

Figure 22. Two teabowls with saucers and teapot. Decoration attributed to Ignaz Bottengruber, Breslau, ca. 1728; one saucer signed "Bottengruber f." Hard-paste DuPaquier (Vienna) porcelain. Formerly Gustav von Klemperer Collection (from Ludwig Schnorr von Carolsfeld, *Porzellansammlung Gustav von Klemperer* [Dresden, 1928] pl. 40)

instead to the hand of Ignaz Preissler.[12] Preissler generally painted in black or iron-red monochrome, in the manner of the late-seventeenth- and early-eighteenth-century Nuremberg glass and faience decorators, who detailed their paintings by scratching through the enamel with a sharply pointed tool. At the end of his life, Preissler expanded his palette with enamel colors purchased for him in Vienna, but he continued to employ the scratch technique, as in the decoration of the bottle in Figure 16.[13]

Figure 23. Jean Bérain. Untitled ornamental design from *Ornemens inventez par J. Bérain . . .* (Paris, 1711). Engraving. The Metropolitan Museum of Art, Rogers Fund, 1921, 21.36.141

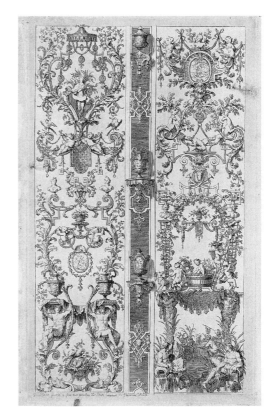

Figure 24. Daniel Marot. Untitled ornamental design from André Berard, *Catalogue de toutes les estampes qui forment l'oeuvre de Daniel Marot* (Brussels, 1865). Engraving. The Metropolitan Museum of Art, Thomas J. Watson Library 201.6M34/B45

Bottengruber may have been influenced by Preissler in turn. On parts of a service decorated with painterly scenes of battle in sepia-black monochrome, the palette and treatment of the subject recall Preissler's services commemorating the War of the Spanish Succession but are attributed to Bottengruber on the basis of style (Figures 18–20). Trophies of Turkish arms and military banners in *Schwarzlot* touched with gold decorate the inside and underside of various pieces of Bottengruber's service.[14]

Another saucer in the Metropolitan belongs to a service painted with hunting capriccios, inspired perhaps by the designs of Daniel Marot (ca. 1663–1752) and Jean Bérain (ca. 1640–1709) (Figures 21–24). The putti are costumed for the hunt; the trophy, netting, and guns are further allusions to the fox hunt taking place atop and within the richly framed cartouche in the center of the Museum's piece. The decoration of the saucers, teabowls, and teapot in the von Klemperer collection, lost in World War II, featured other game animals and birds. On each piece the painterly version of the hunt, executed in black monochrome, is a conventional depiction of the subject rooted in the seventeenth-century prints of Hieronymus

Figure 25. Leaf-shaped dish. Decoration attributed to Ignaz Bottengruber, Breslau, 1726. Hard-paste DuPaquier porcelain. H. 4.5 cm; L. 13 cm. The Metropolitan Museum of Art, Gift of R. Thornton Wilson, in memory of Florence Ellsworth Wilson, 1943, 43.100.40

Figure 26. Jean LePautre. *Oeuvres*, IV, p. 69. Engraving. The Metropolitan Museum of Art, Harris Brisbane Dick Fund, 1933, 33.84

Figure 27. Jean LePautre. *Oeuvres*, IV, p. 39. Engraving. The Metropolitan Museum of Art, Harris Brisbane Dick Fund, 1933, 33.84

Cock, Adrian Collaert, Philip Galle, Antonio Tempesta, and others after the designs of Jan van der Straet, called Stradanus.[15] The quality of the gilding is usually poor on *Hausmalerei*, and this example exhibits the dull, bronzelike appearance of Bottengruber's gilding, a result of applying the gold over brown enamel.

Mythological subjects dominate Bottengruber's oeuvre, and, like the military or hunting subjects, most were conceived as allegorical programs modeled on French sources (Figures 26, 27, 30, 31).[16] The heavy, compact decoration of a leaf-shaped dish in the Metro-

politan, painted with allegorical subjects—Bacchus and autumn—compares with that on a small group of wares datable to about 1726, according to the signed and dated saucer in the British Museum (Figures 25, 28, 29). On the British Museum saucer the central composition of figures has been copied from the left side of an engraving by Jean LePautre (see Figures 29, 30).

On another group of porcelains with allegories of the seasons or months, the capriccios are lighter and more playful, recalling the concept and format of the polychrome military services. Gods and goddesses

Figure 28. Coffeepot with cover. Decoration attributed to Ignaz Bottengruber, Breslau, 1726. Hard-paste Meissen or DuPaquier (Vienna) porcelain. H. with cover 21 cm. Berlin, formerly collection of Max Höhne (photo: from Pazaurek, "Ignaz Bottengruber," pl. V)

Figure 29. Teabowl and saucer. Decorated by Ignaz Bottengruber, signed "W/ IAB 1726." Breslau, 1726. Hard-paste DuPaquier (Vienna) porcelain. Diam. saucer 13.2 cm. London, The British Museum, Franks Coll. 123 (photo: The British Museum)

252

Figure 30. Jean LePautre. *Oeuvres*, IV, p. 213. Engraving. The Metropolitan Museum of Art, Harris Brisbane Dick Fund, 1933, 33.84

Figure 31. Jean LePautre. *Oeuvres*, IV, p. 38. Engraving. The Metropolitan Museum of Art, Harris Brisbane Dick Fund, 1933, 33.84

representing fall and winter join putti symbolizing the seasons on a pair of large, twelve-sided DuPaquier dishes datable to 1728 (Figures 32, 33). On one, Bacchus and Ariadne sit among trailing grapevines and branches heavy with fruit. The other dish shows the winged figure of Boreas, the cold North Wind, appealing to Oreithyia, daughter of an earthly king. Here, the trailing vines bear leaves of ivy and laurel, both evergreen in winter, and the putti are dressed warmly against the cold. Birds and other live attributes complete the program. On a related set of round dishes, putti conduct the labors of the months, supported by signs of the zodiac and other symbolic attributes (Figure 34).[17] Allusions to harvesting and the making and drinking of wine constitute the decoration of a pair of

Figure 32. Twelve-sided dish. Decoration attributed to Ignaz Bottengruber, signed "IAB f. Wrat: 1728." Hard-paste DuPaquier (Vienna) porcelain. Diam. 26.3 cm. Berlin, Kunstgewerbemuseum/ Staatliche Museen Preussischer Kulturbesitz, M 1546

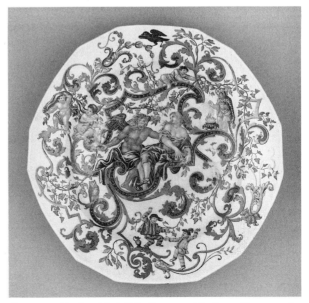

Figure 33. Twelve-sided dish. Decorated by Ignaz Bottengruber, signed "IAB f. Wrat: 1728." Hard-paste DuPaquier (Vienna) porcelain. Diam. 26.8 cm. Berlin, Kunstgewerbemuseum/ Staatliche Museen Preussischer Kulturbesitz, M 1547

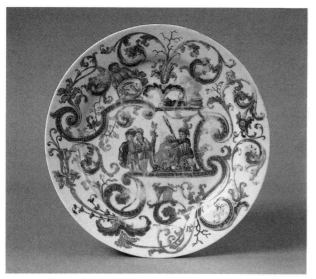

Figure 34. Dish. Decoration attributed to Ignaz Bottengruber, Breslau, ca. 1728. Hard-paste porcelain. Diam. 23 cm. Collection of Jeffrey Tate and Klaus Kuhlemann (photo: courtesy of the owners)

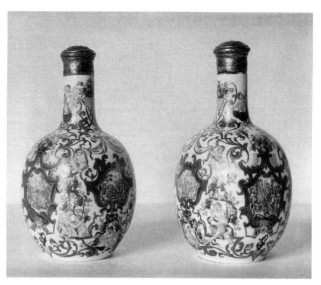

Figure 35. Pair of flasks. Decoration attributed to Ignaz Bottengruber, Breslau, ca. 1726–28. Hard-paste DuPaquier (Vienna) porcelain. Hamburg, Museum für Kunst und Gewerbe (photo: Museum für Kunst und Gewerbe)

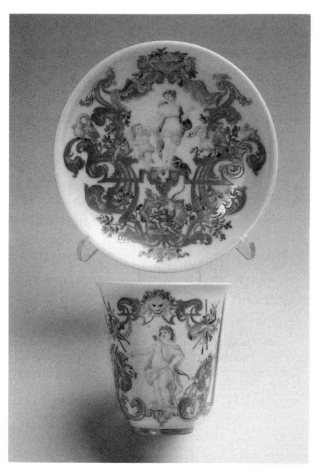

Figure 36. Beaker and saucer. Decoration attributed to Ignaz Bottengruber, Breslau, ca. 1728. Hard-paste DuPaquier (Vienna) porcelain. Beaker H. 2⅜ in., saucer Diam. 4⅞ in. The Arnhold Collection

Figure 37. Beaker. Decoration attributed to Ignaz Bottengruber, Breslau, ca. 1728. Hard-paste DuPaquier porcelain (Vienna). Collection of Jeffrey Tate and Klaus Kuhlemann (photo: Christie's)

square DuPaquier bottles in Hamburg and may indicate their use as wine flasks (Figure 35).[18]

Obviously a skilled miniature painter, Bottengruber was an artist whose understanding of allegory and talent for invention were unique among the *Hausmaler*, who were more draftsmen than artists and copied directly from print sources. For a set of beakers and saucers painted with allegories of the months, it seems likely that Bottengruber worked from published

Figure 38. Claude Audran and others. "Janvier" and "Fevrier" from *Les Douze Mois Grotesques*. Engravings by Jean Audran. The Metropolitan Museum of Art, The Elisha Whittelsey Collection, The Elisha Whittelsey Fund, 1949, 49.20.4 (1)

series, such as *Les Douze Mois Grotesques* by Jean Audran (1667–1756), or from sheets of French-style ornament issued in numbered sets by Christoph Weigel (Figures 36–40).[19] The resulting program is characterized by its freshness and individuality. On each piece episodes from Ovid's lives of the gods are rendered in black monochrome, along with their attributes and animal and bird attendants. A wealth of objects associated with each god is entwined in the meandering strapwork or tied into specialized trophies. On one beaker, bulrushes, anchors, tridents, and oars form the trophies flanking Neptune, who stands beneath a shell portal festooned with branches of coral (Figures 37, 38).

A related program decorates a group of objects that have associations with Charles VI. The life of Apollo, god of the sun, is the subject of the reserved decoration on a Metropolitan coffeepot that also has signs of the zodiac (Figures 41, 42). Opposite the handle, Phoebus drives his chariot through the sky, and on the sides he pursues Daphne and stands before the slain Python. Apollo Musagetes and Asclepius, god of medicine and son of Apollo and Coronis, flank the base of the central cartouche. The signs of the zodiac are variously represented by putti, animals, or signs painted in shield-shaped frames, each incorporating a six-

Figure 39. Paul Decker. Untitled title plate from pattern book no. 99. Engraving. Published by Christoph Weigel (photo: Berliner and Egger, *Ornamentale Vorlageblätter des 15. bis 19. Jahrhunderts* [Munich, 1981] no. 1218)

Figure 40. Another sheet from pattern book no. 99 with title plate illustrated in Figure 39 (photo: Berliner and Egger, *Ornamentale Vorlageblätter des 15. bis 19. Jahrhunderts* [Munich, 1981] no. 1219)

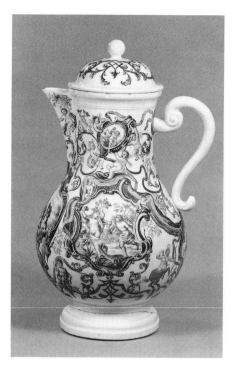

Figure 41. Coffeepot with cover. Decoration attributed to Ignaz Bottengruber, ca. 1728–30. Hard-paste Meissen porcelain. H. with cover 22.2 cm. The Metropolitan Museum of Art, Gift of R. Thornton Wilson, in memory of Florence Ellsworth Wilson, 1950, 50.211.17ab

Figure 42. Alternate view of Figure 41

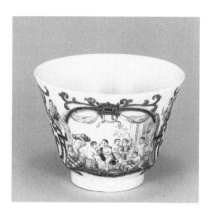

Figure 44. Teabowl. Decorated by Ignaz Bottengruber, ca. 1728–30. Hard-paste DuPaquier (Vienna) porcelain. H. 5.5 cm. Vienna, Österreichisches Museum für ange-wandte Kunst, Ke 6197 (photo: OMak)

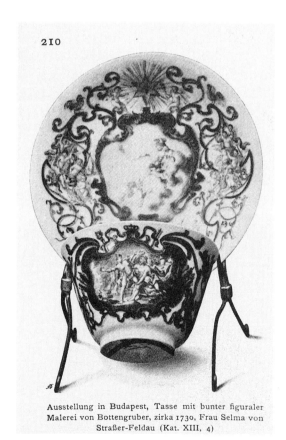

210

Ausstellung in Budapest, Tasse mit bunter figuraler Malerei von Bottengruber, zirka 1730, Frau Selma von Straßer-Feldau (Kat. XIII, 4)

Figure 43. Teabowl and saucer. Decorated by Ignaz Bottengruber, ca. 1728–30. Hard-paste DuPaquier (Vienna) porcelain. Budapest, formerly collection of Selma von Straßer-Feldau (from *Kunst und Kunsthandwerk* 11 [1908] p. 210)

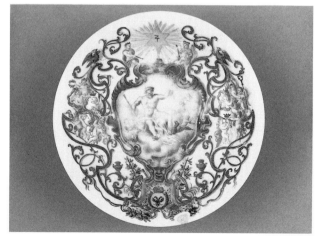

Figure 45. Saucer. Decorated by Ignaz Bottengruber, signed "I.B. f," ca. 1728–30. Hard-paste DuPaquier (Vienna) porce-lain. Diam. 13.1 cm. Vienna, Österreichisches Museum für angewandte Kunst, Ke 6194.2260 (photo: OMaK)

Figure 46. Alternate view of Figure 47, illustrating inside cover with initials

Figure 47. Two-handled bowl with cover. Decoration attributed to Ignaz Bottengruber, ca. 1730. Hard-paste DuPaquier (Vienna) porcelain. H. 12.1 cm. The Metropolitan Museum of Art, The Lesley and Emma Sheafer Collection, Bequest of Emma A. Sheafer, 1973, 1974.356.489

Figure 48. Alternate view of Figure 47, illustrating outside cover

pointed star, the personal device of Emperor Charles VI, as well as Apollo in apotheosis.[20] On a set of five paired teabowls and saucers from a closely related service, the incorporation of the six-pointed star and imperial regalia, including the Austrian two-headed eagle, further substantiates an association with the Hapsburg emperor (Figures 43–45).[21] Painted with the planetary gods—Mercury, Venus, Jupiter, Saturn—the saucer with Jupiter is today paired with the teabowl for Mercury in the Museum für angewandte Kunst in Vienna. The subject of the decoration of the other two teabowls and saucers might have been Diana, the moon, and Mars, the only other planet known at the time.[22] The use of yellow enamel instead of gilding on the coffeepot, compared with the use of gilding on the teabowls and saucers, distinguishes the two services.

Perhaps the clearest indication that Bottengruber was undertaking commissions for objects destined to be presented to members of the imperial family is a covered two-handled bowl painted on the inside of the cover with the crowned entwined initials of Crown Princess Elisabeth Christina (Figures 46–48). Showing scenes of Flora in violet monochrome and winged putti bearing flowers in tribute, the decoration derives from French sources and is at once feminine and regal (Figure 49). Perhaps part of a toilet service, a beaker and saucer with closely related decoration bear the signature "IABottengruber f. Viennae 1730" (Figure 50).

The signed and dated waste-bowl in the Museum für angewandte Kunst also places Bottengruber in Vienna in 1730, but the circumstances of his situation there are unknown (Figure 3). Painted after Heemskerk's *Triumph of Bacchus*, on exhibition in the Stallburg about 1730, the piece features enamel colors that copy the original so closely it is possible to suggest that

Figure 49. Jean LePautre, *Livre de Paneaux pour les Lambris* (title plate). *Oeuvres*, II, p. 209. Engraving. The Metropolitan Museum of Art, Harris Brisbane Dick Fund, 1933, 33.84

Figure 50. Saucer. Decorated by Ignaz Bottengruber, signed "IABottengruber/ f. Viennae 1730," Vienna, 1730. Hard-paste DuPaquier porcelain. 13.2 cm. Vienna, Österreichisches Museum für angewandte Kunst, Ke 228.1622 (photo: Pazurek, "Ignaz Buttengruber," fig. 24)

Bottengruber had seen the picture and was not therefore entirely dependent upon engravings (although he had already produced a monochrome rendering of the scene on a bowl dated 1729).[23] The coffeepot and tea wares discussed above may also belong to the Vienna period, owing to the strong political overtones of the decoration.

Bottengruber was a known artist in Breslau, so it is strange that he completely disappeared after his year in Vienna—unless he was quickly hired by the DuPaquier porcelain manufactory and began to paint there anonymously.[24] Clearly made by the most talented and original of the early *Hausmaler*, his paintings on porcelain are as prized today as they were in the eighteenth century.

NOTES

1. Johann Christian Kundmann, *Sammlung von Natur- und Medizingeschichten* (1723), quoted in Edmund Wilhelm Braun, "Joh. Christ. Kundmann als Quelle für die Kunstgeschichte des XVIII. Jahrhunderts," in *Schlesiens Vorzeit in Bild und Schrift*, N.F. 3 (1904), pp. 109–110. Throughout this essay, quoted passages from Kundmann are copied exactly, retaining all the variations and inaccuracies of the original.

For a discussion of Preissler and further references, see Maureen Cassidy-Geiger, "*Repraesentatio Belli, ob successionem in Regno Hispanico. . .*:

A Tea Service and Garniture by the *Schwarzlot* Decorator Ignaz Preissler," *MMJ* 24 (1989) pp. 239–254.

2. Gustav E. Pazaurek, *Die Deutsche Fayence- und Porzellan-Hausmaler*, 2 vols. (Leipzig, 1925). Pazaurek may be responsible for the introduction of the term *Hausmaler*, the label applied to the independent porcelain, faience, and glass decorators who worked from the mid-17th century in various centers located in the German and Austrian states. While enabling Pazaurek to bring together otherwise unrelated enamelers working in these regions, the term remains in use to distinguish them from factory painters. Later, this comparison unfortunately served over time to denigrate the reputation of the *Hausmaler*, who functioned as private decorators to patrons of wealth and position until the mid-18th century, when the term came to denote amateur practitioners of the art of porcelain painting. Nonetheless, in the 19th century, so-called Nachmalerei was still a concern at Meissen; see Joachim Kunze, "Die Bedeutung des 'Englischen Handels' mit Porzellanen im 'Altfranzösischen Geschmack' der Meissner Manufaktur in der Ersten Hälfte des 19. Jahrhunderts," in *KERAMOS* 95 (Jan. 1982) pp. 37–50.

3. Gustav E. Pazaurek, "Ignaz Bottengruber, Einer der ältesten deutschen Porzellanmaler," in *Schlesiens Vorzeit in Bild und Schrift/ Zeitschrift des Vereins für das Museum Schlesischer Altertümer*, N.F., II (Breslau, 1902) pp. 133-163. The baptismal record, which appears on p. 134, shows that the painter's home (and studio) was located in the same street as the church, Sankt Maria auf dem Sande: "1721. 8. Oktober. Infans: Ioannes Christophorus Franciscus. Pater: Ignatius Battengruber ein Mahler auf dem Sandt. Mater: Maria Eleonora. Patrini: Der hoch- und Wohlgebohren Hr. Alexander Freyherr von Münnich Erbherr auf Gross-Monhaw u. Pertochkenhayn. Tit. Die Hoch- u. Wohlgebohrene Freile Freyin von Glaubitzin auff Direnforth u. Gloschka. Tit. Frau Mariana Caroline Wolckmannin des tit. Hr.

Wolckmanns bei hiesigem Stifft Cantzelisten u. Steiereinnemerss Eheliebste."

4. Kundmann's guides reflect the established tradition of publishing descriptive catalogues of private collections of *Kunstkammer* objects. For a thorough bibliography and further information, see Oliver Impey and Arthur Macgregor, eds., *The Origins of Museums* (Oxford, 1985).

5. The inclusion of painted porcelains in this category reveals that they were viewed primarily as paintings and not as porcelains, curiosities, or useful wares. According to Daniëlle Grosheide, in some instances the inlaid stone panels of Dirck van Rijswijck were also inventoried as paintings as opposed to *Raritäten*, further demonstrating that certain applied arts could attain the status of paintings in the context of the *Kunstkammer*.

Due to the difficulty of locating copies of Kundmann's publications, and in order to illustrate the position of Bottengruber's works as collector's items, the entire description of Pauli's cabinet is reprinted here.

Dr. Johann Christian Kundmann, *Promtuarium Rerum naturalium et artificialium Vratislaviense* (Breslau, 1726) pp. 81–85:

Apparatus, quem in oblectationem animi & suam & amicorum possidet *Tit. Dn. Johannes Georgius P − −* est sequens:

I. *Picturæ.*

1.) Archetypa praeclara Imaginum humanarum, Regionum, Praeliorum, Figurarum minutarum, Animalium, Fructuum, Florum & Rerum rurestrium: ut IV. genualia, Auctor. *Lely, Rosalba, Heribaldo & Agatha, van der Myn, Quellino, Welbero, Brandelio, Jordaëno, Perugino, Sachtleven, Heemskerkio, Bendlero, Antonio Polcke &c.*

2.) Aviarium Silesiae ad naturalem sere similitudinem expressum, colore aqueo a *Bottengrubero.*

3.) Diversa instructa vasorum porcellaniorum eleganter pictorum & encausticorum a *Bottengrubero.*

4.) *Archetypa imaginum summa praestantiae & dignitatis.*

Bachanalia 2. integrarum & 3. dimidiarum figurarum forma supra humanam longe augustiori, praestantissimi opus generis, auctore *Annibale Caraccio* 3½. pedum altitudine, latitudine 4½. moduli Rhenensis.

Magdalena in caverna ante *Christi* crucifixi effigiem genibus nixa, figura integra, auctore *Francisco Florisio,* 3. pedum altitudine, 2. latitudine.

Ecce Homo! cum duabus figuris aliis, pictura diligenter & pulchre colorata, ab *Alberto Durero* de Ann. 1512. 1½. ped. altitud. & 1.¼. ped. latitudine.

Ejusdem generis caput, a *Johanne Bellino.*

Ejusdem generis figura intgra perfecta pulchritudine a *Palma* Sen. 1. ped. altit. & ½. latitudine.

Johannis Bapitistae effigies dimidia ab *Anton. van Dyk.*

Sancta familia integris figuris a *Rubenio* 2. ped. altit. & 1½. latitudine.

Duae Tabulae Ferarum, scilicet cervorum, leonum, pantherarum, & tigridum, ursorum, lyncium, &c. singulariter elegantes, a *Carolo Ruthardo* de Ann. 1666. 2¼. ped. altitud. & 3. ped. latitud.

Caput parvum, a *Francisco Halsio.*

Orpheus cum multis feris, a *Saverio.*

Tabula ovium & gallinarum cum duabus figuris in Italia picta, a *Carolo Screta* 3¼. ped. altitudine & 5¼. latitudine.

Variae species simiarum, miros & ridiculos gestus prae se serentium cum fructibus, vasis argenteis, praeclare prorsus pictae, auctore *Theil Brügel.*

Regio cum figuris, a *Davide Teniers.*

Coronatio Christi cum multis figuris integris, a *Simone de Vos.*

Effigies *Burry* perquam belle expressa, a Pictore Italo.

Effigies *van Dyckii* solo capite expressa.

St. *Maria* Virgo cum *Jesulo,* a *Willmanno.*

Duae Tabulae maximae, in quibus Charitas Romana, authore *Halbaxio.*

II. *Opera miniata.*

Effigies *Henrici VIII.* uno colore expressa (vulgo grau in grau) ab *H. Holbeinio.*

Regio diligenter picta, a *H. Bol.*

X. Tabellae cum floribus & insectis, a Georgio Hoeffnagel.

Effigies num. VI. singulariter elegantes ab eodem.

In IV. Libris multa animalia & pisces marini, item fructus, auctore eodem.

III. *Opera diagraphica.*

1.) Ingens praelium ad exemplar *Raphaelis* artificiose expressum a *pietro van Lint.*

2.) Collectio Picturarum, monogrammarum majoris formae tam Historiarum quam Regionum, autoribus: *Fens, Faventino, S. Rosa, Jac. Jordaëno, Bloemarto, Saverio, &c.*

3.) Ejusdem generis collectio minor Historiarum LXXX. & amplius, & quidem omnino selectarum, in quibus una est a *Raphaele,* 2. a *Polydoro,* 1. a *Maratto,* 1. a *Titiano,* 2. a *Jos. Arpino, Dürero, Aldegrafio, Mart. Schönio, Holbeinio, Luc. van Leyden* s. Lugdunensi Bat. multae a *Wierixio, de Bray, Ostadeno, Brauwero, Bramero,* 1. a *Rubenio,* 1. a *van Dikio,* 1. a *Jac. Jordaëno, Hollaro,* multae a *Willmanno, Rembrando, Bloemarto, Dreveto, Jac. Frey,* &c.

4.) Similis Collectio Regionum in archetypo & quidem selectissimarum numero 100. ab. *Elsheimero, C. Poussino. Cl. Gill. Lorraine, Saverio, Brügelio, Svanefeldio, Sachtleven, Waterloo, Willmanno, Tempesta, P. de Laer, Bril, Mompero, Vingboomio, Nyts, Velden, Seemanno, van Goyen, Rademakero, du Molins, Bendlero,* &c.

IV. *Figuae anea.*

1.) Collectio magna Historiarum Saxrarum & civilium a manu Veterum & Recentiorum, Germanorum, Belgarum, Italorum & Gallorum Artificum, multis voluminibus constans. (ubi Dispositio & ordinatio secundum scholas illorum facta est.)

2.) Ejusdem generis Collectio Imaginum humanarum, in qua Collector non tam Historias quam artem spectavit.

3.) Similis Collectio Ferarum & Venationum.

4.) Similis collectio Regionum.

Collectiones laudatae praestantissima & rarissima cujusque

Artificis, & integra Opera praecupuirum Chalcographorum in arte sua excellentium complectuntur.

V.

Apparatus satis instructus ichnographias munimentorum archetypas auctore *Vaubanio, Branbeu, Devillieres.*

Instrumenta egregia & libros ad Sculpturam, Architeccturam antiquam & modernam, Opticam facientes, comprehendens.

6. Johann Christian Kundmann, *Academiae et Scholae Germaniae praecipue* DUCATUS SILESIAE CUM BIBLIOTHECIS, IN NUMMIS. *oder: Die Hohen und Niedere Schulen Teutschlandes, insonderheit Des Hertzogthums Schlesiens, mit ihren Bücher-Vorräthen, in* MUNZEN . . . (Breslau, 1741) pp. 420–426:

Hr. Johann Bernhard Rembowsky, Königl. Ober-Amts, des Landes Schlesien, und der Stadt Breslau *Advocatus Juratus*, hat einen kostbaren Bücher-Vorrath gesammlet: Insonderheit da ein groß Theil der bald folgenden Paulischen raren Bücher darzu kommen.

Diese hat bestanden in der Holländer und Franzosen schönsten Ausgaben, mit denen besten Annmerckungen, der *Autorum Classicorum*, vieler zur *Critique*, den Alterthümern und Geschicten, it. zur Rechts-Gelehrheit gehörigen prächtigen Wercken, so er ganz besonders sich angeschaffet: deswegen auch nach seinem Tode, welcher An. 1736. den 19 April erfolget, die Bücher, weil viel Geld darinnen gestecket, distrahiret worden, biß auf nöthige, so man einem einzig hinterbliebenen Sohne ausgesetzet. Diese Bücher wurden begierig weggekauffet, und hin und wieder von Liebhabern gründlicher Gelehrsamkeit und Wissenschafften zu Ergäntzung ihres Vorraths ausgesuchet. Der *antiquen* Müntzen, auserlesener Land-Carten, Kupfferstiche, Mathematischer Instrumenten, künstlicher Gemählden und anderer Seltenheiten in grosser Menge, insonderheit des künstlich *en miniature* gemahlten eingeschmeltzen *Porcellains*, so meistentheils aus der Paulischen Verlassenschafft kommen, nicht einmal zu gedencken.

Dieser Herr, Johann George Pauli, Königl. Lieb-*Medici* Sohn aus Dresden, so allhier in Breslau bey seinem Freunden auferzogen worden, und sich auf Universitäten und Reisen gute *Studia* und Wissenschafften beygeleget, fand in Paris Gelegenheit, die raresten Bücher zu sammlen. Am meisten geschaye dieses aus der vortreflichen Bibliothek Stephani Baluzii daselbst, so *Bibliothecarius* der grossen Colbertischen Bibliothek, und *Professor Juris Canonici* im Königl. Collegio gewesen. Er sammlete überdieses die raresten Kupfer-Abdrucke, von denen alten und neuen beruhmten Kupferstechern, wie auch die vortreflichsten Zeichnungen. Da ich nun bald recht wohl mit ihm bekannt wurde, und seine *Collection* von seltenen Kupferstichen und Zeichnungen sahe, verlohr ich zu dieser *Collection* alle Lust: und ob ich zwar auf Reisen und allhier mir auch alle Mühe gegeben, vergleichen zu sammeln; so war doch dieses was schlechtes gegen diesen grosten Vorrath: deßwegen ich an einem vornehmen Freund meine gantze Sammlung verlaßen. Er war über dieses ein fleißiger *Collector* von seltenen Büchern, auch so nur wegen einer kleinigkeit aestimiret werden, . . . Da ich aber dafür kein Geld annehmen wolte, sondern es ihm zum Geschenck übersendete, so bekam ich dafür 'Rumphii' Amboinische Raritäten-Kammer, ein Indianisches Geschirr von Speckstein, ein Rubin-Glas, von denen ersten, so Kunckel verfertiget, vielerlen Orientalische Thiere in *Spiritu vini*, und auch wolche, die getrocknet waren: Also daß ich dieses Gegengeschencke zum wenigsten 50. Rthl.

hoch aestimiren konte.

Dieser bekam hernach aus der von Sternen slesischen Verlassenschafft ein Ecce Homo von Albrecht Dürer für 10. Ducaten zum Kauff, welches ihn aufbrachte, eine Schilderenen-Sammlung anzufangen. Er war hierinnen sehr glücklich: denn da ein gewisser vornehmer Ober-Amts-Rath von seinem Vater ein vortrefliches Bilder-Cabinet ererbet, diesem es aber manchmal am Gelde gebrach, so erhielt er durch einen Niederländischen Mahler, Joh. Franz de Bäcker, daher, wie auch aus andern vornehmen Cabinetern, Stücke von denen besten Meistern.

Er unterhielt über dieses viele Jahre, mit grossen Unkosten in seinem Hause einen künstlichen Miniatur-Mahler, mit Nahmen Bottengruber, welcher ihm zu erst die Vögel von Schlesien, die nur zu bekommen gewesen, nach dem Leben in ein Buch gemahlet, so ist Hr. D. Schumacher allhier besitzet. Darauf verfielen sie auf die Porcellain-Mahleren, und dieser Mahler brachte es so weit, dass er *grau in grau*, oder von braunrother Farbe, so *Crocus Martis* war, und Purpur-Farbe mit Rubin-Fluß aufs mühstamste *en Miniature* gantze Historien auf Dresdner Porcellain, mit Vielem untermischten Gold, auf Schüsseln, Teller, Schalen, Krügchen und Theeschälschen, mahlete und einschmeltzete, dadurch die Mahlerey im geringsten nicht geändert wurden; also das viele derer Vornehmsten dieses mit vielem Vergnügen anzuschauen Belieben getragen; auch ein gewißer Freyherr von Ts – – – von Th – – – an mich gelanget, ein Gefäß dem Hrn. Pauli feil zu machen darauf *Festum Bacchi*, oder ein Götter-Banquet, gemahlet war, ich solte ihm dafür 100. Rthl. offeriren, er konnte es aber dafür nicht erhalten: so hoch aestimirte er diese künstliche Arbeit.

Nach aller diese mühsamen und kostbaren *Collection* verfiel er, durch Anführung eines Kayserlichen *Captains*, auf die Alchymie, und da solte nun der *Lapis Philosophorum* ganz gewiß herauskommen. Da aber diese Kunst mißlunge, so überredete er ihn, das dieße *Elaboration* ein gewisses *Universal Medicament* in allen Kranckheiten sey. Sie fiengen demnach an, an gemeinen Krancken Leuten vor denen Thoren vielfältige Proben anzustellen: da nun von diesen schönen Curen verschiedene verstorbene Patienten hernach meiner Cur sic anvertrauten, so konnte ich nicht anders, ihm, als einem guten Freunde, vergleichen Curen zu widerrathen. Nach welcher Zeit er unversehens von Breslau hinweggezogen, niemanden (außer dem einzigen *Capitain*) wissende, wohin er kommen. Er hinterließ folgende Disposition: daß sein *en miniature* übermahlerer und vergoldeter Porcellain, alle Schilderenen, *Collection* von denen Kupfferstichen und Zeichnungen, die ganze Bibliothek, Mathematische, insonderheit Optische Instrumenta etc. solten verkauffet, und das Geld auf das hiesige Rathhauß geleget werden: Außer wenn die kostbare Schilderen oder *Ecce Homo* von Albrecht Dürer, und *das Bacchanale* von Annibal Carache, nicht hoch bezahlet würde, solten sie stehen bleiben und einen guten Käuffer erwarten.

Daß Jahr darauf erfuhr man, daß er nach Danzig gangen, und daselbst verstorben: welches aber nicht so bald bekannt worden wäre, weil er all da *incognito* unter einem andern Nahmen gelebt, wenn ein Brief nicht von Breßlau nach seinem Tode angelanget, welcher allda dem Haußwirth Auskkunst gegeben, daß er einen Tode hierher berichten können.

[Note: Hereafter, [. . .] used where itemization essentially matches 1726 description.]

Der Betrag dieser Sammlung, wie solchen An. 1726. aus Hrn. Pauli eigenen Händen erhalten, bestand in folgenden: als

I. Mahlerenen.

1) An guten Originalien von Portraits, Landschafften, Bataillen, Kleinen Figuren, Thier-Frucht-Blumen- und Bauer-Stücken: als [. . .]

2) *Aviarum Silesiae* sehr natürlich in Wasserfarben, von Bottengrubern.

3) Unterschiedliche *Garnituren* schön gemahlten und eingebrannten *Porcellains* von Bottengruber.

4) [. . .] Ein Bacchanale von zwey gantzen und drey halben Figuren, von Anibale Carache 3½ Fuß Rheinländisch Maaß hoch, und 4½ breit.

[. . .]

II. Zeichnungen

[. . .]

III. Kupferstiche

1. Eine grosse Sammlung in vielen *Voluminibus* Geist- und weltlicher Historien, alter und neuer, Deutscher, Niederländischer, Italienischer und Französischer Künstler . . .

2. Dergleichen von Portraiten

3. Dergleichen von Thieren und Jagden

4. Dergleichen von Landschafften

Un *Original-Plans* von *Fortification* von *Vauban, Branbeu, Devillieres* (so Hr. Pauli aus Frankreich mit vielem Besorgniß in einem Bücher-Kasten mit doppelten Boden bringen müssen)

[. . .]

Derer Schilderenen waren zusammen 86. St. darunter das Bacchanale von Carache, für 1000 Fl.

[. . .]

Der Kupffer-Stiche, meist grosse Wercke, waren 67 Bände, darunter ein Werck historischer Begebenheiten

von Rubens in 113 Blättern.

von Bloemart in 325 Blättern.

von Albrecht Dürer in 836 Blättern.

von van der Velde in 380 Blättern.

von Carache in 124 Blättern.

von Maratti in 121 Blättern.

von Sadeler in 168 Blättern.

[. . .].

7. The scene painted inside the cartouche to the right of the handle is *The Ass at School*, after a drawing dated 1556 by Pieter Bruegel the Elder (ca. 1525–1569); see Louis Lebeer, *Catalogue raisonné des estampes de Bruegel l'ancien* (Brussels, 1969) pp. 60–62. Kundmann, *Promtuarium*, p. 83, indicates that Pauli owned various satirical works attributed to Bruegel.

8. For an illustration of the painting, see Sylvia Ferino-Pagden et al., *Die Gemäldegalerie des kunst-historischen Museums in Wien* (Vienna, 1991) p. 66 and pl. 300. For the engravings after the painting, consult F. W. Hollstein, *Dutch and Flemish Etchings, Engravings, and Woodcuts* IV (Amsterdam, n.d.) p. 29, no. W.8. According to Kundmann, Pauli owned one or more paintings by Heemskerk.

9. Kundmann, *Academiae et Scholae Germaniae*, p. 422, however, refers to the porcelain used by Bottengruber as "Dresden," meaning Meissen. According to Otto Walcha, *Meissen Porcelain* (New York,

1981) pp. 124–125, an outlet for the sale of Meissen porcelain, including undecorated factory seconds and overstock, was not opened in Breslau until ca. 1740. Presumably the patrons of the *Hausmaler* in Breslau supplied the artists with porcelain.

For a history of the DuPaquier manufactory, see John Forrest Hayward, *Viennese Porcelain of the DuPaquier Period* (London, 1952), as well as Elisabeth Sturm-Bednarczyk, ed., *Claudius Innocentius du Paquier / Wiener Porzellan der Frühzeit 1718–1744* (Vienna, 1994). Bottengruber otherwise utilized a specific type of early-18th-century Chinese porcelain that has a subtle incised floral pattern under the glaze as well as areas of decoration in underglaze blue; for undecorated examples, see John Ayers, ed., *Chinese Ceramics in the Topkapi Saray Museum, Istanbul: A Complete Catalogue* (London, 1986) II, pp. 1071–1075, cat. nos. 2400, 2421. The decoration on the Chinese dishes can be traced to the engravings of Giovanni Andrea Podesta (1620–before 1674).

10. Many examples are noted in Pazaurek, "Ignaz Bottengruber."

11. Wolff's series follows a French model, as discussed in Cassidy-Geiger, "*Repraesentatio Belli.*"

12. For further comparative views, see Pazaurek, *Die Deutsche Fayence*, I, pl. 14 and p. 189, fig. 157.

13. Preissler refers to testing "wienerische farb" in a letter dated March 22, 1731, and transcribed by Annedore Müller-Hofstede, "Der schlesisch-böhmische Hausmaler Ignaz Preissler" in *KERAMOS* 100 (April 1983) p. 47.

14. Another teabowl and saucer belong to the Rudolf von Strasser collection in Vienna (inv. no. P65) and appear in the author's catalogue of the collection, prepared in 1991, as cat. no. 27.

15. Xavier Salmon, *Versailles: les chasses exotiques de Louis XV* (Paris, 1995) pp. 100–115, surveys the influence of Stradanus designs.

16. Bottengruber also treated the subject in a painterly fashion; for examples, see Pazaurek, *Die Deutsche Fayence*, I, pp. 169–171, figs. 135–137, and p. 174, fig. 141. For parts to a service composed of Meissen models painted with processions of sea-gods and -goddesses in violet monochrome, in the tradition of Andrea Mantegna, see Stefan Bursche, *Meissen Steinzeug und Porzellan des 18. Jahrhunderts/ Kunstgewerbemuseum Berlin* (Berlin, 1980) pp. 142–150. A teabowl and saucer painted with Pan and his entourage in iron-red monochrome is illustrated in color in Hermann Jedding, *Porzellan aud der Sammlung Blohm* (Hamburg, 1968) p. 97, cat. no. 121. A waste-bowl in the Museo Civico, Turin (no. 343/9200), is painted with a related bacchic scene but in violet monochrome.

17. The Darmstädter example, representing Aquarius/February, was sold at Lepke, Berlin, March 23–26, 1925, lot 405, p. 84, and pl. 88. The dish with a depiction of Leo/August was sold by Julius Böhler, Munich, May 18–20, 1936, lot 933, and pl. 60, in the auction of the Frau Margarete Oppenheim collection.

18. Another pair decorated en suite was sold by Sotheby's, London, April 15, 1997, lot 128.

19. This series is discussed and illustrated by Daniëlle Kisluk-Grosheide in "Cutting up Berchems, Watteaus, and Audrans: A *Lacca Povera* Secretary at The Metropolitan Museum of Art," in *MMJ* 31 (1996) pp. 88–89, figs. 28–34.

20. See Franz Matsche, *Die Kunst im Dienst der Staatsidee Kaiser Karls VI. Ikonographie und Programmatik des "Kaiserstils"* (Berlin, 1981).

21. At one time, the five belonged to various members of the Fröhlich-Feldau family, while the sixth was in the shop of a Graz

dealer named Pattern; for details, see *Kunst und Kunsthandwerk* 11 (1908) pp. 210–211. Only the teabowl and saucer in the Museum für angewandte Kunst are known today.

22. Uranus was not discovered until 1781, followed by Neptune in 1846 and Pluto in 1930.

23. Pazaurek, *Die Deutsche Fayence,* I, p. 173, fig. 139.

24. The Museum owns a Meissen dish of ca. 1740 painted with the continents that bears the initials "IAB" (59.208.25). A coffeepot and tankard with the signature "Bottengruber" scratched into the enamel decoration of each piece date similarly to the period ca. 1735–40; see Ignaz Schlosser, "Zwei Bottengruber-Kannen," in *Freunde der Schweizer Keramik*, Mitteilungsblatt 16 (August 1950) p. 11 and figs. 5–8. Resembling the work of a *Hausmaler* operating in the circle of the decorator F. F. Mayer of Pressnitz, the signatures and the attributions to Ignaz Bottengruber have raised questions. Some have suggested that his son Johannes executed the decoration of the pieces with the later signatures.

"A Marvel of Woman's Ingenious and Intellectual Industry": The Adeline Harris Sears Autograph Quilt

AMELIA PECK

Associate Curator, American Decorative Arts, The Metropolitan Museum of Art

I‌N 1856, A SEVENTEEN-YEAR-OLD named Adeline Harris (1839–1931) (Figure 1) conceived of a unique project. She decided to collect the autographs of the well-known people she most esteemed. This, in itself, was not unusual; the practice of collecting autographs of famous people was very popular in the middle decades of the nineteenth century. Adeline's collection, however, was different. She asked the signers to write their names in ink on the small diamond-shaped pieces of white silk that she sent to them. After these diamonds were autographed, they were sent back to her; she then cut out more diamonds of brightly colored silks, pieced them together with the signed white ones, and created an all-silk bed quilt. In 1995 the Metropolitan Museum acquired Adeline's extraordinary quilt from her four great-grandchildren. It is a beautiful object, composed of multicolored dress silks and ribbons, which have been immaculately stitched into the trompe l'oeil "tumbling blocks" quilt pattern (Figure 2).

Although quilts that incorporated signed blocks were not uncommon in the 1850s, most served a particular function that Adeline's quilt would not. Baltimore album quilts, in which each square was made and signed by an individual, and each shows a different decorative pattern, are the best-known examples of signature quilts (Figure 3). However, many varieties of signature quilts were created in the United States during this time. They were usually made from cotton fabric and composed of pieces sewn and signed by ordinary women and men in communities or church congregations for presentation to another member of the community or church to commemorate an event, such as a birth, marriage, or leave-taking. Adeline's quilt would commemorate no single event but an entire period in American history. Created from signatures collected primarily between 1857 and 1863, her quilt is a fascinating document that today serves as a portrait of its maker and reveals the political, religious, and intellectual tastes of a particular segment of well-to-do New England society in the American Civil War era.

Adeline Harris was born on April 7, 1839, in Arcadia, Rhode Island (a town about twenty-five miles southwest of Providence), the youngest child of James Toleration Harris (1806–1885) and Sophia Amelia Knight Harris (1812–?). She had two siblings, George (1833–1875) and Eleanor Celynda (1835–1897). Her father owned several textile mills in Arcadia; he retired when Adeline was ten years old, and the family moved a few miles south to Wyoming, Rhode Island.[1] While James Harris's ancestors seem to have been affluent from 1630 on—the time they arrived with Roger Williams as some of the original settlers of Providence Plantation—Adeline's mother came from working-class stock; indeed, a number of Knight family members worked for the Harrises.[2] Adeline's maternal grandfather, Stephen Knight (1780–1848), worked as a farmer for millowner Elisha Harris (1791–1861), a cousin of Adeline's father, who served as governor of

Figure 1. Adeline Harris (Sears), photographed about the time she began her autograph quilt (photo: courtesy of Mrs. Amey Mackinney Harrison)

The notes for this article begin on page 275.

Figure 2. Adeline Harris (Sears) (1839–1931). Autograph quilt. Rhode Island, begun in 1865. Silk, 195.6 x 203.2 cm. The Metropolitan Museum of Art, Purchase, William Cullen Bryant Fellows Gifts, 1996, 1996.4

Rhode Island in 1847 and 1848. Stephen Knight also worked for the Sprague family, another mill-owning clan, whose younger members were close friends of Adeline's father.[3] Prominent members of the Harris and Sprague families would later sign Adeline's quilt.

Adeline's mother was the eldest of nine children. She probably received little formal schooling; it is known that her brothers were sent out to work at very young ages. One of them, Stephen Albert Knight (1828–

1907), became a bobbin boy, working full-time at one of Elisha Harris's mills when he was only six years old.[4] The Knights' fortunes seem to have turned around after Sophia married James Toleration Harris in 1831. According to family history, Harris provided his wife's brothers Benjamin Brayton Knight and Robert Knight with a loan that enabled them to found B. B. & R. Knight, a company that eventually owned and operated a cotton mill empire.[5] At the time of Adeline's uncle

Figure 3. Album quilt by members of the Brown and Turner families. Baltimore, Maryland, begun in 1846. Cotton, 211.8 x 215.9 cm. The Metropolitan Museum of Art, Bequest of Margaret Brown Potvin, 1987, 1988.134

Benjamin's death in 1898, the firm owned twenty-one mills located in fifteen company-run villages throughout Rhode Island and Massachusetts. The mills had a total of eleven thousand looms and employed nearly seven thousand workers.[6]

Adeline certainly grew up in comfortable surroundings. What little is known about her childhood can be ascertained from two sources: a handwritten memoir by her granddaughter Amey Howarth Mackinney in the 1960s, and a page that Adeline wrote about herself in 1912.[7] When Adeline was asked by the Rhode Island Historical Society for "biographical details," her only reply was: "With the exception of a very few months in a public school and three years of boarding school (two years at East Greenwich Academy and one at Mrs. Magennisi's School for Young Ladies, in New London Conn.) I was educated by private tutors, in my father's house."[8] Her granddaughter recounted that Adeline "attributed her long life, and excellent health to her early life in the out-of-doors in Arcadia, & Wyoming R.I., riding horseback, early hours, and sensible living."[9]

Adeline's few years of formal schooling and private tutors seems to have provided her with a very good education, certainly by the standards of what most women were taught at the time. Her granddaughter

remembered her as "a great scholar and student with a brilliant mind."[10] Family legend recounts that Adeline wanted to attend college, but was forbidden by her parents; this, however, may be apocryphal, since there were few opportunities for women to gain college degrees before the Civil War. Her ambitious quilt project, begun in 1856, when her schooling must have been nearly complete, suggests that this intelligent and scholarly young lady's interests were not completely fulfilled either by suitors or the usual round of social visits and parties in which she was expected to participate. Collecting signatures was considered an educational activity by Adeline's contemporaries. One journalist who wrote about the popularity of such collections explained that "the paramount benefit arising from the prosecution of this hobby, is the familiarity the collector acquires with contemporaneous history. His souvenirs are valueless to him, unless he is thoroughly informed of the individuals they represent."[11]

While Adeline's taste for autographs seems to portray her as an intellectual young woman, it also betrays her romantic nature. Among a certain segment of the population, it was believed that a person's signature revealed significant aspects of his or her personality. By owning a signature of an illustrious person, one could

learn about the characteristics that made him or her great and emulate those traits. This belief often led to superstition: many collectors felt that by merely owning a certain person's autograph, and being sensitive enough to perceive how to read the signer's greatness therein, some of that distinction would rub off. As early as 1835 *Godey's Lady's Book* had begun to publish pages illustrating facsimiles of the "Signatures of Distinguished American Citizens," perhaps in the belief that readers would benefit by simply seeing them.[12]

In June 1839 Sarah Josepha Hale, the editor of *Godey's*, wrote a story entitled "An Evening's Conversation about Autographs."[13] It opens with the character of Ellen Marvin, a refined young woman probably not far in conception from Adeline in actuality, querying her schoolmaster as follows: "Did you not say that you thought the characters of individuals might be understood from their handwriting?" He replies: "Some qualities of the character are undoubtedly to be traced in the chirography; and those faculties of the mind which the phrenologists denominate perceptive, particularly order, form, size, may be easily ascertained. Imitation, also, can be judged of—and the temperament of a writer gives, I think, a decided impress to his autograph."[14] The schoolmaster suggests that they study and compare the autographs of a number of "celebrated" women writers of the day, stating "that traits of character and genius may be discoverable in the handwriting."[15]

The belief that a person's character could be deciphered from his or her signature was also held in more serious arenas than the realm of ladies' fiction and closely paralleled the nineteenth-century fascination with other types of pseudoscientific personality discovery, such as phrenology.[16] In 1841 Edgar Allan Poe wrote a popular series of articles for *Graham's Magazine* in which he published facsimiles of the signatures of other writers, taken from letters he had received from them. His primary purpose was to analyze the character of each correspondent through the signature; but he also wished "to furnish our readers with a more accurate and at the same time a more general collection of our *literati* than is to be found elsewhere."[17] He explained why his audience, whom he described as "lovers of literature," would be interested in the series of articles: "Next to the person of a distinguished man-of-letters, we desire to see his portrait—next to his portrait, his autograph. In the latter, especially, there is something which seems to bring him before us in his true idiosyncrasy—in his character of *scribe*. The feeling which prompts to the collection of autographs is a natural and rational one."[18]

By the 1850s autograph collecting had become so popular that articles appeared in the press disputing the magical value of the oft-requested, oft-written signature. Two unsigned articles in the *Home Journal*, obviously written by authors inundated with requests for autographs, tried to stem the demand. The first, which appeared in April 1851, was entitled "A Modest Endeavor to Locate the Compliment in an Autograph." It read, in part:

If we were inclined to show up popular fallacies, we should hardly know where better to begin than with this one:—*That it is a compliment to ask for an autograph.* An autograph is a manifestation—an exhibition of one's private personality—a confession that we think ourselves somebody, (a verity safely owned only to intimate and tried friends)—a proof tangible that our instinctive modesty has suffered some abrasion from contact with the public. It is a spiritual knock, given at the invocation of one who desires to piece out his inward life at our expense. It is a lock of one's mental and moral hair, given to be speculated upon by diviners who are by no means likely to be soothsayers. It is a subtraction from our potency, cheapening all future autographs.[19]

Clearly, the references to unwillingly given locks of human hair and diminishing potency seem to invoke a feeling that among some harried authors, autograph collectors were almost equated with vampires, eager to magically enlarge their own being by sapping the energy of others. This particular author wrote that most illustrious people would like to refuse the numerous requests, but are too polite to do so. In an effort to devalue autographs, he contended that "a name written at the request of a stranger is only about as valuable as the same name stamped by machinery. To have any character, it should have been written in a careless or confidential moment, without the recollection that there was a collection in the world."[20]

An author writing in 1854 was more direct about annoying requests from "persons not burdened with over much to do":

It is one of the penalties of notariety [*sic*] to be solicited incessantly for autographs . . . an autograph—what more easy, more reasonable, and less likely to be refused? And so it comes to pass, that every mail brings to our already over-employed public man, a request, meant to be flattering, for a pen-and-ink memento of his name and talent, which forthwith goes to swell the list of some autograph hunter who . . . [is] only mindful of the imaginary importance they themselves acquire in the possession of this meaningless collection of names, with which no genuine associations can be connected other than those of favors unwillingly granted, and precious moments wasted uselessly.[21]

Even such vehement complaints fell on deaf ears, and by the 1850s, autographs had also gained monetary value. Magazines carried notices reporting on the sales of autographs by book-auction rooms, with detailed accounts as to the worth of certain signatures. George Washington's signature always brought the highest price; in 1856, $11.25 was paid for his autograph at an auction in New York City.[22] Autograph collections were also a valued entree into the social life of antebellum America. Displaying, discussing, and perhaps even exchanging autographs seems to have been a favored pastime at some elite parties. Isabella Lucy Bird, an Englishwoman who visited America in 1854, wrote glowingly of the impression her collection of autographs made at a New York City party:

On one occasion I was asked to exhibit a collection of autographs, and the knowledge of English literature possessed by the Americans was shown by the information they had respecting not only our well-known authors, but those whose names have not an extended reputation even with us. Thus the works of Maitland, Ritchie, Sewell, Browning, Howitt, and others seemed perfectly familiar to them. The trembling signature of George III excited general interest from his connection with their own history, and I was not a little amused to see how these republicans dwelt with respectful attention on the decided characters of Queen Victoria. In return for the pleasure they had experienced, several kind individuals gave me valuable autographs of their own *literati* and statesmen.[23]

Adeline must have been as voracious a collector as those so disparaged by the writers in the *Home Journal*. Although she probably wrote to most of the signers requesting their autographs as described above, she may have had a personal connection with at least some of them. According to the family account and her obituary, her father brought the family to Washington, D.C., before the Civil War. While no record of his being a public servant has been found, he was friendly with many men who were. Adeline's obituary recounts that "at the outbreak of the Civil War [she] was visiting in Washington D.C. and was acquainted with many prominent men in the nation's capital at that time, including President Lincoln. She was present when the first troops of Northern soldiers passed through the streets of Washington at the beginning of the war. She often related to her friends stories of life in Washington during the early years of the war and until her death she preserved letters she had received from Lincoln, Henry Clay, Charles Sumner, and other leaders of that time."[24] Some of those letters may have originally accompanied the autographed silk diamonds. Adeline's granddaughter wrote that James Tolera-

tion Harris "was a close friend of William Sprague, the wartime governor of R.I. The beautiful Kate Chase Sprague was greatly admired."[25] Kate Chase Sprague (1840–1899) was one of the best-known hostesses of Washington, D.C. Her father, Salmon Portland Chase, was Secretary of the Treasury under Lincoln, and signed a quilt diamond for Adeline (column 8, diamond L). In 1863, Kate Chase married William Sprague, who had just been elected a senator from Rhode Island, who also signed the quilt (column 8, diamond F). The Sprague wedding was declared to be one of the most brilliant Washington had ever seen. If Adeline was lucky enough to have been invited to the grand parties held by Kate Chase, who was her contemporary, she certainly had personal access to many of the political figures who signed the quilt.

Adeline actually met Abraham Lincoln, whose signature she acquired (Figure 5, column 7, diamond N). According to her granddaughter, "She danced with Abraham Lincoln at his Inaugural ball, and we still have the silk damask from which her ball gown was made. [She was] an ardent admirer of Abraham Lincoln. She bought, and read, every book practically, that was written about him."[26] This admiration for Lincoln and his beliefs is attested to in the autographs Adeline requested and received from figures in the political arena. Many of the senators, congressmen, and governors whom she included in the quilt were members of the newly formed Republican Party and, as such, Lincoln supporters. Those Southern politicians from whom she received autographs were moderates who did not believe in the secession of the Southern states in the years immediately preceding the Civil War's outbreak. However, after Adeline had gathered their signatures in the late 1850s, some of these Southerners changed their minds and became active members of the Confederate Congress. Following Lincoln's principles, Adeline did not align herself with the radical Abolitionists, although she collected a few signatures from people closely associated with that movement, namely Gerrit Smith, Owen Lovejoy, Wendell Phillips, and Charles Sumner (Figure 6, column 4, diamonds F, G, and H). While many of the politicians she asked for signatures were firmly anti-slavery, implying that Adeline shared their beliefs, the majority were moderates, who did not believe in the immediate abolishment of the institution if it threatened to break up the Union.

Political leaders signed more diamonds than any other single profession represented on the quilt. Seemingly a very logical young woman, Adeline grouped similar professionals together (Figure 4, chart). Columns one through nine generally hold the

Figure 4. Chart of placement of autographs by profession

Figure 5. Detail of Figure 2, diamond 7N

Figure 6. Detail of Figure 2, diamonds 4F, 4G, and 4H

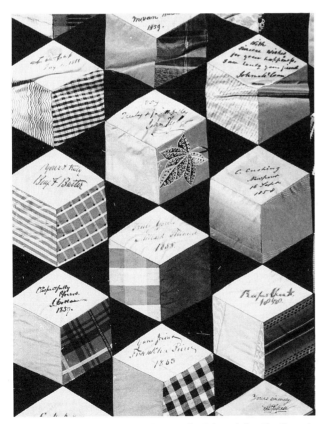

Figure 7. Detail of Figure 2, diamonds 7I (partial), 7J, 7K, and 7L

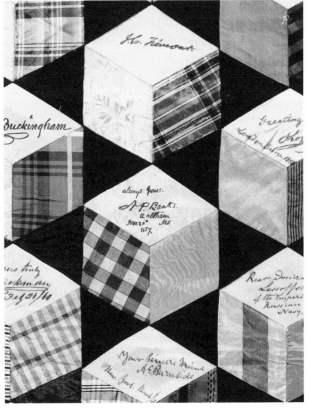

Figure 8. Detail of Figure 2, section of column 2

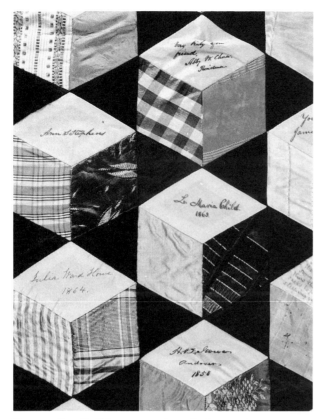

Figure 9. Detail of Figure 2, section of columns 18 and 19

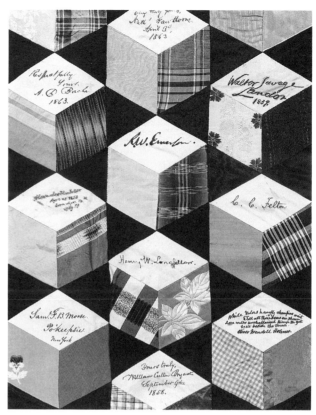

Figure 10. Detail of Figure 2, diamonds 11M, 11N, 11O, and 11P

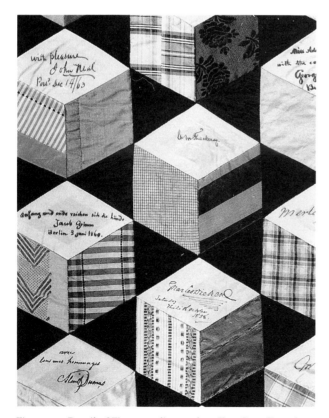

Figure 11. Detail of Figure 2, diamonds 12K, 12L, 13K, and 13L

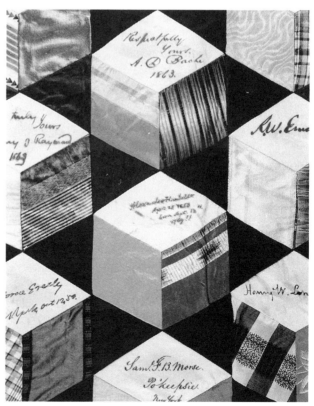

Figure 12. Detail of Figure 2, diamonds 10N and 10O

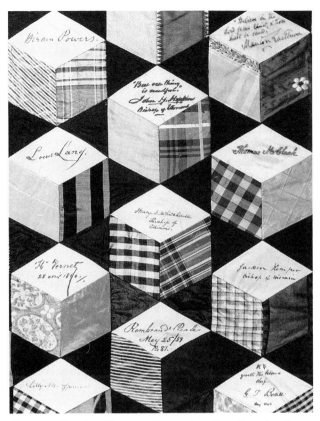

Figure 13. Detail of Figure 2, diamonds 12B, 13E, and 12E

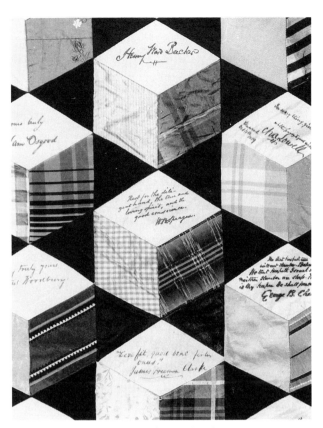

Figure 14. Detail of Figure 2, diamond 19C

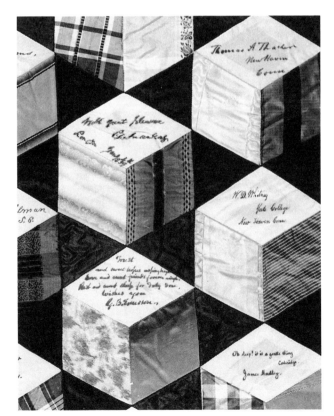

Figure 15. Detail of Figure 2, diamonds 20M, 20N, and 20O

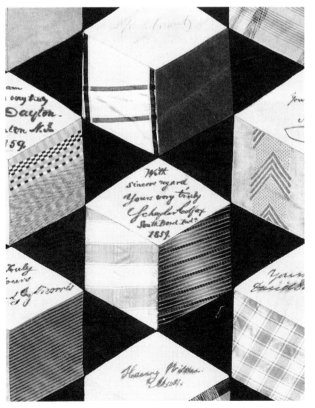

Figure 16. Detail of Figure 2, diamonds 7Q and 7R

autographs of politicians, but Adeline broke down categories within categories. Column seven features presidents and vice presidents of the United States (Figure 7, column 7). Columns two and three display the signatures of Northern military leaders such as Generals John Charles Frémont and Ambrose E. Burnside (Figure 8).

The autographs of literary figures form the next largest group by profession. Within the broad category of literary figures, Adeline divided the authors into sections. First, they are arranged by gender, with the female authors appearing in the center sections of rows sixteen through nineteen (Figure 9). Harriet Beecher Stowe, author of the enormously popular antislavery novel *Uncle Tom's Cabin* (1852), as well as many other books, can be found in this grouping, as is abolitionist Julia Ward Howe of "The Battle Hymn of the Republic" (1861) fame. Here one also finds less familiar female novelists, such as Ann S. Stephens, Caroline Gilman, and Lydia Sigourney, who were some of the best-known writers of their day; after almost a century of obscurity, their works and careers are being once again studied by modern scholars.

The male authors are found in columns nine through twenty. Column eleven lists the period's greatest men of letters. Here one finds Washington Irving, Nathaniel Hawthorne, Ralph Waldo Emerson, and Henry Wadsworth Longfellow, among others (Figure 10, column 11). The European authors Jacob Grimm, Alexandre Dumas, William Makepeace Thackeray, and Charles Dickens appear in rows twelve and thirteen (Figure 11). Adeline often placed authors working in similar genres together, such as poets, novelists, humorists, editors, historians, and writers of travelogues.

In column ten, Adeline arranged the names of some of the most important men of science. Here are found the naturalist Alexander von Humboldt and the inventor Samuel F. B. Morse (Figure 12). A who's who of mid-nineteenth-century American artists appears in the upper reaches of rows eleven through thirteen, including the painter Rembrandt Peale and the sculptor Hiram Powers (Figure 13). Lilly Martin Spencer, one of the few popular American women painters of the period also contributed her signature. The last large group of autographs that Adeline collected were from a variety of Protestant clergymen: Episcopalian bishops from almost every state or territory, as well as Unitarian, Presbyterian, Universalist, Congregationalist, and Baptist clergymen. Their signatures appear in the upper-right-hand quarter of the quilt; perhaps the best remembered of these men today is Henry Ward Beecher, the fiery antislavery minister of the Plymouth Church in Brooklyn, New York (Figure 14). Adeline

seems to have come from a fairly religiously liberal background, and her family had the reputation of being supportive of Christian churches of various denominations. Her uncles, the Knights, built a number of churches in their mill towns and were cited for contributing "liberally to the support of Christian work, irrespective of their denomination; their aid has been extended to the Protestant and the Catholic."[27]

The final row of Adeline's quilt features a mixed group of educators, some with ties to Brown University, in Adeline's home state of Rhode Island, others hailing from Yale College, where Adeline's husband-to-be, Lorenzo Sears, was enrolled at the time. The date of 1859 on one of these Yale signatures may indicate that Adeline was acquainted with Sears (class of 1861) for a number of years before they were wed in 1866. Perhaps she asked him to gather the names of some of his favorite professors, such as the Classics Department's Thomas A. Thacher (Latin), William Dwight Whitney (Sanskrit), and James Hadley (Greek) (Figure 15).

Adeline worked on her project for a long time. While she collected the majority of her autographs between 1857 and 1863, she did not complete the quilt until quite a few years later. The earliest signature is dated 1856, and the latest 1867. Yet she may have continued to work on the quilt well into the 1870s. Column seven, which holds the autographs of the presidents and vice presidents, reads down in order from diamond 7I, Martin Van Buren, the eighth president of the United States (1837–41), to Ulysses S. Grant, the eighteenth president of the United States (1869–77). Under Grant's signature, Adeline placed the autographs of his vice presidents, Schuyler Colfax (1869–73) and Henry Wilson (1873–75). Although both the vice presidents probably signed their squares in the late 1850s (Colfax dated his autograph 1859) when they held lower elective offices, Adeline placed them on the quilt to show where they had attained their highest post. This proves that she was still piecing the quilt together until at least the mid-1870s, almost twenty years after she had started gathering the signatures (Figure 16).

It can be assumed, from the consistency of the tiny whipstitches that hold the diamonds together, that Adeline sewed the entire quilt herself. Because the signatures of various professions are composed in areas, rather than straight columns, it seems likely that Adeline worked the quilt in sections. She did not wait until she had received all the signed diamonds and then lay the entire quilt out. After the areas of the quilt for each profession was completed, these larger sections were probably then sewn together. While it is

tempting to think that her family's mills could have provided the fancy silks that Adeline cut into the multicolored diamonds, there is only an indirect link. The family mills all manufactured cotton; during the 1850s, there were no American mills capable of producing the fancy silks found in the quilt. Certainly the family mills provided her with the money to purchase the colorful imported ribbons and dress goods found in the quilt, and the family interest in textiles may have sharpened her eye to harmonies of color and texture, but the family business did not provide the fabric.

Although creating autograph collections and signature quilts were both popular pastimes in Adeline's day, her project can still be termed unique on the basis of two pieces of evidence. First, as far as modern-day quilt scholars know, no other quilts quite like this one have survived. One or two are known that include a few signatures of famous people, but none display the same number of important autographs.[28] Moreover, Adeline's project was special enough to receive public notice in its day, a rare accomplishment. Adeline had written to Sarah Josepha Hale, the editor of *Godey's Lady's Book*, probably in early 1864, requesting her autograph. Not only did Mrs. Hale comply but she was so impressed with the project that she wrote a two-part article about it (although she never mentions Adeline by name, it is clearly Adeline's quilt) in *Godey's* April 1864 issue and included a diagram of how to set up the quilt blocks in the July issue (Figure 17).[29] In the first part of the April article, Mrs. Hale described how Adeline prepared the diamond-shaped pieces of white silk for autographs. She explained that after the diamonds were cut out, "they should be strained tightly over a card, to make a smooth even surface for writing, which should be done in indelible ink. Muslin, linen, or silk can be used, the silk being the handsomest, while the linen makes the best surface for the signature. The cards may be sent by mail to friends at a distance."[30] Clearly Adeline sent many of these card-backed diamonds to people "at a distance." Mrs. Hale included an illustration of a sample diamond with a facsimile of her own autograph (Figure 18).

The second, most intriguing, part of the article about the autograph quilt was published in a section of the magazine called the "Editors' Table." This editorial area functioned as Mrs. Hale's personal soapbox, where she voiced her opinions on a wide variety of topics of interest to her predominantly female readership. She occasionally offered practical advice for household chores, but just as frequently discussed larger subjects such as the necessity of advanced education for women, as well as her opinions on proper modes of womanly behavior. Her piece on Adeline's quilt fell somewhere in between these common topics, or perhaps included all of them.

She began by telling her readers that "we have lately received a pleasant letter from a young lady of Rhode Island, who is forming a curious and valuable collection of autographs in an original and very womanly way; the design is to insert the names in a counterpane or bedquilt."[31] She described the autograph diamonds, and the other colored fabrics that would surround them, "formed in many instances, from 'storied' fragments of dresses which were worn in the olden days of our country. For instance, there are pieces of a pink satin dress that was flaunted at one of President Washington's dinner parties; with other relics of those rich silks and stiff brocades so fashionable in the last century."[32] Here Mrs. Hale embellished Adeline's project a bit; while she may have known that the dress Adeline wore to Abraham Lincoln's inaugural ball was later cut up into quilt pieces, the evocation of dinner parties held by George Washington was likely considered more politically appealing to her Southern readership than a mention of Lincoln. In any case, the fabrics found in the quilt do not seem to be eighteenth-century silks; they all appear to be contemporaneous with the date the quilt was made. (See Elena Phipps's technical report, which follows this article.)

When Adeline wrote to Mrs. Hale in 1864, she had already obtained 350 signatures and was planning to make a quilt that would contain 556. The quilt eventually contained 360 signatures; so by the time Adeline

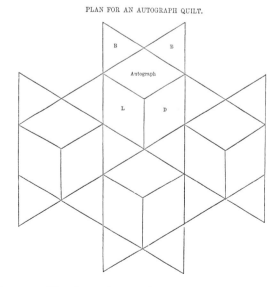

Figure 17. "Plan for an Autograph Quilt," *Godey's Lady's Book* 69 (July 1864) p. 80

contacted Mrs. Hale, the search for signatures may have been winding down. It is not known why she did not collect the roughly 200 more she proposed; perhaps her interest was beginning to wane or many of her requests failed to elicit responses.

Mrs. Hale discussed the process of putting this "very wonderful invention in the way of needlework" together. After mentioning the "resolution, patience, firmness, and perseverance" that it would take to arrange and join the delicate bits of silk properly, she came to what she described as the

intellectual part, the taste to assort colors and to make the appearance what it ought to be, where so many hundreds of shades are to be matched and suited to each other. After that we rise to the moral, when human deeds are to live in names, the consideration of the celebrities, who are to be placed each, the centre of his or her own circle! To do this well requires a knowledge of books and life, and an instinctive sense of the fitness of things, so as to assign each name its suitable place in this galaxy of stars or diamonds.[33]

Obviously, Mrs. Hale held Adeline and her project in high esteem, crediting her with "intellectual" and "moral" gifts regarding her conception for the quilt. Adeline's letter, which has not been located, must have been so engaging and convincing in its statement of her seriousness of purpose that Mrs. Hale attributed some perhaps overly ambitious goals to the quilt:

Notwithstanding the comprehensive design we are attempting to describe, we have no doubt of its successful termination. The letter of the young lady bears such internal evidence of her capability, that we feel certain she has the power to complete her work if her life is spared. And when we say that she has been nearly eight years engaged on this quilt, and seems to feel now all the enthusiasm of a poetical temperament working out a grand invention that is to be a new pleasure and blessing to the world, we are sure all our readers will wish her success. Who knows but in future ages, her work may be looked at like the Bayeux Tapestry, not only as a marvel of woman's ingenious and intellectual industry; but as affording an idea of the civilization of our times, and giving a notion of the persons as estimated in history.[34]

Indeed, Adeline's quilt serves some of the lofty purpose with which Mrs. Hale endowed it, as it does afford an idea of the civilization of Adeline's time. The autographs comprise a nearly complete gathering of the most famous Americans (and some Europeans) in most fields of endeavor at midcentury. It reveals the breadth of the education that a well-to-do young woman from New England received in the 1850s, and

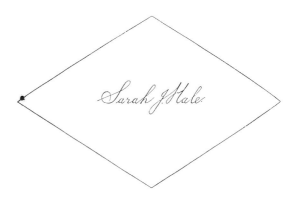

Figure 18. Facsimile of Sarah J. Hale's autograph on a quilt diamond from *Godey's Lady's Book* 68 (April 1864) p. 388

the quilt speaks of the amount of leisure time someone like Adeline had on her hands.

In 1866, her project yet unfinished, Adeline was married to Lorenzo Sears (1838–1916), an Episcopalian priest. Her choosing to marry a member of the clergy, rather than a man of business like her father or uncles, also seems to support the notion that Adeline valued learning. Members of the clergy were usually the best-educated men in antebellum society. Sears was born in Searsville, Massachusetts, a town undoubtedly named for his forebears. His family members were descendants of one Richard Sares, who is listed in the records of the Plymouth colony in 1633.[35] Following his graduation from Yale, Sears completed his studies at the General Theological Seminary in New York City and was ordained in 1864. After his marriage to Adeline, he served as the rector of various parishes in New England; his longest appointment was at Grace Church in Manchester, New Hampshire, where he remained for sixteen years. In 1885, when Sears was in his late forties, he changed careers and became a professor of rhetoric and English literature at the University of Vermont. A few years later, when he was appointed professor at Brown University, he and Adeline returned to the state of her birth. In the years between 1896 and 1914, in addition to teaching, Sears wrote extensively about oratory and American literature; he also authored a series of biographies.[36] One of these was about the orator and abolitionist Wendell Phillips, who had contributed an autograph to Adeline's quilt more than fifty years earlier.

After her quilt's brush with fame in 1864, Adeline lived the remainder of her life out of the limelight. She gave birth to four children, only one of whom, Sophie Harris Sears (1872–1949), survived infancy.[37] In

Providence, the Searses lived at 163 Butler Avenue, in the affluent neighborhood bordering the Brown University campus. Even in her old age, Adeline (Figure 19) apparently retained her intellectual bent and was remembered by her granddaughter as "extremely witty, and a brilliant conversationalist, and retained her inquiring mind to the time of her death."[38]

It is doubtful that Adeline ever slept under this quilt. It seems to have always remained a family showpiece, an embodiment of Adeline's perseverance and intellectual gifts, a treasure carefully guarded by succeeding generations. When it came to the Museum, it had small rings sewn to the upper edge, implying that it had been hung for display at some point in its history. Adeline left her quilt to her daughter, Sophie, an active philanthropist and the head of the Providence Animal Rescue League, who married George Howarth late in life. Sophie had no children of her own, but adopted Howarth's two daughters by a previous marriage. She bequeathed her mother's quilt to her adopted daughters, Amey Howarth Mackinney and Constance Howarth Kuhl. They, in turn, passed it to their children: Amey Mackinney Harrison, Harold A. Mackinney, Constance Kuhl Francis, and Herbert Kuhl Jr. It was in Amey Mackinney Harrison's possession, but

co-owned by all four of Adeline's great-grandchildren, when the Museum purchased it in 1995. Here it remains, an eloquent artwork that speaks volumes about the work and world of one representative young woman who lived in mid-nineteenth-century America.

NOTES

1. This information is taken from "Obituary, Adeline Harris Sears," *The Providence Journal* (May 1931); clipping in the collection of Amey Mackinney Harrison, a great-granddaughter of Adeline Harris.

2. *Representative Men and Old Families of Rhode Island* (Chicago, 1908) I: Harris family, p. 756, and Knight family, p. 29.

3. Ibid., p. 29.

4. Ibid., p. 35.

5. Amey Howarth Mackinney's handwritten memoir of her grandmother, ca. 1960s. It is not certain when the Knight brothers received the loan; it is possible that James Toleration Harris provided money to Benjamin Brayton Knight as early as 1835, four years after his marriage to Sophia. At that point, Knight left farming and purchased a building and lot in Cranston, Rhode Island, near the Sprague textile printworks. There he started a grocery store, which he eventually built up into a large and profitable wholesale grocery business. Knight sold that business in 1849, and two years later he purchased his first mill with his brother Robert. The Knights may have received a loan from Harris at this time or bought the mill with profits from the grocery business.

6. *Representative Men*, p. 30.

7. Amey Howarth Mackinney memoir and Rhode Island Historical Society biographical fact form filled out by Adeline Harris Sears in 1912.

8. Rhode Island Historical Society form.

9. Amey Howarth Mackinney memoir.

10. Ibid.

11. "Autographomania," *Overland Monthly* 3 (Oct. 1869) p. 349.

12. *Godey's Lady's Book* 10 (April 1835) p. 180. Four signatures appear in the top half of the page, including those of Martin Van Buren and Henry Clay. In May 1835 the signatures of James Madison, John Quincy Adams, and Daniel Webster appeared on p. 276.

13. Ibid., 18 (June 1839) pp. 256–259.

14. Ibid., p. 256.

15. Ibid.

16. Phrenology is the study of the shape of the human skull in order to ascertain information about particular character traits and mental faculties. In the 19th century, phrenology was widely accepted as truly scientific. Developed by a German physiologist, it was popularized in this country through the publications of Orson and Lorenzo Fowler. Orson Fowler was also famous for being the main promoter of the health benefits that would come to those who lived in octagonal houses.

17. Edgar A. Poe, "A Chapter on Autography," *Graham's Magazine* 19 (Nov. 1841) p. 225. The article runs from p. 224 to p. 234, and

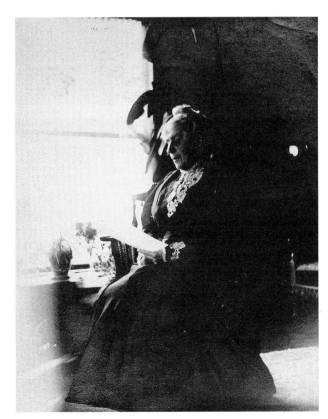

Figure 19. Adeline Harris Sears, ca. 1910 (photo: courtesy of Mrs. Amey Mackinney Harrison)

continues in the issues of Dec. 1841, pp. 273–286, and Jan. 1842, pp. 44–49.

18. Ibid. (Nov. 1841) p. 225.

19. *Home Journal* (April 19, 1851) p. 2.

20. Ibid.

21. Ibid. (Sept. 9, 1854) p. 2.

22. "Sale of Autographs," *United States Magazine of Science, Art, Manufactures, Agriculture, Commerce and Trade* 2 (Jan. 1856) p. 267. Autographs of some of the figures found on Adeline's quilt are reported in this article as being valued at about 10 to 25 cents each.

23. Isabella Lucy Bird, *The Englishwoman in America*, foreword and notes by Andrew Hill Clark (1854; reprinted, Madison/Milwaukee/London, 1966) p. 373. In her quilt, Adeline included the autograph of William Howitt, referred to by Bird as one of the more obscure English authors.

24. "Obituary, Adeline Harris Sears."

25. Amey Howarth Mackinney memoir, pp. 1–2.

26. Ibid.

27. *Representative Men*, p. 33.

28. There is a quilt begun in 1877 by midwesterner Elizabeth Schofield in the collection of the Colorado Historical Society (H.6200.1268) that is similar to Adeline's quilt. It bears the signatures of 192 people, some friends of the maker, and some well-known figures. Like Adeline's quilt, it is pieced in the tumbling-block pattern; yet since it was begun thirteen years after the description of Adeline's quilt was published, one cannot know if Elizabeth Schofield read the 1864 *Godey's* articles about it and was inspired or came up with the idea on her own.

29. "Autograph Bedquilt," *Godey's Lady's Book* 68 (April 1864) pp. 387–388, 396; and "Plan for an Autograph Quilt," *Godey's Lady's Book* 69 (July 1864) p. 80.

30. "Autograph Bedquilt," p. 388.

31. Ibid., p. 396.

32. Ibid.

33. Ibid.

34. Ibid. The Bayeux Tapestry, actually an embroidery, is some 270 feet long by 20 inches wide and chronicles, both in embroidered pictures and words, the Norman Conquest of England by William the Conqueror in 1066. Of coarse linen embroidered with wool, it is thought to have been made ca. 1080 to decorate the cathedral in Bayeux, France, in celebration of the victory. Possibly one of the reasons it was invoked by Mrs. Hale is that throughout the 19th century, the tapestry was thought to be the work of a single woman, Queen Mathilda, William the Conqueror's wife. As such, it was held up as both a pinnacle of woman's achievement and an act of extraordinary wifely devotion. Research in this century has proved that it was actually commissioned from an English workshop of professional women embroiderers.

35. Samuel P. May, *The Descendants of Richard Sares (Sears) of Yarmouth, Massachusetts, 1638–1888* (Albany, 1890) p. 550.

36. Amey Howarth Mackinney memoir and *1861–1911 The Fiftieth Anniversary of the Class of 1861 Yale College, with Biographical Sketches Prepared by the Secretary* (Philadelphia, 1912) pp. 140–141.

37. Telephone conversation between the author and Mrs. Amey Mackinney Harrison, Aug. 5, 1997.

38. Amey Howarth Mackinney memoir.

Appendix: Inscriptions and Biographies

Column 1

A. *Yours very respectfully / L. F. S. Foster / 1859.*
Lafayette Sabine Foster (1806–1880)—editor and senator from Connecticut.

B. *Truly your friend / Jno. A. Bingham / 1860.*
John Armor Bingham (1815–1900)—congressman from Ohio.

C. *Yours truly / A. G. Curtin*
Andrew Gregg Curtin (1815?–1894)—governor of Pennsylvania elected in 1860, Lincoln supporter.

D. *J. R. Doolittle / Wisconsin*
James Rood Doolittle (1815–1897)—senator from Wisconsin; Lincoln supporter.

E. *With / great respect / Edw. McPherson / Gettysburg, Pa / Oct. 18. '59.*
Edward McPherson (1830–1895)—congressman from Pennsylvania, editor, and writer.

F. *[illegible] / friend / John P. Hale / July 4, 1859*
John Parker Hale (1806–1873)—senator from New Hampshire; antislavery.

G. *Yours truly / James T. Hale*
James Tracy Hale (1810–1865)—congressman from Pennsylvania.

H. *Wm. H. Bissell / 1859*
William Henry Bissell (1811–1860)—governor of Illinois.

I. *Very truly yours / I. Washburn, Jr. / May 10, 1859*
Israel Washburn Jr. (1813–1883)—congressman from Maine.

J. *Elihu Washburne / Galena / Illinois*
Elihu Benjamin Washburne (1816–1887)—congressman from Illinois; Lincoln supporter.

K. *Very Truly Yrs. / C. C. Washburn / Lacrosse, Wis. / Oct. 1, 1859*
Cadwallader Colden Washburn (1818–1882)—congressman from Wisconsin.

L. *Respectfully / H. L. Dawes. / 1859.*
Henry Laurens Dawes (1816–1903)—congressman from Massachusetts.

M. *Wm. A. Buckingham*
William Alfred Buckingham (1804–1875)—governor of Connecticut.

N. *Yours truly / Jn Hickman / Feb. 28 '60*
John Hickman (1810–1875)—congressman from Pennsylvania.

O. *Truly Yours / John Cochrane*
John Cochrane (1813–1898)—congressman from New York City.

P. *Very truly yours / John Sherman / H. of Rep. Wash / Jan'y 6 '60*
John Sherman (1823–1900)—congressman from Ohio.

Q. *Yrs. respy. / Wm. Pennington, Newark N. Jersey / November 18, 1860.*
William Pennington (1796–1862)—congressman from New Jersey; former New Jersey governor.

R. *Your Obedt. Svt. / Silas Casey / Maj. Gen.*
Silas Casey (1807–1882)—major general of Northern volunteers, appointed May 31, 1862.

Column 2

A. *With the [illegible] regards of / James Dixon / of Conn / June 21, 1859*
James Dixon (1814–1873)—senator from Connecticut.

B. *Very Truly / your Obedient Servant / Solomon Foot, / Vt.*
Solomon Foot (1802–1866)—senator from Vermont.

C. *Your Obt Serv't / D. W. Gooch. / 1859*
Daniel Wheelwright Gooch (1820–1891)—congressman from Massachusetts.

D. *I am / very respectfully / your friend [illegible] / A. H. Holley / Conn.*
Alexander Hamilton Holley (1804–1887)—governor of Connecticut.

E. *With best regards of / R. E. Fenton / House of Reps. U.S. Jan 29th, 60*
Reuben Eaton Fenton (1819–1885)—congressman from New York.

F. *E. P. Walton / Montpelier / Vermont.*
Eliakim Persons Walton (1812–1890)—congressman from Vermont.

G. *[illegible] / [illegible] / C. [Schrez?]*
—unknown.

H. *With my best regards / Yours / F. [Siyaly?], Maj. Gen.*
—unknown.

I. *Very Resply / Henry M. Naglee / B. G.*
Henry M. Naglee (dates unknown)—brigadier general?, U.S. volunteers (1862–64).

J. *Joseph Hooker / Maj Gnl / [illegible]*
Joseph Hooker (1814–1879)—U.S. major general, Northern troops.

K. *yours truly / Frank P. Blair, St. Louis Mo. / 1859*
Francis Preston Blair (1821–1875)—former congressman from Missouri; antislavery.

L. *J. C. Fremont.*
John Charles Fremont (1813–1890)—explorer and soldier; major general in charge of the Department of the West.

M. *always. yours. / N.P. Banks. / Waltham / MS. / Nov. 20 / 1857*
Nathaniel Prentiss Banks (1816–1894)—congressman from Massachusetts; antislavery.

N. *Your Sincere Friend / A. E. Burnside / New York. March '63*
Ambrose Everett Burnside (1824–1881)—general of Northern army.

O. *I am / very truly your friend / Thomas Francis Meagher / Brig. General / commissioning / The Irish Brigade*
Thomas Francis Meagher (1823–1867)—leader of the Irish Brigade from New York City.

P. *W. S. Rosecrans / Major Gen'l / 1860*
William Starke Rosecrans (1819–1898)—leader of Northern troops.

Q. *very truly yours / Geo. B. McClellan*
George Brinton McClellan (1826–1885)—leader of Northern troops.

R. *Irvin McDowell/ Major General*
Irvin McDowell (1818–1885)—major general of Northern army volunteers.

Column 3

A. *Very Truly Yours / Clark B. Cochrane / Schenectady, N.Y. Sept. 26 1858*
Clark B. Cochrane (1817–1867)—congressman from New York.

B. *I am / Truly Yours / Stephen C. Foster / Pembroke / Maine / October 5. 1859*
Stephen Clark Foster (1799–1872)—congressman from Maine.

C. *Respectfully / C. F. Cleveland / Hampton Ct. / July 16. 1859*
Chauncey Fitch Cleveland (1799–1887)—antislavery politician from Connecticut.

D. *John A. Gurley / Cincinnati / Ohio*
John Addison Gurley (1813–1863)—congressman from Ohio.

E. *J. F. Farnsworth / Chicago / Aug. 19th / 1859*
John Franklin Farnsworth (1820–1897)—congressman from Illinois; antislavery.

F. *Yrs. Very Truly / H. F. Clark / 1859*
Horace Francis Clark (1815–1873)—congressman from New York and railroad director.

G. *I have / the honour / to be Very Truly / Your Obt. Servant / Z. Chandler / March 1859*
Zachariah Chandler (1813–1879)—senator fromMichigan; antislavery.

H. *Truly Yours / Geo G. Meade / Maj. Gen'l of Wes.*
George Gordon Meade (1815–1872)—brigadier general; victor at Gettysburg (1863).

I. *Sam Houston / 1st January 1858*
Samuel Houston (1793–1863)—soldier and governor of Texas; antislavery.

J. *Winfield Scott.*
Winfield Scott (1786–1866)—longtime soldier, presidential hopeful (Whig), and Lincoln supporter.

K. *Your Obt. serv't / John E. Wool / 1860*
John Ellis Wool (1784–1869)—longtime soldier, aide to Winfield Scott.

L. *Your Friend / John A. Dix*
John Adams Dix (1798–1879)—secretary of the treasury (1861–63)

M. *Greeting! / [Snogath?] / London, June 1858*
—unknown.

N. *Rear Admiral / Lessoffsky. / of the Imperial / Russian / Navy.*
—unknown.

O. *General / Forey / Commandant en chef au / combat de Montello / 20 Mai 1859*
Élie Frédéric Forey (1804–1872)—French marshal; commander of the forces sent to Mexico by Napoleon III.

P. *Your's Respecty / S. F. DuPont / Rear Admiral / U. S. Navy*
Samuel Francis DuPont (1803–1865)—naval officer in charge of Northern naval blockades.

Q. *S. P. H. Hintzelman / Major Gen'l / July 1863.*
Samuel P. Hintzelman (dates unknown)—major
general of U.S. volunteers (1862–65).

R. *H. W. Halleck / Gen'l in chief*
Henry Wager Halleck (1815–1872)—military
adviser to Lincoln; general in chief July 11, 1862–
March 1864.

Column 4

A. *Believe me / Most Truly Yours / Galusha A. Grow /
Glenwood June 15 / 58*
Galusha Aaron Grow (1822–1907)—congress-
man from Pennsylvania; Speaker of the House
(1861–62).

B. *Very Truly / Your Friend / P. Bliss / Oct. 14 '59*
Philemon Bliss (1814–1889)—congressman from
Ohio; antislavery.

C. *I am very / respectfully your friend / J. R. Giddings /
Jefferson Ohio*
Joshua Reed Giddings (1795–1864)—congress-
man from the Western Reserve of Ohio;
antislavery.

D. *I am / truly your / friend / B. F. Wade*
Benjamin Franklin Wade (1800–1878)—senator
from Ohio; antislavery.

E. *Gerrit Smith. / 1858.*
Gerrit Smith (1797–1874)—reformer and
abolitionist.

F. *Your / friend / Owen Lovejoy / Aug. 5. 1859*
Owen Lovejoy (1811–1864)—congressman from
Illinois, abolitionist and Lincoln supporter.

G. *Wendell Phillips.*
Wendell Phillips (1811–1884)—abolitionist and
orator.

H. *Charles Sumner.*
Charles Sumner (1811–1874)—senator from
Massachusetts; abolitionist.

I. *Edward Everett / 1858.*
Edward Everett (1794–1865)—senator from
Massachusetts; orator.

J. *Yours, etc. / Thomas H. Benton / Feby. 12. 1858*
Thomas Hart Benton (1782–1858)—senator
from Missouri; moderate.

K. *"one thing is needful" / Theo. Frelinghuysen / 1859.*
Theodore Frelinghuysen (1787–1862)—lawyer,
politician, leader of religious charities, president
of Rutgers University.

L. *Yours etc. / Josiah Quincy / March 29. 1857.*
Josiah Quincy (1772–1864)—congressman from
Massachusetts; mayor of Boston; president of
Harvard University; writer.

M. *Richard Cobden / Paris / 1 Feb of 1860*
Richard Cobden (1804–1865)—English reformer;
member of Parliament, free trade, anti-imperialist.

N. *John Bright / London / April 26, 1860*
John Bright (1811–1889)—English reformer and
orator; member of Parliament.

O. *Charles Francis Adams / Quincy 3 July 1860*
Charles Francis Adams (1807–1886)—congress-
man from Massachusetts; antislavery; American
minister to the Court of St. James's (1861–68),
author, and son of John Quincy Adams, U.S. presi-
dent (1825–29).

P. *Your's truly / J. Van Buren / Kinderhook / Sepbr 2d 63*
John Van Buren (1810–1866)—lawyer, politician,
and son of Martin Van Buren, U.S. president
(1837–41).

Q. *Yours faithfully / Townsend Harris.*
Townsend Harris (1804–1878)—merchant,
politician, and diplomat, founder of the City
University of New York, minister and consul
general to Japan (1855–61).

R. *With sincere / regret for long / delay. / William H.
Seward / Feb. 24 1858*
William Henry Seward (1801–1872)—governor
of New York State (1838–42); U.S. senator
(1848–61); secretary of state (1861–65);
antislavery.

Column 5

A. *Very sincerely yours, / Justin S. Morrill*
Justin Smith Morrill (1810–1898)—congressman
and senator from Vermont; antislavery.

B. *Your Obt Servt / Wm. D. Brayton / 1859*
William Daniel Brayton (1815–1887)—congress-
man from Rhode Island (1857–61).

C. *John Brown Francis*
John Brown Francis (1791–1864)—governor of
Rhode Island (1832–38).

D. *Very respectfully / your servant / C. J. Ingersoll / 1859.*
Charles Jared Ingersoll (1782–1862)—congressman from Pennsylvania (1840–49) and historian.

E. *T. A. Jenckes*
Thomas Allen Jenckes (1818–1875)—congressman from Rhode Island (1862–70).

F. *I have / the honor to be / your friend & servant / Edward Wade / Cleveland / Ohio / 1858*
Edward Wade (1802–1866)—congressman from Ohio (1853–61).

G. *Teaching Domestic Industry / by example / Simon Cameron / Aug. 6. 1859.*
Simon Cameron (1799–1889)—senator from Pennsylvania and secretary of war (1861–62).

H. *I would [illegible] / regard a request / granting which / costs me nothing and / gratifies another / Yours truly, / Lyman Trumbull / Alton Ill. / June 18, 1859.*
Lyman Trumbull (1813–1896)—senator from Illinois (1855–73).

I. *Respectfully yours / James Guthrie / [illegible] Kentucky / October 3rd 1859*
James Guthrie (1792–1869)—businessman from Kentucky and secretary of the treasury (1853–57).

J. *J. J. Crittenden*
John Jordan Crittenden (1787–1863)—lawyer and senator from Kentucky.

K. *With / the respects of / Jno. Bell*
John Bell (1797–1869)—senator from Tennessee (1847–59).

L. *Alexander H. Stephens*
Alexander Hamilton Stephens (1812–1883)—congressman from Georgia; vice president of the Confederacy.

M. *Yours truly / J. L. M. Curry*
Jabez Lamar Monroe Curry—congressman from Alabama (1857–61).

N. *Yr obt servt. / W. L. Underwood / Octbr 1859*
Warner Lewis Underwood (1808–1872)—congressman from Kentucky.

O. *Your obt. svt / C. M. Clay / 1858*
Cassius Marcellus Clay (1810–1903)—governor of Kentucky; abolitionist.

P. *Jno. M. Botts*
John Minor Botts (1802–1869)—politician from Virginia; antisecessionist.

Q. *J. Holt of Kentucky*
Joseph Holt (1807–1894)—judge-advocate general of the Union army.

R. *Henry Winter Davis / of Maryland*
Henry Winter Davis (1817–1865)—congressman from Maryland.

Column 6

A. *Very truly Yr Friend / John H. Clarke*
John Hopkins Clarke (1789–1870)—senator from Rhode Island.

B. *Yours truly / James F. Simmons, 1859*
James Fowler Simmons (1795–1864)—senator from Rhode Island.

C. *Yours Sincerely / John Whipple, Providence 9 March*
Possibly John Adams Whipple (1822–?)—photographer.

D. *Yours Truly / Thomas G. Turner / Warren R.I., May 27 1859*
Thomas Goodwin Turner (1810–1875)—governor of Rhode Island (1859–60).

E. *Yours truly / Elisha Harris*
Elisha Harris (1791–1861)—millowner; former governor of Rhode Island (1847–48); cousin of Adeline's father.

F. *W. R. Staples*
Waller Redd Staples (1826–1897)—politician from Virginia; antisecessionist; later member of the Confederate Congress.

G. *Respectfully / Preston King, July 20, 1859*
Preston King (1806–1865)—senator from New York.

H. *Truly / John A. Gilmer*
John Adams Gilmer (1805–1868)—congressman from North Carolina; antisecessionist; later member of the Confederate Congress.

I. *L. W. Cap / [illegible] 4, 1858*
—unknown.

J. *Yours truly / Benj. F. Butler*
Benjamin Franklin Butler (1795–1858)—lawyer and politician from New York.

K. *Respectfully / Yours, / J. C. Mason / 1859*
John Calvin Mason (1802–1865)—congressman from Kentucky.

L. *G. M. Dallas*
George Mifflin Dallas (1792–1864)—U.S. vice president (1845–49).

M. *Truly Yours / R. J. Walker, Oct. 20, 1859*
Robert John Walker (1801–1869)—secretary of the treasury (1845–49).

N. *Yours Truly / H. Hamlin*
Hannibal Hamlin (1809–1891)—senator from Maine, U.S. vice president (1861–65).

O. *Thos. Corwin / 1857*
Thomas Corwin (1794–1865)—secretary of the treasury (1850–53).

P. *I am / Your's very truly / William L. Dayton / Trenton, N.J. 1859*
William Lewis Dayton (1807–1864)—senator from New Jersey and lawyer.

Q. *Very Truly / Yours / Richard J. Morris*
—unknown.

R. *A. Burlingame / 1856*
Anson Burlingame (1820–1870)—congressman from Massachusetts.

Column 7

A. *Yours very / truly / Thomas Davis, 1859*
Thomas Frederick Davis (1804–1871)—Episcopal bishop of North Carolina.

B. *I am / very truly your friend / John R. Bartlett, March 9, 1859*
John Russell Bartlett (1805–1886)—antiquarian and secretary of state of Rhode Island (1855–72).

C. *I have / the honor to be / your highly flattered / friend & servant / Byron Dimmy*
—unknown.

D. *Your Obt Svt. / H. Y. Cranston, 1859*
Henry Young Cranston (1789–1864)—politician from Rhode Island.

E. *with sentiments of / regard, Very Respy Yours, / Elisha Dyer, 1859*
Elisha Dyer (1811–1890)—governor of Rhode Island (1857–59).

F. *Yours truly, / Christopher Robinson, 1859*
Christopher Robinson (1806–1889)—congressman from Rhode Island (1859–61); antislavery.

G. *S. N. Sherman, 1859*
Socrates Norton Sherman (1801–1873)—congressman from New York.

H. *W. P. Fessenden, June 6, 1859*
William Pitt Fessenden (1806–1869)—senator from Maine.

I. *Respectfully / yours / M. Van Buren, 1859.*
Martin Van Buren (1782–1862)—U.S. president (1837–41).

J. *1859 / Truly & Faithfully / John Tyler*
John Tyler (1790–1862)—U.S. president (1841–45).

K. *Truly Yours / Millard Fillmore, 1858*
Millard Fillmore (1800–1874)—U.S. president (1850–53).

L. *Your friend / Franklin Pierce, 1863*
Franklin Pierce (1804–1869)—U.S. president (1853–57).

M. *James Buchanan, 3 March 1863.*
James Buchanan (1791–1868)—U.S. president (1857–61).

N. *Yr friend / & Servant Abraham Lincoln, 1860*
Abraham Lincoln (1809–1865)—U.S. president (1861–65).

O. *Andrew Johnson*
Andrew Johnson (1808–1875)—U.S. president (1865–69).

P. *U. S. Grant*
Ulysses Simpson Grant (1822–1885)—U.S. president (1869–77).

Q. *With / sincere regard, Yours very truly / Schuyler Colfax / South Bend, Ind'a. / 1859*
Schuyler Colfax (1823–1885)—congressman from Indiana (1855–69); U.S. vice president (1869–73).

R. *Henry Wilson / Mass.*
Henry Wilson (1812–1875)—senator from Massachusetts, U.S. vice president (1873–75).

Column 8

A. *Very truly / Em. Etheridge*
Emerson Etheridge (1819–?)—congressman from Tennessee.

B. *A. B. Meek, Mobile / 1859*
Alexander Beaufort Meek (1814–1865)—lawyer, politician, and author from Alabama.

C. *Yours very truly / James B. Clay, Ashland near / Lexington, KY / Nov. 19th, 1859*
James Brown Clay (1817–1864)—lawyer and politician, son of Henry Clay.

D. *Very gratefully / yours / Henry A. Wise, April 4th, 1858*
Henry Augustus Wise (1819–1869)—naval officer and author.

E. *E. R. Potter / Kingston, R.I. / 1859*
Elisha Reynolds Potter (1811–1882)—politician, educational reformer, and author from Rhode Island.

F. *William Sprague / of R.I. / January 5th, '62*
William Sprague (1830–1915)—governor of Rhode Island (1860–63).

G. *Truly Yours / N. P. Tallmadge / Fond du Lac, Wisconsin / Sept. 10, 1858*
Nathaniel Pitcher Tallmadge (1795–1864)—senator, governor of Wisconsin territory (1844–46), and spiritualist.

H. *R. B. Taney*
Roger Brooke Taney (1777–1864)—U.S. chief justice (1836–1864).

I. *With / sincere wishes / for your happiness / I am truly your friend / John McLean*
John McLean (1785–1861)—U.S. associate justice (1830–61).

J. *C. Cushing / Newport / 16 Sept. / 1858*
Caleb Cushing (1800–1879)—U.S. attorney general (1853–57).

K. *Rufus Choate, / 1858.*
Rufus Choate (1799–1859)—senator from Massachusetts and lawyer.

L. *Yours sincerely, / S. P. Chase*
Salmon Portland Chase (1808–1873)—governor of Ohio (1855–59) and antislavery lawyer.

M. *Robert C. Winthrop / 1858*
Robert Charles Winthrop (1809–1894)—congressman and senator from Massachusetts.

N. *Very Respectfully / E. W. Bates / St. Louis, Mo / 1859*
Edward Bates (1793–1869)—politician from Missouri.

O. *Sincerely Yours / D. S. Dickinson*
Daniel Stevens Dickinson (1800–1866)—senator from New York.

P. *Your friend / Jas. T. Brady*
James Topham Brady (1815–1869)—lawyer from New York.

Q. *Yours truly / David Dudley Field*
David Dudley Field (1805–1894)—lawyer from New York.

R. *"To sleep—perchance / to dream" / H. C. Deming*
Henry Champion Deming (1815–1872)—lawyer and politician from Connecticut.

Column 9

A. *With / the respects of / A. R. Boteler / 1860*
Alexander Robinson Boteler (1815–1892)—congressman from Virginia.

B. *"To sleep, perchance to dream" / Williams W. Boyce, So. Ca.*
Williams Waters Boyce (1818–1890)—congressman from South Carolina.

C. *With / the respects of / W. N. H. Smith, N.C.*
William Nathan Harrell Smith (1812–1889)—congressman from North Carolina.

D. *Thos. A. R. Nelson*
—unknown.

E. *J. Morrison Harris / Maryland*
James Morrison Harris (1817–1898)—congressman from Maryland.

F. *Feb / 1860 / Sherrard Clemens/ Wheeling / Va.*
Sherrard Clemens (1820–1881)—congressman from Virginia.

G. *With / the respects of / W. C. Anderson / 1860*
William Clayton Anderson (1826–1861)—congressman from Kentucky.

H. *J. W. Edmonds / 1858.*
John Worth Edmonds (1799–1874)—lawyer, judge, prison reformer, and spiritualist.

I. *Robert Dale Owen*
Robert Dale Owen (1801–1877)—social reformer, cofounder of Utopian community of New Harmony, Indiana, advocate of emancipation, and spiritualist.

J. *Long Live / Arcadia's Queen! / Isaac T. Goodnow*
Isaac Tichenor Goodnow (1814–1894)—educator and Kansas pioneer.

K. *Yours truly / O. M. Mitchel / 1859.*
Ormsby MacKnight Mitchel (1809–1862)—professor of astronomy and well-known lecturer on the subject.

L. *H. Fuller*
Hiram Fuller (1814–1880)—owner and manager of the *New York Mirror*, later the *Evening Mirror*.

M. *Yours faithfully / John J. Delane*
—unknown.

N. *Very truly yours / Henry J. Raymond / 1863*
Henry Jarvis Raymond (1820–1869)—editor of the *New York Times*.

O. *Horace Greeley / N. York, Oct. 12, '58*
Horace Greeley (1811–1872)—editor of the *New York Tribune*.

P. *Truly Yours, / Thurlow Weed*
Thurlow Weed (1797–1882)—editor of the *Albany Evening Journal* and political boss.

Q. *H. B. Anthony*
Henry Bowen Anthony (1815–1884)—governor of Rhode Island (1849–51) and editor of the *Providence Journal*.

R. *Sleep dwell upon / thine eyes; / Peace in thy breast! / Jos. T. Buckingham*
Joseph Tinker Buckingham (1779–1861)—editor of the *Boston Daily Courier*.

Column 10

A. *"A poor player" / Edm. L. Davenport / Boston 1858.*
Edward Loomis Davenport (1815–1877)—actor.

B. *Very Truly / Edwin Forrest.*
Edwin Forrest (1806–1872)—actor.

C. *Aug. Hoppin*
Augustus Hoppin (1828–1896)—illustrator, originally from Providence.

D. *W. Hoppin.*
William Warner Hoppin (1807–1890)—governor of Rhode Island (1854–56) and first cousin of Augustus Hoppin.

E. *A. Howard Okie, 1856*
—unknown.

F. *Dio Lewis / Boston / Mass.*
Dioclesian Lewis (1823–1886)—temperance reformer and pioneer of physical education for women.

G. *Cyrus W. Field / New York*
Cyrus West Field (1819–1892)—merchant and promoter of the first Atlantic telegraph cable.

H. *Yours Resply / Jas. J. Mapes, Newark / N.J. / July / 1859*
James Jay Mapes (1806–1866)—scientist and agriculturist.

I. *Arnold Guyot. / July 2d 1859.*
Arnold Henry Guyot (1807–1884)—geographer, associate of naturalists Louis Agassiz and Alexander von Humboldt.

J. *Affectionately Yours, / Edward Hitchcock / 1859*
Edward Hitchcock (1793–1864)—geologist.

K. *To / the amiable / Miss Addie A. Harris, / with grateful considerations from / John W. Francis / New York*
John Wakefield Francis (1789–1861)—obstetrician, professor, and founder of the New York Academy of Medicine (1846).

L. *Very truly / your obt servt / Joseph Henry, Oct. 31st 1860*
Joseph Henry (1797–1878)—professor of natural philosophy (physics) and first secretary and director of the Smithsonian Institution.

M. *Respectfully / Yours. / A. D. Bache / 1863*
Alexander Dallas Bache (1806–1867)—physicist, first president of Girard College, and first president of the National Academy of Sciences.

N. *Alexander Humboldt / April 25, 1858 / born Sept. 17th 1769!!*
Alexander von Humboldt (1769–1859)—German naturalist.

O. *Samuel F. B. Morse / Po'keepsie / New York*
Samuel Finley Breese Morse (1791–1872)—artist and inventor.

P. *Yours very truly / L. Agassiz / 1863.*
Jean Louis Rodolphe Agassiz (1807–1873)—naturalist.

Q. *B. Silliman, October 2 / 1858*
Benjamin Silliman (1779–1864)—chemistry and natural history professor at Yale College.

R. *With the best wishes of / yours / James D. Dana, 1863.*
James Dwight Dana (1813–1895)—geologist and zoologist; Silliman's successor.

Column 11

A. *Very Respectfully / Your Obt svt. / P. F. Rothermel, Philad, Ap. 20, 60*
Peter Frederick Rothermel (1817–1895)—history painter; director of the Pennsylvania Academy of Fine Arts (1847–55).

B. *E. D. Palmer, Summer House, Aurora, N.Y. / 1863.*
Erastus Dow Palmer (1817–1904)—sculptor.

C. *A. B. Durand / June 1st / 60*
Asher Brown Durand (1796–1886)—engraver and painter; president of the National Academy of Design.

D. *William Page*
William Page (1811–1885)—portrait painter.

E. *Very truly / Yours / George W. Conarroe, Oct. 31 / 59*
George W. Conarroe (1803–1882 or 1884)—portrait and genre painter.

F. *Yours / truly / Thos. H. Hinckley / Aug. 15, 1859*
Thomas Hewes Hinckley (1813–1896)—animal painter.

G. *Dear / Miss Harris, / Yours very truly, / Robert W. Weir, Oct. 21st 1859*
Robert Walter Weir (1803–1889)—portrait and genre painter and teacher.

H. *As requested—/ Richard H. Dana, Sr.*
Richard Henry Dana Sr. (1787–1879)—poet.

I. *"Oh Sleep, oh [gentle?] Sleep, / Nature's soft nurse" / Richard H. Dana, Jr.*
Richard Henry Dana Jr. (1815–1882)—author of an account of a trip around Cape Horn and lawyer.

J. *George William Curtis / August 17, 1858.*
George William Curtis (1824–1892)—travel journalist.

K. *Fitz-Greene Halleck*
Fitz-Greene Halleck (1790–1867)—poet.

L. *Washington Irving / Feb. 5th, 1858.*
Washington Irving (1783–1859)—essayist and short-story writer.

M. *Nath'l Hawthorne / April 30, 1863*
Nathaniel Hawthorne (1804–1864)—novelist.

N. *R. W. Emerson.*
Ralph Waldo Emerson (1803–1882)—essayist and poet.

O. *Henry W. Longfellow.*
Henry Wadsworth Longfellow (1807–1882)—poet.

P. *Yours truly, / William Cullen Bryant / September 9th. / 1858.*
William Cullen Bryant (1794–1878)—poet and editor of the *New York Evening Post*.

Q. *John G. Whittier / 1858.*
John Greenleaf Whittier (1807–1892)—poet and abolitionist.

R. *Sweet be their dreams, their slumber deep / Who under*

Addie's quilt shall sleep! / J. R. Lowell, 9th Oct. 1859.
James Russell Lowell (1819–1891)—poet, editor, and teacher.

Column 12

A. *A. F. Tait / Morrisania / Westchester, Co. / N.Y.*
Arthur Fitzwilliam Tait (1819–1905)—landscape and animal painter.

B. *Hiram Powers.*
Hiram Powers (1805–1873)—sculptor.

C. *Louis Lang.*
Louis Lang (1814–1893)—portrait painter.

D. *H. Vernet / 28 avril 1860*
Horace Vernet (1789–1863)—French history painter.

E. *Lilly M. Spencer*
Lilly Martin Spencer (1822–1902)—genre painter.

F. *very truly yours / T. Buchanan Read / July 1859*
Thomas Buchanan Read (1822–1872)—portrait painter and poet.

G. *Like gentle eyelid on the gentle eye, / O quilt, on gentle sleeper lie! / O. W. Wight*
Orlando Williams Wight (1824–1888)—author and translator.

H. *Yours truly / Alfred B. Street / Albany / N.Y.*
Alfred Billings Street (1811–1881)—poet; director of the New York State Library.

I. *With the regard of / Henry C. Carey*
Henry Charles Carey (1793–1879)—economist and publisher.

J. *with pleasure / John Neal / Pou[?] Dec. 14, '63*
John Neal (1793–1876)—novelist.

K. *Anfang und ende reichen sich die hände / Jacob Grimm / Berlin 3 Juni 1860.*
Jacob Ludwig Carl Grimm (1785–1863)—German philologist and folklorist.

L. *avec / tous mes hommages / Alexandre Dumas*
Alexandre Dumas *père* (1802–1870) or Alexandre Dumas *fils* (1824–1895)—French novelists and playwrights.

M. *Walter Savage / Landor / 1859.*
Walter Savage Landor (1775–1864)—English playwright and poet.

N. *C. C. Felton*
Cornelius Conway Felton (1807–1862)—classicist.

O. *While Valors haughty champions wait / 'Till all their fears are shown / Love walks unchallenged through the gate / To sit beside the throne. / Oliver Wendell Holmes.*
Oliver Wendell Holmes (1809–1894)—essayist, poet, and teacher of anatomy.

P. *Donald G. Mitchell / Edgewood / 27 Mar. '58*
Donald Grant Mitchell (1822–1908)—agriculturist, landscape gardener, and author.

Q. *The scroll of [illegible] will burn / Where sea & earth consumes / But the case of love in a happier [illegible] / Will live in deathless blooms. / H. T. Tuckerman*
Henry Theodore Tuckerman (1813–1871)—critic, essayist, and poet.

R. *J. T. Trowbridge*
John Townsend Trowbridge (1827–1916)—journalist.

Column 13

A. *Johannes A. Oertel*
Johannes Adam Simon Oertel (1823–1909)—painter of religious subjects.

B. *William H. De Lancey / Bishop of Western New York*
William Heathcote De Lancey (1797–1865)—Episcopal bishop.

C. *"But one thing / is needful." / John H. Hopkins / Bishop of Vermont*
John Henry Hopkins (1792–1868)—Episcopal bishop.

D. *Henry J. Whitehouse / Bishop of / Illinois*
Henry John Whitehouse (1803–1874)—Episcopal bishop.

E. *Rembrandt Peale / May 25/59 / AE 81.*
Rembrandt Peale (1778–1860)—portrait and history painter.

F. *John R. Johnston / Balt., Md / July 7, '60*
John R. Johnston (ca. 1821–ca. 1872)—portrait, landscape, and history painter.

G. *Benson J. Lossing*
Benson John Lossing (1813–1891)—wood engraver, author, and editor.

H. *Schlafen Sie wohl. / Chas. D. Warner*
Charles Dudley Warner (1829–1900)—editor and essayist.

I. *David H. Strother / Lt. Col. 3rd. Va. Cavalry / March 12th, 1863*
David Hunter Strother (1816–1888)—illustrator.

J. *A good conscience / serves sweet repose / O. A. Brownson*
Orestes Augustus Brownson (1803–1876)—author of religious essays.

K. *Wm Thackeray*
William Makepeace Thackeray (1811–1863)—English novelist.

L. *Charles Dickens / Saturday / thirteenth October / 1858.*
Charles Dickens (1812–1870)—English novelist.

M. *With the good / wishes of / Charles Eliot Norton, Christmas. 1863.*
Charles Eliot Norton (1827–1908)—editor, author, and educator.

N. *The fingers light / and eyes so bright, / That made this album quilt, / Have never thought, / And much less wrought, / To cover sleeping guilt. / Geo. Ticknor / Nov. 17, 1859.*
George Ticknor (1791–1871)—educator and author.

O. *You have all my best wishes. / James T. Fields*
James Thomas Fields (1817–1881)—publisher and author.

P. *Ever yours sincerely. / A. W. H. Boyd*
—unknown.

Q. *Faithfully yrs / Peter Bayne.*
Peter Bayne (1830–1896)—Scottish theologian and journalist.

R. *E. P. Whipple.*
Edwin Percy Whipple (1819–1886)—lecturer and essayist.

Column 14

A. *Yours Cordially / Henry A. Neely*
Henry Adams Neely (1830–?)—Episcopal bishop of Maine.

B. *"Believe in the / Lord Jesus Christ & Thou / shalt be saved." / Manton Eastburn*
Manton Eastburn (1801–1872)—Episcopal bishop of Massachusetts.

C. *Thomas M. Clark*
Thomas March Clark (1812–1903)—Episcopal bishop of Rhode Island.

D. *Jackson Kemper / Bishop of Wisconsin*
Jackson Kemper (1789–1870)—first missionary bishop of the Protestant Episcopal Church.

E. *HE / giveth his beloved / sleep. / G. T. Bedell, Aug. 1860*
Gregory Thurston Bedell (1817–1892)—Episcopal bishop of Ohio.

F. *Yours etc. / William Ingraham Kip / Bishop of California / July 1, 1858*
William Ingraham Kip (1811–1893)—Episcopal bishop.

G. *May all that's present [illegible] best / Be imaged ever in thy heart. / And may thy future years be blest / That [benevolent?] as now thou art. / Fred S. Cozzens*
Frederick Swartout Cozzens (1818–1869)—humorist.

H. *Cordially, / John G. Saxe, / Sept. 11 / 1858.*
John Godfrey Saxe (1816–1887)—humorist poet.

I. *Thomas Bailey Aldrich / 1863*
Thomas Bailey Aldrich (1836–1907)—poet and editor.

J. *To Miss Addie A. Harris / with the compliments of / George P. Marsh / Burlington / 1859*
George Perkins Marsh (1801–1882)—diplomat.

K. *Merle d'Aubigne*
Jean Henri Merle d'Aubigne (1794–1872)—Swiss ecclesiastical historian.

L. *T. B. Macauley*
Thomas Babington Macauley (1800–1859)—English historian, author of a history of England.

M. *Miss A. A. Harris / from / George Bancroft / 1858*
George Bancroft (1800–1891)—historian, author of a history of the United States.

N. *J. L. Motley*
John Lothrop Motley (1814–1877)—historian, author of a history of the Netherlands.

O. *W. H. Prescott, 1858*
William Hickling Prescott (1796–1859)—historian, author of histories of Spain, Mexico, and Peru.

P. *Jas. Parton / N.Y. 1867*
James Parton (1822–1891)—biographer.

Q. *with G. S. Hillard's / compliments / Feb. 28, 1863*
George Stillman Hillard (1808–1879)—memoirist.

R. *C. Edwards Lester, March 9, 1863*
Charles Edwards Lester (1815–1890)—historian and biographer.

Column 15

A. [Inscription in Greek?] *W. R. Whittingham*
William Rollinson Whittingham (1805–1879)—Episcopal bishop of Maryland.

B. *I am / very truly / your friend and serv't / T. C. Brownell*
Thomas Church Brownell (1779–1865)—Episcopal bishop of Connecticut.

C. *Horatio Potter / Bishop of New York*
Horatio Potter (1802–1887)—Episcopal bishop of New York.

D. *John Williams*
John Williams (1817–1899)—Episcopal bishop of Connecticut.

E. *M. A. DeWolfe Howe / June 17th 1859*
Mark Antony DeWolfe Howe (1808–1895)—Episcopal bishop of Central Pennsylvania.

F. *Chas. P. McIlvaine / Bishop of Ohio*
Charles Pettit McIlvaine (1799–1873)—Episcopal bishop of Ohio.

G. *William Bacon Stevens*
William Bacon Stevens (1815–1887)—Episcopal bishop of Pennsylvania.

H. *T. B. Thorpe / Oct. 17, 1859.*
Thomas Bangs Thorpe (1815–1878)—author, artist, and humorist.

I. *Wm. Allen Butler / New York, Aug. 21, 1863*
William Allen Butler (1825–1902)—lawyer and satirical poet.

J. *There are gains for all our losses, / There are balms for all our pain / R. H. Stoddard*
Richard Henry Stoddard (1825–1903)—poet, critic, and editor.

K. *I have / the honour to be / Your obedient servant / Louis Blane*
—unknown.

L. *Gott zum Gruss! / To his unknown friend / in Arcadia / R. Bunsen / Charlottenburg, 2 Xh., 1858*
Robert Wilhelm Bunsen (1811–1899)—German chemist.

M. *Tout a vous / Edouard Laboulaye / 1 or Lefebere*
Edouard René Lefèvre Laboulaye (1811–1883)—French author of histories about the relationship of the United States and France.

N. *Truly Yours / Parke Godwin / Feb. 22d, 1863*
Parke Godwin (1816–1904)—journalist, biographer, editor, son-in-law of William Cullen Bryant.

O. *12 o' clock & all is well / S. G. Goodrich, 88 Ninth Street / N. York, May 1859*
Samuel Griswold Goodrich (1793–1860)—children's book writer under the pen name of "Peter Parley."

P. *George W. Greene*
George Washington Greene (1811–1883)—biographer and professor at Brown University.

Q. *With compliments of / S. G. Arnold / May 5th 1859*
Samuel Greene Arnold—author of a general history of Rhode Island.

R. *Wilkins Updike*
Wilkins Updike (1784–1867)—author of histories of Rhode Island institutions.

Column 16

A. *Faithfully yr's / F. [illegible] [Taryton?]*
—unknown

B. *Psalm XX. / 1.2. & 3.4. / B. B. Smith*
Benjamin Bosworth Smith (1794–1884)—Episcopal bishop of Kentucky.

C. *God is love / William Meade*
William Meade (1789–1862)—Episcopal bishop of Virginia.

D. *A. Cleveland Cope / New York / Nov. 14. 1863*
—unknown.

E. *Alfred Lee / Bishop of Delaware*
Alfred Lee (1807–1887)—Episcopal bishop of Delaware.

F. *Henry W. Lee / Bishop of Iowa*
Henry Washington Lee (1815–1874)—Episcopal bishop of Iowa.

G. *Pluck wins the day / In the battle of Life. / Mortimer Thomson, "Doesticks, P.B.", 1863*
Mortimer Neal Thomson (1831–1875)—humorist, under the pen name of Q. K. Philander Doesticks, P. B.

H. *Oh thing of many names, / Impart no pains to her, / But while one shred remains / Be thou a comforter / B. P. Shillaber*
Benjamin Penhallow Shillaber (1814–1890)—humorist.

I. *Faithfully yrs. / Edmund Clarence Stedman, Dec. 1863*
Edmund Clarence Stedman (1833–1908)—satiric poet and journalist.

J. *Emma Willard*
Emma Hart Willard (1787–1870)—educator, founder of America's first academic secondary school for girls.

K. *William Howitt*
William Howitt (1792–1879)—English poet.

L. *Mary Howitt*
Mary Howitt (1799–1888)—English poet and translator.

M. *Sarah H. Whitman*
Sarah Helen Power Whitman (1803–1878)—poet.

N. *Is ten old— / [jon?] nick! / Charles L. Brace*
Charles Loring Brace (1826–1890)—philanthropist and writer.

O. *With the kindest wishes of / John S. C. Abbott. / Farmington Maine / May 3, 1859.*
John Stevens Cabot Abbott (1805–1877)—clergyman, educator, and historian.

P. *With the very sin- / cere regards of / Jacob Abbott / March 1863*
Jacob Abbott (1803–1879)—clergyman, educator, and writer of children's books; brother of John S. C. Abbott.

Q. *Yours truly / J. T. Headley / 1859*
Joel Tyler Headley (1813–1897)—journalist and biographer.

R. *November 06.24.5[?] / P. C. Headley*
Phineas Camp Headley (1819–1903)—clergyman and biographer.

Column 17

A. *God / is Love / Robert A. Hallam, Rector of St. James / New London / Conn.*
Robert Alexander Hallam (1807–1877)—Episcopal clergyman, St. James Church, New London, Connecticut.

B. *W. A. Mulenberg / W.A.M. / March 10th / 1863.*
William Augustus Mulenberg (1796–1877)—Episcopal clergyman, Church of the Holy Communion, New York City.

C. *Francis Vinton DD / A[illegible] Trinity Church / N. Y.*
Francis Vinton (1790–1872)—Episcopal clergyman, Trinity Church, New York.

D. *Grant Horburn; aged [illegible] years/ Feb. 18— 1858*
—unknown.

E. *Elihu Burritt*
Elihu Burritt (1810–1879)—reformer for the cause of world peace and universal brotherhood.

F. *J. Milton Mackie*
John Milton Mackie (1813–?)—biographer.

G. *Theodore Tilton.*
Theodore Tilton (1835–1907)—editor of the weekly *Independent*.

H. *Life is a dream / Now [illegible], now light / May heavens own beams / Dispel thy might / Mary A. McMaking*
—unknown.

I. *Metta V. Victor*
Metta Victoria Fuller Victor (1831–1885)—poet, novelist, and editor of the *Home Monthly Magazine*.

J. *"Marion Harland"*
Mary Virginia Hawes Terhune (1830–1922)—novelist; used pen name of "Marion Hanland."

K. *Edna Dean Proctor.*
Edna Dean Proctor (1838–?)—poet and writer.

L. *Sarah Josepha Hale*
Sarah Josepha Buell Hale (1788–1879)—author and editor of *Godey's Lady's Book*.

M. *L. H. Sigourney / 1858.*
Lydia Howard Huntley Sigourney (1791–1865)—author.

N. *H. F. Gould / January, 1859*
Hannah Flagg Gould (1789–1865)—poet.

O. *May God bless you! / Geo. Sumner*
George Sumner (1817–1863)—political economist.

P. *Dormi bene! / Bayard Taylor.*
Bayard Taylor (1825–1878)—travel writer.

Q. *E. Geo. Squier / Paris, / 1858.*
Ephraim George Squier (1821–1888)—travel writer.

R. *The Rose her petals opens / to the sun / Blushing like Beauty, at / being gazed upon / R. Shelton Mackenzie / 1860*
R. Shelton Mackenzie (1809–?)—journalist and biographer.

Column 18

A. *"The circle of / God's life contains / all life beside." / Alex H. Vinton*
Alexander Hamilton Vinton (1807–1881)—

Episcopal clergyman, Church of the Holy Trinity, Philadelphia.

B. *Submission / to / Womens Rights / Stephen H. Tyng*
Stephen Higginson Tyng—Episcopal clergyman, St. George's Church, New York.

C. *Yours truly / Sam Osgood*
Samuel Osgood (1812–1880)—Unitarian clergyman, Church of the Messiah, New York, and author.

D. *Very truly yours, / Augustus Woodbury*
Augustus Woodbury (1825–?)—Unitarian clergyman, Westminister Unitarian Church, Providence, and author.

E. *Edward E. Hale*
Edward Everett Hale (1822–1909)—Unitarian clergyman, South Congregational Church, Boston, and author.

F. *Charles T. Brooks*
Charles Timothy Brooks (1813–1883)—Unitarian clergyman, Unitarian Congregational Church, Newport, Rhode Island, and translator of German literature.

G. *Small space I require / To fulfil your desire / For Lady, you claim/ But a verse and a name. Geo. W. Pettes.*
—unknown.

H. *Good deed through / thy life shine / Making [illegible] hour / divine / Virginia F. Townsend*
Virginia Frances Townsend (1836–1920)—author and associate editor of *Arthur's Lady's Home Magazine*.

I. *M. J. Holmes*
Mary Jane Hawes Holmes (1825–1907)—novelist.

J. *Ann S. Stephens*
Ann Sophia Stephens (1813–1886)—author and editor.

K. *Julia Ward Howe / 1864*
Julia Ward Howe (1819–1910)—author and abolitionist.

L. *Ann Cora Ritchie / Richmond / Dec. 7th 1858.*
Anna Cora Ogden Mowatt Ritchie (1819–1870)—author and actress.

M. *Respectfully, / W. Gilmore Simms. / September / 30, / 1858.*
William Gilmore Simms (1806–1870)—novelist.

N. *Caroline Gilman / Charlestown S.C. / 1858*
Caroline Howard Gilman (1794–1888)—author.

O. *Dream what thou wilt / Beneath this quilt / My blessing still is / Yours. N. P. Willis.*
Nathaniel Parker Willis (1806–1867)—journalist, poet, and editor.

P. *Truly. / Geo. P. Morris, / Sep. 10 / 1858.*
George Pope Morris (1802–1864)—journalist, poet, and editor.

Q. *Not far we wander from the eternal Halls! / Some voices will stray out to mortal sense, / Some fragmentary music 'scapes to earth, / From th'abodes of peace and innocence! / Richard Willis. / 1860.*
Richard Storrs Willis (1819–?)—journalist, brother of N. P. Willis.

R. *Park Benjamin / New York / Aug. 17, '58*
Park Benjamin (1809–1864)—editor.

Column 19

A. *Henry W. Bellows / Pres't of the U.S. / Sanitary Com'n.*
Henry Whitney Bellows (1814–1882)—Unitarian clergyman, Church of All Souls, New York.

B. *"Pleasant Dreams" to / You! R. S. Storrs, Jr. / Brooklyn NY.*
Richard Salter Storrs Jr. (1821–1900)—Congregational clergyman, Church of the Pilgrims, Brooklyn, New York.

C. *Henry Ward Beecher*
Henry Ward Beecher (1813–1887)—Congregational clergyman, Plymouth Church, Brooklyn, New York, and antislavery activist.

D. *Rest for the dili- / gent hand, the true and / loving spirit, and the / good conscience. / W. B. Sprague*
William Buell Sprague (1795–1876)—Presbyterian clergyman, Second Presbyterian Church, Albany, New York.

E. *"Leve fit, quod bene fortus / onus." / James Freeman Clarke*
James Freeman Clarke (1810–1888)—Unitarian clergyman, Church of the Disciples, Boston.

F. *Yours Truly, / E. H. Chapin. / 1858*
Edwin Hubbell Chapin (1814–1880)—Universalist clergyman, the Fourth Universalist Society, New York.

G. *Character / is the crowning substance / in nature. / Th. Starr King, Boston*
Thomas Starr King (1824–1864)—Unitarian clergyman, Hollis Street Church, Boston.

H. *W. [M?] [illegible] / 1858 / Providence, R.I.*
—unknown.

I. *Bon soir. / Mary B. Goodrich / Southbury. May, 1859.*
Mary Boott Goodrich (dates unknown)—wife of S. G. Goodrich, column 15.

J. *Very truly your / friend. / Abby W. Chace / Providence*
Abby W. Chace (dates unknown)—wife of George I. Chace, column 20.

K. *L. Maria Child. / 1863.*
Lydia Maria Francis Child (1802–1880)—author and abolitionist.

L. *H. B. Stowe / Andover / 1858*
Harriet Elizabeth Beecher Stowe (1811–1896)—novelist.

M. *Sleep is a recreance to the body.— / but when [does?] mind sleep? Martin F. Tupper*
Martin Farquhar Tupper (1810–1889)—English poet.

N. *With great pleasure/ [C. Mackey?] London, March 4, 1859*
—unknown.

O. *Trust / and surest hopes aspiring high / Love and sweet friends forever sigh / Rest and sweet sleep for [illegible] / wishes you / G. B. Emerson*
George Barrell Emerson (1797–1881)—educator.

P. *Respectfully, / Charles Sprague. / August 10, / 1858.*
Charles Sprague (1791–1875)—poet.

Q. *J. G. Holland / Sprgfd. Mass. 1859.*
Josiah Gilbert Holland (1819–1881)—editor and author.

R. *God love you! / Anson G. Chester*
Anson G. Chester (dates unknown)—poet.

Column 20

A. *Yours truly / Orville Dewey*
Orville Dewey (1794–1882)—Unitarian clergyman, New South Church, Boston.

B. *1859 / "He giveth to his beloved / sleep." / Rufus W. Clark / Brooklyn*
Rufus Wheelwright Clark (1813–1886)—Presbyterian clergyman.

C. *In every thing give thanks / with [illegible] good wishes / Cha. Lowell / Elmwood / Oct. 11th 1859*
Charles Lowell (dates unknown)—Unitarian clergyman, West Church, Boston, father of James Russell Lowell, column 11.

D. *He that keepth thee / will not slumber. Behold / He that keepth Israel shall / neither slumber nor sleep. The Lord / is thy keeper. He shall preserve thy soul. George B. Cheever*
George Barrell Cheever (1807–1890)—Presbyterian clergyman, Church of the Puritans, New York.

E. *Phineas D. Gurley*
Phineas Densmore Gurley (1816–1868)—Presbyterian clergyman, Second Presbyterian Church, Washington, D.C.; delivered sermon at Lincoln's funeral.

F. *Noah Porter / Yale College*
Noah Porter (1811–1892)—Congregational clergyman, and professor of moral philosophy, Yale College.

G. *Yours etc. / F. Wayland, March 9. / 1858*
Francis Wayland (1796–1865)—Baptist clergyman, First Baptist Church, Providence, fourth president of Brown University (1827–55).

H. *Employ earthly things; Enjoy heavenly things. / B. Sears, [Freidenmer?], Sept. 2d, 1859.*
Barnas Sears (1802–1880)—Baptist clergyman, fifth president of Brown University (1855–67).

I. *Geo. I. Chace / Providence, R.I. July 2, 1859*
George Ide Chace (1808–1885)—professor of physics, sixth president of Brown University (1867–68).

J. *Yours very truly / James B. Angell*
James Burrill Angell (1829–1916)—professor of modern languages at Brown University and editor of the *Providence Journal.*

K. *Three score armed / men are about his / bed because of [illegible] / in the night. So sang / the wise king in his / song of songs—and / thus the lady fair / seeks to [illegible] her / sleeping guests may [illegible] / B. Silliman*
Benjamin Silliman Jr. (1816–1885)—professor of chemistry at Yale College.

L. *Theodore D. Woolsey / Yale College. / Feb. 21 / 1859*
Theodore Dwight Woolsey (1801–1889)—president of Yale College (1846–71).

M. *Thomas A. Thacher / New Haven / Conn*
Thomas Anthony Thacher (1815–1886)—professor of Latin at Yale College.

N. *W. D. Whitney / Yale College / New Haven Conn*
William Dwight Whitney (1827–1894)—professor of Sanskrit at Yale College.

O. *Oh sleep! it is a gentle thing. / Coleridge. / James Hadley*
James Hadley (1821–1872)—professor of Greek at Yale College.

P. *Yours truly, / Epes Sargent / Sept. 1858*
Epes Sargent (1813–1880)—journalist and poet.

Q. *"To bed—to bed—to bed!" / Lady Macbeth. / George Canning Hill*
George Canning Hill (1796–1871)—poet.

R. Last diamond contains a poem (possibly by Nathaniel P. Willis, column 18): *Miss Addie pray excuse / My disobliging Muse, / She contemplates with dread / So many in a Bed*

Technical Report on the Adeline Harris Sears Autograph Quilt

ELENA PHIPPS

Conservator, Department of Textile Conservation, The Metropolitan Museum of Art

THE SILK AUTOGRAPH QUILT recently acquired by The Metropolitan Museum of Art is one of the finest examples of the period, exquisitely made and well preserved. Created by a highly skilled needle-woman, it is remarkable for its brilliant colors and complex design, known as "Tumbling Blocks," which produce a visually striking pattern, full of optical play and subtle intricacies. The design, composed of silk fabrics cut into diamonds and triangles,[1] forms a trompe l'oeil effect, resembling a three-dimensional block or cube, silhouetted against a black background. The quilter, following an ingeniously crafted and well-planned layout, skillfully enhanced the three-dimensionality of the pattern through her selection of a variety of silk fabrics and their arrangement within the composition. Each block, made up of three fabric components, contains one white silk diamond with an inked signature as the top surface of the cube and two colored- or patterned-fabric diamonds (turned on their sides), as the V-shaped side panels (see Appendix). Black silk triangles flank each unit and, when joined together, create the rich and textured black background.

Three hundred and sixty signature blocks, plus ten partial blocks along the top (without the white signature diamonds), make up the quilt. The blocks are organized into thirty-six and one-half rows (oriented horizontally) and twenty columns (oriented vertically), alternately offset, with ten blocks across each row. Examining the seams along the inside of the quilt top,[2] we can reconstruct the sewing sequence that the quilter used to piece it together: first she stitched the individual diamonds into blocks, then connected the blocks into columns, and finally seamed the columns together across the entire width. In total, she cut and stitched 1,840 individual silk pieces to create the quilt.

The quilt contains more than one hundred and fifty different silk fabrics. Such a wide array represents many types of goods manufactured in the period. For the most part, they appear to have been imported from Europe, although it is possible that some of the solid-colored fabrics might be of American manufacture. Some were produced as dress goods, though most of the silks used are actually ribbons, whose decorative selvaged edges have been seamed into the quilt and are visible on the reverse of the quilt top (Figure 1).

The different fabrics appear to be randomly distributed throughout the quilt, although the simplicity of this seemingly casual planning is deceptive. In some cases, the artist incorporated the same individual fabric in five or six different blocks, even though she never repeated the exact combination of fabrics within the blocks. Her methodical distribution of the various fabrics creates a harmonious and nonrepeating vista across the surface of the quilt. At least five different types of black fabrics are used in the background triangles, and several different types of white silk make up the signature diamonds.

Traditionally, quilts were made from fabric scraps and remnants saved from various family sewing projects. Bits and pieces were salvaged from favorite garments or other items perhaps too tattered, frayed, or unfashionable to be worn again. Some of the fabrics we find in the signature quilt had obviously been used prior to their presence in the quilt—evidenced by stains and marks of wear—possibly as parts of dresses or bonnets, while others were pristine and new at the time they were cut into the triangular and diamond-shaped sections. Some individual diamonds are actually made up of several components seamed together. Holdovers from an earlier time, the seams are testament to the original function of the fabric, for example, as part of a garment (Figure 2). Other seams found in some of the diamonds result from intentionally joining narrow ribbons together in order to span the width required for the diamond shape and must have been sewn at the time the quilt was made.

The quilter used a selection of various types of silk fabrics and ribbons. Patterned or textured in the weave of the cloth, these include solid-color and polychrome plainweaves and satins, stripes, checks, plaids, moirés,

The notes for this article begin on page 294.

Figure 1. Detail showing the back of the top of the quilt (MMA 1996.4). Decorative, scalloped selvaged edges of one of the ribbons used for the right side diamond can be seen, as well as the fine stitching that joins the pieces together. The long, loose white threads (visible around the edges of the diamonds) are the basting threads, which had been cut to remove the paper templates. (photo: author)

Figure 2. Detail showing the back of the quilt top. The dress-fabric diamond at the left has been seamed. The right diamond is a ribbon with decorated selvaged edges; basting stitches are visible. (photo: author)

and ikat and *chiné à la branche* (both dye-patterning techniques). Some are more complexly patterned with supplementary weft, brocaded wefts, and other woven float weaves. Several of the ribbons can be found in multiple colorways—that is, the same woven pattern made in different color combinations—providing a glimpse into the textile manufacturers' variety available at the time. One very interesting group of ribbons has resist-dyed warp-and-weft ikat, which reveals a distinctly Indian or Southeast Asian influence, fashionable in French silks in the mid-nineteenth century. Warp printed silk ribbons, such as some of those found in the quilt, were also known to have been manufactured in America, though primarily later, in the 1890s. Further research on these ribbons will help to determine their place of manufacture.

The quilt face is composed of hand-stitched components, each piece seamed to its neighbor in small, fine overcast stitches.[3] The sharply pointed and uniformly regular shape of the blocks indicates the high degree of skill and craftsmanship that went into the making of the quilt. In order to ensure the sharp corners and exact fit of the blocks to each other, each individual piece would presumably have been basted temporarily around a template, most likely of heavy paper.[4] Although there are now no traces of the templates, remnants of the basting threads are visible from the back; these were cut to release the template after the seaming of the blocks was completed (see Figures 1, 2). Even where the threads are gone, the needle holes (located about one-quarter of an inch above the seams), visible from the front, trace the construction process.

In general, the quilt is in an excellent state of preservation, with its brilliant palette primarily made up of colors produced with natural dyes (some of which were industrially processed by this period). The colors include vivid safflower pinks, insect reds, and indigo blues, as well as many other combinations of dyestuffs creating the reds, purples, yellows, greens, browns, and blacks, and all, for the most part, have been well preserved. Safflower pink is a dyestuff that is very sensitive to light and pH, and it was used in some of the solid-colored satins, moirés, and plaid. A few of these pinks have faded slightly, but, remarkably, most have retained their brilliant hue throughout the quilt. Additionally, several of the early synthetic dyes, notably a mauve color,[5] along with a sulfonated blue, can be found in the quilt.

Among the delicate silk fabrics composing the quilt, many are in pristine physical condition, the result of the good care taken in preserving it over time.[6] Most of the fabrics are of weighted silk—a finishing process popular in the nineteenth century that used the addition of metallic salts to enhance the physical quality of the silk during manufacturing.[7] The weighting, or "loading," of the silk resulted in a heavier fabric, which had an appeal in its drape and hand. Some of these weighted silks have begun to split, a characteristic long-term effect of the process.

The white silk diamonds (probably sewn to their rigid templates) were sent away to be signed by the selected participants, and as a result a variety of household inks were used in the signatures. The inks vary in type, color, and characteristics. Some are black, others

are more grayish in hue. Some have run on the silk, probably at the time of the writing, due to the diluted strength of the ink solution and to the finished surface of the silk fabric. The inks of the period were most likely composed of an iron-tannin mixture,[8] or possibly of a carbon-type. Chemical reactions between some of the inks (presumably the iron-gall type) and the silk have caused deterioration in the ground fabric. In these areas, the silk has almost disappeared, leaving only the negative shape of the signature. One signature (S. G. Goodrich) was drawn in a rare turquoise blue ink.

The quilt is lined with a red silk fabric, composed of five narrow panels (each 16¾ in. loomed-widths) seamed together. A dark red silk grosgrain ribbon was finely stitched in matching silk thread around the edges of the quilt, attaching the front and back together. There is no stuffing in this quilt, nor are there any actual "quilting" stitches between the top and backing. This confirms the impression that it was most likely intended as a showpiece and not to be used on a bed. Small metal rings were stitched to the top for hanging.

Upon examination of the reverse of the quilt top, one curious event in the history of the quilt is revealed. Small needle holes outlining the shape of a diamond can be seen. This seemed to indicate that at some time in the past, one of the diamonds had probably been covered up with a patch, stitched to the quilt after the backing had already been attached. The diamond that had been covered is not one with a signature, but rather, one with a poem in which the last two lines read: "She contemplates with dread / So many in a bed."

While the maker of the quilt placed the poem on the lower-right corner—with its veiled reference to the number of people represented by their signatures sharing the space within the bedcover—perhaps one of her descendants thought it was too risqué and decided to cover it up. By the time the quilt reached the Museum, the patch had been removed.

Appendix

The fabrics composing the design block (defined as one top diamond, two side diamonds, and two lower triangles) that includes the signature of Abraham Lincoln, as an example, were analyzed (see Figure 3).[9] The documentation of the textile components for this unit follows. This includes the upper diamond with the signature (labeled Fabric A), the left-side diamond (Fabric B), the right-side diamond (Fabric C), the lower-left black triangle (Fabric D), and the lower-right black triangle (Fabric E) (see Figure 4).

Fabric A, diamond (top)
Fabric type: solid-colored plain white silk fabric
Fabric structure: warp-faced plain weave
Warp: slight Z twist, 192 per in.
Weft: no twist, 144 per in.
Color: white, undyed. Analysis indicated no significant amount of metallic salts.
Condition: Good, some "foxing" stains at back
Fabric orientation as used in quilt: diagonal left to right
Other: ink in good condition. Cut ends in warp direction have been secured with a zigzag stitch, visible at the back.

Fabric B, diamond (left)
Fabric type: plaid ribbon
Fabric structure: warp-predominant plain weave
Warp: two colors, black and yellow. No twist, 149 per in.
Weft: yellow, no twist, 112 per in.
Color: black, yellow, yarn-dyed. EDS analysis for the black yarns indicates a significant amount of iron and copper in both the warp and the weft yarns.
Condition: good overall, but black yarns are disintegrating.
Fabric orientation as used in quilt: warp direction vertical
Other: ribbon selvages at inside seam. Ribbon width 2½ in.

Fabric C, diamond (right)
Fabric type: solid pink color with "quilted" pattern fabric
Fabric structure: warp-faced plain weave. Perforated pattern
Warp: pink yarn, Z-twist, 192 per in.
Weft: light pink yarn, no twist, 112 per in.
Color: red, yarn-dyed. EDS analysis indicates presence of some tin in both warp and weft yarns. Whether this is from the mordanting or weighting process requires further study.
Condition: some fading, some small yellowish stain (discolor of dye)
Fabric orientation as used in quilt: warp direction vertical
Other: The patterning effect is of a fabric with an overall diamond-shaped design. It appears that the design was made after the fabric was woven, by stitching (probably with a sewing machine) lines and grids. It is possible that the fabric had been quilted to another, prior to the present one, and that the stitching was removed for it to

Figure 3. Reverse side of the Abraham Lincoln design block unit (photo: author)

be used in the quilt, leaving the holes that mark the fabric in a one-inch-square grid pattern.

Fabric D, triangle (lower left)
 Fabric type: black silk fabric
 Fabric structure: warp-faced plain weave
 Warp: black silk, slightly Z twisted, 160 per in.
 Weft: black silk, no twist, 80 per in.
 Color: black, yarn-dyed. EDS analysis indicates the

presence of large amounts of lead and iron, in both warp and weft yarns, and some tin in the warp yarns.
 Condition: generally good, with a few small holes
 Fabric orientation as used in quilt: warp direction vertical
 Other: high degree of luster in the silk

Fabric E, triangle (lower right)
 Fabric type: black silk fabric
 Same fabric as Fabric D
 Condition: somewhat weaker condition than D, with some vertical tears
 Fabric orientation as used in quilt: diagonal

Sewing threads:
 Connecting design elements:
 A to B: white silk thread, 2 Z-twist, S-plied
 A to C: red silk thread, 2 Z-twist, S-plied
 B to C: black silk, 2 Z-twist, S-plied
 B to D: black silk, 2 Z-wist, S-plied
 C to E: black silk, 2 Z-twist, S-plied
 Basting thread used for sewing template: white cotton, 2 Z-twist, S-plied, waxed(?)

Comments:

This particular design unit has a more subdued palette, compared with most of the other units in the quilt. Perhaps this is intentional, in deference to the signer of the white diamond, who was noted for his humble beginnings. The use of the same black fabric for the two triangles occurs in perhaps two-thirds of the quilt. The color of the sewing thread changes throughout, harmonizing with the fabric colors.

From the elemental analysis, we can conclude that some of the fabrics were "weighted" silks. We can assume that the presence of lead in the black silk comes from lead acetate, known to have been used as a weighting substance in the nineteenth century.

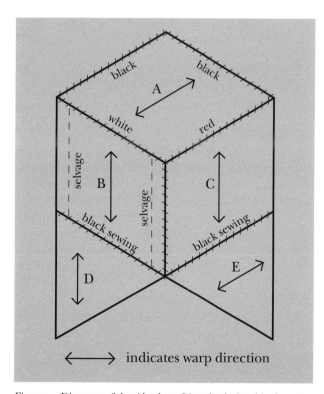

Figure 4. Diagram of the Abraham Lincoln design block unit, indicating the identification of fabrics, their orientation, and sewing elements

NOTES

1. The "diamond" shape is a parallelogram, 2¼ in. high × 3¾ in. wide at the points. All diamonds are exactly the same size and proportion, but because of their orientation they appear to be a different shape. The triangles are exactly one-half the size of the diamonds.

2. The lower edge of the quilt had been too tight and for conservation treatment was opened up. This allowed for examination and photography of the construction details of the quilt that would not normally have been seen.

3. The stitches are extremely fine, with ca. 25 per inch. Seams are

ca. ⅜ in. or 1 cm. The stitches would have been done from the back and are thus nearly invisible from the front.

4. This observation is confirmed by historical documents, noted above in Amelia Peck's essay.

5. Mauve, or mauveine, is considered one of the first synthetic dyes, discovered by Sir William Henry Perkin in 1856. See Helmut Schweppe, *Practical Information for the Identification of Early Synthetic Dyes* (Washington, D.C., 1987).

6. The quilt came to the Museum in an old, handwoven cotton pillowcase—possibly from the same period. How long it had been kept in the pillowcase is not known, but it had been kept out of the light and showed few signs of previous use. It had been preserved by the descendants of Adeline Harris Sears until it came to the Museum in 1993.

7. The weighting process can be applied to yarns prior to weaving or to the fabric as a whole. See Appendix for identification of metallic salts on sample fabrics.

8. For example, Elijah Bemiss, who wrote his treatise on American colorants in *The Dyers Companion* in 1806, provides two recipes for black ink (New York, 1973 [pp. 289–290]). One includes nut galls, copperas, alum and gum arabic, rainwater, and vinegar or sour beer. Another uses ripe walnut "shook," oak sawdust, blue galls, copperas, and gum arabic, along with rainwater.

9. Fabric structure was analyzed under 8x magnification. Fibers were identified under 400x magnification. Sample identification and separation by author. Inorganic elemental analysis EDS (Energy Dispersive X-Ray Spectrometry) was conducted by Mark Wypyski, associate research scientist, Sherman Fairchild Center for Objects Conservation, MMA. Dye analysis was not conducted at this time.

Talking It Over: A Patriotic Genre Painting by Enoch Wood Perry

DOROTHY HESSELMAN

Assistant Museum Librarian, The Metropolitan Museum of Art

O N FEBRUARY 3, 1872, *Talking It Over* (Figure 1), a genre painting by Enoch Wood Perry (1831–1915), signed and dated 1872, made its debut at the Century Association exhibition in New York.[1] The picture reflects a poignant longing for the serene and uncomplicated life of a bygone era. Two farmers sit facing each other in a barn in front of a stall. One figure occupies an upright wooden chair; the other makes do with a sawhorse turned sideways. A horse peers out of the stall between them, its head directed toward the figure at left. A mound of hay is stacked at the right edge of the picture, and on the left there is a large barrel containing wooden rakes and a pitchfork. Some pumpkins have been piled against the stall between the men's feet, and stray ears of corn and bits of hay and straw litter the barn floor. The sun shines in from the upper left, highlighting the men and casting the shadow of a second, unseen horse's head against the barrel. Both men wear white shirts and work pants. The figure on the right holds an unlit clay pipe and wears a soft hat, a neckerchief, a long-sleeved red undershirt, blue pants, and leather boots. He seems the younger of the two, with a full, dark beard and a strong profile. The man on the left, shorter and balding, is turned three-quarters toward the viewer. He is dressed in a brown vest and pants and wears soft leather shoes.

Strong vertical and horizontal lines define the stage-like picture space, and the figures and architectural forms reinforce each other within the boxlike composition. The wall of the horse's stall at the center is constructed of four horizontal planks, which are framed by vertical posts and planks. The floorboards of the barn lead us into the shallow, intimate space; the orthogonal lines of the floorboards direct the eye to the figure on the right. The chair and the figure seated in it form right angles, as does the lower right corner of the stall opening. The figure's facial profile is partially framed by the lower right corner of the stall

and is seen in relief against the horse's flank, a device that incorporates the figure into the environment and confers on him the attribute of permanence. The figure on the left, with his elbows on his knees and his eyes half shut, sits forward between the round barrel and pumpkins behind him, his body in harmony with his physical surroundings. The horse stands behind the men and helps unite them pictorially.

In spite of the title, *Talking It Over,* both men sit in silence, apparently lost in thought. The righthand figure holds his pipe near his knee as he looks toward his companion in an expectant way, which suggests that he is the one who has last spoken. The left figure appears a bit withdrawn as he turns slightly away from his companion and presses the fingertips of both hands together in contemplation. The narrative drama of poses and gestures and the pictorial relationship between the two figures encourage the viewer to speculate about the subject of their conversation. What has been said that keeps them silent now?

Perry was well known and successful throughout his life, producing a few history paintings but mainly rural genre scenes in oil and watercolor and more than thirty portraits of influential persons from both the North and the South, including Andrew Jackson, Jefferson Davis, and Ulysses S. Grant.[2] No searching analysis of Perry's oeuvre has yet been published, but the available references plainly take his pictures at face value. His only biographer to date, Linda Mary Jones Gibbs, characterizes his genre subjects as hardworking and moral citizens whose "simple, yet honorable activities" contributed to the growth of their developing nation. She ascribes a documentary importance to his work, which she says embraces "ideals of patriotism" and records the "labors, leisures, and pleasures" of ordinary people.[3] A local historian wrote that Perry "merely wanted to depict rural Americans at work."[4] His genre pictures were praised in *Appleton's Journal* as "more valuable" than the "new subjects" of the landscape painters Frederic Church and Albert Bierstadt.[5] An article that appeared in *Art Journal* in 1875, when Perry was forty-four years old, states: "Mr. Perry at the

METROPOLITAN MUSEUM JOURNAL 33

The notes for this article begin on page 302.

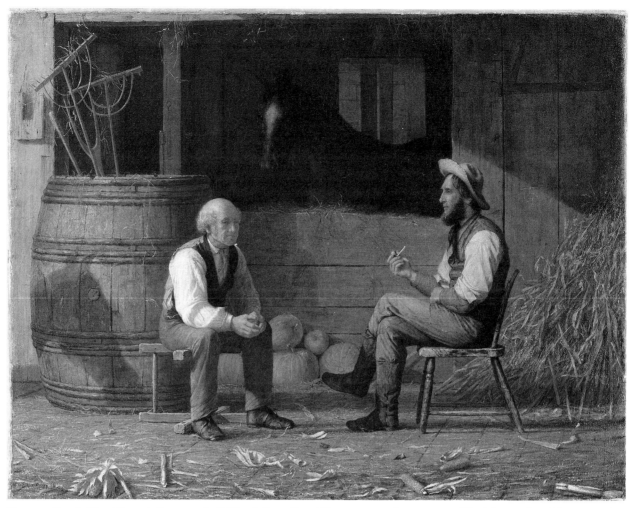

Figure 1. Enoch Wood Perry (1831–1915). *Talking It Over,* 1872. Oil on canvas, 56.5 × 74.3 cm. The Metropolitan Museum of Art, Gift of Erving and Joyce Wolf, 1980, 1980.361

present time occupies a position very nearly at the head of our genre painters. He was one of the first of them to paint American subjects."[6] In modern scholarship Perry's domestic and rural genre scenes are still referred to as embodying quintessentially American themes.

Images of farmers were very popular subjects with nineteenth-century American artists and their patrons. William Sidney Mount painted barnyard scenes, such as *Dance of the Haymakers,* 1845 (The Museums at Stony Brook, New York), and *Bargaining for a Horse,* 1835 (The New-York Historical Society), which prefigure the interior barn setting of *Talking It Over.* Eastman Johnson's *Horse Trade* (Whittling in the Barn), 1866 (Deerfield Academy, Deerfield, Massachusetts; Figure 2), and *Corn Husking,* 1860 (Everson Museum of Art, Syracuse, New York),[7] also anticipate Perry's painting in subject and composition, and presumably Perry relied on pictures like these for his models. Perry's expression

of patriotism proves to be specific and literal when the figures in *Talking It Over* are scrutinized. The farmers, who appear to typify two responsible American citizens contemplating a good harvest, exhibit classic American features. Indeed, Perry selected two of the best-known Americans available for his harvesters: George Washington and Abraham Lincoln. Perry's model for the face of the man on the left appears to have been Gilbert Stuart's "Athenaeum" portrait of George Washington (Figure 3). The sideburns, the cut of the jowl, the thin-lipped and tight-set mouth, even the three-quarter view (in reverse), reflect the Stuart portrait closely, except that Perry made his figure a bit balder than Stuart's Washington. The farmer on the right bears a strong resemblance to Mathew Brady's May 1861 inaugural photograph of Abraham Lincoln (Figure 4). The sharp angle of the hairline at the temple, the cut of the beard, the tilt of the head, the line of the mouth, the direction of the gaze, all seem

Figure 2. Eastman Johnson (1824–1906). *The Horse Trade*, 1866. Oil on canvas, 53.3 × 41.3 cm. Deerfield, Massachusetts, Deerfield Academy, Charles P. Russell Collection (photo: Deerfield Academy)

to be indebted to Brady's portrait.[8] Moreover, Lincoln was a tall, lanky man who typically sat with his legs crossed, and he was frequently portrayed that way.[9] Supporting the identification of the two farmers is the timing of the artist's work on this picture. It was painted in 1872 for the Century Association's exhibition in February, the month of the two presidents' birthdays.[10]

The two portraits by Stuart and Brady were well known. Gilbert Stuart's Athenaeum portrait of George Washington existed in many replicas painted by Stuart and other artists, and the image had been engraved frequently. Stuart called his own copies his "hundred-dollar bills."[11] Mathew Brady's New York studio was on the corner of East Tenth Street and Broadway, just a few doors away from the West Tenth Street Studio Building, where Perry painted *Talking It Over*.[12] The luxurious reception hall of Brady's gallery was used to display his collection of photographs, described by a reporter as "foremost . . . among the local attractions in New York."[13] The first portrait Brady made of Abraham Lincoln, in February 1860 before his election campaign speech at the Cooper Institute in New York, was copied for newspapers, lithographed by

Figure 3. Gilbert Stuart (1755–1828). *George Washington*, 1796. Oil on canvas, 121.9 × 94 cm. Washington, D.C., National Portrait Gallery, Smithsonian Institution; jointly owned with Museum of Fine Arts, Boston (photo: National Portrait Gallery)

Figure 4. Mathew Brady (1823?–1896). Photograph of Abraham Lincoln, May 1861. Fort Wayne, Indiana, The Lincoln Museum (photo: The Lincoln Museum)

Figure 5. *Abraham Lincoln, The Martyr, Victorious*, 1865. Lithograph. Fort Wayne, Indiana, The Lincoln Museum (photo: The Lincoln Museum)

Figure 6. *The Father, and The Saviour of Our Country*, 1865. Lithograph. Fort Wayne, Indiana, The Lincoln Museum (photo: The Lincoln Museum)

Currier and Ives, and widely distributed. Lincoln later remarked, "Brady and the Cooper Institute made me President."[14] Brady was also reproducing carte de visite photographs "by the millions."[15]

George Washington had been revered as the founder of the nation ever since his death in 1799. His portrait was a fixture in American parlors. Joel Headley's biography of Washington was read avidly when it was serialized in *Graham's Magazine* in 1854, and in 1856 seven thousand persons lined up for Edward Everett's lecture in New York City, "The Character of Washington."[16] In 1858 Walt Whitman wrote in an editorial for *The Brooklyn Daily Times*, "The name of Washington is constantly on our lips, his portrait hangs from every wall, and he is almost canonized in the affections of our people."[17] When Lincoln was assassinated in April 1865, he was immediately idolized and was paired pictorially with Washington by journalists and lithographers. Political cartoons and lithographs of the period made liberal use of the conjoined images of George Washington and Abraham Lincoln, and these likenesses were reproduced in every conceivable medium. Patriotic lithographs of 1865 show a saintly Lincoln ascending into the arms of George Washington in heav-

en, there to be crowned with laurel leaves and embraced as "the Preserver of the Union" by "the Founder."[18] *Abraham Lincoln, The Martyr, Victorious* (Figure 5), an engraving that appeared the same year, embellishes the ceremony with winged angels strumming on harps.[19] *The Father, and the Saviour of Our Country* (Figure 6) is representative of the almost idolatrous nature of this popular iconography.[20] A lithograph showing Abraham Lincoln's family, made in 1867, includes a framed portrait of Washington hanging very prominently on the parlor wall behind the family group.[21] Images of Washington and Lincoln together were enlisted to endorse Ulysses S. Grant as the Republican candidate for president in 1872, the same year Perry painted *Talking It Over*. An election broadside titled "YOU MUST MAKE YOUR CHOICE. BIRDS OF A FEATHER FLOCK TOGETHER" (Figure 7) presents Grant between portraits of Washington and Lincoln, all three wreathed in ivy and olive leaves.[22]

Barns and farmers signified the country and its citizens. The farmer was still considered the backbone of the nation and was frequently portrayed as "the ideal American citizen."[23] *Talking It Over*, with its farm subject and evocation of the two great American presidents, is a manifestation of contemporary patriotism. It also refers

Figure 7. *You Must Make Your Choice. Birds of a Feather Flock Together.* 1872 Broadside. Washington, D.C., Library of Congress (photo: Library of Congress)

to the average citizen's awareness of being witness to an influential chapter in American history as the country began to recover from the Civil War and move toward its one-hundredth birthday. Perry reflected the national ethos when he chose to paint two farmers seated in a

barn (the repository of a plentiful harvest, i.e., the country itself), and chose to make the farmers resemble nationally revered presidential leaders. He did this discreetly, so that recognition of their identities is easily overlooked, but it is telling that Perry clothed the Lincoln figure in red, white, and blue. In an era when images of farmers were commonly used as the subjects of paintings and when lithograph prints pairing George Washington and Abraham Lincoln were mass-produced as popular mementos, it would have seemed natural to the artist to combine farm imagery with patriotic portraits.

At the conclusion of the Civil War, another American artist, Winslow Homer, with whom Perry worked in the early 1870s, painted *The Veteran in a New Field* (Figure 8), using harvest imagery to express a national theme.[24] The farmer reaping the grain is a former soldier who has just returned home from the battlefields on which he has served his country; his infantry jacket and canteen lie nearby. But the scythe in his hands, while denoting the honest labor of the harvest, is also a reminder of the earlier harvest of death on the battlefield. As Nicolai Cikovsky Jr. has persuasively argued, the subject and its meaning were prompted by the assassination of Abraham Lincoln, who died in the spring in which *Veteran* was painted.[25] Much as the martyred president was the implicit subject of Homer's picture, he became the disguised subject of *Talking It Over.*

In pictorial language tied tightly to the times, Perry, like Homer, relied upon the farmer to commemorate monumental historic events. With his low-key style Perry made the result so natural-looking that over one hundred years later, in an era far removed from the

Figure 8. Winslow Homer (1836–1910). *The Veteran in a New Field,* 1865. Oil on canvas, 61.3 × 96.8 cm. The Metropolitan Museum of Art, Bequest of Miss Adelaide Milton de Groot (1876–1967), 1967, 67.187.131

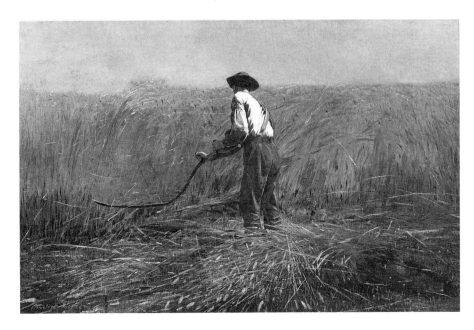

post–Civil War decade, it is easy to miss the casting of the two presidents in the roles Perry makes them play. *Talking It Over* is both a reassuringly familiar farm scene tinged with nostalgia and an artist's tribute to two revered presidents.

ACKNOWLEDGMENTS

This essay is a revision of an exercise prepared for a course in American genre painting taught at The Metropolitan Museum of Art under the auspices of the Graduate Center of City University of New York by Carrie Rebora, Associate Curator, American Paintings and Sculpture, The Metropolitan Museum of Art, and a course on nineteenth-century American painting taught at The Metropolitan Museum of Art under the auspices of Hunter College by Kevin Avery, Associate Curator, American Paintings and Sculpture, The Metropolitan Museum of Art. I am very grateful to them both for their guidance and suggestions. I also wish to thank Harold Holzer, Chief Communications Officer of The Metropolitan Museum of Art and one of the country's leading authorities on Lincoln and Civil War iconography, for his contribution to the findings.

NOTES

1. James L. Yarnall and William H. Gerdts, eds., *The National Museum of American Art's Index to American Art Exhibition Catalogues from the Beginning through the 1876 Centennial Year* (Boston, 1986) I, p. 32, and IV, p. 2768.

2. *Andrew Jackson*, 1860, is owned by the Louisiana State Museum, New Orleans. *Jefferson Davis*, 1861, is in the Department of Archives and History of the State of Alabama, Montgomery. *Ulysses Simpson Grant*, 1875, belongs to the Union League Club, New York. *Inventory of American Paintings* (Washington, D.C., 1996) rec. nos. 73260540, 73260541, 62090068.

3. Linda Mary Jones Gibbs, "Enoch Wood Perry, Jr.: A Biography and Analysis of His Thematic and Stylistic Development" (Salt Lake City, 1981) pp. 86, 107.

4. Nancy Fenn Montgomery, "The Perrys and 'The Studio,'" in *Sixty-Eighth Annual Excursion of the Sandwich Historical Society* (Center Sandwich, N.H., 1987) p. 8.

5. The article concludes, "American art owes him a great deal for his peculiar conceptions, and his return [from his summer sojourn in Europe] to his old subjects will be warmly welcomed." "Art, Music, and Drama," *Appleton's Journal* 10, 230 (Aug. 16, 1873) pp. 219–220.

6. "American Painters—E. Wood Perry," *Art Journal* 1 (1875) p. 216.

7. Patricia Hills, *The Genre Painting of Eastman Johnson, The Sources and Development of His Style and Themes* (New York, 1977) p. 215, fig. 52.

8. Harold Holzer, a Civil War historian, alerted me to the posssible significance of the ears of corn on the barn floorboard that leads to the Lincoln figure. Holzer believes that the corn alludes to the Battle of Antietam, which had been fought in a cornfield. The Confederate general Robert E. Lee had hoped to capture Washington, D. C., from this vantage point in Maryland. His defeat marked one of the bloodiest battles of the Civil War. President Lincoln took advantage of the Northern victory at Antietam to issue the Emancipation Proclamation.

9. Photographs and portraits of Lincoln confirm this. *Abraham Lincoln*, 1864–65, by George Peter Alexander Healy, National Gallery of Art, Washington, D.C., is one well-known example, but there are so many portrait photographs of Lincoln seated with crossed legs that the pose has become iconic. A number of examples by Mathew Brady, Alexander Gardner, and others can be found in Stefan Lorant, *Lincoln, His Life in Photographs* (New York, 1941).

10. Abraham Lincoln's birthday was first observed as a holiday on Feb. 12, 1866. George Washington's February birthday has been observed since 1782. Robert J. Myers, *Celebrations: The Complete Book of American Holidays* (Garden City, 1972) pp. 38, 63.

11. Richard McLanathan, *Gilbert Stuart* (New York, 1986) pp. 95–99. James Thomas Flexner, *Gilbert Stuart, A Great Life in Brief* (New York, 1955) p. 143.

12. James D. Horan, *Mathew Brady, Historian with a Camera* (New York, 1955) p. 28. Perry occupied the Studio Building on West Tenth Street between Fifth and Sixth Avenues from 1867 to 1880. Annette Blaugrund, "The Tenth Street Studio Building: A Roster, 1857–1895," *American Art Journal* 14, 2 (Spring 1982) pp. 64–71.

13. Horan, *Mathew Brady*, pp. 28–29.

14. Ibid., pp. 31–32. "It has been said, perhaps with exaggeration, that over one hundred thousand copies [of the first portrait of Lincoln made by Mathew Brady, on Feb. 27, 1860] were distributed in the campaign that year." Frederick Hill Meserve, *The Photographs of Abraham Lincoln* (New York, 1944) p. 27.

15. A new process developed in 1861 made it possible for commercial photographers to take a picture of a lithograph or an engraving and reproduce it in limitless quantities. These calling-card–sized photographs, called cartes de visite, became very popular and were frequently displayed on the parlor table encased in small leather-bound scrapbooks especially designed for the purpose. Harold Holzer, *Washington and Lincoln Portrayed, National Icons in Popular Prints* (Jefferson, N.C., 1993) p. 67; Horan, *Mathew Brady*, p. 25.

16. Barry Schwartz, *George Washington, The Making of an American Symbol* (New York, 1987) p. 195.

17. Walt Whitman, *I Sit and Look Out*, Emory Holloway and Vernolian Schwarz, eds. (New York, 1932) p. 59.

18. *The Founder and the Preserver of the Union [Apotheosis]*, carte de visite photograph of a lithograph, Philadelphia, 1865 (The Lincoln Museum). Holzer, *Washington and Lincoln*, p. 203; also frontispiece, *Lincoln Crowned by Washington*, a 20th-century copy of an 1865 print by D. W. Butterfield, reissued in October 1931 for the Washington bicentennial.

19. Engraving published by W. H. Hermans, Penn Yann, New York, 1865 (The Lincoln Museum). Holzer, *Washington and Lincoln*, p. 202.

20. *Washington and Lincoln, The Father and the Saviour of Our Country,* 1865 (Currier & Ives), based on a portrait of Washington by Gilbert Stuart and a photograph of Lincoln by Anthony Berger. Holzer, *Washington and Lincoln,* p. 223. Another 1865 lithograph, signed by L. Kurz, portrays the two deceased presidents standing on a map of North America and flanking a shield carrying a coat of arms designed with stars and stripes and emblazoned with the motto Our Country. Washington holds the Constitution, and Lincoln grasps the Emancipation Proclamation. It is titled "NATIONAL PICTURE, BEHOLD OH! AMERICA, YOUR SONS. *The greatest among men,*" and appears in Bernard F. Reilly Jr., *American Political Prints 1766–1876, A Catalog of the Collections in the Library of Congress* (Boston, 1991) pp. 554–555.

21. *President Lincoln and Family Circle,* lithograph, New York, 1867 (The Lincoln Museum). Holzer, *Washington and Lincoln,* pp. 210–211.

22. Reilly, *American Political Prints,* pp. 600–602.

23. Sarah Burns, *Pastoral Inventions, Rural Life in Nineteenth-Century American Art and Culture* (Philadelphia, 1989) p. 99.

24. I am indebted to Kevin Avery for pointing out the relationship between *The Veteran in a New Field* and *Talking It Over. The Veteran in a New Field* was exhibited at the Artists' Fund Society and reviewed in *The Nation* (Nov. 23, 1865). Kathleen Luhrs, ed., *American Paintings in the Metropolitan Museum of Art* (New York, 1985) II, pp. 433–444. An entry inscribed by hand in the Century Association's exhibition record for Feb. 5, 1870, mentions an untitled picture, "Reaper male figure wheatfield," by Winslow Homer. There are also two entries for Perry in the same exhibition record. Mention is made in "Art Notes" in *The Evening Post* (July 8, 1872) p. 1, that "Winslow Homer and E. Wood Perry are at Hurley, Ulster County, N.Y. sketching the quaint old Dutch interiors which abound in that neighborhood."

25. Nicolai Cikovsky Jr., *Winslow Homer* (Washington, D. C.,1995) pp. 25–26, 53.

Balthus's Thérèses

SABINE REWALD

Associate Curator, Department of Twentieth Century Art, The Metropolitan Museum of Art

ONE LOOKS IN VAIN for playful children in Balthus's work. Balthus's children, when awake, never smile. They remain remote, withdrawn, and self-absorbed. Often they are pensive and float in daydreams. These dreams sometimes produce languid abandonment; at other times, they induce the gangling postures that convey the ambiguities that are part of puberty.

The painter's finest portrayals of adolescents are his series of paintings from 1936 to 1939 for which young Thérèse Blanchard served as model. Thérèse and her brother Hubert were neighbors of Balthus at the Cour de Rohan, near the place de l'Odéon in Paris. The two children make their first appearance in the artist's work about 1935 in the small, undated oil sketch *Thérèse and Hubert* (Figure 1), in which Thérèse looks about eleven and Hubert about nine years old. In many years of research on the artist, I tracked down most of his models but, unfortunately, not the Blanchard "children," who, if still alive, would today be adults in their seventies. Thérèse and Hubert posed together in two more paintings, the more famous of which is *The Children* of 1937, discussed below.

Thérèse posed alone or with her cat in at least ten additional paintings, not all of which will be discussed here. One of the earliest of these works is *Thérèse* of 1936 (Figure 2), once owned by the French writer Pierre-Jean Jouve (1887–1976), who was a friend of Balthus's. With tenderness and intuition Balthus has caught the girl's grave look, which, added to the dark dress, endows her with fragile dignity. Only a painter who understood his sitter could have expressed the young model's graveness as movingly as Balthus has done here.

Two years later in the Metropolitan's *Thérèse* of 1938 (Figure 3), the young girl's deadpan expression hints at the boredom of having to sit still too long. The composition recalls Courbet's portrait of his young sister, *Juliette Courbet* of 1844 (Figure 4), whose prim demeanor, however, becomes nonchalance and boldness in the twentieth-century Thérèse Blanchard. The casual ele-

gance of young Thérèse's pose imbues her with the security of someone much older. Likewise, her clothing—the tailored brick jacket and plain dark taupe skirt—has the understated sophistication usually found on adults. She is young yet knowing, vulnerable yet tough.

Thérèse Blanchard also posed for *Girl with a Cat* of 1937 (Figure 5) and its later, more masterly version *Thérèse Dreaming* of 1938 (Figure 6) in the Gelman Collection. With her kneesock falling down and her sleeves pushed up, Thérèse in *Girl with a Cat* looks as if she has been called away from play. Her pale skin and turquoise, white, and red garments stand out against the harsh background of the painter's studio, in which the fat tiger cat blends imperceptibly. Balthus has imbued her quite innocent exhibitionism with suggestiveness. The erotic mood is heightened by the strict discipline of the composition.

In *Thérèse Dreaming* young Thérèse, lost in reverie with her hands folded above her head, a rapt expression on her face, and her legs uncovered, becomes the epitome of dormant adolescent sexuality. With the gray cat lapping milk from a saucer Balthus adds yet another erotic metaphor. The picture presents a haunting description of that stage in life that veers between lassitude and exuberance, innocence and sexual fantasies, reality and dream.

The artist adopted Thérèse's posture in both works from the Man Ray photocollage (Figure 7) that appeared in the same issue of *Minotaure* as Balthus's illustrations for *Wuthering Heights*.[1]

In 1939 Thérèse posed for what seem to be the final two portraits of her (Figures 8, 9). Later that year, the artist was called up for army service and left Paris, returning only after the war. Caught from two different profile views and wearing a floppy white collar, Thérèse already looks less childlike and more prim and glum.

In his series of Thérèse Blanchard, Balthus mingles intuition into his young model's psyche with an overt erotic desire. On the one hand, he gives his model as much dignity and importance as if she were viewed by someone of her own age. On the other hand, he adds a provocative, tantalizing layer to her innocence. This coexistence of empathy and erotic desire for the

METROPOLITAN MUSEUM JOURNAL 33

The notes for this article begin on page 313.

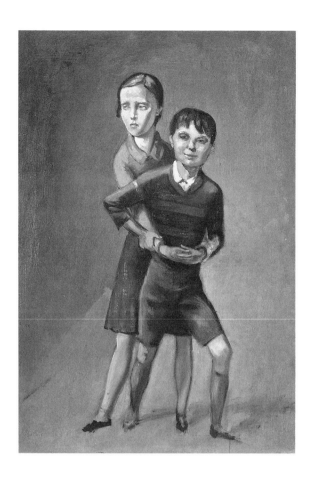

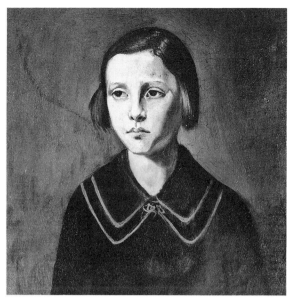

Figure 2. Balthus. *Thérèse*, 1936. Oil on canvas, 60 x 49 cm. Private collection (photo: private collection)

Figure 1. Balthus (Balthasar Klossowski, French, b. 1908). *Thérèse and Hubert*, ca. 1935. Oil on canvas, 91.4 x 66 cm. Washington, D.C., Hirshhorn Museum and Sculpture Garden, Smithsonian Institution (photo: Hirshhorn Museum and Sculpture Garden)

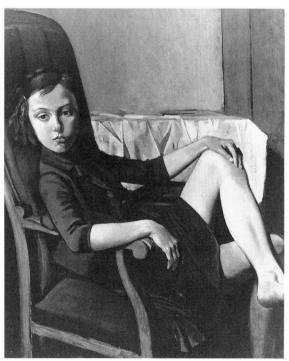

Figure 3. Balthus. *Thérèse*, 1938. Oil on heavy cardboard mounted on wood, 98 x 79 cm. The Metropolitan Museum of Art, Bequest of Mr. and Mrs. Allan D. Emil, in honor of William S. Lieberman, 1987, 1987.125.2

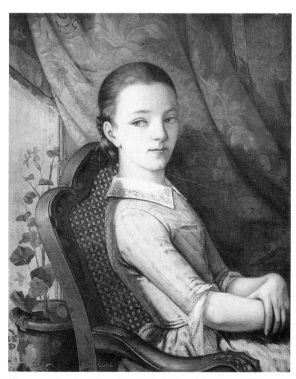

Figure 4. Gustave Courbet. *Juliette Courbet,* 1844. Oil on canvas, 78 x 62 cm. Paris, Musée du Petit Palais (photo: Bullioz, Paris)

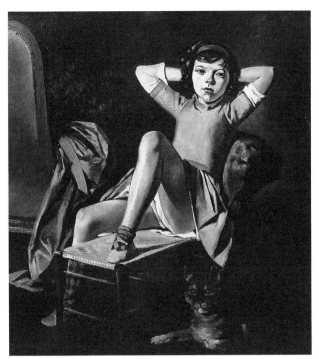

Figure 5. Balthus. *Girl with a Cat,* 1937. Oil on canvas, 88 x 78 cm. Art Institute of Chicago (photo: Eric Pollitzer)

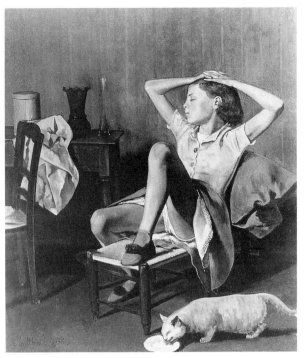

Figure 6. Balthus. *Thérèse Dreaming,* 1938. Oil on canvas, 150 x 130 cm. The Jacques and Natasha Gelman Collection (photo: courtesy Pierre Matisse Gallery)

pubescent girl creates not only an undercurrent of tension, but also an uneasiness that many viewers, especially women, confess to experiencing in front of these pictures. Malaise seems to lurk in these interiors, a tension between "the commonplace and the disquieting, between innocence and blatant immodesty, privacy and public display."[2]

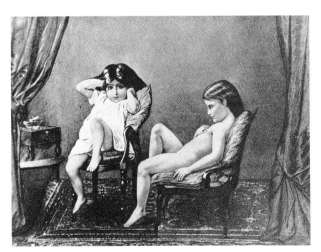

Figure 7. Man Ray. *Photocollage.* Reproduced in *Minotaure* 3 (1935)

The dichotomy between the painter's desire for and empathy with the adolescent girl finds a formal analogy in her titillating posture, which is then severely disciplined by a pictorial order of architectural rigor. It gives these works an added poignancy, which Cyril Connolly described as "the almost deliberate opposition between the choice of subject and the treatment, a kind of counterpoint between them."[3] Another critic described it as the "coexistence between surface calm and predatory desire,"[4] while the French writer André Pieyre de Mandiargues went so far as to say that these pictures are about "impending rape."[5]

Balthus insists that he cares only about structure. His explicit denials of any possible eroticism, however, only add to the ambiguity of these pictures. It is in Balthus's spirit of feigned ignorance that his older son, Stanislas Klossowski (born 1942), suggests in his slim monograph on Balthus that his father's adolescent models belong to an elevated company of muses. He writes that these young girls are "emblematic archetypes belonging to another, higher realm. Their very youth is the symbol of an ageless body of glory, as adolescence aptly symbolizes that heavenward state of growth which Plato refers to in the *Timaeus.*"[6] Balthus's depictions of children are indeed based on earlier prototypes—not, however, the timeless heavenly ones suggested by his son, but willful, nineteenth-century literary ones. His

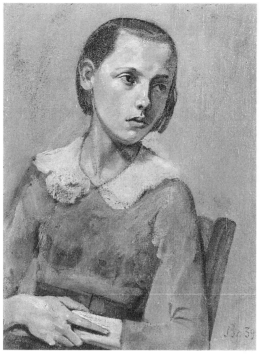

Figure 8. Balthus. *Thérèse*, 1939. Oil on canvas, 61 x 46.4 cm. Private collection (photo: private collection)

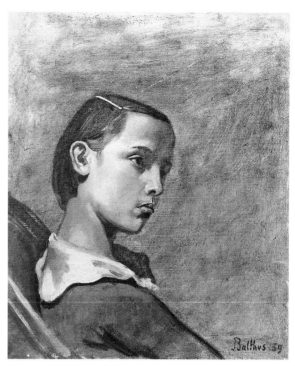

Figure 9. Balthus. *Thérèse*, 1939. Oil on canvas, 55 x 46 cm. Private collection (photo: private collection)

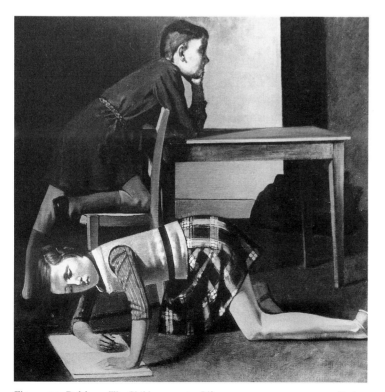

Figure 10. Balthus. *The Children*, 1937. Oil on canvas, 125 x 129 cm. Paris, Musée du Louvre, Donation Pablo Picasso (photo: Musée Picasso)

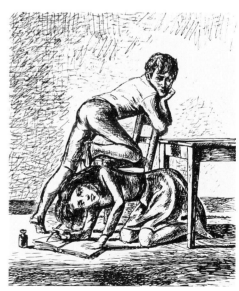

Figure 11. Balthus. "I have got the time on with writing for twenty minutes." Illustration for *Wuthering Heights*, ca. 1934–35. Ink on paper, 25 x 24 cm. Private collection (photo: private collection)

Figure 12. John Carlin. *Forbidden Fruit*, 1874. Oil on canvas, 31 x 25 cm. New York, Hirschl & Adler Galleries (photo: courtesy Hirschl & Adler Galleries)

Figure 13. Anonymous artist. Painting of a girl reading, ca. 1870s. Present location unknown (photo: Sabine Rewald)

fascination with the ambiguities and the dark sides of adolescence corresponds to his infatuation with Emily Brontë's novel *Wuthering Heights* (1848). Balthus was the first artist to attempt, without being commissioned, to illustrate this English novel, which had never been illustrated in France before. Balthus was interested only in the strange childhood of Cathy and Heathcliff on the Yorkshire moors. His final illustrations, dating from 1934 to 1935, therefore cover only the first part of the novel. Balthus identified deeply and personally with this book and gave Heathcliff his own features, while Cathy has those of his future wife, Antoinette de Watteville (1912–1997). Because of his arbitrary interpretation of Brontë's novel, Balthus never found a publisher for his venture. The illustrations, however, did provide him with an opportunity to work with his most personal theme—adolescents isolated in rooms closed to the outside world. In fact, these illustrations form the sources for most of his later works and their variations until today.

The best known of these is Balthus's painting *The Children* of 1937 (Figure 10). This painting—once owned by Picasso—is based on the second of his fourteen illustrations of 1934–35 for *Wuthering Heights* (Figure 11), as indeed are many later variations of this

work done down to the mid-1970s. Again the forbidding austerity of his cour de Rohan studio served as a background in which Thérèse Blanchard posed with her younger brother Hubert. Both children seem much at home in the harsh empty interior, which does not inspire playfulness. But then his children never seem to feel like playing anyway. Their everyday clothes—his schoolboy's classic black smock and her pleated skirt, sleeveless vest, and striped shirt—match the simplicity of the setting. In a never-ending, eventless afternoon, these self-absorbed children seem as remote from each other as they are from the viewer.

How much the stark setting in *The Children* contributes to the painting's impact becomes apparent when the work is compared with similar yet saccharine images of pensive or brooding children by Victorian painters (Figures 12, 13). These artists cast their children as pretty objects in overstuffed interiors together with bowls of fruit, mantel clocks, patterned table covers, and pets.

Balthus's penchant for focusing particularly on the ambiguities of adolescence relates to certain writers and poets who also explore that theme in their works, among them Robert Musil (1880–1942), Rainer Maria Rilke (1875–1926), and Jean Cocteau (1889–1963).

Figure 14. Félicien Rops. *Puberty*. Lithograph reproduced in Jean-François Bory, *Félicien Rops: L'Oeuvre graphique complète* (Paris, 1977, p. 656)

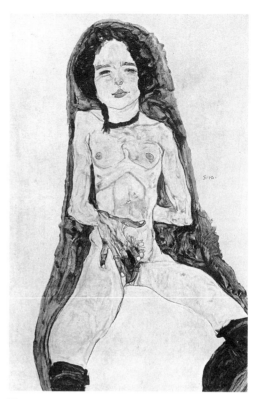

Figure 15. Egon Schiele. *Young Girl*, 1910. Gouache on paper. Bloomington, Indiana, Institute for Sex Research, Indiana University (photo: courtesy Institute for Sex Research)

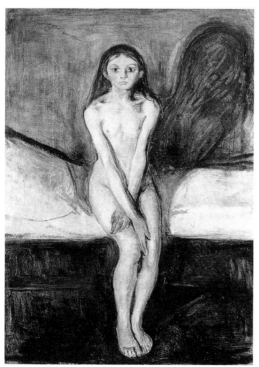

Figure 16. Edvard Munch. *Puberty,* 1894–95. Oil on canvas, 151.4 x 110 cm. Oslo, Nasjonalgalleriet (photo: Nasjonalgalleriet)

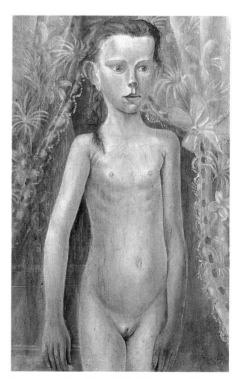

Figure 17. Otto Dix. *Little Girl*, 1922. Oil on canvas, 80.5 x 50.8 cm. The Minneapolis Institute of Arts (photo: The Minneapolis Institute of Arts)

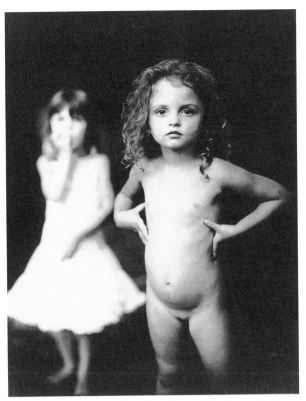

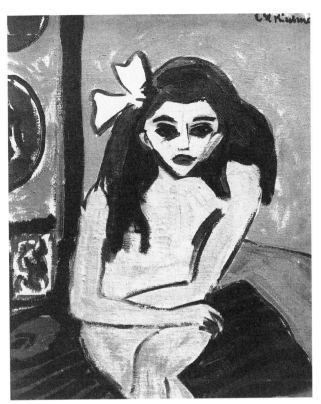

Figure 18. Sally Mann. *Victoria at Four*, 1989 (photo: Sally Mann)

Figure 19. Ernst Ludwig Kirchner. *Marzella*, 1909–10. Oil on canvas, 71.5 x 61 cm. Stockholm, Moderna Museet (photo: Moderna Museet)

In his novel *Young Törless* (1906) Musil describes his adolescent hero's sexual and emotional confusion with as much empathy as if it were told by the boy himself. When Törless escapes into one of his habitual states of complete self-absorption, Musil might be describing young Hubert Blanchard staring into space in *The Children* of 1937: "He thought of nothing, yet was within himself completely occupied. At the same time he observed himself, however, in such a way as if he really looked into the void and perceived himself only as if in an unclear glimmer from the side."[7]

Similarly, the following lines from Rilke's poem "Dauer der Kindheit" (Childhood), written on July 5, 1924, evoke the mood of Balthus's interiors with the Blanchard siblings.

A child's long afternoon
not yet fully alive, still maturing
subject to growing pains
helpless period of waiting . . .
lonely afternoons
gazing from one mirror to another[8]

Rilke always stressed the importance of childhood. The German poet's own childhood, which he regard-ed as unhappy, often served as inspiration for his poetry and prose. Analogies exist between the Rilkean fey world of childhood and the world of Balthus, in whose paintings boys also play only passive roles. If in Balthus's paintings girls and cats dominate, in Rilke's world "only children and women, both young and old, feel at home."[9]

Rilke's and Balthus's children share an air of remoteness and lassitude. Those of Rilke, during their endless afternoons when "nothing happens be it to a thing or an animal," when "loneliness started and lasts until today,"[10] are susceptible to

rain which reduces the entire afternoon to a
single hour, which is not registered by the hour's
chime and which lasts as long as childhood after
 noons
during which one reads with one's head between
 one's fists.[11]

By their capacity for complete self-absorption, Balthus's adolescents also find literary counterparts in the brother and sister Paul and Élisabeth featured in Cocteau's novel *Les Enfants Terribles* (1929), who, living in closed rooms, spend much time in that "state

311

Figure 20. Angel Franco. *Eight-Year-Old Yanela Netier in Her Family's Apartment in Havana, Cuba, January 1998* (photo: Angel Franco, *The New York Times*)

of semi-consciousness in which children float immersed."[12] Their mode of existence, as dreamlike and removed from adult interference as is Cathy and Heathcliff's on the Yorkshire moors, makes of them neurotic, worldly twentieth-century Parisian counterparts. Paul and Élisabeth live in mental and physical disarray in a cluttered room in which most of the story unfolds. These children "fall silent before the approach of older people. They fall silent and resume the ways of another world. As accomplished play actors they can suddenly bristle like a porcupine or arm themselves with the humble sweetness of a plant, without ever revealing the obscure rites of their religion."[13]

We may also draw analogies between this atmosphere, which Cocteau described at the beginning of his novel, and that of Baladine Klossowska's (1886–1969) small two-room apartment in Geneva, where she lived with her two sons, Balthus (born 1908) and Pierre (born 1905), from 1919 until 1921, and later that of her Paris studio on the rue Malbranche, where they lived from 1926 until the early 1930s. Elsewhere I have discussed in detail how Baladine Klossowska's unorthodox upbringing and surroundings influenced the art of her two sons.[14]

Of course, Thérèse in *Thérèse Dreaming* of 1938 might also have appealed to the middle-aged Humbert Humbert of Nabokov's *Lolita* (1955), who has an obsession for "nymphets" between the ages of nine and fourteen, for their "fey grace, the elusive, shifty, soul-shattering, insidious charm."[15]

The eroticism of Balthus is ambiguous, implied and not explicit, seductive and not openly inviting. In Balthus's art, with few exceptions, there is no overt sexuality, the kind other artists have shown in their representation of pubescent girls: salaciously, as in Félicien Rops's lithograph *Puberty* (Figure 14), provocatively, as in Egon Schiele's gouache of a young girl masturbating of 1910 (Figure 15), frightened by forebodings, as in Edvard Munch's *Puberty* of 1894–95 (Figure 16), or with a sense of vulnerability, as in Otto Dix's *Little Girl* of 1922 (Figure 17), one that is echoed in Sally Mann's photograph of 1989 of her provocatively strutting nude child (Figure 18). This unsettling undercurrent in Balthus's works does find analogies in Ernst Ludwig Kirchner's paintings of his twelve-year-old models, Fränzi and Marzella, as for example in *Marzella* of 1909–10 (Figure 19).

The Balthus adolescent has now become a trademark in film, advertisement, and fashion, and surprisingly, served recently as an inspiration for a documentary photograph on poverty in Cuba (Figure 20). In the film *Still of the Night* of 1982, the director Robert Benton used the image of the little girl in a suggestive pose

Figure 21. Scene from Robert Benton's film *Still of the Night*, 1982 (photo: United Artists Corporation)

Figure 22. Calvin Klein advertisement, August 1994 (photo: Steven Meisel)

and wearing a white shirt and white socks (Figure 21). Her appearance at once evoked works like *Thérèse Dreaming* of 1938 or its later variants. The figure appears in the dream of the film's main character, whose sub-conscious—as Benton explained in a letter to this author—"was dealing with a woman who was both innocent and erotic, therefore it would be natural for him to dream in terms of Balthus's imagery."[16]

In the early 1980s, the adolescent featured in Benton's film was still based on the Balthus model. Similar figures channeled into advertising in the mid-1990s are so no longer. The underage models appearing in recent Calvin Klein ads, either sickly, strung-out and sulking, or titillatingly beckoning (Figure 22) make their Balthusian prototypes now look quaintly wholesome and somewhat over the hill. Or do they?

NOTES

1. Man Ray's photocollage accompanied Paul Éluard's essay "Appliquée," *Minotaure* 3 (June 1935) p. 16. This photocollage was based, in turn, on the painting *After Dinner* of 1886 by the Victorian painter Émile Munier (1810–1895), which was used in a Pears' Soap advertisement. See Sabine Rewald, *Balthus*, exh. cat., MMA (New York, 1984) p. 42.

2. R. S. Short, "Erotically Lounging," *Times Literary Supplement* (Sept. 1983) p. 1063.

3. Cyril Connolly, *Balthus and a Selection of French Paintings*, exh. cat., Lefevre Gallery (London, 1952) n.p.

4. Robert Hughes, "Poisoned Innocents, Surface Calm," *Time* (April 16, 1984) p. 76.

5. André Pieyre de Mandiargues, conversation with the author, Paris, July 24, 1982.

6. Stanislas Klossowski de Rola, *Balthus* (New York, 1983) p. 10.

7. Robert Musil, "Die Verwirrungen des Zöglings Törless" (1906) in *Sämtliche Erzählungen* (Hamburg, 1968) p. 71.

8. Rainer Maria Rilke, *Sämtliche Werke* 1 (Wiesbaden, 1955–56) pp. 290–291.

9. Richard Kassner, *Gesammelte Erinnerungen 1926–1956*, Klaus E. Bohnenkamp, ed. (Pfullingen, 1976) p. 6.

10. Rainer Maria Rilke, *Briefe aus den Jahren 1906–07*, Ruth Sieber Rilke and Carl Sieber, eds. (Leipzig, 1930) p. 292.

11. Idem, "Kindheit," in *Sämtliche Werke*, pp. 510–511.

12. Jean Cocteau, *Les Enfants Terribles* (Paris, 1979) p. 23.

13. Ibid., p. 9.

14. See Sabine Rewald, "Balthus Lessons," *Art in America* 9 (Sept. 1997) pp. 88–95, 120–21.

15. Vladimir Nabokov, *Lolita* (Berkeley, 1977) p. 18.

16. Robert Benton, letter to the author, Feb. 9, 1983.